D0516542

# New York Modern

The Arts and the City

# NEW YORK MODERN

William B. Scott
and Peter M. Rutkoff

The Johns Hopkins University Press
BALTIMORE AND LONDON

© 1999 The Johns Hopkins University Press
All rights reserved. Published 1999
Printed in the United States of America on
acid-free paper
9  8  7  6  5  4  3  2  1

The Johns Hopkins University Press
2715 North Charles Street
Baltimore, Maryland 21218-4363
www.press.jhu.edu

Library of Congress Cataloging-in-Publication Data will
be found at the end of this book.
A catalog record for this book is available from the
British Library.

ISBN 0-8018-5998-0

*To our children*

Ansley, Joshua, Laine,
Rebekah, and Scott

and to Charles and
Sylvia Rutkoff

Dada is impossible in New York. New York is Dada.

MAN RAY, 1919

# CONTENTS

# ILLUSTRATIONS

Illustrations

In writing *New York Modern* we have accumulated an enormous number of debts. The most important scholarly debts are to the countless researchers on whose work we have drawn. In our endnotes we have cited the most significant of these. The most important institutional debts are to the National Endowment for the Humanities and Kenyon College. We each received individual fellowships from NEH as well as a two-year project grant. We also received a number of faculty development grants and publication stipends as well as sabbatical leaves from Kenyon College. Quite simply, without their generous support we could not have completed this book.

Other institutions provided generous access to their research collections and their staff members offered valuable assistance—most importantly, the Archives of American Art and the American Museum of Art at the Smithsonian Institution, the Olin Library at Kenyon College, and the Ohio State University libraries. We also received help from the Sterling, Drama, Music, and Beinecke libraries at Yale University, and in New York City the Avery and Butler libraries at Columbia University, the Bobst Library at New York University, the New York branch of the Archives of American Art, the Whitney Museum of American Art, the Museum of Modern Art, the New York Public Library and its research branches at the Schomberg Center for Research in Black Culture, the libraries of Dance, Music, and Drama at the Lincoln Center Library for the Performing Arts and the Lincoln Center Archives, as well as the Museum of the City of New York, the New York Historical Society, and Marlborough Galleries. We also researched in the collections of the Library of Congress and the National Archives in Washington, D.C., the Syracuse University Library, the Newberry Library in Chicago, the University of Texas Library, the South Carolina Historical Society, the Charleston County Library, and the Charleston Museum, the Avery Center for Research in African-American Culture and the Scott Library at the College of Charleston, the Philadelphia Museum of Art, the Wexner and Music libraries at the Ohio State University, the Brooklyn Museum of Fine Art, the Delaware Art Museum, the Oberlin College Library, the Amherst College Library, the Dartmouth University Library, the Goodyear Library at Princeton University, the Institute of Jazz at Rutgers University, Newark, the University Library at the University of Southern Illinois at Carbondale, the Art Institute of Chicago, the Cleveland Art Museum, and the Columbus Museum of Fine Arts.

We received encouragement and support from a number of individuals. Of special importance was Tom Bender at New York University who provided early guidance and advice. Equally important was the help we received from George Roeder at the Art Institute of Chicago who read the entire manuscript and offered important suggestions. Paul Conkin of Vanderbilt University, David Hollinger of the University of California, Berkeley, and Patricia Hills of Boston University offered critical advice and, more importantly, generous support. In a real sense, however, *New York Modern* began and ended with Henry Tom, our editor at the Johns Hopkins University Press, who at critical junctions enabled us to better conceptualize our story.

Acknowledgments

Others who made particularly important contributions are Martin Garhart of the Kenyon Art Department, Garnett McCoy at the Archives of American Art, and John Agresto at St. John's College in Santa Fe. We are also indebted to Jerry Irish of Pomona College, Reed Browning of Kenyon College, the late Martin Williams at the Smithsonian Institution, the late Richard Pommer of Vassar College, Barbara Tischler of Barnard College, and Daniel Singal of Hobart and Williams College. Our colleagues in Tom Bender's NEH Seminar on American Cities and in Richard Pommer's NEH Seminar on Architectural Modernism contributed immensely to our understanding of New York City and the modern arts. We are indebted in a variety of ways to former Kenyon colleagues Robert Hinton at the University of Wyoming, Vivian Conger of Charlotte, North Carolina, Lori Lefkovitz of Philadelphia, and Joan Cadden of the University of California, Davis. We received help from Helen Farr Sloan of Wilmington, Delaware, Betty Radens of the Fieldston School, Bronx, New York, Judith Zilczer of the Hirshhorn Museum, Judy Throm of the Archives of American Art, Judith Johnson of the Lincoln Center Archives, Madeline Nichols at the Dance Division of the New York Public Library for the Performing Arts at Lincoln Center, Wayne Shirley of the Music Division of the Library of Congress, Anita Daquette of the Whitney Museum of American Art, Karen Ecdahl of the Museum of Modern Art, Bennard Perlman of Baltimore, Sherman Pyatt of the Avery Institute, Jack Saltzman, editor of *Prospects,* David Lynn, editor of the *Kenyon Review,* Steve Schwerner of Antioch College, Gordon Davidson of the Mark Taper Forum in Los Angeles, Adam Davidson of New York City, Wendy Cadden of Oakland, California, Nina Freedman of New York City, Larry Chastain of Greenville, Texas, and Katherine Kimball and Carol Zimmerman, our editors at the Johns Hopkins University Press.

At Kenyon we acquired many debts, only a few of which we are able to acknowledge. We especially wish to thank, however, George McCarthy, Wendy Singer, Rita Kipp, Fred Kluge, Melissa Dabakas, Lewis Hyde, Kim McMullen, Micah Rubenstein, Tom Bigelow, and Linda Michaels. Mary Hopper, Jenny Zolman, and Christy Rigg patiently and ably prepared the many drafts of the manuscript. In preparing the final manuscript Jean Demaree saved us from numerous errors and compiled the index. We are also indebted to our many students both at Kenyon and those who attended the Kenyon NEH Summer Seminars on the "American Scene." They listened politely to our ruminations and offered insightful comments. These include Kelli Stenstrom, Melissa Skilken, James Carrott, Sarah Jaicks, Mary Chalmers, Deborah Doolittle, Carol Mason, Bibby Sullivan Terry, Alex Mikan, and Arlene Dowd. We also thank our Kenyon/School College Articulation Program History colleagues who over the last several summers have addressed with us many of the issues raised by *New York Modern.*

One of the joys of writing recent history was the opportunity to interview many of the individuals who played important roles in our story. These included composer John Cage, photographer Berenice Abbott, art historian Meyer Shapiro, poet Allen Ginsberg, music historian Vivian Perlis, painter Raphael Soyer, dramatist Stella Adler, architect Philip Johnson, playwright Arthur Miller, musician Dizzy Gillespie, artist Mimi Gross, art historian Lloyd Goodrich, and gallery owner Bela

Fishko. Because of their generosity we came to "know" our subject in a personal manner rarely allowed historians.

Last, and above and beyond all else, we wish to thank our families who endured much, complained little, and constantly supported and encouraged us—especially Donna. *New York Modern* is dedicated to our postmodern children—Ansley, Joshua, Laine, Rebekah, and Scott and to the devoutly modern Charles and Sylvia Rutkoff.

Between 1876 and 1976, New York artists created an artistic culture that redefined "the modern." Rooted in the American urban realism of Walt Whitman, Thomas Eakins, and Edith Wharton, New York Modern assimilated the revolutionary ideas and styles of European modernism and the vernacular images drawn from American commercial, folk, and popular culture. Even as they adopted the vocabulary of European modernists, New York artists never abandoned their realist preoccupation with modern life as manifested in New York City. Frequently expressed abstractly, at times radically so, the subject of New York Modern remained urban life, in all its elusive complexity and variety.

In the modern arts of painting, music, drama, sculpture, dance, photography, and architecture, New York artists reflected, analyzed, and helped to construct their city. The locales and details of New York, with its bustling economy, diverse peoples, and incipient egalitarianism, offered a vast array of subjects, which its artists depicted from a variety of perspectives—narrative and expressionist, factual and mythical, rhythmical and dissonant, formal and improvisational. Across styles and mediums, New York artists addressed modern urban life. They listened and responded to the cacophony of voices that echoed through the city's bars and cafés, tenements and town houses, and skyscrapers and docks. They deemed New York the quintessential modern city, a microcosm of the contemporary world.

Within New York's boisterous and irreverent confines, New York Modern emerged, the confluence of a long-standing tradition of urban realism, a more recently arrived European modernism, and the ever present, ever changing American vernacular. Except for brief moments, New York's complexity made it impossible for any single school, academy, museum, or patron to establish a dominant style or aesthetic canon. The city's artists proved ungovernable. Like New York's contentious populace, its artists refused to accept any unified, prescriptive notion of the modern. Instead, by the late 1950s, New York Modern had matured into an artistic culture that celebrated diversity and controversy. New York Modern was neither a style nor a school; rather, it was an artistic dialogue—part engagement, part resistance, part alienation, part celebration—that invited artists from a variety of backgrounds and with divergent concerns to voice their own understandings of modern life.

As makers and interpreters of modern culture, New York artists shaped American life. The images they created led Americans to reimagine contemporary life and to reconstitute their own lives and communities consistent with the urban values that underlay New York Modern. Much of contemporary American culture, from advertising to political rhetoric, derived from the rich imagery created by New York's modern artists. The city's artists, in turn, drew on images that they discovered in America to give their art an explicitly American cast, accessible to a broad national audience.

A hallmark of New York Modern has been its antiacademicism, in part, a consequence of its urban, New York provenance. To succeed, New York artists had to please demanding constituencies—fellow artists, private patrons, newspaper crit-

ics, and a public that read critical reviews in their daily newspapers, purchased art, attended concerts and exhibitions, and visited galleries. New York artists lived in the city; they confronted it daily, and when successful, they became public figures, subject to scrutiny and judgment. Their work was never simply their art. It was also New York's art.

Since New York's founding as an outpost of the Dutch empire in the seventeenth century, the city has undergone constant, sometimes extraordinarily rapid, change, its fortunes tied to capitalist enterprise and, since the eighteenth century, also to democratic politics. In the nineteenth century, industrial manufacturing, commerce, and transportation transformed New York from a small North Atlantic seaport into one of the largest, most dynamic, and wealthiest cities in the world. No other city changed as rapidly and as profoundly. Washington Irving's tale of Rip Van Winkle, who awoke from a long sleep to an entirely reconstructed world, was a New York City fable. Almost daily, New Yorkers have awakened to a city different from the one they had known the night before—with different shops, different fashions, different technology, and different people. This constant change—the building and rebuilding, the struggle for power among a segmented and diverse elite, the confrontation between the newly arrived and the already established, and above all, the efforts of successive avant-gardes to institutionalize their artistic vision—shaped New York Modern.

In the aftermath of the Civil War, New York became the center of American art when it eclipsed its earlier rivals, like Boston and Philadelphia. By 1890, American art was largely New York art. New York's dominance of American visual and performing arts lasted a full century. In this span New York art also achieved international prominence. By the eve of World War I, the city had become a major center of modern art, comparable in stature to Berlin and Vienna. After the Nazi occupation of Paris in 1940, New York became the center of the modern arts, a status held unchallenged until the 1970s. It is unlikely that a single city will so dominate art again.

Until the mid-twentieth century, only a few New York artists supported themselves exclusively as artists or held tenured academic positions. Most painters taught or engaged in commercial art. Architects designed offices, train stations, and private homes to suit private and public patrons, while dramatists, actors, composers, and dancers frequently turned to the world of Broadway entertainment for their livelihood. The intimate tie between art and commerce, between inspiration and making a living, influenced New York art. In twentieth-century New York, the absence of clear boundaries between art and employment, entertainment and commerce, or even between social classes exposed its artists to a wide range of experiences that expanded the reach and scope of New York Modern while undermining the assumptions of upper-class taste. In the seat of class-ridden Western capitalism, New York Modern often expressed explicitly democratic values and anticapitalist sentiment. By the 1960s the notion of fine art, with all its upper-class connotations, had become an anachronism in New York.

Once the exclusive province of white Protestant males, New York's visual and performing arts embraced, haltingly and incompletely, the change and variety of its in-

habitants. As the city became ethnically and racially more diverse between the world wars, so too did its artistic communities. By the 1960s, African Americans, women, and homosexuals had secured a place, although a narrow one, among New York's recognized artists. Until the 1980s, however, the city's newest immigrants, the Hispanics and Asians, were excluded.

New York has always been racially divided, despite a tradition of civic tolerance. African Americans had lived and worked in New York for more than three hundred years. Yet, because of their systematic exclusion from much of the city's life, they constituted an almost permanent racial avant-garde at odds with the city's political establishment and its cultural institutions. A part of New York, but apart from it, Harlem has served as the cultural capital of African America, a place of refuge and inspiration for the nation's black intellectuals, writers, and artists. Since World War I, Harlem has exerted a powerful force on New York and its art and demanded that modern New York and New York Modern include all New Yorkers, not just its European descendants. In turn, Harlem's artists and writers infused New York Modern with a new vitality and an openness to non-European ideas and expression.

*New York Modern* is the history of the articulation of a modern artistic culture that took place in twentieth-century New York. Our analytical narrative addresses the historical events and contexts in which the modern arts emerged, in part as an articulation of those events and contexts and in part as a response to those very events and contexts. Apart from examining the art and artists of New York Modern, much as Victor Turner advocated in *From Ritual to Theater* (1982), we address the "world" in which New York modern artists lived and worked. We also provide the kind of "thick description" that Clifford Geertz has championed, in *The Interpretation of Cultures* (1973) (see also Roger Abrahams, *The Man-of-Words in the West Indies: Performance and the Emergence of Creole Culture* [1983]). That is, we look in detail at both the larger community to which New York artists belonged as well as the particular artistic medium and context in which they worked. Equally important is the dynamic relation between the never entirely separate public and artistic worlds as each affected the other (see Sacvan Bercovitch, *The Rites of Assent: Transformations in the Symbolic Construction of America* [1993], and Betsy Erkkila and Jay Grossman, *Breaking Ground: Whitman and American Cultural Studies* [1996]). The connections between the public and the artistic gave to New York Modern its significance as well as its historical vitality. New York Modern emerged just before World War I, established its public identity between the world wars, reached its apotheosis in the two decades following World War II, and reconstituted itself during the turbulent 1960s and 1970s. New York Modern was never a fixed, well-defined artistic style nor an aesthetic canon but was, rather, a seventy-five-year artistic and political dialogue over the nature of modern art and its relation to modern life.

We use the term *modern* to denote the broad range of art produced by artists who defined themselves as modern. We use *modernism,* or *modernist,* in reference to the much narrower, but still broad, range of European art that consciously rejected realism and historicism. European "modernists" insisted that art should not be mimetic, should not correspond to sensory experience, but rather should express artists' inner consciousness, their subjective perception of sensory experience. As such,

modernism included, but was not limited to, such postimpressionist movements as cubism, expressionism, dada, and surrealism. The Museum of Modern Art, under the directorship of Alfred Barr, sought to formalize the definition of modern art. Following World War II, art critic Clement Greenberg narrowed this formalistic modernism even further by emphasizing style over content and by radically divorcing art from politics and social context. In contrast, we use *modern* to denote all postimpressionist art, *modernism* to denote nonmimetic European or European-inspired art, and *formalistic modernism* to denote the essentialized definition of modern art advanced by Alfred Barr at the Museum of Modern Art and popularized by Clement Greenberg.

Whether or not the modern era has come to a close, New York dominance of modern art has ended. The economic revival of Europe and Asia, the growing prosperity of Latin America, and the emergence in North America of other powerful and wealthy metropolitan centers have substantially reduced New York's economic power and cultural influence. No city will ever again dominate Western art, certainly not world art, as New York did after World War II.

# New York Modern

# Before the Modern
## The New York Renaissance

On the evening of March 31, 1895, following the closing of Chicago's Columbian Exposition, New York's three hundred most notable artists and patrons gathered in Madison Square Garden to honor the fair's chief architect, Daniel H. Burnham. Bordering New York's most prestigious public square, Madison Square Garden seemed built for the occasion. Arriving by carriages in livery, New York's fin de siècle tastemakers, dressed in top hats, black tie, and tails and accompanied by their glitteringly attired female companions, leisurely entered Stanford White's resplendent Madison Square Garden, whose Florentine tower held aloft the colossal bronze sculpture of Diana, Greek goddess of the hunt.[1]

Pressing into the Garden's inner court, the guests glimpsed banquet tables set with cut flowers, fine crystal, silver, and linen. The ballroom itself was bedecked with evergreens and palms and "three immense crimson banners" suspended from the ceiling, "each bearing a wreath of gilded laurel"—on one inscribed the word *Painting,* on another *Architecture,* and on the third *Sculpture.* The men assembled in the ballroom, while, in conformance with Victorian custom, their wives and consorts looked on approvingly from the gallery above. The Hungarian Band provided light music. Afterward, with the lights dimmed, the male guests broke out cigars while everyone viewed a stereoscopic presentation of Chicago's *White City.*

When the light show ended, Richard Gilder rose from his seat at the table of honor and raised his champagne glass, ostensibly to toast Burnham and the Chicago World's Fair. Gilder and his artistic friends had convened to honor Burnham's Columbian Exposition but also to celebrate the triumph of New York's beaux arts renaissance—the crowning moment of American Victorian art. For the occasion, Gilder composed a poem, *The White City.* He toasted the Columbian Exposition and the neoclassical American renaissance, which he and his fellow New York hosts had orchestrated. To them, finally, American art stood on equal footing with that of Eu-

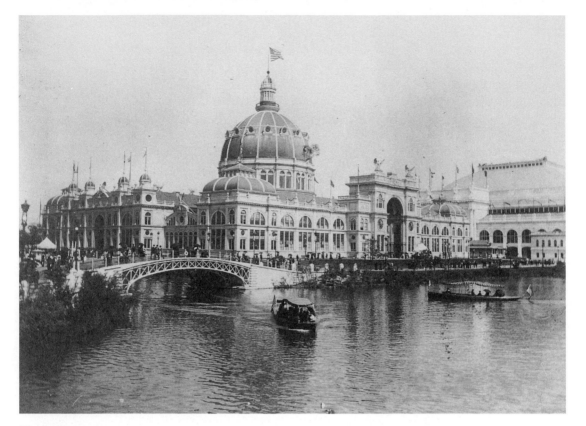

The American renaissance on exhibit at the Columbian World Exposition, Chicago (1893). Beaux arts Court of Honor and Lagoon. *Library of Congress*

rope. Burnham and the Chicago World's Fair, in effect, proclaimed New York's artistic preeminence.

In the nineteenth century New York had become a world city. Its dramatic growth resulted in the proliferation of near-uninhabitable slums, a dramatic increase in crime and violence, filth, political corruption, and a pervasive fear, creating among its social elite a sense of despair. Nationally, too, events had shaken the confidence of New York's genteel leaders. In response to the failure of southern Reconstruction, widespread labor violence, and the embarrassment arising from Philadelphia's 1876 Centennial World's Fair, New York's Gilded Age millionaires sprang into action. They initiated political reforms, encouraged a variety of municipal projects directed at the poor, and patronized the American renaissance, a movement modeled after the Académie Française that was intended to create a national culture. As a result, in the three decades following the Civil War, the New York artists of the American renaissance, led by the architectural firm of McKim, Mead, and White, altered the character of American public spaces and established an American style based on beaux arts neoclassicism. The American renaissance derived from European, aristocratic, even antimodern sources, but it constructed the aesthetic foundation for urban America, freeing American art from the morbid shadows cast by the Civil War and a rural-oriented Protestantism.

New York artists dominated the American renaissance, much as the city's busi-

ness leaders commanded the nation's economic life. The wealth of New York's up-start millionaires, with their insatiable appetite for fine art and their propensity for conspicuous display, drew artists from throughout the United States. Gilded Age New York became the center of American art. In the last quarter of the nineteenth century, the artists of the American renaissance refashioned the nation's public art from a hodgepodge of regional styles into an elegant and urbane national aesthe-tic. Across the nation, public spaces—courthouses, libraries, statehouses, public squares, churches, railway stations, streets, bridges, statuary, parks, auditoriums, and museums—conformed to the beaux arts neoclassicism of New York's renais-sance. American cities, heretofore without civic grandeur, followed suit, reconsti-tuting themselves as centers of urban culture, built in the image of New York.[2]

The term *American renaissance* expressed the national vision of New York's New Movement, but its name obscured its explicit urban outlook and its New York ori-gins. *New York renaissance* would have been a more accurate term, but it would have betrayed the movement's metropolitan vision, which insisted on representing itself as an American art. To be metropolitan, declared New York art critic Herbert Croly, a city "must not only reflect large national tendencies, but it must sum them up and transform them. . . . A genuine metropolis must be . . . both a concentrated and se-lected expression of the national life."[3] By 1900, New York stood apart from other American cities. Like Paris, London, and Berlin, it had become its nation's metro-politan city.[4]

The American renaissance altered and dramatically expanded American public art, infusing it with a neoclassical aesthetic influenced by European academic art. More in harmony with Roman imperialism than American democracy, the Ameri-can renaissance endowed the nation with a unifying civic culture at a time of im-mense economic and social conflict. Like the White City, it created a facade of social cohesion, political stability, and domestic harmony. The renaissance's ideal-izations of beauty, peace, prosperity, and virtue masked the nation's bourgeois and industrial foundation, its economic and social inequities, its political compromises and racial divisions, its oppression of women, and its sexual obsessions—in short, its modernity. Late-Victorians, the artists of the American renaissance, uninten-tionally heralded the modern.[5]

The American renaissance, or the New Movement, was not an isolated phe-nomenon. It took place within the context of New York's metamorphosis into a met-ropolitan city. By 1870, much of Manhattan had been developed, and the metropol-itan population had doubled to about 1.5 million. In the last quarter of the nineteenth century the city's metropolitan population exploded to 3.5 million people.[6] Although rich in wealth and people, New York on the eve of the Civil War seemed culturally impoverished in comparison with London, Paris, Rome, and Vienna. Bereft of pub-lic parks, the city supported a meager public school system, no public library to speak of, no art museum, neither zoological nor botanical gardens, and no real university. Urban but not urbane, at midcentury New Yorkers lacked civic pride or even a col-lective identity.[7]

At the same time, New York had earned a reputation for its male-dominated sport-ing life. On the Bowery and along Sixth Avenue, men flocked to nude girlie shows,

gathered at saloons, cheered at cockfights, gambled recklessly at cards, dice, and horses, and frequented the city's legions of male and female prostitutes. At night, no respectable woman willingly walked its streets unescorted. New York women faced the unhappy choice of remaining sequestered in their homes at night, being accompanied wherever they went, or being accosted on the streets as prostitutes.[8] Concerned citizens responded in two ways. Religious zealots like Anthony Comstock led an unrelenting campaign to purify the city by shutting down bars and bordellos, suppressing pornography, criminalizing abortion, and imposing their morality on the remainder of the city.[9] Others were as repelled by Comstock's puritanical fanaticism as by the city's flourishing sporting life. In the 1850s, New York civic leaders concluded that uncontrolled growth and greed had overwhelmed the city. They advocated tenement and civil service reform, orphanages, protective housing for young women, improved public education, and publicly sponsored and supervised recreation. Protestant in faith and metropolitan in vision, these civic reformers articulated the moral concerns and social ambitions of New York's growing middle classes and its cultural elite.[10]

Central Park was the most dramatic achievement of New York's pre–Civil War civic reformers. Between 1865 and 1905, propelled by the development of Central Park, Upper Manhattan became decidedly middle class. In the 1870s real estate developers built hundreds of apartment houses on the avenues and streets adjacent to Central Park to accommodate New York's expanding middle class. The completion of the Sixth Avenue elevated train in 1878 enabled middle-class families to live in comfortable Upper West Side apartments while husbands commuted to work downtown. By the 1880s, New York's middle classes had made the Upper West Side their own.[11]

New York's cultural institutions trailed the wealthy and polite classes northward. In 1870 the city built a permanent home for its popular menagerie in Central Park. On Central Park West, in 1877, the Museum of Natural History opened the doors of its brownstone, Victorian Gothic home designed by Calvert Vaux. In 1888, on the opposite side of the park, the Metropolitan Museum of Art constructed its own new building.[12] New York's prestigious art galleries also moved north, forming an uptown gallery row, just below Central Park, along 57th Street. On West 57th Street, Andrew Carnegie built Carnegie Hall to house the New York Symphony just two blocks east of the new Fine Arts Building, which accommodated the Society of American Artists, the Art Students League, and the Architectural League of New York—the institutional core of the American renaissance.

While the American renaissance expressed its ideals in a variety of mediums—painting, stained glass, sculpture, and murals—architecture defined the movement. New York's extraordinary post–Civil War growth offered its architects previously unimagined challenges and opportunities. The leading architects of the American renaissance—Henry Hobson Richardson, Richard Morris Hunt, and Charles McKim—received their professional training at the Ecole des Beaux-Arts in Paris. The architectural curriculum of the Ecole des Beaux-Arts rested on several principles, collectively known as "scientific eclecticism" or "scientific historicism." Drawing on archaeological information of earlier Western architecture,

Beaux-Arts-trained architects designed buildings to meet specific activities, expressing function through decorative detail and allusion to well-known structures that had served similar purposes.[13]

The training at the Ecole des Beaux-Arts underscored the primacy of public space and the need for architects to relate buildings to their surroundings. For American architecture students, having grown up in a nation with only modest public buildings and few public amenities, the Beaux-Arts's reverence for public space, couched in neoclassical monumentalism, came as a revelation.

The reconstruction of New York began in the 1870s, under the direction of Henry Hobson Richardson, Richard Morris Hunt, and the firm of McKim, Mead, and White. Together, they trained a generation of American architects who rebuilt New York in accord with the principles of beaux arts civic monumentalism. Between 1879 and 1910, McKim, Mead, and White, the most influential architectural firm of the American renaissance, executed more than three hundred commissions in the New York metropolitan region, establishing beaux arts neoclassicism as the New York style. The firm's three senior partners lived in New York and loved its "gaiety, festivity, light, and color."[14] Rejecting red brick neo-Gothic and brownstone, McKim, Mead, and White used light brick, marble, and glazed terra-cotta to design neoclassical structures that took advantage of incandescent lighting to create a city bathed in light and color. They employed skilled immigrant craftsmen and quoted freely from Italian Renaissance and classical architecture as well as from neoclassical English and American Georgian buildings. McKim, Mead, and White weaned New York architects from an earlier dependence on neo-Gothic styles rooted in medieval Christianity in favor of a neoclassical, urban humanism.

When added to the buildings and groupings by New York's other renaissance architects, the designs of McKim, Mead, and White shaped New Yorkers' perception of their city as a place of pride and pleasure. The American renaissance recast the city from a commercially driven, dreary expanse of brownstones, shops, factories, business offices, and tenements, bound by the city's street grid and tied together by a noisy and ugly elevated railway system, into an urbane city of small and large parks, promenades, and recreational wharfs, with a small zoo in Central Park and an aquarium at Battery Park, all undergirded by an efficient subway system. By 1900, New York's beaux arts reconstruction had replaced the earlier brownstone New York with a sophisticated and variegated beaux arts city. In its exuberant details and preposterous historicism, New York was at once ostentatious and wonderful. The architects of the American renaissance created enclaves that citified, civilized, and even plastered over the "other" New York. Now genteel women, as well as men, could delight in New York and the civic art created by its New Movement.[15]

The decade that followed the Civil War had been traumatic for the nation as well as for New York City. Extraordinary expansion of manufacturing and transportation in the United States had led to unprecedented urbanization and immigration in the face of a defiant white South, which resisted all efforts to dismantle its racial caste system. For the nation's upper and middle classes, 1876 and 1877 were especially disheartening years. The 1876 Philadelphia Centennial Exposition had been intended to celebrate the achievements of American democracy. Instead, except for the ex-

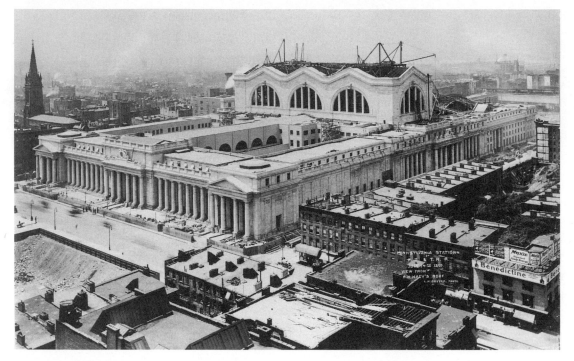

Beaux arts neoclassi-
cism defined late
nineteenth-century
New York City.
McKim, Mead, and
White, Pennsylvania
Station (1902–11).
*Photograph by L. H.*
*Dreyer. Avery Library,*
*Columbia University*

hibits on industrial technology, the Centennial Exposition publicly displayed the na-
tion's inferiority, in particular, its cultural poverty, its lack—by European academic
standards—of cultural refinement.[16]

Disillusioned by industrial violence, the failure of Reconstruction, and wide-
spread political corruption, Richard Gilder, New York civic leader and editor of the
influential *Century* magazine, believed that American artists, through a "new move-
ment," could create an uplifting and unifying national art that at one and the same
time would restore American social and political harmony and match European
artistic achievements. In Gilded Age New York, art replaced politics as New Move-
ment artists constructed an illusion of unity and order in a city of increasing diver-
sity and conflict.

Accustomed to the ambience of Paris after formal study in Europe, New Move-
ment artists sought out one another in New York. In the 1870s and 1880s many rent-
ed apartments and studios in the neighborhoods surrounding Washington and
Madison Squares and Gramercy Park. They secured institutional support nearby at
the National Academy of Design's Venetian Palace, on Fourth Avenue at 24th Street,
and at the 10th Street Studio Building, which architect Richard Morris Hunt had
designed in 1857 as a center for the city's artists. At first, the Metropolitan Museum
of Art, founded in 1870, virtually ignored American art, but its increasingly rich col-
lections gave New York artists convenient access to European masterpieces. New
Movement artists joined the Salmagundi, Lotus, Tile, Century, and Union League
Clubs and were welcomed at painter William Merritt Chase's studio in the 10th
Street Studio Building, the architectural offices of McKim, Mead, and White at 57

6

Broadway, Augustus Saint-Gaudens' 34th Street sculpture atelier, and, on Friday evenings, at Helena and Richard Gilder's "Studio" on East 15th Street, just off Union Square.[17]

Initially unwelcomed at the art school of the National Academy of Design, New York's young, European-trained artists turned to the newly organized Art Students League, a student-run art school. The Art Students League was founded in 1875 by a group of New York art students as an American equivalent to the Ecole des Beaux-Arts. The league rapidly became the most important art school in the United States, setting the standard for American art education until World War II. In the first ten years, enrollment at the Art Students League jumped to 423 students, with nine instructors, including William Merritt Chase and Augustus Saint-Gaudens.[18] Initially located on Fifth Avenue at 16th Street, in 1882 the league moved to larger quarters on West 14th Street. In 1892, it moved again, into the spacious new Fine Arts Building on West 57th Street, which it shared with the Society of American Artists and the Architectural League. At the Art Students League, which conducted its drawing and life classes much like those at the Ecole des Beaux-Arts, young American artists reconstituted the best of the European experience. Student control, comparable instruction for men and women, and European academic standards made the Art Students League a mecca for late-nineteenth-century American art students, and for women, it offered even better opportunities than Paris.

The New Movement appealed especially to the younger artists. Indeed, within ten years, membership in its newly formed Society of American Artists—created in protest against the old-boy policies of the older National Academy—became a virtual prerequisite for membership in the National Academy. By 1880 nearly every important American sculptor and painter had joined the New York–based Society of American Artists. While ability seems to have been the prevailing criterion for selection, the society defined merit in European academic terms. Of the 113 members in 1889, 85 had studied in Europe, most in Paris.[19]

Together, the Art Students League, the Society of American Artists, and the National Academy of Design gave the New Movement the institutional means to reshape American art in the image of Beaux-Arts Paris, just as McKim, Mead, and White rebuilt New York in conformity with beaux arts neoclassicism. Paradoxically, the New Movement brought American art into conformity with European academic standards at the very moment that rebellious French painters abandoned the Académie Française entirely. American artists' affirmation of academicism was not, however, fortuitous. New York renaissance artists were attracted to European academic art because it offered a cohesive and elegant civic culture. Overwhelmed by urban chaos and unrefined materialism, they believed that academic art would discipline American democratic impulse, transcend the nation's social and regional differences, and refine the tastes of American capitalists. Committed to social uplift and cultural refinement, the New York renaissance embraced the civic conformity of the Ecole des Beaux-Arts, not the artistic freedom of French impressionists.[20]

Augustus Saint-Gaudens' sculpture, *Diana,* depicting the goddess of the hunt, poised atop Stanford White's imposing Madison Square Garden tower, distant from New York's turmoil, violence, and rampant poverty, embodied important aspects of

7

the American renaissance: its penchant for public art, its collaborative bent, and its Victorian ambivalence towards nudity and sexuality. Following the Philadelphia Centennial, John Quincy Adams Ward, Augustus Saint-Gaudens, Daniel Chester French, Karl Bitter, and Frederick MacMonnies revived American sculpture. Trained in the modernized classicism of the Ecole des Beaux-Arts, they sculpted hundreds of historic figures, mythological images, and female personifications of civic ideals, such as *Courage, Commerce,* and *Honor.* The historical figures were almost exclusively male and Caucasian, clothed according to their historical era. Draped or nude figures, usually females or children, frequented the mythological scenes. The personified idealizations were almost exclusively female. American renaissance sculptors' exclusion of women from historical events conformed to Victorian notions that men engaged in public life while women cloistered themselves at home, overseeing their families' domestic and spiritual lives. The renaissance's frequent representation of female nudity covertly challenged Victorian proprieties by adding sexuality to the feminine sphere of virtuous motherhood.[21]

American renaissance statuary occupied the centers of American public spaces, much as Saint-Gaudens' *Diana* became the most noted feature of Madison Square Garden. Bronze and marble sculptures of nymphs, heroes, native Americans, virtues, and stylized animals graced the nation's newly built public parks and buildings, railroad terminals, libraries, schools, art museums, statehouses, and the Capitol itself. Most were unexceptional, many were overdone, and some were mass-produced, mail-order zinc castings. But a few were powerful, enduring works, which, in association with beaux arts architecture, redefined American public space. Public sculpture alerted Americans to their communal traditions, recalling the nation's heroes, central historical events, mythologies, and ideals. The most influential of the American renaissance sculptors was Augustus Saint-Gaudens.[22]

The strength and appeal of American renaissance sculpture was its civic consciousness. It expressed communal, if class-bound, values in a society otherwise dominated by private interests and splintered by ethnic and racial differences. American renaissance sculpture also sought to heal the wounds caused by the Civil War to create a new set of public icons without conceding to white Southerners the justice of their lost cause on behalf of slavery. The most powerful sculptures of the New York renaissance depict northern Civil War heroes—Daniel French's *Lincoln* in the Lincoln Memorial, Olin Warner's *William Lloyd Garrison,* and Frederick MacMonnies' *Defenders of the Union* as well as Saint-Gaudens' *Robert Gould Shaw Memorial,* which portrayed Shaw leading his black regiment against the Confederate defenses of Charleston.[23]

As Victorians, American renaissance sculptors articulated conventional notions of gender, sanctioning in their statuary a patriarchal order that excluded women from active political participation and professional life. At the same time, the sculptors of the American renaissance carved out an important, if secondary, public place for women as the republic's spiritual and moral guardians, who carried out their responsibilities in the home as mothers and wives and in the community as teachers, social workers, civic leaders, and artists. Sexually mature, draped or nude female figures adorned American public fountains, courthouses, libraries, and parks, person-

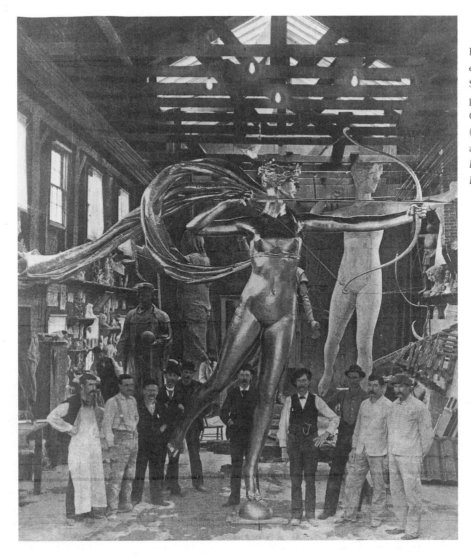

Idealization and Liberation. Augustus Saint-Gaudens preparing *Diana: Goddess of the Hunt* (1892–94) in his atelier.
*Dartmouth College Library*

ifying such metropolitan virtues as peace, learning, law, commerce, civility, and beauty, fusing the evangelical ideal of female purity and the civic ideal of public service with the American renaissance ideal of refined sexuality. Neither simply a sexual consort nor a disembodied saint, the ideal American renaissance woman warranted respect and attention, if not equality.[24]

New York renaissance artists painted and sculpted the nude because, as academically trained artists, they considered the nude the most difficult and the noblest artistic expression.[25] To equal European academic art, American artists had to create nudes comparable to those of Europe. In truth, academic nudes were rarely fully revealed. Except for male infants, artists discreetly obscured the genitals of their subjects or, in the case of females, portrayed undraped figures shorn of pubic hair as well as innocent of genitalia. With misogynous condescension, Thomas Eakins

Gilded Age New Yorkers' palace of decorous entertainment. McKim, Mead, and White, Madison Square Garden (1889–90). *Dartmouth College Library*

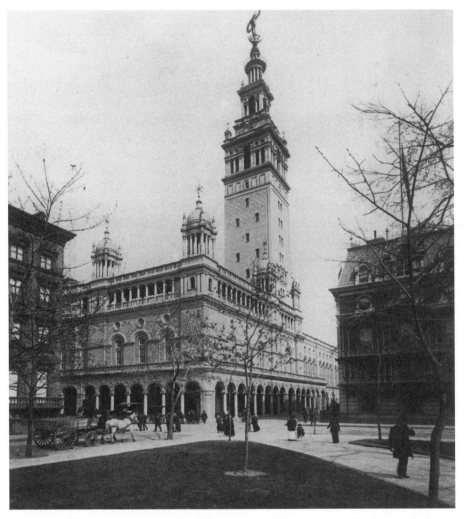

feel it, you must marvel more at its union of individuality and heterogeneousness. It is this that makes its character, and it is this that makes that character unique."[33]

In the 1870s, guided by Richard Gilder, New Movement artists had viewed themselves as insurgents. They attacked the National Academy of Design in the name of progress, artistic freedom, and creativity. By the 1890s, however, most had themselves become academicians, proudly attaching the initials *N.A.* after their names in exhibition catalogs. Skeptical of avant-garde movements in Paris and Vienna, the American renaissance sought to institutionalize the beaux arts tradition, founding first the American Academy in Rome for architecture and then, in 1898, the National Institute of Arts and Letters. The National Institute consisted of 250 lifetime members, including virtually all the major New York renaissance artists. In 1904, the National Institute formed a second, more select organization, the American Academy of Arts and Letters, consisting of 50 lifetime members elected from the ranks of the National Academy.[34]

When informed of his election to the American Academy, Henry James politely declined, saying that he saw no reason to belong to an organization whose sole purpose seemed to be its members' desire to celebrate their own significance.[35] Longtime secretary of the academy and associate editor of *Century,* Robert Underwood Johnson portrayed the academy's function differently. The mission of the American Academy, he declared, was to uphold good taste and moderation against vulgarity, degeneracy, and novelty.[36] Johnson voiced an anachronistic idealism. He defended a dying vision that had once, under the leadership of his mentor Richard Gilder, been robust, tied to the ideals of the nation's urban middle classes.

The decline of the American renaissance can be explained in exclusively aesthetic terms: a powerful, irrepressible modern artistic movement swept it away. While true, such an interpretation fails to account for a broader, related change, the collapse of a highly formalistic Victorian culture and its replacement by a less communal and hierarchical, more diverse, commercial, and flexible modern culture. The transition from Victorian to modern signaled a shift in the tastes, philosophical orientation, and ethnic backgrounds of America's urban middle classes.[37]

The American renaissance, however, was not the tragic victim of events. It declined because it lost touch with the source of its power and influence, New York's middle classes. After 1900, New York art patrons no longer found the idealized art of the American renaissance credible. New technology, waves of new immigrants, changing attitudes towards women and sexuality, and an expanded marketplace demanded a new art that addressed the realities of a new New York. Like Chicago's White City, the American renaissance passed into memory. Even before its demise, following the lead of Walt Whitman, Edith Wharton, and Thomas Eakins, a rising generation of New York artists were already laying the foundations for a new art, whose subject was modern life itself.

# Times Square
## Urban Realism for a New New York

Minutes prior to midnight on New Year's Eve 1905, boisterous crowds encircled Times Tower. Men and women threw confetti, hugged and kissed, blew horns, rang bells, drank champagne, and broke into song.[1] Even so, not all New Yorkers thronged to Times Square to ring in the New Year. The police also reported record crowds at the traditional places of celebration—Trinity Church near Wall Street and Grace Church in Greenwich Village. The Times Square revelry not only upstaged the festivity downtown, it also initiated a new urban celebration, complete with new music, new dress styles, new behavior. At Times Square, a new New York assembled and joyously proclaimed the city its own. A year later, the crowds at Trinity and Grace Churches had dwindled to a small, loyal remnant of older congregants, happy to be with one another, away from the maddening crowds of Times Square, distant from modern New York.[2]

In Times Square, the modern city emerged. The celebration of the New Year in Times Square was the child of corporate vanity. In 1904, the New York Times Company erected its new office tower at the intersection of Seventh Avenue and Broadway. The Singer Building was taller, but Times Tower, located uptown on higher ground, reached a greater elevation, making it the highest structure in New York. Having relocated at the crossroads of the city's entertainment district, the New York Times Company scheduled the opening of its new tower for New Year's Eve. On the front page of its December 31 edition, the *New York Times* invited the city to a gala opening to celebrate "the Removal of the NEW YORK TIMES to ITS NEW BUILDING" with "Music and Fireworks."[3] At the stroke of midnight, the Times Tower exploded with light, rockets, and music. On its roof a large, illuminated "1905" shown brightly. Spotlights gyrated wildly across the faces of the crowd that looked up from the streets below; incandescent lights glowed from the tower's windows; and the hired brass band blared joyous ragtime tunes.

On New Year's Eve, New Yorkers expressed themselves on a grand scale. But they

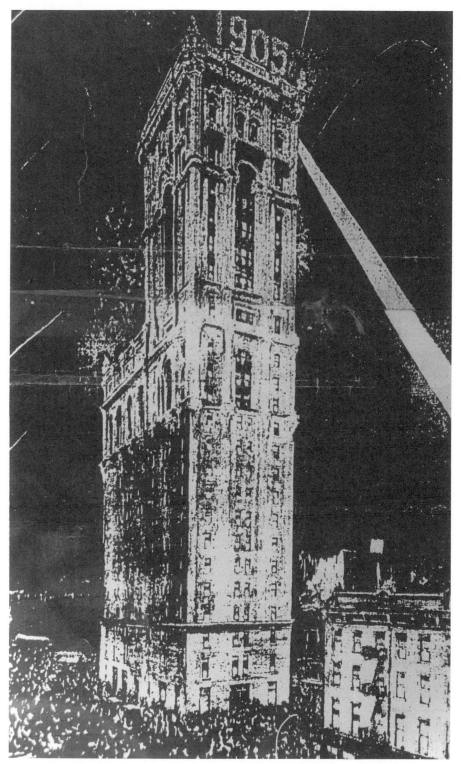

The first New Year's celebration in Times Square (January 1, 1905).
New York Times *photograph*

celebrated and were entertained similarly, though less dramatically, every night of the week on Times Square. Out for a night on the town, dressed in their best clothes, New Yorkers from a variety of ethnic neighborhoods and from all social classes thronged to Times Square's dance halls, theaters, nickel movie houses, restaurants, bars, and other places of entertainment, both licensed and illicit. Money opened the doors to the enticements of Times Square. Whether working class or genteel, female or male, young or old, immigrant or native, straight or gay, in or around Times Square, on any night of the week white New Yorkers and millions of annual visitors could dream of instant, if short-lived, gratification. Broadway theaters produced shows that played to audiences across the nation. Composers along Tin Pan Alley, a short walk from Times Square, wrote the music and lyrics sung by Americans from Maine to southern California. In the restaurants, cabarets, nightclubs, roof gardens, and dance halls of Times Square, New Yorkers set the pace of American nightlife.[4]

More than simply an emporium of fantasy and eroticism, Times Square reflected fundamental changes in the city's life. In the quarter century prior to World War I, New York assumed its modern form. By 1905 the city's builders had developed virtually all of Manhattan and extended settlement into the Bronx, Queens, Brooklyn, and Staten Island. In Manhattan, single-family housing had virtually disappeared as the middle classes moved into apartment houses and the poor crowded into tenements. High-rise business offices and hotels towered over the city, while private traction companies operated a massive, electrically powered subway and elevated-rail system that rushed passengers from one end of the city to the other. Compared with European cities, New York was a technological wonderland—its telephone system, steel-framed skyscrapers, elevators, subways, railroads, palatial department stores, and electrical lighting the embodiment of modern urban life.[5]

The first Times Square celebration of New Year marked the simultaneous emergence of modern New York and New York urban realism. The Times Square entertainment district and all that it represented inspired the urban realism implicit in the city's skyscrapers and in its new painting, dance, and music. Heirs of Walt Whitman, Thomas Eakins, and Edith Wharton, New York urban realists cast aside the static beaux arts neoclassicism of the American renaissance and embraced the modern city. New York's new immigrants, its influx of black migrants, the feminism of native-born women, the city's enormous wealth, its democratic culture, and its dynamic consumer economy all cried out for new forms of artistic expression. New York's vibrancy, diversity, and inventiveness precluded any single, unified aesthetic. Torn between the prestige of beaux arts traditions and the demands of modern urban life, faithful to their identity as Americans, and attentive to the lure of popular and financial success, New York's first modern artists created in the decade and a half prior to World War I a new, eclectic modern art cast in the language of urban realism.

New York's new generation of artists heralded the city's headlong rush into modern times. Unlike many of the European avant-garde, who for the most part repudiated bourgeois culture, New York's first modern artists, some even denizens of Times Square, were intimately tied to the city's commercial culture.[6] Employed as vaudeville dancers, popular-song writers, and newspaper artists and critics, New York's ur-

ban realists rejected the academic art of the American renaissance, declaring it archaic and artificial, removed from and irrelevant to the lives of most New Yorkers. They celebrated, instead, the rambunctious, polyglot, and spirited newness of the city. But they did so as pioneer moderns unsure of their direction, their art shaped both by their Victorian past and by the city's modern prospect.[7]

## THE NEW NEW YORK

New York had changed dramatically since the start of its renaissance in the 1870s. In 1897, Lincoln Steffens observed that anyone who had left the city two decades earlier and returned "would search in vain for the face of his city. . . . Old Trinity still stands, its steeple, like the spires of the old cathedrals, uplifted high above the earth; but its solitary prominence is gone. The modern office building has risen higher than the head of the cross, and the church has lost its distinction. The enterprise of business has surpassed the aspiration of religion."[8] So startling were the changes that Henry James, on a visit in 1906, hardly recognized the city. All that remained of his boyhood New York was an occasional side street, Trinity and Grace Churches, and several blocks of rundown mansions and town houses between Washington Square and 14th Street.

Acknowledging the change, in 1898 the New York state legislature reconstituted New York City, creating the legal entity of Greater New York, which included Manhattan, the Bronx, Brooklyn, Queens, and Staten Island, incorporating more than 3.5 million people.[9] In 1875 the region had contained only about 1.5 million people, and the development of Manhattan had extended only to the southern boundary of Central Park. By 1905 private and public development reached into all five boroughs, while an additional 1.5 million people resided in the immediate hinterlands of Westchester County, Long Island, and New Jersey, creating a sprawling metropolis of more than 5 million.[10]

Most of New York's population growth derived not from natural increase but from immigration and migration. The 1900 census classified 1,270,080 New Yorkers as foreign born, about one in three. Given that most of those whom the Census Bureau designated as "native-born" were either migrants to New York City or the children of foreign born, the newness of New York was overwhelming. New Yorkers themselves had changed. In the quarter century following the Civil War, the demographics of the city had shifted from white, predominantly Protestant, native-born British and German to an ethnic mix in which Protestants had become a minority, displaced by the massive inflow of Jews and Catholics from central, eastern, and southern Europe. After 1900 immigration from Russia, eastern Europe, and Italy increased fourfold, while British and German immigration held steady. Similarly, from 1900 to 1920, the city's population of African Americans, most from Virginia, the Carolinas, Georgia, and the West Indies, increased 400 percent. Henry James encountered not only an almost entirely rebuilt city but an almost entirely new city of New Yorkers, as well.[11] New wealth, as well as new people, had shoved aside the old Knickerbocker elite of Henry James and Mariana Van Rensselaer. The fortunes of the Vanderbilts, Rockefellers, and Morgans derived from railroads or other newly

important enterprises such as department stores, commercial real estate, tenement investing, entertainment, banking, municipal traction companies, and garment, coal, oil, and steel manufacturing. By 1905, New York had become the center of American finance, commerce, corporate business, law, publishing, entertainment, and art. Just as no single artistic style or school defined New York's art, no vision controlled the city's growth or business life.[12]

In 1905, the leadership of a much larger, wealthier, and more diverse New York numbered several thousand unrelated families, in contrast with the several hundred elite families clustered around Washington Square who had controlled New York's post–Civil War cultural life. The new elite of the new New York came from a wide variety of backgrounds—Knickerbocker (Dutch), Irish, German, Jewish, New England, southern, midwestern—scattered in neighborhoods across the city, with the very wealthiest families aligned along Fifth Avenue, above 59th Street, adjoining Central Park. Disparate in background and interests, New York's new elites lacked the social cohesion and shared taste of the patrons of the New York renaissance. Irascible, arrogant, adventuresome, ambitious, often uncultivated, New York's new elite supported a broad range of art from the scrupulously traditional to the ribaldly scandalous and the freshly insightful, offering New York artists a bounty of new patronage.[13]

The most striking feature, however, of the new New York was what journalist Jacob Riis called "the other half."[14] Fully one half of all New Yorkers lived in miserable poverty, shunted off into crowded, rundown, and unsanitary tenements on the city's Lower East Side, the downtown factory district below Houston Street, and west of Broadway above Wall Street up to Central Park. New York's nearly 1.5 million poor—men and women, children and adults—labored in sweatshops, constructed subways, streets, and buildings, served as domestic help in upper- and middle-class homes, worked on the docks, and performed all other manual and menial labor for wages that barely sustained life. Aware of the city's other half, New York's new artists rejected the idealized art of the New York renaissance as irrelevant. They had little sympathy for the notion that art functioned as a force of moral uplift and cultural cohesion.[15] New York's new urban realists embraced the city as a whole, making its variety and its life their subject.

It was modern technology, not art, that bound the new New York together. The first elevated railroad, built in 1878 along Third Avenue, was soon joined by the Sixth Avenue elevated. By the 1890s, "els" ran the length of Manhattan through the Bronx, Brooklyn, and Queens, moving several hundred thousand passengers each day for modest fares. In 1904, the privately owned IRT Broadway Subway Line opened, inaugurating a new era in the city's transportation. By 1914, the addition of other subway lines, with extensions into the outlying boroughs, enabled the most distant resident of the city to travel to downtown Manhattan in less than an hour. The two major transportation hubs at Grand Central and Pennsylvania Stations connected the subway and elevated systems to suburban commuter lines and regional railroads, making midtown Manhattan, around Times Square, the busiest and most densely occupied urban center in the world.[16]

The introduction of the telephone in 1876, electricity in 1882, the Croton Aque-

duct in 1890, and skyscrapers after 1895 accelerated the city's pace and congestion. In 1896, the New York telephone directory contained fifteen thousand listings, permitting businesses to operate without face-to-face contact. Instantaneously, the telephone placed firms in contact with clients across the United States, fostering the concentration of corporate headquarters and national banking in New York. Electricity powered the subway and elevated-train systems and diminished the gloominess of building interiors that received little or no natural lighting. By providing nighttime illumination, electricity also created a new nocturnal world unbound by traditional notions of time, space, and behavior. The lighting of Times Square and Broadway dispelled the darkness and much of the danger traditionally associated with nighttime in the city. Brightly lit roof gardens, nightclubs, theaters, vaudeville shows, movie houses, and sidewalks became accessible to everyone, encouraging after-hours activities and creating new opportunities for entertainment, especially for women and working people.[17]

The 1895 opening of Oscar Hammerstein's Olympia Theater at 44th Street and Broadway marked the theater district's shift to midtown. Other theaters quickly joined the Olympia, creating along Broadway, between 40th and 50th Streets, the legendary "Great White Way," whose brilliantly lit marquees and billboards beckoned to New Yorkers and visitors alike. In 1905 more than four hundred entertainment touring companies worked out of New York from locations near Times Square. On the eve of World War I, eighty live theaters had opened in the Times Square area, joined by hundreds of movie houses, restaurants, nightclubs, cabarets, hotels, dance halls, and bars.[18]

Modern urban nightlife unfolded in Times Square. Unlike the male-oriented sporting life of New York's nineteenth-century Bowery and Tenderloin district, women participated in the nightlife of Times Square without fear or loss of respectability. Indeed, Times Square theaters, dance halls, and restaurants catered to women, relegating prostitution and strip shows to the tenement districts on its southern and western borders. The Great White Way created an ambience for festive, safe amusement. Sensitive to the changes, Times Square producers F. F. Proctor and Martin Beck distanced themselves from the city's raunchy stage entertainment, offering wholesome family fare in their palatial, but ungenteel, vaudeville theaters. Led by David Belasco and Charles Frohman, the Broadway stage featured light, sometimes naughty, but rarely overtly lewd comedy and melodrama that attracted men and women. After the show, theatergoers gathered informally for a drink or dinner nearby in the late-night restaurants and cabarets of Times Square. The affluent, too, were drawn to Times Square, lavishly entertaining themselves and their companions at Broadway's "lobster palaces," which boasted opulent French decor, live music, and fabled late-night lobster and champagne dinners.[19]

The Times Square entertainment industry created an unprecedented demand for music and musicians. Broadway shows, vaudeville acts, and nightclubs clamored for catchy new songs. Musicians, composers, music houses, and publishers clustered along Times Square's mythical Tin Pan Alley, where tunesmiths such as Irving Berlin hammered out the next hit on their pianos. Times Square music houses distributed Broadway show songs throughout the country in the form of sheet music and play-

er piano rolls. Determined to corner the nation's entertainment market, after 1886 the New York–based Theatrical Syndicate gained control of the nation's live stage through ownership of theaters in and around New York. No matter where they lived, American audiences attended Broadway shows, spoke its lingo, imitated its dances, dressed its styles, mimicked its ways, and sung its songs. On Times Square, art, entertainment, and commerce flourished side by side, competing and borrowing from one another.[20]

In 1905, freelance writer H. G. Dwight described New York as the quintessential modern city. New York's pulsating streets and energetic people, its great expanse, and its towering buildings overwhelmed visitors accustomed to the slower pace, the historic architecture, and the ethnic homogeneity of European cities. Echoing other commentators, Dwight wrote that New York "forces the observer to see in modernity—poor, noisy, untoned, inchoate, incoherent modernity—its own value as the factory of the future and the past in embryo. . . . It is a pioneering eye, even now, that can see the picturesqueness of steel and steam."[21]

From throughout the United States, the pioneering eyes of American artists fixed on New York much as an earlier generation had looked to Paris. Entrepreneurs, entertainers, writers, dancers, composers, and painters discovered in Manhattan unmatched stimulation and opportunity. American artists adopted New York as their own. Impatient with both European aristocratic snobbery and the pretensions of American gentility, New York's first modern artists gloried in a city that harbored enormous wealth alongside unimaginable poverty, suffered fools and charlatans, and scoffed at convention and propriety, all the while honoring accomplishment and creativity. New York's new artists identified with the city's newness, believing it embodied the future and unblinkingly celebrating the grittiness and excitement of a new urban life, but they did so in a confusing, often contradictory array of images.[22]

## THE SKYSCRAPER PROBLEM

The Times Tower served as a paradoxical symbol of modern New York. Designed by Eidlitz and MacKenzie, the thirty-two-story Times Tower was midtown's first skyscraper. Clad in a retrograde and awkward beaux arts facade, the tower, with its steel-frame construction, high-speed elevators, electrical illumination, telephone and telegraph communications, and powerful printing presses, embodied modern technology. Briefly the highest building in New York, the Times Tower housed the New York Times Company, an exemplar of corporate propriety and power, which controlled publication of one of the world's great newspapers, an instrument of authority and respectability. At night, however, the Times Tower benignly watched over Broadway's boisterous nightlife.[23]

A complex icon of New York, beaux arts skyscrapers exemplified the contradictions of New York's early modern art. Between 1890 and 1914 the skyscraper evolved from its origins as an efficient but spartan office building into a visually striking and elaborately decorated work of art. The skyscraper symbolized willfulness, technological virtuosity, and the triumph of commerce. Until the 1890s, with the construction of George Post's Pulitzer Building on Park Row near City Hall, New York

lacked any truly tall buildings. In 1890, the Trinity Church steeple on lower Broadway, at 284 feet, was the highest structure in Manhattan. Enamored with the horizontal orientation of beaux arts urbanism, New York architects had allowed Chicago builders to pioneer the skyscraper.[24]

The development of safe and rapid elevators and electrical lighting made tall buildings possible. Weight-bearing masonry construction, however, placed a practical limit on height. The taller a masonry building, the thicker its lower walls had to be to support the added weight. The sixteen-story Monadnock Building in Chicago, designed in 1891 by Burnham and Root, was the tallest weight-bearing masonry office building ever built, its first-floor walls six-feet thick. An architectural masterpiece, the Monadnock was an economic dinosaur. Apart from the inconvenience of its fortresslike lower walls, weight-bearing masonry buildings proved expensive to build, and their thick walls diminished valuable ground-floor space.[25]

The solution lay close at hand. Prior to the Civil War, Chicago builders had pioneered their famous balloon houses, constructed of lightweight two-by-four pine framing. The balloon frame enabled Chicago contractors to build inexpensive but strong and durable wood-frame structures from standardized milled lumber. Pressed to provide businesses with inexpensive downtown space, Chicago architects used steel frames to adapt balloon construction to tall office buildings. The external walls remained masonry, but structural steel cages, encased in terra-cotta for fire protection, bore the weight. The exterior walls were really non-weight-bearing, masonry curtains much like the clapboards on Chicago's balloon frame houses.

In 1883, George Post designed New York's first metal-framed structure, the Produce Exchange at 2 Broadway. Technically sophisticated, the four-story Produce Exchange was a low-rise building, not a skyscraper. The breakthrough in New York skyscraper construction did not come until Post's 1890 steel-framed Pulitzer Building. The Pulitzer Building launched the age of the New York skyscraper and with it the architectural debate that critic Montgomery Schuyler called the "skyscraper problem."[26]

The skyscraper problem, according to Schuyler, was that the building's function could not be expressed by conventional architecture. As an engineering masterpiece, the structural steel cage was efficient, simple, and economical. By distributing weight throughout the structure rather than down the external walls, builders could construct buildings as high as they wished. Except for the first floor, however, each story of the skyscraper served the identical function of office space, and each floor consisted of identical steel-cage construction. Beaux arts–trained architects resolved the problem by treating the skyscraper as an analogue to the classical column, with a base, a shaft, and a capital. This allowed architects to design the first several floors as a single entity, to group the middle floors into a second architectural expression, and to combine the upper floors into a crown. In creating a unified structure that conformed to classical notions of symmetry, the beaux arts strategy expressed the unique quality of a skyscraper, its verticality. But such an expediency deceived viewers. It failed to articulate the function and structure of the building. More disturbingly, it equated classical columns with modern office towers.[27]

Montgomery Schuyler judged Cass Gilbert's neo-Gothic Woolworth Building a

masterpiece. Built in 1913 on the southwest corner of City Hall Park, the Woolworth Building overlooked the Pulitzer Building, McKim, Mead, and White's Municipal Building, and the Brooklyn Bridge. Gilbert's eight-hundred-foot-high Woolworth Building, which towered over nearby St. Paul's Chapel, restated the tension between historicist decoration and modern function. In designing the world's tallest building, Gilbert demonstrated the unmatched drama of the mature skyscraper. Schuyler acknowledged its beauty and virility: "What an 'uplift' there is in that sudden, rocket-like shooting of the white and channelled shaft. There is no point of view from which it comes in wrong."[28] But clad in neo-Gothic detail, the Woolworth Building harked back to a precapitalist, Christian world rather than heralded a modern New York.

## VISUALIZING THE NEW

Schuyler clearly continued to think as a Victorian. In contrast, New York's new painters felt at one with the city's newness. But like Schuyler, they too only partially broke free from nineteenth-century patterns. Urban realists George Luks, John Sloan, Everett Shinn, George Bellows, and William Glackens, together with their mentor Robert Henri, formed New York's first circle of modern painters. Unlike New York architects, they rejected beaux arts academicism in favor of a more expressive urban realism. Led by Henri, they painted New York's working-class life, its slums, its sexuality, its prostitution, and its violence. In challenging the beaux arts notion of art as refined and uplifting, they unmasked the hypocrisy of late-nineteenth-century Victorian culture. Public professions of Christian charity, the sanctity of womanhood, and political democracy notwithstanding, Gilded Age New York had reeked of racism, religious bigotry, class prejudice, and sexual exploitation. Like their literary contemporaries Edith Wharton, Theodore Dreiser, and Stephen Crane, Robert Henri and his circle portrayed life as they experienced it in New York, not as academic aesthetes sentimentalized it.[29]

Painter Guy Pène du Bois recalled, "The Henri class at the New York School of Art was the seat of sedition among the young. . . . Henri set the class in an uproar. Completely overturned the apple cart: displaced art by life, discarded technic, broke the prevailing gods as easily as brittle porcelain. The talk was uncompromising, the approach unsubtle, the result pandemonium. . . . Life certainly did that day stride into a life class. For me, at least, it also strode into America."[30] Despite an unsettled childhood in Atlantic City, New Jersey, Robert Henri received a classical education. At the age of twenty-one, he gained admission to the Pennsylvania Academy of the Fine Arts, months after Thomas Eakins had been dismissed from the same academy. The Pennsylvania Academy, nonetheless, continued along the lines set down by Eakins. Thomas Anschutz, an Eakins student, replaced him on the faculty, teaching painting in the Eakins manner.

Henri adopted the Eakins-Anschutz creed that art should reflect life rather than rarified aesthetic ideals or upper-class taste. Under Anschutz's direction, Henri painted in Eakins' tradition. He studied anatomy, performed vivisections at the nearby Jefferson Medical College, worked extensively in the life classes, and developed

a strong painting technique. Anschutz had a gift for directing students to everyday, unrefined subjects. After two years at the Pennsylvania Academy, Henri felt he had learned all that it had to offer and left for a three-year stay in Paris. He lived on a five-hundred-dollar-a-year allowance provided by his family. "There is a charm to this Bohemian life," he wrote home. Attracted to the impressionists, he disliked the postimpressionist work of Vincent van Gogh, Paul Gauguin, and Henri Rousseau. In 1891, on his third try, Henri passed the admissions exam to the Ecole des Beaux-Arts, but, disappointed with the Ecole, he returned to Philadelphia later that year.[31]

In Philadelphia, Henri accepted a teaching position at the Philadelphia School of Design for Women and joined the Charcoal Club, an art cooperative formed by John Sloan to provide artists live models without the expense of academy tuition. Henri assumed leadership of the Charcoal Club and gathered a nucleus of students who included, besides Sloan, Everett Shinn, William Glackens, George Luks, Stirling Calder (father of sculptor Alexander Calder), and Edward Davis (father of painter Stuart Davis). Self-consciously antiacademic, the members of the Charcoal Club read Ralph Waldo Emerson, Emile Zola, Honoré de Balzac, Henrik Ibsen, Leo Tolstoy, Henry David Thoreau, Charles Gilman Norris, Hamlin Garland, Stephen Crane, and especially Walt Whitman, discussing the relevance of their writing to art. The members of the Charcoal Club studied painting with Anschutz, and some knew Eakins and Whitman personally. Sloan, Luks, Shinn, and Glackens worked as illustrators for Philadelphia newspapers, which required them to produce quick sketches from notes, heightening their awareness of the details of urban life.

In 1900, Henri moved to New York, hoping to secure commissions to paint portraits for the city's wealthy families. He took an apartment on East 58th Street, accepted a teaching position at a private girls school, and painted cityscapes. Having secured work as newspaper illustrators, William Glackens and George Luks had preceded Henri to New York and introduced him to painters Arthur Davies, Ernest Lawson, and Maurice Prendergast. Davies' studio, above the Macbeth Galleries at 450 Fifth Avenue, became a gathering place for painters, as did Henri's studio. With Luks and Glackens, Henri regularly lunched with the art critics of the *New York Sun* at Mouquin's and the Café Francis.

In 1902, William Macbeth offered Henri a solo show. The same year the New York School of Art, directed by Douglas Connah, recruited him as a painting instructor. Henri quickly became the premier teacher at the New York School of Art, overshadowing its previous star, William Merritt Chase. Henri communicated his intensity to his students, especially the male students.[32] Henri sustained a lofty and compelling vision of art. He demanded that his students look to themselves and life for inspiration. "Cherish your own emotions and never undervalue them," he admonished. "We are not here to do what has already been done. I have little interest in teaching you what I know. I wish to stimulate you to tell me what *you* know."[33] Henri vehemently rejected the idea that painters should merely create accurate representations of external reality. He insisted that artists must draw on their experiences: "Faces are not permanently beautiful to us, nor are landscapes. . . . No *thing* is beautiful"—clearly an anti–beaux arts attitude.[34]

In 1909, following a dispute at the New York School of Art, Henri set up his own

school, the Henri School of Art, at 1947 Broadway in the Lincoln Arcade Building at Lincoln Square, just northwest of Columbus Circle. Elected in 1906 to the National Academy, Henri never abandoned his antiacademic attitude. Even while a member of the National Academy, he organized independent exhibitions and an insurgent art movement, all the while trying to liberalize the exhibition policies of the National Academy.[35]

In the spring of 1907, Henri's patience ran out. The jury for the *National Academy Spring Annual* rejected the work of several of Henri's protegés—Luks, Sloan, Glackens, and Rockwell Kent. When the jury refused to alter its judgments, Henri withdrew his own paintings and declared in a statement published in the *Sun*, "I believe in encouraging every new impulse in art. I believe in giving every American artist a chance to show what he can do, no matter whether he abides by the conventions or not. I do not believe that these exhibitions every year should be of selected pictures, but rather of something broader in its scope, something that will reveal the true progress of art in America."[36] Infuriated, the National Academy ceased appointing Henri to its juries and refused to elect to membership any of his nominees.[37]

*Robert Henri and "his boys." New York School of Art (1903). Photograph from the collection of Julie Chatterton Van de Water, courtesy of Bennard B. Perlman*

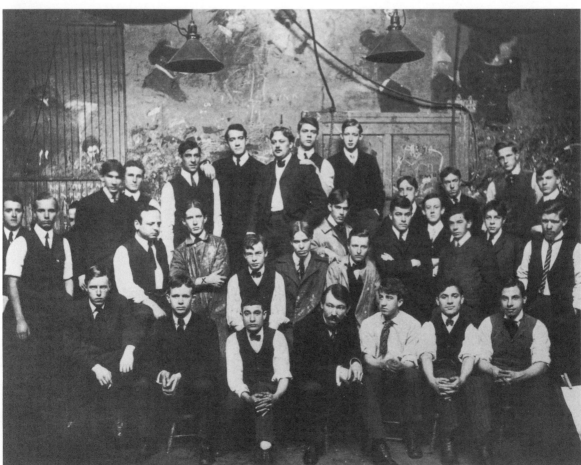

Unchastened, Henri and John Sloan marshalled their forces. In early April, Sloan and Henri met with Glackens and then with George Luks, Arthur Davies, Ernest Lawson, Everett Shinn, and Maurice Prendergast. These eight agreed to publicize the works that the National Academy had excluded by holding an independent exhibition the following winter. Arthur Davies approached William Macbeth to use his galleries, and Henri and Sloan handled the exhibition details.[38] On May 15, the *New York Sun* publicized the upcoming exhibition: "Eight Independent Painters to Give an Exhibition of Their Own Work Next Winter: A group of eight painters who have been expressing their ideas of life as they see it in quite their own manner, and who therefore have been referred to as 'the apostles of ugliness' by a larger group of brother artists who paint with a T square and a plumb line, have formed themselves into a body, it was announced last evening, without leader, president, or formal organization."[39]

*The Eight,* as the exhibition came to be known, opened on February 3, 1908, in the Macbeth Galleries. The response proved greater than anyone had anticipated. John Sloan calculated that nearly three hundred visitors came in every hour, filling the two small galleries to overflowing. Macbeth estimated the total attendance at about four thousand. Sales—two by Henri, four by Davies, and one each by Lawson, Shinn, and Luks—exceeded two thousand dollars. Vanderbilt heiress Gertrude Whitney bought four paintings, the beginning of her collection of contemporary American painting, which later served as the core for the Whitney Museum of American Art.[40]

*The Eight Exhibition,* endorsed by the *Sun,* gained its participants extensive public exposure and notoriety. Despite Henri's disclaimers that each artist offered a distinct vision, the Eight shared many common themes. All painted in representational styles, and all, except Henri, shunned academic techniques. Prendergast portrayed lively scenes with bright colors and crude shapes; Davies painted mythical arcadian canvases in a flattened style, reminiscent of the Japanese print, while Sloan, Glackens, Luks, and Shinn presented earthy urban subjects—workers, tenements, street scenes, bars, and brothels. Compared with Parisian postimpressionists, however, the Eight painted in a conventional manner.[41]

Unfavorable criticism centered on the coarseness of subject matter and stylistic "crudeness." Typical was an anonymous review published in *Town Topics:* "Vulgarity smites one in the face at this exhibition, and I defy you to find anyone in a healthy frame of mind who for instance wants to hang Luks' posteriors of pigs or Glackens' *At Mouquin's* or John Sloan's *Hairdresser's Window* in his living room or gallery. . . . Bah! the whole thing creates a distinct feeling of nausea."[42] The unqualified support of James Huneker and Frederick Gregg in the *Sun* and Mary Roberts in the *Craftsman* offset the negative comment. In a summary of the reviews of the exhibition, the art editor for *Current Literature* concluded that "all eight of these painters are dominantly concerned with the portrayal of American life here and now."[43]

John Sloan's *Sixth Avenue and Thirtieth Street* expressed the spirit and the intent of the Eight. Using vibrant but somber colors, Sloan captured a moment in the heart of New York's notorious Tenderloin district, with Times Square distantly outlining the horizon. He portrayed a disheveled, heavy-bodied, careworn woman, clothed in

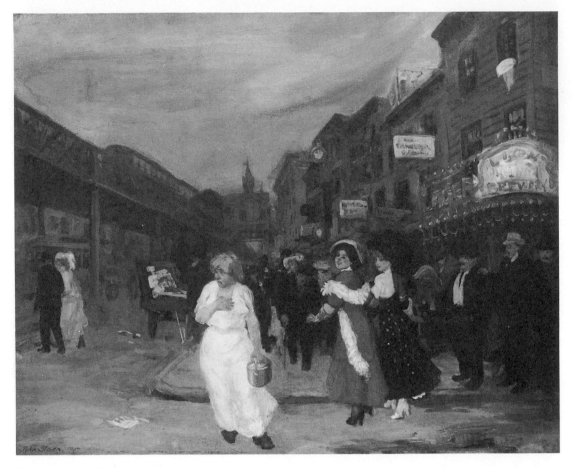

Commerce, technology, sexuality, and art. John Sloan, *Sixth Avenue and Thirtieth Street* (1907). *Philadelphia Museum of Art, gift of Mr. and Mrs. Meyer P. Potemkin*

a simple and tattered white dress, crossing Sixth Avenue and carrying a growler of beer. Staring at her intently, two gaily dressed and attractive women stand on the pavement behind her. In the background, in front of a theater advertising a girlie revue, two men appraise the women standing on the street below them. In the background to the left, arm in arm, a couple scurry away under the Sixth Avenue el. Without censure, Sloan presented a middle-aged woman who had once, very likely, looked as gay and attractive as the two young prostitutes who view her with such concern and interest. Sloan found much of the new New York at the intersection of Sixth Avenue and 30th Street—commerce, technology, men and women, entertainment, sexuality, joy, and sadness. He painted a compelling but neither uplifting nor pretty picture.[44]

At the time, the Eight seemed the beginning of a new movement. Henri hoped for an annual independent show. Due to previous commitments, however, Macbeth could not sponsor a second independent show the next year, frustrating Henri's effort to create a permanent secession from the National Academy. Undiscouraged, in 1910 Sloan and Henri, at the suggestion of painter Walt Kuhn, organized the *Exhibition of Independent Artists* in a vacant building at 29–31 West 35th Street, near Penn Station. More inclusive than *The Eight* show, the *Exhibition of Independent*

*Artists* included the work of 103 artists, half of whom were students or former students of Henri. Despite favorable publicity and attendance, little work was sold, effectively ending Henri's secession.[45]

By 1910, Henri's influence had already ebbed, his avant-garde status eclipsed. Young painters returning from Paris found the work of Henri and his friends quaint, not revolutionary, when compared with the work of Henri Matisse and Pablo Picasso. Photographer Alfred Stieglitz, who had opened a small gallery at 291 Fifth Avenue to promote progressive American artists, considered the Eight's work *retardaire,* not worth exhibiting. Henri, discomforted by postimpressionists, called them "strange freaks."[46] Such a reaction was rare. Henri continued to paint and to teach as before, encouraging young painters to experiment and to seek out fresh visions while adjusting himself to his increasingly secondary role in New York's modern movement. Modern in outlook, Henri considered art a means to enrich life, never simply an end in itself. His understanding of art as a creative, open-ended enterprise attuned to the surroundings of the artist put American painters in touch with contemporary life in New York. In sustaining the realist tradition, Henri and his circle reformulated it in explicitly urban terms, but in execution his work was closer to academic painting than to postimpressionism.

## PIONEERS OF MODERN DANCE:
## RUTH ST. DENIS AND ISADORA DUNCAN

Trained as academic painters, Robert Henri, John Sloan, and New York's other urban realists discovered artistic inspiration in the freewheeling atmosphere of Times Square and all that it represented in the city. Modern dance, however, was a child of Broadway, and no academy existed to teach aspiring American dancers. A handful of French and Italian ballet masters offered classes in New York, Philadelphia, and other large cities, but no organized instruction existed. The Metropolitan Opera's corps de ballet was almost exclusively European. In the absence of dance academies, Americans who wanted to become professional dancers turned to Broadway's dance revues, chorus lines, and leg shows. Fickle and often leering, Broadway audiences nonetheless provided American women an opportunity to dance professionally, if only as entertainers.[47]

In the wake of the American renaissance, Americans associated gentility with the fine arts. Upper- and middle-class women were encouraged to become artistic, which meant learning to play the piano or the violin, taking up embroidery or needlepoint, or dabbling in poetry, painting, sculpture, and ballet. The feminization of American high culture, however, did not lead to professional opportunities for women in the arts beyond teaching piano or giving dance lessons in their homes, usually to young, almost always female, children. As in most other fields, in the arts, only men became professionals. The career patterns of Art Students League graduates documented a double tracking for men and women art students. From 1876 to 1914 women constituted an overwhelming majority of Art Students League enrollments. Yet while more than a hundred male Art Students League graduates became recognized painters or sculptors, only two female students succeeded as profes-

sional artists. The faculty was exclusively male. For American women, the arts offered only avocational possibilities.[48]

A few American women achieved professional artistic standing. Sculptor Harriet Hosmer and painters Mary Cassatt and Cecelia Beaux pursued successful careers in the arts. But they lived in Europe as expatriates, daughters of wealthy families, exempted, in part, from prevailing sanctions against professional women and from the need to make a living from their art. Edith Wharton and a few other American women writers sustained productive professional careers. With the exception of Wharton, however, none supported herself exclusively on her writing. Such individual exceptions highlight the general pattern. In late-nineteenth-century America, the arts offered women no professional opportunities in painting, sculpture, or music. But, for women unconcerned with gentility, the commercial stage did. On Broadway, as actors, comedians, acrobats, dancers, animal trainers, or strippers, hundreds of women performed as professional entertainers.[49]

Determined to become artists, dancers Ruth St. Denis and Isadora Duncan exploited the opportunities of Broadway and Times Square. As entertainer-artists they created a new, female-oriented art dance. Abandoning the commercial stage because it treated them as objects of sexual titillation, St. Denis and Duncan also disdained classical ballet because, in the name of art, it distorted the female body. They responded by inventing an art dance that revered the natural movement of the female body and treated dancers as artists, not erotic entertainers.

Following the Civil War, New York theater producers had hit on the "spectacle-extravaganza" to arouse male audiences without transgressing the boundaries of Victorian propriety. Once organized, these spectacle-extravaganzas traveled across the country, recruiting their corps de ballet from town to town.[50] An exotic experience for their audiences, the spectacles ignited the artistic fantasies of young girls who looked on in wonder.[51] Impatient with Victorian proprieties, hundreds of young American women, determined to become dancers, flocked to New York seeking theatrical and vaudeville jobs. For a fee, a number of former European ballet dancers offered professional instruction. Many of these young women's ambitions were fostered by their mothers, who frequently left their families to join their daughters' quest for stardom.

Ruth Emma Hull Dennis was such a mother. Born in upstate New York, Ruth Hull graduated from the University of Michigan Medical School in 1872. Chronically ill, Hull suffered a nervous breakdown early in her career. Attracted to holistic cures, Hull moved to a commune near Raritan Bay, New Jersey, composed of social radicals, former abolitionists, free thinkers, feminists, and an atheist alcoholic, Thomas Dennis, who became her common-law husband. Ruth Hull Dennis rejected Victorian dress codes, which specified tightly laced corsets, in favor of loose undergarments and free-flowing gowns. Obsessed with her health, she maintained a strict diet, largely vegetarian, and practiced the Delsarte method, a system of physical and aesthetic exercises as much theatrical as gymnastic. Born in 1879, her daughter, also named Ruth, became the object of Ruth Hull Dennis's obsessions.[52]

Healthy and active, young Ruth adopted her mother's ideas. After seeing the Barnum and Bailey extravaganza, *The Burning of Rome,* Ruth dreamed of becoming a

dancer. As an adult she recalled, "Always at [twilight] a train passed on its way to New York, and it would sound its whistle in the valley—a long-drawn, melancholy sound that seemed so poignant and tragic."[53] Ruth Hull Dennis encouraged her daughter's dreams, taking her to New York for dance lessons at the age of ten. At sixteen, with her mother at her side, Ruth auditioned at several vaudeville theaters.

New York stage entertainment in the 1890s was, if nothing else, diverse. It included Buffalo Bill, Annie Oakley, and Sitting Bull, circuses, blackface minstrelsy, musical comedy, vaudeville, curio museums, freak shows, and theatrical stock companies, as well as classical ballet and opera performed at the Metropolitan Opera House. The young Ruth secured her first job at the Worth Museum at Sixth Avenue and 30th Street, which featured clog dancers, jugglers, stand-up comedians, and animal acts. She performed an acrobatic skirt dance eleven times a day that required back bends, cartwheels, and splits. Ruth rarely complained as she struggled to break into show business. She later attributed her determination, in part, to her awareness of the stark options that young women faced. On a visit to her happy and carefree childhood friend Lizzie, St. Denis found "a somber, careworn creature whom I scarcely recognized. . . . I laid it all to marriage. . . . I vowed never to be caught in the same trap."[54]

In 1896, the Dennis family sold its farm and moved to Brooklyn. Everyone pitched in. Ruth took a job as a clerk at Abraham and Strauss Department Store, performed bit parts in musical comedies, and danced in theatrical choruses. Her mother took in boarders, and her father modeled for the life classes at Pratt Institute. Tall, athletic, brown-eyed, and brown-haired, Ruth Dennis commanded the attention of her audiences and the eyes of David Belasco and Stanford White. Both men considered her the essence of American feminine beauty and vitality. Belasco offered Dennis minor parts in several road shows and suggested that she change her name to St. Denis. White courted St. Denis, taking her dining and dancing, giving her gifts, and lending her money.[55] Not content with being a seductive chorus girl, Ruth St. Denis searched for a dance form that would allow her to retain her female vitality and athleticism while enabling her to become an artist.[56]

In 1905, inspired by a visit to Coney Island, St. Denis conceived of *Radha,* a mystical "Oriental" costume dance that she first performed at Keith's Theater on 14th Street, where wealthy socialite Mame Anthon Fish saw her dance. Fascinated, Fish invited St. Denis to perform *Radha* at the 10th Street Studio Building for an artistic soirée. "Here I found people who understood the language of art warmly responsive to *Radha,*" wrote St. Denis. The dance was an instant sensation, and a group of women art patrons asked St. Denis to give a matinee performance of *Radha* at the Hudson Theater.[57]

At the door, a man attired in traditional Hindu dress greeted the guests. After a twenty-minute wait, St. Denis appeared from behind an oriental curtain, carrying incense and accompanied by exotic music. Draped in translucent fabric, she walked and swayed and performed stylized bows, trailed by a stream of incense. According to reviews, St. Denis mesmerized her audience. As Radha, St. Denis transported her audience into another realm, wholly of her imagination. Her sexual movements, the ornamental stage effects, and her high seriousness fashioned the curious combina-

29

tion of Delsarte dance movements, show business eroticism, and Coney Island exoticism into a novel and moving dance. St. Denis described her intent in *Radha*: "I tried to restate man's primitive use of dance as an instrument of worship. . . . The discipline of spiritual consciousness is the only force that can enlarge the artist's capacities and free him from his own temperamental limitations"[58] St. Denis's use of male pronouns in reference to artists, even female artists, indicates the powerful strictures that she confronted.

*Radha* established St. Denis as a serious artist, on a par with Loie Fuller and Isadora Duncan, who were at the time the rage of Europe. Sensitive to the penchant of New York patrons for art with a European cachet, St. Denis set out for France. Earlier, Loie Fuller, after touring with Buffalo Bill's Wild West Show, had decided that only in Europe could she be appreciated as an artist. A native of Illinois, Fuller became a sensation in Paris at the Folies Bergère. Fuller's *Fire Dance, Lilly Dance,* and *Sepertine* converted vaudeville skirt dancing into an artistic medium. But Fuller's performances with lights and moving veils, however striking, were not dances. Fuller failed to move her body. Instead, she exploited the new electrical stage lighting by creating unusual optical effects by waving her translucent colored veils through beams of light.[59]

Influenced by Fuller, Isadora Duncan combined motion and bodily gestures with Fuller's theatrical effects to create a new dance. Duncan distanced herself from both the acrobatics and the overt eroticism of Broadway show dances and shunned the regimented movements and stilted costumes of classical ballet. Born in San Francisco, Duncan, like St. Denis and Fuller, had grown up in the American provinces. Her father, a failed financial speculator, abandoned his family when Isadora was a young child. A pianist, Mary Duncan encouraged her children's interest in music and dance but cared little about formal education. Isadora later viewed her parents' failed marriage as a fortuitous blessing.[60]

At seventeen, Isadora Duncan and her mother set out for Chicago, leaving the other children to care for themselves. Like St. Denis, Duncan made her debut as a skirt dancer on the popular stage. She caught the attention of Chicago's stylish bohemian art community, leading to an engagement in New York, where she and her mother arrived in August 1895. "My first impression of New York," recalled Duncan, "was that it had far more beauty and art in it than Chicago." She supported herself and her family with bit parts in road shows and by teaching dance in a studio she rented at Carnegie Hall. As she had in Chicago, Duncan attracted the attention of society women looking for art entertainment. Duncan was invited by Madeline Force Astor to dance for friends and performed regularly in a number of Newport drawing rooms. After four years of surviving on meager handouts, the Duncan women decided that Isadora's only hope lay in Europe. The Duncans collected three hundred dollars from interested society matrons and in 1899 embarked for London on a cattle boat.[61] "[In all] my experience of New York," Isadora later declared, "I had found no intelligent sympathy or help for my ideas."[62]

For nearly a year, exploiting her New York society connections, Duncan pursued her ambitions in London, joining a Pre-Raphaelite art group. Her most important experience in London, however, was the discovery of Greek statuary at the London

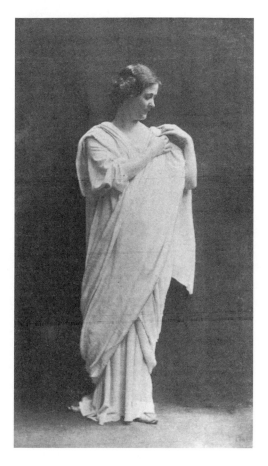

The "new woman." Isadora Duncan (1908).
Craftsman Magazine *photograph*

Museum. The gestures, attitudes, and dress of ancient Greek dancers prompted Duncan's artistic epiphany. Suddenly, she understood what dance could be and why classical ballet violated the most fundamental principles of dance. "All the movements of our modern ballet school are sterile movements because they are unnatural: their purpose is to create the delusion that the law of gravity does not exist for them," declared Duncan. "The ballet condemns itself by enforcing the deformation of the beautiful woman's body."[63] Instead, Isadora felt, modern dancers should treat as their object the unadorned female body and its movement.[64]

Heartened, but frustrated by her indifferent reception in London, Isadora Duncan left for Paris, where she worked out a theory of modern dance. "[I] sought the source of the spiritual expression to flow into the channels of the body filling it with vibrating light. . . . There they reflected themselves in Spiritual Vision not the brain's mirror, but the soul's and from this vision I would express them in Dance."[65] Duncan danced barefoot, in flowing togalike robes, with an abandon that offered audiences a new vision of female movement. She created a sensation among audiences accustomed to corseted women and stilted ballet dancers. The reaction to Duncan was phenomenal, particularly among men, who viewed her as the embodiment of their fantasies. John Sloan, after first seeing Duncan dance, voiced what became a

common reaction, *"Isadora Duncan! . . .* I feel she dances a symbol of human happiness as it should be, free from unnatural trammels. Not angelic, materialistic—not superhuman but the greatest human love of life. Her great big thighs, her small head, her full solid loins, belly-clean, all clean—she dances away civilization's tainted brain vapors, wholly human and holy—part of God."[66] A heavy woman, Duncan exuded a sensuality and female vitality that forced her audiences to rethink their ideas of womanhood. For many like Sloan, Duncan became "the modern woman."

In 1908, Duncan signed a contract with Broadway producer Charles Frohman for an American tour. After her performance at the Metropolitan Opera House, Duncan garnered the attention of the New York art community, but outside New York her tour fared poorly. At the encouragement of her close friend Mary Fanton Roberts, Duncan rented a studio in the Fine Arts Building and offered small performances for her devotees. After seeing her dance, conductor Walter Damrosch invited Duncan to dance to Beethoven's Seventh Symphony, accompanied by the New York Symphony Orchestra. The novel combination of art dance and classical music created a sensation. Encouraged, Damrosch asked Duncan to join the New York Symphony on tour. The Duncan-Damrosch tour drew enormous crowds, offering American audiences outside New York their first glimpse of modern dance.

The year 1909 was the *annus mirabilis* for art dance in New York. Isadora Duncan, Loie Fuller, and Ruth St. Denis, the creators of art dance, all returned to the United States in triumph. During the 1909–10 season, art dance established a foothold in New York as a legitimate art. Art dancers performed at Carnegie Hall and the Metropolitan Opera House; Duncan accompanied the New York Symphony; and New York society women adopted art dancing as their own.[67] Eager to stay abreast of the latest art developments, art patron and Vanderbilt heiress Gertrude Whitney took lessons from Ruth St. Denis. Whitney won several dance contests in New York and Newport, leading one critic to describe her as "one of the seven best amateur society dancers in the world."[68] In their 1912 classic, *Dancing and Dancers of Today,* Caroline and Charles Caffin certified the authenticity of art dance. "Beauty for the sake of beauty," declared the Caffins, "no longer the cult of the few, is becoming the heritage of the many."[69] In fifteen years, art dancing had moved from the variety houses along Sixth Avenue uptown to the Metropolitan Opera, Carnegie Hall, and the ballrooms of Fifth Avenue millionaires.

In New York, however, nothing stood still. Every year New Yorkers rang out the old and rang in the new. In 1913, ragtime and the fox-trot became the rage of Times Square, pushing St. Denis and Duncan offstage. Irene and Vernon Castle, accompanied by the syncopated rhythms of James Reese Europe's Harlem-based Clef Club Orchestra, introduced Times Square audiences to the fox-trot, the Grizzly Bear, the Bunny Hug, and the Charleston, revolutionizing American popular dance and creating a crisis for art dance.[70] No longer a popular rage, art dance had to refine itself as an art or disappear like so many other Times Square–Broadway fads.

Ruth St. Denis and Isadora Duncan had broken free from classical ballet and the stylized formalism that forced women to perform movements at odds with the realities of mature female bodies. They had also rejected Broadway show dancing that treated women as sexual objects and entertainers but not artists. Influenced by fin

de siècle exoticism, late-nineteenth-century feminist health reform, and Broadway's appetite for new forms of popular entertainment, St. Denis and Duncan forged a female art dance that, while neither ballet nor Broadway show dancing, was not yet fully modern.

Feminists to the core, they took the first steps towards modern dance, but by 1911 their New York moment had passed. Having completed her American tour in the spring of 1911, Isadora Duncan left for France, where she organized a dance school for girls and lived as an expatriate. Ruth St. Denis, a stalwart New Yorker, hung on. Upstaged by the fox-trot and other new dances, St. Denis reluctantly left New York in 1915 for Los Angeles to open the Denishawn Dance School with her husband, Ted Shawn. Until its revival in 1923, led by St. Denis's protegées Martha Graham and Doris Humphrey, art dance disappeared from the New York stage, its modern promise yet unrealized.[71]

## MODERN AMERICAN MUSIC

Even as Ruth St. Denis and Isadora Duncan moved towards a modern dance, music critic James Huneker and composers Scott Joplin and Charles Ives pioneered modern American music. James Huneker used the daily newspaper to introduce New Yorkers to modern European and American music, and Scott Joplin's ragtime gave New York its first modern urban music, opening the way for the later jazz revolution. Charles Ives created a modern American music that combined the radically dissonant sounds of European modernism with allusions to American popular music. Prior to World War I, Huneker, Joplin, and Ives reinvigorated American music by introducing audiences to the sounds and rhythms of the new New York.

An impish dandy, James Huneker looked and dressed the part he chose to play, New York's resident iconoclast and playboy. Short and stocky, Huneker sported a well-trimmed goatee and mustache, wore gold-rimmed glasses, drank heavily, and dominated conversation. Superficially obnoxious, his friendly, puckish manner endeared him to those who relished the intensity of turn-of-the-century bohemian New York. Huneker jeered at and violated virtually every convention he encountered. Few individuals have loved their time and place more than James Huneker loved his New York. Attuned to the new New York, James Huneker shifted the city's discussion of art from the gentrified pages of middle-class monthlies to plebeian daily newspapers.

Born of Catholic Irish-German parents, Huneker received a firm grounding in European symphonic music, sufficient to feed his ambition to become a concert pianist. In 1878, supported by his father, Huneker left for a nine-month stay in Paris. Impatient with regimentation, Huneker announced that "official art and literature in Paris are, of necessity, antipathetic to novelty. . . . Genius comes not by compulsion."[72] In 1886, he arrived in New York, bringing with him a command and appreciation of contemporary European high culture. He quickly established himself as New York's most outspoken and informed advocate of modern art and writing.[73]

Huneker sought out the bars, cafés, and taverns frequented by New York's performing artists. When he arrived, most of the city's artists still resided near Union

Square and Broadway above 14th Street. For fifteen years, as a columnist for the *Musical Courier,* Huneker offered New Yorkers spicy art opinion. He rendered judgments on Beethoven, Strauss, Chopin, and Bach and familiarized New Yorkers with modern European writers and composers. Whimsical in style, irreverent in tone, and titillating in the content of his writings, Huneker believed that a critic should introduce artists to their audiences. Sensitive to his newspaper readers, Huneker rarely idealized artists, refusing to treat them as superior beings with special insights into an otherwise inaccessible reality. Unequivocally modern and popular, Huneker declared, "Let us study each man according to his temperament and not ask ourselves whether he chimes in with some older man's music. . . . To miss modern art is to miss all the thrill and excitement that our present life holds."[74]

Huneker's arrival in New York coincided with a profound change in American musical taste. Centered in Boston and New York, the New Movement in American music had been born with the New Movement in painting and sculpture. With few exceptions, New Movement musicians looked with disdain on American vernacular music, considering it crude and unsophisticated. They preferred, instead, European concert music, largely Mozart, Beethoven, Schubert, Mendelssohn, and Liszt.[75]

New York assumed leadership of the symphonic movement in the United States. In 1842, the New York Philharmonic Society was founded as a performers' cooperative. In 1878, Leopold Damrosch, fresh from Germany, formed the New York Symphony Society. In 1892, Andrew Carnegie built Carnegie Hall on 57th Street, giving New York an unrivaled concert facility.[76] By 1900 both the New York Philharmonic and Symphony Orchestras performed a series of concerts each year in New York as well as visiting performances in select cities throughout the country. German art music, symphonic orchestras, and opera became the talismans of New York's new gentility, making social and aesthetic snobbery interchangeable.[77]

Huneker both approved and disapproved of these developments. He shared the New Movement's preference for European concert music and its contempt for Protestant hymns, band music, and minstrel shows. A convert to European high culture, he saw himself as a missionary of cosmopolitanism to a backward and boorish nation. Infatuated with German music, particularly Wagner, Huneker also loved Paris and French impressionism and championed continental and Irish playwrights and authors. He disdained social pretension and scoffed at the aristocratic posturing of New York's nouveau riche—even individuals, such as Carnegie, who funded the New York Symphony, which Huneker's close friend Walter Damrosch, Leopold's son, directed.

In 1900, Huneker joined the staff of the daily *New York Sun,* serving variously as music, art, drama, and literary critic until 1917. He made the *Sun* a voice of modern culture, the champion of New York's pre–World War I artistic avant-garde. Indeed, *Sun* critics formed the nucleus of a small group of artists, writers, and critics. These self-styled bohemians met regularly at Mouquin's, a "red plush" French restaurant located under the Sixth Avenue elevated near 28th Street on the Tenderloin's southern boundary, and at the Café Francis near Penn Station, which advertised itself as "New York's most popular resort of New Bohemia." Here, Huneker caroused with painter George Luks and was often joined by Broadway producer David Belasco,

sculptor Jo Davidson, urban realist painters William Glackens, John Sloan, and Everett Shinn, and New York attorney and avant-garde art patron John Quinn.[78]

Huneker's lively, iconoclastic style meshed well with the demands of a mass circulation daily like the *Sun.* In an unpretentious and lively style, he extended serious art discussion beyond the narrow circle of subscribers to the middle-class monthlies to the much larger newspaper-reading public, acting as an informed guide to New York's variegated culture. The eclectic taste of Huneker and the *Sun* mirrored its readership. New Yorkers looked to daily newspapers for news and entertainment, not for moral guidance. In the *Sun,* under the influence of Huneker, New York art became news in New York, and artists became public figures.

New York's new immigrants, however, made Huneker uneasy. Poor, uneducated, and of peasant stock, they seemed unmindful of the cultivated continental culture that he cherished. He especially disliked the African American rhythms of ragtime, which he did not consider music at all. Moreover, while he unrelentingly attacked Victorian notions of womanhood that suppressed female sexuality, Huneker opposed women's efforts to secure political equality. For him, women remained either respectable matrons or sexual objects, only rarely intellectual equals and friends. A bohemian in Victorian America, Huneker clung to the forms, if not the substance, of nineteenth-century European high culture. A central figure in New York's early modern movement, by World War I Huneker had become a crotchety old man, nostalgic for the past, uncomfortable with the present, anxious about the future, and fearful of New York's other half.[79]

Scott Joplin distilled his classic ragtime from the nether world of Huneker's Victorian America, a world that respectable women encountered only in their nightmares and genteel men in their surreptitious nighttime excursions. Most late-nineteenth-century American cities harbored a lively sporting district within easy reach of its respectable neighborhoods. The saloons and brothels of these red-light districts offered men of all social classes and races liquor, gambling, raunchy entertainment, and a variety of sex. The New Orleans sporting district was known as Storyville, and St. Louis called its Chestnut Valley. New York's fabled Tenderloin, at the turn of the century, lay to the south and west of Times Square. In the shadows of respectable society, black pianists, who called themselves ticklers or professors, created ragtime.

In the post–Civil War South, itinerant African American musicians first created ragtime, a "ragged," or syncopated, music based on a marchlike 2/4 rhythm. Ragtime became widespread in the South as black musicians, looking for work, followed the railroads from town to town, playing the bars and saloons, the lumber camps, and occasionally joining a traveling minstrel show. Many of the popular cakewalks and "coon songs" published as sheet music in the 1890s were apparently "rags" waiting to be named.[80] In 1896, Ernest Hogan copyrighted *All Coons Look Alike to Me* with a "Negro 'Rag' Accompaniment." The same year the cover notes to Ben Harney's *You've Been a Good Old Wagon but You've Done Broke Down* described Harney as the "Original Introducer to the Stage of the Now Popular 'Rag Time' in Ethiopian Song." Ragtime seems to have appeared as recognized music among African American musicians in St. Louis and Chicago several years earlier. A writer for the *St. Louis Post-*

*Dispatch* described ragtime as "a veritable call of the wild, which mightily stirred the pulses of city-bred people."[81] An early form of ragtime was popular during the 1893 Chicago World's Fair, which drew large numbers of African American musicians from New Orleans and the Midwest to play in the saloons and brothels outside the fairgrounds. Whatever its origins, by 1897 ragtime had become a national craze, setting the tempo for American cities prior to World War I.[82]

In 1899, with the publication of the *Maple Leaf Rag,* Scott Joplin became ragtime's leading composer. Born in 1868 near Texarkana, Texas, the son of former slaves, Joplin grew up wanting to be a musician. As a child, Joplin heard the patting juba, ring shouts, and spirituals of plantation blacks as well as the European music of southern whites—quadrilles, schottisches, and waltzes. His mother taught him to play the banjo, and he practiced the piano in the homes where she worked. He so impressed his mother that, despite the family's poverty, she managed to buy a used piano for him to play at home. A prodigy, Joplin became well known in Texarkana music circles and received formal lessons from interested teachers.[83] Around the age of sixteen, Joplin quit school and left home to tour with the Texas Medley Quartet, a vocal group that he had formed with his brothers and friends. Between 1885 and 1893 he lived in St. Louis, working as a saloon pianist in Chestnut Valley, until

he left for the Chicago World's Fair. When the fair closed, he moved to Sedalia, Missouri, securing a job at the Maple Leaf Club. He also enrolled in the music program at George R. Smith College for Negroes, taking courses in composition and notation.

Joplin established himself as Sedalia's best piano player. He also composed songs and taught music. Attractive but serious at age twenty-eight, Joplin commanded respect. Although the first two rags Joplin submitted for publication in 1898 were rejected, a year later John Stark, the white owner of a Sedalia music store, heard Joplin play *Maple Leaf Rag* and offered to publish it as sheet music for a fifty dollar advance and a royalty of one cent per copy sold for five years. At a time when most publishers paid composers a one-time, flat fee of twenty-five to fifty dollars, it was a fair contract. In the first three months of publication, *Maple Leaf Rag* sold more than seventy-five thousand copies, and within a year sales exceeded one million. Its publication proved momentous for both men. Stark had moved to Sedalia in 1883 to open a music store, but until *Maple Leaf Rag* he had been unsuccessful. He remained Joplin's primary publisher until 1908 and later published the work of Joplin's most important students and protegés—Scott Hayden, Arthur Marshall, James Scott, and Joseph Lamb, whose collective works constitute "classic ragtime."[84]

*Maple Leaf Rag* proved to be more than a successful popular tune. It altered ragtime's informal, syncopated style into a complex musical form. Joplin intended his classic ragtime to be played as he wrote it, without improvisation. Like the European tradition, Joplin limited musical creativity to the composer. He drew on the African American folk music of the rural South, the cakewalk, buck dances, and breakdowns but based his harmonies on the popular European ballroom music of his day.[85] Joplin and his fellow ragtime composers rejuvenated American popular music. Ragtime fostered an appreciation for African American music among European Americans by creating exhilarating and liberating dance tunes, changing American musical taste. Its syncopation and rhythmic drive gave it a vitality and freshness attractive to young urban audiences indifferent to Victorian proprieties. But without its European harmonic structure, carefully crafted melodic lines, and familiar march rhythm, white listeners would have found ragtime incomprehensible. Joplin's ragtime expressed the intensity and energy of a modern urban America. Moreover, commercial success allowed Joplin to move out of the sporting houses to seek artistic recognition.[86]

In 1900, John Stark moved to St. Louis, and Joplin followed. In 1905, Stark moved his publication offices to New York's Tin Pan Alley near Times Square. Joplin followed two years later, purchasing a boarding house at 252 West 47th Street, just west of Times Square. Distancing himself from New York's Tenderloin, Joplin supported himself through royalties, piano lessons, and letting out rooms in his boarding house to black entertainers. He joined New York's black bohemia, a circle of Times Square musicians and performers who gathered regularly at the Marshall Hotel on West 53d Street.[87] At the Marshall, James Reese Europe, members of his Clef Club Orchestra, comedian-songwriters Bert Williams and George Walker, and other black entertainers discussed "the manner and means of raising the status of the Negro as a writer, composer, and performer in the New York theatre and world of music,"

the kind of respectable artistic community that Joplin had always dreamed of belonging to.[88]

Not satisfied with his commercial success, Joplin wanted to write an opera in the European grand tradition. The theater section of the *New York Age,* the city's foremost African American newspaper, announced, "From ragtime to grand opera is certainly a big jump. . . . Critics who have heard a part of his new opera are very optimistic as to its future success."[89] Since leaving the Sedalia sporting clubs, Joplin had wanted to compose art music. The unenthusiastic response to his first opera, *A Guest of Honor,* of which no known copy survives, failed to discourage him. At the height of his musical powers, financially secure and domestically content, Joplin composed the folk opera *Treemonisha,* his most ambitious undertaking. Set in the rural South, *Treemonisha* is a mythical story of black emergence into the modern world. The strength of *Treemonisha* lay in Joplin's use of familiar materials—a story about his own people that drew on African American music and dance.[90]

In *Treemonisha,* Joplin utilized African American music and folk legend and drew on Broadway musicals. He encased *Treemonisha* in the structure of European opera, which included the overture, the aria, the recitative, the chorus, and the ballet. Yet, *Treemonisha* broke with European opera in its use of popular music, its African American idioms, and its Broadway dance revues. But like Joplin's ragtime, it failed to break free of nineteenth-century European music or even such Victorian notions as progress, uplift, and the belief in the inherent tension between civilization and savagery. Neither rigidly traditional nor consistently modern, *Treemonisha* exhibited the same tension between the past and present as the Times Tower, St. Denis's *Radha,* Henri's urban realism, and Huneker's iconoclasm. Although new, fresh, and American, *Treemonisha* remained constrained by earlier conventions, characteristic of this first phase of New York Modern.

And whereas *Treemonisha* ended happily, Joplin's life did not. After a disastrous single performance of the opera in a Harlem hall, with Joplin accompanying on the piano, Joplin suffered a breakdown. He was bankrupt, discouraged, and worn out. In 1916, Lottie Joplin committed her husband to the Manhattan State Hospital, where he died a year later of "dementia paralytica-cerebral."[91] Joplin's artistic accomplishments matched the tragedy of his life. Few American artists of his generation faced such obstacles. *Treemonisha* went unnoticed and unreviewed, largely because Joplin had abandoned commercial music in favor of art music, a field closed to African Americans. Even so, Joplin's successful ragtime and the renown of the Marshall Hotel group—Bert Williams, George Walker, and James Europe—signaled the rise of an urban African American musical community, the wellspring of a new American music.

The popularity of Joplin's ragtime contrasted starkly with the almost complete artistic isolation of Charles Ives, the pioneer American modernist. Ives' isolation encouraged eccentricity, removing all incentives and pressures to conform. More than any other pre–World War I American composer, Charles Ives rejected nineteenth-century European concert music. He wanted to create a genuinely American music, manly in character and democratic in inspiration, based on native traditions that addressed contemporary life. In rejecting the conventions of nineteenth-century

European art music, Ives opened American composition to a wide variety of influ-
ences—avant-garde, popular, non-Western, and nonmusical.[92]

Born in 1874, Ives grew up in Danbury, Connecticut, a Yankee to the core. Ives'
father scraped out a meager living as a musician, ostracized by Danbury's respectable
families, including his own. Like his father, who served as the town bandleader,
Charles Ives loved music above all else, but, seared by his father's experience, he de-
cided early in life not to pursue a musical career.[93] At Yale, Ives played on the base-
ball team, banged out ragtime tunes on the upright piano at impromptu parties, and
took an active role in his fraternity. Few of his friends guessed that he nurtured se-
rious musical interests. Under the Munich-trained Horatio Parker, a highly regard-
ed music teacher and composer, Ives gained a superior education in composition
and German art music. Nonetheless, throughout his life Ives expressed contempt
for Parker and for the genteel musical culture he represented. Ives declared Euro-
pean concert music overrefined, alien to American experience, and effeminate. Un-
willing to pursue a musical career, in part because of his contempt for Parker's prig-
gishness, Charles Ives headed for New York and a career in the insurance business.[94]

A square-jawed, serious man, Ives lived a conventional life. For a few years, he
sustained his musical interest by working as an organist and choir director for the
Central Presbyterian Church on West 57th Street, just blocks from the Joplins'
boarding house. In 1902, Ives quit his part-time position at Central Presbyterian; as
Ives put it, "I resigned as a nice organist and gave up music."[95] But, although he did
resign as an organist, Ives did not give up his music. Instead, he composed for him-
self, with little concern for public recognition, even cutting himself off from other
composers. He shunned the city's music groups and only irregularly attended con-
certs. Rebuffed in his few efforts to have his music performed, Ives had almost
no contact with the musical life of New York after 1914. Concert musician Franz
Milcke, after trying to play Ives' First Violin Sonata, declared, "This cannot be played.
It is awful. It is not music." Yet Ives asked, "Are my ears on wrong? No one else seems
to hear it the same way."[96]

Ives was one of the first composers to integrate ragtime tunes into art music. Fas-
cinated with the results, he turned to other American vernacular songs—church
hymns, band marches, and folk tunes. At the same time, he altered the traditional
forms of European art music, introducing countermelodies, complex rhythms, poly-
tones, quarter notes, and nonmelodic sounds. Ives considered music a form of com-
munication between composer and listener, not a craft that conformed to accepted
styles and techniques. He listened for new sounds, what he called the sounds of life,
to write into his music. For those receptive to new musical forms and sounds, Ives
offered a dynamic American music, attuned to twentieth-century life.[97]

Like his music, Ives' life brimmed with contradictions. His music expressed a
genuine affection for New York City. *Central Park in the Dark* and *From Hanover
Square North* were inspired by his experiences in the city, a world radically different
from his boyhood in rural Connecticut. Ives' nephew recalled, "He loved the sound
of the elevated train as it approached and left; it brought back his memories of New
York. He had a real fondness for New York."[98] A friend, John Becker, recalled Ives
commenting, "I am looking out over Washington Square which is on the edge of

Charles Ives at Battery Park (1913). *Charles Ives Papers, by permission of Yale University Music Library*

Greenwich Village. Some place! Artists, composers, poets, perverts, inverts, prostitutes, and thieves."[99] Ives, however, remained a Connecticut Yankee. Many of his compositions dealt with New England themes or childhood memories—*The Bells of Yale, Concord Sonata, Country Band March, The Fourth of July, The Housatonic at Stockbridge,* and *Three Places in New England.* Ives isolated himself to avoid involvement with other New York artists, whose bohemianism he considered anathema to his small-town, New England ethos. He once lived on West 11th Street and

then on Waverly Place, both in Greenwich Village, but he rejected the bohemian artistic life of the Village. At the same time, he considered Harvard and Yale graduates reactionaries, judged Jews progressive, gave money to the Jewish Theological Seminary, and supported Al Smith for president, in part, because Smith was Catholic and a New Yorker.

A successful businessman, Ives endorsed a radical economic program that he called "restricted property rights," which guaranteed universal ownership. A libertarian, Ives supported unrestrained majoritarian rule. He composed radically dissonant modern music that liberally quoted musical phrases from traditional and popular tunes, including *Yankee Doodle Dandy, Swing Low, Sweet Chariot,* and *The Battle Hymn of the Republic.* Committed to an art that drew from everyday life and addressed the experiences of the workaday world, he wrote music that, before World War I, only he appreciated. Ives valued ragtime music when most serious composers treated it with contempt. A brilliant and radical composer, Charles Ives bridged the gap between art and vernacular music by combining avant-garde forms with popular expressions to democratize and modernize American music.[100] In turning his back to New York's entertainers and other artists, Ives gained the freedom to compose radically new music, unencumbered by popular taste or musical convention. And, like his music, Ives remained uncorrupted by commerce or fellowship, but also obscure and remote, his artistic isolation a testament to the modernity of his music and his personal eccentricity.[101]

The careers of Charles Ives, Scott Joplin, Isadora Duncan, and Ruth St. Denis followed parallel paths. They created new forms of music and dance that challenged conventional conceptions of art, race, and gender. They infused their art with the vitality of American popular and commercial entertainment, disregarding the beaux arts distinction between fine art and popular art. Each also suffered significant disappointment. In the 1890s, all four pursued careers outside the arts. At his death, the public knew Scott Joplin only for his popular ragtime music, ironically, largely for the *Entertainer,* rather than for his proudest accomplishment, *Treemonisha.* In the 1920s, Charles Ives gained recognition among avant-garde musical circles, but he had composed nothing after World War I. In 1927, her life in shambles, Isadora Duncan died in France, strangled to death by her scarf, which had become entangled in the hub of her automobile's wheel. Despite significant accomplishment, all four fell short of their ambitions. "The horrid fact remains," Ruth St. Denis remarked in her autobiography, "that the only real profit I ever made was found in the despised Vaudeville."[102]

Pioneer moderns, these New York artists were also Victorians in transit. By 1900, late-Victorian culture, with its beaux arts aesthetic, had lost much of its vitality, but no full-blown alternative had yet appeared. Each of these early modern artists, like Times Square itself, exhibited a mixture of conventionality and modernity. Montgomery Schuyler saw the beauty in modern skyscrapers but judged them by antiquated standards and endorsed archaic embellishments that masked modern function. James Huneker introduced newspaper readers to the early European moderns and publicly thumbed his nose at Victorian sexual proprieties. He, however, drew

the line of artistic acceptability at impressionists like Debussy, refusing to accept Schoenberg's tone row, Stravinsky's dissonant compositions, or Joplin's ragtime as music. Huneker described Schoenberg's work as the "ecstasy of the hideous." Despairing at the popularity of ragtime, Huneker declared, "American music must be white man's music or it will be naught."[103] Similarly, he could not imagine women as equals and ridiculed feminist efforts to secure women the right to vote. Huneker wanted New York to remain culturally European, dominated by males.

Robert Henri and his circle of urban realists also envisioned a male-dominated world. His band of artists not only excluded women; like Ives, they also affirmed rigid Victorian notions of manliness. Nonetheless, Henri's antiacademic stance, his insistence that art represent individual experience, his determination that his students paint all of New York's faces, and his political anarchism led him and his followers to embrace change, even when such change challenged their own work. Personally uncomfortable with postimpressionist painting, Henri accepted it as a legitimate expression of a modern artistic imagination.

To the end, Isadora Duncan was torn between her identity as a new woman and her love of classical civilization. A political revolutionary, for many the embodiment of modern womanhood, Duncan repudiated classical ballet as an unnatural imposition on the female body. Declaring marriage a form of slavery, she openly acknowledged her sexual liaisons, proudly bearing children out of wedlock. Her dancing and costumes, however, affirmed an idealized vision of classical antiquity, not contemporary life. Like the fin de siècle Pre-Raphaelites, who encouraged her art dancing, Duncan believed that art occupied an idealized realm, apart from and uncorrupted by the banalities of everyday existence. Art should elevate and refine life, not articulate it. For this reason Duncan objected to the earthiness and overt eroticism of jazz. To be legitimate, dance should exhibit "no rhythm from the waist down, but from the Solar Plexus, the temporal home of the soul." She declared, "It seems monstrous that anyone should believe that the Jazz rhythm expresses America. Jazz rhythm expresses the primitive savage." Modern art dance "will have none of the inane coquetry of the ballet, or the sensual convulsion of the Negro. It will be clean."[104]

Even Ruth St. Denis, who found her most appreciative audience in vaudeville, distanced herself from what she perceived as the coarse, commercial demands of the popular stage. Her art dances, however, with their exotic scenery, costumes, and stylized poses, were pure Broadway kitsch. Not surprisingly, the Denishawn Dance School provided early movie directors the corps de ballet for their "casts of thousands" in Hollywood's early film spectaculars.[105]

Scott Joplin, too, only partially assimilated the changes taking place in New York. He created a new dance music that introduced urban Americans to African American rhythms, but he composed his classical ragtime out of nineteenth-century European ideas of harmony and structure, making no allowances for improvisation. Even *Treemonisha,* in which Joplin anticipated later developments of modern opera, stood much closer in form and appeal to the light opera of Gilbert and Sullivan than to Bertholt Brecht's *Three-Penny Opera* or even George Gershwin's *Porgy and Bess.* Like St. Denis, Joplin craved respectability more than avant-garde status, and he

sought respect within the conventions of European fine art and New York genteel society.

Such confusions and contradictions reflected the confusions and contradictions of pre–World War I New York art. In every direction, changes were afoot—in architecture, painting, music, dance, patronage, and audience. Following the Civil War, New York had developed a number of major art institutions—the Metropolitan Opera, the Metropolitan Museum, the New York Philharmonic and Symphony Orchestras, the Society of American Artists, and the American Academy of Arts and Letters—but by 1905 these powerful Victorian organizations failed to contain the city's artistic ferment because they failed to address the realities of modern New York.

Even as the beaux arts establishment consolidated itself along 57th Street and Central Park, adventurous New York artists turned to Broadway, Greenwich Village, Harlem, and Paris's Left Bank in search of new experiences, new patrons, and new expressions. Like the stately Times Tower, which stood uneasily over Broadway's rowdy and seductive nightlife, in 1913, New York's first moderns confronted Europe's equally rowdy and seductive, but far more radical, avant-garde. In New York on the eve of World War I, the tension between art and commerce, avant-gardism and democratic culture, persisted unresolved.

# Paris and New York
## From Cubism to Dada

"In this spring and early summer of nineteen fourteen the old life was over," noted Gertrude Stein.[1] World War I had stilled the raucous antics of the Parisian Left Bank. Yet, France's loss became New York's gain as the spirit of the prewar Parisian avant-garde found sanctuary in New York. Many European artists left behind by the war looked elsewhere for refuge. A few, especially several modernist painters, chose New York. On his arrival in New York in October 1915, French cubist Albert Gleizes commented, "I could not work in Paris. . . . I could not think. . . . Everywhere one heard nothing but the horror of war, saw nothing but war's agonizing blight. . . . The contrast in New York was astonishing. . . . Here everything is calm and ordered. The individual counts. Here art is possible."[2] Kenneth Hayes Miller, a young painting instructor at the Art Students League, found the presence of European modernists exhilarating: "The town is full of Cubist and Futurist exhibitions now. They hold the center of the stage."[3]

Marcel Duchamp, who had gained American notoriety at the 1913 *Armory Show* with his *Nude Descending a Staircase,* explained the attraction of New York: "I came over here, not because I couldn't paint at home, but because I hadn't any one to talk with. . . . I love an active and interesting life. I have found such a life most abundantly in New York. I am very happy here."[4] New York's avant-garde lionized Duchamp as a modernist hero. For nearly a decade, photographer Alfred Stieglitz, inspired by Gertrude Stein, had championed the work of Parisian modernists. Beginning in 1906, at his 291 Gallery Stieglitz introduced New York to the work of Henri Matisse, Pablo Picasso, and Auguste Rodin. Then in 1913, two years prior to Duchamp's arrival, the American Association of Painters and Sculptors sponsored the landmark Armory exhibition of modern art that featured a broad range of modernist work characterized by outrageous colors, abstract images, jarring juxtapositions, and flattened perspectives. While many New Yorkers refused to accept such modernist work as art, the city's modern artists were enthralled.[5]

The influx of European modernists after 1914 led to a flurry of modern exhibitions in New York galleries. In 1914, according to *Art News,* New York boasted sixty-two art establishments, more than twice the number of London and Paris combined.[6] By 1918 nearly a hundred art dealers operated in New York. A dozen of these, most notably Daniel Gallery, Stieglitz's 291, the Modern Gallery, Robert Coady's Washington Square Gallery, the Anderson Galleries, the Berlin Photographic Gallery, and the Carroll Galleries, specialized in modernist work, while Macbeth Galleries, Knoedler and Company, and Montross Gallery featured American realists, as did the Lotus Club, the MacDowell Club, the Penguin Club, and the Whitney Studio Club. Compared with the prestigious 57th Street and Fifth Avenue uptown galleries, who favored old masters and French impressionists, modern art remained on the fringe of the New York art market. Still, thirty-four different New York galleries or clubs presented more than 250 modern exhibitions between 1913 and 1918, making wartime New York a more important market for modern painting and sculpture than Paris.[7]

Alfred Stieglitz's 291 Gallery offered a congenial and stimulating haven for American modernists. Through his art magazine, *Camera Work,* Stieglitz promoted promising American modernists and published a rich variety of articles on modern art criticism and theory. Through her Whitney Studio Club in Greenwich Village, Vanderbilt heiress and sculptor Gertrude Whitney was even more generous.[8] John Quinn, a New York corporate attorney, championed modern art with even greater enthusiasm and discrimination, while Lizzie Bliss, Walter Arensberg, Agnes Ernst Meyer, and Katherine Dreier supported modern artists, purchased their work, and enthusiastically embraced a wide range of modern art.[9] Virtually all of the city's daily newspapers, led by the *New York Sun,* maintained a regular art section, as did several New York magazines, including *New Republic, Nation, Seven Arts,* and *Vanity Fair.* These patrons and publications provided New Yorkers with informed opinion, on the whole sympathetic to modern art.[10] The arrival of Duchamp, Gleizes, and other modernists in the winter of 1915 transformed New York's vital but loosely defined modernist secession into an important movement, comparable to similar movements in Berlin, Zurich, and Cologne. By freeing American artists from naturalistic images, modernism offered new possibilities, giving New York artists a modern alternative to the urban realism of the Eight.

Like Beaux-Arts neoclassicism, modernism was a Parisian transplant. Through the efforts of Gertrude Stein, Edward Steichen, Alfred Stieglitz, and the stunning 1913 *Armory Show,* New York artists discovered European modernism. Enthused by the possibilities and their sense of participation in a revolutionary movement, New York artists of the time nonetheless found modernism menacing. At the moment when American realists had finally emancipated themselves from European art, modernism threatened, once again, to reduce them to the status of French colonials. Elements of modernist painting—its abstract images, its nonmimetic intent, its use of color and forms, and its emphasis on artistic subjectivity—had been present in American art since the mid-nineteenth century. Modernism, however, accelerated changes already under way in American art, giving them new direction and form, enriching and altering American art but not displacing it. In New York, the School of Paris found its most precocious and receptive pupils.

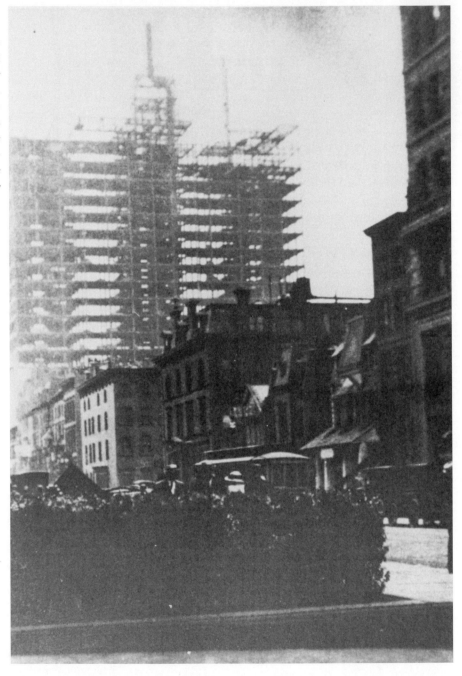

The arrival of "the modern." Alfred Stieglitz, *Old and New New York* (1910). *Steiglitz Archive, Collection of American Literature, Beinecke Rare Book and Manuscript Library, Yale University*

## NEW YORK'S PROTOMODERNISTS

New York's modernists were not the first American artists to seek an alternative to realism. American artists since the New England transcendentalists and other proponents of romanticism had sought to penetrate beyond sensory perception to

gain insight into a more profound reality. After the Civil War, traces of romantic ide-
alism lingered as minor motifs in the otherwise neoclassicism of the New York re-
naissance. Much of American idealism was explicitly antimodern, a reaction to the
presumed intellectual shallowness and coarseness of American democratic capital-
ism. In art nouveau and impressionism, American art patrons found seductive im-
ages of a quiet, refined world, secluded from the scramble and harshness of modern
urban life.[11]

New York's beaux arts critics were especially attracted to French impressionism.
In 1892, William Crary Brownell declared that Claude Monet had "worked a revo-
lution in his art" and that no one in the future "will be able to dispense with Mon-
et's aid."[12] By 1890, New York art collectors had purchased more impressionist work
than had Parisians, laying the foundation for the rich impressionist collections in
American art museums.[13] American impressionist expatriates John Singer Sargent
and Mary Cassatt were especially effective in persuading American collectors of the
value of impressionism.[14] Encouraged by the purchases of its New York clientele,
in 1886 Paul Durand-Ruel, the Parisian impressionist art dealer, presented a land-
mark New York show, *Works in Oil and Pastel by the Impressionists of Paris*. Pleased
at the enthusiastic response, in 1888 Durand-Ruel opened a gallery in New York.[15]

New York painters, too, were attracted to impressionism and formed a group led
by John La Farge. The American impressionist group included John Alden Weir,
William Merritt Chase, John Twachtman, and George Inness. La Farge, who had
never fully embraced the academic formalism of Beaux-Arts academicism, sought
an art that did not suffocate individual creativity or deny the mystical dimension of
life. La Farge declared, "There are no foreknown limits of art; all that we know of the
laws of art comes from the works of certain men which established these limits." La
Farge asserted that artists created significant work only by breaking conventions and
discovering fresh insights.[16] Led by William Merritt Chase, Albert Pinkham Ryder,
and George Inness, New York's "dark" impressionists painted still lifes, nocturnes,
hazy landscapes, and private, contemplative moments, removed from the pressing
concerns of daily existence. While representational, their paintings portrayed for-
mal arrangements of color, shapes, and light rather than descriptive images—poet-
ic rather than factual, suggestive rather than assertive. Their dark palettes created
shadowy and foreboding images, in contrast with the lighter, more pastoral images
that characterized much of French impressionism.[17]

Precursors of a new art, New York's impressionists were not themselves mod-
ernists. Arthur Wesley Dow, however, was. Influenced by Japanese printmaking and
watercolors, Arthur Dow rejected nineteenth-century painting, including impres-
sionism. Born in 1857 in Ipswich, Massachusetts, Dow initially gravitated to the New
Movement painters. In 1884 he traveled to Paris, first studying under Gustave
Boulanger and Jules Lefebvre at the Académie Julian. He moved to Pont Aven in
Brittany, preferring Barbizon landscapes to studio painting. On his return to the
United States in 1889, Dow became interested in the abstract qualities of the work
of William Morris Hunt, Claude Monet, and especially James Whistler. He also
studied Japanese prints. In 1891, Dow met Ernest Fenollosa, curator of the oriental
collection at the Boston Museum of Fine Arts.[18] The son of a Spanish musician and

a native Bostonian, Fenollosa graduated from Harvard as first scholar in 1874. Uncomfortable with Western materialism, he became interested in Asian art, traveling to Japan in 1878. A faculty member of the Imperial University in Tokyo, he argued that Western art lacked the spirituality and refined sense of beauty characteristic of Japanese art. By 1888 he had become a leading authority on Japanese art and received an appointment first to head the Tokyo Fine Arts Academy and Imperial Museum and then to curate the Boston Museum of Fine Arts's new Oriental Department in 1890. Under his leadership, the Boston Museum became an important center for Asian art.[19]

Under Fenollosa's tutelage, Dow became a convert to Japanese art. In his landscapes, he adopted the Japanese *notan* concept of harmonious arrangement of darks and lights as well as calligraphic techniques. He portrayed an "ambiguity between depicted imagery and literal surface."[20] Convinced of the superiority of Japanese art, with its stress on composition and design rather than on drawing and accurate representation, Dow taught his students the importance of abstract arrangement and harmonious design. In 1893, Fenollosa appointed Dow his assistant, and in 1895 the Oriental Department presented a show of Dow's woodcut prints. But in the same year, the Boston Museum of Fine Arts fired Fenollosa because of the scandal arising from his divorce and remarriage.[21] Fenollosa's firing proved momentous for Dow. The Pratt Institute in Brooklyn immediately offered both Fenollosa and Dow art instructorships, initiating Dow's twenty-year teaching career in New York, first at Pratt, later as a lecturer at the Art Students League, and finally, in 1903, as director of the Department of Fine Arts at Columbia University's Teachers College. In 1899, Dow published *Composition,* which became the most widely used art instruction book in the United States prior to World War I. Painting, Dow argued, was the harmonization of colored spaces, not mimetic representation. "Abstract design," he wrote, "is, as it were, the primer of painting, in which principles of Composition appear in a clear and definite form."[22] He admonished his students, "The art-sense must have freedom; it resents regulation whether by ruler, an academy, or popular opinion."[23]

Dow's Japanese-inspired compositional-spiritual approach to painting emancipated his students. In the two decades prior to World War I he rivaled Robert Henri as New York's most influential art teacher, serving as the mentor for the first generation of American abstract painters. His most important students included Max Weber, Maurice Prendergast, Georgia O'Keeffe, and photographer Alvin Langdon Coburn. Dow had his greatest impact on New York modernists, however, through his friendship with photographer Gertrude Käsebier, who also taught at Pratt and who introduced Dow to Alfred Stieglitz and Photo-Secession.[24]

## PHOTO-SECESSION

Photography influenced all European and American painters trained after 1850. In the United States, however, the link between photography and modern art was quite direct. From 1890 to 1907, Alfred Stieglitz propelled American art photography into international leadership; then, beginning in 1907, Stieglitz oversaw New York's modernist secession, which patterned itself after Parisian postimpressionism.[25]

Trained as a photographer, Stieglitz looked at the world differently than artists trained in the fine arts. Paintings had always seemed to him creative compositions, not accurate representations of the natural world. From its beginning in the 1840s, photography had challenged traditional ideas of painting. The mimetic superiority of photography undercut one of the primary functions of post-Renaissance painting, the accurate depiction of nature.[26] Photography, however, represented more than simply an aesthetic challenge. By offering inexpensive but extremely accurate portraits and scenic views, photography destroyed many painters' primary means of support.[27]

Photography also altered painters' understanding of their art. Convinced that they could not equal the realistic portrayals of photographers, late-nineteenth-century painters, led by the impressionists, emphasized the creative and expressive dimensions of their work. Imaginative qualities became more important than factual representation. Moreover, photography expanded the visual perception of painters. Due to the static quality of a painting and the time required to create a single image, painters tended to portray reality in unified, singular images. Photography, however, led painters to recognized the transient and plural character of images. The image of London Bridge was no longer limited to memories, sketches, and notes but included multiple, true photographic images, captured at different times from different perspectives by a variety of individuals. By producing multiple images of singular objects, photographers provided compelling evidence for the subjective basis of perception.[28]

Late-nineteenth-century painters and sculptors expanded their visual research with photography. Quite literally, painters moved nature to their studios. Painters acquired rich photographic collections of masterworks scattered throughout museum and private collections. Artists studied and referred to photographic notes in their own studios, at their own convenience.[29] Photography also enabled artists to use models more efficiently. Rather than hire models for the duration of their projects, artists could, in a single session, take a series of photographs of their models in a variety of poses, significantly reducing their studio expenses. Moreover, by freezing action and capturing images in infinite detail, photography led artists to see things heretofore obscured. Eadweard Muybridge's famous series of photographic sequences, *Animal Locomotion*, which he produced with Thomas Eakins at the Pennsylvania Academy, documented photography's enhancement of visual perception.[30]

Eakins and Muybridge used photography as a tool to strengthen the fine arts, but Alfred Stieglitz wanted it to become a fine art in itself. Stieglitz spent his early childhood in Hoboken, New Jersey, where his parents had settled following their immigration from Germany. In 1871, Alfred's father, a successful wool merchant, moved his family to a New York City brownstone on East 60th Street. After Stieglitz's graduation from City College, his parents took the family to Germany for an extended stay, in part, to enroll their children in what they considered superior German schools. Attracted to the rich cultural life of Berlin, Stieglitz spent more time at concerts, operas, theaters, and racetracks than on his studies. Berlin became his cultural model. A renewed interest in photography led Stieglitz back to his studies. He

enrolled in a course on photochemistry, mastering the most advanced photographic techniques. "Photography," Stieglitz later recalled, "had become a matter of life and death."[31]

In 1890, at his parents' urging, Stieglitz returned to New York, where his father set him up in a photoengraving business. Compared with Berlin, he found New York culturally barren, but in his explorations of the city Stieglitz discovered unexpected pleasures in music concerts, vaudeville comedy, a performance of *Camille* by Eleanora Duse, and New York itself. Uninterested in the photoengraving business, Stieglitz prowled the city with his camera. The result was a portfolio of cityscapes that anticipated the urban genre paintings of Robert Henri and the Eight. Stieglitz's most important New York photographs included *Winter, Fifth Avenue,* and *Reflections—Night, New York.* Encouraged by critical acclaim, in 1895 Stieglitz abandoned the photoengraving business to take up a ten-year campaign to establish pictorial photography as a fine art and to bring American photographers into the forefront of international photography.[32]

Stieglitz saw New York as a great modern machine, which, if carefully observed and recorded, offered artists a unique opportunity to comprehend the modern. Stieglitz's almost religious commitment to "straight," unmanipulated photography reflected his quest to behold the modern soul encased in its machines and machinelike cities. Stieglitz stalked the alleys and byways of New York, hoping to capture the city's unsuspecting soul. His nocturnes, particularly, conveyed a spiritual presence—*The Savoy Hotel* illuminated by gas lamps mirrored on the wet pavement; *The Hand of Man* with a steam locomotive driving into an otherwise empty rail yard at dusk, emitting a dark column of steam; and *From a Back-Window, "291,"* which looked at the lighted rear windows of adjoining buildings. Each offered an evocative image of New York, but an image less of the city than of its being.[33]

In 1893, the Society of Amateur Photographers asked Stieglitz to edit their New York–based magazine, *American Amateur Photographer.* He accepted enthusiastically, using the magazine to educate American photographers by publishing the best international work as well as critical essays. He also kept his readers informed of the latest art photography events in Europe, especially the large annual exhibitions in London, Paris, and Hamburg. In 1896, Stieglitz became editor of *Camera Notes,* a magazine sponsored by the New York Camera Club. In *Camera Notes,* Stieglitz continued his efforts to introduce American photographers to the best European work and to highlight the work of the most promising American photographers. Through it, he created a photographic movement in the United States comparable to the British Linked Ring. Stieglitz, along with Boston photographer F. Holland Day and a handful of photographers associated with *Camera Notes,* created an American school of photography that by 1901 ranked with the most distinguished photographers in Europe yet lacked effective institutional support. Stieglitz responded by founding Photo-Secession. "The Secessionist," asserted Stieglitz, "lays no claim to infallibility, nor does he pin his faith to any creed, but he demands the right to work out his own . . . vision."[34]

In 1901, Stieglitz plotted to replace the retrograde Philadelphia Salon with a New York photography salon under his leadership. He asked Durand-Ruel to sponsor a

photography show in his New York gallery. Discouraged by the costs, Stieglitz approached Charles de Kay, director of the National Arts Club in New York and brother of Helena de Kay Gilder, to present a group show of the best young American photographers. De Kay agreed, giving Stieglitz full authority to organize a show for the spring of 1902. Held at the National Arts Club, the *American Pictorial Photographers* exhibition included thirty-two photographers and identified them with Photo-Secession, effectively establishing Stieglitz's leadership of the movement. As yet, Photo-Secession remained only a name.[35]

Two events gave impetus to its organization: Stieglitz's resignation from the editorship of *Camera Notes* to form his own journal and Edward Steichen's return from Paris. In August, Stieglitz announced the formation of his own independent magazine, *Camera Work*, "devoted to the furtherance of modern photography." Superficially, *Camera Work* seemed but a continuation of *Camera Notes* under a slightly revised name. Stieglitz published many of the same photographers that he had in *Camera Notes*; he featured essays on modern photography by many of the same authors; and he composed the journal with the same meticulous concern for layout, choice of paper, type, and printing. But the new journal was quite different. *Camera Work* was an art quarterly, not a general-interest camera-club publication. As a privately owned magazine aimed at a relatively small circle of art photographers and patrons, Stieglitz ran it as he saw fit, with advice solicited from trusted friends. No longer compelled to compromise, Stieglitz used *Camera Work* to promote his views and to further the cause of a still vaguely defined "Photo-Secession."[36]

When Edward Steichen returned to New York from Paris in 1902, he clarified the ambitions of Photo-Secession. Steichen urged Stieglitz to organize a group of selected photographers, using *Camera Work* to promote their ideas and work. The first meeting took place in December 1902. At Stieglitz's insistence, the group stipulated neither constitution nor by-laws and only three stated aims—to advance photography as an art, to provide an organization for art photographers, and to exhibit the finest work of American art photographers. Nominally national in scope, Photo-Secession was a New York organization, consisting entirely of Stieglitz loyalists. Photographers Gertrude Käsebier, Clarence White, Alvin Langdon Coburn, Steichen, and Stieglitz formed the heart of Photo-Secession.[37] Stieglitz explained, "Its aim is loosely to hold together those Americans devoted to pictorial photography . . . to compel its recognition . . . as a distinctive medium of individual expression."[38] Stieglitz imagined Photo-Secession as a national organization but one whose leadership resided in New York. Indeed, the establishment of Photo-Secession provided Stieglitz with an organization to sustain his own leadership, to promote art photography, and to insure New York's continued hegemony in American photography.[39]

Except for Steichen and Stieglitz, the most striking feature of Photo-Secession was the fin de siècle character of its images. In subject matter, in presentation, and in composition, the work resembled American impressionist painting.[40] Photo-Secessionists insisted that photography be treated as a fine art and that photographic exhibits be restricted to artistic works—the same goals that the New Movement artists had advocated for painting in the 1870s. Photo-Secession sought to uplift photography, not to question the basis of Western art. Indeed, Stieglitz's proudest

achievements for Photo-Secession were its shows at the Corcoran Art Gallery in Washington, the Carnegie Institute in Pittsburgh in 1904, the 1910 photography show at the Albright Art Gallery in Buffalo, and the numerous Photo-Secession traveling exhibitions in the United States and Europe.[41]

At first more a social climber than a revolutionary, Stieglitz had worked to separate art photography from the work of commercial and amateur photographers, not from the fine arts establishment. With the founding of the Little Galleries in 1905, however, Stieglitz recast Photo-Secession into a genuinely secessionist movement. At Steichen's suggestion, Stieglitz leased three rooms on the upper story of 291 Fifth Avenue, just across the hall from Steichen's studio. On November 5, 1905, Stieglitz formally opened the Little Galleries of Photo-Secession. The first show included one hundred Photo-Secession photographic prints, hung on a line, in unobtrusive frames. During the 1905–6 season, Stieglitz counted more than fifteen thousand visitors and sales receipts of nearly three thousand dollars. If accurate, this record represented a phenomenal achievement. In the spring of 1906, Steichen returned to Paris, leaving Stieglitz with full responsibility for the Little Galleries.[42]

Apart from Stieglitz, Edward Steichen was by far the most important Photo-Secessionist. Trained as a commercial artist, with unsurpassed gifts as a portraitist, Steichen's technical knowledge of photography approached Stieglitz's. Prior to 1913, he also acted as the primary conduit for Parisian modernism to the United States. Steichen introduced Stieglitz to modern painting, provided young American painters entrée to Parisian modernist circles, and sent to New York examples of the most radical work being done in Paris, making Stieglitz's Little Galleries at 291 Fifth Avenue a center of modernist art.[43]

## 27, RUE DE FLEURUS

When Steichen returned to Paris in 1906, he discovered the Steins—Gertrude, Leo, Sarah, and Michael—the patron saints of the Parisian avant-garde.[44] The Steins played the same role for twentieth-century American modernists as the Ecole des Beaux-Arts had played for the New Movement academicians. On the Left Bank, at 27, rue de Fleurus, aspiring American modernists found a hospitable home. Gertrude Stein, in particular, befriended and encouraged members of the Stieglitz group—Marsden Hartley, Max Weber, Arthur Dove, Mabel Dodge, and Steichen. The difference between the Ecole des Beaux-Arts and the Steins, however, was dramatic. The Ecole served as the artistic academy of American Victorian culture; 27, rue de Fleurus was a hothouse of modern culture. Eschewing hierarchy, Gertrude Stein offered no authoritative theories on art, only open-minded support. Art, to Stein, was a matter of personal expression and appreciation. It needed no other justification.[45] Virtually mythological figures of the modernist movement, the Steins recognized, almost from the start, the significance of modernism. With remarkable discernment, they identified and befriended nearly every important prewar Parisian modernist. When no one else took seriously the work of Matisse, Picasso, Rousseau, and Constantin Brancusi, the Steins championed them; they purchased ambitiously and encouraged their friends to do likewise, validating the radically new art.[46]

All of the Stein children were born in Pittsburgh or, as Gertrude insisted, in nearby Allegheny, Pennsylvania. In 1879 the family moved to San Francisco. Their father, Daniel, invested in real estate, railroads, and the San Francisco stock market and bought a large Victorian home in Oakland, where the children attended public schools, with supplemental education provided by private tutors. In 1888, following their mother's death from cancer, Michael Stein, the oldest child, left Johns Hopkins University to take over the family's affairs.[47] Michael proved an able if reluctant businessman, managing the family's investments well enough for the children each to receive a trust-payment of about $150 a month for the remainder of their lives. In 1892, Leo entered Harvard, and in 1893, Gertrude enrolled at Radcliffe. Together, they imbibed the heady pragmatism of the Harvard philosophy department that included William James, George Santayana, and Josiah Royce. Gertrude became a disciple of William James and one of his favorite students. James' theories of pragmatic truth, a pluralistic universe, and the will to believe deeply influenced her thinking. In 1897, upon graduation from Radcliffe, Gertrude entered Johns Hopkins Medical School. Leo, with no clear ambitions, followed her to Baltimore, where they shared an apartment. Gertrude persisted in her medical studies until 1902, when she left with Leo for a year of travel. In early 1903, they leased a small newly built house on the Left Bank of Paris at 27, rue de Fleurus so that Leo could pursue his art interests and Gertrude could work on her novel, *Three Lives*. Later the same year, Michael and his wife, Sarah, acquired a house nearby at 58, rue Madame.[48]

On their 1902 arrival in Paris, Leo and Gertrude Stein started to collect art works, purchasing a Cézanne landscape from art dealer Ambroise Vollard. Soon afterward, they purchased several Cézanne nudes, a couple of Renoirs, two Gauguins, and a Cézanne portrait about which American painter Alfred Maurer joked, "You could tell it was finished because it was framed."[49] At the first Salon d'Automne, Gertrude and Leo became entranced with Henri Matisse's controversial *La Femme au Chapeau*. Initially offering less than the asking price, after several days of bargaining the Steins purchased the work for Matisse's full price. The Steins and the Matisses became close friends, visiting frequently at each other's homes. Anxious to show off his work, Matisse brought friends to the Steins' home at 27, rue de Fleurus, and as reports of the Steins' unusual collection spread, others dropped by. Gertrude graciously showed visitors her paintings, offering lunch while Leo gave extemporaneous lectures on individual works and modern painting.[50]

The Steins continued to collect. They purchased paintings by Edouard Manet, Manguin, Honoré Daumier, Valloton, Maurice Denis, Pierre Bonnard, Eugene Delacroix, and Henri Toulouse-Lautrec and bought regularly from Matisse and increasingly from Picasso. Soon, Friday evenings at the Steins' became an ongoing salon for avant-garde art, as Matisse, Picasso, Brancusi, Guillaume Apollinaire, their friends, and interested visitors came to see and discuss the new art.

Given the size and arrangement of the Steins' studio, it would have been difficult to do anything else. Furnished with heavy Italian Renaissance furniture, with a fireplace on one end and a long, benchlike table in the center, the white plastered walls of the one-room studio were covered with paintings from ceiling to floor, according to Leo, "two deep." The paintings changed as Gertrude and Leo acquired new ones

American moderns in Paris. Gertrude Stein and Alice Toklas ministering to American doughboys (1917). *Gertrude Stein Collection, Beinecke Rare Book and Manuscript Library, Yale University, by permission of the Gertrude Stein Estate*

and sold others, but most were by Matisse and Picasso, and all were provocative.[51]

In 1907, Gertrude Stein established a lifelong relationship with Alice B. Toklas. She maintained a regular and demanding work schedule for her writing, and she lived within her modest means, which derived from investment income and her considerable writings. An admirer of Herbert Hoover and a de facto Republican, Stein declared her American identity proudly; she opened her home to American doughboys during World War I and to GIs during World War II and became an American hero and the founding mother of the New York modernist movement. From its origins, under the nurturing wings of Stein and Toklas, New York Modern rejected Victorian notions of patriarchy and sexuality. For Stein and Toklas, "the modern" meant sexual liberation, female equality, and artistic modernism.[52]

The year 1907 proved an eventful one for the Steins: Leo left for New York, Alice

Toklas arrived from San Francisco to live with Gertrude, and Matisse, at Sarah's suggestion, organized a painting school. While Gertrude lost interest in Matisse after 1907, focusing her attention instead on Picasso, Michael and Sarah became Matisse's champions and patrons. Drawing on many of the Stein studio habitués, Matisse offered a modernist atelier that, from 1907 to 1911, included Americans Sarah Stein, Walter Pach, Maurice Sterne, and Max Weber.[53]

Weber, who had lived in Paris since 1905, assumed leadership, with Edward Steichen, of a growing contingent of American modernists drawn to Paris. In 1908, Weber, Steichen, and Alfred Maurer formed the New Society of American Artists, a secession from the Beaux-Arts-oriented Society of American Artists that Augustus Saint-Gaudens had founded in the 1870s. In addition to Weber, the New Society included Stieglitz protegés Arthur Dove and John Marin. None of the New Society's exhibition plans materialized, but it coalesced a group of American modernist painters, several of whom were associated with Stieglitz. The dominant figure of the group was Max Weber.[54]

As a young boy, Weber had emigrated with his mother from Bialystok, Poland, settling in 1891 in Brooklyn, where he attended public school. In 1898, Weber enrolled at Pratt Institute, where he came under the influence of Arthur Dow. Weber supported himself with a variety of teaching jobs, all the while saving his money to go to Paris. He enrolled in several private art academies, including the Académie Julian, but resented the imitative regimen of his instructors. After seeing Paul Cézanne's work at 27, rue de Fleurus and the 1906 Salon d'Automne, Weber experienced an artistic awakening. A close friend of Sarah and Michael Stein, he helped Sarah organize Matisse's art class, during which he adopted Matisse's ideas of drawing, expression, and color and came to value non-Western art, especially African sculpture. At the same time, Weber became a close friend of Henri Rousseau as well as an acquaintance of Picasso, Denis, and Apollinaire. Well regarded, he showed in the Salon d'Automne in 1906, 1907, and 1908 and in the Salon des Indépendants in 1907. Just before leaving for New York in 1908, Weber attended the famous Rousseau banquet hosted by Picasso.[55]

In New York, when Weber had difficulty finding employment and having his work shown, Steichen suggested that he approach Stieglitz. Despite a cool reception, by 1909 Weber had become a regular with the Stieglitz circle, providing firsthand accounts of the Parisian avant-garde as well as a sophisticated understanding of Cézanne, Matisse, and Picasso and compelling arguments on African and pre-Columbian art. In 1911, Stieglitz gave Weber his first solo show at his new 291 Gallery. The show received a nearly unanimously negative reaction from critics, including James Huneker. Nevertheless, no American prior to 1913 had so effectively absorbed the insights of Picasso and Matisse.

Weber's 1913 painting, *Fleeing Mother and Child,* made no concessions to naturalistic representation. In the background of a stark red canvas, Weber sketched a leafless blue tree on which perched two colorful, carrion-like birds. In the foreground is a grey woman carrying and consoling a frightened child. Throughout the composition Weber used bold earth-toned colors made to look like a child's crayon drawing. Spare but emotionally laden, Weber's painting seemed to refer to his own

mother's flight in the face of a Russian pogrom as well as to the precariousness and loneliness of modern life. Weber's use of color and his fauvist images proclaimed the arrival of a radical new form of art and visualization. Except for encouragement from Stieglitz and others at 291, Weber received only disdain and ridicule. Prior to World War I, to most New York artists and critics Stein and Parisian modernism seemed but another bizarre and ephemeral French farce, unworthy of serious consideration. Alfred Stieglitz, however, believed modernism offered a vision of the future, a glimmer into the modern.[56]

## 291

Max Weber's return to New York in 1909 coincided with Stieglitz's recasting of Photo-Secession into a full-blown modernist secession. In 1908 the lease for the Little Galleries expired. Stieglitz negotiated a contract for Steichen's vacated studio across the hall at 293 Fifth Avenue. Disregarding the change of address, Stieglitz named his gallery 291. Much smaller than the Little Galleries, 291 had only one exhibition room, about fifteen feet square, and a hall-like storage room. Marsden Hartley recalled his first visit in 1909: "I was eventually presented to the presiding spirit of this unusual place, namely Alfred Stieglitz with his appearance of much cultivated experience in many things of the world. . . . There was likewise a Parisian tone pervading this place. We began to hear names like Matisse, Picasso, Cézanne, Rousseau, and Manolo."[57] At 291, Stieglitz prepared *Camera Work,* met friends, and exhibited and sold work, all the while forging an avant-garde of artists, critics, and supporters. The New York equivalent of 27, rue de Fleurus, 291 was as different from the Left Bank as Alfred Stieglitz was from Gertrude Stein and as New York was from Paris.

Stieglitz cultivated an ambience that emphasized the preciousness, even sacredness, of art. At 27, rue de Fleurus, located in a quiet backstreet of the Left Bank, Gertrude Stein unpretentiously welcomed all. Visitors viewed and discussed her paintings freely. Stein made people feel at home. At 291, located in downtown Manhattan on a busy commercial block of Fifth Avenue, Stieglitz intentionally kept visitors off balance. To those who seemed genuinely interested yet confused by modern art, Stieglitz showed the utmost patience, sometimes selling a work for only a fraction of its value. But those who voiced skepticism or amusement he treated with scathing contempt, refusing to sell them anything at any price. Most of the time, however, when he was not occupied with editorial and gallery duties, he conducted an ongoing seminar on modern art with whoever happened to be in the gallery.[58]

Disappointed with the representational quality of the work of Robert Henri and the Eight, Stieglitz introduced American artists and collectors to the most radically experimental work being done in Europe. From Paris, Steichen energetically collected works to be shown at 291. In January 1908, Stieglitz inaugurated a series of modernist shows with a collection of Rodin drawings, which were much less naturalistic than his sculpture. Stieglitz followed the Rodin show with a Matisse exhibition, secured through Sarah Stein. The Matisse show created a stir among New York art critics, who simply could not comprehend the work. Stieglitz exhibited Toulouse-

Lautrec lithographs, mounted second shows for Matisse and Rodin, and in 1910 presented a postimpressionist show that included work by Manet, Cézanne, Auguste Renoir, Toulouse-Lautrec, Rodin, and Rousseau. These were followed by Picasso's first American show and solo shows for Matisse, Francis Picabia, and Brancusi.[59]

Stieglitz accompanied these exhibits with essays in *Camera Work* on modern art written by Wassily Kandinsky, Gertrude Stein, and Max Weber as well as critical discussions by American critics Charles Caffin, Marius de Zayas, and Benjamin De Casseres. Throughout, Stieglitz steadfastly resisted identifying a school or endorsing one particular theory of modern art. Stieglitz explained his distaste for doctrinaire positions thus: "I have always been a revolutionist if I have ever been anything at all. . . . At heart I have ever been an Anarchist. All truthseekers are that whether they know it or not. But even that label as label I hate. So I am a man without labels and without party."[60] Indifferent to ideological purity or consensus, at 291, Stieglitz encouraged serious discussions about art and creativity, all the while developing his own ideas and becoming increasingly sensitive to the power of modernism, especially the flattened perspectives, intense colors, and abstract and distorted representations so at odds with his own straight photography.[61]

During his 1907 visit to Paris, Stieglitz, accompanied by Steichen, had visited the Bernheim-Jeune Galleries to see the work of Cézanne and Matisse. At first overwhelmed, in time he found that the work helped him to see new shapes and relationships in his own photography. In the summer of 1909, Stieglitz visited 27, rue de Fleurus, where he again found himself overwhelmed. He viewed Picasso's work for the first time and met Matisse. He momentarily came under the spell of Leo Stein. Back in New York, Max Weber continued Stieglitz's education. Stieglitz returned to Europe in 1911, visiting the German expressionists in Munich and becoming more familiar with the work of the Parisian avant-garde.[62]

Stieglitz placed Cézanne, van Gogh, Picasso, and Matisse at the center of modernism. After failing to interest the Metropolitan Museum of Art in a combined Cézanne, van Gogh, Matisse, and Picasso exhibit, Stieglitz devoted the entire August 1912 issue of *Camera Work* to these major modernists. The issue included Gertrude Stein's essays on Picasso and Matisse and photographs of several works by Matisse and Picasso. In July, Stieglitz had reprinted in *Camera Work* excerpts from Wassily Kandinsky's manifesto in behalf of abstract art, *On the Spiritual in Art*. Outraged at New York art critics' reception of Kandinsky's work, in 1913 he purchased a large Kandinsky painting for himself. Despite such promotional efforts, he was not interested in the European avant-garde as such. Rather, he used European modernists to challenge American moderns.[63]

Stieglitz did not return to Europe after 1911. Instead, he devoted himself almost entirely to the promotion of New York's promising modernists. Besides Weber, these included painters John Marin, Arthur Dove, and Marsden Hartley, all members of the New Society of American Artists in Paris and habitués of 27, rue de Fleurus. Apart from Weber, the two most radical of the 291 painters were Arthur Dove and Marsden Hartley. Dove's 1910–11 series of oils, *Abstractions* (nos. 1–6), placed him among the most experimental modernist painters in his use of colors and shapes and in his degree of abstraction.[64] Marsden Hartley's paintings were as radical as Dove's.

Hartley's modernist awakening came in 1909, when he discovered the paintings of Albert Pinkham Ryder. Rebuffed by Henri's realist circle, Hartley turned to 291 and quickly made it his second home, participating in the discussions and studying the exhibits, particularly the 1910 Matisse and 1911 Picasso shows.[65]

In 1912, with the encouragement of Stieglitz and Arthur Davies and with the financial support of Agnes Meyer and Lizzie Bliss, Hartley sailed for France.[66] In Paris, Hartley joined the circle of American modernists at Gertrude Stein's. He quickly adopted the colors and composition of Cézanne and Matisse and the formal cubist distortions of Picasso and Georges Braque. Intrigued by Kandinsky's spiritual defense of abstract painting, Hartley traveled to Berlin and Munich, where he came under the influence of Franz Marc and Kandinsky. By 1913, Hartley had moved to the front ranks of modernist experimentation, developing a style that he called cosmic cubism. The ragged shapes, colors, and mysterious numbers in his 1913 painting, *Military,* reflected German expressionist influence and his obsession with numerology, while the title indicated Hartley's fascination with uniforms, armies, and male soldiers.[67]

From 1907 to 1913, Stieglitz assembled and encouraged a talented group of painters whose work reflected the most advanced ideas of American modernism. None of the painters associated with 291, however, approached the stature or the originality of Picasso, Matisse, or Kandinsky. Although the 291 circle painted American subjects, their styles were largely borrowed. The modernists at 291 had freed themselves from American urban realism but failed to generate their own distinctive styles. The derivative character of their work became obvious in the winter of 1913 at the *International Exhibition of Modern Art* at the Sixty-ninth Armory.[68]

## THE *ARMORY SHOW*

According to Walt Kuhn, the executive secretary of the *Armory Show,* "Two things produced the *Armory Show*: a burning desire by everyone to be informed of the slightly known activities abroad and the need of breaking down the stifling and smug condition of the local art affairs as applied to the ambition of American painters and sculptors."[69] Determined to produce a true New York extravaganza, the sponsors of the *Armory Show* took their cues as much from David Belasco and Charles Frohman's Broadway as from Gertrude Stein's Left Bank. Backed by the *New York Sun* art critics, promoted by a special edition of *Arts and Decorations,* and featured in all of the city's dailies, the *Armory Show* was New York's first blockbuster, international art show.

The idea for an international exhibition of modern art arose in 1911 during an informal discussion between Walt Kuhn, Jerome Myers, Elmer MacRae, and Henry Fitch Taylor. The group met regularly at the Madison Gallery to discuss how to promote the work of young artists and what they identified as progressive art—urban realism and modernism.[70] On December 14 the group formally organized itself as the American Association of Painters and Sculptors (AAPS) and invited several others, including painters Arthur Davies, William Glackens, and George Luks, to join. With Walt Kuhn as executive secretary, the AAPS membership expanded to twen-

ty-five, most of whom considered themselves progressives, such as George Bellows and Mahonri Young, but it also included several academic artists such as John Alden Weir and sculptor Gutzon Borglum. Despite the initial aloofness of both Henri and Stieglitz to the proposal, the *Armory Show* brought together the city's two most important avant-garde groups with New York's most progressive academic artists.[71]

On January 3, 1912, the American Association of Painters and Sculptors publicly announced its formation and later selected Arthur Davies as president. The appointment of Davies proved critical to insuring the avant-garde character of the show. The association had one declared goal: to introduce the American public, through exhibitions, to the best contemporary art of the United States and Europe. The AAPS adopted a nonjury policy of exhibiting only invited works. At the suggestion of several members, Kuhn approached the commander of the Sixty-ninth National Guard Regiment about renting the armory at Lexington Avenue and 25th Street. In May the commander and the AAPS signed a lease for five thousand dollars. New York attorney and art collector John Quinn drew up the contract as well as a corporate charter for the AAPS, joining Gertrude Whitney and Lizzie Bliss as the *Armory Show*'s principal financial angels.[72]

The exact scope of the exhibition had never been discussed, and Davies, Borglum, and Kuhn were left with wide discretion over its content and presentation. Davies and Kuhn took charge of painting and graphics, while Borglum oversaw the selection of sculpture. Shortly after signing the armory lease, Davies came across the catalog for the upcoming Cologne Sonderbund show that included the work of Europe's most important modernists. Davies realized that he had been unaware of much that was going on in Europe and that for the *Armory Show* to represent contemporary art adequately it must exhibit the full range of European modernism. He asked Kuhn to visit the Cologne show; Kuhn arrived on the last day of the exhibit.

The show proved as rich as Davies had anticipated. Kuhn desperately tried to absorb everything he saw and at the same time secure commitments from the artists present. He visited The Hague to examine the sculpture of Odilon Redon, and while there he gained pledges for several paintings by van Gogh. Next, he traveled to Munich and Berlin, to recruit German expressionists, and then to Paris. Accompanied by Alfred Maurer and Walter Pach, Kuhn visited artist studios and galleries. A week later Davies arrived in Paris. In ten frantic days, Davies, Kuhn, and Pach received commitments from the Villon brothers, Braque, Picasso, Alexander Archipenko, Amedeo Modigliani, Rodin, Brancusi, Picabia, and Matisse and from Americans in Paris—Patrick Henry Bruce, Morgan Russell, and Elie Nadelman. Art dealer Ambroise Vollard offered to lend works by Cézanne, Gauguin, Redon, Renoir, and Toulouse-Lautrec, and Durand-Ruel promised a collection of impressionist paintings. The Steins provided introductions to the fauves.[73] Running out of time, Davies and Kuhn dispatched to see Roger Fry's postimpressionist Grafton show in London. To their great satisfaction it did not approach the scope and richness of their own upcoming exhibition. Nonetheless, they arranged for several of the most interesting Grafton exhibits to be sent to New York.[74]

Back in New York, Davies turned his attention to the details of the exhibition. A surprisingly able administrator, Davies set policy, assigned responsibilities, and

raised money. William Glackens headed the committee that would choose the American works. *New York Sun* editor Frederick Gregg and painter Guy Pène du Bois oversaw publicity. George Bellows resolved the structural problems of exhibiting in an armory. Gertrude Whitney paid for the decorations. And John Quinn managed the legal work of shepherding the European works through U.S. Customs.[75] For the moment, those involved set aside their individual differences. Henri ignored the eclipse of his leadership by Davies. Stieglitz, likewise, though feeling slighted and disapproving of a large public exhibition, supported the show in principle and lent several of his own works to the exhibit. In January, however, Gutzon Borglum became concerned with Davies' choice of sculptures. Unmindful, Davies accepted a number of works over Borglum's objections. On February 1, Borglum resigned, insuring that the *International Exhibition of Modern Art* would, indeed, be a show of modern art, severing its last, tenuous tie to New York's beaux arts establishment.[76] "The pine tree flag of the American Revolution was adopted as our emblem," recounted Kuhn. "The tree was reproduced on campaign buttons to signify the 'New Spirit.' . . . The show finally opened . . . on the night of February 17, 1913. All society was there, all the art public, and success seemed assured."[77] In two days the AAPS hung and arranged nearly thirteen hundred works, about a third of them European. The *Armory Show* remained open for four weeks. Sparse at first, attendance increased the last two weeks, reaching 10,000 on the last day, for an estimated total

paid attendance of 70,500. The *Armory Show* exceeded everyone's expectations. The American Association of Painters and Sculptors achieved its stated goal.[78]

Davies organized the exhibit historically so that viewers could trace the development of modern art. The European section began with modern old masters, Francisco Goya, Ingres, and Delacroix, followed by the impressionists, postimpressionists, fauvists, and cubists, with separate rooms for Cézanne, van Gogh, Gauguin, and sculptor Redon. Except for Kandinsky's *Improvisation #27,* the only nonrepresentational work in the New York show, German expressionism was not represented, and, despite their inclusion in the exhibition catalog, the Italian futurists were excluded entirely. Clearly, the *Armory Show* documented the continuing influence of Paris on American art. The special issue of *Arts and Decoration,* published at the time of the show under AAPS sponsorship, read like a manifesto of the School of Paris.[79]

The exhibits in the American section included the work of artists whom Davies considered modern precursors, such as James Whistler, Mary Cassatt, and Albert Pinkham Ryder, as well as the Eight, most of the 291 group, and independents such as Walt Kuhn, Edward Hopper, Jo Davidson, Stuart Davis, Marguerite and William Zorach, and Joseph Stella. Davies did not include American modernists Max Weber, Arthur Dove, Stanton Macdonald-Wright, Man Ray, or Charles Demuth. Despite the omissions, the show was, if anything, too large to be absorbed—exactly what Davies had intended—overwhelming the American art public with the magnitude, variety, and power of the modern movement. To that end also the *Armory Show* succeeded.[80]

Critics viewed the *Armory Show* as an event of momentous significance. It shattered the complacency of American artists, offering the American public a foreshadowing of a fundamentally new art. No one failed to notice the difference between American modern work and European modernism. Reviewers generally appreciated and understood the impressionists. New York critics expressed ambivalence towards Cézanne, van Gogh, and Gauguin but not towards the cubists, whose room drew the most attention. Most visitors found cubism incomprehensible. Individually, Picabia, Redon, Marcel Duchamp, and Jacques Villon received the most attention and sold well. Duchamp's *Nude Descending a Staircase* became the cause célèbre of the exhibit, the object of jokes, frequent review, bitter criticism, and staunch support. Frederick Torry of San Francisco purchased it for $324—probably, the best bargain at the show. Redon's success seems a consequence of his somewhat mystical style. Walt Kuhn liked Redon's work and had agreed, on impulse, to show about fifty of his works.

At the time, Redon was considered the "discovery" of the *Armory Show.* The real discoveries, however, were Picabia and Ryder. Picabia benefited from being the only European painter in the show who was available for interviews in New York. Albert Pinkham Ryder, near the end of his career, received his first significant recognition at the *Armory Show.* Despite Ryder's influence on Marsden Hartley, even Stieglitz had overlooked Ryder's hauntingly modern paintings.[81]

The most searching comment, however, came from those reviewers who realized that the *Armory Show* signified much more than controversial art. Academic critics

Kenyon Cox, Frank Jewett Mather Jr., and Royal Cortissoz feared that modernism also represented an assault on refined culture and traditional Western values. Writing virtually interchangeable criticisms, Cox, Mather, and Cortissoz objected not simply to the work exhibited at the *Armory Show* but to the entire modern movement. Cox considered himself sensitive and progressive, but he had no use for modern art.[82]

On March 15, after four weeks, the *Armory Show* closed in New York. It reopened in Chicago at the Art Institute and in May was shown for three weeks at Copley Hall in Boston. Total attendance at the three exhibitions exceeded 250,000. The publicity was enormous, thrusting modern art into the nation's headlines for nearly three months. One hundred seventy-four works were sold, thirteen of them European. While somewhat disappointing, the *Armory Show* sales formed the nucleus of several major American collections of modern art, including those of John Quinn, Arthur Eddy, Albert Barnes, Walter Arensberg, Lizzie Bliss, A. E. Gallatin, and Katherine Dreier. Quinn alone spent fifty-eight hundred dollars on *Armory Show* purchases, many on works by his friend Walt Kuhn. Eddy paid nearly five thousand dollars for eighteen paintings and seven lithographs. The Metropolitan Museum of Art purchased its first Cézanne for sixty-seven hundred dollars.

To celebrate its accomplishment the AAPS sponsored a formal beefsteak dinner at Healy's Restaurant at 60th Street and Columbus Avenue for its "friends and enemies." Reminiscent of earlier, all-male annual dinners held by the National Academy and the Society of American Artists, guests included Cortissoz, Stieglitz, Quinn, Pach, and nearly every major male figure in the New York art world. In social behavior, at least, the sponsors of the *Armory Show* remained firmly attached to the male rituals of the disappearing Victorian world that the *Armory Show* had assaulted. It took the American Association of Painters and Sculptors more than a year to pay off its obligations and to terminate its affairs. At the final accounting, the three-month, three-city run of the *Armory Show* cost about ninety thousand dollars. Whatever else it accomplished, the *Armory Show* removed modernists from the rarified environment of 291 and placed them, if only temporarily, in the mainstream of American culture and opinion.[83]

The *Armory Show,* by itself, did not change American artistic tastes. Most American art collectors, museums, and artists continued to prefer more narrative, representational, and naturalistic art. It did, however, accelerate interest in modernism, especially in New York art circles. Stuart Davis, Lloyd Goodrich, Georgia O'Keeffe, and Marguerite and William Zorach all attested to the show's impact on their work. Several new galleries featuring modern work opened in the wake of the *Armory Show,* and several other traditional galleries, such as Montross, began to offer modern paintings and sculpture. Moreover, with purchases from the *Armory Show,* new collectors began to assemble substantial collections of modernist work. Indeed, exhibits of modernist works became commonplace in New York after 1913. But, unlike the urban realism of the Eight, modernism prior to World War I remained an almost purely aesthetic expression, the concern of a small handful of artists and critics, largely disconnected from American life. This changed with World War I and the arrival in New York, after 1914, of refugee European modernists.

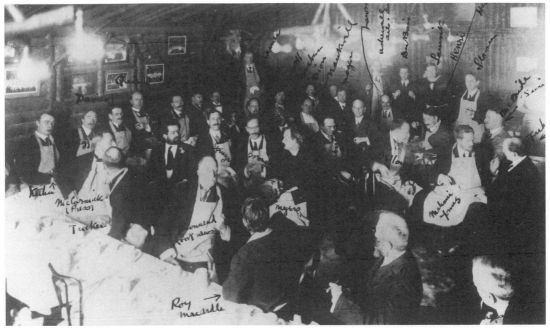

Celebrating the *Armory Show* with beefsteak at Healy's (1913). *Photograph by Percy Rainford. Walt Kuhn Family Papers, and Armory Show records, Archives of American Art, Smithsonian Institution*

## NEW YORK DADA

Kenyon Cox believed that the modernist work exhibited at the *Armory Show* represented the final and complete unraveling of Western art, the logical culmination of the rejection of academic standards. He was wrong. Led by Marcel Duchamp, Francis Picabia, and Man Ray, New York dadaists during World War I attacked modernist formalism as a pretentious deception and pseudoacademic art, an accomplice to the arrogance that had precipitated the war's senseless carnage. Dadaists not only rejected any and all aesthetic standards and judgments, they rejected art itself, including modernism, even as they affirmed its experimental spirit. By the time of his death in 1919, Kenyon Cox might well have longed nostalgically for the *Armory Show.*

Dada, as an artistic phenomenon, understood itself as a nonrational reaction to the irrationality of the world war. In one sense, the term *New York dada* is anachronistic. Those associated with New York dada did not adopt the term *dada* until 1920, after the movement had largely ended. Nonetheless, *dada* accurately described the activities of a self-conscious group of New York painters, poets, and hangers-on who, from 1915 to 1923, adopted an "antiart" stance consistent with the various expressions of European dada. Three of the key figures of New York dada—Marcel Duchamp, Francis Picabia, and Man Ray—played important roles in the international dadaist movement. In *Bulletin Dada,* Tristan Tzara, the chief promoter of dada, "officially" anointed New Yorkers Walter Arensberg, Mabel Dodge, Alfred Stieglitz, Abraham Walkowitz, and others of Walter Arensberg's avant-garde circle as members of "New York Dada."[84]

One of the difficulties implicit in the term is that dadaists strenuously denied that

they constituted a movement.[85] Whether or not international dada was a movement, in New York it was not. Never numbering more than twenty or thirty individuals, New York's dadaists, beginning in 1916, congregated nightly at poet and art collector Walter Arensberg's apartment on the Upper West Side. At most, New York dada was an attitude and a moment.[86] Dadaists refused to view art as a source of special spiritual insight. They found especially amusing those modernists who conducted themselves like a religious cult, offering their works to the public as quasi-religious icons.

The moment of dada was World War I.[87] In New York, as in Zurich and other neutral European cities, artists and poets reacted to the irrationality and the horror of World War I. Much as the war destroyed the European political structure, among New York artists it sanctioned unprecedented experimentation, sweeping away academic resistance. From 1914 to 1920, experimentation, not academicism, became the norm. New York dada ended with the Armistice. Before its demise, however, dada deeply affected the work of American artists by placing modernism, by which they meant the excessive formalism of the School of Paris, in a critical perspective and encouraging American modernists to recognize the rich artistic possibilities in the United States and in American subject matter.[88]

Parisian Francis Picabia, the child of a Cuban-born Spaniard, first visited New York in 1913 on the eve of the *Armory Show,* at which time he was befriended by Alfred Stieglitz and others at 291. Euphoric on his arrival, Picabia thrilled his hosts when he proclaimed to a *New York Times* reporter, "France is almost outplayed. It is in America that I believe that the theories of the New Art will hold most tenaciously."[89] Picabia declared himself invigorated by "the spirit of New York . . . the crowded streets . . . their surging unrest, their commercialism, the atmospheric charm."[90] Before returning to Paris, Picabia completed a series of New York watercolors, which Stieglitz exhibited at 291 and published in *Camera Work.* He lived in New York several months and returned in 1915 for another visit of about a year. His second sojourn marked the beginning of New York dada.

On his 1915 return, Picabia rejoined Stieglitz's circle at 291, helping edit *Camera Work* and joining the staff of *291,* the first identifiably New York dadaist publication. Picabia first published his celebrated "machine portraits" in *291,* attributing his fascination with machine imagery to his sense of modern America: "Almost immediately upon coming to America it flashed on me that the genius of the modern world is in machinery, and that through machinery art ought to find a most vivid expression. . . . Since machinery is the soul of the modern world, and since the genius of machinery attains its highest expression in America, why is it not reasonable to believe that in America the art of the future will flower most brilliantly?"[91]

Picabia's portraits were really cartoons using mechanical images. In *Portrait of a Young American Girl in the State of Nudity,* the subject is symbolized by a spark plug; *Here, This Is Stieglitz* is a drawing of a camera with a semicollapsed bellows, suggesting a limp phallus. In the summer of 1916, fearful that he would soon face military charges for his unauthorized leave, Picabia fled to Barcelona. There he published his own avant-garde magazine, *391,* modeled after *291,* although much more nihilistic and mean-spirited. On his return to New York in April 1917, accompanied by his wife, Gabrielle Buffet, Picabia spent most of his time at Walter Arensberg's

apartment, diverting himself with sex, alcohol, and drugs. Alienated by his womanizing, which included a publicized affair with Isadora Duncan, Buffet left her husband in New York. Before the end of the year, repentant but unreformed, Picabia followed his wife to Switzerland. Picabia did not return to New York, but his machine images, his outrageous behavior, and his nihilism became legendary in New York dada circles.[92]

"From 1915 to 1920," declared American-born dadaist Man Ray, "the home of Walter Arensberg in New York was the home of American Dada."[93] When Marcel Duchamp arrived in New York in June 1915, Walter Pach met him at the pier and drove him to the apartment of Walter and Louise Arensberg at 33 West 67th Street, just off Central Park. Pach had first met Duchamp in Paris at the Steins' and had been instrumental in securing Duchamp's *Nude Descending a Staircase* for the *Armory Show*. Subsequently, Pach became Walter Arensberg's art adviser and confidant. At Pach's invitation, Duchamp came to New York, initially staying with the Arensbergs until securing an apartment in the nearby Lincoln Arcade Building.[94]

On a 1913 trip to New York, Arensberg, on impulse, had visited the *Armory Show*. According to one account, the show so mesmerized Arensberg that for several days he forgot to go home. He purchased several paintings from the exhibition, including Cézanne's *Bathers*, Gauguin's *Project for a Plate,* and Villon's *Sketch for "Puteaux."* Fascinated with the artistic ferment and excitement, in 1914 the Arensbergs moved to New York. They purchased modernist paintings and sculptures from Stieglitz at 291 and from de Zayas's Modern Gallery.[95]

When he first arrived in New York, Duchamp spoke no English. To put him at ease, the Arensbergs regularly invited his Parisian friends to the apartment, and they entertained guests in their main studio, dominated by a stone fireplace, a grand piano, and some forty modernist paintings and sculptures. With Duchamp as the main attraction, the Arensbergs' apartment quickly became a center for New York's avantgarde. Besides Pach and the French expatriates, the regulars included poets Wallace Stevens and William Carlos Williams, art patron Katherine Dreier, and American modernist painters Charles Sheeler, Charles Demuth, and Man Ray.

By the standards set by the original dadaist group at the Cabaret Voltaire in Zurich, the Arensberg circle remained private, sedate, and apolitical. The salon frequently lasted all night, with the Arensbergs providing drinks and chocolate. The conversation was intense and chaotic. At times, Louise Arensberg could be prevailed on to play the piano or Isadora Duncan to dance, and if all else failed, either "Baroness" Elsa von Freytag–Loringhoven or Arthur Cravan could be counted on to do something outrageous.[96] Called "the mother of dada," Elsa von Freytag–Loringhoven had been stranded in New York when her husband, a German envoy to the United States, returned to Germany and committed suicide in protest against the war. Impoverished and alone, von Freytag–Loringhoven gave up her apartment in the Ritz Hotel and migrated to a Greenwich Village cold-water flat on 14th Street, securing work as a model for Village artists.[97] Painter Louis Bouche remembered von Freytag–Loringhoven thus: "She was the Original Dada. She wore also at times a black dress with a bustle on which rested an electric battery tail light. When I asked her why she wore it she said: 'Cars and bicycles have tail lights. Why not I?'"[98]

At other times the baroness placed a coal scuttle on her head as a hat, wore her dead husband's German officer's helmet, once shaved her head and painted it red, decorated her dresses with kitchen utensils, and wore vegetables on her hat and tomato cans on her breasts. She wrote avant-garde poetry, which Margaret Anderson published in *The Little Review,* and became a close friend of Djuna Barnes and photographer Berenice Abbott. Prone to physical outbursts, the baroness ended her relationship with poet William Carlos Williams by punching him in the mouth and, while working at a cigarette factory, had her own front teeth knocked out by a female fellow factory worker. Her first love, however, was Marcel Duchamp. Bouche recalled, "One day while posing for me, I brought her a clipping of Duchamp's *Nude Descending a Staircase.* She was all joy, took the clipping and gave herself a rub down with it, missing no part of her anatomy."[99]

Boxer-poet Arthur Cravan conducted himself as outrageously as the baroness but died sooner. Swiss born, Cravan's given name was Fabian Lloyd. A wild child, he ran away to the United States at the age of sixteen and then bounced from country to country, often just ahead of the police. In 1909, Cravan won the French Amateur Boxing Championship in his weight division, and in 1910 he won the French light-heavyweight championship. In 1911 he changed his name to Arthur Cravan and founded *Maintenant,* an avant-garde literary magazine. Five years later Cravan staged a fight with boxer Jack Johnson, who annihilated him, ending Cravan's not quite promising boxing career. In 1917, Cravan turned up in New York and, through Francis Picabia, was introduced to Walter Arensberg's circle of dadaists. Mina Loy recounted her early impression of him at the Blind Man's Ball: "He was wrapped in a sheet evidently ripped at the last minute from his bed, his head swathed in a towel. . . . Toward the end of the Ball I came upon him again; by this time he was completely drunk, lurching among the mob, demanding women for their telephone numbers. 'You may give me yours,' he instructed me, 'I will ring you up *if* I find the time. So many other women desire me.'"[100] Cravan and Loy were married in Mexico in January 1918. Loy then returned to Europe, and Cravan was to follow. Instead, he disappeared with no explanation and was rumored to have died at sea. Cravan's putative death and Loy's lifelong search for him became central elements of the dada myth.

The Arensbergs convened New York dada. They provided the ambience and the refreshments, and they determined its membership, assuring its private, naughty rather than riotous, apolitical character. But as Mina Loy asserted, Marcel Duchamp was "King Dada." The Arensberg group derived much of its prestige from Duchamp's reputation. His radical artistic ideas gave New York dada its significance. Duchamp's submission of his *Nude Descending a Staircase* shocked the 1912 Salon des Indépendants for its depiction of a nude, its nonrepresentational character, and its expression of motion. In 1913, Duchamp constructed his first ready-made by mounting the front wheel of a bicycle on a stool. His next, *Pharmacy,* consisted of an old lithograph of a winter scene on which Duchamp painted one red and one green dot. Duchamp created his third ready-made by signing his name to a metal bottle-drying rack. He insisted that by removing objects from useful contexts and signing his name to them, he transformed them into artistic objects. Conception, not construction, determined artfulness. In 1913, Duchamp also completed the *Chocolate Grinder,* a

carefully drawn and painted food mill consisting of three geared drums. Made to resemble a technical drawing, the *Chocolate Grinder* alluded to the bawdy saying that the bachelor at a wedding could only go home and "grind his chocolate." Indifferent to commercial success, Duchamp pursued his antiart activities for the amusement it provided him, content to support himself as a librarian at the Bibliothèque Sainte-Geneviève. Gratified by the New York reaction to his *Nude Descending a Staircase* and disillusioned with wartime Paris, in 1915 Duchamp accepted Walter Pach's invitation to visit New York.[101]

Despite his celebrity, in New York, Duchamp continued to live a modest, unassuming life. Having ceased painting altogether, he worked on a large glass construction that occupied him for the next eight years. Duchamp could easily have turned his reputation to profit. Instead, he eked out a living giving private French lessons for two dollars an hour, spending his leisure time playing chess. New York fascinated Duchamp; an inveterate subway user, he thoroughly enjoyed his explorations of the city. He explained, "For a Frenchman, used to class distinctions, you had the feeling of what a real democracy a one-class country could be. People who could afford to have chauffeurs went to the theater by subway, things like that. . . . It was much, much freer than in Paris, and people left you alone more."[102]

Sometime during the winter of 1916–17, working with Arensberg and Katherine Dreier, Duchamp conceived of a great independent show. Apart from the intrinsic interest of such a show, Arensberg and other supporters of the *Independent Exhibition,* as the show came to be called, were motivated by what they considered the narrowness of the previous winter's *Forum Exhibition of Modern American Painters* sponsored by the Anderson Galleries. The *Forum Exhibition* had been limited to sixteen artists chosen from among the individuals represented by Stieglitz's and Charles Daniel's galleries. Adopting a narrow, formalistic definition of modern, the *Forum Exhibition* exhibited only nonrepresentational abstract works that dealt with such formal qualities as "order, rhythm, composition, and form."[103] In contrast, Duchamp's *Independent Exhibition* allowed anyone, with the payment of a five-dollar fee, to exhibit two works. To further insure against selective judgments, Duchamp insisted that the works all be shown on line in alphabetical order, according to the artists' last names, and suggested a random drawing to determine the first letter of the order, which turned out to be *R.*

On April 10, 1917, the first annual exhibition of the Society of Independent Artists opened at Grand Central Palace on 46th Street. More than twelve hundred artists were represented by twenty-five hundred works. There had never been anything like it in New York. Unjuried and with no prizes, the *Independent Exhibition* was so large and so diverse that critics and viewers hardly knew what to make of it. The most noted works were by women: Gertrude Whitney's beaux arts sculpture *The Titanic Memorial,* Dorothy Rice's portrait of the very large *Claire Twins,* and Beatrice Wood's crude drawing of a nude female with a real bar of soap covering the pubic region. Constantin Brancusi's polished bronze, *Princess X,* which resembled male genitalia, was the most interesting piece.

Duchamp, however, again stole the show. The committee violated its own rule that anyone who paid the five-dollar entry fee could exhibit two works of their choice.

The hanging committee caused an uproar by rejecting Duchamp's ready-made *Fountain,* a porcelain urinal by "R. Mutt," a reference to a New York plumbing firm. In protest, Duchamp resigned from the exhibition committee and in the April issue of *Blind Man* ridiculed the intolerance of the exhibit's sponsors.[104]

Almost immediately, the furor over the *Independent Exhibition* was overshadowed by the declaration of war against Germany by the U.S. Congress. As an ally of France, the United States agreed to honor extradition requests, thus ending its asylum for French draft evaders. Enjoying a medical deferment, Duchamp remained in New York until the summer of 1918, working on his large glass construction for the Arensbergs and completing *Tu m',* his last painting, for Katherine Dreier. In the summer of 1918, Duchamp departed for Buenos Aires, followed by Katherine Dreier. Shortly after the Armistice was signed, Duchamp received word that his brother had died from a combat injury, and he subsequently joined Tristan Tzara and Francis Picabia in Paris, making postwar Paris the international center of dada. At Picabia's urging, Tzara initiated a correspondence with Arensberg, formalizing his group's association with dada. Arensberg responded enthusiastically. In January 1920, Duchamp returned to New York, where he presented Arensberg an ampoule of Parisian air. The previous five years, however, had taken their toll on the Arensbergs' finances. In the fall, the Arensbergs left New York for California, which became their permanent residence.[105]

New York dada declared its official existence only after the Arensbergs' departure, on April Fool's Day 1921, under the auspices of the Société Anonyme. In early 1920, Katherine Dreier had invited Duchamp to join her and Man Ray in forming an organization for the promotion of modern art. Dreier explained, "We hope to present, every six weeks, a new group of pictures enabling the public to study the serious expressions of serious men. We do not claim that every movement we exhibit will become permanent or an integral part of art, but we do feel that the serious expression of men should be seen and studied."[106] Duchamp and Man Ray met with Dreier to set up a new organization. Man Ray suggested the name, Société Anonyme, believing it to mean "anonymous society." Duchamp explained that *société anonyme* was the French term for a limited stock company (comparable to the American *incorporated*), but, delighting in the pun, he endorsed the name. To compound the fun, the three agreed to name their organization Société Anonyme, Inc.[107]

Along with the Arensbergs and John Quinn, Dreier had amassed one of the largest modernist collections in the United States. She had grown up in Brooklyn, overlooking the harbor. Encouraged by her parents to be independent and socially responsible, Dreier was drawn to philanthropic and reform causes, especially the settlement house and woman suffrage movements. As a young girl, hoping to become an artist, she had first studied under a private tutor. She began her course work at the Brooklyn Art School, took art classes for a year at the Pratt Institute, and then studied privately with Munich-trained painter Walter Shirlaw. In Paris, Dreier encountered modernist paintings at the Steins', and in 1913 two of her paintings were accepted for exhibition at the *Armory Show,* after which she became a central figure in the New York avant-garde, frequenting 291 and the Arensbergs' apartment and accumulating a rich collection of German modernist paintings and sculptures.

In 1920, following the Arensbergs' departure, Stieglitz's termination of *Camera Work,* and the closing of 291, Dreier assumed responsibility for sustaining the modernist movement in New York. Always the moralist, she devoutly believed that modern artists would remake the world destroyed by World War I. Dreier's high moral seriousness highlighted the lighthearted amorality of Duchamp and Man Ray, who as dadaists fully appreciated their unlikely association with Dreier.[108]

Man Ray was the only American to join the Parisian dadaists. Born Emmanuel Radensky, he had moved from Poland to Brooklyn with his family in 1897. The first art that he remembered completing was a crayon drawing of the battleship *Maine.* Determined to become a painter, Man Ray secured art-related jobs as an engraver, a commercial artist for an advertising company, and later an illustrator for a map publisher, all the while taking art classes at night. Sometime around 1912, Man Ray enrolled in free night classes at the Ferrer Center—sometimes called the Modern School—an anarchist school on East 107th Street run by the philosopher Will Durant and frequented by Emma Goldman, Lincoln Steffens, Margaret Sanger, and Robert Henri. At the Ferrer Center, Man Ray imbibed the anarchism of Emma Gold-

man and Henri's commitment to artistic freedom, but he found himself drawn to the modernist work exhibited in Stieglitz's 291.

For the next several years Man Ray explored several styles, including urban realism, visually distorted cityscapes, cubism, mechanical drawings, and airbrush paintings.[109] His most interesting painting, *The Rope Dancer Accompanies Herself with Her Shadows,* was a painted collage composed in true dada fashion. Having seen a rope dancer in a vaudeville show, Man Ray sketched the acrobat on several differently colored pieces of paper and cut them out. To suggest movement, he arranged them in a series of transitions from one color to another. Unhappy with the results, he glanced at the floor. There, among the scraps of colored paper at his feet, he found an interesting composition. "They made an abstract pattern that might have been the shadows of the dancer or an architectural subject. . . . I set to work on the canvas, laying in large areas of pure color in the form of the spaces that had been left outside the original drawings of the dancer. No attempt was made to establish a color harmony: it was red against blue, purple against yellow, green versus orange, with an effect of maximum contrast. . . . What to others was mystification, to me was simply mystery."[110]

Despite radical differences in outlook, Dreier got along well with Man Ray and Duchamp and replaced the Arensbergs as the patron of New York dada. At her own expense, she rented space for the Société's gallery in an old brownstone at 19 East 47th Street, near the Ritz Hotel. On April 20, 1921, the Société Anonyme admitted the public, for 25 cents admission, to its first show in a suite of rooms whose walls were covered in bluish-white oil cloth and floor carpeted with ribbed industrial rubber matting. Parodying the preciousness of Stieglitz's 291 exhibitions, Man Ray and Duchamp framed each piece of work with dime-store white paper lace. The Société Anonyme subsequently sponsored several serious lectures on modern art and poetry, which at Dreier's insistence were conducted with decorum, despite the best efforts of Man Ray and Duchamp to cast them as true dada happenings.[111]

On their own, however, Man Ray and Duchamp gave New York a mild taste of true dada. In 1921 they published the first nominally New York dada magazine, set in deliberately skewed type. The four-page *New York Dada* contained a letter from Tristan Tzara authorizing New York dada, a cartoon by Rube Goldberg, and a nude photograph of Elsa von Freytag–Loringhoven with shaven head. The cover presented a bottle of perfume whose label featured Duchamp, dressed as a woman, under the pseudonym, Rose Selavy, a pun on "C'est la vie." In January 1923, Duchamp left for Paris. As a going-away gift, Man Ray produced a homemade film, entitled *The Baroness,* of a barber shaving von Freytag–Loringhoven's pubic hair as she presented herself to Duchamp. Although the film was damaged in processing, Man Ray salvaged a single frame and sent it to Duchamp with the hand-written inscription, "dada cannot live in New York." Man Ray quickly followed Duchamp to Paris, as did the baroness, ending New York dada except for the activities of Dreier's Société Anonyme and a poetry group led by Matthew Josephson.[112]

Before leaving New York, Duchamp finally completed the large glass construction on which he had been working since 1915. On his arrival in New York, Duchamp had explained, "I bought two big plate-glass panes and started at the top, with the

Bride. I worked at least a year on that. Then in 1916 or 1917 I worked on the bottom part, the Bachelors. It took so long because I could never work more than two hours a day. You see, it interested me but not enough to be *eager* to finish it. I'm lazy, don't forget that."[113] Radical in his conception and use of materials, at several key points Duchamp also resorted to random effects in his construction, deliberately leaving the glass uncovered for six months in his studio to allow the accumulation of New York dust, which he preserved with a shellac fixative. Nonetheless, few works of art have been so meticulously planned. Duchamp had thought about the large glass since 1913, and over the years he drew up elaborately detailed plans, which he kept in a journal, itself a work of immense and calculated complexity that resembled architectural drawings more than notes for an art construction.[114]

In its final form, many of Duchamp's plans for the large glass, *The Bride Stripped Bare by Her Bachelors, Even,* went unrealized.[115] An apt conclusion to his artistic career, *The Bride Stripped Bare, Even* exemplified Duchamp's playful and detached cynicism. The work was elaborately designed and painstakingly constructed; yet when movers broke it in 1926, Duchamp responded with a shrug and patiently piecing it back together, insisting that the glued fracture lines fulfilled his design. Duchamp treated art, like chess, as a distraction, an amusement. When he ceased enjoying the process, he ceased making art, despite numerous financial offers to continue. A celebrated modernist, Duchamp's antiart critique was especially telling. Duchamp, Man Ray, and other dadaists rejected the idea that modernism represented a new form of religion that provided insight into a higher reality; they denied that it explained the world at large; and they vigorously protested the use of art as an instrument of either class snobbery or political manipulation.[116]

Compared with European dada, New York dada appeared tame. Dadaists' antics made it look like an interesting but silly moment in American art, an appendage to the more important European movement. New York dada, however, represented a critical moment in modern New York art. At the most tangible level, Picabia and Duchamp sanctioned the use of New York to symbolize the modern. Encouraged by their support, John Marin, Marguerite Zorach, Charles Demuth, Joseph Stella, Georgia O'Keeffe, and numerous other modern American artists painted powerful New York cityscapes that went far beyond the naturalism of earlier impressionists and realists. Picabia's fascination with machinery and his description of technology as the "spirit" of the modern, the "essence" of the United States, provoked American painters to incorporate factories, machinery, and technology into their work. But dada's influence went beyond imagery.[117]

Stunned by the modernist work exhibited in the *Armory Show,* New York artists seemed destined to follow in the footsteps of the earlier New Movement, imitating what they judged to be superior European art. Much to their surprise, Duchamp himself ridiculed all such efforts. Refusing to treat modernism as more than individual artistic expression, comparable to a porcelain urinal or a zinc bottle rack, Duchamp and his fellow dadaists enabled American artists to address critically not simply modern life but modern art as well. By rejecting modern art, even modernist work, as pretentious and bourgeois, like World War I, dada destroyed the illusions

of the past and helped American artists to overcome their sense of inferiority towards Europe and European art and thereby to establish American artistic independence.[118]

Dada's contemptuous dismissal of European art, together with Duchamp and Picabia's enthusiastic embrace of New York, freed American artists to create a modernist vocabulary that explored the special character of their own country, uninhibited by any aesthetic orthodoxy. In his autobiography, Stuart Davis, a disciple of Robert Henri, recounted the impact that the *Armory Show* had on him: "I resolved I would definitely have to become a 'modern' artist." Davis's use of the term *modern* indicated his intention to abandon urban realism for some form of modernism. Instead, in the 1920s Davis used modernist ideas to reconfigure his urban realism, creating paintings distinctly his own, identifiably American, and inherently modern in subject and expression. In the aftermath of the *Armory Show* and the dadaist convulsion, New York artists, like Davis, discovered new subjects close at hand—in the city, in the countryside, in factories, on the shore, in the streets, and in the emotions they elicited. After generations of deference to European artistic authority, American artists during World War I finally achieved the independence and the confidence to create modern American art.

Still, dada was only half the story. In Greenwich Village during the war, American radicals also raised the banner of modern art to launch a revolution that altered not just American art but American culture. For Greenwich Village radicals, "modern" entailed much more than the modernist work exhibited at Stieglitz's 291. It also entailed radical notions of individual expression, gender, and sexuality. In wartime New York, Kenyon Cox's worst fears were realized.

# Bohemian Ecstasy
## Modern Art and Culture

In the fall of 1913, the Liberal Club, founded in 1907 by Episcopal priest Stickney Grant, split in two, igniting the Greenwich Village rebellion. Grant had organized the Liberal Club to bridge the growing gap between his church on Fifth Avenue and 10th Street and the influx of young bohemian radicals attracted to inexpensive housing in the Village. "Like all Gaul," observed Ascension Episcopal congregant Edith Hulbert Hamilton, "the Liberal Club is, or was, divided into three parts—the Greenwich Villagers, who are the extreme left; the Socialists and the Ascensionites." At the Liberal Club, near fashionable Gramercy Park on East 19th Street, members discussed the labor movement, the minimum wage, child labor, tenement conditions, public education, and other social issues. Bitter disagreement over personal morality, however, not political economy, polarized the Liberal Club.[1] The refusal of member Henrietta Rodman to disassociate herself from what appeared to be an extramarital sexual relationship led to the crisis at the Liberal Club. Rodman, a public school teacher, had at first concealed her marriage to avoid compliance with a New York School Board regulation that required female teachers to register their marriages with the board and to cease teaching if they became pregnant. In protest against the school board's discriminatory policy, Rodman announced, but did not register, her marriage.

This did not disturb Ascension moderates, who shared her disapproval of the New York School Board policy towards women. But when the details of Rodman's marriage were made public, the Ascension faction became outraged. Rodman acknowledged that she and her husband, Herman de Fremery, continued to live with Fremery's common-law wife in their Bank Street apartment. Moreover, rumors circulated that other members of the Liberal Club enjoyed sexual relations with the de Fremery–Rodman ménage. Rodman insisted that the Liberal Club had no business inquiring into her private conduct, and indeed, she supported the principle of free love. On the departure of the moderate faction, the Village faction promptly

Rebels in Greenwich
Village. Herb Roth,
*The Liberal Club*
(1914).
*Press Publishing*

moved the Liberal Club from its Gramercy Park quarters to a disheveled town house near Washington Square in Greenwich Village. From 1913 to 1920, led by the radicalized Liberal Club, Greenwich Village radicals fomented a cultural revolution centered on sexual freedom, socialism, and modern art.

Ernest Holcomb, a city engineer, and his wife, social worker Grace Potter, assumed leadership of the new Liberal Club. The Liberal Club secured rooms at 137 MacDougal Street, one of four adjoining row houses. Just south of Washington Square, these four houses—133, 135, 137, and 139 MacDougal Street—formed the command post of the Greenwich Village rebellion. In addition to the Liberal Club, Polly's Restaurant occupied the basement of 137 MacDougal Street, the Boni brothers' Washington Square Book Shop leased 135 MacDougal Street, and the Provincetown Theater moved into 139 MacDougal Street. Various Village radicals rented apartments on the upper floors and lofts of the four buildings.[2] The club rooms included two high-ceiling parlors with fireplaces and an attached sunroom, which overlooked a grassy courtyard that led to the outside entrance of Polly's Restaurant in the basement below. The rooms contained comfortable used furniture, a beat-up upright piano, and a scattering of old chairs and tables; the walls were decorated with Greenwich Village scenes painted by Charles Demuth and Marsden Hartley and an assortment of political cartoons by Art Young. The Liberal Club furnished Village radicals a comfortable, inviting home, living up to its motto, "A Meeting Place for Those Interested in New Ideas."[3]

At the Liberal Club, Village poets Edna St. Vincent Millay and Louise Bryant gave poetry readings, and Floyd Dell and Sherwood Anderson organized impromp-

tu one-act plays that led to more organized efforts by the Washington Square Players and the Provincetown Theater. Here, the staff of the socialist magazine the *Masses* congregated to discuss upcoming editions, to play all-night poker, and to catch a quick meal at Polly's. The Liberal Club sponsored discussions on birth control, free love, socialism, woman suffrage, modern art, and poetry, and members used the club rooms and the club's battered piano for spur-of-the-moment dances and parties. In nearby dance halls the Liberal Club held the annual Pagan Routs that gained city-wide notoriety for participants' bizarre costumes, sexual dancing, heavy drinking, and reputed nudity.[4]

In 1915, the Liberal Club became even more congenial for Village radicals when Albert and Charles Boni opened the Washington Square Book Shop next door. A common doorway joined the two. Never profit makers, the Bonis stocked their shelves with radical books and magazines and invited club members to use it as a private reading room, making the shop available as additional seating space for the Liberal Club's frequent and informal one-act plays. The Bonis published the work of Village writers and poets, and their bookstore was run more like a private library than a business. At its height, about a hundred Villagers were affiliated with the Liberal Club, ate at Polly's, and frequented the Bonis' bookstore.[5]

New York radicals coalesced in Greenwich Village during World War I. Through organizations like the Liberal Club, salons, labor organizations, magazines, dramatic productions, and art exhibits, Village radicals created a diverse community unified by their opposition to World War I, a rejection of Victorian sexual constraints, a desire for social change, and the affirmation of modern art. Blending urban realism with modernism, the artists of the Greenwich Village rebellion—from the Whitney Studio Club to the *Masses*—recast New York's modern movement away from narrow aesthetic concerns into an inclusive vision of modern life defined by social equality, feminism, socialism, and free love, bolstered by personal creativity and expression. The Village rebellion culminated in 1919 with the commercial success of the Provincetown Theater's production of Eugene O'Neill's experimental play *The Emperor Jones*. At the end of World War I, the Greenwich Village community fragmented, but its artists, writers, and playwrights took with them the outlook and attitude of the Village Rebellion.

## GREENWICH VILLAGE AND ITS RADICALS

Platted before planners imposed a uniform grid on the city, Greenwich Village maintained its own street pattern, giving it a special status in the city. Even before the Civil War, artists and writers had been drawn to the Village. Edgar Allan Poe and Thomas Paine had lived and written there, and after the Civil War, Henry and William James and Edith Wharton had grown up near by. Because of the sandy subsoil, buildings in the Village rarely exceeded five stories, leaving its nineteenth-century town houses, mansions, stables, and carriage houses on Washington Square, Fifth Avenue, and the adjoining streets and alleys virtually untouched by modern construction until the 1920s.

In the 1890s, when the population of the city shifted north, bypassing the Village,

landlords constructed numerous tenements to the south and west of Washington Square. Artists took advantage of the low rents and convivial setting. An in-between neighborhood, Greenwich Village lay north of the Jewish Lower East Side, Chinatown, Little Italy, and the Lower West Side factory district and south of the fashionable neighborhoods of Chelsea and Gramercy Park. The Village gloried in its ethnic, occupational, and class mix. For artists, writers, political radicals, and hangers-on, the Village seemed ideal, offering cheap rent, quaint old-world streets, used-book shops, numerous restaurants, coffee houses, and easy access, by elevated trains and buses, to the remainder of the city.[6]

With Washington Square as its center, Greenwich Village stretched from 14th Street south to Houston Street between Broadway and West Street. After 1913, radicals claimed Greenwich Village as their neighborhood. At times, they behaved as an autonomous, self-governing community, at one point even jokingly seceding from New York to form the "Republic of Greenwich Village." In addition to the Liberal Club, Polly's, and the Washington Square Book Shop, they gathered at Mabel Dodge's mansion on Fifth Avenue and the Brevoort Hotel, with its Parisian ambience. Lesbians found companionship at Jane Heap and Margaret Anderson's apartment. Gay males frequented the Turkish baths at the Lafayette Hotel on University Place, while political radicals gathered at the Rand School, headquarters of Branch One of the American Socialist Party, and at the editorial offices of the *Masses* on Greenwich Street. The Village boasted an active Socialist Party, an anarchist school, militant woman suffrage and labor organizations, radical and avant-garde magazines, independent publishers such as Boni and Liveright and B. W. Huebsch, and several experimental theaters. Henrietta Rodman welcomed writers and feminists at her apartment on Bank Street, artists gravitated to Marguerite and William Zorach's apartment on West 10th Street and Gertrude Whitney's studio on West Eighth Street, and on any evening Villagers gathered for drinks at either the Hell Hole Saloon on West Fourth Street or the Working Girls' Home, a bar at Greenwich Avenue and Christopher Street. On Wednesday night Mabel Dodge welcomed all to her salon on Fifth Avenue, just off Washington Square.[7]

Much of the Village's appeal was the wide array of art-related jobs available in New York. Many artists worked as illustrators for the city's daily newspapers, magazines, and book publishers; some supported themselves on portrait commissions, while others taught in the city's numerous art schools. In 1914, more than two dozen recognized art schools operated in the city, with an aggregate student enrollment of about twenty-five thousand.[8] Beyond art, the most important political concerns of the Greenwich Village rebellion were sexual liberation, personal freedom, the equality of women, and birth control. A survey of four hundred Village radicals revealed that most hailed from urban America. More than half of the Village radicals, out of a sample of 141, came from New York City or towns in New York state, Massachusetts, New Jersey, Pennsylvania, and other eastern states. Twenty-nine grew up in foreign countries, and twenty-seven came from the Midwest, most from Chicago, Cleveland, St. Louis, and Milwaukee.[9]

About half of the Villagers were the children of rich or well-to-do families (forty-nine out of ninety-seven). Only about 20 percent came from truly poor families. The

remaining 30 percent were the children of middle-class or lower-middle-class homes. Sixty percent of the Greenwich Village radicals surveyed had attended college—this, at a time when only 10 percent of the population in the United States between eighteen and twenty-two years of age did so. Many of the others had either gone to prep school, traveled to Europe, or studied at an art school. The most striking characteristic, however, was the rebels' perception of parental roles within their families. Of eighty-eight Villagers who provided information about their parents, twenty-four (27%) grew up in families without a male head, because of death, divorce, or desertion. Sixteen other Villagers (18%) described their fathers as failures. Twenty-two Villagers (25%) characterized their fathers as successful but tolerant of nonconformism and generally nonauthoritarian. Only six portrayed their fathers as both successful and authoritarian. In sum, two out of three Greenwich Village radicals grew up in what they characterized as female-dominated families.[10]

The women actively involved in the Greenwich Village rebellion included such notables as Djuna Barnes, Louise Bryant, Willa Cather, Dorothy Day, Mabel Dodge, Isadora Duncan, Crystal Eastman, Elsa von Freytag–Loringhoven, Susan Glaspell, Emma Goldman, Theresa Helburn, Mina Loy, Edna St. Vincent Millay, Margaret Sanger, Gertrude Whitney, and Marguerite Zorach. Greenwich Village rebels hardly mirrored American life, nor did they represent their generation. Far from rebelling against small-town, patriarchal childhoods, Village radicals were themselves the children of affluent, urban, middle-class, and egalitarian families. From 1913 until the Armistice, these middle-class radicals created in Greenwich Village a modern alternative to Victorian culture, built around sexual liberation, gender equality, socialist politics, and modern art.

## 1913

In 1913 a sequence of events triggered the Greenwich Village revolt. By themselves, each of these events attracted attention; together, they formed a movement dedicated to subverting the remnants of a suffocating Victorian culture and attacking the social inequities of American capitalism.[11]

In January 1911, Piet Vlag, a Dutch immigrant who worked as a cook at the socialist Rand School on East 19th Street, founded the *Masses* magazine to promote cooperative socialism through worker ownership. From its first issue, the *Masses* was something of an anomaly. Its articles and editorials offered a regular and dreary fare that advocated socialist cooperatives, but its lively and fresh illustrations, supervised by Art Young, made the *Masses* an immediate success. By the end of its first year, however, publication costs forced Vlag to raise the per copy price from five to ten cents, cutting circulation dramatically. Vlag considered merging the *Masses* with a Chicago magazine.

Determined to keep the magazine in the Village, Art Young called an emergency staff meeting in the summer of 1912, to which he invited freelance writer Mary Heaton Vorse, artists John Sloan and Glenn Coleman, and Socialist Party activist Dolly Sloan, wife of John Sloan. The staff elected Dolly Sloan treasurer and convinced John Sloan to assume temporary editorship. Under the Sloans' direction, the

Headquarters of the Greenwich Village re-
bellion. Lithograph by Glenn Coleman, *91
Greenwich Avenue* (1914).
*Published in* The Masses

*Masses* discarded its didactic writing and editorials in favor of irony and humor. Mod-
eled after the European satirical magazines *Punch* and *Simplicissimus,* political mil-
itancy and the absence of advertising set the remodeled *Masses* apart from other
American magazines. Those in attendance agreed, however, that the *Masses* need-
ed a full-time editor.[12]

Art Young suggested Max Eastman, who had expressed an interest in editing a so-
cialist magazine. A philosophy student at Columbia University and founder of the
Men's League for Women's Suffrage, Eastman seemed perfect. The cover of the De-
cember 1912 issue, the first with Eastman as editor, augured change. Unlike earlier
covers that depicted romanticized portraits of brave and courageous workers, the
*Masses* now sported a two-color drawing of a gaily dressed clown looking into a crys-
tal ball. Inside, Eastman announced, "There are no magazines in America which
measure up in radical art and freedom of expression to the foreign satirical journals.
We think we can produce one, and we have on our staff eight of the best-known
artists and illustrators in the country ready to contribute to it their most individual
work. . . . We shall produce with the best technique the best magazine pictures at
command in New York."[13]

From this first issue in 1912 to the final one in 1917, Eastman and his staff pub-
lished a politically lively, artistically interesting magazine. The masthead read:

THIS MAGAZINE IS OWNED AND PUBLISHED COOPERATIVELY BY ITS EDITORS. IT HAS NO
DIVIDENDS TO PAY, AND NOBODY IS TRYING TO MAKE MONEY OUT OF IT. A REVOLUTION-
ARY AND NOT A REFORM MAGAZINE; A MAGAZINE WITH A SENSE OF HUMOR AND NO RE-
SPECT FOR THE RESPECTABLE; FRANK, ARROGANT, IMPERTINENT, SEARCHING FOR THE
TRUE CAUSES; A MAGAZINE DIRECTED AGAINST RIGIDITY AND DOGMA WHEREVER IT IS
FOUND; PRINTING WHAT IS TOO NAKED OR TRUE FOR A MONEY-MAKING PRESS; A MAG-

AZINE WHOSE FINAL POLICY IS TO DO AS IT PLEASES AND CONCILIATE NOBODY, NOT EVEN
ITS READERS — THERE IS A FIELD FOR THIS PUBLICATION IN AMERICA.

Max Eastman faithfully delivered on his promises.

Eastman had grown up in upstate New York. Following his birth, his mother re-
fused to have further sexual relations with his father and otherwise dominated the
family. Eastman's father suffered a nervous breakdown and physical collapse. Fol-
lowing his graduation from Williams College in 1907, Eastman enrolled in political
science at Columbia University but switched to philosophy to work on a doctorate
under John Dewey. Eastman sustained his mother's moral seriousness while reject-
ing her doctrinaire Christianity, her celibacy, and her stern otherworldliness. In 1911,
Eastman married Ida Rauh, an attorney and feminist activist who later became an
actress and director of the Provincetown Players. Rauh's Washington Square apart-
ment became a hotbed of radical activity.[14]

Eastman quickly discovered what he had most feared. The demands on his time
as editor, publisher, and fund-raiser were all-consuming and left him little time to
write. In the summer of 1913, frustrated and ready to resign, he asked the *Masses* staff
to hire an assistant editor. The staff, sympathetic to Eastman's complaints, agreed
to hire Floyd Dell, who had just resigned an editorship at the *Chicago Evening Post*
and who shared Eastman's views on sexuality, feminism, and socialism. Dell ac-
cepted, freeing Eastman to write and to raise money. Together, Eastman and Dell
used the *Masses* to create a sense of radical communal purpose. They proved well
matched.[15]

Eastman and Dell considered themselves socialists, but their thought had been
shaped more by John Dewey and Sigmund Freud than by Karl Marx. Disdaining all
doctrinaire thought, Eastman and Dell offered their readers a variety of radical opin-
ion that focused on specific wrongs rather than systematic political reform. Although
they touted the *Masses* as a socialist magazine for the working class, Eastman and
Dell cared far more about art, poetry, and personal freedom. Feminism was their spe-
cial cause. Eastman had founded the Men's League for Women's Suffrage, and his
wife, Ida Rauh, had served as a leader in the prewar women's movement. Consis-
tent with the *Masses* policy, Dell declared, "There is only one argument for woman
suffrage; women want it; there are no arguments against it." Suffrage is but a means
to equality, he wrote. "The woman who finds her work will find her love—and I do
not doubt will cherish it bravely. But the woman who sets her love above all else I
dismiss . . . as belonging to the courtesan type . . . who makes a career charming,
stimulating, and comforting men."[16]

Iowa-born Dell, a close friend of playwright Susan Glaspell and her husband Jig
Cook, who founded the Provincetown Players, went to Chicago in 1909, where he
participated in the Chicago literary renaissance. On arriving in New York in 1913,
Dell persuaded other figures in the Chicago renaissance—Carl Sandburg and Sher-
wood Anderson, along with Cook and Glaspell—to move to New York, where Dell
published Anderson's *Winesburg, Ohio* in serial form in the *Masses*. Prompted by the
Little Theater in Chicago, Dell and Anderson introduced New York to the experi-
mental theater movement, producing and directing a number of one-act plays at the
Liberal Club.[17]

Dell and Eastman shared many Villagers' preoccupation with sexual freedom, and they promoted psychoanalysis in the pages of the *Masses*. Freud's 1909 lectures at Clark University had received wide attention in the United States, and soon afterward, American psychiatrist A. A. Brill, a student of Freud's, translated into English key works of Freud and Jung. Brill formed a New York psychoanalytic circle closely associated with Greenwich Village radicals. Brill analyzed, among others, Mabel Dodge and Max Eastman, while Samuel Tannebaum analyzed Dell.[18]

Few Villagers understood the subtle complexities of psychoanalytical theory, but they were tantalized by Freud's notion that sexuality lay at the heart of the human psyche and that acute sexual repression, usually unconscious in origin, led to depression and alienation. For many, Freudianism was little more than an intellectual fashion that allowed them to talk about previously forbidden subjects, shocking their less informed listeners. For others, it provided scientific justification for sexual experimentation. For Village radicals, Freudian analysis, combined with their militant feminism, authenticated the sexuality of women and challenged Victorian prudery, providing impetus for wide-ranging discussions on prostitution, birth control, the viability of the patriarchal family, and the sources of human affection and creativity.[19]

For some in the Village, sexuality became a political issue, for others a religious obsession far more important than Marx's class struggle. Led by Emma Goldman and Margaret Sanger and influenced by the writings of Havelock Ellis and Ellen Key, Village radicals demanded an end to the Victorian double standard that labeled female sexuality a sin while allowing men to enjoy extramarital sex. Village radicals believed that modern birth control methods eliminated the dangers associated with extramarital intercourse, and they treated sexual relations as a private matter between consenting adults. Dell, Eastman, and others associated with the *Masses* characterized extramarital sexuality as free love, unencumbered by bourgeois restrictions that made men masters over their wives. Radicals lionized the sexual exploits of Isadora Duncan, Edna St. Vincent Millay, and Mabel Dodge as honest and heroic, exemplary models for the "new woman." While most Village radicals sustained heterosexual relationships, Dodge and Sanger freely acknowledged latent lesbian impulses, and Village radicals accepted without comment or judgment the open homosexuality of Jane Heap, Djuna Barnes, Willa Cather, Margaret Anderson, Marsden Hartley, and Charles Demuth.[20] The heroine in Louise Bryant's play *The Game* declared what might have served as the Villagers' sexual credo: "To be supremely happy for a moment—an hour—that is worth living for."[21]

On Fifth Avenue, just off Washington Square, even as Eastman and Dell reorganized the *Masses,* Mabel Dodge launched a radical salon in imitation of her close friend Gertrude Stein. An heiress daughter of a Buffalo banker and the wife of Boston architect Edwin Dodge, Mabel Dodge arrived in New York in 1912 at the age of thirty-four, having spent the previous several years in Europe with the Steins and other American expatriates.[22] The Dodges gravitated towards Stieglitz's 291 circle and involved themselves in the preparations for the *Armory Show.* Outgoing and dark haired, flirtatious and voluptuous, Mabel Dodge quickly moved out of the shadow of her introverted husband. At the request of Mary Fanton Roberts, Dodge wrote an article for the special *Armory Show* edition of *Arts and Decoration* in which she dis-

cussed Gertrude Stein's writing. Restless and stimulated by the social ferment of the Village, Dodge became dissatisfied with her marriage. "Edwin had always seemed curiously unaware of the possibilities lurking in the soul. . . . New York . . . widened the distance between us. . . . Edwin blocked my growth, and my need for new ideas. . . . If I wanted to go ahead and live mentally, I had to send Edwin away."[23]

Beginning in early 1913, each Wednesday evening for the next three years, except for the summer months spent in Provincetown on Cape Cod, Mabel Dodge welcomed selected guests to her Fifth Avenue apartment. Virtually everyone who was anyone in the Village enjoyed a standing invitation. The boisterous soirees often lasted late into the morning and were regularly reported in the city's newspapers. Dodge wrote:

Imagine, then, a stream of human beings passing in and out of those rooms; one stream where many currents mingled together for a little while. Socialists, Trade-Unionists, Anarchists, Suffragists, Poets, Relations, Lawyers, Murderers, Old Friends, Psychoanalysts, I.W.W's, Single Taxers, Birth Controlists, Newspapermen, Artists, Modern Artists, Clubwomen, Woman's-place-is-in-the-home Women, Clergymen, and just plain men all met there and, stammering in an unaccustomed freedom a kind of speech called Free, exchanged a variousness in vocabulary called, in euphemistic optimism, Opinions! I kept meeting more and more people, because in the first place I wanted to know everybody, and in the second place everybody wanted to know me.[24]

By bringing Villagers in contact with one another, Dodge instigated a number of important Village events—none more important than the Madison Square Garden Pageant.

The Madison Square Garden Pageant publicly announced the Greenwich Village rebellion. On February 23, 1913, twenty thousand Paterson, New Jersey, silk workers, led by the radical Industrial Workers of the World, walked off their jobs to protest an increase in the number of looms each operator was required to tend with no increase in pay.[25] The previous year the IWW had won an important strike in the textile mills of Lawrence, Massachusetts, establishing itself as a formidable rival to the moderate American Federation of Labor for leadership of the American labor movement. The IWW's future in the industrial Northeast hinged on its success at Paterson. Frequently expressing sympathy for American workers, Village radicals were drawn to the plight of the Paterson strikers.[26] In April, Mabel Dodge invited IWW organizer "Big Bill" Haywood to her apartment to meet several interested Villagers, including her lover, John Reed, and her friend, writer Hutchins Hapgood. Haywood complained that the New York papers refused to publish reports about the strike, making it difficult for the IWW to mobilize outside support for the silk workers. "Why don't you bring the strike to New York," Dodge suggested, "and show it to the workers . . . hire a great hall and re-enact the strike over here . . . [in] Madison Square Garden!"[27]

Haywood jumped at the idea. Dodge and Reed recruited Villagers for the production committee, which included Margaret Sanger, John Sloan, and Mary Heaton Vorse. Mabel Dodge and Dolly Sloan raised money to underwrite the production, John Reed wrote the script and rehearsed the striking silk workers for their parts, and John Sloan painted a hundred-foot banner portraying the striking workers. In a

series of six scenes in which more than a thousand workers participated, marching to *L'Internationale* and *La Marseillaise,* the pageant dramatized the events of the strike, beginning with work in the mills before the strike and ending with a symbolic funeral procession by children of the strikers. As political drama the pageant was a hit, filling Stanford White's stately Madison Square Garden for its single performance. Financially, however, the Paterson Pageant flopped—costs exceeded income from ticket sales and contributions. Six weeks later, the strike collapsed, effectively stalling the IWW offensive in the Northeast. In the Village, however, the Paterson Pageant immeasurably enhanced the community's reputation for heroic behavior.

By the fall of 1913, the rapid succession of events—Eastman and Dell's reorganization of the *Masses,* the opening of Dodge's salon, and the Armory exhibition of modern art, followed by the Madison Square Garden Pageant and the radicalization and relocation of the Liberal Club—had fomented the Greenwich Village rebellion. Socialist in politics, egalitarian, and sexually awakened, Village radicals turned to art to advance their vision of modern life.[28]

## THE WHITNEY STUDIO CLUB

Greenwich Villagers believed that art played a critical social role. Art enabled individuals to express otherwise unutterable feelings, and it offered a means to communicate publicly censored values. Because of Greenwich Villagers' enthusiastic support of the *Armory Show,* outsiders frequently associated the confusing and abstract images of modernism with the Village rebellion. Greenwich Village radicals, however, preferred the urban realism of the Eight to the modernism of 291. Virtually all of the artists associated with the *Masses* were urban realists, and most had close personal connections to Robert Henri. While a few modernists participated in the Village rebellion—Marguerite and William Zorach, Marsden Hartley, Charles Demuth, and Marcel Duchamp—Villagers used the term *modern art* broadly, to include radical political art, urban realism, modernism, and dada. Villagers defined modern as much by the cultural and political commitments of the artists as by the particular style of their work. For them, modern art affirmed socialism, feminism, anarchism, Freudianism, bohemianism, sexual liberation, and Marxism, whether it assumed the form of urban realism or of modernism. The Whitney Studio Club embraced and institutionalized Greenwich Villagers' inclusive and insurgent definition of modern art.[29]

Curiously, the matriarch of New York's interwar avant-garde was herself an unreconstructed academic sculptor. Gertrude Whitney's most famous work, *The Titanic Memorial,* harked back to late-nineteenth-century beaux arts sculpture. In 1896, at the age of twenty, the dark-haired and attractive Gertrude Vanderbilt, who was the daughter and heiress of financier Cornelius Vanderbilt, had married Harry Payne Whitney, a multimillionaire in his own right. Unhappy with her marriage and encouraged by John La Farge, Gertrude Whitney decided to become a sculptor, asking first Augustus Saint-Gaudens and then Daniel Chester French for lessons. Both declined. She turned to New York sculptor Hendrick Christian Andersen, enrolled

in classes at the Art Students League, and studied privately in Paris. Whitney ex-
hibited her first work in 1901 at the American Exposition in Buffalo and irregularly
thereafter. In 1906 she met Robert Henri in Aiken, South Carolina, a winter outpost
of the New York thoroughbred horse set, where Henri had been commissioned to
paint a portrait of one of Whitney's friends.[30]

With Henri's encouragement, Whitney purchased an apartment in Greenwich
Village at 19 MacDougal Alley, just off Fifth Avenue, and converted a stable on the
property into a sculpture studio, much as the Gilders had done forty years earlier.
Whitney, who associated herself with Henri's independents, purchased a painting
from *The Eight Exhibition* at Macbeth's, and in 1910 she sponsored Sloan's and Hen-
ri's second independent show. Along with John Quinn, Whitney contributed three
thousand dollars to defray the costs of the *Armory Show*. But she became disen-
chanted with Davies, Henri, and the other *Armory Show* sponsors when the sculp-
ture committee refused to accept her submissions.

Prior to her *Armory Show* snub, Whitney had already charted her own course.
When she moved to the Village in 1907, she hired Juliana Rieser to serve as her per-
sonal secretary—to arrange for models, to insure that the sculpture casts were done
properly, and to act as host to Village artists. In 1912, Whitney purchased a town
house at 8 West Eighth Street, adjoining her MacDougal Alley studio, to provide a
neighborhood gallery for Village artists. During the critical winter of 1912–13, 8 West
Eighth Street, the official address of the Whitney Studio, became a refuge for Vil-

lage artists. Guided by Rieser, who was now Juliana Force, and funded with Whitney money, the West Eighth Street galleries quickly became a hive of activity that featured war-relief benefit shows and a regular round of artist parties, which attracted the most prominent Village artists. Impresarios of modern American art, Juliana Force and Gertrude Whitney worked as one. Whitney granted Force extraordinary discretion over Whitney art activities, and in turn, Force conducted herself in a thoroughly loyal manner. However, because of Whitney's other interests and Force's preoccupation with Village artists, Force largely shaped the Whitney art enterprise on MacDougal Alley.[31]

Whitney and Force launched one project after another in their first ten years together, but their ventures had no clear direction. In 1917, groping for new ideas, they conceived of three group shows on a common theme, "To Whom Should I Go for My Portrait." Each show featured portrait work of six or eight artists. The exhibits publicized the work of the Village's avant-garde painters and photographers but otherwise served no artistic purpose. Reviewing a show that featured Photo-Secessionist photographers—Alfred Stieglitz, Edward Steichen, Clarence White, and Gertrude Käsebier—New York Post art critic Forbes Watson opined that the exhibition was terrible because it was not part of a well-conceived program of exhibition. Watson remarked that the Whitney exhibitions seemed silly efforts to entertain the dilettante tastes of New York's socially prominent, rather than a serious effort to promote and define good art.[32]

Watson's judgment, however harsh, was apt, and Whitney and Force reorganized their program accordingly. Following the suggestions of Henri, du Bois, and Sloan, on February 19, 1917, Whitney announced her new exhibition policy of no juries, no prizes. "But," declared Whitney, "the money which has been offered as prizes will be spent by the prize givers themselves in purchasing any work of art sent in for the exhibition which appeals to them for its beauty and its merit." "The young artist will be encouraged," Whitney explained, "by the fact that some one actually wants to possess his work, instead of being encouraged merely by a jury whose opinion he perhaps does not value, or by a society that sends him a check and returns his picture." With such support, she continued, "we hope that American art will become what it promised to be, a fresh and vital expression of a new great art."[33] In committing herself to regular purchases, Whitney also assured the steady growth of her increasingly important collection of modern American art.

A year later the Greenwich Village Spectator announced the formation of the Whitney Studio Club, to be located in a four-story brownstone at 147 West Fourth Street: "The Whitney Studio Club will be a meeting-place and consultation room for those who take their work seriously, and have either already accomplished something worth-while, or show an ambition and talent to achieve."[34] Remodeled to Force's specifications, the first floor of the West Fourth Street building contained two small galleries and the receptionist's office, furnished and painted in light gray. The basement, decorated in bright orange, blue, green, red, and purple, provided a billiard room, a library, and a writing room. Force converted the second and third floors into apartments, and on the fourth floor she built an artists' studio where members could gather for sketching classes. The classes, which offered live models, were

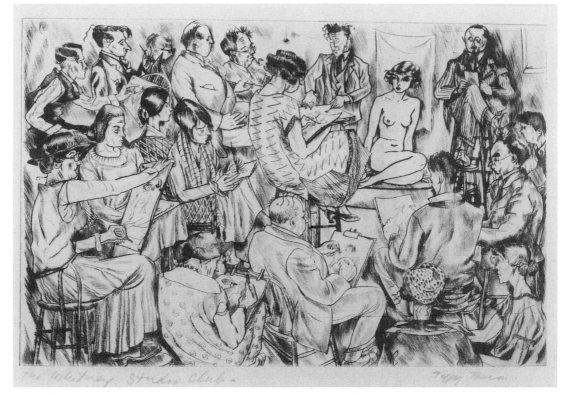

Greenwich Village artists. Peggy Bacon, *The Whitney Studio Club* (1925). *Photograph ©1998 Whitney Museum of American Art, gift of Gertrude Vanderbilt Whitney*

popular with Village artists, and club members could attend for a nominal charge of twenty cents a session.[35]

To encourage membership, Force asked John Sloan to announce the opening of the Whitney Studio Club to his Art Students League classes and to recruit other league faculty. Both Sloan and Kenneth Hayes Miller, also a painting instructor at the Art Students League, became active members. By the early 1920s, Sloan's and Miller's students Peggy Bacon, Stuart Davis, Katherine Schmidt, Yasuo Kuniyoshi, Lloyd Goodrich, and Reginald Marsh, along with Charles Demuth, dominated the activities and exhibitions of the Whitney Studio Club, making the Whitney Club an adjunct to the uptown Art Students League.

In 1923, Whitney purchased an adjoining mansion at 10 West Eighth Street. At Whitney's instructions, Force supervised the renovations, making the two mansions appear as a single building by installing a salmon-pink stucco facade across the adjacent fronts and cutting doors through the adjoining walls of the two buildings. Like its art activities, the Whitney Studio Club building encompassed the private lives of Whitney and Force. Ten West Eighth Street served as the public entrance to the Studio Club, while Whitney and Force used 8 West Eighth Street as a private entrance to their own apartments.[36]

At its peak, the Whitney Studio Club carried three hundred artists on its rolls. Whitney described the Studio Club as a place "where artists of all viewpoints met, exhibited their work, and occasionally read about their favorite art subject. The club

was founded to give a basis of operation for artists of every tendency; there was to be no jury, no dogma, no mandatory rules set down for the artists."[37] Despite the Whitney Studio Club's sponsorship of several modernist shows and Whitney's insistence that the club include "all viewpoints," the domination of the club by Sloan, Miller, and their students secured for urban realism a preferred status among Greenwich Village radicals and in New York modern art circles.[38]

Defining themselves primarily as artists, only a few Whitney Studio members, such as John Sloan, Stuart Davis, and the Zorachs, participated directly in Greenwich Village politics. Their art, however, often contained quite radical meanings, echoing the pages of the *Masses,* the meetings at the Liberal Club, and conversations at Mabel Dodge's salon. Whitney artists openly addressed sexuality, portrayed women in nondomestic roles, and included the city's poor in their urban scenes. Their portrayal of New York's ethnic variety, racial diversity, and erotic pursuits created a vision of New York and urban life fundamentally at odds with Victorian norms.[39]

Charles Demuth's New York watercolors, painted between 1914 and 1920 while he was an associate of the Whitney Club, were among the most forceful statements of the Village rebellion. Demuth captured the ambience of Greenwich Village life even as he affirmed a radically new modern culture. Using vibrantly colored shapes rather than carefully drawn details, Demuth affectionately and faithfully recorded the forbidden acts and places of the Village avant-garde. *At the Golden Swan* presents a raucous dinner at the Hell Hole Saloon in which a black male waiter playfully fondles an encouraging white female patron. *Negro Jazz Band* depicts a Harlem nightclub seething with energy, drugs, and sexuality, while *Cabaret Interior* portrays critic Carl Van Vechten, Marcel Duchamp, and Demuth mingling with black patrons at the black-owned Marshall Hotel north of Times Square.[40]

Combining fauvist colors and forms with urban subjects and details, Demuth celebrated the Times Square entertainment district and Greenwich Village, focusing on vaudeville performers, circus acts, and Village bars and hangouts. In sensually muscular portraits, he captured the vitality and athleticism of dancers, acrobats, bicyclists, and musicians. His watercolors abound with covert sexuality as Demuth suggestively coupled men with women, men with men, and women with women. In *Dancing Sailors* he presents four male sailors dressed in bright blue, skintight uniforms dancing in close embrace, two with women and two with one another. In *Turkish Bath,* several nude and partially nude males engage in intimate conversation, touching one another, surrounded by beckoning phallic shapes. Demuth hinted at homosexual intimacy but did not assert it. For Greenwich Villagers, the meanings were clear enough.[41]

The pervasive eroticism of Demuth's New York watercolors challenged the prevailing prudery of American society. His allusions to homosexuality rejected conventional sexual morality altogether. As Demuth's watercolors made clear, in Greenwich Village, modern art affirmed a radically new culture that openly embraced sexuality, for men and women, heterosexual and homosexual, white and black. For Greenwich Villagers, modern art heralded a new, liberated age as artists, poets, writ-

ers, and playwrights forged a modern culture, defining modern as the antithesis of Victorian.[42]

## THE POLITICS OF ART

From the start of their editorship of the *Masses,* Eastman and Dell had fused art and politics. In their enthusiasm they also precipitated a dispute between the Village's artists and its political radicals. World War I quickened the pace of New York's cultural revolt. As Dell observed, "The wartime years turned the Village into a melting-pot in which all group boundaries were dissolved. Artists, writers, intellectuals, liberals, radicals, IWWs, bohemians, well-to-do patrons, onlookers—all were hurled into a miscellaneous social melee in which earnestness and frivolity were thoroughly intermingled." The relaxation of conventional restraints during the war also led to serious disagreements over the appropriate boundary between art and politics.[43]

Art and artistic freedom remained at the heart of the *Masses'* politics. John Sloan explained, "The *Masses* offered to many artists a first chance to make really good drawings for publication. And many good artists and writers enjoyed taking part in what is a noble movement for the good of humanity, provided it wasn't connected with something revolutionary or doctrinaire. We got men opposed to those things who gave their work out of good will and the pleasure of creating without editorial direction."[44]

The *Masses* group believed that their understanding of art and their commitment to artistic freedom represented an implicit political statement. Moreover, all of the *Masses* artists—John Sloan, Robert Henri, Art Young, Arthur Davies, Cornelia Barnes, George Bellows, and Stuart Davis—identified themselves as either socialists or anarchists and were associated with either the nearby socialist Rand School or the Upper West Side anarchist Ferrer Center. Their political commitments encompassed a generalized hostility to capitalism, organized religion, and Victorian culture. They endorsed the libertarianism of Walt Whitman and voiced a visceral hatred of all forms of injustice. After August 1914, however, the *Masses* became nearly obsessed with the senseless carnage of World War I, and Eastman and Dell demanded that its artists fall in line.[45]

The artists of the *Masses* clearly enjoyed their work with a radical magazine, participating in the Thursday evening editorial meetings held either at the *Masses* office on Greenwich Street, just off Sixth Avenue, at Polly's, the Liberal Club, or in one of the artists' studios. The staff evaluated all submissions, often in the presence of the self-conscious writer or artist. The supervision of art, however, fell to John Sloan. Having grown up in Philadelphia, Sloan secured employment as an illustrator for various Philadelphia newspapers before enrolling in classes at the Pennsylvania Academy of Arts and Design. Sloan worked under Thomas Eakins' protegé Thomas Anshutz and privately with Robert Henri, establishing close friendships with William Glackens, Wyatt Davis, Everett Shinn, and George Luks. With his wife Dolly (Anna Wall), Sloan left Philadelphia in 1904 to join Henri, Luks, Shinn, and Glack-

ens in New York. While establishing his reputation as a painter, Sloan illustrated books and magazines, composed crossword puzzles for the *Philadelphia Press,* and taught for a short stint as Henri's replacement at the New York School of Art. For the most part, however, the Sloans depended on Dolly's income from a variety of jobs.[46]

A regular at gatherings at Mouquin's and Pepita's restaurants, Sloan received his first important recognition as a painter in 1908, at *The Eight Exhibition* at Macbeth Galleries, which he and Henri had organized. Like Luks, Shinn, and Glackens, who had also worked as newspaper illustrators, Sloan was fascinated with New York, as he made its people and their lives the subject of his art, especially the activities of working-class women. Sloan's etching *Night Windows* captures two women in the light of their tenement windows. One dutifully hangs her family's clothes on a line running out of her window, while the other erotically unpins her hair in preparation for bed. Refusing to portray working-class life as drab and dingy, in his oils Sloan painted young, full-bodied, vibrant women working, playing, engaged in domestic chores, and sustaining sexual lives. He presented them in bright colors, walking briskly to and from work, hand in hand with other women or in the embrace of attentive men.[47]

Shortly after *The Eight Exhibition,* at Dolly's encouragement, Sloan joined Branch One of the Socialist Party headquartered at the Rand School, and he and Dolly began their affiliation with the *Masses.* Sloan, a printmaker as well as a painter, found little of interest in the increasingly abstract images of modernism and steered clear of Stieglitz's 291 circle, preferring to capture the lives of everyday New Yorkers. He exhibited two paintings in the *Armory Show* and considered himself an artistic modern, open to new ideas. Sloan's socialist sympathies, engaging personality, and sincere interest in working-class subjects drew him to the *Masses.*[48]

Sloan's participation with the *Masses* presented him with a dilemma. He rejected the notion that art served any end other than aesthetic expression. Art was not the handmaiden of anything, not of upper-class society, not of religion, and certainly not of politics. Nonetheless, he took politics seriously and believed that concerned individuals, acting in concert, had a responsibility to improve the human condition. Good art improved life by enhancing the quality of human experience, helping people see and appreciate things that they would have otherwise overlooked. But Eastman insisted that Sloan use his art for overt political ends, as a propagandist. Sloan resolved his dilemma by distinguishing between his formal art—paintings and etchings—and his political art—cartoons, largely—much as he distinguished between his art and his commercial illustrations.

At first, this worked. Sloan's cartoons for the *Masses* were overtly didactic, but his formal artwork remained free of sermonizing. Sloan believed that he maintained his artistic integrity even in his political cartoons because they expressed his ideas and did not simply illustrate someone else's politics. He strongly resisted efforts by Eastman and Dell to determine the choice of cartoons or to write captions for his and the other artists' work. Sloan believed that such decisions should be exercised by the artists themselves, based on their own sense of artistic merit. Writers who judged art, even political art, were guilty of violating artistic freedom. As Eastman and Dell

had initially deferred to the artists on the staff, Sloan had had little difficulty with the magazine's political militancy.

This uneasy peace between the writers and editors of the *Masses* and its artists ended in 1916, as American entry into World War I became likely. The staff artists, including Sloan, resigned in protest, accusing Eastman of shaping the editorial policies of the *Masses* to please wealthy contributors.[49] Young, Eastman, and Dell dismissed the crisis as a dispute between serious, worldly political cartoonists and writers and art-for-art's-sake painters. Following the painters' secession, the editorial board of the *Masses* recruited John Barber, Boardman Robinson, and Robert Minor, three of the best political cartoonists in the country. The quality of political cartooning in the *Masses* improved accordingly. Paradoxically, the other art of the *Masses* became less political, even apolitical. In response to the arty, at times abstract, work of the *Masses'* newly recruited artists—Arthur Davies, Hugo Gellert, and Frank Walts—a Village wit quipped:

> They drew nude women for the *Masses,*
> Denuded, fat, ungainly lasses,
> How does that help the working classes?[50]

Politics, not art, however, led to the undoing of the *Masses.* Much of the conflict between the artists and nonartists had been precipitated by Eastman and Dell's outrage over the war, which blamed the conflict on imperialism spawned by capitalist greed. Their stance upset many who supported the war. Prior to American entry in April 1917, the editors of the *Masses* had been answerable only to their financial backers and their readers. With American entry and congressional passage of the Espionage Act in June 1917, they became accountable to the federal government. The Espionage Act authorized the U.S. Postal Service to deny mailing privileges to any publication that condoned "treason, insurrection, or forcible resistance to any law of the United States."

In July 1917, the Postal Service notified the *Masses* that its upcoming August issue could not be mailed. Eastman challenged the prohibition in federal court. The government charged that several cartoons, including Boardman Robinson's *Making the World Safe for Capitalism* and Henry Glintenkamp's *Conscription,* a poem by Josephine Bell, and editorials by Eastman and Dell defending conscientious objectors and draft evaders violated the Espionage Act. Federal district judge Learned Hand, however, accepted the argument of the *Masses* that none of these pieces obstructed the war effort or threatened to overthrow the government. Hand explained that Congress had intended the act as protection from foreign enemies, not from the free expression of its own citizens. The government appealed Hand's decision, securing a stay of execution that allowed the mailing ban against the *Masses* to stand. In November, a federal appeals court overruled Hand. Without mailing privileges, the *Masses* could not continue to publish. It closed in December 1917, five years after Eastman's arrival.[51]

John Reed had already left to report on the Russian Revolution; Floyd Dell and George Bellows enlisted in the army; a number of others came out in support of the

war; Maurice Becker and Henry Glintenkamp fled to Mexico to avoid conscription; Mabel Dodge and others had already left the Village; federal immigration authorities had detained Emma Goldman; and the Wilson administration used the Espionage Act to suppress the IWW, as it had the *Masses* and other radical publications. To a remarkable degree, the Wilson administration silenced Villagers' criticism of the war and the government's war-related policies. Faced with internment or deportation, most Village socialists, anarchists, and pacifists ceased their public opposition to the war.

American intervention in the world war brought to a close the first phase of the Greenwich Village rebellion. But for Village artists and writers associated with the Provincetown Players, the federal government's decision to enter the war triggered a second wave of creative activity. During World War I, the Provincetown Players launched modern New York drama, extending the Village rebellion to the footlights of Broadway.[52]

## THE PROVINCETOWN PLAYERS

Prior to the founding of the Provincetown Players in 1915, Broadway offered New York theatergoers light comedy, variety, and melodrama. Except for an occasional European play or revival, Broadway producers presented little of interest to discriminating theatergoers, largely because Broadway did not produce shows for sophisticated, urban audiences.[53] Instead, it directed its performances to audiences in small and medium-sized towns throughout the United States and to those New Yorkers who sought light entertainment. Responding to its out-of-town audiences, before World War I, Broadway served as the national booking agent and production center for road companies that thrived on the light entertainment and big-name stars that tourists, out-of-town audiences, and working-class New Yorkers preferred.[54]

Just prior to World War I, Broadway's on-the-road era drew to a close, displaced by inexpensive motion pictures. Broadway producers cultivated a new, more theatrically sophisticated audience even while they continued, on a smaller scale, to cater to its traditional working-class and lower-middle-class patrons with musicals, comedies, and melodrama. Such fare, however, was now available more conveniently and less expensively at neighborhood movie houses. As photography had narrowed patronage for paintings, so the emergence of movie theaters narrowed the patronage for live theater.

Faced with a shrinking and increasingly demanding audience, Broadway producers searched for offerings to attract educated ticket buyers, audiences who viewed the theater both as art and entertainment and who shunned movie houses as vulgar and plebeian.[55] After World War I, Broadway audiences included those who flocked to performances at the Metropolitan Opera and Carnegie Hall as well as those who attended vaudeville. New York's little theaters produced serious drama heretofore ignored by Broadway. But only the Provincetown Players dedicated their theater exclusively to original American plays.[56]

By 1915 a small coterie of Greenwich Village radicals had made Provincetown, at the tip of Cape Cod, a summer colony. Freelance writer and *Masses* staff member

Mary Heaton Vorse and her journalist husband, Joe O'Brien, had led the way in 1907 when they bought a fishing shack in Provincetown. Each summer Vorse and O'Brien encouraged their friends to escape the heat of New York to join them at what seemed like the end of the world. Vorse described how Provincetown looked when she first arrived: "The little town was remote from anywhere. And roads cut it off from the mainland. It still felt itself an island as it did before the stagecoach lumbered over the sand hills behind the Eastern Harbor and linked it to the areas of the Cape."[57]

In the summer of 1915, Vorse, O'Brien, and their friends were especially dispirited. The Provincetown colony now included Mabel Dodge, her friends Hutchins Hapgood and his wife, writer Neith Boyce, Max Eastman and Ida Rauh, John Reed, Floyd Dell, and modernist painters Marguerite and William Zorach as well as on-again-off-again companions Charles Demuth and Marsden Hartley, George "Jig" Cram Cook, a boyhood friend of Dell's from Iowa, and Cook's wife, writer Susan Glaspell. Their winter realization of the tragedy of the world war carried over to the summer and created in them a sense of demoralization and disillusionment. Hutchins Hapgood described the colony's psychological state that led to the first Provincetown performances: "But as the year passed their spiritual disappointment became even greater. . . . The positive response to these negative forces was also present with the group; it found expression in an inchoate creative urge."[58]

These Greenwich Village radicals redefined American drama, first at Provincetown and later on MacDougal Street, unintentionally recasting themselves from a bohemian avant-garde into professional dramatists. Initially viewing their creative efforts as parlor games to amuse themselves and to pass the time, the Provincetown Villagers gave their first productions at the Hapgood-Boyce's rented cottage on Commercial Street, without costumes or sets. The actors performed Neith Boyce's *Constancy,* a satire of John Reed's sexual escapades, on the porch while the audience watched from the living room. At nightfall, audience and players changed positions. From the porch the audience watched *Suppressed Desires,* Susan Glaspell and Jig Cook's spoof of Villagers' obsession with Freudian theory. As word of the evening spread, those who had missed the original performances asked that they be restaged. Flattered by the interest, the friends formed themselves into a theatrical group to offer public performances of their two plays.[59]

Across the road from Cook's rented house stood a wharf. Built in the middle of the nineteenth century and purchased in 1915 by Vorse and O'Brien, the wharf consisted of a hundred-foot pier with three weather-beaten, cedar-shingled structures on the end. The largest, a fish house twenty-six-feet wide and thirty-six-feet long, served as the first Provincetown theater. After dragging out the boats and nets, the Provincetown players constructed a ten-by-twelve-foot stage, erected enough wooden benches to seat about a hundred spectators, and installed several footlights and a movable door behind the stage that could be opened to create an ocean backdrop.

The Provincetown Players offered two playbills at the wharf that first summer. In August they presented Boyce's *Constancy* and Glaspell and Cook's *Suppressed Desires,* and in September they produced Cook's comedy, *Change Your Style.* The latter play satirized the conflict between modern and traditional art by focusing on a young Village artist who shifted from an academic to a cubist style to sell his first

modernist painting, entitled *The Spiritual Form of the Navel*. The play seemed especially funny to the audience since Charles Demuth played the young modernist and Brör Nordfeldt, a cubist painter and director of the Modern Art School in the Village, played the head of a postimpressionist art school. For the second playbill the group produced a second new play, Wilbur Daniel Steele's *Contemporaries,* an account of betrayal and a commitment to mobilize New York churches in behalf of the city's homeless. The series was a local hit, and as the colony decamped, they all looked forward to getting back to their primary activities—everyone except Jig Cook.[60]

A child of a prestigious Davenport, Iowa, family, Jig Cook had searched all his life for a "beloved community." An early convert to socialism, he studied Greek at Iowa, Harvard, and Heidelberg and taught briefly at the University of Iowa and Stanford before returning to his hometown to become a truck farmer. An irrepressible philanderer and alcoholic, Cook had divorced twice before his marriage to novelist Susan Glaspell in 1912. In Davenport, he, Dell, and Glaspell had become close friends. When Dell went to New York in 1913, Cook followed, hoping to find in Greenwich Village the community he sought.

From the start, Cook was taken with the theatrical activities of the Provincetown colony, doing everything from building the benches at the Wharf Theater to writing plays. While everyone else viewed the production as a summer distraction, Cook dreamed of something more, something quasi-religious—in Glaspell's words, a "Beloved Community of Life-givers." Through the winter he kept coming back to a sentiment that he and Neith Boyce had jointly expressed and that he believed lay at the root of classical Greek drama: "One man cannot produce drama. True drama is born only of one feeling animating all the members of a clan—a spirit felt by all and expressed by the few for the all. If there is nothing to take the place of the common religious purpose and passion of the primitive group, out of which the Dionysian dance was born, no new vital drama can arise in any people." As Glaspell observed, "The people who came back that next summer had little chance of escaping. Purpose had grown in him." Jig Cook "was going to take whom he wanted and use them for the creation of his Beloved Community."[61]

Once again, the Provincetowners dragged out the "old boat, took oars and nets and anchors to various owners," and bought lumber to renovate the fish house. On July 13, 1916, the rapidly coalescing collective presented its first publicized playbill, performing to a capacity crowd for fifty cents a seat. It included three one-act plays: a revival of *Suppressed Desires,* Neith Boyce's tragedy, *Winter's Night,* and John Reed's farce, *Freedom.*[62] Aroused by their success and Cook's exhortation, the group immediately set about planning a second evening of one-act performances. By chance, on the day that the group planned to consider new plays, Glaspell met "two Irishmen," Terry Carlin and Eugene O'Neill, who had moved into a shack up the street, and invited O'Neill "to come to our house at eight o'clock to-night, and to bring some of his plays." O'Neill showed up with *Bound East for Cardiff.* On reading the play, the Provincetown players immediately recognized O'Neill as a writer of serious drama. Through O'Neill, Jig Cook's dream of a spiritually revitalized theater seemed possible.[63]

The summer's second program featured O'Neill's *Bound East for Cardiff,* in which Yank, played by Jig Cook, while lying on his bunk in a rusty steamer, contemplates his imminent death and searches for meaning in his dreary, transient life. O'Neill offered Yank only the consolations of his friendship with his fellow crewmen, the tattered memories of the barmaid Fanny at the Red Stork Tavern, and Yank's oneness with the sea.[64] The audience responded to Yank's lonely despondency, realizing that they had seen much more than just another amateur summer production.[65]

Two weeks later the Provincetown collective produced a third bill that included Susan Glaspell's *Trifles,* the group's second discovery of the summer. A deceptively simple play, *Trifles* examines the bonds that tie women to one another. Set in the kitchen of an abandoned farmhouse, the play revolves around a murder investigation by the local sheriff and district attorney. Two women accompany the male investigators—the sheriff's wife and a neighbor. Based on evidence that the men have dismissed as "trifles," the women piece together the unbearable circumstances of the farmer's wife: "I tell you, it's queer. . . . We live close together and we live far apart." Fearing their discoveries will implicate the abused wife, the two women destroy the incriminating evidence. Finding only trifles, the sheriff and district attorney, convinced of the wife's guilt, nonetheless abandon the investigation.[66]

An early example of feminist drama, Glaspell's *Trifles* compared favorably with O'Neill's *Bound East for Cardiff.* The two plays marked the maturation of the Provincetown Players. No longer content to entertain their audiences with spoofs of modern sex and Village life, Glaspell and O'Neill grappled with serious concerns—female companionship, the frequent brutality of marriage, and the rootless isolation of modern life bereft of religion, family, or community. Glaspell and O'Neill had written sobering plays, modern in their concerns, and like the urban realists on the *Masses* staff and at the Whitney Club, they drew on American themes and circumstances. Immature, even amateurish, nonetheless Glaspell's and O'Neill's plays set a new course for American drama.

At the end of the summer season, the collective, under Cook's leadership, looked towards forming a permanent theatrical company in New York. In September they held their first official meeting. The group included twenty-nine active members ("Active members must either write, act, produce, or donate labor"). Responding to O'Neill's wishes, the group declared: "The primary object of the Provincetown Players [is] to encourage the writing of American plays of real artistic, literary, and dramatic—as opposed to Broadway—merit." They affirmed that the playwright would direct the plays "without hinderance according to his own ideas."[67] Formally organized as the Provincetown Players and naming their theater the Playwright's Theater, most of the Provincetown colony hurried back to Greenwich Village, and Jig Cook was delegated to find a theater. On September 9, Cook wrote excitedly to Glaspell: "139 MacDougal Street leased by Provincetown Players! Hurray! Paid $50.00 first month's rent from Oct 1st. So that much is settled."[68]

The impulse for the Provincetown plays had been spontaneous. The idea to create the Provincetown Players, however, was Jig Cook's alone. Drawing on the iconoclastic idealism of his fellow Greenwich Villagers, Cook's enthusiasm, his belief in the group's creative potential, and his long-standing dream of a Dionysian commu-

nity of artists sustained the theatrical collective. Infatuated with the religious origins of Greek drama, Cook believed that creativity arose not from lone individuals but from individuals within communities, who in moments of ecstatic insight transcended themselves and their circumstances to glimpse a higher, truer reality. Indifferent to conventional religion, Cook believed that a vital new theater would come into being, in the words of historian Robert Sarlós, the product of "inspiration and intoxication, not training and craftsmanship."[69] Cook believed that of all the arts, drama alone retained the Dionysian power to create a communal culture.[70]

According to Hutchins Hapgood, Jig Cook seized the "energy" and "unbridled imagination," sparked by Greenwich Village radicalism and the disillusionment engendered by World War I, to inspire the collective "with a desire to be truthful to their simple lives, to ignore, if possible, the big tumult and machine and get hold of some convictions which would stand the test of their own experience."[71] Alienated by Victorian notions of patriarchy and family, the Provincetown Players were, as Glaspell recalled, "drawn together by the thing we really were, we were as a new family." Cook viewed Provincetowners' legendary drinking and philandering not as immoderate and foolish or even indulgent but as a reversion to pre-Christian, even presocial sources of psychic bonding.[72] Susan Glaspell and Eugene O'Neill were but two of dozens who profited from the "creative chaos" of the Provincetown Players.[73]

Few playwrights have begun their careers in such favorable circumstances. A precocious but untried playwright, Eugene O'Neill found in Cook and the Provincetown collective the theatrical means and the intellectual stimulation to hone his dramatic skills. Born in the Barrett House, a theatrical hotel a block off Times Square, O'Neill was a child of Broadway. His father had enjoyed a legendary career on the late-nineteenth-century American stage in his role as the Count of Monte Cristo. Eugene O'Neill disassociated himself from his philandering father, his opium-addicted mother, and the commercial theater. Rebelling against his father's repeated efforts to make him an actor, O'Neill deliberately flunked out of Princeton and then, for the next several years, wandered from seaport to seaport as a merchant marine, destroying his health and nearly killing himself in the process. Slender, with sharp features and dark hair, Eugene O'Neill, like his father and older brother, became an alcoholic and in 1913 suffered a nervous breakdown. Following his discharge from Gaylord Farm, a mental institution in Wallingford, Connecticut, O'Neill started to write plays that dealt with the bleakness of modern life and, in particular, the torment inherent in the traditional American family.[74]

Lacking formal theatrical training, in 1914 O'Neill enrolled in George Pierce Baker's 47 Workshop at Harvard. Begun as English 47 at Radcliffe in 1903, Baker's 47 Workshop trained the first generation of professional American playwrights and critics, including S. N. Behrman, Theresa Helburn, Heywood Broun, and Robert Edmund Jones. With Baker, O'Neill confronted rigorous criticism and studied the major works of classical and modern drama.[75] After a year O'Neill chose not to return, preferring to strike out on his own, subsisting on handouts, hanging around New York bars with his merchant marine cronies, and writing feverishly. Quite likely, he drifted out to Provincetown in 1916 with Terry Carlin because he had heard that a group of Greenwich Villagers were performing original plays.[76]

94

Back in New York, the Provincetown Players held their organizational meeting on October 5, 1916, in John Reed's apartment at 43 Washington Square South. They agreed to buy the Liberal Club's stage equipment for forty dollars and approved Cook's other expenditures. In the meantime, the players worked energetically to transform the town house at 139 MacDougal Street, adjoining the Liberal Club, into a small theater. In a circular announcing the opening of the Provincetown Theater, Cook explained that the Provincetown Players had organized themselves "as a club to avoid the legal disabilities consequent on establishing a public theater." Legally prohibited from box office sales, the group depended entirely on donations and subscriptions.[77] John Reed saved the project when he convinced each of the New York Stage Society's two hundred members to purchase two season memberships to the Provincetown Players (constituting 400 of the Provincetown's 450 subscriptions).

In November 1916, the Provincetown Playhouse opened with Eugene O'Neill's *Bound East for Cardiff,* Louise Bryant's *The Game,* and Floyd Dell's *King Arthur's Socks.* In the first season the Provincetown Players presented eight playbills of one-act plays, recruiting poets Edna St. Vincent Millay, William Carlos Williams, Mina Loy, and Alfred Kreymborg as member-playwrights. Almost immediately, however, the players ran afoul of their own rules requiring that playwrights direct their own plays. Frequently, they found, playwrights lacked the ability to translate their ideas into theatrical practice. O'Neill, especially, did not enjoy detailed involvement in his productions. Moreover, it soon became evident that the amateur ambience so appropriate for the Cape could not be sustained in the professional milieu of New York. Despite the collective's determination to remain faithful to their amateur origins, some of the players aspired to Broadway.[78]

In response to criticism that the first several performances had been clumsily produced, Cook recruited Stanford-trained dramatist Nia Moise to oversee rehearsals and architect Donald Corley to take charge of scenery. By the end of the season theatrical professionals directed all of the plays, gaining favorable comment from New York drama critics. Just prior to the close of its first season, in a stormy organizational meeting, the Provincetown Players authorized a salaried position of production director and issued a public statement reaffirming their amateur status: "We have a theater because we want to do our own thing in our own way. We have no ambition to go uptown and become a 'real theater.' We believe that hard work done in the play spirit for the pure joy of doing it, is bound to have a freshness not found in the commercial theater."[79]

Professions of amateur intent notwithstanding, in the fall the Provincetown Players installed more comfortable seating and constructed a cloakroom, a lounge, a business office, dressing rooms, a scene dock, and new second-floor club rooms. Moreover, after rejecting repeated offers, Cook accepted the financial support of wealthy New York art patron Otto Kahn, who financed the move to a larger building next door at 133 MacDougal Street. Cook tried to maintain the spirit of the Cape by regularizing rowdy opening-night parties at which he ritually obliged members to imbibe his "fish house" punch—four quarts of brandy, two quarts of rum, two quarts of peach brandy, and two quarts of lemon juice, cooled by a block of ice.[80]

At the close of the season the collective faced a second major crisis, again the

consequence of its increasing professionalism. The move to a larger facility result-
ed in increased expenses, a larger organization, and decreased spontaneity. Just as
bothersome to many, as the Provincetown Theater gained prestige and recognition,
much of the public's attention fell to O'Neill rather than to the collective. Cook, al-
though sympathetic, found himself helpless to resist the changes. To increase the
public visibility and to garner critical acclaim, he subscribed to a clipping service,
established a free-ticket list for drama critics, augmented the advertising budget,
and hired a permanent secretary, Eleanor Fitzgerald, a close friend of Emma Gold-
man.[81]

In the spring of 1918, the Provincetown Players, concerned but undiscouraged,
affirmed once again their amateur commitment—one that, in the face of American
entry into World War I, seemed all the more vital.[82] At the end of the 1919 season
the Provincetown Players again faced what had become a spring rite. The tensions
between the older members, committed to the idea of an amateur collective, and
the newer members, ambitious for professional recognition, resurfaced when Ida
Rauh expressed to a reporter her hope that the Provincetown Players would soon
present three of their best plays uptown, "just for a week, or maybe six plays, for two
weeks." Glaspell defused the tension by convincing Cook, for creative reasons, to
take a year's sabbatical, leaving Rauh and director James Light in charge.[83]

The younger members, led by Light and Rauh, had joined the Provincetown Play-
ers not to be a part of a "beloved community of life givers" but as a means to advance
their theatrical careers. In Cook's absence, Rauh further professionalized the
Provincetown Theater by attracting better actors and directors through modest
salaries, giving Light more authority over productions, improving the scenery, cos-
tumes, and lighting, and paying more attention to Broadway critics. The most event-
ful performance was O'Neill's *The Dreamy Kid,* the story of an African American
gangster wanted by the police for murder. Rauh, who directed the play, recruited an
all-black cast from Harlem, the first to perform on a New York stage outside Harlem
since 1910. Most critics concurred that under Rauh's leadership the season's plays
were consistently well presented. Successful commercially and experimentally, in
Cook's absence the Provincetown Players became a semiprofessional company.[84]

In 1920, the Provincetown Players completed their transformation from an ama-
teur group to a successful commercial theater with Jig Cook's direction of Eugene
O'Neill's *The Emperor Jones,* a play O'Neill jokingly referred to as his "silver bullet."
That summer, at O'Neill's insistence, Glaspell and Cook had struggled through a
storm across Provincetown's blowing dunes to O'Neill's house, Peaked Hill Bar, an
abandoned Coast Guard station purchased from Mabel Dodge, for a reading.
Glaspell recounted the evening:

Before the cheerful logs in a room where life-boats had swung Gene read us his new play.
Then Jig knew he wanted to go back to the theater. He had been wavering. . . . But walking
back across the dunes next morning, Jig said he must leave instantly for New York. "Here is a
challenge! This is what I have been waiting for—a play to call forth the utmost each one can
do, and fuse all into unity. . . . I've got to reorganize the Provincetown Players and produce
'The Emperor Jones.'. . . One thing . . . we've got to put in a dome. Money or no money—the

Emperor has got to play against that dome. And the Emperor has got to be a black man. A blacked-up white is not in the spirit of this production."[85]

Cook returned to New York in a frenzy that did not subside until the opening night of *Emperor Jones*. Determined to make *Emperor Jones* the Provincetown Players' definitive statement, Cook spared no expense. For the lead part of Brutus Jones, he secured Charles Gilpin, a gifted African American actor who was at the time employed as an elevator operator. Next he constructed in the Provincetown Playhouse his fabled dome, inspired by an earlier dome used by Max Reinhardt in Berlin. Built of plaster, Jig's dome entirely covered the ceiling of the stage, creating an endless horizon that gave the audience a feeling of being under an open sky. Finally, he recruited Cleon Throckmorton, a professional set designer, to construct the scenes, and he arranged for Edna Millay, her sisters, and her mother to sing the chorus. Most reviewers agreed that the dome and Gilpin's stellar performance, combined with the Millay chorus and Throckmorton's sets, did justice to O'Neill's play, fulfilling Jig Cook's dream.[86]

The play opened, according to O'Neill's stage directions, in the "audience chamber in the palace of the Emperor—a spacious, high-ceiling room with bare, whitewashed walls. The floor is of white tiles."[87] Jones, a former railroad conductor and convict, has fraudulently established himself as the emperor of a small Caribbean island. Seemingly the bearer of civilization, Jones exploits the vulnerable inhabitants of the island for his own aggrandizement, aided and abetted by a white soldier of fortune. Eventually, the people revolt and hunt down Jones. O'Neill called for a drum to be beaten throughout the play, approximating the human heart that increased in tempo with Jones' desperation. The play ends with Jones' people executing him with a magical silver bullet.

In *Emperor Jones,* O'Neill confronted his audience with the disillusioning prospect of political opportunism, checked not by reason and law but by superstition and violence—a chilling specter, coming in the wake of World War I. Written in the summer of 1920, *Emperor Jones* can also be seen as O'Neill's condemnation of Woodrow Wilson's presidency. In 1916, Wilson had campaigned for reelection with the slogan, "He kept us out of war." In the wake of his victory, however, Wilson mobilized the nation for war, much as Jones donned the uniform of a tin soldier. Obsessed with the war, Wilson, too, had suppressed critics of his policies. Immediately following the war, Wilson had allowed his attorney general to engage in an unprecedented and relentless campaign against political radicals that included the jailing of hundreds of suspected radicals, the destruction of the Industrial Workers of the World, and the deportation of Emma Goldman, alienating Wilson's supporters much as Jones had alienated his. In October 1919, Wilson suffered a crippling stroke that effectively ended his presidency and doomed American membership in the League of Nations. Wilson's stroke paralleled Jones' death by silver bullet, which spared his people further agony at the hands of a crazed, though once decent, leader.

Unlike the Broadway productions that O'Neill had known as a child, *Emperor Jones* did not portray blacks in whiteface, nor did it require that black performers dance, sing, and perform comic, slapstick routines that pandered to the racial stereo-

Opening the curtain on modern American drama. Charles Gilpin playing the Emperor Jones in the Provincetown Players production (1921). *Photograph published in* Current Opinion

types of white audiences. Instead, O'Neill created Brutus Jones as a fully embodied, complex individual capable of bearing the weight of high tragedy and serious political commentary. Skeptical of democratic leaders, disillusioned by World War I, pessimistic about the future, and impatient with white racism, Eugene O'Neill opened the way for the serious drama that postwar New York audiences increasingly demanded.

New York critics recognized that, finally, an American playwright had written an important modern play. Heywood Broun wrote, "'The Emperor Jones' seems to us the most promising play which has yet come from the most promising playwright in America." W. E. B. Du Bois, editor of *Crisis,* declared *Emperor Jones* "a splendid tragedy" and its author one of "our great benefactors. . . . Eugene O'Neill is bursting through. . . . No greater mine of dramatic material ever lay ready for the great artists' hands than the situation of Negro blood in modern America."[88]

Audiences reacted with equal enthusiasm. Night after night, *Emperor Jones* played to a packed house. Gilpin became an instant celebrity. At the end of its extended MacDougal Street run, the *Emperor Jones* played for 20 performances at the Selwyn, 128 at the Princess Theater, and 15 more on the road. The Provincetown Theater's receipts for the 1920–21 season exceeded twenty-six thousand dollars. The following year O'Neill earned nearly fifteen thousand dollars in royalties from *Emperor Jones.* The previous year, his total royalties had been less than five hundred dollars. By 1923, O'Neill's annual royalties surpassed forty thousand dollars and remained at that level for the next decade.[89]

New York's formal honoring of the *Emperor Jones* became itself a tragicomedy that underscored the city's persisting racism. In February 1921, following the play's November opening, the Drama League selected Charles Gilpin and Eugene O'Neill for its distinguished achievement awards. At the last moment, responding to the protest

of several of its members for honoring an African American, the league withdrew Gilpin's invitation to the awards banquet. Barely suppressing his anger, Gilpin explained to reporters that he had another engagement that night and had not planned to attend anyway. Furious at the league's action towards Gilpin, O'Neill declined his invitation and asked that others do so as well. Embarrassed by the publicity and facing a mounting boycott, the Drama League reissued its invitation to Gilpin. Mollified, O'Neill agreed to attend, as did Gilpin, who nonetheless arrived late, making only a token appearance.[90]

After the success of *Emperor Jones,* O'Neill left the Provincetown Players for Broadway, followed by many of the collective's other ambitious and talented members. The next season Cook put together five productions, including Glaspell's *The Verge* and *Chains of Dew,* Theodore Dreiser's *Hand of the Potter,* and O'Neill's *The Hairy Ape,* but as an experimental theatrical group, the Provincetown Players had ceased to exist. Dispirited, Glaspell and Cook left for Greece, canceling the 1922–23 season. After several efforts at reorganization, O'Neill, Kenneth Macgowan, and Robert Edmund Jones incorporated the company as the Provincetown Playhouse, promising to produce original American plays, the best of the classics, and distinguished modern European plays.[91] Disillusioned with the notion of a democratically governed, amateur collective, O'Neill advised Macgowan to run the new organization differently: "You ought to be absolute head with an absolute veto. To hell with democracy!"[92]

Jig Cook died in Greece on January 14, 1924. The Provincetown Players disbanded a year later. Cook had believed that financial success necessarily corrupted and degraded art: Inevitably, pleasing audiences would become the primary goal of drama. Dramatists would judge their art by its popularity rather than by its unswerving presentation of truth. But not everyone agreed. *New York Times* drama critic Brooks Atkinson's declaration that after the *Emperor Jones,* the "old Broadway is finished" was perhaps an overstatement; but the commercial success of O'Neill's *Emperor Jones* awakened Broadway producers to the box office appeal of modern drama. Gratified by the prospect of fortune and fame, in the 1920s, O'Neill, along with Maxwell Anderson, Robert Sherwood, S. N. Behrman, and Elmer Rice, brought serious American theater to Broadway.[93] To be sure, the old Broadway lived on, its greatest successes yet to come.[94]

Nonetheless, Atkinson correctly identified O'Neill's *Emperor Jones* as the first commercially successful production of serious American drama. In the *Emperor Jones,* O'Neill demonstrated that artistic and commercial success could go hand in hand. Indeed, commercial success seems to have stimulated O'Neill's creativity. His subsequent plays, *Anna Christie* and *The Iceman Cometh,* were phenomenal commercial successes and American masterpieces. Much as John Sloan at the *Masses* had maintained a delicate balance between art and politics, so O'Neill juggled commercial success with artistic integrity. For Jig Cook, who had been shaped by classical drama as taught in American universities, commerce was anathema to art. For Eugene O'Neill, who had been conceived on the road and born just off Times Square, commerce authenticated art.

* * *

O'Neill's box office success underlined the impact that the Greenwich Village rebellion had on New York Modern. Drawn to the radical politics and cultural experimentation of prewar America, Greenwich Village radicals vested modern art with important nonaesthetic values. Eschewing all orthodoxies, they defined the *modern* as personal liberation and identified the patriarchal family as a primary source of human unhappiness. They accepted John Sloan's portraits of working-class women as expressions of the modern, as they did Max Eastman's socialism, Emma Goldman's anarchism, Charles Demuth's and Margaret Anderson's homosexuality, Eugene O'Neill's *Emperor Jones,* Mabel Dodge's highly publicized affairs, the Liberal Club's Pagan Routs, Margaret Sanger's campaign for birth control, and the bohemianism of Polly's restaurant.

In 1947, Floyd Dell, by then a successful novelist, recounted, "To me this bohemia seemed a place where improbable and delightful things could happen. And so they did."[95] The Greenwich Village rebellion was that and much more. Aroused by a brutal and controversial war and a ruthless and obsessed president, for a brief moment Greenwich Village radicals articulated a vision of modern life that encompassed democratic politics, economic justice, artistic creativity, radical forms of expression and behavior, gender equality, and sexual fulfillment. With peace, their utopian vision seemed naive, unsuited for serious-minded, ambitious artists and writers.

The bohemian radicalism of wartime Greenwich Village, however, did not disappear. O'Neill's plays found a larger popular audience, and during the Jazz Age, American art and writing were infused with the vision of Greenwich Village's bohemian radicals. Following World War I, American artists and writers, heirs to the Greenwich Village rebellion, resisted the bureaucratization and stratification of American life, declaring personal freedom and fulfillment the highest social value. Enriching the tradition of urban realism with European modernism, the Greenwich Village rebellion reformulated New York's modern movement by embedding it in a new, modern culture anchored in urban life.

The Greenwich Village community dissolved in 1919, but the movement did not. The outlook and attitude of the Village rebellion provided the cultural framework for New York Modern. Asked to choose between social justice and personal freedom, politics and art, artistic integrity and commercial success, abstract art and realist art, Europe and America, the universal and the specific, postwar New York artists chose not to choose. As New Yorkers, they wanted it all, and in Jazz Age New York, all seemed possible.[96]

# New York Modern
## Art in the Jazz Age

In 1920 I gathered my strength," declared painter Joseph Stella, "to assault the theme that for years had become an obsession: THE VOICE OF THE CITY OF NEW YORK IN-TERPRETED." The Italian-born Stella explained,

I had witnessed the growth and expansion of New York proceeding parallel to the development of my own life . . . and therefore I was feeling entitled to interpret the titanic efforts, the conquests already obtained by the imperial city in order to become what now She is, the center of the world. . . . Continually I was wandering through the immense metropolis, especially at night, in search of the most salient spectacles to derive from the essentials truly representative of her physiognomy. And after a long period of obstinate waiting, while I was at the Battery, all of a sudden flashed in front of me the skyscrapers, the port, the bridge, with the tubes and the subways.[1]

Stella was not alone. Following World War I, American artists discovered New York. Young architectural critic Lewis Mumford exclaimed, "The world, at that moment, opened before me, challenging me, beckoning me, demanding something of me. . . . Here was my city, immense, overpowering, flooded with energy and light . . . transmitting through me the great mysterious will . . . and the promise of the new day that was still to come."[2] Although Paris continued to assert its lure on postwar American writers, avant-garde American painters and sculptors no longer found France overpowering. Instead, visual artists turned to New York and other American subjects. After the war New York artists visited Paris briefly, renewed acquaintances, observed the European avant-garde, and then returned, convinced that New York, not Paris, was the wellspring of the modern. Even Marcel Duchamp, who had left in 1919, asserted that the modern could be truly encountered only in New York and that American painters should free themselves from the influence of Paris.

The discovery of their city often came as a surprise to New York artists. Frustrated with their work, they had scraped together the money for passage to Europe, toured the continent, and, in Paris, sought out Gertrude Stein, expecting to recap-

ture the prewar euphoria. Instead, they found themselves isolated, homesick for New York and the United States. Charles Demuth, on his arrival in Paris in the fall of 1921, wrote to his friend and patron Alfred Stieglitz, "I feel 'in' America even though its insides are empty. Maybe I can help fill them. Strange that I should feel this; I don't think it has shown yet in my work. . . . Sometimes it seems almost impossible to come back—we are so out of it. Then one sees Marcel [Duchamp] or Gleise [Albert Gleizes] and they will say 'New York is the place, there are the modern ideas—Europe is finished.' How wonderful a time it is."[3]

Demuth's close friend, the poet William Carlos Williams, also made the obligatory pilgrimage to Paris. Williams visited the American expatriates on the Left Bank, who gathered at Sylvia Beach's Shakespeare and Company, drank tea with Gertrude Stein and Alice Toklas, conversed with James Joyce, heard Igor Stravinsky, and renewed his friendship with Baroness von Freytag–Loringhoven, who advised Williams "to contract syphilis from her" to free his "mind for serious art."[4] After six months Williams, eager for New York, fled "from a Paris that was dead, dead, dead." He later explained, "In art as in politics, in spite of our faults, the time drift favors America. We, if we have the guts to grasp it, are today the direct inheritors of the ages. All modern trends are rooted in us. . . . When an impasse in modern art is encountered the clarification of it is to be found not elsewhere but in us, in what lies closest to hand in our familiar environment."[5]

No single impulse awoke the New York avant-garde to a sense of themselves as American artists and to New York as the embodiment of all things modern. Independently, each concluded that cubism, expressionism, and surrealism, however provocative, expressed European ideas and feelings. As American artists, they felt compelled to create modern art that drew on American subjects and expressed the richness and tensions of contemporary life. Although the subjects of their art varied widely, virtually all dealt with aspects of modern life—machinery, motion, cities, and urban people. The most prevalent theme by far, however, was New York itself. New York's Jazz Age avant-garde defined modern American life in terms of New York and the cultural modernity of the Greenwich Village rebellion. In the 1920s the New York avant-garde matured into a broad artistic movement, establishing journals, galleries, art schools, museums, and a patronage network. Drawing on elements of European modernism as well as American realism, by 1930 they had collectively created a forceful—yet incomplete—tableau of modern America.[6]

In so doing, New York painters and sculptors resolved the dilemma that the 1913 *Armory Show* had presented—how to be both modernist and American. They confronted a Hobbesian choice—continue to paint in a realist manner and be relegated to the dustbin of art history or adopt a modernist style that was, at best, a technically well-executed copy of European work. By 1920, after the initial flourish of fauvist, expressionist, and cubist art, New York painters abandoned their efforts to imitate European modernists. What was at first true of only a few artists by mid-decade had become widespread, as New York avant-garde painters and sculptors developed explicitly American styles that were both representational and modernist in their use of color, shape, and perspective. These American styles ranged from the

quite realist paintings of Edward Hopper to the radically abstract work of Stuart Davis. Much as New York affirmed the great variety of its people, so New York's modern artists, in the 1920s, affirmed a variety of modern styles, distinct and identifiably American.[7] In each case, however, Jazz Age New York art included only Americans of European descent. New York's African American artists, with rare exceptions, continued to live and work in a world apart.

## THE YOUNG AMERICANS

The belief that New York artists must create work both modern and American was widely shared by postwar New York writers, poets, dramatists, and musicians. Before the war, literary critic Van Wyck Brooks had declared despairingly, "We Americans do not feel the inspiration of American life because we shut ourselves off from understanding it. . . . And we further divorce ourselves by living abroad. . . . A dilettante is an artist without a country, an artist who feels no vital connection with some one spot of soil and the myriad of forms of life that have grown out of it."[8] During the war, Brooks, along with his close friend and fellow critic Randolph Bourne, and others associated with the radical magazine *Seven Arts* concluded that artists and writers, as a cultural vanguard, must shun politics and, through their art, create a modern, democratic culture. The *Seven Arts* group, or the "Young Americans," as they called themselves, insisted that through art, American life could be reconstructed, liberated from the inequities of free market capitalism and the tyranny of Victorian moralism. By embracing urban life, democratic values, and personal freedom, artists and writers could build a new America, constituting a "beloved community" of free and socially conscious individuals.[9]

Following the demise of *Seven Arts,* in the summer of 1918, Martyn Johnson and Scofield Thayer purchased the *Dial* magazine and moved it from Chicago to New York, ostensibly to provide Brooks, Bourne, and the other Young Americans a vehicle for a second American renaissance. From their offices at 152 West 13th Street in Greenwich Village, a succession of *Dial* editors orchestrated what they hoped would be a "reconstruction" of American life, by which they meant augmented government control over the economy, expanded welfare services, and increased guarantees of personal liberties. Receptive to a broad spectrum of modern expression, the *Dial* published the poetry of Hart Crane, Amy Lowell, and William Carlos Williams; critical essays by Kenneth Burke, Malcolm Cowley, and Edmund Wilson; and the painting of Americans Charles Demuth, George Bellows, and Georgia O'Keeffe and Europeans Pablo Picasso and Henri Matisse.

In its first decade the *Dial* regularly featured a "London Letter," by T. S. Eliot, a "Paris Letter," by Ezra Pound, and a "Dublin Letter," by George Moore. Paul Rosenfeld's "Musical Chronicle" kept *Dial* readers informed on the work of Igor Stravinsky, Arnold Schoenberg, Edgar Varèse, Béla Bartòk and modern American composers Aaron Copland, Roger Sessions, Roy Piston, and Virgil Thomson. Henry McBride's column, "Modern Art," featured the School of Paris and Alfred Stieglitz's New York modernists, while George Santayana, Bertrand Russell, and Leo Stein

contributed essays on art theory. The great coup of the *Dial,* however, was the first publication of Eliot's bombshell, *The Waste Land,* and Pound's *Cantos* 4 through 22 and 27.[10]

Waldo Frank, Paul Rosenfeld, and William Carlos Williams outlined the concerns of what Scofield Thayer of the *Dial* called the new "American Renaissance." In *Our America,* Frank declared, "We are in revolt against the academics and institutions which would whittle America down to a few stale realities current fifty years ago when our land in all but the political surface of its life was yet a colony of Britain. But we are in revolt as well against that organized anarchy today expressed in industrialism which would deny to America any life—hence any unity at all—beyond the ties of traffic and the arteries of trade."[11]

Paul Rosenfeld wrote *Port of New York* to demonstrate just how far the reconstruction of American culture had already come. "It is not Paris we want," wrote Rosenfeld, "it is more New York, more Chicago, more Kalamazoo, Omaha, Kenosha, more loop, more gumbo and gravel, more armature spiders."[12] For Rosenfeld, New York was both the center and the source of the modern American renaissance. "There is no one not aware something has happened in New York," he declared. "Out of the American hinterland, out of the depths of the inarticulate American unconsciousness, a spring has come, a push and a resilience; and here where Europe meets America, we have come to sit at the focal point where the two upspringing forces balance . . . giving the Port of New York a sense at last, and the entire land the sense of the Port of New York."[13] Alfred Stieglitz endorsed Rosenfeld's assertion: "Yes, you have struck it—why it's so important: America without that French flavor! It has made me sick all these years. . . . That's why I continued my fight single-handedly at 291. That's why I'm really fighting for Georgia [O'Keeffe]. She is American. So is [John] Marin. So am I."[14]

If Frank and Rosenfeld proclaimed the postwar artistic agenda, the poet William Carlos Williams embodied it. The child of an English father and a Latin American mother, Williams grew up in East Rutherford, New Jersey, commuting daily to the Horace Mann School near Columbia University. Committed to his mother's art and his father's spiritual understanding of science, Williams attended the University of Pennsylvania Medical School but modeled himself after Keats. In Philadelphia, Williams established lifelong friendships with Ezra Pound, Marianne Moore, and Charles Demuth. Shortly before World War I, Williams joined the New York avant-garde, regularly visiting Stieglitz's 291, writing plays for the Provincetown Players, and attending soirées at the Arensbergs'.[15] A practicing physician and a published poet, Williams insisted that art and life be connected. "Art is a repository for the perplexities of mind which surround us. It is not like religion and philosophy, a proposed dissolution of our difficulties. It is the repository where we lay them away. . . . The artist is the most important individual known to the world."[16]

Williams, a strong, athletic man with large hands and short-cropped dark hair, began his medical practice as an intern at the old French Hospital on West 34th Street near the present Lincoln Tunnel, in what was then called the French Quarter. Death and human misery were constants in his life. His patients included the poor and the despised—cripples, beggars, prostitutes, transvestites, and homosex-

uals. Following his internship, Williams accepted a residency at the Nursery and Child's Hospital at 61st Street and 10th Avenue in the tenement district of San Juan Hill, adjoining Hell's Kitchen. He delivered "babies free every hour, any color desired, 100 percent illegitimate." Williams had hoped that his New York internship and residency would lead to a position at a major New York hospital, but when he refused to approve an improper payment to the mistress of his department head, the hospital board asked for his resignation, closing off the possibility of a lucrative city practice. Disillusioned, Williams returned to New Jersey, where he set up a family practice that served the working-class neighborhood of East Rutherford.[17]

In 1913, with the help of his close friend Ezra Pound, Williams published his first book of poems, *Tempers*. That same year he visited the *Armory Show* and, through Charles Demuth and Marianne Moore, was introduced to the Greenwich Village avant-garde. Williams wrote, "I'd sneak away mostly on Sundays to join the gang." He costarred with Mina Loy in Alfred Kreymborg's Provincetown production of *Mushrooms*, and, with Kreymborg and Maxwell Bodenheim, Williams published *Others*, a protodada magazine. "We were destroyers, vulgarians, obscurantists to most who read," he confessed.[18] A full-fledged member of the Arensberg circle, Williams became especially close to Man Ray, Marcel Duchamp, and Malcolm Cowley.

Marianne Moore invited Williams to join the *Dial* group that gathered at the 14th Street apartment of Margaret Anderson and Jane Heap. Williams argued late into the night with Kenneth Burke, Marsden Hartley, and Charles Demuth about creating a new American art and poetry, "where we all instinctively felt our purposes come together to form a stream." One such confluence occurred when a fire engine, with a gold "#5" emblazoned on its side, swept past Williams as he stepped into Hartley's apartment. Williams was struck by the lingering image of a "golden figure 5 on a red background flash[ing] by. . . . The impression was so sudden and forceful that I took a piece of paper out of my pocket and wrote a short poem about it." After reading Williams' poem, Charles Demuth painted *The Figure 5 in Gold*, a visual depiction of a powerful instant. In Demuth's painting, the figure "5" in gold remains in the foreground of the mind even as it recedes in space, suspended amid the sounds and lights of the city. His "portrait" of Williams' memory is neither naturalistic nor simply abstract. Rather, Demuth tried to capture a pure perception of an experienced event, free of rationalized ordering and relationships—the figure "5" flashing by, in association with a blaring siren, street lights, voices, and the night.[19]

For an instant, poet, painter, and city were conjoined.[20] "Then out of the blue," related Williams, "the *Dial* brought out *The Wasteland* and all our hilarity ended. It wiped out our world as if an atom bomb had been dropped on it and our brave sallies into the unknown were turned to dust." Eliot's achievement left Williams dazed and immobilized. "Critically, Eliot returned us to the classroom just at the moment when I felt that we were on the point of an escape to matters much closer to the essence of a new art form itself—rooted in the locality which should give it fruit. . . . He gave the poem back to the academics, chilling the young poets."[21]

Hardly knowing how to respond, Williams took a year's leave from his medical practice to spend six months in New York and six months in Paris. During his sab-

Young Americans and
New York Modern.
Charles Demuth, *The
Figure 5 in Gold*
(1928).
*Alfred Steiglitz Collec-
tion, Metropolitan
Museum of Art, 1949
(49.59.1)*

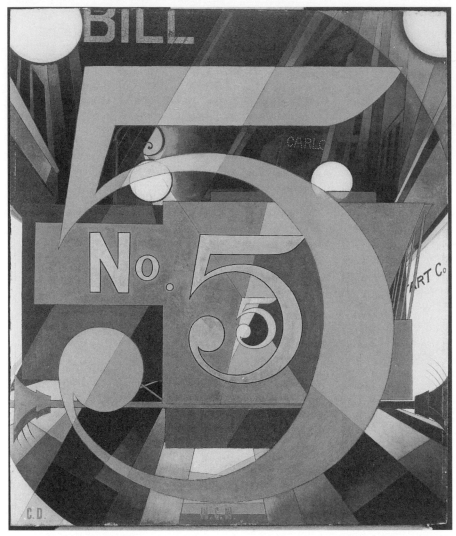

batical he wrote a series of prose essays, collected in *In the American Grain*, about individuals and events that had formed America—Christopher Columbus, Ponce de León, the Salem witch trials, Daniel Boone, Aaron Burr, slavery, Edgar Allan Poe, and Abraham Lincoln.[22] Begun in 1922 and published in 1925, *In the American Grain* answered Eliot's *Wasteland*. Williams asked the New York avant-garde to ground their work in the particulars of the American life, much as Charles Ives had done in his modernist compositions.

The painters associated with the *Dial* shared Williams' Whitmanesque dream of a new America, but unlike the poets they were largely untouched by *The Waste Land*. Earlier, at the *Armory Show,* New York visual artists had suffered a similar experience. By the end of the war, however, having regained their confidence, they had absorbed the ideas of postimpressionism and cubism while developing their own styles and images. In 1922, New York artists were already at work "in the American grain."

## IN THE AMERICAN GRAIN

In the 1920s, for American artists, New York symbolized the modern. The city's newly constructed art deco skyscrapers, its up-to-date subway system, its diverse population, and its unprecedented prosperity offered unlimited possibilities. Jazz Age New Yorkers sported colorful, informal clothing and engaged in lively, uninhibited entertainment. Prohibition enticed individuals to violate the law and to treat with contempt traditional restraints on personal behavior.[23] More than anything else, however, the 1920s marked the triumph of city values. A majority of Americans lived in what the Census Bureau defined as "urban communities," and urban values and tastes permeated national life. Magazine advertising, motion pictures, radio broadcasts, and paved highways placed even the most remote regions of the nation under the sway of its cities. The city—its technology, freedom, opportunities, amenities, and amusements—became synonymous with postwar American life.

The images of modern urban America were not drawn haphazardly from an amorphous monolithic urban culture. Rather, most derived from New York City. New York fashions, restaurants, transportation, cuisine, skyscrapers, and behavior defined the modern in postwar America—particularly for American artists. To Edward Hopper, Georgia O'Keeffe, Stuart Davis, Charles Demuth, Joseph Stella, and other New York painters associated with the *Dial,* New York embodied the modern. They filled their American scenes with its skyscrapers, its subways, and its people.[24]

Painter Joseph Stella recounted his awakening: "In 1913 I contributed three pictures to the famous *Armory Show,* that memorable exhibition which remains epic as the resurrection of modern art in this country." Inspired by the exhibit, Stella painted his *Battle of the Lights, Coney Island.* "I built the most intense dynamic arabesque that I could imagine in order to convey in a hectic mood the surging crowd and the revolving machines generating for the first time, not anguish and pain, but violent, dangerous pleasures. I used the intact purity of the vermilion to accentuate the carnal frenzy of the new bacchanal and all the acidity of the lemon yellow for the dazzling lights storming all around."[25]

No one before Stella had so successfully captured the intensity and vitality of modern New York. Few, however, were prepared for his *Brooklyn Bridge.* "In 1918 I seized the other American theme that inspired in me so much admiration since I landed in the country, the first erected Brooklyn bridge. To realize this . . . I appealed for help to the soaring verse of Walt Whitman and to the fiery Poe's plasticity."[26] Stella expressed the complex emotions felt by Jazz Age New York artists. A native of Muro Lucano in southern Italy, he came to New York in 1896 to live with his brother, a New York physician. Stella studied at William Merritt Chase's New York School of Art and supported himself by illustrating for the *Century, Everybody's, Outlook,* and the *Survey.* In 1902, the *Survey* commissioned Stella to complete a series of drawings of Pittsburgh, an experience he never forgot. "It was a real revelation. Often shrouded by fog and smoke, her black mysterious mass—cut in the middle by the fantastic, tortuous Allegheny River and like a battlefield, ever pulsating, throbbing with the enumerable explosions of its steel mills—was like the stunning realization of some of the most stirring infernal regions sung by Dante."[27]

In 1910, Stella returned to Italy, and in 1911 he visited Paris to study. "At my arrival, Fauvism, Cubism and Futurism were in swing. There was in the air the glamour of a battle, the holy battle raging for the assertion of a new truth. . . . And when in 1912 I came back to New York I was thrilled to find America so rich with so many new motifs to be translated into a new art. Steel and electricity had created a new world. . . . A new architecture was created, a new perspective."[28] Stella saw New York as if for the first time. For the next eight years he painted immigrants at Ellis Island, fuel tanks, factories, sweatshops, and shipyards, along with highly abstract compositions that included geometric shapes, color, and light.

In 1920, Stella completed his master work, an altarlike panorama of his city, *New York, Interpreted.* The work consists of a large central canvas, entitled *The Skyscrapers,* flanked on either side by two pairs of smaller panels, *White Way, I, White Way, II, The Port,* and *The Bridge.* The four small panels measure 54″ × 90″; the large center canvas stands 54″ × 102″. Composed of jarring but arresting colors and shapes, the five-panel, mural-size work extends a monumental twenty-two and one-half feet in length. Stella filled the central picture, *The Skyscrapers,* with unmistakable phallic shapes, apparently in celebration of the triumph of man over nature. In *White Way, I* and *White Way, II,* Stella's stained-glass images present New York as a cacophony of joyful sounds, movement, and light, whereas *The Port,* with its dark, ominous hues and shapes, projects an inferno of industrial life. Together, the panels depict an alluring and fearful city.[29]

Stella was not alone in his infatuation with modern New York. Marguerite Thompson Zorach, also in 1920, created her own modern New York panorama, entitled, *The City of New York in the Year Nineteen Hundred and Twenty.* Thirteen years earlier, Marguerite Thompson, the daughter of a northern California pioneer family, had left for Paris to become a painter. An acquaintance of Gertrude Stein, Thompson attended the fauves' 1908 Salon D'Automne exhibition. Sculptor William Zorach, meeting Thompson in 1910 at a painting class, described her work as that of a "wild, post-impressionist." Thompson returned to the United States and married Zorach, and in 1912, the couple moved to Greenwich Village, where their 10th Street apartment became a center for Village radicals.

Indifferent to current fashions, Marguerite Thompson Zorach dressed in plain, free-flowing gowns, wore a knitted hat pulled tightly over her bobbed hair, and sported round wire-rimmed glasses, fulfilling the popular image of the "new" Greenwich Village woman.[30] At the *Armory Show,* both Zorachs exhibited paintings, but only Marguerite's *Cubist Study* received critical, if unsympathetic, attention.[31] Summering in Provincetown, the Zorachs joined the Provincetown theater group, designing sets, sewing costumes, and occasionally acting in both Provincetown and Greenwich Village productions. By 1916, Marguerite Zorach had become an established modern painter, exhibiting her work at most of the major New York shows and galleries, including the 1916 modernist *Forum Exhibition.* Strongly influenced by Matisse and Picasso, Zorach dealt with American themes in her paintings—*Man among the Redwoods, Provincetown,* and *Sunrise-Moonset, Provincetown.* After 1916, she continued to work with American themes, using bright colors and geometric shapes, but her work became increasingly representational, even narrative.[32]

With the birth of her first child in 1915 and a second in 1917, Zorach shifted away from painting, because it demanded too much of her sustained attention, to embroider tapestries of silk and wool that she could pick up and put down at any time. The first exhibition of her tapestries, in 1917 at the Daniel Gallery, caught the eye of Abby Aldrich Rockefeller, whose purchases and commissions enabled Zorach to sell everything she made at high prices. The most interesting of her Rockefeller commissions, *The Rockefeller Family at Seal Harbor,* narrated the saga of Rockefeller family summers in Maine. Zorach's 1923 exhibition at Montross Gallery, which included tapestries, rugs, and bedspreads, received favorable reviews. Her most noted piece was a tapestry, *The City of New York in the Year Nineteen Hundred and Twenty,* a panoramic mosaic of the city embroidered in bright colors, which depicted dozens of stylized images—automobiles, the Hudson River, the Statue of Liberty, the docks on the East River, Brooklyn Bridge, the Woolworth Building, elevated railroads, Central Park, and Marguerite and William Zorach in a Greenwich Village apartment.[33]

Ironically, Zorach's artistic reputation was a victim of her success. Wealthy private buyers purchased almost all of her work even before completion, treasuring them as heirlooms as much as art and refusing to sell the tapestries to dealers or to give them to museums. Consequently, after the 1920s, Zorach received relatively few offers to exhibit, and museums acquired only a handful of her works. In 1956 she reflected, "These works are created out of my life and the life around."[34] In New York, Zorach succeeded as an artist. Taking advantage of the changed climate towards women artists after 1913, she experimented with modernism, and by 1920 she had discovered a style and a medium that embodied her modern commitments, her feeling for American life, her identification with New York, and her special interests as a woman, which included her artistry and her family.

In the 1920s, Georgia O'Keeffe also focused on New York. Born in 1887, the same year as Marguerite Zorach, O'Keeffe followed a different professional path. A native of Sun Prairie, Wisconsin, O'Keeffe's Irish Catholic parents moved to Williamsburg, Virginia, when she was fifteen. Determined to become an artist, O'Keeffe attended the Art Institute in Chicago. In 1907 she left for New York, where she enrolled in William Merritt Chase's painting class at the Art Students League and also visited several modern shows at Stieglitz's 291 before leaving the city.

In 1916 she returned to New York, this time to study with Wesley Dow at Columbia Teachers College. At the end of the term, out of money, she resumed teaching at Columbia College, a Methodist women's college in South Carolina. After classes, working late into the night, O'Keeffe completed a series of charcoal drawings that she sent to Anita Pollitzer, an art student friend in New York. Pollitzer, without consulting O'Keeffe, showed them to Stieglitz. Stieglitz reportedly replied, "Finally a woman on paper. . . . Tell her they're the purest, finest, sincerest things that have entered 291 in a long while."[35] At the end of the fall term, O'Keeffe resigned her teaching position to return to New York. Stieglitz, who exhibited her drawings in May, not only fell in love with O'Keeffe's work, he also became infatuated with her. His own sense of artistry aroused, Stieglitz closed 291 and ceased publishing *Camera Work,* recommitting himself to photography. O'Keeffe and Stieglitz married

in 1924, and until his death in 1946, Stieglitz promoted O'Keeffe's work, serving as her exclusive agent.[36]

It is easy to understand Stieglitz's personal and artistic attraction to O'Keeffe. Tall, slim, strong, at twenty-nine she carried herself with an unmistakable seriousness. Art was her life. O'Keeffe epitomized for Stieglitz the modern American woman—forthrightly sexual, confident, rooted in rural America but drawn to New York. The distinctiveness of O'Keeffe's work derived, in part, from her marginal acquaintance with modernism. Unlike Stella and Zorach, O'Keeffe's training and professional experience was exclusively American, largely in New York. Reflecting Dow's influence, no matter what her subject O'Keeffe painted bold, forceful compositions. In the 1920s she executed a number of New York cityscapes, many of the Shelton Hotel on Lexington Avenue near 48th Street, where she lived with Stieglitz, or views of New York as seen from their thirtieth-story apartment, including *Radiator Building—Night, New York, New York—Night,* and her somber green-toned *East River No. 1.*[37]

While O'Keeffe was painting her New York cityscapes, she began her famous series of floral paintings. O'Keeffe presented her flowers close up, often focusing on their sexual elements. Unmistakably vaginal, O'Keeffe's floral paintings affirmed female sexuality through suggestive and colorful, genital-like flowers—*Red Canna, Canna Lily,* and *Pink Sweet Peas.* O'Keeffe's life with Stieglitz, her standing as an artist, her New York cityscapes, and her erotic florals brought together major components of postwar New York painting—sexual freedom, urban life, artistic creativity, and feminism.[38]

Stella, Zorach, and O'Keeffe, along with Charles Sheeler, Charles Demuth, Edward Hopper, Stuart Davis, Paul Strand, John Marin, and Alfred Stieglitz, employed images of New York to identify and, in most instances, to affirm modern urban life. They did not, however, restrict themselves to explicitly urban or New York images. Among Stella's most interesting works were stylized paintings of birds and flowers, nocturnal swans, and pomegranates. Such a range of subject and style typified the work of other postwar New York artists. Georgia O'Keeffe painted hard-edged cityscapes and pastel florals.[39] Zorach's *City of New York* garnered critical attention at the time, but equally impressive were her works dealing with domestic themes and summers in New England. Other postwar New York painters, whose work examined the impersonal, machine-driven modern city, also expressed affection for rural, personalized havens, such as John Marin's and Edward Hopper's New England seascapes, Alfred Stieglitz's clouds over Lake George, and Charles Sheeler's paintings of rural Pennsylvania.[40]

Such duality marked much of modern art. French impressionists had embedded railroads, bridges, factories, and steamboats in their bucolic landscapes. But they did so in soft pastels and hazy shapes, prospects of bourgeois life presented in benign, even pastoral, compositions. In contrast, German expressionists had depicted the city and modern life as horrifying and dehumanizing. Stella, O'Keeffe, Zorach, and other postwar New York painters neither sentimentalized the city, like the impressionists, nor adopted the overtly antimodern and antiurban stance of German expressionists. Instead, they presented New York matter-of-factly, as an irrevocable

condition of modern life that offered its populace opportunity and excitement, destruction and danger.

Charles Demuth's work exhibited the duality of his artistic generation but also an embittered tension. Demuth suffused his urban watercolors with warmth and vitality, whereas his hard-edged rural pictures bristled with hostility. The child of an old Lancaster, Pennsylvania, family, Demuth reluctantly left New York in the early 1920s, for reasons of health, and returned home to live with his mother. To the homosexual Demuth, Lancaster presented a hostile, dehumanizing, homophobic presence that he portrayed in *Lancaster,* in which a menacing black water tower oppresses the town's skyline. Similarly, *My Egypt,* a hard-edged portrait of industrialized agriculture dominated by hostile phallic grain elevators, alludes to Demuth's sense of almost biblical exile in patriarchal rural Pennsylvania.[41] These harsh precisionist paintings contrast radically with Demuth's soft watercolors of Bermuda, which he completed while visiting there with Marsden Hartley, his light-hearted renderings of Parisian café life, and his affectionate watercolors of New York nightclubs, jazz musicians, vaudeville dancers, and naked men consorting in Turkish bath houses. Demuth's paintings testify to the tension between modern urban life and traditional rural communities. Whereas Sheeler, O'Keeffe, Hopper, and Stella found comfort in traditional images, Demuth found affection and warmth in images of New York.[42]

In 1927, New York painters' interest in technology and in the modern served as the theme of the *Little Review*'s *Machine-Age Exhibition* at Steinway Hall. Featuring the precisionist work of Sheeler, Demuth, and other New York artists, the *Machine-Age Exhibition* displayed paintings, architectural drawings, and photographs. According to the exhibition catalog, "The dominant trend today . . . beneath all the apparent chaos and confusion is towards order and organization which find their outward sign and symbol in the rigid geometry of the American city, in the verticals of its smoke stacks, in the parallels of its car tracks, the squares of its streets, the cubes of its factories, the arch of its bridges, the cylinders of its gas tanks."[43] Most of the work utilized machine imagery—sometimes forebodingly, sometimes affectionately—to highlight the technological basis of modern American life, with New York as the preeminent symbol of modern America.

New York's postwar painters created a complex image of modern life, powerful and dynamic but also impersonal and ominous. They pictured New York not as an important and interesting provincial city but as the embodiment of modernity. Accepting the power and dynamism of the city as inherently modern, New York's postwar avant-garde acknowledged their attraction to and dependence on New York. In southern Italy, Joseph Stella could not have become an artist; Rutherford, New Jersey, valued William Carlos Williams as a physician, not as a poet; Charles Demuth painfully suffered the isolation and moral strictures of Lancaster, Pennsylvania; and Georgia O'Keeffe could not paint in Williamsburg, Virginia. Cleveland, despite the best efforts of its patrons, failed to provide either William Zorach or Marsden Hartley the artistic resources or stimulation they required. New York did.[44]

Yet, while acknowledging their dependence, postwar New York painters were not

transfixed by the city. Other images and other places remained important to them. New York's intensity, its size, wealth, and complexity, at times overwhelmed and dehumanized its inhabitants, necessitating escape. In the summer, as their patrons fled the city's heat, New York artists, too, sought out summer refuges in Provincetown, Woodstock, Martha's Vineyard, Cape May, Lake George, Santa Fe, and Taos. Away from the city, sequestered in the rural countryside, they painted seascapes, mountains, landscapes, and small-town rural scenes. New York artists came from all over the world and the United States, but once in New York, they spent much of their time trying to leave it. Away from the city, they discovered the variety and expanse of their own country, fostering in their work mixed feelings towards urban and rural, modern and traditional, individualistic and communal, cosmopolitan and provincial.

Even in their escapes, however, New York's artists conformed to the rhythm of urban life. In the fall, they dutifully returned, taking up residence in the city. Here, they received patrons in their studios and apartments; they taught art classes, engaged in commercial work, exhibited their art, and painted studio scenes or features of urban life that often included hard-edged, flattened machine images. Consciously drawing on European modernism, postwar New York painters also used American images, some quite traditional, to address but not to resolve the contradictions inherent in modern urban life.

## ESTABLISHING THE MODERN

The postwar New York avant-garde understood itself as the modern counterpart to the Beaux-Arts-inspired New Movement of the 1870s. From Paris, in 1921, Charles Demuth wrote Stieglitz, "New York is something which Europe is not. . . . All the others, those who count, say that all the 'modern' is to us [sic] and of course, they are right. . . . Together we will add to the American Scene, more than has been added since the 60s and 70s—maybe more than they added."[45] Richard Gilder had urged the New Movement to create an academy—in part, to provide New York artists aesthetic standards independent of the marketplace. But these efforts proved futile. Private patronage was always more important for New York artists than official support.

On the eve of World War I, the New York art academy had consisted of the National Academy of Arts and Letters, the National Academy of Design, the Art Students League, and the Metropolitan Museum of Art. But as art establishments went, New York's was weak and ineffective, its oppressive power largely a carefully nurtured fiction of the city's avant-garde. After World War I, except for the Metropolitan Museum, the frail remnant of a New York academy all but disappeared, replaced by the Whitney Studio Club and a modernized Art Students League. Together, these two institutions served as an embryonic modern academy, promoting modern painting and sculpture, shielding the city's visual artists from market pressures, and opening the door for women artists.

The change of the New York art establishment from beaux arts to modern and from male dominance to female participation had begun before the war. The *Armory*

*Show* had been sponsored by New York's emerging modern art establishment. The city's patrons of modern art—Gertrude Whitney, Lizzie Bliss, and John Quinn—helped finance the exhibition, and most of New York's best-known modern artists, including Art Students League faculty and students, exhibited in the show. Despite the generous support of Whitney and Bliss, the American Association of Painters and Sculptors remained as much an all-male organization as the National Academy. Refusing to be relegated to the balcony, Whitney formed her own art organization, the Whitney Studio Club.[46]

Beginning in 1916, the Art Students League became the virtual uptown branch of the Whitney Studio Club. John Sloan and Kenneth Hayes Miller acted as the informal leaders of the Whitney group, forming what came to be called the Fourteenth Street School of urban realists. After the war, a number of women artists assumed important roles in the Whitney Studio Club, forming the first important cohort of American women painters. Almost all these Whitney women trained at the Art Students League with either Sloan or Miller.[47]

Like their mentor, Robert Henri, Sloan and Miller focused on urban life with an emphasis on the human figure. Unlike Henri, they refused to conduct their art classes as all-male clubs. They welcomed women to their classes and included them in all art-related activities. Sloan's and Miller's acceptance of women as full-fledged professionals coincided with the change of the Art Students League from beaux arts to modern. The changes had begun in 1911, when the school hired urban realist George Bellows to replace William Merritt Chase. The following year the league engaged Kenneth Hayes Miller to instruct the life class, replacing Kenyon Cox. But the sea change did not occur until 1916, when the league elected former Henri student Gifford Beal as president. Soon afterward, Beal hired Henri and Sloan to teach painting and urban realist Mahonri Young as sculpture instructor. With these changes, the Art Student League became a bastion of urban realism.[48]

For the next twenty-five years, the faculty list of the Art Students League read like an honor roll of New York modern artists—Max Weber, Maurice Sterne, Stirling Calder, José de Creeft, Guy Pène du Bois, George Luks, William Zorach, Rockwell Kent, Stuart Davis, Chaim Gross, and Walt Kuhn—whose students included nearly every important post–*Armory Show* American painter and sculptor. By 1920, no art school in the country rivaled the Art Students League. From 1913 to 1945, in its beaux arts building at 215 West 57th Street, the Art Students League nurtured and molded New York modern art. An outpost of the Greenwich Village insurgency in the very heart of the uptown gallery district, the faculty of the Art Students League instilled in their students the avant-gardism of Greenwich Village radicals and the art ideas of Robert Henri.[49]

Boasting a faculty of twenty-six and an enrollment of more than twenty-eight hundred students, the 1924–25 *Catalog* reaffirmed the Art Students League's insurgent origins. "The Art Students League is based on a sound principle. It is run for and by students, the interest of no outside group or individual is served. Its very life therefore comes from the needs of those who compose it. Here is practically the only place where new ideas can be given a chance. In this way the school lives and grows in normal fashion. To offer freedom to pursue a well-rounded course of study is its only

object."[50] Beal and his faculty understood the league as a student cooperative. League students elected the school's governing board and president, who in turn hired a director to run the league, to oversee classes, and to hire faculty. This usually translated into faculty control, as students largely followed their mentors' directions, but, unlike the Ecole des Beaux-Arts, the faculty of the Art Students League was accountable to its students, not to governmental officials. The cooperative, even democratic, relationship between faculty and students accounted, in part, for the special character of the Art Students League from 1914 to 1945.[51]

Consistent with its charter, the league's board consisted of equal numbers of men and women, apart from the president, who had always been male. From its beginning, a majority of league students had been women, but prior to World War I the league had viewed women art students as amateurs, not as aspiring professionals. During World War I, the league's attitude towards female students changed.[52]

After 1903, although no longer required, life classes remained the core of Art Students League instruction. Until 1917, the league, like all other American and European art schools, had strictly segregated the men's and women's life classes, accepting the Victorian dictum that men and women should not view human nudity in one another's company. Since its founding, the league had insisted that all of its students, women as well as men, receive equivalent instruction. In practice, this meant that most courses were open to both men and women, but in those courses that required nude models, the league provided separate classes. Despite formal declarations of equality, the league scheduled the men's life classes for the afternoon hours, when natural lighting was optimum. The women's life classes took place in less desirable morning light. Moreover, the league offered a supplementary life class at night, but one that excluded women.[53]

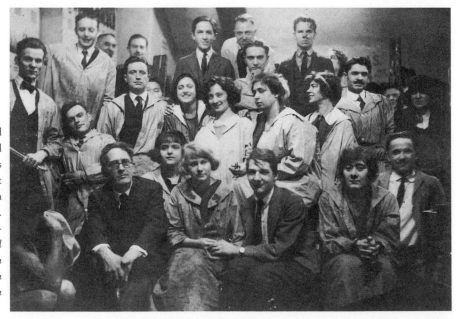

Training women and men as professional artists. John Sloan's life classes at the Art Students League in the 1920s. *Paul Juley, Peter A. Juley and Son, National Museum of American Art, Smithsonian Institution*

With American entry into World War I, the Art Students League faced a crisis. Because of military enlistment and conscription, its male enrollments plummeted, whereas its female enrollments surged. Determined to make the best of the situation, Kenneth Hayes Miller merged his women's and men's life classes. Miller asserted that all of his students were professionals and that the segregation of women and men into separate life classes was cumbersome, expensive, and silly. The only professional distinction Miller recognized among his students was that between beginning and advanced. John Sloan followed Miller's lead. After the war Miller and Sloan continued their practice of admitting students solely on the basis of ability.

In 1922, in advertising its Woodstock Summer Art School, the Art Students League included photographs of men and women in the same class using nude models. By the mid-1920s, photographs of mixed life classes became standard features of Art Students League catalogs. Mixed classes had become not simply the norm but, from the perspective of prospective students, the preference. The league's new policy and attitude towards female art students coincided with a substantial increase in the number of women trained at the league who subsequently became professional artists. Miller's and Sloan's students at the Art Students League included Georgia O'Keeffe, Isabel Bishop, Peggy Bacon, and Katherine Schmidt.[54]

Kenneth Hayes Miller's admission of men to his women's life class in 1918 marked a new era in American art education. The decision ended a sanction that had haunted American art educators since Thomas Eakins' confrontation with the trustees of the Pennsylvania Academy of Design and Augustus Saint-Gaudens' with women sculpture students at the Art Students League. Just as important as Miller's decision, however, was the impact of his teaching. Miller was a formidable classroom presence. Sternly serious, with closely clipped mustache and dressed in a coat and tie, he insisted on the primacy of art. If students intended to be professional artists, everything else had to be secondary.[55]

Miller instilled in his students the idea that artists were inherently radical and

Training women and men as professional artists. Kenneth Hayes Miller's life classes at the Art Students League in the 1920s.
*Paul Juley, Peter A. Juley and Son, National Museum of American Art, Smithsonian Institution*

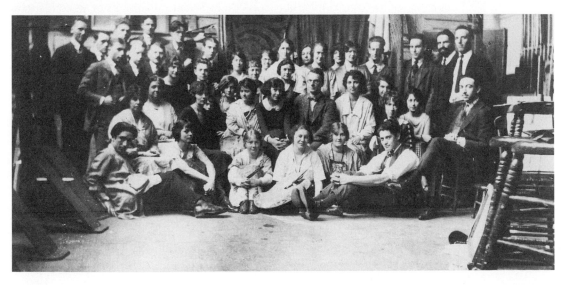

that social acceptability was inimical to good art. Born into a radical community that repudiated Victorian notions of patriarchy and sexuality, Miller saw himself as a dissenter and considered his choice to become an artist an affirmation of his radicalism, which he pursued with the same intensity with which his grandparents had pursued their desire for sexual freedom by joining the Oneida Community.[56] But because of his mother's unhappy experience at Oneida, Miller scorned the communalism that many Greenwich Village radicals found so attractive. A socialist, Miller considered art a political act in behalf of individual freedom. Having witnessed firsthand the authoritarian potential of rural communities, Miller identified freedom with urban life and, like Sloan and Henri, encouraged his students to paint the city. Reginald Marsh recounted a conversation with Miller. "I am glad to be alive," declared Miller. "This is the greatest landscape in the world. . . . I haven't been out of New York for ten years. My only recreation is a ball game. . . . I am a painter of the body. You are a painter of the body. Sex is your theme."[57]

Miller's artistic traditionalism expressed itself in his devotion to the human form. Although he painted only a few nudes, they were among his best paintings. Nearly all of Miller's paintings included sexually mature women, who looked as if Miller had first painted the figures nude and had later added contemporary clothing. Thoroughly unsympathetic with the effort of modernists to disassemble the human form, Miller, like Sloan, seemed obsessed with the female body. Also like Sloan, Miller was interested in a broad range of women—old and young, strikingly beautiful and solidly plain, women alone as well as women associating with other women, women of all social classes and races. He painted women, necessarily, from a male perspective, but his perspective was neither patriarchal nor merely sexual.[58]

Other postwar New York visual artists shared Miller's and Sloan's preference for representational art, especially for the female nude. Stieglitz took hundreds of near-worshipful nude photographs of Georgia O'Keeffe; Abraham Walkowitz reputedly drew more than a thousand figures of Isadora Duncan; and the Art Students League and other New York art schools prided themselves on their life classes. The preoccupation of postwar New York artists with the female nude was not an antimodern affirmation of an anachronistic form of aesthetic idealism. Rather, it represented a recognition and a celebration of modern emancipated American women. As Joseph Stella explained,

Around 1924 I came back to New York [from Naples]. I was struck by the conquests in every domain by woman. My admiration for her became keener, and I painted her on a canvas entitled *Amazon* (the Amazon of our time). To celebrate her beauty and her efficiency I employed precious chromatic attributes: blue, gold, silver, ivory, vermilion. . . . To uplift her PRESENCE in a legendary realm, for her background I painted a rich ultramarine blue sea, compact as a crystal, containing the elongated carved image of CAPRI, THE ETERNAL SIREN, and to proclaim her a GODDESS, with vermilion I rendered her bust a volcanic pedestal refulgent of power as an ORIFLAMME.[59]

Few went as far as Stella. New York's Jazz Age avant-garde accepted women as professional equals, and Miller, Sloan, Stieglitz, Walkowitz, Bishop, and Hopper painted women as strong, sexual, reflective, and self-reliant. Their portraits, even those by women painters such as Isabel Bishop and Katherine Schmidt, seem paint-

ed from a male perspective, often inspired by classical and Renaissance works. Tellingly, most of their nudes were of adult women. The insistence of painters that artistic images of undressed humans were nude rather than naked hardly masked their erotic interest in unclothed women and the sexual appeal of such nudes to male viewers. Objectified, eroticized, and portrayed from a male, even voyeurist, point of view, these images of female sexuality did not, however, demean women as helpless or dependent. The frank depiction of female nudity, free of earlier idealizations, and of women as sexual objects and sexual agents distanced these works from Victorian painting. Undeniably sexual, the artistic images were of everyday modern women.[60]

The death of Albert Pinkham Ryder, William Merritt Chase, Thomas Eakins, and Kenyon Cox between 1917 and 1919 heralded the end of an era in American art. The acceptance of women as professional equals and the displacement of Beaux-Arts instruction at the Art Students League by the urban realism of Henri and his followers signaled a generational change. But these changes signified much more. The rising generation had itself been changed by their exposure to the work exhibited at the *Armory Show,* the Greenwich Village rebellion, and World War I. In contrast with the overt male ambience of the Eight, the Art Students League, staffed with Henri's protegés, accepted women as professional artists. The equalization of instruction for women at the Art Students League was part of the postwar expansion of gender equality in American society. In the 1920s, New York women pioneered numerous changes in female conduct. Women's widespread adoption of cosmetics, unencumbering dresses, shorter hemlines, public dancing, and the use of cigarettes and alcohol were drawn, in part, from the prewar feminism of Greenwich Village, which championed female sexuality and autonomy. The ratification of the Nineteenth Amendment in 1920, extending the vote to women, and the proliferation of liberalized state divorce laws gave legal force to these changes. In the 1920s, for the first time, American colleges and universities enrolled nearly equal numbers of women and men, as about a quarter of the nation's college-age high school graduates attended a college or university.[61]

Gertrude Whitney and other women played important roles in opening the doors of New York art to women. Since the Civil War women had actively participated in New York art activities, particularly as patrons. Helen de Kay Gilder and Mariana Griswold Van Rensselaer had occupied central places in the New Movement, and in the 1890s, New York patrons proudly collected the work of expatriate painters Mary Cassatt and Cecilia Beaux and sculptor Harriet Hosmer. With the founding of the Art Students League in 1875, aspiring women artists gained access to the best professional education available in the United States and, at least formally, were not excluded from the city's art organizations and institutions. But in practice, despite their nominal presence and eligibility, prior to World War I few women were among New York's recognized painters and sculptors.

The glaring exceptions were sculptors Gertrude Whitney and Anna Hyatt Huntington. Whitney and Huntington used their inherited wealth to circumvent professional restrictions against female artists. Gertrude Stein, however, broke new ground by forming her own avant-garde salon and by assembling the first important collection of postimpressionist art. Following Stein's example, a number of other Ameri-

Impresario of New York Modern.
Peggy Bacon, *Juliana Force* (1934).
*Photograph ©1998 Whitney Museum of
American Art*

can women amassed significant collections of modern art, including Stein's close friends Clarabel and Etta Cone, Stieglitz's associate at 291, Agnes Ernst Meyer, Katherine Dreier of the Société Anonyme, Gertrude Whitney, and Abby Rockefeller and Lizzie Bliss, cofounders of the Museum of Modern Art. In 1913, Mabel Dodge, emulating Stein, organized an avant-garde salon in Greenwich Village. Because of their influence—even power—the wives and daughters of New York's wealthy patriarchs created professional opportunities for postwar women artists—none more so than Gertrude Whitney.

In 1922, on the death of its publisher and editor, Hamilton Field, Gertrude Whitney purchased the popular magazine *Arts*. On the recommendation of Juliana Force, Whitney appointed Forbes Watson editor. Watson recruited Guy Pène du Bois, Lloyd Goodrich, and Alan Burroughs as assistant editors and invited art collectors Ferdinand Howald and Abby Rockefeller, Harvard art historian Paul Sachs, and Whitney's sister, Dorothy Straight, to serve on the board with Whitney. In his first issue, Watson, reflecting Whitney's eclectic taste and disdain for dogma, assured readers that the *Arts* represented all schools, modern and traditional, European and American, and when possible, he included essays on music, drama, and literature, although the emphasis was on painting and sculpture.[62]

With Force's support and Whitney's money, Watson remade an undistinguished quasi-trade magazine into the foremost art magazine in the country. With circulation on the increase, Watson and the *Arts* seemed secure until late 1929, when Juliana Force, with whom Watson had been romantically involved, discovered that he was seeing another woman.[63] Watson soon received a letter from Whitney informing him that due to reverses in the stock market she could no longer afford to support the *Arts*. Watson, long the beneficiary of the Whitney-Force largesse, suddenly found himself forced to seek new funding for his magazine. He explained to

potential donors that "THE ARTS is an investment" and that, with their help, he would make "it pay for itself." But to no avail: in 1931, the *Arts* ceased publication. Without a job, Watson left New York, to accept a government position in Washington.[64]

Bored with the Whitney Studio Club, on September 7, 1929, Whitney suddenly announced its closing and its replacement, at the same address, by the Whitney Studio Galleries, a commercial gallery that would sponsor individual and group shows, charging artists a 25 percent gallery commission on all sales.[65] Following the death of her husband, Harry, in 1930, Whitney withdrew further and consolidated her wealth. Long interested in advancing American art, she offered the Metropolitan Museum her collection of twentieth-century American art. But Edward Robinson, the director of the Metropolitan, declined, explaining to Whitney his disinterest in American art: "What will we do with them my dear? We have a cellar full of those things already."[66] Whitney stormed out of Robinson's office and, to the delight of Juliana Force, announced the formation of the Whitney Museum of American Art, which became the institutional cornerstone of American painting and sculpture for the next two decades.[67]

## MARKETING MODERN ART

Prior to World War I, modern artists only marginally benefited from New York's preeminence as an international art market. Most of the city's art galleries along fashionable 57th Street, just below Central Park, specialized in either European old masters, French impressionists, or archeological artifacts. Moreover, much of the city's avant-garde, clustered in Greenwich Village, gloried in their hand-to-mouth existence, expressing contempt for material wealth. Many, like John Sloan, Robert Henri, and Art Young, affirmed a craft guild ethos. They viewed themselves as skilled artisans who had learned their craft from the masters and who expected to receive not wealth but a fair and honest price for their labors. Unlike medieval guild members, however, their artistic livelihoods depended on an unregulated, unrestricted marketplace composed of a dozen New York newspaper and magazine critics, a score of private galleries, periodic public auctions, independent exhibitions, a hundred or so private buyers, and about a dozen independently owned art schools. Living in a society that judged success by income, even avant-garde artists craved the recognition that high prices validated.

In the 1920s, New York's avant-garde found it difficult to resist equating financial success with artistic accomplishment. In a familiar complaint, Charles Demuth wrote to Alfred Stieglitz, "I wish that some 'movie star' or whatever, would make the art of the U.S. fashionable. Appreciation is too much to hope for—but at times I think we may see it become fashionable in our time. That would help—as you know—would in one way be appreciation."[68] Much to the surprise of Demuth and others, in the 1920s an increasing number of Americans came to appreciate modern art and paid high prices for the best American work, especially modern work that expressed explicitly American images and themes.[69]

The success of modern art in the 1920s had two results: the acceptance of European postimpressionism and modernism, largely Parisian, as legitimate art and a

willingness to take American art seriously. Prices for American paintings set records in the decade. A work by Albert Thayer brought forty thousand dollars, Winslow Homer's *Eight Bells* commanded fifty thousand dollars, and the owner of George Inness's *Spirit of Autumn* received sixty thousand dollars. Albert Pinkham Ryder's paintings were in demand, and Thomas Eakins' widow sold his work piece by piece for increasingly higher prices. European postimpressionists commanded equally high prices. At the 1922 Dikran Kelekian sale Lizzie Bliss purchased Cézanne's *Still Life* for twenty-one thousand dollars, and the entire auction of European and American moderns netted a total of $254,000, an unprecedented sum for an auction of modern art. Private galleries enjoyed similar success. Stieglitz priced individual paintings by Charles Demuth, John Marin, Marsden Hartley, Charles Sheeler, and Georgia O'Keeffe between fifteen hundred and five thousand dollars; and George Bellows, Walt Kuhn, Joseph Stella, Guy Pène du Bois, and Edward Hopper supported themselves almost exclusively through their paintings, abandoning teaching and commercial art altogether.[70]

Predictably, these changes occurred outside established art institutions. Led by the Metropolitan Museum of Art, the nation's prestigious art museums largely ignored modern and American art. Under the direction of Edward Robinson, New York's Metropolitan Museum steadfastly obstructed the recognition of modern and American art, despite the best efforts of its curator of painting, Bryson Burroughs. Hired by Roger Fry in 1906, Burroughs, a native of Cincinnati, had studied at the Art Students League, the Ecole des Beaux-Arts, and the Académie Julian. In 1905 he gained momentary notoriety when Anthony Comstock demanded, on grounds of decency, that a private gallery remove one of Burroughs' paintings from public display. With Fry's departure in 1910, Burroughs, a thin, scholarly, but tenacious man, stood virtually alone at the Metropolitan Museum as advocate of modern and American art. His purchase of Cézanne's *La Colline des Pauvres* from the *Armory Show* opened the Metropolitan's door, however narrowly, to postimpressionist work. Burroughs also used the Hearn endowment to present retrospectives of major American painters, including the work of Thomas Eakins, Albert Pinkham Ryder, and Winslow Homer.[71] On the whole, however, during the 1920s American art museums, while otherwise enriching their collections, remained, in one critic's words, "morgues for masterpieces."[72]

As a consequence, New York visual artists relied almost exclusively on private patrons and galleries. But here, they were unusually blessed. In 1925, Alfred Stieglitz returned to the gallery business, exhibiting his favored artists' work in a room provided by the Anderson Galleries, which he called the Intimate Gallery. In 1929 he renamed it An American Place. Katherine Dreier, under the auspices of the Société Anonyme, sponsored a number of European modernist exhibitions during the decade, culminating in the *International Exhibition of Modern Art* held at the Brooklyn Museum in the winter of 1926–27. Throughout the 1920s, Chicago art collector Jerome Eddy purchased modern paintings from New York dealers, as did Pennsylvania collector Albert C. Barnes and Columbus, Ohio, collector Ferdinand Howald. Duncan Phillips, A. E. Gallatin, Lizzie Bliss, and Abby Rockefeller each amassed important collections of European and American moderns, much of which they pur-

chased through New York dealers. The most active galleries included the Daniel Gallery, Marius de Zayas's Modern Gallery, Carl Zigrosser's Weyhe Gallery, and the Anderson Galleries. In the 1920s, a score of New York galleries sold modern American and European work.[73]

New York's two most important buyers of modern art, Alfred Stieglitz and John Quinn, however, saw themselves more as patrons than as buyers. They purchased art to benefit artists, not to earn profits. Both appreciated artists' need for recognition and income, but neither conceived of their own buying and selling of art as a commercial enterprise. Stieglitz, exhausted and with diminished financial resources, had withdrawn from his gallery activities in 1917, following the closure of 291. For the next eight years Stieglitz devoted himself to his own photography and to furthering the career of Georgia O'Keeffe.[74]

Yet, as patron and gallery owner, Stieglitz masterfully practiced the business of art, unstintingly promoting the work of his chosen artists—O'Keeffe, Marin, Hartley, Dove, Demuth, and Strand—through shows, published essays, and correspondence.[75] To clinch a possible sale, Stieglitz lent, unsolicited, two Marin seascapes to *New York Sun* art critic Henry McBride. Stieglitz filled his letters to McBride with details of the latest sales success. His efforts paid off, especially for Marin and O'Keeffe. In April 1928, Stieglitz boasted to McBride that he had sold six O'Keeffe paintings for a total of twenty-five thousand dollars. Later the same year, he gleefully informed McBride that Marin had received a "record price," exclaiming, "The Gods are satisfied and I can die in peace." Two weeks later, Stieglitz again wrote McBride, "[Duncan] Phillips offered *considerably more* than his 'record' price for a Marin for the *Blue Mountain*. But . . . he was too late."[76] Stieglitz's relentless sales tactics and his refusal to sell good paintings for low prices forced art buyers to pay generously for the best contemporary American work, ending the practice of what Stieglitz called the treatment of American art as "marked down bargain day remnants of Europe."[77]

Stieglitz worked privately, out of the public glare, and his efforts received little public notice. John Quinn, too, preferred to remain behind the scenes, quietly buying a painting here and there, lending work to exhibitions, and showing a sculpture to an interested friend but never publicly displaying his collection. Such privacy ended with Quinn's death in 1924, when his estate dispersed his collection through public auctions and private sales. The sales list indicates that Quinn had accumulated the largest and most important collection of modern art in the United States—more than twenty-five hundred paintings, drawings, etchings, and sculptures, including fifty works by Picasso, Seurat's *La Grande Jatte*, Brancusi sculptures, Matisse's *Blue Nude*, Rousseau's *Sleeping Gypsy*, and other works by the School of Paris, along with a substantial collection of modern American work by Prendergast, Kuhn, Davies, Sloan, Marin, Stella, Sheeler, Weber, and Hartley. The Quinn estate realized nearly six hundred thousand dollars from the sales—to the New York art world, an astronomical sum for modern art. The New York auction alone netted more than any previous auction of modern art. To doubters, the dispersal of the Quinn collection confirmed the monetary worth of modern art.[78]

In truth, most works in the collection secured quite modest prices, some at or be-

low what Quinn had originally paid. Within the next twenty years, a few individual
works commanded more than the Quinn estate received for the entire collection.
The modest prices were consistent with Quinn's role as art patron. A New York sec-
ond generation Irish American and a corporate attorney, Quinn started collecting art
around 1900. Sloan and Henri had introduced Quinn to Greenwich Village radicals.
Beginning with the *Armory Show,* Quinn moved to the center of New York avant-
garde art. He lent the *Armory Show* eighty of his own artworks, donated money, and

purchased nearly six thousand dollars worth of paintings. Quinn regularly gave money to the *Masses,* helped with the Madison Square Garden Paterson silk workers' pageant, participated in the *Forum* and the Society of Independent Artists exhibitions, and in the 1920s subsidized both Margaret Anderson's *Little Review* and Ford Maddox Ford's *transatlantic review,* all the while building his collection of modern art, under the guidance of Walt Kuhn and Walter Pach. Quinn's death, at the age of fifty-four, came as a shock to the New York art world and a blow to the city's avant-garde.[79]

Quinn valued his collection, but he cared more about its artistic merit than its monetary worth.[80] And like other advocates of the avant-garde, John Quinn viewed art academies, with their assertion of official standards of art, as the enemies of artistic creativity. To Quinn, art academies functioned like medieval trade monopolies, extending to a select few unmerited privileges that stifled trade and discouraged innovation. Drawing on his experience as a Wall Street attorney, Quinn believed that private patrons, by providing artists an alternative to official or institutionalized patronage, fostered artistic honesty and creativity.

Both Stieglitz and Quinn understood artists' need to sell their work to support themselves and to validate their worth. But because both also viewed art as a spiritually redeeming force in a materialistic society, they avoided haggling with artists over prices. Artists were never simply producers of valuable objects, and art was not just a rare commodity to be bought and sold like carriage-trade merchandise. In that sense, they shared the fine-art sensibilities of the nineteenth century more than the consumer-driven ethos of the Jazz Age. Edith Halpert, however, viewed art and patronage quite differently and applied modern marketing techniques to modern art.

In November 1926, Halpert announced the opening of her Downtown Gallery on West 13th Street, promising to market the work of Village artists much as she had earlier sold stocks and bonds for S. W. Straus. With the arrival of the Downtown Gallery, Halpert introduced Greenwich Village to Madison Avenue, initiating the modern gallery system. Halpert had four stated ambitions—to secure recognition for avant-garde Village artists, to increase their income through sales, to become an important figure in avant-garde art circles, and to make money. In 1940, when Halpert moved her gallery uptown to East 51st Street, her Downtown regulars were the best-known and highest-paid painters and sculptors in the country. She served as the exclusive representative for Edward Hopper, Stuart Davis, John Sloan, Marguerite and William Zorach, Kenneth Hayes Miller, Max Weber, Charles Sheeler, and Joseph Stella.[81]

In 1925, Halpert took a year's leave of absence from S. W. Straus to join her husband, the painter Samuel Halpert, in Paris. On her return, she opened the Downtown Gallery, the first commercial art gallery in Greenwich Village, in a remodeled brownstone at 113 West 13th Street. Halpert aggressively recruited artists, promising them a generous two-thirds of the proceeds from sales of their work in return for exclusive control over sales. In several instances, she paid artists modest monthly allowances, which she subtracted from subsequent sales. The Downtown Gallery exhibited only American work, imposed no charges on artists, acquired no art for speculative profits, and served as the artists' agent on a commission basis.[82]

Halpert energetically pursued buyers. In her first catalog, she offered customers "extended payments" and even "moderate monthly rentals." Halpert quickly earned a reputation for aggressive merchandizing but also for hard bargaining. The sculptor William Zorach recalled, "She has a soft spot in her makeup, and she never says die. . . . No matter how many fights and misunderstandings she has with artists and people she is never through. She always comes back. But she will never reduce her commission, although she admits she makes much more than she knows what to do with. So she starts a foundation. She gives some of this money to finance scholarships and to buy works of needy, young unknown artists and gives them to museums. That's a very laudable and fine attitude—that part of it."[83]

In its first four years the Downtown Gallery sponsored more than forty individual and group shows. Halpert's most publicized effort, the *Exhibition of Modern Painting and Sculpture* at Wanamaker's Department Store in the fall of 1927, included the work of Robert Laurent, Stuart Davis, Arthur Davies, Joseph Stella, Marguerite and William Zorach, and Abraham Walkowitz. In response to a reporter's query, Halpert described modern art as fashionable decor. "It may be said with truth that the modern department store, among its many functions, should be a museum of the present, a place where the best examples of contemporary art and craftsmanship may be seen. . . . We believe that the patrons of the Wanamaker Galleries will study the works of this exhibition with interest, that they will enjoy them, and that they will find them delightful additions to the furnishing and decoration of their home."[84] While William Zorach and other Downtown artists complained that Halpert was mercenary, her tactics sold art. Halpert's methods, however, raised apprehensions that commercial galleries, concerned primarily with profits, would make modern art just another commercial commodity, rather than, as Stieglitz and Quinn hoped, a means to redeem American life from its obsessive materialism.

## BUT IS IT ABSTRACT?

Halpert's success in marketing American art paralleled a revived interest in the 1920s in American themes. But the use of explicitly American themes opened New York writers and artists to criticism that their work was provincial. As some had argued following the *Armory Show,* to be truly modern American art must be abstract and universal. Identifiably American work was provincial and retrograde and thus, by definition, not modern. Bolstered by Duchamp and their own growing confidence, postwar New York artists rejected this European modernist judgment. Sculptor William Zorach and painters Edward Hopper and Stuart Davis went well beyond the mimetic realism of Robert Henri and the Eight. Without imitating European modernism, they resolved the seeming dilemma between abstraction and representation by using both.[85]

American sculptors, like American painters, found themselves threatened by European modernism. With his distorted bronze figures, Auguste Rodin had rebelled against Beaux-Arts sculpture much as French impressionism had overturned historicist painting. To escape Rodin's powerful influence, modernists Constantin Brancusi and Jacques Lipchitz rejected naturalism altogether, confronting Ameri-

can sculptors with the dilemma of how to be both modern and American. Traditional sculptors, such as Daniel Chester French and Gertrude Whitney, simply ignored the issue, continuing to sculpt according to beaux arts academicism. Anna Hyatt Huntington, influenced by art nouveau, chose to cast playful stylized bronze animals and mythological pagan figures, while Jo Davidson, Maurice Sterne, Gaston Lachaise, and Mahonri Young created Rodinlike contemporary portraits and figures.[86]

William Zorach took another tack. Trained as a cubist painter, after World War I Zorach turned away from painting when he realized that he could not express himself effectively in such an abstract, two-dimensional medium. Zorach found that by carving directly on material that "retained its volume" he could better translate his feelings into art. Moreover, natural materials—stone, wood, and metal—forced him to "collaborate" with nature. In 1921, Zorach published an essay in the *Arts* explaining and defending modern art, but in doing so he justified his shift from abstract painting to a more natural, representational sculpture. "To the modern artist," wrote Zorach, "nature is material with which to work, not an effect to be transferred to canvas. . . . Within nature and within man lie infinite possibilities for the development of vision and aesthetic enjoyment. . . . In collaboration with nature man develops his vision. Nature alone cannot produce art. Nor can man produce art without nature."[87]

Modern art meant much more to William Zorach than simply a style of art. It also meant a way of life radically at odds with the world in which he had grown up. Zorach's parents had emigrated to the United States in the 1890s as Orthodox Russian Jews fleeing a pogrom. Zorach quit school in the third grade to work for a lithographic company. He enjoyed commercial art, but after taking night classes at the Cleveland School of Art, he decided that he wanted to be a painter and left for New York, where he secured employment as a lithographer while attending evening classes at the National Academy of Design and the Art Students League. In 1910, Zorach left for Paris, where he met Marguerite Thompson. "I was completely disturbed and upset by the whole atmosphere of Paris," recounted William Zorach, "because I felt that being a young man and entering a new world, this was more of an expression of our age and more alive than what I was doing in America."[88]

When Zorach returned to New York in 1911, he was surprised by what he found. "Everything was new, very active, and very progressive, and up-and-coming looking."[89] Unhappy with his painting, after 1914 Zorach experimented with wood carving, apparently influenced by Marius de Zayas's exhibition on African art at 291 as well as by nineteenth-century New England ship carvings. Zorach regularly visited the Aztec, Mayan, and Inuit collections at the Museum of Natural History in New York. "There I felt more akin to the Ice Age, so to speak, to the early ages, than I did to our civilization of today."[90] Encouraged by sculptor Gaston Lachaise, Zorach executed a number of figures, largely of his family, carved from natural materials chosen for their aesthetic appeal—granite, glacial stone, marble, and mahogany. Most, however, he chiseled out of marble or other stone that allowed him to create a smooth, polished, almost classical surface. His most characteristic images were of reclining female nudes, several dozen in all.

Zorach also carved several figures of his children and their pets. His *Child with*

*Cat,* completed in 1926 and carved from black Tennessee marble, consists of the upper torso and head of a young girl clutching a cat to her breast, looking intently ahead. Although Zorach's daughter and cat served as the models, the subject could be any adolescent girl and her pet, from the stone age to the present. In nearly all of these pieces, the figures exhibit stocky bodies and short limbs, resembling Inuit statuary. All of Zorach's sculptures were representational, but they were also abstract, three-dimensional distillations of natural objects, not naturalistic constructions.[91]

Lacking formal training as a sculptor, Zorach adopted direct carving, which broke with the methods of traditional sculpture by requiring carvers to involve themselves intimately in the entire sculpting process. Working from rough sketches or simply intuition, direct carvers shaped and altered their images as they worked, as the material allowed them, and as unforeseen opportunities presented themselves—a process that required both composition and improvisation. Taking advantage of the openness that Greenwich Village artists enjoyed after 1913, he and Marguerite balanced the tensions of modern life in their personal lives and in their art. He fashioned his modern sculpture utilizing a traditional artisan craft; she created a modern fine art out of a traditional domestic craft.[92]

In the 1920s, Edward Hopper—like Zorach, a modern artist to the core—painted narrative representations. Hopper, too, had begun as a commercial artist and had studied and worked in New York and Paris. In his compositions of New York, Hopper created riveting images of modern urban life. Unlike Zorach, however, the tall, taciturn, and partially bald Hopper kept to himself, shielding his private life. He granted few interviews, did not write an autobiography, and left almost no personal papers. As a consequence, Hopper's paintings are his most revealing documents—precisely how he had wanted it.[93]

Edward Hopper grew up in Nyack, on the Hudson, just north of New York City. On graduation from high school, he enrolled at a commercial art school in New York. Later, at the New York School of Art, he studied painting with William Merritt Chase, Kenneth Hayes Miller, and Robert Henri. Characteristically, Hopper went his own way, taking no part in the fraternity-like antics of Henri's other students. Hopper supported himself as a magazine illustrator and by teaching. He saved his money so that he could regularly travel to Paris to visit the art museums, tour, and paint. Unimpressed by modernism, Hopper's early work resembled that of the impressionists. In New York, he exhibited with other Henri students at the 1910 *Exhibition of Independent Artists* and at the MacDowell Club. Hopper showed one oil at the *Armory Show* that sold for $250. The same year, he moved to a third floor apartment at 3 Washington Square North, where he lived for the remainder of his life.[94]

Summering in Provincetown and Gloucester, Hopper, a close friend of Guy Pène du Bois, hovered on the periphery of Greenwich Village's boisterous life. Taking advantage of the twenty-cent modeling sessions, he affiliated with the Whitney Studio Club. By the early 1920s, Hopper's summer seascapes of Cape Cod and his bright but stark scenes of New York had started to sell. Taking advantage of his financial independence, Hopper gave up commercial art in 1924 and, at the age of forty-two, married Jo Nivison, a longtime friend and fellow Village artist, ending his foray into Village bohemianism. Shortly after his marriage, Hopper ceased attending the Whit-

ney sketch class because Jo refused to allow him to use female models other than herself.[95]

The Hoppers remained fixtures, if not active participants, in the Greenwich Village art community. By the end of the decade Hopper had established himself as a major American painter, one of the few capable of supporting himself entirely on his art. Success, however, did not alter the Hoppers' life. Childless, they lived frugally in their spare Washington Square apartment. Every winter day until his death in 1967, Hopper dutifully hauled a bucket of coal up the three flights of stairs to keep their coal stove burning.[96]

More than any other painter, Edward Hopper created an enduring image of the modern American city. With painstaking detachment Hopper observed the still moments of individual existence, catching people in reflection, even resignation. Unmoved by political reformers or the millennial claims of avant-gardists, Hopper accepted the city as a fact of existence, to be neither idealized nor transformed. After 1924, though financially able to live anywhere they wished, he and Jo remained in New York, attending the theater and concerts, walking Manhattan's streets and avenues, strolling Central Park, eating at neighborhood restaurants, coming and going each summer. Hopper discovered visual images, much as writers search for exciting stories, in a variety of places—a set from Elmer Rice's play *Street Scene,* an Honoré Daumier lithograph at the Metropolitan Museum, a near-empty theater as patrons wait for the curtain to go up, or a glimpse of a train tunnel on entering the city. Each Hopper painting not only immortalized a moment, it also altered viewers' perception, becoming, for many, their image of modern city life.[97]

Hopper's images captivated because of their selectivity. A quiet watcher, Hopper portrayed static things—railroad tracks, hotels, storefronts, houses, tunnels, gas stations—that contained remarkably few people, and those, nearly always, solitary individuals. His work was markedly different from Reginald Marsh's jostling crowds at Coney Island, Sloan's and Miller's intimate groups, or Stella's kaleidoscopes of sound and light. Yet, Hopper's Greenwich Village abounded with conviviality and frivolity, much of it involving his personal and professional friends. In his paintings Hopper ignored this aspect of New York and, instead, captured the city in its quiet moments and places of repose as individuals paused, caught their breaths, anticipated an imminent event, or simply reflected on themselves and their circumstances. He caught people waiting and the places where they lived and rested. Hopper's women lurk on the edge of sexual activity, anticipate a liaison, calculate an affair, or, as in *Girly Show,* strut their stuff, alone on the stage, reminding viewers of the solitude, if not the isolation, of their lives, the frenetic intensity of the city notwithstanding.

The overall theme of Hopper's work, however, was modernity. Hopper loved to paint old buildings, but always as weathered, desiccated structures separated from the viewer by an unbridgeable modern barrier, such as the railroad track in his painting *House by the Railroad.* Except for some of his almost purely abstract seascapes, Hopper delineated virtually all his landscapes and cityscapes with a railroad track, a telephone line, a paved roadway, or a steel bridge. The archaic architectural features, which first attract the viewer's attention, on further examination turn out to

be anachronistic remnants of an earlier time, an experience distant and inaccessible from Hopper's own modern, technologically driven present. The paintings themselves, usually done in earth tones, are simple, if powerful, compositions, surprisingly flat in perspective and largely free of detail. Their realism is not a consequence of photographic naturalism but derives from their capacity to stir psychological memories through color, shape, composition, and ambience. Powerfully representational, the appeal of Hopper's paintings lies in their modernity, their human scale, and his evocative use of color and abstraction.

Stuart Davis, the artistic and personal antithesis of Hopper, created equally powerful, fully American abstract and modernist paintings. A student of Robert Henri and a close personal friend of John Sloan, Davis came to New York in 1909 from Newark, New Jersey, where his father served as the art editor for the *Newark Evening News*. Through his father, Davis became an intimate of Henri's circle, exhibiting at the 1910 *Exhibition of Independent Artists*. In 1913 he joined Sloan at the *Masses*. According to Davis, Henri taught his students "to avoid mere factual statement and find ways to get down some of the qualities of memory and imagination involved in the perception of it. We were encouraged to make sketches of everyday life in the streets, the theater, the restaurant and everywhere else."[98] Accomplished in the sketchlike urban realism that Henri had taught, the modernist works at the *Armory Show* overwhelmed Davis. "It gave me the same kind of excitement I got from the numerical precision of the Negro piano players in the Negro saloons."[99]

Davis studied the work of Matisse, Picasso, and Gauguin, trying to adapt their ideas to his own painting. In the two summers after the *Armory Show,* he worked with Demuth in Provincetown, learning to flatten his perspectives, to brighten his palate of colors, and to paint bolder, simplified shapes free of detail. By 1920, Davis considered himself an American cubist. William Carlos Williams, struck by the correspondence between Davis's use of apparently unrelated images in a single composition and his own "simultaneous improvisations," used one of Davis's drawings for the cover of a collection of poetry, *Kora in Hell.* In his easel paintings of the 1920s, Davis employed images derived from commonplace events and the marketplace. He, however, transformed, rather than replicated, characteristically American objects—cigarette packages, kitchen utensils, and light bulbs, "painted constructions"—inspired by the graphics used by New York advertising agencies in the 1920s and in a manner reminiscent of the cubist-dadaist assemblies of Picabia and Duchamp.[100]

Juliana Force, recognizing the significance of Davis's work, gave him his first individual show in 1926. To encourage Davis's experimentation, Force also offered him $125 a month to work on his pathbreaking *Eggbeater* series. Davis, explaining his understanding of the relationship between realism and abstraction, said:

In the first place, my purpose is to make realistic pictures. I insist on this definition in spite of the fact that the type of work I am now doing is generally spoken of as ABSTRACTION. The distinction is important because it may lead people to realize that they should look at what is there instead of hunting for symbolic suggestions. A picture is always a three-dimensional illusion regardless of subject matter; i.e., the most illustrative type of painting, and the so-called modern abstraction, are identical—in that they both represent an illusion of the three-

dimensional space of our experience. They differ in *subject* which means they choose a different character of space to represent. People must realize that in looking at Abstractions, they are looking at pictures as objective and realistic in intent as those commonly accepted as such. . . . It is my belief that this type of work has greater aesthetic utility than any other type.[101]

Force recognized, besides the importance of his work, Davis's need to work firsthand with European modernists. She offered Davis nine hundred dollars for three paintings, including *Eggbeater # 1,* on the condition that he use the money to spend a year in Paris. Davis, who had never traveled outside the United States before, leaped at Force's offer. The next month he was in France.[102]

Paris confirmed Davis's commitment to cubism. As had other American artists, he fell in love with the city, whose nineteenth-century beaux arts buildings, broad avenues, relaxed pace, and café life contrasted with the intensity and newness of New York. Davis dutifully called on Gertrude Stein and fraternized with American expatriates Man Ray, Berenice Abbott, and Alexander Calder. After a year, Davis reluctantly returned to New York, where he appreciated anew the city's importance to his art—the "giantism" of this "frenetic commercial engine."[103] In a later interview with Henry McBride, Davis insisted that his visit enabled him "to spike the disheartening rumor that there were hundreds of talented young modern artists in Paris who completely out classed their American equivalents. . . . It proved to me that one might go on working in New York without laboring under an impossible artistic handicap. It allowed me to observe the enormous vitality of the American atmosphere as compared to Europe and made me regard the necessity of working in New York as a positive advantage."[104]

As the foremost American cubist, Davis's infatuation with Paris and European modernism, coupled with his enthusiastic return to New York, exemplified the change that had taken place in American painters after the war. Paris remained the "city of lights," but as an American, Davis "needed the personal dynamics of New York City."[105] Paris supplied a valuable respite, much like Provincetown and Santa Fe, but for Davis, New York was the center of the modern world. He also realized that despite his affinity to cubism and dadaist collages, he remained an American artist. "Art is not a matter of rules and techniques, or the search for an absolute ideal of beauty," he explained. "It was the expression of ideas and emotions about life of the time." He believed that his painted constructions, which depicted familiar objects in unfamiliar shapes and relationships, were appropriate expressions for a modern society, in harmony with the scientific and technological bases of contemporary life that altered familiar phenomena into unforeseen things. In the modern world, objects were never what they seemed. Nonetheless, Davis created his confusing compositions from familiar and identifiably modern, commercial, and American objects—matchbooks, eggbeaters, and gas stations.

Like so many other Jazz Age New York artists, Davis drew his abstract images from recognizably New York objects and places. His conscious melding of modern, American, and New York into unified images was unmistakable in his *Abstract Vision of New York,* which he submitted to the Museum of Modern Art's exhibition, *Murals by American Painters and Photographers.* In the winter of 1931–32, Lincoln Kirstein,

then a curator for the recently organized Museum of Modern Art, became incensed on discovering that the murals planned for Radio City Music Hall at Rockefeller Center would all be painted by foreign artists. When he questioned the decision, Kirstein was told curtly that there were no American muralists of consequence. Seemingly to no avail, Kirstein cited Stella's *Brooklyn Bridge,* Thomas Hart Benton's newly completed American scene mural at the New School for Social Research, and Boardman Robinson's murals for the Kaufman Department Store in Pittsburgh. Doggedly he persisted, convincing Alfred Barr, director of the Museum of Modern Art, itself a Rockefeller edifice, to sponsor an American mural contest to prove the Rockefellers wrong. In February, Kirstein announced the show, the first exhibit in the museum's new quarters on West 53d Street near Rockefeller Center.[106]

Kirstein invited about forty painters and a dozen photographers to submit designs. The painters included Stuart Davis, William Gropper, Glenn Coleman, Georgia O'Keeffe, Ben Shahn, and George Biddle, the photographers Edward Steichen and Berenice Abbott. (Apparently out of spite, Kirstein ignored Abby Rockefeller's request to invite Marguerite and William Zorach.) The rules were simple. Kirstein asked the invited artists to submit three small sketches, each about 16″ × 24″, on any "postwar subject." Additionally, they were to construct a fourth, mural-size painting or photomural, 4′ × 7′. The Museum of Modern Art agreed to pay for the cost of materials and transportation. Davis submitted a bill for $28.99.[107]

When the show opened in May, it received what, in retrospect, seemed unfair reviews. Nearly a third of the submissions were fully as good as those ultimately painted on the walls of Radio City. Of particular interest were Ben Shahn's *The Passion of Sacco and Vanzetti,* Berenice Abbott's photomural, *New York,* Edward Steichen's *George Washington Bridge,* Charles Sheeler's *Industry,* Glenn Coleman's *Manhattan: Old and New,* and Georgia O'Keeffe's *Manhattan.* Davis's brightly colored *Abstract Vision of New York,* however, stood apart.[108] On a blackened canvas, Davis painted a score of flattened but vibrant images arranged in a collage across a stylized Manhattan skyline. The images included Governor Al Smith's derby, the Empire State Building, a gas pump, a crescent moon, bow ties, a kite's tail, New York mayor Jimmy Walker's empty champagne glass, and a tiger's head, symbolizing Tammany Hall. Davis's iconography of New York drew on Mexican murals, dadaist construction, social realism, cubism, and New York. In *Abstract Vision of New York,* Davis fused urban realism and European modernism with vernacular New York.[109]

The mural show had an unexpected influence on Davis's painting. Prior to *Abstract Vision,* Davis's largest canvases were 3′ × 4′, a standard large easel painting. *Abstract Vision of New York,* at 4′ × 7′, was twice as large. Shortly afterward, Davis completed a second mural-size easel painting, *Men without Women,* a gigantic, 11′ × 17′ canvas—nearly two hundred square feet. Unintentionally, Kirstein's mural show had conflated mural painting with easel painting. In the 1930s, the Works Progress Administration commissioned hundreds of murals throughout the country, many painted on movable canvas, such as Davis's *Men without Women* and Thomas Hart Benton's New School murals. While Davis's images changed during the 1930s, becoming less abstract, he did not return to the smaller format of traditional easel painting. After 1930, Davis rarely painted a picture smaller than 3′ × 4′.

After World War II, when Jackson Pollock and other New York abstract expressionists adopted mural-size painting, they were following the lead of Benton, Davis, and the WPA.

Taken as a whole, Kirstein's *Murals by American Painters and Photographers* exhibition represented a retrospective of New York Modern. Free to choose any postwar topic, 90 percent of the forty-two exhibitors chose explicitly modern images—technology, leisure, justice, sports, and science. Revealingly, 75 percent of these modern images were of New York—its towering buildings, its heterogeneous population, its regimented work, its busy port, its corrupt politicians, its enormous wealth, its contentious radicals, its familiar landmarks, but most importantly, its inherent modernity. Some, such as Shahn, adopted the style of social realism; Mexican muralists influenced others; O'Keeffe and Sheeler worked in a hard-edged, precisionist mode; Reginald Marsh painted as an urban realist; and Henry Billings and Stuart Davis created cubist-inspired collages. Cosmopolitan, socially aware, contemporary, and urban, New York's would-be muralists all composed representationally even as they created highly abstract, conceptualized art. Abstract and realist, modern and American, New York Modern expressed the vitality and variety of the city. New York shaped the artists who created the art that, in the 1930s, constituted the American scene. In the Jazz Age, New York artists found their voices.

In the decade of the 1920s, painting and sculpture thrived in the United States. Sixty additional art museums were organized, and numerous older museums, including the Philadelphia Museum of Art, the Newark Museum, and the Detroit Institute of Art, built new, spacious quarters. One estimate places Americans' expenditure on fine art during the 1920s at nearly a billion dollars. While most of this activity was in behalf of traditional European art, a shift to American and modern art was evident in the Metropolitan Museum's construction of its American Wing in 1924, the founding of the Museum of Modern Art in 1929, and the formation of the Whitney Museum of American Art in 1930. In the pages of the *Dial*, Scofield Thayer promoted an American modern that paralleled Van Wyck Brooks's discovery of American literature and Lewis Mumford's efforts in behalf of an American architecture.

New York painters and sculptors participated and benefited from these activities, which were, in part, a reaction to a disillusionment with Europe following World War I and with American postwar prosperity. New York proponents of modern art, however, resisted the wholesale adoption of modernism. Even the most radical moderns consistently based their abstract art on details and experiences drawn from American life. To do otherwise, they argued, would divorce their work from its cultural roots, creating a spiritually empty art that lacked aesthetic and social meaning. In Americanizing their work, New York painters rejected the temptation to create an esoteric art, divorced from shared experience and understandable only to a cult of aesthetic initiates. Even radical innovators, such as William Carlos Williams and Stuart Davis, argued that their apparently incoherent work offered a new language that, in time, everyone would comprehend. Williams explained, "But the obscurity that lies in the thought is permanent, it cannot be written out. We all for humanity's sake wish for a universal language. In *Finnegans Wake* Joyce practiced it. Is that so

impossible to comprehend?"[110] Similarly, Stuart Davis wrote, "In short, what I want to say is that the type of pictures I am making is not designed to confuse art connoisseurs, nor befuddle laymen. . . . On the contrary . . . it is painted with particular adaptability to the offices and houses they live in."[111]

New York's avant-garde moderns maintained the vision and the values of the Greenwich Village rebellion. Their uncompromisingly modern work affirmed their desire to communicate to a broad public, much as Walt Whitman had directed his poetry to the people at large. Acknowledging the influence of Nietzsche, Freud, Croce, and Marx, when asked to identify the sources of their modernity New York's Jazz Age painters and sculptors, almost to a person, answered Whitman and New York. Such an urban, democratic vista in part explains why the most radical forms of European modernism had little impact on New York artists in the 1920s.

New York's postwar moderns avoided what they considered the dogmatic cynicism of German and eastern European expressionists. Increasingly, Parisian cubism appeared dated and old fashioned. Surrealism presupposed an alienated irrationalism that few New York artists shared, whereas the reactionary aestheticism of T. S. Eliot and Ezra Pound, grounded in bigotry and the radical despair of their expatriatism, seemed a repudiation of America itself. In contrast, New York moderns accepted the city and democratic society as necessary, even desirable, conditions of modern life. Not surprisingly, in modernizing and Americanizing their work, they did so as New Yorkers. Manhattan's street grids, its skyscrapers, its diverse and dynamic population, its technology, its architectural landmarks, its entrepreneurial capitalism, and its new women became familiar reference points in the modern American mosaics created by New York modern artists.

During the Jazz Age, in New York, both American and modern art came of age. In the 1930s, in the face of unprecedented economic and political calamity, New York Modern was transformed into a national art under the auspices of the Whitney Museum and the New Deal and proved a resilient and powerful force in behalf of an inclusive, urban, and democratic society. But as Charles Gilpin, Bessie Smith, and Duke Ellington well understood, the visual images of the modern, which the Whitney artists created, were, like the artists themselves, almost exclusively white. Although distinct, this Jazz Age version of New York Modern represented American life in narrowly racial terms. Once New York artists absorbed and understood the thrust of African American writing and art, their work became even more American and modern. Tellingly, the Times Square entertainment industry, once again, served as a conduit for African American music into New York art, the very source of the Jazz Age.

# Rhapsody in Black
## New York Modern in Harlem

I am interested in Negro poets and Jazz pianists," Carl Van Vechten wrote to Gertrude Stein in 1924. "There's always something in New York, and this winter it is decidedly Negro poets and Jazz pianists."[1] Van Vechten, a New York dance critic and bon vivant of the avant-garde, sorely underestimated the significance of his encounter with "Negro poets and Jazz pianists." Far more than a winter's "something," Harlem's jazz musicians were fomenting a musical revolution. Crowded into a racial ghetto just north of fashionable Central Park, they created a vital music, accessible to black and white audiences alike. Distinctly American, Harlem jazz set the tone and rhythm for much of twentieth-century urban life.

In the 1920s, on phonograph records and on the radio, in Harlem and Times Square nightclubs, white New Yorkers first heard jazz. Prior to World War I, in New Orleans, African American musicians had originated a radically modern music. Jazz musicians first saw themselves as entertainers, composing and playing a fast-paced dance music for popular audiences. After World War I, in Harlem, ragtime musicians altered New Orleans jazz, adapting it to an orchestra format and making it musically accessible to white audiences. Duke Ellington went further still. In hundreds of original compositions, Ellington created jazz that was as much art as entertainment.

In the 1920s, Harlem's Big Band sound replaced ragtime as the dominant American popular music. In the process, jazz musicians altered the rhythm and sound of American culture, making it explicitly urban and non-European. The New York avant-garde's discovery of jazz in Harlem nightclubs ended their dependence on European culture. After the jazz revolution, New York modern art became American, not just in images and tone but in its very spirit. Jazz did not simply provide New York artists a means to create an American art; because of its non-Western roots, jazz gave them a new means to express their modernity in far less parochial ways than European modernist music, which could only be understood and appreciated within the Western concert tradition.

## NEW YORK MODERN

After World War I, *jazz* and *modern* became virtually interchangeable terms. In Harlem during the Jazz Age, New York's African American artists redefined what it meant to be American. Confronting, but only partially overcoming, American apartheid, they created a new, more encompassing notion of the modern—free of the racism and classism implicit in European-based art yet reflecting the limits and frustrations dictated by Jim Crow.

## THE DISCOVERY OF HARLEM

Like most other white New Yorkers, Carl Van Vechten first heard jazz downtown at Paul Whiteman's "First American Jazz Concert." On a winter evening in February 1924, in the comfortable confines of the Aeolian Concert Hall, Whiteman introduced white New York to jazz. Whiteman's evening of jazz received a positive reaction. *New York Times* music critic Olin Downes gave a sympathetic review: "[*Livery Stable Blues*] is a glorious piece of impudence, much better in its unbuttoned jocosity and Rabelaisian laughter than other and more polite compositions that came later."[2] Van Vechten shared the *Times*'s interest and its portrayal of jazz as primitive, vibrant music. He too had discovered jazz relatively late.[3]

American avant-garde composers had encountered jazz prior to Van Vechten's evening with Whiteman at Aeolian Hall. Aaron Copland recounted, "When I finished with my studies in Europe, I returned home with a strong desire to write recognizably American music. Jazz seemed to supply the basic source material for such music."[4] Writing in 1923, New York art critic Gilbert Seldes, in his best-selling book, *The Seven Lively Arts,* pronounced, "Jazz is . . . the symbol, or the byword, for a great many elements in the spirit of the times. . . . As far as America is concerned it is actually our characteristic American expression."[5] Popular composer George Gershwin wrote his symphonic jazz piece, *Rhapsody in Blue,* for Whiteman's Aeolian concert. American moderns—Copland, Seldes, Gershwin, and Van Vechten—saw in jazz an indigenous source for an American music, rich in new themes, interesting rhythms, and novel sounds, an expression of a "primitive" people, uninhibited by bourgeois culture.[6]

Tall, blond, and blue eyed, almost albino in appearance, the Iowa-born Carl Van Vechten left home for New York and then Paris, where he became a close friend and confidant of Gertrude Stein. After her death, he served as Stein's literary executor. Throughout his life Van Vechten maintained a close and affectionate relationship with his wife, Fania Marinoff, despite their homosexual reputations. A companion of the New York and Paris avant-garde, Van Vechten lived fashionably and wrote art criticism and novels for middle-class readers, serving as their go-between with the avant-garde. Self-appointed guide to Harlem's nightlife, host to New York's first interracial social gatherings, and author of several best-selling New York novels—*Blind Bow-Boy, Firecrackers,* and *Nigger Heaven*—in the 1920s Carl Van Vechten was Manhattan's Jazz Age gadfly.[7]

Van Vechten's impact was dramatic and profound. More than any other white critic of his generation, he worked to erase the color line that had barred black writers and artists from full participation in New York cultural life. Through articles in

The "downtown" hosts to the Harlem renaissance. Fania and Carl Van Vechten (1930).
*Photograph by Nickolas Muray. Carl Van Vechten Estate, Beinecke Rare Book and Mauscript Library, Yale University*

*Vanity Fair* magazine and his New York novels, Van Vechten made Harlem and its jazz a part of New York life. In January 1925, after attending several gatherings in Harlem hosted by black community leaders, Van Vechten reciprocated by inviting NAACP (National Association for the Advancement of Colored People) officer Walter White and several other African Americans to his home for dinner, cavalierly casting aside New York's interracial taboos. Several white guests also attended. Not since Reconstruction had African Americans been welcomed as social equals in the homes of upper-class white New Yorkers. Even the Greenwich Village avant-garde had contented itself with visits to Harlem nightclubs and occasional invitations to parties at the homes of individual blacks. In the Village, *Emperor Jones* had played to an almost exclusively white audience, and on Broadway, municipal ordinances restricted

blacks to the upper balcony. After 1925, however, largely due to Van Vechten's highly publicized efforts, select African Americans gained access to New York's social and public life.[8]

Van Vechten, however, harbored residual and unexamined racial and class prejudices. He enthusiastically declared jazz sophisticated and refined; he unstintingly praised African American writers such as Langston Hughes, Countee Cullen, Zora Neale Hurston, and Claude McKay; and he treated as equals such educated and cultivated African Americans as James Weldon Johnson, Jessie Fauset, and Walter White. But his fascination with jazz and blues rested, in part, on his belief that they sprang from primitive, primordial roots, no longer extant in whites. In his letters to Gertrude Stein, Van Vechten described his forays into Harlem nightlife as safaris, even referring to black patrons and musicians as "Sambos." At his famous interracial dinner parties, Van Vechten at times treated his black guests as colorful exhibits, featured attractions, regaling white friends with tales of the sexual exploits of working-class Harlem blacks. Towards cultivated, middle-class African Americans, Van Vechten seemed free of racial prejudice; but towards working-class African Americans, he harbored an image of blacks as exotic primitives.[9]

Van Vechten's belief that African-inspired jazz and blues were emblematic of primitive, precivilized impulses characterized much of the modern movement. The cubists were drawn to African sculpture because of its iconographic, nonnaturalistic forms and because they imagined that it expressed fundamental childlike human attributes, free of the repressions of civilization. Despite the complex and sophisticated qualities of African sculpture, European modernists imagined that it offered insight into the archaic nature of the human psyche. American moderns also shared this distorted view. Marius de Zayas in his 1914 exhibit at Stieglitz's 291 Gallery, *African Negro Art,* O'Neill in *Emperor Jones,* and Gershwin in his Broadway hit *Porgy and Bess,* like Van Vechten, treated Africans and African Americans as embodiments of the primitive.[10]

Van Vechten, as much a voyeur as a companion, introduced white New York to what he characterized as Harlem's junglelike nightlife. He displayed Harlem as an alien but fascinating world apart. Following Van Vechten's lead, whites found in Harlem's nightclubs opportunities to partake of forbidden things—marijuana and cocaine, illicit sex, and contact with disreputable, even dangerous, people. After World War I, few whites, no matter how radical, chose to move uptown to Harlem. It remained, in Van Vechten's borrowed but suggestive phrase, "Nigger Heaven," a place for whites to venture, perhaps, but not to live. For those who found even a visit to Harlem menacing, Van Vechten's best-selling novel, *Nigger Heaven,* extended a fictional, armchair tour.

In the summer of 1925, Van Vechten reported to Gertrude Stein his plans to write *Nigger Heaven.* "This will not be a novel about Negroes in the South or white contacts or lynching. It will be about NEGROES, as they live now in the new city of Harlem (which is a part of New York. About 400,000 of them live there now, rich and poor, fast and slow, intellectual and ignorant). I hope it will be a good book."[11] Van Vechten had listened attentively to his educated, middle-class African American

friends, and in *Nigger Heaven* he expressed their concerns. The novel portrays the tragic destruction of a young middle-class black couple by Harlem's irresistible and sordid street life of mobsters, pimps, prostitutes, bootleggers, and entertainers. The book played to the fears of Harlem's middle class as well as to Van Vechten's white readers. Publisher Alfred Knopf, in identifying the novel's class perspective, noted, "The contrasts in NIGGER HEAVEN are very strong. I mean the low people and the low café life are so utterly different from the high Harlem society types. These latter are not what we understand of the African but are very modern and beautiful."[12]

In 1903, in *The Souls of Black Folk,* W. E. B. Du Bois had wrought a revolution in African American consciousness. As a historian, sociologist, educator, and agitator, Du Bois struggled with his "twoness—an American, a Negro; two souls, two thoughts, two unreconciled strivings; two warring ideals in one dark body."[13] Du Bois felt that the "double self" possessed by African Americans enabled them to turn the negative judgment of white racism into a positive affirmation of black "racialism." To be black no longer had to mean the absence of something essential—whiteness—but could, instead, be seen as the addition of a special quality that enriched American life and connected it with other non-Western cultures.[14]

Although sympathetic to Du Bois's assertion of African American "racialism," Carl Van Vechten failed to comprehend Du Bois's vision of a reconstituted, racially inclusive American culture. But Van Vechten did grasp the dilemma that educated African Americans faced, of being American and at the same time being excluded from American life. His provocative title, *Nigger Heaven,* captured the ambivalent feelings of Harlem's middle class. Van Vechten borrowed his title from the racial epithet used to describe the upper balcony of New York theaters, the only seating available to black patrons. Harlem was, indeed, heavenly—a place where blacks could be blacks. Nowhere else in the United States, nowhere else anywhere, in the 1920s, did blacks enjoy such freedom and dignity. "The Negro's situation in Harlem is without precedent in all his history," wrote James Weldon Johnson in *Black Manhattan.* "Never before has he been so securely anchored, never before has he owned the land, never before has he had so well established a community life."[15] Here, Du Bois's dream of racialism seemed realizable. Yet, the white racism explicit in the word "nigger" in Van Vechten's title had driven New York's African Americans into their racial sanctuary. Other than Harlem, no place in New York welcomed blacks.[16]

Black Harlem was a relatively new community. In the last half of the nineteenth century, New York had banished its black citizens to the Tenderloin and its adjoining West Side slums between 6th and 10th Avenues from Greenwich Village to Times Square, a dilapidated district of rundown cold-water tenements, bars, brothels, dance halls, warehouses, stables, slaughterhouses, and sweatshops. Slowly the city's black district crept northward, first to Hell's Kitchen, just west of the theater district, and then to San Juan Hill, west of Columbus Circle. Middle-class blacks deeply resented living in slums, and all blacks feared the ever present threat of violence at the hands of their Irish neighbors, who resented the intrusion of blacks into their exclusive turf. Irish dominance of the New York police force made the threat of violence all the more ominous. One observer described the 1900 Hell's Kitchen

race riot thus: "It was the night sticks of the police that sent a stream of bleeding colored men to the hospital. . . . Men who were taken to the station house . . . were beaten by policemen without mercy."[17]

With such memories fresh, around 1905 middle-class blacks started to buy property in Harlem, then an affluent Jewish neighborhood with an oversupply of unrented apartments and unsold town houses. Harlem offered middle-class African Americans an almost suburban retreat, free from the noise, squalor, and violence of the West Side tenements. Located north of Central Park, east of Cathedral and Riverside Heights, and south of Washington Heights with the Harlem River forming its eastern boundary, Harlem seemed bucolic and safe. With its new smartly designed and well-built low-rise homes, broad avenues and cross streets, ample parks, up-to-date schools, imposing synagogues and churches, and with affluent neighbors on three sides, Harlem beckoned to middle-class African Americans. And in Harlem, African Americans devoted themselves to being middle class, making Harlem the "New Negro" Manhattan, certainly not "nigger heaven."[18]

West Side black churches migrated northward, often buying the buildings of fleeing white congregations. The NAACP moved its offices to Harlem, along with the editorial staff of its magazine, *Crisis,* edited by the already legendary Du Bois. The city's two black newspapers, *New York Age* and the *Amsterdam News,* joined the trek to Harlem, while the Harlem YMCA and the Harlem branch of the New York Public Library became centers for African American culture. James Van DerZee's fashionable portrait studio served Harlem's prosperous middle classes, while the Lafayette and Lincoln Players catered to the theatrical tastes and ambitions of black Harlemites. On Sundays, middle-class Harlem families dressed in their best clothes and promenaded conspicuously along Seventh and Lenox Avenues, much as white middle-class New Yorkers paraded along Fifth Avenue.[19]

By middle-class white standards, Harlem was not special. For African Americans, however, Harlem marked a new beginning, a chance to fulfill the promises of Emancipation, to throw off, once and for all, the servility of Jim Crow segregation and the onus of racial inferiority. Harlem's middle classes saw themselves as exemplars of a "new" Negro, in all ways equal to the white middle class and, in all important ways, no different. Both a magnet and a promise for ambitious African Americans, Harlem had, by 1920, become the most important center of organized black cultural activity in the United States. The New York–based Urban League, the Rosenwald Fund, the Harmon Foundation, and the American Fund for Public Service all focused their efforts towards racial uplift on Harlem and its growing community of professionals, intellectuals, artists, and writers.[20]

Following World War I, the Urban League established the magazine *Opportunity* to promote and publicize African American accomplishment, recruiting Charles Johnson as editor. Under Johnson's leadership, *Opportunity* encouraged black creativity through monthly literary prizes for prose and poetry and its exuberant praise of promising black writers. Johnson, along with Howard University philosopher Alain Locke, writers Walter White and Jesse Fauset, and scholar James Weldon Johnson, acted as a catalyst for the Harlem renaissance. The patrons of the Harlem renaissance hoped to create a body of African American writing comparable to the

best European writing. In 1925, Alain Locke announced the birth of the Harlem re-naissance with the release of *The New Negro*. Published by the Greenwich Village press of Albert and Charles Boni, *The New Negro* offered an expansive collection of poetry, fiction, and essays that set the agenda for a black cultural flowering.[21]

A remarkable document, *The New Negro* brought to public attention the work of several unknown writers, outlining the enormous possibilities for black creativity. Locke's belief in Harlem's nascent renaissance was warranted. In the interwar decades Harlem offered black artists and writers resources and appreciative audi-ences for their work. In return, Harlem's writers and artists produced an impressive number of works, some of exceptional quality. Claude McKay, Zora Neale Hurston, and Langston Hughes wrote poetry, fiction, and autobiography, and *Crisis* and *Op-portunity* ranked among the most successful of the dozens of literary little magazines spawned during the 1920s.[22]

Alain Locke, sometime Harlem resident and the first African American Rhodes Scholar, called on the postwar generation of African American writers and artists to fulfill Du Bois's dream. Pleased with the interest of Van Vechten and other well-intended whites, Locke was nonetheless disturbed by the modern infatuation with primitivism. He cautioned, "Liberal minds today cannot be asked to peer with sym-pathetic curiosity into the darkened Ghetto of a segregated race life. . . . Nor must they expect to find a mind and soul bizarre and alien as the mind of a savage, or even as naive and refreshing as the mind of the peasant or the child."[23] Rather, liberal whites should follow the examples set by painters Winslow Homer, Robert Henri, and George Bellows, who realistically portrayed African American subjects with sympathy and sensitivity. "No more Uncle Remuses, Aunt Chloe's or Jemimas or pickaninnies for Bellows, or through his influence, progressive American art." Draw-ing on African American sources, Locke asserted, American artists could transcend the narrow conventions of Western art, creating a genuinely human art. "Negro art does not restrict the Negro artist to a ghetto province, but only urges him to sustain his share in its interpretation, with no obligation but the universal one of a duty to express himself with originality and unhampered sincerity."[24]

Art, however, required patronage, and African American art enjoyed few patrons. In 1926, in response to appeals by Du Bois's *Crisis* and Charles Johnson's *Opportu-nity,* the William E. Harmon Foundation established an annual art competition and exhibition for African American artists, awarding a gold medal and a four-hundred-dollar prize in eight fields of artistic expression. Although modest, the Harmon prizes granted black artists formal recognition for their work, and the annual Harmon ex-hibitions brought to public attention scores of previously unknown black artists. Harmon exhibitors and prizewinners included sculptors Augusta Savage and Rich-mond Barthé and painters William Henry Johnson, Palmer Hayden, and Archibald Motley. The Harmon Foundation discontinued its awards and exhibitions in 1934.[25]

For painting and sculpture, the Harlem renaissance proved a time of planting and nurturing. With three exceptions—the work of Archibald Motley, William Henry Johnson, and Aaron Douglas—African American painting and sculpture did not ma-ture until later. Palmer Hayden, who won two Harmon gold medals in painting, ac-complished his best work in the 1930s and 1940s, long after the first Harlem renais-

sance had dissipated. Of the three who accomplished significant work in the 1920s, Chicagoan Archibald Motley conformed most closely to the New Negro vision of Du Bois and Locke. Motley wrote, "I feel my work is peculiarly American, a sincere personal expression of the age, and I hope a contribution to society. . . . [It] is, indeed, a racial expression and one making use of great opportunities which have long been neglected in America. The Negro is part of America and the Negro is part of our great American art."[26] After winning the Harmon Prize in 1929, and supported by a Guggenheim Fellowship, Motley studied in Paris for a year. In 1930, Motley returned to Chicago, where he painted exuberant pictures of black urban life, participating in the Harlem renaissance only from a distance.[27]

Similarly, William Henry Johnson, a native of Florence, South Carolina, only marginally took part in the Harlem renaissance. After World War I, Johnson trained at the National Academy of Design and in 1926 went to Paris. In 1929, Johnson returned to New York, winning the Harmon Prize in 1930 only to depart immediately for Europe. Johnson lived in Scandinavia until 1938. Fearing Nazi invasion, he settled in New York, where, institutionalized following a mental breakdown, he lived as a virtual expatriate until his death in 1970. Johnson, too, focused on African American life but did not limit his interest to urban subjects. Although he painted New York street musicians and other urban scenes, during World War II he also painted a series on black soldiers and after the war completed a group on black South Carolina sharecroppers and tenant farmers.[28]

Of the African American painters who gained recognition in the 1920s, only Aaron Douglas lived and worked in Harlem. Douglas grew up and received his professional training in Kansas. In 1925 he came to Harlem, where Charles Johnson took Douglas under his wing, introducing him to the Harlem renaissance inner circle. Responding to Locke's New Negro artistic imperative, Douglas adopted a cubist-precisionist style and committed himself almost exclusively to African American themes. Douglas illustrated the publications of several Harlem renaissance publications, including Du Bois's *Crisis*, Locke's *The New Negro,* and James Weldon Johnson's *God's Trombones*. In *God's Trombones*, Douglas combined stylized African imagery with cubist shapes and flattened perspectives. Douglas also painted a number of impressionist cityscapes, including *Power Plant in Harlem* and *The Old Waterworks*, that presented Harlem in bucolic, almost sentimental images.[29]

Before the Harlem renaissance, African American artists had failed to achieve recognition in the patronage-dependent arts of painting and sculpture. In music, however, African American spirituals, ragtime, blues, and jazz had virtually defined popular American music. But the New Negro proponents felt uncomfortable with the rural roots of black music. They wanted African Americans, drawing on their folk traditions, to compose art music, comparable to European symphonic music. Locke wrote, "Eventually the art-music and the folk music must be fused in a vital but superior product. Neither America nor the Negro can rest content as long as it can be said: 'Jazz is America's outstanding contribution, so far, to world music.'"[30]

In the 1920s several black singers fulfilled Locke's hopes for an African American art music, including Roland Hayes, Marian Anderson, and Paul Robeson, all of whom received national recognition in the 1920s and all of whom sang African

American–inspired music. William Grant Still, however, was the Harlem renaissance's proudest musical prodigy. Educated in Ohio at Wilberforce University and Oberlin College, Still composed for W. C. Handy during World War I. After the war Still became musical director of Harry Pace's Phonograph Company in Harlem, selling art music to Harlem's middle class. In the 1920s, Still focused almost exclusively on African American themes. His compositions included *Darker America, From the Black Belt, La Guiablesse,* and his masterpiece, *Afro-American Symphony,* performed in 1931 by the Rochester Philharmonic Symphony Orchestra, the first performance by a major orchestra of a symphony composed by an African American.[31]

The accomplishments of Harlem's musical renaissance, however, went well beyond the scope of the New Negro program of art music. In 1921, Eubie Blake and Noble Sissle produced the runaway hit, *Shuffle Along,* featuring Josephine Baker and Florence Mills, the first black-produced black-performed Broadway musical in more than a decade. In the 1920s, Mills, Charles Gilpin, Paul Robeson, and Bill "Bojangles" Robinson consistently received top Broadway billings, while Fletcher Henderson, at the Roseland Ballroom just off Times Square, directed the first important jazz orchestra, opening the way for the big swing bands of the 1930s and 1940s. Harlem's entertainers affirmed the racial pride championed by the Harlem renaissance. Like its painters and writers, Harlem's musicians realized that their art contributed much to American life. Finally, it seemed, their day had dawned.

## HARLEM AFTER DARK

Much as Van Vechten's *Nigger Heaven* had portrayed Harlem from the viewpoint of its black middle class, so Harlem's middle classes ignored and looked down on working-class blacks, who, after World War I, also claimed Harlem as their home. In 1925, when *The New Negro* appeared, Harlem had already begun to resemble Hell's Kitchen and San Juan Hill, inundated with impoverished West Side blacks, poor migrants from Virginia, the Carolinas, and Georgia, and even poorer immigrants from the West Indies. Spurred by the economic boom triggered by World War I, southerners, launching the "Great Migration," streamed into the industrial cities of the North, including New York.[32] Harlem's reputation as a black metropolis made it especially alluring to black southerners. Hopeful but poor southern blacks, arriving at Pennsylvania Station or a West Side pier, hurried down into the Eighth Avenue subway and pushed their way onto the uptown A train. They disembarked at 125th Street, where Harlem promised them a new life.

Their arrival also signaled profound change in Harlem. Although it promised a safe sanctuary from white violence, Harlem lacked sufficient housing and public services for the influx of poor newcomers. Few builders were willing to construct new housing in Harlem, and almost no one considered building low-income housing. As Harlem's population swelled, the quality of its life deteriorated after 1914. With an ever larger number of people crowded into a fixed supply of housing, rents rose in Harlem even as the quality of housing plummeted. Harlemites paid 25 percent more than other New Yorkers for comparable apartments. Moreover, despite the industrial boom, black employment in New York was largely limited to domes-

tic service for women and custodial and other menial labor for men—long hours at low pay. Consequently, after 1914 ever increasing numbers of poor, uneducated people crowded by the score into Harlem apartments designed to accommodate only four or five.[33]

In the years following World War I, Harlem suffered a disastrous combination of inflated rents, high unemployment, low wages, illiteracy, chronic poor health, and rampant disease. Its death rate soared. During the decade, violent deaths increased by 60 percent, and Harlem's rate of venereal disease mounted to three times the level of New York at large. A majority of Harlem's children exhibited signs of malnutrition. Although all of Harlem's black residents might approve of the lofty aims of its middle class, for most the Harlem renaissance seemed far removed from their lives. Van Vechten's *Nigger Heaven* was less an exposé of black Harlem than a sympathetic account of the destruction and degradation of Harlem's black middle class at the hands of its impoverished, violent, and passionate masses.[34]

Whereas many of Harlem's New Negro middle class, living on Sugar Hill and Strivers' Row, snubbed and even feared the masses of poor African Americans surging into Harlem, Langston Hughes welcomed them. Hughes declared black southerners the true source of African American creativity:

Let the blare of Negro jazz bands and the bellowing voice of Bessie Smith singing Blues penetrate the closed ears of the colored near-intellectuals until they listen and perhaps understand. Let Paul Robeson singing "Water Boy," and Rudolph Fisher writing about the streets of Harlem, and Jean Toomer holding the heart of Georgia in his hands, and Aaron Douglas drawing strange black fantasies cause the smug Negro middle class to turn from their white respectability, ordinary books and papers and catch a glimmer of their own individual dark-skinned selves without fear or shame. . . . The tom-tom cries and the tom-tom laughs.[35]

The crowding together of working- and middle-class blacks that so disturbed Van Vechten and his black middle-class friends was, paradoxically, the source of Harlem's genius. The middle classes brought to Harlem intellectual sophistication and racial pride; the working classes brought their rambunctious, earthy ways, and a rural culture rooted in southern American and West African traditions. Beyond the well-appointed drawing rooms of the New Negroes, Harlem's jazz musicians created a renaissance of far more immediate significance. Directed to Harlem's dispossessed yet drawing on the rich musical culture of New York—symphonic and commercial—Harlem's jazz musicians reshaped New Orleans and Chicago jazz into a music that appealed to blacks and whites alike.[36]

In the 1920s, Harlem was second only to the Times Square area as a center of New York entertainment. Black New Yorkers ordinarily preferred Harlem to Broadway, assuring Harlem's entertainment industry loyal patronage. Harlem's legitimate theaters, the Lafayette and the Lincoln, presented serious drama, sponsoring two black theater groups that trained Charles Gilpin, Rose McClendon, Paul Robeson, Abbie Mitchell, and other pioneering African American actors. For sheer entertainment, the Manhattan Casino and the Palace Casino featured top black bands that played the latest dances, including the lindy hop, the fox-trot, and the Charleston, serving as the off-Broadway tryout circuit for such African American musical hits as *Shuffle Along, Chocolate Dandies, Black Birds,* and *Keep Shuffling.*[37]

Harlem's dance palace, the Savoy Ballroom, stood apart, occupying an entire block between 140th Street and 141st Street on Lenox Avenue. Opened in the winter of 1926, the Savoy featured two jazz bands, Fletcher Henderson's Harlem orchestra and the Charleston Bear Cats. The Savoy offered its largely middle-class patrons a 50′ × 200′ dance floor "of the best quality maple flooring, polished to the highest degree" and two bandstands, one for its house band and the other for a visiting band. The other half of the ballroom seated guests who listened to jazz while imbibing soft drinks purchased from the soda fountain. The Savoy was illuminated by chandeliers, and its battery of multicolored spotlights picked out visiting celebrities, white and black. A Savoy "cutting contest" with Chick Webb's house band became a rite of passage for jazz bands new to New York. Fletcher Henderson, Duke Ellington, Benny Moten, Louis Armstrong, and, in the 1930s, Benny Goodman and Count Basie all eagerly accepted the Savoy challenge.[38]

Frequently, Savoy jazz musicians also played after hours at Harlem nightclubs that provided patrons more than a soda fountain. With Prohibition, mobsters transformed Harlem into an oasis of illicit entertainment. Harlem had much to attract gangsters—a vital nightlife, easy accessibility by taxi from midtown, and large numbers of people desperate for money. Prohibition offered opportunities in Harlem for small-time entrepreneurs, as well. In the 1920s, nightclubs, brothels, cabarets, speakeasies, strip joints, and dives proliferated, tendering booze, sex, drugs, gambling, and—in about a dozen places—jazz. Baron's, Connie's Inn, the Cotton Club, and Leroy's were Harlem's most famous "black and tans," whose black bands and light-tan female floor shows catered to an almost exclusively white audience—in some cases, a "whites only" audience. Less famous, but more important musically, were Small's Paradise, the Nest, and the Lenox Club, after-hours clubs where musicians came after finishing their gigs at the Savoy, a downtown club, or one of Harlem's "black and tans."[39]

Here, serious musicians, black and white, jammed, free to play jazz rather than the commercial dance music and watered-down jazz often required at the more popular white clubs. Jam sessions went on for hours, lasting until ten or eleven o'clock in the morning. Duke Ellington recalled, "Nobody went to bed at night, and around three and four in the mornings you'd find everyone making the rounds bringing their horns with them. . . . Small's was the place to go, the one spot where everybody'd drop in. . . . Then on Sunday's Small used to hire a guest band, the best he could get, and there'd be a regular jamboree."[40]

## BLACK NEW YORK MUSIC

Even prior to the Great Migration of southern blacks to Harlem during World War I, New York had been a magnet for black entertainers. In 1903 the most successful, Bert Williams and George Walker, formed their own theatrical company, which produced *In Dahomey,* one of Broadway's first all-black shows. Williams and Walker belonged to a small but talented constellation of black New York entertainers who gathered regularly at the Maceo and Marshall Hotels on West 53d Street. The Marshall Hotel group included Williams and Walker, Bob Cole, Rosamond

Johnson, his brother James Weldon Johnson, Will Marion Cook, Paul Laurence Dunbar, Scott Joplin, and James Reese Europe. In 1910, James Reese Europe, with the support of his Marshall-Maceo friends, formed the Clef Club, a combination booking agency, union, and professional organization for New York's black musicians.[41]

Europe came from a musical family. His brother played piano professionally in New York, and his sister taught music and directed a choral group in Washington, D.C. Growing up in Washington, Europe had studied composition and theory and became accomplished on the violin and piano. Arriving in New York, in 1903, at the age of twenty-two, the thin, dark-skinned Europe accepted a job playing piano in a Times Square nightclub while continuing his musical studies with Harry T. Burleigh, a protegé of Antonin Dvořák. Despite his credentials, Europe found it impossible to pursue a career as a composer. His admission to the select Marshall Hotel circle and his success as a Broadway director did not compensate for the racial exclusion he experienced. Undeterred, he organized the hundred-piece Clef Club Orchestra, which, in 1910, opened at the Manhattan Casino in Harlem. The orchestra played popular music, waltzes, and ragtime tunes, including Europe's own *Clef Club March*. Two years later the Clef Club Orchestra performed to a packed house in Carnegie Hall, an unprecedented accomplishment for a black orchestra performing black music. With a series of orchestras under his direction, Europe moved beyond the ragtime of Times Square, anticipating aspects of jazz.[42]

A dance band rather than a symphonic orchestra, Europe's Clef Club Orchestra consisted of an eclectic assortment of instruments. Cellos, double basses, trombones, cornets, and clarinets coexisted with saxophones, drums, banjos, mandolins, guitars, and ten pianos. In 1913 his smaller Exclusive Society Orchestra became a favorite at New York society balls, leading to Europe's association with white dancers Vernon and Irene Castle, who propelled him to the top of New York's entertainment world. Europe's Castle Band played ragtime, waltzes, syncopated versions of popular Broadway dance tunes, and most famously, fox-trots. His use of syncopation and 4/4 time and his choice of harmonic chords gave his music an African American sound. Europe remarked, "We colored people have our own music, that is the product of our souls. It's been created by the sufferings and miseries of our race. Some of the melodies we play were made up by slaves, and others were handed down from the days before we left Africa. We have developed a kind of symphony music that lends itself to the playing of peculiar compositions of our race."[43]

From 1913 to 1915, Europe's Castle Band reigned supreme among New York dance bands. Europe and the Castles turned the fox-trot into a national craze, initiating the Jazz Age. In 1915, at the height of the Castles' popularity, Vernon Castle enlisted in the British army. Within a year Europe joined the American Expeditionary Force as a lieutenant and director of the Fifteenth Regimental Band, which also served as a combat unit. Nicknamed the Hell Fighters or the Harlem Hell Fighters, Europe's band compiled a distinguished combat record and later toured France, introducing the French to what one contemporary observer called the "jazz germ." Following the Armistice, the Harlem Hell Fighters returned to a heroes' welcome, which included a Fifth Avenue parade viewed by an estimated one million New Yorkers. On his

Lt. James R. Europe and his Harlem Hell Fighters in Paris. The 369th Regiment Infantry, 93d Division (May 5, 1918). *National Archives*

discharge, Europe reassembled the Harlem Hell Fighters as an independent band, scheduled a national tour, and signed a recording contract with Pathé Records as the "Jazz King."[44]

The model for later big-band jazz, the Harlem Hell Fighters interspersed their syncopated music with occasional nondiatonic notes and improvised breaks and laid down a rhythmic momentum that gave it an unmistakable, if subdued, swing. Europe's career ended abruptly, and tragically, in Boston on May 9, 1919, when a disgruntled band member stabbed him. Following a colossal funeral procession through Harlem, Europe was transported to Washington, D.C., and was buried across the Potomac River, in Arlington National Cemetery.[45]

In addition to serving as a bridge between ragtime and jazz, James Reese Europe

broke through the formidable barriers that barred African American musicians from professional careers in music. Trained as a symphonic musician, Europe exploited the sparse but significant opportunities available to black entertainers on Broadway in the early years of this century. Despite its African American sound, Europe's music remained largely European in structure, harmony, and tone. By capturing the musical imaginations of white and black audiences, with the Castles, Europe launched the Jazz Age and took the first stride towards a New York Jazz.

## NEW YORK JAZZ

The term *jass* came into use as a musical term around 1915 to distinguish improvised New Orleans band music from formally arranged, piano-based ragtime. The origin of the term is obscure. A New Orleans slang word, some believe it derived from a brothel term for sexual intercourse; others attribute *jass* to a brand of New Orleans perfume. Very likely, both the name of the perfume and the music derived from brothel slang. In any case, at the turn of the century New Orleans musicians developed a syncopated band music similar to piano ragtime, rhythmically freer and with a strong blues influence, which they called *jass*. The classic New Orleans jazz ensemble consisted of five to eight instruments, including trumpet, trombone, clarinet, drums, banjo or guitar, bass or tuba, and piano. The trumpet led, striking out on an improvised melody, usually answered by the trombone or clarinet, with the rhythm instruments providing a steady 4/4 ground beat. As New Orleans musicians traveled upriver and on railroads across the country, they carried with them their exuberant, polyphonic jazz, which, by 1917, displaced ragtime as the country's hot, popular music.[46]

Prior to 1917 a number of New Orleans jazz musicians had played in New York, and a few New Orleans bands had appeared in New York vaudeville shows. Harlem musicians quite likely picked up some New Orleans ideas, and James Europe's band played a near-jazz sound.[47] In 1915, at the Winter Garden Theater, Freddie Keppard and his six-piece Creole Band played New Orleans jazz. For the next year and a half, the Creole Band gigged around New York, staying in Lottie Joplin's boarding house, now on West 131st Street in Harlem. Keppard, however, proved an inept leader. His band broke up when most of the musicians returned to New Orleans.[48] Nevertheless, Keppard's band and other itinerant New Orleans musicians introduced elements of New Orleans jazz to Harlem musicians even before jazz influenced the downtown scene and even before Harlem musicians called it *jazz*.

New York jazz made its downtown debut on January 19, 1917, when the Reisenweber Restaurant, at Columbus Circle, announced the appearance of the Original Dixieland Jass Band (ODJB), a five-piece, white New Orleans group that had recently played in Chicago. Appearing north of the Times Square entertainment district, the band at first received scant attention. But as word spread, people flocked into Reisenweber to hear New Orleans "jass" music. By July, the ODJB had recorded for Columbia, Victor, and Aeolian. Their Victor record, *Livery Stable Blues,* sold more than a million copies. The band's overnight success introduced the term *jass*

into the American lexicon. The spelling was quickly altered to *jazz,* which named, even if it did not yet define, an emerging, blues-based ragtime-derived urban music. Jazz was identifiable by its 4/4 time, improvised melody, syncopation, and novel sounds—in the case of the ODJB, a crowing rooster, a whinnying horse, and a braying mule. In truth, the ODJB played set pieces, only pretending to improvise, but by simplifying New Orleans ensemble jazz and sustaining a hard-driving, if heavy, rhythm interspersed with breaks, honks, bells, and braying, the ODJB introduced white audiences to a watered-down version of New Orleans jazz, similar to what Van Vechten heard seven years later in Aeolian Hall.[49]

Much of the ODJB's success was a consequence of its 1917 recordings. Jazz and commercial phonographic recording evolved simultaneously. From the start, the popular recording industry featured jazz and jazz-related blues.[50] In 1918, a black insurance executive, Harry Pace, and black composer W. C. Handy moved to New York to form the Pace-Handy Music Company, publisher of sheet music. In 1921, Pace left to form his own record company, which specialized in black music. Named for the African American opera singer Elizabeth Taylor Greenfield, "the Black Swan," Pace's Black Swan label initiated the production of what the industry called "race" records—music directed at black audiences—though the first hit race record was produced not by Black Swan but by the General Phonograph Corporation on its OKeh label.[51]

In December 1920, OKeh arranger Perry Bradford, on a whim, distributed copies of Mamie Smith's recent recording, *Crazy Blues,* to Harlem record shops. A month later Smith's *Crazy Blues* had sold an amazing seventy-five thousand copies in Harlem alone. Sensing the sales potential of this untapped African American market, OKeh immediately recorded as many blues singers as it could get under contract, kicking off the blues craze that led to the discovery of Ethel Waters, Bessie Smith, and Gertrude "Ma" Rainey. The radio broadcast of race records provided black musicians access to regional, urban-based, African American audiences attuned to their music and eager to buy their records.[52]

The early jazz, popularized during the blues craze, originated in New Orleans. But New Orleans was not the only source of African American music. Indeed, the blues were sung throughout the South. And while Harlem attracted a few New Orleans musicians, such as Freddie Keppard, most of its jazz musicians, like its population as a whole, came from northeastern cities, the Carolinas, and Georgia. Keppard's inability to keep his New Orleans band together can be explained, in part, by the discomfort that his New Orleans jazzmen felt living in Harlem. The African American population in Harlem was different from that of New Orleans. Of Harlem's nearly three hundred thousand African American residents, in 1920 only about two thousand came from Louisiana. Nearly one hundred thousand arrived from the Carolinas and Georgia, and most of these from the predominantly black Gullah or Geechie rice counties near Charleston and Savannah. Because of their rural isolation, these coastal Carolina and Georgia blacks retained significant West African cultural traits. Gullahs spoke a pidgin dialect based on West African words and syntax. Aspects of Gullah religion and burial customs can be traced directly to

West African sources. Their music included ring shouts, stomps, and communal songs suffused with calls and responses, complex, even esoteric, rhythms, and non-diatonic blue notes.[53]

New York's black dockworkers disproportionately came from Charleston and Savannah. In Harlem joints, they requested "their" music, which, as employed union laborers, they could pay for. Garvin Bushell, a native of Ohio who played clarinet for such top New York jazz bandleaders as Fletcher Henderson, Chick Webb, and Cab Calloway, recalled that "the Charleston was introduced in New York at Leroy's. Russell Brown came from Charleston and he did a Geechie dance from the Georgia Sea Islands. It's called a cut out dance. People began to say to Brown, 'Hey, Charleston, do your dance!' They finally called it the Charleston."[54]

The Carolinas also influenced New York jazz through musicians trained in the Jenkins Orphanage Band. The Charleston orphan band toured the United States and Europe annually, playing regularly in New York. In addition to its conventional concert music, the band played fast-tempo, African American–inspired marches and ragtime numbers. More importantly, the Jenkins Orphanage Band trained an enormous number of musicians, dozens of whom came to New York. The Jenkins Orphanage Band also provided the music for the premiere of George Gershwin's Charleston-inspired opera, *Porgy and Bess.* The most important Charleston influence, however, was Duke Ellington's extraordinary trumpeter Bubber Miley, who refined the muted trumpet and composed such jazz standards as *East St. Louis Toodle-OO* and *Black and Tan Fantasy.*[55]

New York was not simply the destination of jazz musicians. Like New Orleans, Chicago, and Kansas City, it was itself a major source of jazz, most importantly, of jazz piano. By 1920, Harlem pianists had developed their own jazz, known as Harlem stride. During the ragtime craze, a tradition of eastern piano playing developed in Baltimore, Washington, D.C., Boston, Philadelphia, Pittsburgh, and New York. The most famous of the Harlem stride pianists were Willie "the Lion" Smith, James P. Johnson, Fats Waller, and Duke Ellington. Although each worked in his own style, they all played a two-handed ragtime in which the right hand carried the melody as the left, alternating between bass note and middle-register chord, sustained a steady beat, creating a distinctive "oompah" sound. Garvin Bushell explained, "New York jazz was nearer the ragtime style and had less blues. There wasn't an eastern performer who could really play the blues. We later absorbed it from the southern musicians we heard, but it wasn't original with us. We didn't put that quarter-tone pitch in the music the way the southerners did. Up north we leaned toward ragtime conception—a lot of notes."[56]

Formally trained, the Harlem stride pianists could read music and, like James Europe, had been influenced by European symphonic and Broadway show music. Their use of proper fingering, balanced chords, and virtuoso techniques awed spectators.[57] James P. Johnson explained how he synthesized southern folk blues and ragtime music with sophisticated European musical techniques and ideas:

I did double glissandos straight and backhand, glissandos in sixths and double tremolos. These would run the other ticklers out of the place at cutting sessions. They wouldn't play after me. . . . From listening to classical piano records and concerts . . . I would learn concert ef-

Masters of Harlem stride. Fats Waller and Willie "the Lion" Smith (1920s). *Photograph by Charles Peterson. ©Duncan Scheidt Collection*

fects and build them into blues and rags. Sometimes I would play basses a little lighter than the melody and change harmonies. When playing a heavy stomp, I'd soften it right down—then I'd make an abrupt change like I heard Beethoven do in a sonata. . . . With a solid bass like a metronome, I'd use chords with half and quarter changes. Once I used Liszt's *Rigoletto Concert* paraphrase as an introduction to a stomp. Another time, I'd use pianissimo effects in the groove and let the dancers' feet be heard scraping on the floor.[58]

Harlem's stride pianists were entertainers, showmen in the best Broadway tradition, and none more so than Willie "the Lion" Smith, who, in a studied performance, entered a bar in an expensively tailored coat complete with derby, silk tie, gold cuff links, silk handkerchief, and a gold-headed cane. Smith moved to the piano in a slow, deliberate stride; took off his coat, which he carefully folded and ceremoniously handed, with his cane, to an honored onlooker; dusted off the piano bench with his handkerchief; and, finally, began to play a familiar song, such as his *Echoes of Spring.* Smith later recalled, "We would embroider the melodies with our own original ideas and try to develop patterns that had more originality than those played before us. Sometimes it was just a question as to who could think up the most patterns within a given tune. It was pure improvisation."[59]

Harlem's stride pianists recast the ragtime piano into an expressive jazz instrument. They absorbed the feel and rhythm of southern blues while borrowing ideas and techniques from symphonic and popular show music. The dean of the stride pianists was James P. Johnson. His *Carolina Shout, Harlem Strut, Snowy Morning Blues,* and *The Mule Walk* provided the musical foundation for the jazz piano.[60] Johnson influenced Fats Waller and Duke Ellington, and later, through his records,

his music inspired Earl Hines, Teddy Wilson, Count Basie, and Thelonious Monk.[61]

The influence of Harlem stride went beyond the jazz piano. Harlem stride brought to jazz the conceptual and technical sophistication of New York music. In their frequent cutting contests, stride pianists challenged other musicians to equal the richness, complexity, and variety of their music. Harlem stride embodied the rhythm, vitality, and improvisation of New Orleans ensemble jazz, the feeling and harmonic structure of blues, and the individual musical genius of such virtuoso jazz soloists as James P. Johnson and Fats Waller.[62] The result, declared Duke Ellington, was "real invention—magic, sheer magic."[63] Most of all, however, James P. Johnson and the other Harlem striders captured the energy and enthusiasm of Harlem in the 1920s.

## URBAN BLUES

Blues and instrumental jazz did not simply parallel one another in the 1920s. The blues had been a part of jazz from its inception, although at first New York jazz, with its strong ragtime influences, exhibited little blues feeling. As jazz clarinetist Garvin Bushell recounted, "Gradually, the New York cabarets began to hear more of the real pure jazz and blues by musicians from Florida, South Carolina, Georgia, Louisiana, and other parts of the South. What they played was more expressive than had been heard in New York to that time"—and none more so than the voice of Bessie Smith from Chattanooga.[64]

Smith began her singing career as a teenager under the tutelage of Ma Rainey. Prior to Rainey and Smith, blues had been a rural music, sung largely by males who accompanied themselves on banjo, guitar, or fiddle. The lyrics focused on work, religion, and rural southern life. Blues singers such as Ma Rainey and Bessie Smith, working the southern minstrel and vaudeville circuits, adapted blues themes for their urban audiences, dwelling on love, sex, alcohol, drugs, and violence. Although they adhered to the formal structure of traditional blues, urban blues singers also absorbed the livelier and more complex rhythms of the jazz musicians who accompanied them, creating a secular and urban African American music, a progeny of the Great Migration.[65]

Bessie Smith did not record until 1923 and did not work in New York until the late 1920s. Since 1914, when she left Rainey to sing on her own, Smith had prospered working for the southern Theater Owners' Booking Agency (TOBA), earning about seventy-five dollars a week.[66] Independently successful, she did not aggressively seek out New York recording companies. Moreover, Black Swan, Victor, and OKeh objected to the rough, earthy lyrics that Smith's southern audiences demanded. In 1923, Frank Walker, recording director for Columbia Records, took a chance, signing Smith to an exclusive contract. Her first two songs, *Down-Hearted Blues* and *Gulf Coast Blues,* became instant hits. Columbia sold more than two million of Smith's records in the first ten months, six million in the first six years, and nearly ten million by the time she died in 1937, saving Columbia from bankruptcy and making Bessie Smith the reigning Empress of the Blues.[67]

Smith's recordings exuded power and appeal. Her clear, strong, sonorous voice,

Bessie Smith, "The Empress of the Blues." Recording cover photograph (1923–24). *Photograph ©Duncan Scheidt Collection*

with its sure jazz rhythm, openly addressed sexuality, betrayal, and loneliness. Smith had immense stage presence. Audiences watching Smith sing *Empty Bed Blues, Bye, Bye, Blues,* or *Worn Out Papa Blues* felt the personal, confessional quality of her songs. Listeners understood that Bessie Smith, too, loved her man, that she had suffered faithless love, and that she, too, buried her sorrows in gin and dope. Her life, like theirs, was torn by unrequited love, unending labor, and bitter disappointment. Sudden violence and unexpected death stalked her. Smith sang, loved, danced, drank, and cried, just as her listeners did. Bessie Smith expressed their pain as intensely as they lived their lives.[68]

Shortly after Carl Van Vechten had written to Gertrude Stein to announce his discovery of jazz, he heard Bessie Smith sing at the Orpheus Theater in Newark, New Jersey. Van Vechten imagined Smith as an African sorcerer, casting a spell over her audience.[69] Smith's influence went beyond the words of her songs and her stage presence. She fortified the twelve-bar blues already characteristic of jazz. As a vocal form, the blues conformed to a formal structure identified by its three-line stanza pattern:

> Standing in the Rain and not a drop fell on me.
> Standing in the Rain and not a drop fell on me.
> My clothes are all wet but my flesh is dry as can be.

The harmonic structure remained constant from one performance to another, but singers varied or improvised the melody. The blues also provided jazz its distinct tonal quality. Blue notes did not conform exactly to the diatonic scale (major and minor) of European music—the white and black keys of the piano. In the blues, derived as it was from West African music, most notes had diatonic equivalents, but a few blue notes did not. Blues vocalists sang blue notes in exact nondiatonic tones. Blues string players adapted the blues to European instruments by "bending" the blue tones to conform to the diatonic scale. Jazz horn players, by manipulating their lips or the valves of their instruments, produced nearly true blue tones. Most jazz pianists, because the keys played a fixed diatonic scale, simply "made do" with flatted third, seventh, and fifth notes rather than true blue notes. Modulated and adapted, the blues gave jazz musicians a flexible harmonic structure that preserved the distinct tones of African American music.[70]

By 1925, despite Bessie Smith's continued popularity on black concert circuits, the sales of blues records was flagging. Smith's heavy drinking led to increasingly erratic, often violent, behavior and sexual binges involving men and other women. Her 1926 marriage to Philadelphia policeman Jack Gee, which remained troubled throughout, only momentarily stabilized her life. Smith's powerful voice deteriorated, although she continued to record for Columbia until 1933 and occasionally produced a remarkable performance. After 1930, the economic depression further diminished record sales, concerts, and club dates, and in 1930 her old standby, TOBA, collapsed, ending an era of African American entertainment. In desperation, Smith left New York for Philadelphia, where she felt more at home. Almost mercifully, in 1937, her career ended, with her life, in an automobile accident. An estimated seven thousand mourners attended her funeral in Philadelphia, paying final tribute to jazz's greatest singer.

Bessie Smith's meteoric rise from an obscure TOBA singer to the Empress of the Blues and, just as quickly, her near-total self-destruction, all within a ten-year span, resembled the tragic careers of other popular entertainers. Her impact on jazz, however, was unique and lasting. Smith gave the blues a modern, secular, and urban interpretation. She sang the blues with a power and effectiveness never heard before. Smith, with other blues singers, enriched jazz, giving it a flexible musical structure, a steady rhythm, and psychological depth.[71]

## THE BIG BAND SOUND

By the early 1920s, Harlem's small club bands had absorbed the sounds and rhythms of the blues and the pulsating rhythm and improvisation of New Orleans and Chicago jazz. But the large dance bands, which played at the Roseland Ballroom, the Savoy, and the Cotton Club, were discouraged from playing improvised jazz that swung. Many of Harlem's best jazz players often found themselves unhappily playing stilted, rhythmically monotonous popular tunes for their dance audiences. The initial impulse that pushed New York's dance bands into jazz came from a recording company.

In 1920, Harry Pace, while still a partner in Pace-Handy Music Company, hired Fletcher Henderson to demonstrate sheet music for customers. When Pace formed his own Pace Phonograph Company, he took Fletcher Henderson with him as music director. Henderson's responsibilities involved organizing and leading backup bands for recording sessions at the company's Harlem studio on West 138th Street. As a publicity gimmick, Pace created a nine-piece touring band, the Black Swan Troubadours, with Henderson as director and Ethel Waters as featured singer. With the demise of the Black Swan label in 1923, Henderson, with Coleman Hawkins on saxophone, Kaiser Marshall on drums, Charles Dixon on banjo, and Don Redman on saxophone, recorded as the Fletcher Henderson Orchestra. Following a recording session at Columbia, the band talked Henderson into what became a successful audition as house band for the Club Alabam, a cellar club on West 44th Street.[72]

At Club Alabam, Henderson's jazz band competed with the flashy, high-powered Times Square entertainment industry, epitomized by Paul Whiteman's Orchestra. Henderson, with Don Redman as his arranger, responded to the challenge, creating the modern "swing" orchestra that would dominate jazz for the next twenty-five years. Tall, thin, and retiring, Fletcher Henderson seemed poorly cast in his role as originator of the swing orchestra. Henderson's parents, who taught school in Georgia, had sent him to Columbia University for graduate study in chemistry. Skeptical of his chances of success, the genteel Henderson accepted the position at Pace-Handy. When Henderson followed Harry Pace to Black Swan, the blues craze had just begun. Although trained as a classical musician, Henderson readily agreed to accompany Black Swan singers. In the process, he became a competent jazz pianist, accompanying Ethel Waters on her 1921 hit *Down Home Blues*, which sold more than a hundred thousand copies.

When Black Swan folded, Henderson inherited a top-flight jazz band and easily secured the job at Club Alabam. In August 1923, the Fletcher Henderson Orchestra played its radio debut on WDT in New York. A year later, shortly after Whiteman's Aeolian concert, the Henderson orchestra landed a long-run engagement at the Roseland Ballroom on Broadway at 51st Street, a popular whites-only dance hall whose shows were broadcast live by Radio WHN. In the meantime, the orchestra cut several important records for Columbia, including the band's theme song, the jazz classic *Copenhagen*. No longer simply a black Harlem jazz band, by 1925 the

Fletcher Henderson Orchestra had achieved a national reputation second only to Paul Whiteman's.[73]

Few now consider Whiteman's orchestra a jazz band. To most white listeners in the 1920s, however, the exuberant and polished Whiteman sound was jazz, and the 1924 Aeolian Hall concert solidified its image as a jazz band. Moreover, Whiteman respected and listened attentively to the top black jazz bands, borrowing ideas and even purchasing their arrangements. He also employed the very best white jazz players, including Bix Beiderbecke, Frank Trumbauer, and Tommy and Jimmy Dorsey. Whiteman's most important contribution to jazz, however, was his restructuring of the large American dance band along the lines of European orchestras.[74]

Under the direction of Ferde Grofé, Whiteman's orchestra did, at times, play jazz, complete with polyrhythms, syncopation, and even some improvisation. Grofé divided Whiteman's thirty-plus-piece orchestra into brass, reed, and rhythm sections. On cue, each section played in unison, contrapuntally, or in response to another section. Grofé interspersed improvised jazz solos throughout the orchestra's arrangements, so that when Bix Beiderbecke or Jimmy Dorsey stood to play, they played jazz. Finally, Whiteman acquired arrangements from jazz bands such as Fletcher Henderson's, making his orchestra sound as if it were playing original improvised jazz. For audiences unfamiliar with jazz, Whiteman's off-the-rack symphonic jazz sounded genuine. But even the orchestra's jazziest pieces, such as *Changes* and *Lonely Melody,* with their energetic syncopated rhythms, did not truly swing, nor did the Whiteman orchestra, except for its soloists, improvise. Despite its polished sound and technical proficiency, Whiteman's music lacked the emotional depth, the nondiatonic tones, the rhythmic drive, and the spontaneity of blues-based jazz.[75]

Fletcher Henderson enjoyed the same advantages growing up that Whiteman had. They both came from cultivated middle-class families who had provided them with extensive training in European music. Both came to jazz as adults, learning it as a "second" music. Neither was ever considered a top jazz musician. Henderson, however, had one advantage denied Whiteman. He lived in Harlem and associated on a day-to-day basis with self-taught jazz musicians. In Harlem, Henderson could not escape the ever present influence of jazz. Harlem imprinted on Henderson the inherent beauty and power of a blues-based syncopated jazz. Unlike Whiteman, Henderson could not be satisfied with a glitzy show band that played only commercially successful, but ersatz, jazz.

As the leader of a Harlem jazz band playing in Times Square, Henderson structured his band so that it could hold its own with Whiteman and other downtown white bands. But he did so without sacrificing the originality or the blues feeling and rhythm of jazz. Arranger and saxophonist Don Redman enabled Henderson's band to play jazz successfully on Times Square. Conservatory trained, the stocky, immaculately dressed Redman served as codirector of the Fletcher Henderson Orchestra until 1927. Under Redman's guidance, Henderson reorganized the orchestra, much as Grofé had restructured Whiteman's, into reed, brass, and rhythm sections. Unlike Grofé, Redman wrote true jazz arrangements that allowed improvised solos, calls and responses, New Orleans–derived riffs, and short, repeated rhythmic refrains. Redman freed Henderson's stellar instrumentalists—Louis Arm-

strong, Coleman Hawkins, and Joe Smith—to play their best jazz within a larger composition that was greater than the sum of its solos. The Fletcher Henderson Orchestra, playing Redman's arrangements of *Copenhagen, Henderson Stomp, Hop Off, The Stampede, Sugar Foot Stomp,* and *Go 'Long Mule,* quickly established itself as a top jazz orchestra. Its nightly appearances at Roseland, its regular broadcasts, and its steady record production enabled the Fletcher Henderson Orchestra to become the prototype for the big swing bands of the 1930s and 1940s.[76]

For all of Redman's efforts, however, the Henderson orchestra did not swing until Louis Armstrong joined it in the summer of 1924. Armstrong had grown up in New Orleans, coming to Chicago to play second cornet for Joe Oliver's Creole Jazz Band. Almost immediately, Armstrong established himself as the equal of Chicago's best jazz horn players. Henderson, aware of Armstrong's talent, offered him a position. The prospect of playing in New York with Henderson's up-and-coming orchestra proved enticing, and for a little more than a year, Armstrong played trumpet for the Fletcher Henderson Orchestra. Armstrong gave the Henderson orchestra the best jazz soloist in the country, teaching the entire Henderson band to swing to an underlying pulse that gave their music rhythmic momentum.[77]

In 1928, Fletcher Henderson's good fortune finally ran out. Henderson was seriously injured in an automobile accident, and during his recovery he lost control of his orchestra. For the next two years, the band scraped by on its reputation. But after 1930 it disintegrated, and Henderson's best musicians went elsewhere. Even as the Henderson orchestra fell into disarray, in Harlem, at the Cotton Club, Duke Ellington had embarked on a career that ultimately overshadowed every other jazz performer and every other American composer.

## DUKE ELLINGTON

Edward Kennedy Ellington grew up in a middle-class family in Washington, D.C. Pampered by his parents, like many other middle-class children, Ellington endured music lessons but learned little except that he preferred to play baseball. As a teenager Ellington was drawn to the ragtime that he heard in local bars, cajoling the ticklers to teach him the keyboard. After mastering three or four popular songs, he and a group of friends—Sonny Greer, Toby Hardwick, Arthur Whetsol, and Elmer Snowden—formed the Washingtonians, who gigged for Washington-area parties and dances. Ellington became an accomplished ragtime pianist, impressing James P. Johnson by playing Johnson's *Carolina Shout* in true Harlem stride fashion. In 1922, the Washingtonians headed for New York, eager to break into big-time jazz. The Harlem jazz scene proved difficult to crack, but from the first, the regally handsome, always well-mannered, and immaculately dressed Ellington caught the eyes of onlookers and no doubt eased the group's introduction to New York's nightlife.

We went out every evening regardless of whether we had money or not, and we met all the hip guys. I got a big thrill when I strolled into the Capitol Club at 140th and Lenox, down in the basement and found "the Lion" working there. We went the rounds every night, looking for the piano players. We didn't have any gold, but then Sonny was good at that sort of thing. He would stride in, big as life, and tell the man . . . "Hello, Jack, I'm Sonny. I know So-an-So,

and he told me to look you up. Meet my pals, Duke and Toby." Then the man would hear that Duke played a whole lot of piano. I'd sit down after "the Lion," and then Fats Waller would sit down after me.[78]

After a few weeks without gigs, and out of money, the band caught the train back to Washington. Having made up his mind to become a jazzman, Ellington gave up a scholarship to attend the Pratt Institute of Art, turning his full attention to jazz. On hearing a rumor of a band opening, the Washingtonians headed back to New York. This time, just as they were about to give up hope, Ada "Bricktop" Smith took them under her wing, securing the Washingtonians a job at Baron's, one of Harlem's top clubs. In September 1923, the downtown Hollywood Café, later renamed the Kentucky Club, offered the Washingtonians a contract as its house band.[79]

The Washingtonians had arrived. Located in the Times Square district, the Hollywood Café offered its customers a live jazz band and a "hot" revue of light-brown showgirls. Radio station WHN broadcast the performances after 2:00 A.M. "All that air-time helped to build up our name," Ellington explained.[80] During the band's Hollywood Café–Kentucky Club gig, two events transformed the Washingtonians from a successful popular dance band into a premier jazz orchestra. In 1923, Ellington hired trumpeter Bubber Miley to replace Arthur Whetsol, who had resigned to attend Howard University Medical School. And, in 1925, Irving Mills became Ellington's agent.[81]

Bubber Miley's family had moved from South Carolina to New York, where his three sisters sang professionally as the South Carolina Trio and Miley played briefly with the Carolina Five. Before joining Ellington, Miley had accompanied Mamie Smith, touring with her through the South. Miley's muted trumpet, in combination with the "growling" trombone of Joe "Tricky Sam" Nanton, created the "jungle" sound that became the signature of the Ellington orchestra. The growling, sometimes haunting, often salacious horns of Miley and Nanton infused Ellington's music with an earthy, gutbucket, blueslike tone. Not content with a novelty band that relied on "weird" noises, Ellington selectively used the exotic sounds of Miley, Nanton, and later, Cootie Williams to compose dozens of original jazz compositions.[82]

In a quite different manner, Irving Mills freed Ellington to concentrate on music. In the 1920s, African Americans remained on the periphery of American entertainment. In New York, public theaters shunted blacks into racially segregated upper balconies, and the Times Square clubs denied them admission even to shows in which black bands, singers, and dancers performed. Most of Harlem's top clubs were owned by whites and excluded blacks. Through race records, black musicians secured access to their own market, but the top white bands earned big money from movie contracts, record sales to white buyers, and bookings at colleges and hotels. Mills, an experienced white agent, promised to spare Ellington such concerns. For half of Ellington's net, Mills negotiated recording sessions, secured club dates, dealt with movie directors, arranged publicity, and scheduled national and international tours. While Mills' take was high, half of a lot proved much more than most of a little. And Mills made sure that both he and Ellington received a lot, more than any other black entertainer of the time.[83]

In addition to securing its fame and fortune, Mills helped reorganize the band. The Washingtonians, like many other pickup jazz bands, functioned cooperatively. Initially, the band as a group hired new musicians, fired problem members, approved engagements, and divided up the profits. When the Washingtonians accepted the Hollywood Café–Kentucky Club engagement they did so as a band. Ellington did not become the band's director until Elmer Snowden resigned at the start of the Hollywood gig. But Irving Mills cared little about the band's cooperative organization. He negotiated a contract with Ellington, not the band. If the band wanted to benefit from Ellington's relationship with Mills, they had to accept Ellington's leadership and become members of Duke Ellington and His Famous Orchestra, with the emphasis on "Ellington" and "His." Mills gave Ellington the organizational authority to shape a band consistent with his musical vision.[84]

Confident and in control, after 1926 Ellington took advantage of every opportunity. His big break came a year later, when the Cotton Club refused to renew the contract of its house band and approached Mills, who accepted the club's offer on Ellington's behalf. The Cotton Club, owned by mobster Owney Madden, insisted that Ellington start immediately, even though the orchestra was under contract for a short engagement in Philadelphia. When the Philadelphia theater owner refused to release Ellington from his contract, according to legend, Madden asked Philadelphia mobster "Boo Boo" Hoff to intervene. Hoff's emissary reportedly explained to the theater owner, "Be big or you'll be dead!" The next night Duke Ellington and His Orchestra premiered at the Cotton Club for what turned out to be a five-year engagement.[85]

Owney Madden had purchased the Club Deluxe in 1922 from black prizefighter Jack Johnson, renaming it the Cotton Club and establishing its whites-only policy. Johnson hoped to cash in on the current fad of black entertainment, demonstrated by the success of the all-black Broadway musical revue *Shuffle Along*. The Cotton Club, with its "jungle" decor, featured fast-paced floor shows, elaborate sets and costumes, sophisticated lighting, tall, beautiful, light-brown chorus girls, and jazz. Customers watched the 12:00 A.M. or 2:00 A.M. Ziegfeld-inspired floor shows while dining or dancing to the band's catchy music. By the mid-1920s, the Cotton Club had become a celebrated New York night spot, resplendent with Broadway and film stars, sports celebrities, gangsters, politicians, and Carl Van Vechten's wide-eyed white guests. At the Cotton Club, the curious watched the rich and famous mingle with the exotic and dangerous. Through its nightly radio broadcasts, the Cotton Club became nationally famous, its entertainers national personalities—an ideal situation for a young, ambitious band director like Duke Ellington.[86]

Mob ownership did not dampen Ellington's enthusiasm for the Cotton Club. Wherever jazz thrived, whether in New Orleans, Kansas City, the South Side of Chicago, San Francisco's Barbary Coast, or Harlem, it did so in association with illicit entertainment. Mob-owned clubs, with their jazz bands, catered to their clientele's appetite for forbidden amusement. Moreover, black jazz musicians, like gangsters, were social outcasts, who shared a disdain for respectable society and conventional morality. Many gangsters appreciated good jazz, and on the whole, they treated jazz musicians with regard, paying them well. Jazz pianist Lil Harden made

The Duke at the Cotton Club. The Duke Ellington Orchestra (1920s). Photograph ©Duncan Scheidt Collection

$2.60 a night playing at a legitimate Memphis dance hall, in contrast with the $250.00 a week she earned at the mob-owned Dreamland on Chicago's South Side. Saxophonist Bud Freeman explained the clubs' attraction for jazz musicians: "The better hotels and restaurants employed pianists and violinists who played . . . very old fashion music. We were happy to have a [mobster] place to play the kind of music we loved."[87]

At the Cotton Club, Duke Ellington and gangster Jerry Sullivan became fast friends. Sullivan arranged for his bodyguard to chauffeur Ellington around New York in a bullet-proof limousine, insured that when Ellington played out of town no one bothered him, and arranged for him first-class accommodations at otherwise segregated white hotels. Ellington was well paid, enjoyed artistic discretion, was treated royally, and enjoyed protection wherever he went. Sullivan, in turn, enjoyed the satisfaction of being the friend and patron of the most important musician in the country, whose reputation soon exceeded even the Cotton Club's. Madden's Cotton Club acted as patron to Ellington and other jazz musicians, much as Stieglitz's 291 had patronized New York avant-garde painters, but Madden paid better, and Ellington's influence and fame extended far beyond avant-garde circles.[88]

By 1930, the Ellington orchestra had earned a national reputation. It featured Harry Carney, Johnny Hodges, and Barney Bigard on clarinet and saxophone, Sonny Greer on drums, Joe "Tricky Sam" Nanton and Juan Tizol on trombone, Fred Guy on banjo and guitar, Wellman Braud on bass, Freddie Jenkins and Cootie Williams on trumpet, and Ivie Anderson as principal vocalist, with Ellington on piano. Of its twelve members, only Bigard and Braud were New Orleans trained. Ivie Anderson came from Los Angeles, and Cootie Williams had grown up in Pensacola. The remainder were eastern in their jazz training. Johnny Hodges and Harry Carney came from Boston, Sonny Greer from New Jersey, and Joe Nanton from New York. Although Tizol was born in Puerto Rico, he had learned his jazz with Ellington in Washington, D.C.[89]

The Ellington orchestra was a solidly eastern organization, and much of its distinctive "jungle sound"—melodic more than rhythmic, more compositional than swinging—derived from its eastern origins. Bubber Miley, frequently credited with defining the Ellington sound, was born in South Carolina and had lived in New York from the age of six. The orchestra's two New Orleans members, Bigard on clarinet and Braud on bass, both hired in 1927, might have been added, as Armstrong had been to the Henderson orchestra, to give the Ellington band more New Orleans–derived swing. Their influence on the band was at best marginal. More important were its New York influences, in particular, James Reese Europe and the Harlem stride piano tradition, of which Ellington was a direct heir.[90]

Ellington possessed a fertile musical imagination and a gift for collaborative work. Because Ellington lacked training in composition, he did not write out his music. He offset this disadvantage with his uncanny ability to select musicians for particular sounds, exploiting his band members' musical talents to compose and to arrange. Ellington took big-band jazz one step further by allowing his musicians to improvise on the melody. Each member contributed phrases and ideas to a pre-arranged composition. A few—Bubber Miley, Johnny Hodges, Barney Bigard, and Harry Carney—composed whole pieces on their own, including some of the orchestra's best-known songs, such as *Mood Indigo* (Bigard and Ellington), *East St. Louis Toodle-OO* (Miley and Ellington), *Doing the Voom Voom* (Miley and Ellington), *Rockin' and Rhythm* (Carney and Ellington), and *Rent Party Blues* (Hodges and Ellington). Ellington's creativity stemmed directly from the orchestra. He and his orchestra were integrated parts of a whole.[91]

Finally, however, the band's greatness lay with Ellington himself. Ellington was no isolated genius, working alone and producing compositions unrelated to the world around him. He listened attentively to other bands, visited downtown ballrooms, and watched Broadway shows, always seeking new ideas and sounds. Realizing that he lacked the skills sufficient for complex compositions, Ellington sought out James Reese Europe's old friends from the Marshall Hotel days, Broadway veterans Will Marion Cook and Will Vodery. Cook, a graduate, like William Grant Still, of Oberlin College Conservatory, taught Ellington to arrange conventional melodic sequences in unexpected ways. Equally important, Ellington listened attentively to Harlem's self-taught jazz musicians, whose music exuded the ideas and sounds of African American music. Through the use of unusual chords, a preference for the

minor scale, unorthodox tonal sequences, and a bent for dissonance, Ellington expanded the range of jazz.[92]

Two songs—*East St. Louis Toodle-OO* and *Black and Tan Fantasy*—displayed the range of Ellington's talent. Composed by Bubber Miley in the standard thirty-two-bar form of popular music, *East St. Louis Toodle-OO* (pronounced "toadle-owe") contained three themes, in B-flat minor, A-flat, and E-flat. Recorded in November 1926, in memory of Toad, a black East St. Louis derelict whom Ellington had glimpsed from his train window, the piece alternated between haunting minor and bright major themes, creating a series of contrasts that resembled a train streaming past a succession of landscapes. Constantly on tour across the country, Ellington saw and felt a world that, as an African American, he could neither touch nor join. Nearly a third of Ellington's compositions were train songs. Ellington's train music also expressed the mood of a man who had grown up in a middle-class family but as an adult worked in Harlem's notorious nightclubs, a sensitive black man caught in a hostile white world, and a composer striving for artistic recognition in a society that accepted him only as a talented entertainer.[93]

Less commercially successful than *East St. Louis Toodle-OO,* in 1927, Ellington recorded *Black and Tan Fantasy,* whose title and tone questioned racial segregation. At the time, critics, especially European critics, considered *Black and Tan Fantasy* Ellington's best work. At the outset of the song, Miley and Nanton took the lead playing a minor theme, emulating a funeral dirge. The song unexpectedly switched to a lighter tone, followed by a series of blues solos that made up much of the remainder of the song, creating a somber, ethereal mood, and concluded with a paraphrase of Chopin's *Funeral March* ("Pray for the dead and the dead will pray for you"), a device that appealed to critics but was in fact a gimmick borrowed from Jelly Roll Morton's *Dead Man's Blues.*[94]

Significantly, *East St. Louis Toodle-OO* and *Black and Tan Fantasy* authenticated Ellington's early maturity prior to the band's historic Cotton Club engagement. In its four-year stint at the Cotton Club, the Ellington orchestra recorded some of its most important songs, including *Doin' the Frog, The Moochie, Tiger Rag, Double Check Stomp, The Cotton Club Stomp, Rockin' in Rhythm, Creole Rhapsody, Ring Dem Bells,* and *Mood Indigo.*[95] By the time the orchestra left the Cotton Club in 1932, it had established itself as a preeminent jazz band. Despite efforts by other orchestras, such as Luis Russell's, to emulate it, none could duplicate the Ellington sound.[96]

Ellington did not just compose well-executed, highly polished show-music jazz. To be sure, he was a commercial entertainer. At the Cotton Club, twice every night, Ellington faced a demanding, impatient audience, and with few exceptions, night after night he delivered. Drawing on New York's rich commercial and symphonic tradition and having studied under James P. Johnson, Willie "the Lion" Smith, and Fats Waller, Ellington combined the sophisticated sound of New York music with the funky sounds and blues feel of Harlem. More than just good dance music that swung, for hours audiences listened to Ellington's opulent, often contemplative, jazz.[97]

Much of Ellington's music derived from his fertile imagination, but he also con-

sciously drew on his surroundings, particularly his African American identity. Although Ellington rarely wrote conventional blues, his music faithfully sustained a blues mood. The list of his song titles reads like a sampler of Harlem-inspired African American culture—*Jungle Nights in Harlem, Stevedore Stomp, Creole Rhapsody, Mood Indigo, Black and Tan Fantasy, Black Beauty, Bojangles, Across the Track Blues, Take the A Train, East St. Louis Toodle-OO, Ko Ko* (in reference to Congo Square, in New Orleans, where slaves had congregated), and *Perdido* (the street in Storyville where Louis Armstrong learned to play jazz). In an interview, Ellington explained the relationship between Harlem and his music: "And take my *Harlem Air Shaft*. So much goes on in a Harlem air shaft. You get the full essence of Harlem in an air shaft. You hear fights, you smell dinner, you hear people making love. You hear intimate gossip floating down. You hear the radio. An air shaft is one great big loudspeaker. You see your neighbor's laundry. You hear the janitor's dogs. The man upstairs' aerial falls down and breaks your window. You smell coffee. A wonderful thing, that smell. An air shaft has got every contrast. . . . I tried to put all that in *Harlem Air Shaft*."[98]

Duke Ellington and other New York jazz musicians brought Harlem and African America into American popular music, forcing white Americans to reassess their racial categories. When Carl Van Vechten first encountered Bessie Smith, he heard in her blues the voice of a primitive people, psychically rooted in what he imagined was a primitive Africa. But during the Jazz Age, white music critics and audiences alike learned to hear the complexities inherent in blues and jazz. As Leopold Stokowski, conductor of the Philadelphia Symphony Orchestra, noted, "Jazz has come to stay because it is an expression of the times, of the breathless, energetic, superactive times in which we are living. . . . The Negro musicians of America . . . are not hampered by conventions or traditions, and with their new ideas, their constant experiment, they are causing new blood to flow in the veins of music. The jazz players make their instruments do entirely new things. . . . They are pathfinders into new realms."[99]

After World War I, despite persistent and pervasive racism, American culture became suffused with African American music. Duke Ellington, Bessie Smith, Fletcher Henderson, and Fats Waller were much more than Harlem's ambassadors to white America. They altered American music, and in so doing they altered American culture. The modern movement, since its inception, had sought to deprovincialize Western art. Moderns wanted art to speak to contemporary life, not simply to the middle and upper classes of Europe and America. But their art remained imprisoned within Western categories. Before Ellington, explained Oklahoma-born New York writer Ralph Ellison, "our most highly regarded musical standards remained those of the Europe from which the majority of Americans derived. Fortunately, however, not all Americans spring from Europe (or not only from Europe), and while these standards obtained, Negro American composers were not really held to them, since it seemed obvious that blacks had nothing to do with Europe. . . . Ellington was at odds with European music and its American representatives, just as he was at odds with the racial attitudes of the majority of the American popula-

tion, and while primarily a creative composer, he was seen mainly in his role as entertainer."[100]

In the Great Migration to northern cities, southern blacks carried with them far more than their meager material possessions. Leaving the rural South, they brought to America's northern cities a rich, complex, evocative culture. Drawing on their West African and southern folk roots, African American blues singers and jazz musicians gave American music a non-Western mode of expression. African American sounds, rhythms, and values became a part of American culture. Complex and demanding because of its origins in folk and commercial entertainment, in New York jazz addressed a racially diverse audience, challenging the boundaries between art and entertainment, Western and non-Western, respectable and African American, white and black. Blues-inspired jazz created a musical foundation for modern culture, at once urban, secular, erotic, improvisational, and inclusive.[101]

New York jazz musicians reformulated jazz, making it accessible to white listeners attuned to American popular music. Ellington joined Langston Hughes, Alain Locke, Carl Van Vechten, and other participants in the Harlem renaissance to bridge the racial chasms that fragmented modern life. Refusing to allow their racial ghetto to imprison them, Harlem's jazz musicians reworked New Orleans–Chicago jazz into a popular music capable of elaboration and refinement. Working artisans more than patronized artists, Harlem's jazz musicians thrived in the turbulence of the New York entertainment world. Their jazz, while describing a racial experience alien to most of their listeners, expressed the excitement and the danger, the promises and the brutalities, of modern life. Jazz represented a modern American art that expressed individual creativity and personal freedom. Exploiting the rich legacy of African American music, New York commercial entertainment, and the European symphonic tradition, Harlem's jazz musicians created an identifiably American and modern music. In the 1920s and 1930s, however, Harlem and most of its residents remained apart, distant, from the rest of the city. Despite the pervasive presence of jazz, racism continued to separate New York's modern artists. Not until the 1950s would the full significance of the Jazz Age become realized in New York Modern. In the immediate future, however, New York artists confronted the political and economic crises of the 1930s. A new day for New York's African American artists remained on a distant horizon.

# Modernism versus New York Modern
## MoMA and the Whitney

The Museum of Modern Art and the Whitney Museum of American Art were founded one year apart—MoMA in 1929 and the Whitney in 1930. Together, they engaged in an aesthetic and political dialogue—between the Whitney's eclectic and inclusive understanding of New York Modern and the prescriptive, neoacademic modernism of MoMA. The architecture of the two museums expressed the difference— the Whitney's open and informal setting welcomed all, whereas MoMA's rendition of the International Style remained aloof and refined.

The distance between MoMA and the Whitney, however, signified much more than dissimilar styles and tastes. Hierarchical in structure and formalistic in approach, under the leadership of Alfred Barr and Nelson Rockefeller, MoMA canonized a variation of European modernism—in particular, the painting and sculpture of the School of Paris and the International Style of architecture—as *the* modern. In contrast, the matriarchal Whitney functioned as an extended family that embraced all expressions of modern American art, from the urban realism of the Eight to the abstract compositions of Stuart Davis. The difference between the two museums became especially evident during the depression that stalled the American economy in the 1930s. The Whitney pioneered the New Deal art programs that offered relief to unemployed artists, promoted public art, and championed the "American scene," while MoMA turned inward, refining its modernist canon, enriching its collection, and promoting its high modernist International Style architecture.

## NEW YORK ARCHITECTURE IN THE JAZZ AGE

New York's construction boom of the 1920s resulted in an extraordinary array of new skyscrapers and a variety of new architectural styles. Ely Kahn, Irwin Chanin, and Raymond Hood designed vibrantly eclectic buildings—the Radiator, Century, and Chrysler Buildings—that celebrated New York's modernity and its diversity. The

extravagant proliferation of tall buildings following World War I paralleled the compression of more people into Manhattan than ever before, defying the city's efforts to control and manage growth. In 1915, the Equitable Life Assurance Society, in Wall Street's financial district, had built a thirty-nine-story office building that covered a full city block. The Equitable Building's 1.2 million square feet of office space, which housed fifteen thousand workers, created an uproar. Fearing the obliteration of sunlight by such massively tall structures, city officials, in the 1916 "set-back" ordinance, prohibited the construction of any new building that took up more than twelve times the area of its site. The set-back law marked the end of the "great box" and inaugurated Manhattan's postwar era of "wedding cake" skyscrapers.[1]

In the 1920s, the set-back ordinance, combined with the demand for prime commercial and office space, forced New York architects to question the efficiency of the beaux arts style. The elegant, civic-oriented architecture of McKim, Mead, and White no longer seemed economical. The leisurely ornamentalism of beaux arts, with generous public plazas, lost favor as businesses demanded that architects design utilitarian space at lower cost.[2] By the 1920s the Gothic-clad Woolworth Building had already become an anachronism.[3] A variety of architectural styles displaced New York's beaux arts historicism as the city's postwar architects adopted self-consciously modern styles. Using new materials and shapes, Raymond Hood and others created a "free-form eclecticism" that included the jazzy deco tops on Chanin's Majestic and Century apartment buildings on Central Park West, the Chrysler Building's gargoyles that mimicked the company's automobile hood ornaments, and the "proto-jukebox" look of Hood's McGraw-Hill Building.[4] Much of the inspiration for these departures from the beaux arts tradition derived from the 1925 *Exposition des Arts Decoratifs.*

The Paris exposition, held in Le Corbusier's Pavilion de l'Esprit Nouvelle, featured the work of Soviet constructivists, Viennese modernists influenced by the Dutch de Stijl movement, and Parisian cubists, especially Fernand Léger. Intended to demonstrate modern styles for a new Europe, the exposition emphasized the role of machine-age forms, textures, ornaments, and colors as expressed in the decorative arts.[5] The exposition's combination of geometric shapes and industrial materials encouraged New York architects to experiment with a variety of modern styles and designs, animating New York Jazz Age architecture.[6]

Raymond Hood typified New York's postwar architects. Rhode Island born, Hood attended Brown, MIT, and the Ecole des Beaux-Arts before settling in New York, where he first designed radiator covers. In 1921, John Mead Howells, a colleague from the Ecole des Beaux-Arts, asked Hood to collaborate on a design for the *Chicago Tribune* competition. Howells, too busy to submit his own design, promised Hood the cash award if their collaborative entry won the competition. When their design took the prize, Hood instantly became the most celebrated American architect of the decade. In New York during the 1920s, Hood designed the Radiator, the *Daily News,* and the McGraw-Hill Buildings, each in a different modern style, each embodying the commercial spirit of New York in the 1920s.[7]

The McGraw-Hill Building, completed in 1931, incorporated a variety of modern architectural ideas into a unified design. Its banded windows wrapped around the

building's corners, creating a curved horizontal, which Hood integrated into the building's five stepped vertical levels. Hood washed his tower in color. Deep blue and vermilion accents, bisected by vertical blue-green stripes, recast the industrially inspired design into a contemporary sculpture at one with the spirit of the *Exposition des Arts Decoratifs*. Hood, who died in 1934 just after the completion of his RCA Building for Rockefeller Center, had become the city's great eclectic modern architect.

The Great Depression devastated New York's building industry. The piers of the uncompleted George Washington Bridge stood like desolate hulks of grey stone and steel rising above the beleaguered city. The bridge was designed in 1923 by Swiss-born architect Othmar Hermann Ammann, chief engineer for the newly created Port Authority, with Cass Gilbert as the consulting architect. The original plan called for two granite and concrete towers, whose "elemental classicism" supported the cables, and a two-level roadbed for the thirty-five-hundred-foot span.[8] The twin towers, designed by Gilbert, were to house observation decks and restaurants. The onset of the depression, however, led to a more simplified design. Gilbert's observation decks and restaurants and ornate granite sheathing were omitted, which created a structure that conformed to the modern dictum that form follows function and which unintentionally ended New York's playful art deco era.

In contrast, the monumental Rockefeller Center was designed and executed in a Spartan, modern style characteristic of the 1930s. Bounded by 48th and 51st Streets between Fifth and Sixth Avenues, the fourteen-building Rockefeller Center was New York's only "large and permanent . . . project planned and executed between the start of the Depression and the end of the Second World War."[9] John D. Rockefeller Jr. built the center on land leased from Columbia University. In the late 1920s the construction of the Queens lines of the Independent subway had created such a noisy howl that real estate values in the neighborhood stagnated. The Rockefellers believed that the center would revitalize Sixth Avenue, rescue it from its dreary seediness, and create an urban artery extending from Greenwich Village to Central Park.

Rockefeller Center covered six square blocks and comprised office, entertainment, commercial, and public spaces. Initially proposed in 1930, the complex took nine years to complete. Hood and his architectural associates overruled John D. Rockefeller Jr.'s preference for Gothic architecture, insisting on unadorned, grey granite facing. The RCA Building, 850 feet tall, was Hood's contribution to Rockefeller Center.[10] It dominated the center's smaller structures, casting a shadow for blocks. To its east lay the center's low Maison Française and the British Empire Buildings along Fifth Avenue, separated by the Channel Gardens, which offered a shady walkway and an oasis for shoppers and office workers. The Channel led to a sunken restaurant and ice-skating rink, creating an open courtyard in front of the RCA Building, watched over by Paul Manship's statue *Prometheus*.

Rockefeller Center was completed at the end of the decade. The *WPA Guide to New York* noted that the center's buildings were as distinctive to New York as the Louvre was to Paris.[11] Massively elegant, Rockefeller Center gave New York a major new commerce and entertainment complex and considerably enhanced the Rockefeller family's extensive midtown real estate holdings. Radio City Music Hall,

Massive elegance and
urban renewal. Artist's
sketch of Rockefeller
Center (1931).
©*Museum of the City
of New York*

the center's most public space, opened in December 1932, at the depth of the depression.

During that Christmas week, rain and fog, brought in by an unseasonable warming trend, shrouded the city.[12] The opening of Rockefeller Center's Radio City Music Hall brightened the otherwise dreary season. Ballyhooed as the entertainment capital of the world, the cavernous hall accommodated sixty-two hundred patrons and boasted an innovative revolving stage with two hundred spotlights and a hydraulic orchestra pit. The hall's entry foyer, 140 feet long and 45 feet wide, featured marbled walls that rose sixty feet above the art deco interior; murals by Stuart Davis

and Georgia O'Keeffe graced the rest room walls—Davis's in the men's, O'Keeffe's in the women's.

The cavernous music hall became an immediate New York landmark. The interior of the building, which was housed next to the as yet uncompleted RCA Building, recalled the playful geometric, expressionistic influences of the earlier work of architects Eric Mendelssohn and Joseph Urban. Near the commercial center of Manhattan, with its art deco office and residential buildings, the music hall looked back to the eclectic architecture of the 1920s, in contrast with the stern monumentalism of the remainder of Rockefeller Center. Radio City Music Hall's opening night, part popular entertainment, part high culture, also echoed the carefree Jazz Age.

S. L. Rothafels—"Roxy"—presided over Radio City's December debut. For the occasion, the legendary showman assembled a four-hour extravaganza that showcased New York entertainment. Roxy introduced Radio City's resident company of eighty singers and sixty ballet dancers, featuring the soon-to-be-renamed Roxyettes.[13] In addition to the veteran comedy act of Weber and Fields, first-nighters heard an aria sung by Vera Schwartz and applauded the gospel offerings of the colorfully robed Tuskegee College Choir. In the midst of the lavish entertainment setting, Martha Graham executed a somber modern dance, included by Roxy to add a "little class" to the opening night.[14]

But in Radio City, a little modern art went a long way. Prior to the opening, Roxy had removed William Zorach's aluminum sculpture, *Spirit of the Dance,* from the music hall's grand lounge because he was offended both by the sculpture's modern style and by its nudity. Later that evening, at her Downtown Gallery, Edith Halpert proudly displayed a plaster cast of the Zorach work, which Edward Alden Jewell of the *New York Times* called "one of the most significant pieces of plastic art ever produced in America."[15]

The artistic and political comedy that pitted Roxy against Zorach previewed the more serious conflict that raged inside the RCA Building a year later. Nelson Rockefeller had commissioned Diego Rivera to paint a mural in the building's lobby. Bathed in red, *Man at the Crossroads* depicted the destruction of a decadent social order by popular revolution. At the last minute, Rivera painted Lenin's face over that of an anonymous labor leader, provoking Rockefeller's wrath. The twenty-four-year-old Rockefeller, who had spent "night after night" with the Mexican muralist on the scaffold, asked Rivera to replace Lenin with an "unknown young man." When Rivera offered Lincoln surrounded by John Brown and Nat Turner, Rockefeller ordered the mural covered—or, more precisely, "smashed to powder." Rivera accepted Rockefeller's check for fourteen thousand dollars before being escorted out of the building, saying, "I'm of the last generation in which a great fortune will be in the hands of a single family."[16]

Even the economic impact of Rockefeller Center caused controversy. The building added thousands of square feet of office and commercial space to midtown Manhattan at a time of unprecedented economic crisis. The Rockefeller's private skyscraper city combined mixed-use urban planning with monumental high-rise

construction. The scale and unadorned elegance of the RCA Building and its flank-
ing office towers conformed to new architectural ideas and the economic impera-
tives of midtown, but the center's generous public spaces evoked older Beaux-
Arts notions of civic architecture. Opulent appointments, rooftop gardens, deluxe
restaurants, and welcoming walkways drew pedestrians along Fifth Avenue into the
center, giving New York a popular new public space a step above garish Times
Square. But the center's timing could not have been worse. Its empty offices and ex-
pensive furnishings, shops, and restaurants underlined the economic and political
crisis of the depression and heightened public awareness of the distance between
the Rockefellers and the remainder of New York.

## THE MUSEUM OF MODERN ART AND
## THE INTERNATIONAL STYLE

One block north of Rockefeller Center, the Rockefellers donated land for and un-
derwrote much of the cost of the city's newest art museum, the Museum of Mod-
ern Art. Because of high costs, plans for a walkway to link the museum on 53d Street
with Rockefeller Center were never realized. Nonetheless, under the direction of
Alfred Barr, the Rockefellers' Museum of Modern Art thrived during the depression.
Barr used the museum to privilege an art-for-art's-sake redefinition of modernism
that pried modern art away from its radical political roots and its grounding in con-
temporary life.

Founded on the eve of the Great Depression, the Museum of Modern Art insu-
lated itself and its art from the life of most New Yorkers. By the end of the 1930s the
museum embraced a modernist canon that excluded the eclecticism of New York's
Jazz Age architecture, the urban realism of the Whitney Museum, and all manifes-
tations of radical politics. Although the Museum of Modern Art billed itself as a mu-
seum of the experimental and the provisional, over the course of the decade it be-
came the proponent of a modern academicism that sought to essentialize Parisian
modernism, transforming it from an important modern style into an archetype for
all modern art.

The Rockefellers were among a handful of wealthy Americans who had amassed
significant collections of European modernist work, which American art museums
refused to exhibit.[17] Wealthy collectors, the Rockefellers among them, wanted New
York to be the nation's cultural capital and felt that this could not be achieved with-
out a contemporary art museum. Moreover, the Metropolitan Museum of Art, like
the Louvre and the National Gallery, collected only art of established reputation and
value, the art of earlier elites. These modern patrons wanted their collections vali-
dated in prestigious museum collections. They also realized that in the 1930s mod-
ern art could be obtained for bargain-basement prices.

In the late 1920s, New York art patrons Abby Rockefeller, Mary Quinn Sullivan,
and Lizzie Bliss, together with Singer Sewing Machine heir Stephen Clark and
Frank Crowninshield, editor of *Vanity Fair,* founded the Museum of Modern Art.[18]
In what came to be known as the Luxembourg Plan, the founders of the museum
proposed an institution with formal ties to the Metropolitan Museum, analogous to

the Luxembourg's ties to the Louvre and the Tate's to the British Museum.[19] They wanted a museum that identified, acquired, and displayed the original and creative in contemporary art. Having established its value, the Museum of Modern Art would transfer the best of its collection to the Metropolitan for permanent installation.

In the spring of 1929, the founders of MoMA widened their circle to include Conger Goodyear, the director of the Albright-Knox Gallery in Buffalo, Paul Sachs, the director of the Fogg Museum at Harvard, and Alfred Barr, a young art historian and protegé of Sachs. Goodyear also owned an important collection of modern European sculpture. Bliss, Sullivan, and Rockefeller invited Goodyear to be the museum's first president, a position he held for a decade. Paul Sachs, scion of the German Jewish Goldman-Sachs banking family and art historian and curator at Harvard and the Fogg, trained a generation of American art curators and museum directors. Unwilling to spend his time on fund-raising, Sachs nevertheless agreed to help Goodyear select a director.[20] In 1929, John and Abby Rockefeller summoned Goodyear to the Eyre, their secluded Maine residence, to offer him the presidency of their museum.[21] The Rockefellers also invited Alfred Barr, who subsequently resigned from Wellesley College to become the museum's first director.

In the 1930s, with Rockefeller support and Barr's leadership, the Museum of Modern Art became New York's academy of modern art. At the time of MoMA's infancy, modern art lacked a canon or definition. Like the city's eclectic architecture, modern art encompassed an enormous variety of expression and styles. Personal taste and private advice had determined the collections of MoMA's original patrons. Over the next ten years, however, Barr and Goodyear formulated a coherent modern aesthetic that guided MoMA's acquisition policy, its exhibitions, and its publications. By the eve of World War II, under Barr's supervision, MoMA had reduced the rich and diffuse range of modern work to a narrow, almost sectarian, aesthetic.

Barr, however, had begun to develop his understanding of modern art well before MoMA's founding. In 1926, the Harvard *Crimson* had published an article by one Alfred Barr, then a Harvard graduate student in art history teaching at Wellesley College. Barr roundly criticized Boston's art establishment for its conservative, self-righteous, and uninformed stance toward modern art, suggesting that the city needed a modern art museum. "BOSTON A PAUPER," read the headlines in the *Boston Herald* and *Boston Examiner*.[22] For two days Alfred Barr enjoyed the fame of controversy. To alleviate Boston's cultural poverty, Barr prescribed a museum of modern art whose collection would feed the city's established museums. A descendant of a wealthy Detroit family and the son of a Presbyterian minister, Barr had studied at Princeton with Rufus Morey, professor of medieval art, who taught Barr that art was synonymous with civilization. Art expressed the "spirit" of its age. A surrogate religion, art suffused and informed all expressive media of its era—painting, sculpture, architecture, design, and decoration.[23] On graduation, Barr moved to Harvard, where he took his only course on modern art, a study of twentieth-century drawing from Paul Sachs. A year later, Barr began what promised to be a conventional teaching career at Wellesley College, while retaining his Harvard affiliation.

Alfred Barr made his first European pilgrimage in 1927.[24] He visited Paris, Berlin, and Dessau, where he met Walter Gropius and toured the Bauhaus, the experi-

mental art school of Weimar Germany. In the Soviet Union, Barr encountered a Soviet version of the *neue Sachlichkeit,* the "new objectivity," which he associated with the Bauhaus. Later, Barr met with the constructivists Vladimir Mayakovsky and Alexander Rodchenko, whose work he described as "rational, materialistic, aggressively utilitarian," and he dined with experimental film director Serge Eisenstein. Barr characterized Eisenstein and his colleagues as the "idealists of materialism."[25] Fresh from his European education, Barr returned in the fall of 1928 to Cambridge and to his teaching at Wellesley.

Barr's year at Wellesley, together with his visit to the Bauhaus and the Soviet Union, shaped his thought and marked his turn against all associations between art and politics.[26] At Wellesley he taught one of the first American college courses on modern art and organized a show for the Wellesley College museum, entitled *From Daumier and Corot to Post-Cubism.* In the exhibit Barr presented examples of twentieth-century painting that he believed embodied the "modern spirit."[27] The show included paintings by nineteenth-century modern masters Delacroix, Ingres, Gustave Courbet, Manet, Cézanne, van Gogh, and Gauguin, alongside the canvasses of such modern painters as Georges Rouault, Max Beckmann, Léger, Marc Chagall, Matisse, André Derain, Braque, and Picasso. Indifferent to chronology and social context, Barr focused on the development and persistence of those principles he believed embodied the "modern spirit."

Barr argued that modern artists worked by imposing a sense of "order, mind, or spirit" on the sensory world, what Barr characterized as "external nature," a disorderly series of visual impressions. From the raw materials of the "inner" and "outer" experience, the modern artist composed images. Using color and line, light and dark to organize and intensify the elements of painting, artists translated vision and experience into art, resulting in a "visible, permanent record of the external and internal life of the artist." Barr highlighted the agency of the creator in the creative process. Modern artists simplified the visual images of their sources, creating distortion and abstraction and at times eliminating any distinction between inner and outer worlds, producing a distillation or purified essence of their consciousness. Such abstract art became modern art. Modern artists redefined nature. They reorganized it, as the cubists and constructivists had done; or they intensified it, as the fauvists had done; or they infused it with emotional expression in form and color, as the expressionists had done. As Barr explained to his friend and mentor Paul Sachs, "Abstract Art is, now in its purist form, some thirty years old, and although it no longer bears the character of an avant-garde or revolutionary movement, it is still perhaps the most characteristic and original movement in twentieth-century painting."[28]

In the summer of 1929 the founders of the Museum of Modern Art had not yet thought beyond their original rationale for a new museum. For Rockefeller, Bliss, Clark, and even Goodyear, the need for a New York Luxembourg was self-evident. Such a new museum—tentatively called the Manhattan Gallery or the Modern Gallery of Art—would exhibit modern masters, European and American.[29] The first prospectus, dated June 1929, called for shows on Cézanne, Matisse, Eakins, Daumier, Derain, and Toulouse-Lautrec.[30] Additionally, several of the museum's

trustees wanted to display their personal collections. Bliss and Sullivan owned works by important French postimpressionists and early American moderns.

The Museum of Modern Art followed its premier exhibit, *Van Gogh, Seurat, Cézanne, Gauguin,* with the show entitled *Painting in Paris* and a Homer-Ryder-Eakins show in 1931.[31] Between 1931 and 1934 the museum presented a series of modern painting and sculpture exhibits that included German expressionism, the murals of Diego Rivera, and what became the heart of MoMA's collection, French-inspired modernist work.[32] The museum's early shows reflected the taste and judgment of its collector-trustees rather than Barr's modernist aestheticism.

Barr and his Harvard coterie, including Philip Johnson and Henry-Russell Hitchcock, did not fully realize their plans for a museum of modernist art until 1937. By then the Museum of Modern Art had broken ground for its own building, assembled the core of a permanent collection, and institutionally embraced a vague, genteel understanding of "art as civilization." But it was in the earlier 1932 *International Style Architecture,* MoMA's first landmark show, that Barr, Hitchcock, and Johnson committed the museum to their modernist aesthetic of art for art's sake.

Barr, Johnson, and Hitchcock possessed the leisure and the money to discover modern art and architecture. Upper class in background, they shared an easy friendship and collegiality. All came from well-to-do, provincial, Protestant families, and each attended Harvard.[33] During his first teaching job, at Vassar in 1927, Hitchcock had met a young Italian instructor, Margaret Fitzhugh, whom he introduced to Barr at the opening of the Museum of Modern Art in 1929. The next year, Barr and Fitzhugh were married. Philip Johnson, who had inherited a block of shares in the Aluminum Corporation of America, met Barr at Wellesley while attending his sister's graduation. Johnson's mother, a leader in the Wellesley alumnae association, had already told Johnson of Barr's reputation as a teacher. A philosophy student, Johnson had traveled extensively in Europe and had "converted" to the religion of architecture after viewing Europe's classical monuments. Following a visit to the Bauhaus and a meeting with the Dutch architect J. J. P. Oud, Johnson became an acolyte of modern architecture.[34]

The year 1927 was an important one for modern architecture. In Stuttgart, Germany, the great modern architects of Europe—Corbusier, Oud, and Gropius—collaborated to rebuild Stuttgart's Weissenhof suburb as a demonstration of "new" architecture. Combining modern aesthetics—accents on horizontal lines and simplicity of design—with new machine-made materials and a commitment to working-class housing, the Weissenhofsiedlung represented European hopes for a better world. Postwar architectural ideals for social improvement stemmed directly from the Bauhaus and its ethos of democratic socialism.[35]

In their 1932 *International Style* exhibit at the Museum of Modern Art, Johnson and Hitchcock embraced the modern aesthetic of the Bauhaus but studiously disconnected their own modern aestheticism from the Bauhaus's social-democratic politics. The *International Style* show enabled Johnson to articulate the essential principles of modernist architecture. Paying his own salary and expenses, Johnson recruited his close friend, architectural historian Henry-Russell Hitchcock, and architectural critic Lewis Mumford.[36] In early March 1931, Hitchcock and Johnson

presented their proposals to MoMA's trustees. Hitchcock's effort, entitled *Built to Live In,* anticipated the catalog of the show and the language of the exhibition's scholarly publication, *The International Style.* At the same time, Johnson presented a "confidential statement" to the museum's officers and trustees that clarified the show's intent.[37]

"The Museum of Modern Art," Johnson wrote in his confidential memo, "which until now has exhibited only works of painting and sculpture, has long since felt the need for such an [architectural] exhibition. . . . American architecture finds itself in a chaos of conflicting and very often unintelligent building. An introduction to an integrated and decidedly rational mode of building is sorely needed." Johnson declared Ludwig Mies van der Rohe's work the epitome of "the modern."[38] Although Johnson planned to include the work of Raymond Hood and Frank Lloyd Wright in the exhibition, his principles of modernist architecture led him to characterize them as predecessors, rather than as practitioners, of modern architecture.

An academic, Henry-Russell Hitchcock lacked Johnson's flamboyance and his rhetorical vision. Trained in architecture at Harvard, in the 1920s Hitchcock had traveled to Paris to study. To his surprise he discovered the deep chasm between the academic system in which he had been trained and the vitality of modern architects who repudiated the Beaux-Arts tradition.[39] Hitchcock argued that modern architecture could reintegrate technology and aesthetics, which he believed the nineteenth-century beaux arts system had divorced. In 1924 and again in 1925, at the Bauhaus and in Paris, Hitchcock found the most honest architecture, by which he meant architecture that related function and design, in the "factories and laboratories where the builders sought only the perfect technical solution of their practical problems."[40] Hitchcock gave up the practice of architecture to become an architectural historian.

Hitchcock regarded the future warily.[41] In 1927 he contributed critical essays to *Hound and Horn,* the modernist journal edited by his Harvard classmate Lincoln Kirstein.[42] Hitchcock feared that the excesses of the Beaux-Arts tradition might lead to fascist functionalism, wherein the "'modern state' tends to find the virtues of contemporary architecture solely in the perfection of its technics."[43] Hitchcock concluded one article with a Nietzschean prophecy of a time when "all those who are too sophisticated to delight with the mob in gaily attired corpses and too skeptical to seek consolation in the myths of science are left with a world in which technics for technics' sake remain the only intellectual occupation."[44] Fearing the triumph of "surrealism"—by which he meant functionalism—Hitchcock turned to Frank Lloyd Wright and the Dutch architect J. J. P. Oud, who had been influenced by Wright's prairie houses. Hitchcock regarded Wright, whom he likened to Whitman, as a quintessentially American artist, one who combined the spirit of "machinisme" with a wholly American "adoration of nature" in the tradition of Louis Sullivan and H. H. Richardson.[45] Together, Richardson, Sullivan, and Wright constituted what Hitchcock called the new tradition—architectural artists whose strength and vision broke with the tyranny of Victorian romanticism.[46]

In his first work, *Modern Architecture: Romanticism and Reintegration* (1929), Hitchcock reassessed the problems of modern architecture. The new architecture,

he wrote, had reintegrated building with art, and its integrity lent itself to a wide variety of sites and circumstances. It merited attention not because it imposed an orthodoxy but because it reassembled the components of design and construction, art and technics, which had disintegrated during the nineteenth century. Modern architects rejected romantic eclecticism and applied aesthetics to the diverse problems of human dwelling and culture. Praising Lewis Mumford's new book, *The Brown Decades,* Hitchcock agreed with Mumford's central point—the American school of Richardson, Sullivan, and Wright had unified architecture "aesthetically and technically" and were, thus, pioneers of the modern.[47]

In a broad, historically based understanding of modern architecture, Hitchcock included works that utilized contemporary materials and emphasized utility and grace to achieve "practical expression in every line of building." He promised MoMA's audience that in the *International Style* exhibition "the majority of Architects will represent America . . . the others, Germany, France, and Holland."[48] Seeking the roots of modern architecture in earlier work, Hitchcock offered an expansive definition of modern architecture and continued to hold American architecture in high regard. However, Johnson's narrow, apparently apolitical, more European understanding prevailed.

Philip Johnson, a convert to the magic of architecture and to a modernist aestheticism, possessed a facile personality. "I know nothing about sociology," he acknowledged. Fluent in German and extensively traveled, Johnson was particularly taken with Mies van der Rohe's Barcelona Pavilion, a building Hitchcock had seen only in photographs. As he prepared the show, Johnson anxiously tried to make contact with the German architect.[49] Unlike the scholarly Hitchcock, Johnson acted as a partisan for the propagation of a modernist architectural canon. "I'm a second-rate thinker," he said, reflecting on his relationship with Barr and Hitchcock, "but a first-rate talker and propagandist."[50] In the 1930s propagandists thrived—in and out of art.

During the summer of 1931, as he planned MoMA's first architecture show, Johnson worked furiously to obtain exhibition models, plans, and permissions from architects and their patrons. Mies proved especially difficult to reach. Johnson, discouraged, complained, "The other patrons of Mies are mostly Jews and do we want them?"[51] Still, by late 1931 Johnson had persuaded Mies to become the chief planner for MoMA's architecture show and to speak at the exhibition's opening. In August, Johnson traveled to Germany to negotiate with Mies. He considered commissioning Mies to design a special house for the exhibit but abandoned the plan when Barr preferred a model of Mies's Brno house.[52] By fall Johnson realized that Mies would not become his collaborator.

Events in Germany had overtaken the politics of modern architecture. Mies, who had assumed directorship of the Bauhaus, found himself in the middle of Germany's rapidly escalating political crisis and barely had time to send the models and photographs that Johnson wanted.[53] By the opening of the exhibit, in February 1932, Mies was focusing his full attention on salvaging the Bauhaus. A year later, during the week of Hitler's assumption of power, the German architect wrote Johnson proudly that the new Bauhaus was open for business as usual.[54] Mies remained in

Germany another five years, his stark, functionalist architecture accepted by the Nazis because they saw it as neither Jewish nor Communist.

Hitchcock and Johnson, along with Mumford, arranged the show in the museum's three small galleries on the upper floors of the Heckscher Building on East 57th Street. More than thirty thousand visitors squeezed into MoMA's cramped quarters to see the architectural prophecy. The show itself was a rich and complex affair, exhibited on three levels—the first, a demonstration of the wide variety of modern architectural styles, the second, an exhibit of the works, models, and photographs of the four masters, and the third, a section on housing. Hitchcock and Johnson organized and wrote about the first two, whereas the housing segment of the exhibit, isolated physically and politically, was the work of Lewis Mumford, who wrote the text, and Clarence Stein, Henry Wright, and Catherine Bauer. But in its catalog, the show declared European modernists—Oud, Corbusier, Gropius, and Mies—modernism's master builders.[55]

Mies van der Rohe, however, dominated the exhibit. Johnson equated modern architecture with Mies's rational, spare, and sophisticated modernism.[56] The exhibit acknowledged Corbusier as a visionary who ignored planning; it described Wright as the best exponent of nineteenth-century architecture; it accepted Richard Neutra as an important writer; it complimented Hood and William Lescaze for their withdrawal from the Beaux-Arts-dominated Architectural League; and it praised Oud for his liberation from neoplasticism—all progenitors of Miesian modernism.[57] The low, flat-roofed, glass-banded houses that Mies carefully articulated into larger surrounding spaces, declared Johnson, embodied the essence of modernism.

Through Mies's ideas and work, Hitchcock and Johnson used the *International Style* exhibition to formalize a canon of modern architecture based on three principles.[58] The International Style, asserted Hitchcock and Johnson, consisted of the replacement of mass with space, of symmetry with regularity, and of ornament with simplicity.[59] They defined modern architecture as an art form. In formalizing its characteristics, they omitted the social requirements of architecture and its relation to its context. Modern architecture, abstracted from its social utility, became an expression of elegance, serenity, rationality, and the triumph of art over nature, politics, and society.

The *International Style* exhibition established MoMA as an important voice for modern art. Packaged as a traveling show, the exhibit visited a dozen cities, underlining Barr's intent to use MoMA as an educational institution. The exhibit inaugurated the museum's new department of architecture and design, organized and funded by Philip Johnson. A modern museum, Barr believed, had to become a modern university whose subject was modern art. Barr's inclusion of Johnson's department of architecture and design represented a bold initiative for any art museum. The show also marked the museum's last exhibition in its original quarters on the twelfth floor of the Heckscher Building on 57th Street.[60] In late 1932, the Museum of Modern Art moved to an expanded space on East 53d Street, where it remained until 1939, when it moved into its current building on the same site.

The exhibit also ended the collaboration between Barr, Hitchcock, and Johnson. Having set the museum's course, Barr was granted a sabbatical in Europe,[61] where

he witnessed the eventful spring when Hitler took power in Germany. On Barr's return he did not personally direct any installations until the *Cubism and Abstract Art* exhibit of 1936. Hitchcock resumed his academic pursuits, completing his study of H. H. Richardson and accepting a teaching position at Smith College. After organizing an exhibit on industrial design for MoMA, Philip Johnson, an early admirer of the Nazi regime, traveled to Germany and then to Louisiana, where he worked for Huey Long. In the late 1930s, Johnson returned to Harvard to study with Walter Gropius, a refugee from Hitler's Germany.

## MODERNISM ON FIFTY-THIRD STREET

In the depths of the depression the Museum of Modern Art enjoyed its most prosperous year. More people saw its exhibitions in 1932 than in any previous year, a record unsurpassed until the museum's mammoth Picasso show in 1939.[62] The *International Style* exhibition validated Barr's intuition that a segment of the art public would respond to the innovative ideas of European modernists. His sabbatical in 1932–33 gave him the time to consider the future of the museum. In April 1933, resting comfortably in Switzerland, he submitted a report to the board that argued for the creation of a permanent collection. Barr wrote, "The Permanent Collection may be thought of as a torpedo moving through time, its nose the ever advancing present, its tail the ever receding past." The museum needed such a collection, he said, because whereas the "New Yorker can see a Sargent or a Meissonier all year round, he has to wait til hot weather sets in, or go to Chicago, before he can be sure of seeing a van Gogh or a Matisse, or a Kandinsky."[63]

Barr had returned to his earlier notion with a vengeance. The Museum of Modern Art would serve as the Metropolitan's Luxembourg, transferring works of art to its uptown neighbor when they had become middle-aged. Barr imagined the Metropolitan's permanent collection bobbing in the wake of MoMA's ever churning torpedo. Retaining his European point of reference, Barr argued that for "politico-artistic reasons it might be poor strategy to abandon our American permanent collection at this time of rising nationalism and raising money." He predicated his plan on the generosity of donors and trustees and the eventual acquisition by the museum of a building to house and display the new collection. He thought 1935 an ideal time for MoMA to announce its plans in the form of a special exhibition to "reestablish and confirm the Museum's original purpose." Closing his report, he stated that should the Museum of Modern Art fail to adopt his policy, it "may as well change its name to [the] 'Exhibition Gallery for Almost Anything Interesting that comes along.'"[64] Determined to institutionalize his aesthetic, Barr's 1936 *Cubism and Abstract Art* and 1937 *Magical Art: Dada and Surrealism,* along with the earlier *International Style* exhibition, defined the museum.

In the 1930s, Barr's aestheticism seemed a part of a profascist upper-class conspiracy of silence. But Barr himself, although temperamentally apolitical and subject to a genteel form of antisemitism, was culturally naive. When an old friend from Baltimore, Gilman d'Arcy Paul, wrote to ask Barr what he knew about a German refugee, Rudolf Rietstahl, who had applied for a job, Barr replied, "[Rietstahl] is of

pure Bavarian blood—the last syllable of his name is *stahl* not *tahl* (if you see what I mean)." Barr later signed a letter in which American intellectuals protested against the "fate of the Jews in Germany." "Use my name but not my position," he replied. "It is true that I am very much concerned (over) their fate. . . . But I am even more concerned over the difficulties of gentiles, especially artists. The Jews after all have their fellow Jews representing vast wealth to look toward."[65] In the 1930s, when antifascists protested German policy, Barr and the Museum of Modern Art unflinchingly pursued their goals of artistic disinterest.

In contrast with Philip Johnson, however, Barr understood that the Nazis intended to control and politicize Germany's entire artistic and cultural life. Appalled, Barr wrote an extended essay on the relation between art and politics under the Nazi order. In Germany, he wrote, Nazi policy systematically trampled artistic freedom, depriving creativity of its necessary and essential expression. Barr saw Nazism as evil because it attacked art. Only later did Barr acknowledge the degree to which the Nazis attacked the moral basis of society, a perception that Philip Johnson, who had lived in Berlin, did not share.[66] Barr wrote to his friend Lincoln Kirstein, editor of *Hound and Horn,* proposing a three-part essay on the destructive impact of Nazism on the arts. He wanted Kirstein to publish the essays under a pseudonym—Barr proposed "Katrina Brown." "My name is not to appear in connection with the articles," Barr explained, because at the present, "we stand fairly well with the Nazi government through Philip's conversation in Berlin, and wish to borrow in the future some early nineteenth-century German pictures."[67] The essays, however, were not published until the end of the war, at which time Barr authorized his signature.

In 1931, Lizzie Bliss's bequest gave MoMA eleven Cézanne oils and her early-twentieth-century American collection, which were augmented by gifts from other trustees, particularly Stephen Clark's gift of Edward Hopper's *House by the Railroad.* The Bliss and Clark gifts coincided with Nelson Rockefeller's election as chair of the museum's Junior Advisory Committee. Rockefeller had suggested that the board adopt a policy concerning the museum's developing collection. By 1934, the collection included ninety-one works from seventeen donors, forty-nine of which were from the Bliss bequest. But as Barr noted, only a handful could be regarded as representing the "radical innovations of the twentieth century."[68] By Barr's own admission, until 1934 the Museum of Modern Art remained inferior to the Société Anonyme, Katherine Dreier's collection of abstract, dada, and surrealist art, and the Guggenheim family collection of European, mostly expressionist, art.

Following his sabbatical, Barr thrust MoMA into the forefront of modern art. He accomplished this through two masterfully curated shows on cubism and surrealism and the purchase of a number of significant twentieth-century works by Braque, Kurt Schwitters, Chagall, Kandinsky, Max Weber, Matisse, Picasso, Joan Miró, Giorgio De Chirico, Salvador Dalí, and Jean Arp. Support for these additions came principally from the Rockefeller family. By 1938 a major gift from Irene Guggenheim enabled Barr to acquire Picasso's *Girl Before a Mirror,* followed by a major purchase of van Gogh's *The Starry Night.* In 1935, Barr received word from Paris that Picasso's *Three Musicians* was available for ten thousand dollars. The Philadelphia Museum of Art purchased the painting, however, when Barr managed to raise only forty-eight

hundred dollars. In 1949, MoMA acquired a larger version of the Picasso painting, which it displayed in its permanent collection.[69]

*Cubism and Abstract Art* opened in March 1936. Curated by Barr, the show expressed his personal understanding of modernism. *Cubism and Abstract Art* recapitulated the history of European modern art based primarily "upon material collected in Europe during 1927–28 and given in the Spring of 1929."[70] The show was Barr's Wellesley course. Assembling more than four hundred works, Barr traced the historical evolution of modern art. Beneath the complexity of modern art, he believed, there flowed two major streams. The first, beginning with Cézanne and Georges Seurat and passing through cubism, found "its delta in the various geometrical and constructivist monuments." The second located its source in Gauguin and included fauvists and the abstract expressionism of Kandinsky, a tradition that reappeared in the form of surrealism. The first, said Barr, was concerned with form, classical and intellectual; the second dealt with the emotional, the decorative, and the romantic. These two strands of modern art both abandoned "the imitation of natural appearance." Barr asserted that artists were concerned with organizing "color, line, light, and shade." Essentially European and abstract, modern art consisted in artistic vision, not the discovery of nature. Even surrealism, he pointed out, with its reference to internal representation, abandoned subject and symbol in "virtually an abstract design."[71]

Equating modern art with modernism, Barr argued that modern art preferred form to nature, that modern artists self-consciously and self-referentially derived their vision from art itself. Barr used the internal history of modern artistic styles to account for the contemporary emergence and vitality of modernism. His diagram for the show, the family tree of modern art, showed the direct descent of abstract art from neoimpressionism by way of cubism. Art, as he imagined it, inhabited an autonomous realm unaffected by politics, society, or economics. Barr's *Cubism and Abstract Art* show, and its accompanying catalog, enjoyed considerable critical acclaim. Most critics approved of its "purity" and noted its remarkably close affinity to the 1913 *Armory Show*. Modernism had come of age in Barr's museum.[72]

A year later Barr presented *Fantastic Art: Dada and Surrealism*. The images jarred the museum's public, grown comfortable with a modern aesthetic of "form and technique." As Barr realized, surrealist images of a distorted and disintegrating inner world challenged the formalized aesthetic of cubism. Alongside works by Dalí, De Chirico, Miró, and Balthus, Barr presented the historical precursors of the movement, Hieronymus Bosch and Goya, juxtaposed against a more controversial exhibit of art taken from the works of children and "the insane."[73] This so angered Katherine Dreier that she withdrew the sixteen works loaned by the Société Anonyme.[74] Still, the show was a success. Approximately fifty thousand people attended over an eight-week period, leading Barr to proclaim that the museum had broken new ground.

Working against the backdrop of the depression and the rise of Nazism, Barr believed that MoMA must create a great institution in which important works of the modern movement could be permanently displayed. But his torpedo analogy required the creation of a space devoted exclusively to the preservation and propaga-

tion of modern art. The 1931 Bliss bequest expedited Barr's plans. He wrote to the trustees, "How can a museum intend ever to be permanent if it can not accept a $750,000 gift of 'key' modern paintings when the only condition of that gift is a reasonable guarantee of permanency."[75] Who, he asked, is the museum's public?

Barr identified the "400"—a small, powerful elite knowledgeable about modern art, who defended it passionately and influenced the opinion of the "Social Group," a less-informed but wonderfully wealthy segment of patrons. Below those two strata Barr imagined what he called "the Action Group"—composed of the well-heeled followers of the newest styles, who believed that "good art is good business" and whose hallmark was education and breeding, and finally "the public," whose acceptance of modern art represented "a victory for the '400,' a reassurance of the influence of the Social Group, and the effort of the Action Group."[76] Barr understood the task of the Museum of Modern Art to be that of art educator of the many according to the tastes and standards of the few.

*Dada and Surrealism* marked the end of the Museum of Modern Art's program in the Rockefeller town house on West 53d Street. In 1935, with the active support of the Rockefellers to enlarge the museum's permanent collection, Barr and the other trustees planned for a new building. The museum and the majority of its trustees had accepted Philip Johnson's equation of the International Style with modern architecture. In early 1935 they approached the American Internationalist architects George Howe and William Lescaze to design a building suitable for the museum's collection and exhibition needs. Howe and Lescaze developed a series of presentations for the trustees, who were dominated by Nelson Rockefeller. One of their models, a six-story series of cantilevered gallery floors stacked one atop the other at alternating right angles, resembled a constructivist version of Joseph Urban's New School building. Other plans represented variations on this neocubist scheme.[77] By the early summer of 1936, however, the board had failed to reach an agreement on the design. Then, in late June 1936, the trustees informed Barr that they had decided to ask fellow board member and architect Philip Goodwin and "his assistant Stone" to design the project.[78]

Barr was doubly disappointed. The Goodwin-Stone partnership would not deliver the modernist design he desired. Barr preferred Mies van der Rohe. When Goodwin and Rockefeller refused Barr's request to interview Mies in Europe, Barr angrily resigned from the building committee.[79] In June 1937, thirteen months after the board had established a permanent collection, the Museum of Modern Art vacated its premises on West 53d Street and moved to temporary quarters in Rockefeller Center. Philip Goodwin, assisted by Edward D. Stone, oversaw the completion of the new building. Having viewed Stone's preliminary studies, Barr confessed to Philip Johnson that "the building is Jewish. It looks like an upper Fifth Avenue front."[80] The Museum of Modern Art building evoked the industrialism of a classic Bauhaus design, conforming to the letter of the International Style but lacking the experimental spirit and refined elegance of the Howe and Lescaze design. The building affirmed the museum's modernist aesthetic and its trustees' conventional taste. Low slung, faced in translucent glass and banded window strips, the Goodwin and

The International Style institutional-ized. The Museum of Modern Art, 11 West 53rd Street (1939). ©*Museum of the City of New York*

Stone building broke dramatically with the phalanx of Beaux-Arts-inspired brownstone and limestone town houses in the neighborhood.

The building advertised its contents. From the architectural lettering that ran down its east wall to the skylight ventilators on the flat roof, with its Oud-inspired curving inner wall, the Museum of Modern Art conformed to its own architectural canon. At the last moment John D. Rockefeller donated extra funds for a sculpture garden, which Philip Johnson designed for the museum's inner courtyard. Barr still brooded that he had not gotten the building he wanted, but others agreed with *Architectural Forum,* which declared it a "distinguished addition to the best [that] modern architecture has produced."[81] Critic Henry McBride dissented: "Philip Goodwin and Edward Stone . . . doubtless read . . . all that the most famous Le Corbusier ever said about houses being 'machines to live in' and resolved to make the museum a machine to show pictures in and nothing more."[82]

Despite his disappointment with the building itself, Barr had completed his mission. The Museum of Modern Art had become the New York institution of the modern. Beginning with an initial investment of two hundred thousand dollars, the Rockefellers endowed a permanent collection of twentieth-century painting and sculpture.[83] Barr used the collection and his first exhibits to document his vision of modern art defined in abstract, apolitical, and European terms. His understanding of modernism, bolstered by MoMA's rich collection of modern works, shaped the thought of a generation of New York art critics and museumgoers. Even art historian and critic Meyer Schapiro, who rejected Barr's essentialist model, grudgingly admitted how much he enjoyed the abstract show. The works "were terribly moving and filled me with a level of apostolic zeal in defense of these fine old aesthetic principles which I thought I had so long ago completely rationalized that I would never feel any passion for."[84] Barr, his associates, and MoMA's wealthy patrons had created a shrine and an academy to modern aestheticism. By the end of the depression, the Museum of Modern Art assumed the mantle of aesthetic authority once worn by the Ecole des Beaux-Arts.

## THE AMERICAN SCENE:
## THE WHITNEY MUSEUM OF AMERICAN ART

On November 18, 1931, forty blocks to the south of the Museum of Modern Art, on a far less commercial street in Greenwich Village, the Whitney Museum of American Art opened its doors to the public. The contrast to the Museum of Modern Art could not have been greater. Gertrude Vanderbilt Whitney presided over her museum with understated dignity, a foil to the combative and boisterous Juliana Force, who administered the Whitney art enterprise. Neither woman would have been comfortable in the male, academic environment of MoMA. The Whitney Museum reflected the personality of its patron, Gertrude Whitney, the fierce determination of its director, Juliana Force, and the vision of its historian-curator, Lloyd Goodrich.[85]

The Whitney Museum emerged from the overlapping activities of the Whitney Studio Club, the Whitney Studio, and the Whitney Studio Gallery. The Whitney art

complex on Eighth Street included the work of more than four hundred artists. In 1928, Whitney and Force concluded that their art activities had outgrown the Whitney Studio Gallery. Whitney's collection of close to six hundred pieces of American art required more space.[86] The rationale for the Whitney Museum of American Art bore close resemblance to Alfred Barr's Luxembourg Plan. "Our first concern will be with the present and future," Whitney and Force explained in the museum's first catalog. "In short, it is our desire to help create rather than to conserve a tradition."[87] Recognizing that the new Museum "has the . . . distinction of embracing . . . work . . . it helped to create," Whitney and Force chose artists Herman More, Edmund Archer, Karl Free, and Adolph Glassgold as curators.

The Whitney was open and accessible, and its informality encouraged dissent and discussion, reflecting the spirit of Greenwich Village bohemianism. Nonetheless, until 1936 the Whitney remained the property of its founder. In contrast with Barr and the Rockefellers, however, Force and Whitney endorsed artistic pluralism, not just in terms of stylistic expression but socially, as well. In "a country . . . where diverse racial strains are inextricably woven into the texture of American character," they argued, it would be impossible to create a single standard or trait that defined the essence of American art.[88]

On November 16, 1931, two days prior to the public opening of the Whitney Museum of American Art, Force and Whitney invited critics and reviewers to a luncheon, which kicked off the afternoon press opening. The press found a setting for contemporary art unlike any other museum they had attended. Viewers who wandered into the museum's newly remodeled brownstones on West Eighth Street, off Fifth Avenue, saw about a third of Gertrude Vanderbilt Whitney's collection. The hospitable and congenial Whitney Museum contrasted with the Bauhaus-inspired Museum of Modern Art. Architects and interior designers worked closely with Whitney and Force to create a flexible exhibition space. Within the four interconnected Victorian town houses, the architects decorated the interior galleries distinctively, each with its own identifying color, "from canary yellow to powder blue."[89] The main gallery, the "White Room," extended through the museum, from the street entrance to the rear. Here, visitors to the inaugural show saw about twenty canvasses, including Edward Hopper's *Early Sunday Morning,* Reginald Marsh's *Why Not Use the "L"?,* John Stuart Curry's *Baptism in Kansas,* Stuart Davis's *Place Pasdeloup,* Guy Pène du Bois's *Woman With a Cigarette,* and the newly acquired *My Egypt* by Charles Demuth.

Edward Alden Jewell, of the *New York Times,* judged the museum a historic triumph. The Whitney opening attested to the maturity of modern American art and offered persuasive evidence that the "celebrated (. . . and thoroughly press-agented) Ecole de Paris must give way before this resolute charge of the home militia." Ignoring the works themselves, Jewell contrasted the Whitney collection with other galleries that allowed their artistic agenda to be set "once more" by Paris.[90] The editors of *Hound and Horn* heaped condescending praise on the new institution, acknowledging that the paintings were perfectly hung and looked "astonishingly handsome on the spacious clean walls." The *Hound and Horn* critic complained, however, that "no work showed that last desperate twist that makes a masterpiece." The male

Home of American modern. Whitney Museum of American Art, 8 West 8th Street, Noel and Miller, architects (1930). *Photograph by F. S. Lincoln. Whitney Museum of American Art*

editors of *Hound and Horn* found the Whitney opening un-French, led by "two women of remarkable flair and energy," and bound to have a "resounding suburban success like the Theater Guild or the Book of the Month Club."[91]

During the Whitney's first three years, Juliana Force focused on financial and artistic consolidation. Force administered the Whitney from her apartment on the upper floor of the museum, but the museum remained the personal property of Whitney. The Whitney's four artist-curators produced a series of moderately priced studies of contemporary artists, which the museum sold for two dollars apiece.[92] Force and Whitney, with the advice of the curatorial staff, expanded the museum's holdings, adding works by Alexander Stavenitz, Henry Varnum Poor, Max Weber, John Marin, Clifford Beal, and Peter Blume. Many of the new acquisitions, however, were drawings, prints, and watercolors. In January 1932, the staff informed Whitney that they would have to postpone the planned *Recent Acquisitions* show: "Because of present economic conditions the museum found it necessary to curtail purchases."[93]

Facing its first crisis, the staff voiced concern that critics would react adversely. In the meantime, Whitney and Force had negotiated with Thomas Hart Benton for a set of murals to decorate the reading room of the new building. Whitney averted the crisis simply by contributing more money. The staff used Whitney's gift of twenty thousand dollars to fund the *Whitney Biennial,* purchasing work that the invited artists submitted and continuing Whitney's older policy of "no juries, no prizes." Whitney agreed to serve as the sales agent for pieces the museum did not purchase.

Whitney inside the Whitney. Lobby of the Whitney Museum of American Art (1931). Interior designer, Bruce Butterfield. Center sculpture (fountain): Gertrude Vanderbilt Whitney, (1913); left sculpture: John Gregory, *Wood Nymph* (1917). *Photograph by F. S. Lincoln. Whitney Museum of American Art*

The *Biennial,* exhibiting in alternate years the works of living painters with works in sculpture, prints, watercolors, and drawings, became the trademark of the Whitney Museum, establishing a tradition that endured for half a century.[94]

After identifying two hundred painters to be invited to the first *Biennial,* Force bluntly informed the artists that their accustomed prices were, in the face of the depression, excessive and asked them to lower their prices. In return, Force agreed that the Whitney would have special sales representatives available at the *Biennial* who would make every "effort to sell the pictures with no commission."[95] The artists agreed. Max Weber, Walter Pach, Ward Lockwood, John Sloan, and Stuart Davis cut their prices by half. Weber remarked, "I am fully aware of the frightful conditions in the art world, and your letter convinces me how tragic conditions really are." Others confessed their own state of desperation and offered to sell at significantly low-

er prices if offered cash. Stuart Davis sized up the situation, saying, "A picture in someone's house is worth two in the studio."[96]

In January 1931, even before the unveiling of Benton's panoramic New School murals celebrating modern American life, several Whitney curators examined Benton's preliminary sketches and purchased fourteen lithographs and drawings for the permanent collection.[97] Although they declined to purchase the studies for the New School murals, Force and Whitney commissioned Benton to paint the seven panels of the *Arts and Life of America* series for installation in the museum's reading room. Chronically short of funds, Benton accepted a payment of $1,000, with a supplement of $1,751 for expenses and a $3,000 loan for a house on Martha's Vineyard.[98] Anointed "America's greatest living mural painter," Benton's immediate notoriety forced the Whitney staff to limit public access to the museum's reading room. Benton's Whitney murals extended the theme of his New School panels. With characters larger than life, Benton depicted an America based on myth, comic book, and entertainment. A tribute to the arts of the people, not the art of refinement, the series spoke a common language, presenting its subject by region—the West, the South, and the city—and offering the spectacle of American leisure that included crap shooting, Bible thumping, bronco busting, card playing, fiddling, dancing, and drinking. "The real subject of this work," Benton wrote, "is, in the final analysis, a conglomerate of things experienced in America."[99] Benton's mural articulated the inclusive ideals of the Whitney's founders.

Benton modified naturalistic conventions to force observers to confront, not abandon, reality. Utilizing the techniques of European modernism, he celebrated the variety of American life in the spirit of the urban realism of Eakins and the Eight, identifying himself with the optimistic, celebratory, and democratic outlook of Whitman.[100] Benton sought a balance between form and content, between artistic image and American reality.

The Whitney Museum and its young curator Lloyd Goodrich nurtured and celebrated the New York realists of the 1930s and the sheer variety of contemporary American art. It held in special regard, however, a group of artists who chose New York as the subject of their work. Many Whitney artists, most of whom lived and worked in the Village not far from the museum, had studied at the Art Students League under John Sloan and Kenneth Hayes Miller. They included Edmund Archer and Lloyd Goodrich, of the museum, as well as Peggy Bacon, Isabel Bishop, Alexander Brook, John Graham, Marsden Hartley, Edward Hopper, Stuart Davis, Rockwell Kent, Reginald Marsh, Paul Cadmus, Katherine Schmidt, and Yasuo Kuniyoshi.[101] Whether as social realists, urban realists, abstractionists, or "American scene" painters, they were all heirs to the urban concerns of the Eight. The Whitney painters of the 1930s, however, were more than mere extensions of the Greenwich Village rebellion. They addressed modern life, many using machine-like tubular and geometric forms and focusing on a wide variety of urban subjects. On the whole, the Whitney artists offered sober, critical, and satiric images of contemporary life. As realists living in New York and painting the city, they created modern art that fell outside Alfred Barr's modernist canon but well within Lloyd Goodrich's notion of the modern.[102] As an early participant in Miller's classes, then as a writer for

the *Arts,* and finally as an administrator, historian, and curator at the Whitney, Lloyd Goodrich pioneered the study of American art and artists. "Paris has its Luxembourg, London its Tate Gallery," wrote Goodrich in the *Nation* on December 4, 1929, "but New York, the most modern of cities and the undisputed art center of America, has been in the strange position of possessing no single institution where one could see a really representative collection of contemporary art." In his review of the opening of the Museum of Modern Art, Goodrich echoed Barr's Boston critique. Goodrich understood that the Museum of Modern Art was a cultural necessity and a contradiction. "Just as the great Armory show of 1913 was the opening gun in the long bitter struggle for modern art in this country," wrote Goodrich, "so the foundation of the new museum marked the final apotheosis of modernism and its acceptance by respectable society." Yet Goodrich felt that the new Museum of Modern Art, much like the dowager Metropolitan Museum, failed to exhibit contemporary American art of a "radical or even a liberal tendency."[103]

Applauding the original plans of MoMA to alternate modern European with American painting, Goodrich proclaimed Parisian modernism a dogma waiting to be overthrown. He expressed his disappointment that MoMA had evolved into a narrowly defined, almost sectarian, institution.[104] Not only was modernism "old," its leaders and theories of only "temporary significance"; Goodrich firmly believed that MoMA's most fundamental tenet, the "superiority of abstract to representational art," endorsed a narrow and wrong-headed view of modern art.

Goodrich recalled visiting the 1913 *Armory Show* three or four times. As a senior in high school in Nutley, New Jersey, where he and painter Reginald Marsh grew up, Goodrich had found the *Armory Show* a "great revelation" that altered his understanding of art, leading him to haunt Steiglitz's 291. Goodrich's father had encouraged his son's interest in art.[105] In 1914, at the age of seventeen, Goodrich enrolled in classes at the Art Students League, where he studied with Kenneth Hayes Miller. Goodrich sat next to Yasuo Kuniyoshi, Peggy Bacon, and Katherine Schmidt during the life class, but in 1917 he abandoned painting.[106] Following intensive Freudian analysis, Goodrich believed his path lay in writing, and soon Forbes Watson, who had been introduced to Goodrich by Alexander Brook, a fellow student at the Art Students League, offered him a job.[107] As associate editor of the *Arts,* Goodrich formed a close association with the Whitney Studio and expanded his interest beyond art criticism into American art history. Goodrich first studied Thomas Hart Benton and Charles Burchfield but shifted his attention to Thomas Eakins. Goodrich's interest in Eakins was "a reaction in the first place against the very grave weight given to European modernism [and] the exclusiveness of certain advanced modernists; the feeling that only they counted. I suppose I'm more democratically minded."[108] When Goodrich visited Paris in 1927 he found it the "most exciting city I know." He had come not to worship Parisian art but to come to terms with it. As an American cultural ambassador for the *Arts,* he wanted to introduce Europeans to American art. After six months he returned, his faith in American art unshaken.

Goodrich's reading of Van Wyck Brooks, together with his European grand tour, reinforced attitudes that had drawn him to Thomas Eakins. Indeed, Eakins, Goodrich, and the Whitney became interconnected entities, much like the associ-

ation of Picasso, Barr, and the Museum of Modern Art. Although Goodrich's first essay on Eakins appeared in the October 1929 issue of the *Arts,* he had developed an interest in Eakins during the Metropolitan Museum's 1923 Eakins retrospective. In 1925, Goodrich's friend Reginald Marsh bought several Eakins paintings from Susan Eakins, the artist's widow, and staked Goodrich to five hundred dollars to do a book about the painter. Goodrich discovered an ally in Eakins. In Goodrich's own struggle to validate American art, Eakins represented the antithesis of "our modern system of 'pure' aesthetics, with its disdain of 'literary' and naturalistic elements."[109]

Aware of Goodrich's interests, Alfred Barr approached him to write the catalog for the Museum of Modern Art's 1931 show on Homer, Eakins, and Ryder, but Whitney had already appointed him as its "writer in residence." Force and Whitney wanted their museum to function as a center for scholarly inquiry. Not content with the creation of a significant library and the publication of the Whitney monograph series on American painters, they proposed a major project on the history of American art and offered Goodrich five thousand dollars to serve as the Whitney Museum's first writer.

In 1933, the Whitney Museum published Goodrich's *Thomas Eakins: His Life and Work.* Goodrich presented a comprehensive portrait of the Philadelphia realist. Accompanied by a complete catalog identifying Eakins' works by subject, date, owner, and model, the book documented Eakins' artistic importance. Unlike his beaux arts contemporaries, Eakins did not view the United States as an "aesthetic wilderness." Rather, he lived an ordinary American life and used the American experience to create great art. "Like Whitman, he was deeply at home in his native land. . . . Few of his contemporaries accepted their environment with such a robust affirmation, or pictured it with such understanding."[110]

Goodrich's move to the Whitney proved fortunate for him and for the museum. The Whitney acquired an articulate scholar-writer, and Goodrich joined an institution committed to establishing the importance of American art. In April 1933, Goodrich presented the keynote address, "The Problem of Subject Matter and Abstract Esthetics in Painting," at a Whitney symposium on the aesthetics of painting, in which he defended the American realist tradition. Arguing that modern art bore a direct relationship to social, intellectual, and technological change—specifically, the rise of the middle class, the surge of science, and the development of photography—Goodrich characterized abstract art as historically predictable but limiting. Abstraction represented a reaction against the "bad literary art of the salons" and had originated with the impressionists' infatuation with still life and the pure qualities of "form, color, line, and texture."[111] Despite their innovations, Goodrich argued, many modern artists had lost the narrative content of art. Radically abstract modernism had reduced art to pure form, relegating itself to a decorative role and negating intellectual content. Only by restoring content could artists play an active part in contemporary life. The challenge for contemporary artists, declared Goodrich, lay in recreating art's "literary" qualities in terms of modern life and aesthetics.

While Goodrich had used his study of Eakins to answer Barr's modernist aestheticism, his greatest concern was for the Whitney's own group of contemporary urban realists. In the 1930s, guided by Goodrich's defense and supported by the

Reginald Marsh, *Why Not Use the "L"?* (1930). *Photograph ©1998 Whitney Museum of American Art*

Whitney's resources, New York's urban realists turned to depression-era New York as their subject. Ben Shahn, Raphael Soyer, Katherine Schmidt, Reginald Marsh, Philip Evergood, and Paul Cadmus each sought out the city's prospect, and each painted ordinary life. These Whitney artists recorded New Yorkers enduring the despair of unemployment, the cold winter below the elevated, boisterous throngs at Coney Island, and the isolation of the depression-era city.[112] Edward Hopper examined the nature of urban loneliness, and Raphael Soyer combined his interest in the figure with a concern for the down and out. Philip Evergood transposed the tenement window into fanciful myth, and Reginald Marsh found pleasure in the crowded vitality of New York's public places.

Reginald Marsh also painted the 1930s as a time of gloom and despair, depicting his daytime city as noisy, exuberant, and filled with the rush of humanity. Marsh reveled in the honky-tonk, seedy, crowded, public world of 14th Street, Coney Island, and the burlesque house, delighting in the "mad profusion" of New York. His paintings *Why Not Use the "L"?* and *Twenty-Cent Movie* became mainstays of the Whitney collection. A lifelong friend of Goodrich, Marsh eschewed the overtly political, though he was by sentiment a socialist. In 1936, however, he wrote a satirical autobiographical sketch for *Art and Artists of Today*.[113] "Well, what should we do,"

asked Marsh in mock response to the accusation of the left that he and his colleagues were social fascists, "be ashamed of being what we are—or imitate Orozco, Grosz, African sculpture, and draw endless pictures of gas masks, cossacks, and caricatures of J. P. Morgan with a pig-like nose? Whatever you say, there is a tradition to be proud of."

In contrast, Katherine Schmidt painted her socialist politics. Also a close friend of Goodrich, Schmidt received one of the Whitney's first art fellowships. The Ohio-born Schmidt had attended the Art Students League and studied with Kenneth Hayes Miller, along with her future husband Yasuo Kuniyoshi. In the 1920s she established herself as a Whitney regular, having sold eight of her canvases to Whitney from her solo show in 1926. Following the breakup of her marriage to Kuniyoshi, in 1933, she married Irving Schubert, a socialist lawyer, and became active in the radical American Artists' Congress. Her work, always figurative, took on a new social consciousness as she painted the homeless and the unemployed of New York. In 1935, Schmidt and Raphael Soyer came across an elderly man, Broe, in their neighborhood near the Whitney. Broe fished for coins through a subway grate, using a pole and chewing gum. Schmidt's painting *Broe and McDonald Listen In* was the first of ten in which Broe served as a model. "From the moment I saw him he appeared to me as a subject to be painted," Schmidt explained.[114] Her realism and her political activism typified many of the Whitney painters, who transformed their experience in depression-era New York into art through "line, form, and color." Neither abstract nor sentimental, the Whitney artists often found themselves, like Broe, confronting unemployment.

## THE PUBLIC WORKS OF ART PROJECT

At the time that MoMA presented its landmark *International Style* exhibit, the Whitney Museum was helping to launch the nation's first public arts program. In early December 1933, Juliana Force excitedly telephoned Lloyd Goodrich to inform him that the federal government, at last, was "going to do something for artists." Congress had authorized a Public Works of Art Project, and the Roosevelt administration had appointed Force to direct the New York Region. She told Goodrich, "I want you to be on it."[115] The Public Works of Art Project (PWAP) lasted for six months. Compared with the other New Deal art programs that followed, its accomplishments went largely unnoticed. Still, as a precursor to the three subsequent federal art programs—the Treasury Section of Painting and Sculpture (the Section), the Treasury Relief Art Project (TRAP), and the Federal Art Project of the WPA (FAP)—the PWAP played a pivotal role in government support for the arts.[116] Of the four federal art programs, the PWAP was the smallest in terms of funding and duration, but it demonstrated the importance of governmental patronage. Moreover, PWAP administrators acquired experience and clout to shape the larger Treasury and WPA art programs. Finally, it set the precedent by which New York received between 20 and 30 percent of all federal support for the arts during the New Deal, further consolidating New York's preeminence in American art.

The PWAP offered the Whitney Museum an unprecedented opportunity to sup-

port several hundred artists in the New York region and to further the art of the American scene. The PWAP consolidated the existing welter of local and state efforts in behalf of unemployed artists into a coherent, if conflict-ridden, national program. The New York Region of PWAP exhibited the contradictions and issues that plagued all subsequent federal arts programs, including questions of audience and taste, relief and patronage, artistic freedom and government censorship. In the difficult winter and early spring of 1933–34, these were not academic questions but issues of genuine concern to New York artists.

Statistical definitions of misery are difficult and misleading. The standard measurement of the depression's effect on American well-being has been the rate of unemployment. By most estimates, unemployment in 1932 had reached 25 percent nationally, including between nine thousand and ten thousand artists in New York. Countless others abandoned art for other work. Moses Soyer reported in his PWAP application that he taught Hebrew.[117] The entire national program of the PWAP, funded by the pre-WPA Civil Works Administration (CWA), received slightly more than $1,000,000 to serve 2,500 artists and 500 laborers. The New York Region, defined to include Westchester, Long Island, and Northern New Jersey, received $334,000 of the $1,312,000 spent on the project, supporting about 750 artists, or 7.5 percent of the region's estimated unemployed artists.[118]

The immediate impetus for the PWAP sprang from two Washington insiders, George Biddle and Edward Bruce. They used their social connections to mobilize policymakers in behalf of the arts. George Biddle, school friend of Franklin Delano Roosevelt at Harvard and Groton and an admirer of the Mexican muralist tradition, wrote to Eleanor Roosevelt in 1933, "Modern art can never be important unless it is expressing a great social and collective ideal. . . . That is why the best in Radio City was doomed to fail."[119] Even as Biddle proposed a national mural project, Edward Bruce, amateur painter, lobbyist, and recent appointee to the Treasury Department, worked for a program to decorate public buildings. On October 31, 1933, Bruce hosted a dinner meeting for Supreme Court Justice Harlan Stone, Jacob Baker, assistant to Harry Hopkins, and Ralph Renault, of the *Washington Post*. The group agreed to convene a larger committee of artists, museum officials, and political leaders to sponsor the mural project and to see it through congressional hurdles.[120] Biddle and Bruce joined forces to approach the president's uncle, Frederic Delano, chairman of the National Planning Board. As Bruce explained, "Mr. Delano there are a lot of old dodos who have never done a thing for American art or American artists. Now we want to get rid of that sort of academic art."[121]

The "dodos," members of the National Commission of the Fine Arts, served as the guardians of the Capitol Plan to preserve the neoclassical tradition of federal art. Biddle and Bruce did their work well. Less than a month after their interview with Delano, they persuaded presidential adviser Rexford Tugwell, Labor Secretary Frances Perkins, and Interior Secretary Harold Ickes to carve a Public Works of Art Program out of the four hundred million dollar appropriation for the Civil Works Administration.[122] Bruce convened a series of meetings, created a national organization of sixteen regions, each led by an unpaid museum administrator, and pushed through the injunction to paint the "American scene." The canny, experienced, and

opinionated Bruce steered between the guardians of beaux arts academicism and moderns who "wanted to be free of the past . . . [to] focus on personal feelings which they could best express in non-representational patterns."[123]

The same issue surfaced during the political maneuvering that accompanied the creation of the New York PWAP regional office. On December 8, Juliana Force joined Biddle, Eleanor Roosevelt, Bruce, Saint-Gaudens, and Duncan Phillips to discuss the New York operation. Bruce had already assembled an administrative team, which included Forbes Watson as the project's technical adviser. Watson's appointment, along with Juliana Force's leadership as the director of the New York Region, fortified the Whitney influence and complemented Bruce's directive to paint the American scene. Biddle, sensing the historic nature of the occasion, wrote, "This may be the dawn of a new epoch in American art." His optimism, though, was dampened when Force complained that Rockefeller interests had maneuvered Alfred Barr onto the regional committee.

Bruce, with Force and Goodrich, refereed conflicts that arose over the style of art appropriate for federal patronage. He carried his American scene preference with him to the Treasury Department's "Section," whereas the Federal Art Project, under the direction of Holger Cahill, adopted a more inclusive position on questions of style and content. By the same token, conventional academic art interests feared that Force would abandon the traditional to the modernists. Using the importance of standards to bolster their position, beaux arts traditionalists equated modern art with the vulgarization of art.

Bruce and Force found themselves in the middle of a tug of war. Roosevelt and Hopkins cared less about aesthetics than about providing work to unemployed artists, whereas Bruce argued that painting the American scene took precedence over unemployment relief. Force agreed. She also realized that abstract painters and sculptors were more likely to encounter difficulty in finding jobs than those who worked in representational styles. Both understood that a policy that favored recognized talent over relief also favored realism over abstraction. Force and the New York Region of the PWAP chose talent and representational art.

The conflict over policy reflected confusion in Washington. In December 1933, two days after the project's opening, Bruce telegraphed his regional directors to inform them that "the word relief should be eliminated by you in all reference to the project. . . . We want to put competent artists to work who are out of work, you must use your discretion." On another occasion Bruce said simply, "We are putting artists to work and not trying to make artists out of bums." The final report of the PWAP, however, noted that "a dual test was set up. . . . First, that [those hired] were actually in need of employment, and second that they were qualified as artists. . . . The primary aim of the Public Works of Art Project was relief to the artists."[124]

On December 16, 1933, sixty-seven artists in the New York Region received their first checks from the PWAP office at the Whitney Museum. As regional director, Juliana Force engaged several luminaries in the museum world to assist her. The Whitney team administered the PWAP in the New York Region. In addition to Barr, the regional advisory committee included representatives from the Metropolitan, Newark, Brooklyn, and Buffalo art museums. Force included Goodrich and turned

over the day-to-day administration of the New York PWAP to him. Force and Goodrich responded as best they could to the two sets of conditions—the uncertainty of funding from Washington and the criticism of artist organizations. Goodrich, along with Whitney curators Herman More and Edmund Archer, chose and supervised the New York artists who received PWAP support, and Force dealt with the bureaucracy in Washington and the ever volatile local art community. In a time of widespread unemployment, government aid to a few raised the expectations and anger of many.

In New York, artists seeking PWAP employment submitted samples of their work, along with a detailed planning questionnaire in which they proposed the subject matter, size, medium, and time required to accomplish their projects. Goodrich and his colleagues evaluated the submissions and worked with city agencies to find locations for the proposed work. Having approved the artist and the project for federal support, the Whitney staff expected artists to devote thirty hours a week to the project and to agree that all works produced would become the property of the government. In return, artists were paid a weekly salary of between $26.50 and $42.50, a scale comparable to wages for other skilled crafts.[125] Force and Goodrich felt that anyone who made less than $60.00 a week was eligible for employment in the PWAP. Five thousand artists sought support from the New York PWAP, although Goodrich received funds to employ only six hundred to seven hundred.[126] Artists often wrote directly to Force and Goodrich asking for work—"I have not sold any painting during the past 20 months. . . . I would appreciate anything you could do to help me" was typical.[127]

Bruce's instructions to his regional supervisors were specific: "The American Scene should be regarded as a general field for subject matter for paintings, with latitude for topical subjects appropriate to special projects."[128] Later, Goodrich recalled that he and Force had run the New York office more flexibly. "We simply told them to go ahead and paint." But Goodrich chose artists, in part, on the basis of their qualifications as realists. When artists applied to the Whitney for PWAP employment, Goodrich and the staff examined their portfolios, evaluated their work, and awarded three classes of distinction. In painting, artists who received a first-class rating were generally assured employment. Second- or third-class ratings guaranteed, at best, apprentice status. Milton Avery received only a third-class rating for his proposal of three nonrepresentational landscapes in oil because, his evaluation read, "Oil work submitted [is] very poor." The PWAP funding specified, rather than his proposed landscapes, an "industrial scene . . . with the Queensboro Bridge in the distance." Similarly, Whitney curators suggested that Ilya Bolotowsky "might be given unimportant landscapes to do."[129]

Representational artists received a more sympathetic hearing. In several important cases Goodrich openly championed the work of those whose work the PWAP discovered, including Philip Evergood and Paul Cadmus. Evergood, who gained his first recognition from his PWAP efforts, found acceptance for his proposal to paint *North River—Manhattan* for both an easel painting and a mural study, although Goodrich's evaluation of Evergood's preliminary submissions was ambivalent. Still, between mid-January and late April 1934, Evergood executed at least three easel

works for the PWAP. Each dealt with, in his words, "the human side of New York" and earned him a reputation as a remarkable social painter.[130]

Paul Cadmus, a young painter-muralist whom Goodrich also favored, completed a painting called *The Fleet's In* as his first easel work for the PWAP. To Cadmus's surprise, Force and Bruce chose his work for inclusion in a national exhibition of PWAP art held at the Corcoran Gallery in Washington. Displaying five hundred works, the show, which Bruce compared favorably with the *Armory Show,* underscored the cultural nationalism of the PWAP. *The Fleet's In,* an affectionate portrayal of men and women in open heterosexual and homosexual embrace, proved controversial enough for a retired admiral, who pressured Bruce into removing the painting from the show.[131]

The controversy over Cadmus's painting, however, seemed trivial to other New York painters whose art Force and Goodrich had deemed inferior. Unemployed Artists, a New York artists' union and the predecessor to the CIO's New York artists' affiliate, challenged the Whitney policies, arguing that they violated the relief provisions of Civil Works Administration. When Force announced the formation of the PWAP and solicited names of artists who would qualify for the program, she failed to approach Unemployed Artists. Undeterred, the union submitted a list of its membership and accused Force, the museum, and the federal government of running an elitist program that ignored young radical artists. Force responded, imperiously, "Need is not in my vocabulary." In January 1934, Unemployed Artists picketed the Whitney, intending to force the museum to accept relief as the PWAP's goal and to recognize Unemployed Artists as a collective bargaining agent for New York artists.[132]

Force and Goodrich steered a middle course in the dispute. Following the initial confrontation in early January, leaders on each side failed to convince the other of their good intentions. Threatened, Force exerted all the authority she could muster and complained to the Manhattan district attorney about the radical artists who met at Stewart's Cafeteria. Unemployed Artists, in turn, alleged that Force had sent spies to their strategy sessions, calling the Whitney proprietress "Mrs. Farce."[133] The artists grew even angrier when they learned that well-known and employed artists John Sloan and William Zorach had secured commissions from the PWAP. Embarrassed by the publicity, Sloan and Zorach resigned their PWAP commissions.

Unappeased, Unemployed Artists, led by Philip Bard and Bernarda Bryson, assembled five thousand protesters in front of the New York office of the CWA and the Whitney, in early February. By this time officials had already depleted their budgets in anticipation of the program's termination in mid-April. Force and Goodrich realized that they could not meet Unemployed Artists' insistence on an end to the three-tiered classification system. In the face of dwindling federal funds and hostile artists, Force moved the regional office from the Whitney Museum to the New York City Municipal Building. Undeterred, Unemployed Artists, having changed their name to the Artists' Union, continued to protest. Artists' Union leaders appealed to Bruce in Washington. Bruce replied, "It is not fair or sporting on your part to complain to this group of people about the Project when there would have been no Project if it

had not been for them." Although he made a valid point, Bruce failed to address the substance of their complaint.[134]

Despite the controversy, PWAP artists in the New York Region produced approximately 563 oils, 72 drawings, 400 lithographs, 140 works of sculpture, and numerous public murals. Seven hundred fifty artists participated in the project, the most important of whom were Aaron Douglas, Ben Shahn, Edward Lanning, Rockwell Kent, Stuart Davis, and Arshile Gorky. While many of the larger works remained unfinished, the PWAP commissioned a number of significant works, the most noteworthy, its public murals. The PWAP murals included a variety of political points of view and a variety of styles.

The works of PWAP artists graced the city, from murals at Samuel Gompers High School in the Bronx to lithography at the Museum of Natural History and sculpture at the Manhattan Federal Building. Shortly before his death in 1987, Lloyd Goodrich, reflecting on the PWAP experience, remarked, "I worked harder on the Project than I ever had or would."[135] Such effort did not go unappreciated by PWAP artists. Wrote Isaac Soyer, "I would like to explain to you how imperative it is for me to be employed . . . in order that I may continue to paint."[136]

Defined by strong-willed directors and curators and backed by the financial resources of wealthy New York families, in the 1930s the Museum of Modern Art and the Whitney Museum of American Art advocated two quite different understandings of the modern. The two museums' buildings reflected their understandings of modern art. The domestic warmth of the Whitney in Greenwich Village contrasted with the corporate coolness of the midtown MoMA. Goodrich and Whitney favored urban realism and identified with Greenwich Village's tradition of political radicalism and artistic dissent. Alfred Barr's reformulation of a modernist aestheticism derived from his academic training at Princeton and Harvard, institutions far removed from the turmoil and conflict of New York City.

During the depression the Whitney's patronage of the American scene, reinforced by Bruce and the PWAP, momentarily gained ascendancy in New York—but not dominance. Even its own acquisition and exhibition policies acknowledged the importance of social realism and abstraction. Moreover, in the 1930s, the Museum of Modern Art established itself as New York's most important patron and voice for modern art. In severing modern art from modern life and the School of Paris from its Left Bank origins, the Museum of Modern Art conferred on the once-controversial abstractions of modernism a mantle of social respectability, even gentility. Once the crisis of the depression had passed, the Museum of Modern Art stood ready to impose its newly minted modernist canon. But as the Whitney's experience with Unemployed Artists made clear, in the 1930s neither powerful art museums nor popularly elected governments could control New York art. The founding of New York's two museums of modern art seemed of small moment in the face of Hitler's seizure of power, Stalin's domination of the Soviet Union, and Roosevelt's landslide electoral victory. In every direction, radical voices demanded change, even in the rarified world of New York art.

CHAPTER SEVEN

# True Believers on Union Square
## Politics and Art in the 1930s

To the truly committed, the artistic politics of the Whitney and the Museum of Modern Art during the depression appeared upper class and irrelevant. Communists and socialists insisted that art should contribute to the defeat of fascism, the socialization of the economy, and the teaching of social justice. Radicals in and out of the Communist Party who first organized the John Reed Clubs to train a generation of socially conscious artists and writers later convened a series of Artists' and Writers' Congresses to mobilize the intelligentsia in the Popular Front struggle against fascism.

Radicals, socialists, and communists, however, found that their fellow artists—particularly in the theater experiments of the decade, the Group Theater and Federal Theater programs—and dedicated New Yorkers were at best backsliding political believers. Diverse in background, New York artists valued free speech, dissent, and independence. Just as they resisted the efforts of MoMA to impose a version of aesthetic orthodoxy, so also they resisted left-wing efforts to impose political and ideological discipline. Despite the enormous efforts in the 1930s in behalf of social realism and the American scene, New York artists affirmed their particular identities, whether socialist, communist, or independent, Jewish, Italian, or African American. Heterodox to the core, New York Modern spoke in a variety of New York dialects in the Red Decade—Marx and the Marx Brothers, Stein and Steinway, W. E. B. Du Bois and Dubose Heyward, Blitzstein and blitzkrieg. In the 1930s no single voice could shout down the cacophony of New York Modern.

The depression left most New York artists without patronage, without work, and often without hope. Most believed that they could no longer cling to outmoded notions of artistic independence. To divorce art from politics seemed irresponsible, if not economically suicidal. In the 1930s, however, they faced competing demands of political patronage. Both the New Deal and the Communist Party expected loyalty from the artists they supported. During the ascendancy of the Popular Front, be-

tween 1936 and 1939, the New Deal and the Communist Party courted New York's artists, forcing them to choose between political patronage and artistic independence. After an initial flirtation with organized politics, New York artists retained their independence. By 1941 little remained of the lofty and ringing calls to unite the artistic left. By the start of World War II, the participants in the Group and Federal Theaters, the John Reed Clubs, and the Artists' and Writers' Congresses had retreated from politics, leaving it to Franklin Roosevelt to fulfill his promise to destroy fascism and secure freedom.

## THE POPULAR FRONT IN NEW YORK

Shortly after Roosevelt's election in 1932, Fiorello La Guardia and Robert Moses attacked New York's deep-seated municipal corruption. In the 1920s, population growth, unprecedented surface traffic, and chronic political incompetence and corruption nearly strangled the city, creating a political climate that demanded reform. In different ways, Moses and La Guardia, independent of both major political parties, embodied the New Deal in New York. In the 1930s, Moses conceived and built the key link in New York's arterial road and bridge system—the Triborough Bridge, which joined Manhattan with the Bronx and Queens. Moses fashioned the parks at Jones and Orchard Beaches, assembled the rudiments of the parkway system that connected midtown New York to the suburbs in Nassau and Westchester Counties, and constructed scores of city playgrounds and parks. Still, the city eluded control. Each new highway that Moses steamrolled created even more new traffic in its wake. Each improvement accelerated middle-class abandonment of the city. Moses became a symbol of unrestrained public power—anathema to most New Yorkers.[1]

La Guardia and Moses inherited a city fraught with contradictions. One of the world's great cities, New York had grown uncontrollably, without foresight, leaving it especially vulnerable to the depression. From 1917 to 1933, New York's population had climbed by more than a million. The budget of New York City grew two and a half times, and its debt service accounted for one-third of its expenditures, larger than the total debt of all forty-eight state governments. The Seabury Commission reported that under Tammany mayor Jimmy Walker more than 40 percent of the city budget had been syphoned off to patronage positions, leaving less than a third to fund current services. In 1931, the Walker administration responded to the corruption scandal by firing eleven thousand public school teachers, the only municipal employees Tammany did not control.[2]

The bloated patronage system nearly crippled New York's surface transportation. Between 1917 and 1933, the number of private vehicles registered in New York City grew ninefold. During that time the city did not build a single mile of highway, freeway, or expressway. The Lincoln and Holland Tunnels and the newly opened George Washington Bridge poured thousands of vehicles into Manhattan, but once in the city, drivers found themselves at the mercy of New York's congested and potholed streets.[3]

The depression made these problems worse. Apple stands, panhandlers, soup kitchens, Hoovervilles, and breadlines bore witness to massive layoffs and econom-

ic decline. When La Guardia took office in 1934, one-third of New York's workforce was unemployed, ten thousand businesses had closed their doors, and 1.6 million women and men survived on public assistance. The new mayor personified New York's ethnic working classes. In the 1920s his German Jewish–Italian background and his command of Italian, Yiddish, German, French, and Spanish helped him win an East Harlem congressional seat, his stepping stone to the mayoralty victory in 1933. Originally a progressive who opposed prohibition and supported child labor laws, old-age pensions, and unemployment insurance, La Guardia endorsed much of the New Deal's program a decade before its enactment. Running as a Republican fusion candidate, La Guardia remained independent of the national Democratic Party and represented the New Deal in New York.[4]

Robert Moses, born to a prosperous German Jewish family, educated at Yale and Oxford, and armed with a doctorate in politics from Columbia, exuded the detached gentility that La Guardia disdained. In the 1920s, Moses became a protegé of Governor Al Smith, whose animosity towards Roosevelt made Moses unwelcome in New Deal inner circles. But, as an anti-Tammany politician, Moses could not be ignored. La Guardia appointed Moses to the Triborough Bridge Authority and named him director of the New York City Parks Department, charging him with creating a unified bridge and parkway system for the metropolitan area.[5]

Moses' accomplishments in the 1930s were legendary. His system of roads, highways, parks, and bridges endured for half a century. Under his leadership, New York received more federal funds than any other region in the nation. The din of bridge, tunnel, beach, park, school, and fire station construction generated capital expenditures of more than a billion dollars between 1935 and 1939, more than the city's capital expenditures for the previous fifteen years. Hostile to La Guardia, whom he denigrated as "the little organ grinder," Moses contributed to the economic recovery of New York, earning the respect, though not the affection, of the mayor.[6] Identifying with Napoleon III's great Parisian urban planner, Moses saw himself as the Baron Haussmann of New York. Like Haussmann, Moses was as brutal as he was bold. "When you operate in an overbuilt metropolis," he boasted, "you have to hack your way with a meat axe."[7]

In contrast, La Guardia's fusion strategy converged with the goals of Roosevelt's New Deal coalition, and in 1936 the alliance faced the difficult challenge of linking reform Democrats, socialists, and independents to vote Democratic on the national level while supporting La Guardia and reform Republicans on the local level. To court New York's militant trade unionists, La Guardia welcomed the inclusion of new CIO (Congress of Industrial Organizations) unions in the Non-Partisan League, which in turn became the American Labor Party (ALP).[8] In the 1936 election the ALP enrolled more than half a million voters in New York.[9] The ALP provided La Guardia his margin of victory in his 1937 reelection. One in five La Guardia voters was a member of the ALP.[10]

La Guardia and union leaders Sidney Hillman and David Dubinsky constituted the leadership of New York's Popular Front. Faced with the leftward shift of the New Deal in 1936–37, New York communists had little choice but to participate. In 1936, the ALP attracted thirty thousand communist voters, and the Communist Party lost

its place on the state ballot when its candidate for governor received fewer than fifty thousand votes.[11] Following its decision to remain an open political organization, and because of its need to attract members of the CIO and the needle-trades unions, in 1936 the New York Communist Party openly supported the New Deal, becoming a reluctant partner of the reformist La Guardia and Roosevelt administrations.

By 1938, the ALP functioned as the fulcrum of Popular Front politics in New York. With strong organizations at the borough level, especially in Manhattan, the ALP offered voters a viable alternative. Although its leadership remained under the control of Dubinsky and Hillman, its membership represented a pragmatic coalition of anti-Tammany Democrats, reform Republicans, Socialists, and Communists—many of them artists.

## NEW YORK ARTISTS AND RADICAL POLITICS

In the politically charged 1930s, New York's Popular Front seemed light-years removed from the Jazz Age politics of Jimmy Walker and Tammany Hall. So, too, did its artists. Even more than during World War I, New York artists turned to radical politics; for a time, politics was art. In the 1930s, the city's young artists and writers hoped to create a new American culture that reflected their own urban, secular, and socialist values. But political engagement threatened to compromise their artistic independence.[12]

When radical writer Malcolm Cowley returned from his self-imposed exile in the late 1920s, he found the United States and New York ravaged by depression, lacking both will and direction.[13] Like the Greenwich Village radicals a generation earlier, in the 1930s New York's radical artists and writers believed that cultural reconstruction depended on political reconstruction. As Cowley wrote, "The artist and his art had once more become a part of the world, produced by and perhaps affecting it; they had returned to their earlier task of revealing its values and making it more human."[14] Writer and political journalist Mike Gold, who founded the *New Masses* in the 1920s as a radical journal to unite modernists with Americanists, art with politics, seemed to embody Cowley's ideal. The magazine occupied a small but important place in New York letters, aligned, but not affiliated, with the city's Communist Party.

The ties of the *New Masses* to the Communist Party alienated older, prewar radicals, especially after 1929, when the American Communist Party followed the Comintern's orders to embark on a revolutionary and isolated "Third Period," and the *New Masses* followed in step. Gold believed that the depression called for proletarian art produced by artists and writers committed to the struggle against liberal reformism.[15] To stimulate proletarian art, in 1929 the *New Masses* formed the John Reed Clubs and endorsed the American Communist Party resolutions that drummed Nicolai Bucharin and Upton Sinclair out of all party organizations. When the Soviet Union turned to forced collectivization in 1932–33, the editors of the *New Masses* continued to embrace a policy of no tolerance for bourgeois democracy or artistic formalism—by which they meant nonsocialist art.[16]

In New York, the Communist Party remained small, sectarian, and isolated. Even the *New Masses* commented, in 1928, that "of the twenty thousand in the Commu-

nist Party, only three thousand speak English." When the party elevated William Z. Foster to its chair, it also declared itself in opposition to "social fascists" and "fellow travelers," meaning socialists and liberal reformers. In 1931, New York's Communist Party ended its militant isolation. In response to the Scottsboro case, in which a white southern jury had convicted several young black men of rape based on conflicting evidence, the New York office of the Communist Party instructed its Harlem functionaries to "enlist non–Communist Party blacks" in the civil rights struggle.[17] For the next two years, Communist Party activists rallied Harlem around the defense of the "Scottsboro Boys."

Between 1931 and 1935, Communist strategy in Harlem ran counter to national and international policy. At a time when the American Communist Party maintained its Stalinist position of nonalignment, the New York party reached out to independent intellectuals. Organizing rent strikes and boycotts, speaking out against Jim Crowism, and supporting the racial integration of trade unions, the New York Communist Party used its mobilization of Harlem as a precedent for Popular Front participation. As an open, reform-minded, pragmatic political organization, the New York chapter of the Communist Party attracted independent, but radicalized, artists and writers. Three years before the announcement of the Popular Front, the New York Communist Party had already jettisoned the Comintern's directive to form "a tightly knit political machine with a disciplined membership."[18]

The presidential election of 1932 tested the alliance between the New York Communist Party and the city's radical artists and writers. With little in the campaign to stir the imagination, many prominent writers and intellectuals, some veterans of the violent Harlan County coal miners' strike, found Herbert Hoover and Franklin Roosevelt equally objectionable. In a dramatic gesture, Theodore Dreiser, Lincoln Steffens, Malcolm Cowley, Countee Cullen, and Langston Hughes signed a manifesto titled "Fifty-Three Writers and Intellectuals [Who Align] Ourselves with the Frankly Revolutionary Party, the Communist Party." On their own terms these New York radicals supported the presidential campaign of William Z. Foster.[19] Under Foster's leadership the American Communist Party accepted their support and, with it, the support of the John Reed Clubs.

The John Reed Clubs were initially established by the *New Masses* to promote proletarian art, a position that Gold later abandoned to recapture the magazine's more prosperous readership. Curiously, by 1933 the *New Masses* returned to a wide range of writing and art, whereas the John Reed Clubs remained devoted to the politics of proletarian art. Many young New York artists and writers gravitated to the John Reed Clubs, where they attended lectures, readings, and short courses and committed themselves to the slogan "Art Is a Class Weapon."[20] Some members of the John Reed Clubs affiliated with the Communist Party, but most were simply young, idealistic artists and writers. At times, the John Reed Clubs became hotbeds of artistic experimentation, engaging in discussions labeled by some as "bourgeois formalism."[21]

The New York John Reed Club became the largest and most active chapter in the national organization, which included outposts in twenty-three cities, including Boston, Santa Fe, Cleveland, and Carmel, California. By 1933, the clubs claimed

seven hundred members, one-third of whom lived in New York. The success of the New York John Reed Club led to its move in 1932 to larger quarters on the corner of 14th Street and Sixth Avenue, just off Union Square, where it offered classes and studios for drawing, painting, sculpture, mural painting, and political cartooning. Anton Refregier, a founding member of the New York John Reed Club, described the 1932 student art exhibition as "bold and varied in style. All students show individuality rather than the influence of their instructors." At the same time, Refregier praised members of the political-cartoon class for their "clear political thinking." He concluded that the art school fulfilled its goals: "to make the club a functioning center of proletarian culture; to clarify and elaborate the point of view of proletarian as opposed to bourgeois culture; to extend the influence of the club and the revolutionary working-class movement."[22]

The writers' and artists' sections of the New York John Reed Club met jointly on the third Friday of every month.[23] The writers' school included courses in Marxism by Joshua Kunitz, fiction by Horace Gregory, and literature by Kenneth Burke. The club supplemented the courses with Sunday evening lectures and panel discussions, such as one by Burke and Kunitz entitled "Bourgeois and Proletarian Types in World Literature." The club invited English radical John Strachey to lecture on literature and fascism and used the money raised to fund the club's new magazine, *Partisan Review*.[24] The artists' section of the club, which offered courses and regular shows such as *The Social Viewpoint in Art* and *Hunger, War, and Fascism*, held special Wednesday evening events where members and guest speakers such as Louis Lozowick, Robert Minor, Meyer Schapiro, and Lewis Mumford spoke.[25]

When events forced the American Communist Party to reconsider its cultural isolation, the leadership decided to follow the example of its New York branch and the John Reed Clubs.[26] Communist Party affiliation rose steadily between 1931 and 1936, resulting in the moderation of its new membership, which included trade unionists, writers, artists, women, and blacks. The new members brought their independent ways to the party. Between 1934 and 1936 most who supported the party—the John Reed Clubs, the Pierre Degeyteer Club, the Composers' Collective, the Group Theater, the Artists' Union, and the Workers' Alliance—did so as participants in the Popular Front, not as members of a revolutionary party. As independent reformers, these new recruits forced the American Communist Party to adopt the Popular Front stance of its New York branch.

In New York, from which the party drew close to half of its national members, Earl Browder replaced William Z. Foster as party secretary in 1934. The National Organizational Department declared that the "Party must be transformed from narrow inner circles into live political bodies."[27] The *Daily Worker* ratified the changes when it added sports and home pages, welcoming to its readership those "unwilling to make politics the sole priority of their lives."[28] Three years later the *Daily Worker* redesigned its masthead, replacing the hammer and sickle with the slogan, "New York *Daily Worker*: People's Champion of Liberty, Peace, and Prosperity."[29]

These changes corresponded with the activities of the New York John Reed Club. In 1934 the club enrolled several hundred members, many of whom were eligible for federal relief. The following year militants from the clubs formed the backbone of

New York's artist and writer organizations and forged a citywide Workers' Alliance that claimed to represent all artists, writers, and musicians employed by New York's federal projects. Unlike the Communist Party, each of these groups maintained an open membership policy and internal democratic procedures, constituting themselves as Popular Front organizations.[30]

The New York John Reed Club's sponsorship of the *Partisan Review* indicated its growing political independence. Although the literary section of the club had published a bulletin, many of its members chafed under dominance of the *New Masses*. In other cities, John Reed Clubs sponsored small proletarian literary magazines. The first issue of *Partisan Review*, "A Bi-Monthly of Revolutionary Literature," appeared early in 1934. Its editors, Philip Rahv and William Phillips, offered the revolutionary left an alternative to the *New Masses*, which they judged "politically isolated and aesthetically conventional."[31] Rahv and Phillips shaped the *Partisan Review* into an independent socialist publication that stood for a "radical critique of the left literary movement."[32] In the spring of 1935, when the Communist Party called for the dissolution of the John Reed Clubs, *Partisan Review* severed its ties to the party. With the advent of the Popular Front, the *Partisan Review*'s fusion of modernist literature and radical politics no longer set it apart. In 1936, Rahv and Phillips suspended publication of the *Partisan Review*. After 1935, New York's radical artists and writers, like Rahv and Phillips, left the Communist Party to affiliate with Popular Front organizations that included the Artists' and Writers' Congresses.

## RADICAL ARTISTS AND WRITERS, 1935–1942

In the second half of the 1930s, New York artists and writers organized. New York radical artists formed groups and congresses and constituted unions and associations in and out of the Democratic and Communist Parties.[33] Four American Writers' Congresses took place in New York, in 1935, 1937, 1939, and 1941, as did the three American Artists' Congresses in 1936, 1937, and 1939. New York artists and writers constituted more than three-quarters of the membership of both organizations, and the city served as national headquarters for both.

The congress movement began in the fall of 1934, when Alexander Trachtenberg addressed the delegates at the national convention of the John Reed Clubs. "Trachty," editor of the Communist Party's publishing house, International Publishers, served as the unofficial cultural commissar of the American Communist Party. At the 1934 convention, Trachtenberg proposed merging the John Reed Clubs into a national writers' organization, a congress, to enlist nonaligned intellectuals in behalf of "the revolution." Trachtenberg and a committee of radical writers—Malcolm Cowley, Granville Hicks, Orick Johns, and Henry Hart—planned the American Writers' Congress, scheduled for April of 1935, and sketched out the organization of the League of American Writers. Hicks, who wrote the call for the congress in the *New Masses*, argued that although the party spoke for radical American writers, it needed the support of noncommunist artists to exercise any influence.[34] The poet W. H. Auden remarked, "As in most such organizations, the Liberals were lazy, while

the Communists did all the work and, in consequence, won the executive power they deserved."[35]

An intellectual and a party functionary, Trachtenberg looked like a cross between La Guardia and a Soviet bureaucrat. Short and stocky, with bushy eyebrows, he regularly sported dark, heavy, woolen suits. An immigrant from Odessa, he arrived in the United States in 1906 after a year's imprisonment for political activities during the Russian Revolution of 1905. He enrolled at Trinity College and then at Yale, where he earned a doctorate in labor history. In the early 1920s, Trachtenberg worked as an economist for David Dubinsky's International Ladies Garment Workers' Union, and in 1921 he became a founding member of the American Communist Party. In 1924, Trachtenberg formed International Publishers, and he remained at the center of Communist cultural affairs for the next forty years.

Trachtenberg's dissolution of the John Reed Clubs and the formation of the Writers' and Artists' Congresses ushered in a new era for New York's radical artists and writers. Committed antifascists, the radical writers discussed the changing nature of their audience, their art, and the politics of writing. Over the course of four congresses between 1935 and 1941, they moved from the narrow sectarianism of the early 1930s through the optimism of the Popular Front to bitter disillusionment at the end of the decade. Each of the congresses began with a public session during which prominent literary figures set the tone of the proceedings. The congresses then moved to several days of private sessions, where participants presented and argued about the nature and meaning of art. The organizers of the congress also created a permanent secretariat, the League of American Writers, which oversaw the planning of subsequent congresses. Through the league, membership eligibility steadily broadened to include any published writer, critic, playwright, or essayist.

In his opening address for the second congress at Carnegie Hall in June 1937, Cowley called for a merging of bourgeois and proletarian culture as a defense against fascism. Joined by an array of honorary guests—Ernest Hemingway, Earl Browder, and John Dos Passos—Cowley urged the overflow crowd of more than three thousand to support the Republican loyalists in Spain.[36] Buoyed by greetings from Albert Einstein, Thomas Mann, and Upton Sinclair, the congress set about its business. Thoroughly within the political mainstream, the League of American Writers proudly accepted the membership of Franklin Delano Roosevelt.[37] Endorsing the slogan of writers in "defense of a democratic culture," the second congress affirmed a broadened definition of the radical left.[38] Featuring panels on the democratic tradition and the role of the American writer, papers at the closed sessions supported the Spanish Republican cause and the ideals of the Popular Front. "Our problem," members of the executive board had agreed, "is to find a Marxist approach to individualism."[39]

The Popular Front "coalition for practical reform," which allowed artists to "remain outside the Party [and] still be a part of the family," coincided with the leftward turn of the New Deal.[40] The American Communist Party supported the New Deal as the best defense against fascism, and in abandoning its image as a party of professional revolutionaries, it became "a party of human beings."[41] "You'll be sur-

prised," wrote Cowley to Hicks, "when you see how far the United Front is going in literary circles; Trachtenberg beaming on Dreiser. No fights at present except with Hearst and the Trotskyites."[42] Although individual party members remained active, their influence was muted. When Earl Browder asked Hicks to reassume the position of literary editor of *New Masses* in the name of "Party hegemony in all intellectual fields," Hicks refused. A year earlier Hicks had similarly declined Browder's invitation to make several editorial and political changes in his biography of John Reed. In each instance Hicks's cooperation was more important than his compliance.[43]

The Hitler-Stalin pact and the Nazi invasion of Poland shattered the American Writers' Congress. By late fall of 1939, the League of American Writers, and with it the cultural Popular Front, stood in shambles. Condemned by the Trotskyite left, represented by philosopher Sidney Hook and art historian Meyer Schapiro, as well as by Rahv and Phillips, for its silence over the Hitler-Stalin Pact, the league lost supporters. Auden pronounced, "The Popular Front is destroyed."[44] When the fourth and final congress met in June of 1941, the league had lost more than one-third of its membership. On June 24, two days after Hitler's invasion of the Soviet Union, Cowley wrote to Hicks, "The Party comes out of this without enough shreds of moral or intellectual responsibility to hide the pimples on its bare bottom."[45]

Like the writers in the 1930s, New York's radical artists also organized a series of congresses.[46] Unlike the American Writers' Congress, the American Artists' Congress struggled to maintain its ties with the John Reed Clubs. It accomplished this by associating with the Artists' Union, whose radical, class-conscious program addressed the economic needs of younger artists whose lives depended on continued employment in the federal art projects.

In May 1935 a group of artists met at the studio of Eitaro Ishagika to form an Artists' Congress. Convened at the invitation of "Comrade Trachtenberg," the initial group consisted of a "fraction" of artists from the John Reed Clubs who met throughout the summer on Friday evenings at Herman Baron's American Contemporary Artists' Galleries.[47] Fifty-two New York artists eventually signed the call for the American Artists' Congress. The John Reed Club "fraction" appointed Stuart Davis executive secretary. Davis's social commitments and his work as an abstractionist made him a respected figure in New York art circles. A vigorous man in his early forties, a prolific painter, and an articulate political activist, Davis looked powerful. Yet, his short, compact build projected open-handed friendliness.

"There is no such thing," Davis wrote, "as non-political art in the sense that every artist is always in a specific political relation. . . . But this political relation is . . . not the subject of his art, which consists of his own contribution to the affirmation of order in the materials of art."[48] Davis's attacks on regionalist painting and the stodginess of the American scene gave him a reputation for independence.[49] Davis distinguished between the Artists' Union, which represented the issues of artists "as workers," and the more bourgeois Artists' Congress, which addressed broader political concerns. Under his leadership, the Artists' Union and the Artists' Congress allied in the face of the "menace of fascism."[50] The Artists' Congress reached out to established artists in an effort to teach them that there could not be "an eternal art value immune from social, economic, and political storms."[51] In the fall of 1934, the

membership of the Artists' Union totaled seven hundred. A year later, following the organization of the WPA and the dissolution of the John Reed Clubs, the union's membership doubled. With representatives on the permanent council of the Artists' Congress, the Artists' Union maintained its voice in the congress. Thanks to Davis's editorship of *Art Front,* the Artists' Union defined the politics of the Artists' Congress.

The three-day Artists' Congress, held in mid-March 1936 at Town Hall and the New School for Social Research, echoed the theme of the Writers' Congress. The Artists' Congress, subtitled "Against War and Fascism," presented speakers and workshops to two thousand attending artists, affirmed the need for a permanent and stable federal presence in the arts, endorsed an art rental policy, argued for racial equality, and ended with a ringing cry for the defense of a democratic culture. "Let it be understood," Davis wrote a week before the congress opened, "that we are united."[52] Many of the artist participants at the first congress also exhibited their work at the show, *Against War and Fascism: An International Exhibition of Cartoons, Drawings, and Paintings,* held at the New School for Social Research. Eight months later, the congress opened *America Today,* an exhibition of one hundred prints shown simultaneously in thirty cities, juried by members of the congress who also included their own work. Art, its organizers believed, could be accessible in a number of ways. With prints by Davis, William Gropper, Louis Lozowick, and Philip Evergood, the show's images of dingy tenements and unproductive factories, workers and strikers, and hawkers and lynch mobs expressed, far more eloquently than long-winded speech-making ever could, the social and political concerns of the artists.[53]

Davis worked tirelessly behind the scenes to prevent the congress from splintering into either a narrowly political or an entirely apolitical body. He concluded in March 1937 that the congress had to be both against "war and fascism" and "primarily interested in art matters." To resolve the dilemma, Davis created a political committee empowered to "raise the political level of the membership."[54] By the end of 1938, the American Artists' Congress had enrolled eight hundred members in a dozen regional branches, with more than half the dues-paying participants coming from New York. He insisted that the congress was not political (but that it ought to have a political committee) and that it expressly addressed artists of standing while catering to a broad spectrum of membership by endorsing virtually all the demands of the Artists' Union. Davis's inclusive New Deal–Popular Front understanding of the Artists' Congress defined the organization.

Between 1935 and 1937, through Davis's efforts, *Art Front* continued to address the Artists' Union's rank and file. Critics like Elizabeth McCausland (writing as Elizabeth Noble), and Meyer Schapiro, and photographer Berenice Abbott argued that American artists needed the support of an enlightened federal government and the freedom to develop an artistic language accessible to a large public. Schapiro believed that art should bring about the solidarity of the artist and the worker, whereas McCausland argued that American artists deserved the same support from the government as "other workers." The danger, they agreed, was that the WPA wanted "safe and harmless clichés."[55] When government officials threatened to curtail programs or declared depictions of sweatshops inappropriate for federally funded mu-

Philip Evergood in front of Stuart Davis mural at the Federal Art Gallery, Municipal Building (1939). *National Museum of American Art, Smithsonian Institution*

rals, the union and *Art Front* protested, demonstrated, and boycotted. In January 1934, August 1935, December 1936, and June 1937, artists in New York demonstrated or struck against what they regarded as hostile actions on the part of the federal arts programs. In 1937, seven thousand of New York's nine thousand WPA "white collar" workers "took to the streets" in the spirit of a general strike to protest the 25 percent congressional cut in the arts programs.[56]

*Art Front* and the Artists' Congress also spoke out against racial discrimination. The Artists' Union worked to ensure the employment of black artists and supervisors on the art projects. With muralist Aaron Douglas a prominent figure in the congress, the second national meeting in 1937 featured discussions of the role of the Negro artist.[57] Additionally, the Artists' Congress and the Artists' Union also pressed for the adoption of a rental policy requiring museums and galleries to pay rent on the assessed value of artworks at the rate of 1 percent per month to a maximum of one thousand dollars. Supported by the American Society of Painters, Sculptors, and Gravers, the rental proposal merged the professional interests of established artists with the trade unionism of the Artists' Union.

The outbreak of World War II did not, at first, fracture the consensus that Davis had built in the Artists' Congress. The Communist Party faction had never exercised significant influence on the Artists' Congress, and Davis minimized the political impact of the Nazi invasion of Poland. The congress's Executive Committee continued to meet and supported the same issues it had since 1936—federal support of the arts, the rental initiative, racial equality, and collective action. Privately, however, Davis was troubled by the American Communist Party's uncritical support of Soviet foreign policy.[58]

Although the Nazi invasion of Poland failed to precipitate a crisis in the American Artists' Congress, the Finnish-Soviet war in the winter of 1939–40 did so. Members of the congress who had ties with *Partisan Review* and with the Trotskyite left, such as art historian–critic Meyer Schapiro, asked the congress leadership if the organization were prepared to "follow the Stalinist line." With the congress poised to split over support for the Soviet invasion, Davis privately wrote, "I would not support a resolution to condemn the Soviet Union . . . but only say we are studying the question." Unwilling to publicly condemn the Soviet Union, Davis nevertheless refused to follow the leadership of the American Communist Party.[59] Davis's efforts to straddle the issue failed, and resignations from the congress decimated the organization. In May 1940, Davis estimated that only one-third of its active members continued to support congress politics. Davis himself resigned from the American Artists' Congress when the Executive Committee voted to support the Soviet Union. Later, echoing Auden, he recalled the last days of the independent congress: "The valid cultural issues that made its organization possible were interpreted in black and white political terms by certain energetic elements in the membership."[60] Like the American Writers' Congress, the American Artists' Congress failed to negotiate the changing currents of the 1940s, largely because its membership insisted on retaining their political independence.

## EXPERIMENTAL THEATER IN DEPRESSION-ERA NEW YORK

The precarious relationship between art and politics in the 1930s took an even more dramatic turn in New York's two innovative theatrical experiments—the Group Theater and Federal Theater projects, which combined theater with politics. By the end of the decade, both theaters had closed. But unlike the John Reed Clubs and the Writers' and Artists' Congresses, the Group and Federal Theaters profoundly altered New York's theatrical culture, bringing to Broadway new ideas, new personalities, and an engagement with modern life. The two theater groups refused to believe that New York audiences would attend only "bloody romance or broad farce."[61] In the 1930s, taking their cues from the Provincetown Players, the Moscow Art Theater, and German expressionism, the New York experimental stage demanded that their audiences confront, not escape, life.

New York's experimental theater had begun prior to World War I, with the establishment of the Neighborhood Playhouse, the Provincetown Players, and the Washington Square Players. The Neighborhood Playhouse, sponsored by the Henry

Street Settlement House, provided a local theater devoted to modern productions of European drama from Galsworthy to Ibsen. In 1924, members of the Neighborhood Playhouse joined Richard Boleslavsky to form the American Laboratory Theater. The American Laboratory Theater, directed by Boleslavsky and his Moscow-trained colleague Maria Oupenskaya, aspired to be the American version of the renowned Moscow Art Theater, created and directed by Konstantin Stanislavsky.

At its height, the American Laboratory Theater enrolled about five hundred students in studio courses designed to teach what Boleslavsky and Oupenskaya called the "inner" technique of acting. The American Laboratory Theater, whose method was derived from Stanislavsky, stressed the implicit relation between the actors' imaginative creativity and the playwright's intent. To develop the interpretative powers of the actor, Boleslavsky and Oupenskaya created a series of exercises—improvisations—designed to recall the actual feelings of the participants.[62] The appearance of the Moscow Art Theater for a short season in New York in 1923 demonstrated the potential of bringing the new techniques to modern European drama. Stanislavsky's productions of Chekhov and Gorky quickened New York audiences' appreciation for modern drama, providing the impetus for Boleslavsky's departure from the Neighborhood Playhouse to begin his own school. In the 1920s many of the principals of the Group Theater—Stella Adler, Harold Clurman, and Lee Strasberg—received their initial training at the American Laboratory Theater.

New York's third little theater company, the Washington Square Players, was founded in 1917 to bring new standards "uptown to challenge the enemy in its own camp."[63] A spin-off from informal theatrical evenings at the Liberal Club on MacDougal Street in the Village, the Washington Square Players acquired a small theater, the Bandbox, on the corner of 52d Street and Third Avenue. After a year of weekend productions they moved to 42d Street, on the fringes of the theater district, and devoted themselves to the plays of Ibsen and Shaw. Inspired by Chicago's little theater renaissance as well as the Abbey and Moscow Art Theaters, the founders of the Washington Square Players saw themselves as progressive reformers challenging the financial and artistic monopoly of the Theatrical Syndicate. In 1919 the directors reorganized the Washington Square Players as the Theater Guild. Unwilling to limit itself to modern European plays, the Theater Guild regularly performed original American productions. In 1923, the guild offered its first play by an American playwright, Elmer Rice's experimental and expressionistic *The Adding Machine*.

Rice's first play, *The Trial,* was produced in 1914. Influenced by Ibsen, John Galsworthy, Zola, and Upton Sinclair, Rice became a socialist during World War I and opposed American military involvement. A utopian, artist, and self-styled progressive, Rice argued that "social betterment can only be achieved through individual affirmation and creativeness."[64] He described *The Adding Machine* as "a case history of one of the slave souls who are both the raw material and the products of a mechanized society."[65] Using stylized language and special lighting effects, Rice made the play's protagonist, Mr. Zero, a human machine, to demonstrate the chasm between the mechanical life of Zero's character and his still extant but wholly submerged humanity.[66] *The Adding Machine* shared German expressionism's aim "to convey the inner significance of events" through stylized images.[67]

The success of *The Adding Machine* fulfilled the Theater Guild's ambition to challenge Broadway's financial and artistic hegemony. Over the next two years the guild raised six hundred thousand dollars in bonds, acquired its own theater on West 52d Street, and organized itself as a permanent company. In 1928, the guild sent several companies on the road, and in the 1929 season it offered four New York and nine road productions. By 1930, the Theater Guild had produced plays like *Porgy, Marco's Millions,* and *Strange Interlude* and attracted young actors Alfred Lunt, Lynn Fontaine, Edward G. Robinson, and Franchot Tone to the company. The success of the Theater Guild convinced two of its younger members, Harold Clurman and Cheryl Crawford, to embark on an even more ambitious experiment.

## THE GROUP THEATER AND
## FEDERAL THEATER PROJECTS

In 1931, all theatrical ventures entailed enormous risk. After two years of economic depression, half of the commercial theaters in New York had gone dark. Experimental theaters—including the Theater Guild—suffered even more. Competition from film and vaudeville combined with rising production costs made plays both more expensive and less accessible. "In fact, investing in theatrical production was becoming more and more like betting on horses."[68] The Group Theater filled the space created by the splintering of New York's theatrical world.

"We were a bizarre trio," explained Crawford of her partnership with Clurman and Strasberg, "two old testament prophets and a wasp *shiksa*."[69] Within a year of the crash, Cheryl Crawford, who came to the guild by way of an Akron, Ohio, Congregationalist family and Smith College, first suggested to Strasberg and Clurman that they create a new theater. A petite, wiry woman of intense features and character, Crawford had known Strasberg and Clurman at the American Laboratory Theater. Following her graduation from Smith College, Crawford enrolled in the Theater Guild's drama school and quickly established herself as a stage manager, casting director, and producer. In the late 1920s, Crawford, Clurman, and Strasberg worked with virtually all of the alternative theater groups and schools in New York, along with a younger group of theater people—Morris Carnovsky, Stella Adler, Sanford Meisner, Franchot Tone, and Julius Garfinkle. In 1929, the Theater Guild asked Clurman to become a play reader, to "bring plays previously regarded as uncommercial to a big middle-class audience."[70]

The ninety-one theaters, movie houses, and radio studios that constituted New York's entertainment industry in the 1930s stretched along Broadway and its side streets between 44th and 48th Streets. At the height of its popularity, in the late 1920s, Broadway theater held its professionals and public in thrall. Eighty theaters in 1928 hosted more than three hundred dramatic productions, enabling more New Yorkers than ever to see professional live drama. The depression sent Broadway into retrenchment, so much so that by the end of the decade only fifty live theaters remained.[71] By 1932–33 the cycle of economic downturn combined with high production costs and ticket prices led producers to mount even more conventional productions—mostly comedies, musicals, and melodramas. Yet the 1930s witnessed the

debuts of a remarkable generation of American playwrights—Maxwell Anderson, Lillian Hellman, Thornton Wilder, and Clifford Odets—though for every *Children's Hour* by Lillian Hellman or *Our Town* by Thornton Wilder, Broadway offered dozens of plays like George S. Kaufman and Edna Ferber's *Dinner at Eight* or the musical comedy *Yokel Boy,* which starred Buddy Ebsen. An era that began with the twelve-performance run of the first American production of *Three Penny Opera* ended with *Life with Father,* the Howard Lindsay–Russel Crouse drawing-room comedy, which endured until 1949, when it closed after 3,224 record-breaking performances.[72]

Clurman, like Crawford and Strasberg, bridled at the Theater Guild's commercial success. He dreamed of something different. Between 1929 and 1931, assisted by Crawford and Strasberg, Clurman presided over a nonstop theatrical salon, held first at the Hotel Meurice and later in Crawford's apartment on West 47th Street. Not content with creating a new theater devoted to modern themes and techniques, Clurman envisaged a new "sense of theater in relation to society," a theater that embodied his vision of a just society.[73]

Beginning with the more conventional notion that the new theater required a permanent company, Clurman asked his friends to consider what kind of method was appropriate to their enterprise and how "a philosophy of life could be adapted to a philosophy of theater."[74] Clurman had in mind a group of artists whose common commitment transcended individual attainment. He also wanted a theater community engaged socially as well as artistically. "Our interest in the life of our times," he wrote, "must lead us to the discovery of those methods that would most truly convey this life through the theater."[75] Clurman wanted to do something for the public. The new theater, he argued, could do anything, but it had to justify itself by giving "voice to the essential moral and social preoccupations of our time."[76] He conceived the Group as an American theater, one which would be more than "a place of amusement," which should strive to be "a direct and universal register of American spiritual activity."[77]

In June 1931, twenty-eight actors, three directors, "twenty-one victrolas, three radios, and assorted dogs and cats," spouses, and children left New York for Brookfield Center, Connecticut, where the newly formed Group Theater trained for its inaugural production.[78] The average age of the human members of the company was twenty-seven.[79] Cheryl Crawford came up with a new site for each summer—in 1931, Brookfield Center, Connecticut; in 1932, Dover Furnace, New York; in 1933, Green Mansions, New York; and in 1934, Ellenville, New York. The Group suffered the winters in cold-water flats, and they lived for the summers. At their "resort" colonies, with screened-in bungalows and threadbare lawns, they became the Group.

Initially, the summer was Strasberg's. As Clurman, who had first met Strasberg a decade earlier, remembered, "Craft was Strasberg's specialty." Clurman played the role of the philosopher, giving the Group its spiritual nourishment each winter, and Strasberg performed as the technician in June and July. Strasberg crafted the Group's theatrical direction, although he did so in what Stella Adler called a "skitzy" way. Adler was not being flip. Strasberg seemed to possess at least two personalities—the devoted disciple of Stanislavsky and the Moscow Art Theater and the rebel

who protested against both the theater of commerce and the Group's excessive idealism.[80] He objected to Broadway's oppression for two reasons—its conventional artistry, in teaching actors to pretend to be what they were not, and its economic dishonesty, which exploited the actor and made dramatic art impossible.[81] Clurman and Strasberg agreed that they opposed "the gross commercialism and trivialization of the American theater" and planned for a new theater, one that was collective and emotionally intense.[82] Lee Strasberg, part immigrant Marxist, part Stanislavskian master, and part encounter-group psychiatrist, wanted to create a theater of liberation. His students regarded him as an extraordinary teacher whose "method" was controversial and authoritarian.[83] When Clurman talked endlessly about the need to connect art and life, his young colleagues listened patiently. In contrast, when Strasberg exploded at the immature deficiencies of a young actor, the students resented him. "We are," he yelled one day at Morris Carnovsky, "aiming at collective theater here. For anyone to transgress is a crime."[84]

Taking his lead from the Moscow Art Theater, Strasberg tried to erase the line between acting and reality. He taught that Stanislavsky had designed the method, a whole series of techniques ranging from improvisations to exercises in "affective memory" and mime, to recreate human physical and emotional action. Strasberg planned his exercises in affective memory to foster the rediscovery of the forgotten emotion in the experience, to train students to portray the reality of a character's inner self.[85] Some of these encounters were difficult and produced a sense of heightened vulnerability; others were hilarious. To stimulate the imagination in practice sessions, Strasberg would call out an idea to be "embodied" without words. To the command, "America," Clifford Odets "went to sleep. He awoke suddenly, looked to the alarm clock and then began frantically to dress. He rushed into an imaginary subway . . . entered an office, hastily took off his hat and coat, sat down at his desk, and then—leaned back on his chair, put his feet on the desk and placidly smoked on with nothing to do."[86]

By the second summer some members of the Group complained of Strasberg's intensity. Stella Adler found it too introspective: "I was disturbed. . . . The emphasis was a sick one." Others, however, found Strasberg's innovations to be just what they needed. Often the Group read aloud from the revered texts of Chekhov—at dinner. Many remembered the improvisation of one actor who, when asked to demonstrate the existence of opposites, created a shivering cleric taking a cold shower while reciting Walt Whitman's "I sing the body electric."[87] Bud Bohnen wrote to his parents that Strasberg and Clurman had devised a course on primitive theater, a study of elementals—the sun, motion, and religion. Strasberg also invoked modern painting when he asked his students to freeze in poses conjured from images by German expressionists Käthe Kollwitz or George Grosz.[88] Employing Marxian perspectives, Freudian psychology, Stanislavskian method, and his own inventiveness, Strasberg drove his company. Those like Adler, who had been traditionally trained, or Odets, who needed constant approval, resented Strasberg's intrusion, arrogance, and authoritarianism. Others considered him a genius.

The poverty of the Group's early years engendered a spirit of comradeship. Although most who participated in the Group identified with the political left, their

drama did not yet reflect such commitments. Even *Red Rust,* which the Group produced for the Theater Guild Studio, was "red" only in its Soviet origins. Starring Franchot Tone and Luther Adler, Stella's brother, the play ran on Sundays for a few months in 1929. The Group mounted its first production, *The House of Connelly,* by Paul Green, in much the same vein. Prepared by Strasberg and Clurman during the Group's first summer, in 1931, the play was a Chekhovlike study of the decadence of the Old South. Subsidized by the guild and a donation from Eugene O'Neill, the play featured two black actors, Rose McClendon and Georgette Harvey.[89] *The House of Connelly* received good notices and ran a modest ninety-one performances. Clurman and Strasberg felt that they had accomplished something "new." Speaking at the John Reed Club of New York, they characterized the Group as too left for the guild and too right for groups like the Workers' Laboratory. In February 1932, the Group Theater declared its independence from the Theater Guild and began planning its next season.

The next twelve months proved difficult. The Group's second play, *1931,* ran for less than two weeks, and John Howard Lawson's *Success Story,* staged in the fall of 1932, belied the play's title. With almost no funds, the Group floundered in destitution. In desperation they secured a sprawling ten-room flat overlooking the idle railroad yards on West 52d Street, just blocks from the Museum of Modern Art. For fifty dollars a month, a dozen members of the Group secured shelter, however dreary, for the winter. "It seemed to me," wrote Clurman, "as if the very color of the city had changed. From an elegant bright grey by day and sparkling gold by night the afternoons had grown haggard, the nights mournful. . . . We could smell the depression in the air."[90] The Group's communal apartment, which Odets christened Groupstoy, became the winter version of the Group's summer community. In the hard winter months of 1932–33, the Group became a depression family, with Clurman as sole breadwinner and head of the household. Clurman passed the winter with long walks, accompanied by Odets, through the cold and empty streets of Manhattan and even longer talks over endless cups of coffee at all-night diners. Finally, Odets asked Clurman to read a play he had written.

In contrast to the Sorbonne-educated Clurman, Odets came from a working-class Jewish family that in 1913 had moved from Philadelphia to the Bronx. Odets had indeed written a "secret" play, *I Got the Blues,* about a working-class Jewish family living in the grey tenement poverty of the Bronx. Retitled *Awake and Sing!,* Odets' play, he explained, was about "a struggle for life among petty conditions."[91] Initially, Clurman thought Odets's effort "messy kitchen realism" cluttered with "gross Jewish humor." Odets felt crushed. Both proved wrong. *I Got the Blues,* when rewritten as *Awake and Sing!,* lost much of its Yiddish, but not its Yiddishness, as Odets transposed the Greenbergs into the Bergers.

At the same time, the Group produced Sidney Kingsley's *Men in White,* which became its first unqualified hit, winning the Pulitzer Prize and securing the company's artistic reputation. The Group moved through 1933–34 on the wings of relative prosperity. *Men in White* ran for more than three hundred performances, bringing needed financial backing. With success came ambition. The directors made plans for a summer visit—really a pilgrimage—to the Moscow Art Theater, and for a fall

1934 season in Boston. Despite the success of *Men in White,* Odets and Elia Kazan continued to talk of doing political drama. As the more radical members of the Group, Odets and Kazan joined with the more artistically independent to form a Clurman faction, which in the spring of 1934 questioned the Group's conservative artistic and political choices.

The Group's radicalization grew with the deepening depression. In the spring of 1934 only Elia Kazan, among the Group, joined the Communist Party, although several others, including Odets, later affiliated. Both left the party in 1936. "When I entered the Group Theater in 1932 three quarters were left-wing," recalled Elia Kazan. The Group "expressed all my resentments . . . against Turks, Williams, and fraternities," he said. "I went to 12th Street to get orders. They [the Communist Party] wanted us to take over the Group Theater."[92] Kazan distinguished between the Group as a left-wing artistic and political movement of the 1930s and the Communist Party. For a time the two were in agreement on most issues, but the Group never affiliated, artistically or politically, with the Communist Party. To be a member of the Group did not entail membership in or even sympathy with the party.

When the Group encamped at Ellenville, New York, in the summer of 1934, Stella Adler delivered an artistic and political bombshell. Adler had returned from several weeks in Paris talking with Stanislavsky. Scion of a Yiddish acting family, Adler had long been at odds with the Group's ensemble character. She resented Strasberg's "stress on the use of emotion."[93] Taking careful notes from Stanislavsky, she returned to the Group to report—or, as she put it, to deliver the "sledgehammer" message—that Strasberg had got the method wrong.[94] He placed too much emphasis on affective memory exercises and not enough on realistic technique. Strasberg reacted defensively but then admitted that what he had seen in his concurrent visit to the Soviet Union contradicted his use of the method.

Adler's challenge succeeded. She taught acting classes for the first time that summer, drawing upon her experience in the Yiddish and Broadway stage, and Clurman, who had not yet directed, decided that he no longer had to remain hidden behind Strasberg's artistic shadow. When the Group left camp for Boston for a fall season, the company was in flux. Matters grew more difficult when the Boston experiment failed and, in late November, the Group retreated to New York.[95] In late 1934, the members of the Group believed that they had played out their string. As Cheryl Crawford recalled, "There we were, stuck in mid-winter at the height of the depression with zero prospects."[96] But Clifford Odets's *Waiting for Lefty* would save the day.

Odets originally wrote *Waiting for Lefty* for a New York Theater League competition. Clurman agreed to allow Sanford Meisner and Odets to direct *Waiting for Lefty,* which began its Sunday run on January 5, 1935, at the Civic Repertory Theater. While Odets and Meisner spent December and early January readying *Lefty,* the Group stood on the verge of bankruptcy. In late December, Clurman assembled the company to announce his plans to end the season. Instead, led by Adler, many in the Group proposed that they do "Clifford's other" play—the one that he had worked on for two summers, the one which Strasberg didn't like—*Awake and Sing!* Clurman agreed to stage the play as his directorial debut.

In the dreary days of January 1935, with virtually no money, the Group rehearsed what some considered its self-portrait, *Awake and Sing!* At the same time, other members of the company made theater history with the January opening of *Waiting for Lefty.* The play's openly militant politics, its depiction of the lives and speech of ordinary New Yorkers, and above all its immediate emotional appeal fit the times.

The stunned audience at the premiere of Odets's one-act play witnessed a performance that was part agit-prop, part minstrel show, and part working-class melodrama based on New York's bitter 1934 taxicab strike. Set in a union hiring hall where the striking drivers await the arrival of their leader, Lefty, the play ends with the announcement of Lefty's death and the cabbies' betrayal. As Elia Kazan's words, "Strike! Strike! Strike!" rang out, Group actors salted in the audience picked up his invocation. Within moments the entire theater reverberated with Odets and Kazan's exhortation to strike. Odets recalled, "The audience stopped the show, they got up, they began to cheer and weep. . . . You saw for the first time theater as a cultural force. . . . The proscenium had disappeared. When that happens emotionally and humanly you have great theater."[97] Odets had remade the stage into a political moment, moving Clurman to declare, "It was the birth cry of the thirties. Our youth had found its voice."[98]

Six weeks later, *Awake and Sing!* opened at the Belasco Theater. Although it was greeted tepidly by the *Times* reviewer, Brooks Atkinson, by 1939 *Awake and Sing!* had become an American classic.[99] Odets created a generation of Bergers, a damaged yet proud urban American family, situated between overbearing parents. Less defeated than dispirited by the depression, the Bergers cling to one another, waiting for their solidarity to prevail over what Odets called the "petty" conditions of life. The Bergers reveal the illusion of their dreams and their individual failures, as father and children alike struggle to succeed in a world still governed by middle-class dreams. A poor family eroded by the times, the Bergers reach for the brass ring of American promises. Only Uncle Jacob, an introspective figure who quotes Nietzsche and the psalms of the Old Testament, has any sense of the way out. "Arise, arise, Awake and Sing (all ye who dwell in dust)," he chants. The play ends with departures, punctuating Odets's message that the future lies not in the family but rather with the working classes.

The relationship between *Awake and Sing!* and *Waiting for Lefty* was intimate. Lefty's union hall is just off stage from the Bergers' apartment. The names Odets gave his characters—"Fatt," "Lefty," and "Berger"—offer clues to his intention. The corrupt Fatt, the martyred working-class hero, Lefty, and the desperate lower-middle-class Bergers struggle to maintain some long-vanished shred of dignity.[100] These characters and symbols would have been familiar to the Group's new depression audience, and the Group wanted to play to them. *Lefty* and *Awake and Sing!* represented the Group, now embodied by Clurman and Odets.[101]

Only in retrospect do *Lefty* and *Awake and Sing!* appear as the high-water mark in the Group Theater's history. In early 1935, with two successful shows under its belt, the Group experiment bowed to critical acclaim. The Group matched its 1935 level of artistic and popular success, quite differently, two years later in Clurman's direction of Odets's new play, *Golden Boy.* By that time much had changed within

the Group. Crawford and Strasberg left the company earlier that year, and many others, following the recognition of *Awake and Sing!* and *Waiting for Lefty,* sought fortune and distraction in California. Adler, Clurman, Odets, and Bohnen were both tempted and repelled by Hollywood's pursuit of wealth and fame. Clurman, too, found his loyalties and commitments deeply divided. Having gained artistic control over the Group, he tried to institutionalize it, hoping to create a permanent repertory company, complete with actors' and directors' studios, that would compete with Broadway.[102] He wanted the Group to become what the Theater Guild had been.

The cumulative effects of past success, followed by artistic disappointment, and the lure of the movies had diminished the Group's familial cohesion. *Golden Boy* made the Group and Odets prosperous once again. It restored their respectability after their commercial work at MGM and spurred productions on the West Coast and then London. Odets had written *Golden Boy* as exciting drama about things that mattered. It bore the fruit of the Group's earlier labor.[103] Although the Group remained intact for another three years, time, success, and the loss of embattled youth undercut its cohesion. In 1938, the Group revived *Awake and Sing!* to renewed critical acclaim and attempted a new Odets play—the "dentist" play, *Rocket to the Moon*—which received disappointing reviews because of its psychological orienta-

tion. Finally, in the summer of 1939, in an attempt to rekindle their spirit, the Group trooped off to summer camp.[104]

By that time, Odets had been chastised by the third American Writers' Congress for his psychological turn, and Clurman persuaded the Group's company that it needed to do Chekhov to restore its "spiritual center." Ensconced at a Christian Science school near Smithtown, Long Island, the Group lapsed into self-examination. Confused and aware of their own stagnation, they awaited Odets's reworked *Silent Partner,* a play about immigrants, strikes, and the decline of the American dream. But Clurman had rejected it kindly in 1936, and he did so again. The last eighteen months of the Group Theater seemed an afterthought. The Group produced two noteworthy plays in 1940, *Thunder Rock,* by Robert Audrey, and Odets's *Night Music,* and embarked on a third, Odets's *Clash by Night,* which Lee Strasberg directed. But the community that the Group Theater dreamed of, and momentarily realized, had dissolved. As the United States and New York awoke from the depression and prepared for war, the Group's weighty political and social drama had lost its audience appeal.

## THE FEDERAL THEATER PROJECT

The success of the Group Theater coincided with the birth of the more ambitious, far-reaching, and politically troubled Federal Theater Project. The original idea for the Federal Theater had come from playwright Elmer Rice. In its first five years, from 1930 to 1935, the Group Theater presented a dozen American plays, sustained itself with relatively meager financial resources, and suffered almost no political interference. In contrast, between 1935 and 1939, the Federal Theater presented hundreds of shows on a national scale at a cost of more than forty million dollars, enduring constant bureaucratic and political harassment from Washington. Harry Hopkins' promise of a "free, adult, uncensored" theater proved empty. Yet the Federal Theater experiment, like that of the Group Theater, altered New York, and American, drama. As was true of federal programs in art, music, and writing, the Federal Theater Project provided unemployment relief and professional apprenticeship for a new theatrical generation. Whereas the Group Theater trained the next generation of acting teachers—Adler, Carnovsky, Bobby Lewis, Kazan, Clurman, Bohnen, and Strasberg—the Federal Theater introduced new theatrical techniques and stage designs developed in the politically charged and technically precocious theater of Weimar dramatists Bertolt Brecht, Max Reinhardt, Hans Eisler, and Erwin Piscator.

Elmer Rice, the Federal Theater's regional director for New York, and Halle Flanagan, the national director, gave the project its artistic and political stamp. Flanagan recalled that during the Federal Theater's four-year history 30,400,000 people had paid two million dollars, an average of about sixty-six cents a seat, to see 63,728 Federal Theater performances given in at least seven languages in twenty-one states and the District of Columbia. Employing between seven thousand and twelve thousand people, the Federal Theater Project cost forty-six million dollars, with New York City accounting for approximately one-third of the total expendi-

ture.[105] Although the most important projects originated in New York, the Federal Theater brought quality professional theater to the nation. The Federal Theater, especially with its Negro Theater Project in Harlem, also trained a new generation of black actors, technicians, and playwrights, challenging the racial segregation of the New York stage. At its most successful, the Federal Theater received its greatest acclaim when it spoke to its times, appearing as "non-sectarian social drama."[106]

On April 8, 1935, the U.S. Congress passed the Federal Emergency Relief Appropriations Act to fund a broad program of unemployment relief. In August 1935, President Roosevelt signed an executive order establishing the Works Progress Administration to administer the new act. Between April and August 1935, Harry Hopkins and others planned the new art projects—in painting, sculpture, music, writing, and drama—collectively known as Federal Project Number One. In May 1935, Hopkins invited Vassar College's experimental theater director, Hallie Flanagan, a fellow midwesterner with whom he had attended Grinnell College, to Washington to talk about "unemployed actors" and to discuss some of the recommendations that Elmer Rice had already placed before him. Indeed, Rice had already nominated Flanagan to be national director for the Federal Theater.[107]

Rice had prepared himself well for his role as instigator, adviser, and maverick of the Federal Theater. His play *Street Scene* won the Pulitzer Prize in 1929, and he had acquired the Belasco Theater in 1934 with plans to build an independent, noncommercial New York company. Unable to accomplish that goal, Rice leased the Belasco to Cheryl Crawford for *Awake and Sing!* In 1935, Rice planned the Theater Alliance, an organization to provide the basis for "a non-commercial, repertory theater presenting new American names at depression ticket prices."[108] Unable, again, to find sufficient financial support, he wrote to Hopkins' assistant Jacob Baker with details for his project. Baker summoned Rice to Washington and asked him to make some recommendations to shape a federal relief policy for theater. Rice proposed a project embodying four principles—high artistic quality, low admission price, permanent employment, and decentralization. Flanagan and Hopkins endorsed the principles, well aware of the difficulties in implementation. They realized the inherent tension between relief and professionalism, between regional decentralization and New York. As Flanagan wrote, "The New York City project became the best and worst of the Federal Theater. . . . It was everything in excess. In short, it reflected the city."[109]

On August 27, 1935, Hopkins named Flanagan to direct the Federal Theater Project, and she, in turn, asked Rice to administer the New York Unit. Together, Rice and Flanagan set out to create a program consonant with Hopkins' promise of "free, adult, and uncensored" national theater. Flanagan and Rice planned five units for the New York region alone, with two, the Living Newspaper and the Negro Theater, promising social and artistic innovation. The Federal Theater Project divided the nation into a half dozen other regions, each with a local artistic director, in Boston, Philadelphia, Cleveland, Chicago, Pasadena, and New Orleans, in addition to New York.[110]

Throughout 1935–36, while Rice planned his first Federal Theater season in New York, Flanagan worked with the regional directors to create a system designed to "in-

sinuate" itself into local communities, less to compete with commercial theater than to enrich it. Flanagan's ideas fit uncomfortably with the New Deal's concern for popular support. Artistically experimental, she hoped to reconstruct American culture through art. "Drama," she wrote, "can influence human thought and lead to human action." She aspired to "rebuild, rethink, and redream" America.[111]

A partisan of the Moscow Art Theater, Flanagan had visited Moscow as the first female Guggenheim Fellow in 1926.[112] She received critical acclaim for her 1931 Vassar production of *Can You Hear Their Voices* which she adapted from a short story by Whittaker Chambers. Done in the agit-prop style of stylized characters, a didactic chorus, and minimalist scenery, *Can You Hear Their Voices* presaged the Federal Theater's division—the Living Newspaper—and its heralded 1936 edition, *Triple-A Plowed Under*.[113] Flanagan's direction, "novel, advanced and European" in style, contrasted with the play's American theme. Set in the Arkansas tenant-farming backcountry, *Can You Hear Their Voices* pleaded for agricultural relief.[114] To draw from reality a picture of immediate need, the production utilized loudspeakers, blackouts, and statistical charts.

Flanagan and Rice, in cooperation with the Newspaper Guild, formed the Living Newspaper, which they designed as a New York performance daily to "dramatize the news without excessive scenery, just living actors, light, music, and movement." An editor-in-chief, managing editors, and reporters—all unemployed members of the Newspaper Guild—combined to create "authoritative dramatic treatments, at once historic and contemporary, of current problems."[115] Rice and Flanagan wanted to build a new theater that would synchronize all aspects of the stage. With director Joseph Losey, who believed that "facts are explosive," Flanagan and Rice wanted the Living Newspaper to juxtapose art with life: "Light must talk, sound becomes visible, and pauses speak louder than words."[116] They scheduled the first edition of the Living Newspaper, *Ethiopia,* which dramatized fascist Italy's invasion, for the end of February 1936.

A researcher for the Living Newspaper wrote to the White House requesting a recording of one of President Roosevelt's addresses. Hopkins responded by ordering the Federal Theater not to use the actual voices of any of the contemporary figures it portrayed—FDR, Mussolini, and Haile Selassie. Faced with this "request," which appeared tantamount to censorship, Rice invited critics to see an unrevised pre–opening night performance of *Ethiopia.* The next evening he dutifully obeyed Washington's injunction, canceled the production, and resigned.[117] Almost immediately Rice's successor, Philip Barber, who also stage-managed the Group Theater, announced plans for the second Living Newspaper, *Triple-A Plowed Under.*[118]

The Living Newspaper forged ahead with plans for a new edition. As with *Ethiopia,* the editors intended *Triple-A Plowed Under* as "a committed documentary that informed audiences . . . of a social problem." Employing projections, masks, spotlights, ramps, loudspeakers, and characters hidden in the audience, the play argued for collective action, higher wages, and affordable food.[119] *Triple-A* played first in New York and then traveled to Chicago, Cleveland, Milwaukee, and Los Angeles. The Federal Theater had taken experimental New York drama on the road, complete with contemporary themes and German expressionist techniques.

Washington's desire for "safe plays" came into increasing conflict with Flanagan's wish to give voice to a "new" theater.[120] Flanagan's New York unit, led by Barber, a Group Theater veteran, pushed for independence and innovation. In its second season the New York unit, assisted by the 1936 creation of a Play Policy Board, produced Sinclair Lewis's *It Can't Happen Here*. A critique of American demagoguery as exemplified by the Huey Long–Father Coughlin phenomenon, *It Can't Happen Here* sold out its New York season three months in advance. Coinciding with the first anniversary of the Federal Theater Project, the play opened simultaneously in twenty additional cities. In response to regional demands the national companies offered versions in Spanish and Yiddish.

In four months, 275,000 people paid thirty cents per ticket to see *It Can't Happen Here*.[121] The Federal Theater office estimated that many in the audience were "attending a legitimate theater for the first time."[122] New techniques in marketing, including the distribution of free tickets, the creation of theater parties, and subsidized prices made it possible to "bind the Federal Theater to its new audience."[123] Similarly, the 1938 Living Newspaper production of *One-Third of a Nation*, an homage to FDR's second inaugural address, played nationally to more than a quarter of a million people. Later, a successful New York production of T. S. Eliot's *Mur-*

The Living Newspaper on stage. *One-Third of a Nation* (1938). Set design by Howard Bey. *Theater of the Thirties Collection, Special Collections and Archives, George Mason University*

*der in the Cathedral,* featuring an expressionistic set, ran for six weeks before thirty-nine thousand people. The Federal Theater Project's greatest success, however, was the John Houseman–Orson Welles production of *Macbeth* at Harlem's Lafayette Theater, on 131st Street.

Throughout its history, African American theater in New York had been a segregated affair. World War I marked a turning point for black theater in New York. In 1917, the Lafayette Stock Company produced Ridgley Torrence's *Three Plays for a Negro Theater,* to the acclaim of black critics. James Weldon Johnson called it a watershed in Negro theatrical history. Black actors, however, either remained exceptional performers in occasional commercial ventures or worked in Harlem. Through the 1930s, New York's theaters offered black audiences segregated seating, and black actors, technicians, and playwrights rarely found professional employment outside Harlem. The depression exacerbated the traditional "last hired, first fired" principle for black employment in the New York theater.

In 1935, when Rice and Flanagan organized the Federal Theater Project's New York Unit, they confronted the city's persistent pattern of racial discrimination. Initially, they intended to directly challenge artistic Jim Crow by establishing the Negro Theater entirely under black direction. The Lafayette Players pushed for black leadership and asked that their theater be included in the federal program. Following the Harlem race riots of March 1935, however, Rice and Flanagan balked. The veteran actress Rose McClendon suggested that she and John Houseman codirect the Harlem unit. Supported by Communist activists in Harlem, McClendon's recommendation of Houseman addressed the concerns of those who insisted on integrated leadership for the program. Houseman and McClendon agreed to appoint two additional black deputies, Edward Perry and Carlton Mars. Eventually, the Negro Theater Project employed 750 workers, including five hundred actors, the majority of whom were nonwhite.[124] As in all WPA projects, 10 percent of those hired could be established artists, neither unemployed nor on relief, making it possible for the Negro Theater to hire Eubie Blake, Countee Cullen, and Zora Neale Hurston.

Following McClendon's death, the English-educated Houseman became director of the Negro Theater Project. Houseman arrived in the United States in 1929, published in the *New Masses,* and gravitated to the Group Theater. By 1933 he had written several plays, worked with Clurman, and gained entrée into the salon of Constance and Kirk Askew. The Askews introduced Houseman to Virgil Thomson, who had just composed the musical score for *Four Saints in Three Acts,* an opera with a libretto by Gertrude Stein, which the Askews had agreed to produce. At the Askews', A. E. Austin, of the Wadsworth Athenaeum in Hartford, indicated to Houseman that he needed a director for the opera.[125] Thomson had suggested an all-black cast and a set filled with "dolls, lace, and feathers, crystal and cellophane." When asked to become the unpaid producer-director, Houseman readily agreed.[126] A remarkable opera, *Four Saints* earned notoriety from its use of black actors in "nonnegro" roles.[127] In 1934, after playing for a short time in Hartford, *Four Saints* reopened successfully in New York.

Two years later Houseman took over the Negro Theater Unit. Believing that the Harlem unit should produce plays by and for black people, Houseman also wanted

to produce plays that cast talented black actors "without reference to color."[128] Houseman produced *Walk Together Chillun* by the black playwright Frank Wilson and an adaptation of *Macbeth* directed by Orson Welles—an extraordinary "voodoo" *Macbeth.* Concerned that the play might be perceived as a "vast burlesque intended to ridicule the Negro in the eyes of the white world" and aware that its rehearsal at the Lafayette made it a Harlem event, Houseman and Welles pulled out all the stops. Welles had originally intended to recast the witches as voodoo priestesses, but he gradually turned the play into a massive and extravagant exploration of power and corruption. Welles' *Macbeth,* set in Haiti, starred Jack Carter, Canada Lee, and Eric Burroughs and featured a troupe of African drummers. It became a landmark production.[129]

With the opening scheduled for early April 1936, Houseman recalled, "little else was talked about above 125th Street."[130] In the days preceding the sold-out opening, Houseman stenciled the title, MACBETH, in luminous paint on every street corner between 125th and 140th Streets from Lexington Avenue to Broadway. Opening night seemed a combination of Bastille Day and a Garveyite rally. Abe Fedors, a colleague in the production, outfitted himself in a blue and gold military uniform resplendent with "footwide epaulets of red cord," and the Negro Elks provided an eighty-piece band to entertain the crowd of ten thousand that gathered.[131] Inside, first-nighters saw an expressionistic and tropical Burnham Wood set amid the fire and smoke of Napoleonic Haiti.

In the *New York Times,* Brooks Atkinson praised the play and its federal patrons, whereas the *Herald Tribune* damned both. Virgil Thomson's music, the African drummers, Jack Carter's brooding presence, Welles' imaginative direction, and Houseman's perseverance crafted an evening that transcended the play itself. "Voodoo" *Macbeth* played for ten weeks at the Lafayette and on Broadway for another eight. The Federal Theater subsequently produced it nationally. When the black actor who played Macbeth fell ill for a week in Indianapolis, Welles did the role in black-face. Requesting a new assignment in the summer of 1936, Houseman informed Flanagan that the Negro Theater Unit could be entrusted to black artistic leadership.[132]

The Negro Theater Unit of the New York Federal Theater Project constituted only one of sixteen black regional theaters organized under the Federal Theater Project. In the last two years of the project these companies produced works by and for African Americans. Although none achieved the notoriety of *Macbeth,* on the whole, "no American Theater project has meant more to negro theater players . . . than the Federal Theater Project.[133] Houseman recognized that although the Federal Theater commissioned a number of works by black playwrights, many went unproduced. According to Houseman, black drama remained chained "within the galling bounds of stereotyped roles."[134]

After leaving the Negro Theater Unit, Houseman and Welles proposed a new "classical" unit for the Federal Theater Project in New York. Flanagan and the Play Policy Board agreed. They invited Houseman and Welles to direct WPA Project 891, the 1936 production of Marc Blitzstein's *The Cradle Will Rock.*[135] When Houseman heard Blitzstein sing his recently completed opera, he decided to produce the play

despite impending budget cuts in the WPA. The decision drove the Federal Theater into a head-on collision with New Deal administrators determined to save the relief program from conservative attacks directed against controversial projects. *The Cradle Will Rock* forced Flanagan to choose between a national theater that measured up to a lofty artistic and social vision or one that was a governmental art agency that paid lip service to free expression.[136]

In 1934, Blitzstein had returned to New York from Europe with part of his opera already written and endorsed by Bertolt Brecht. The son of a Philadelphia barber, Blitzstein had studied at the Curtis Institute of Music and in the mid-1920s became a student of Arnold Schoenberg and Nadia Boulanger. In the early 1930s, Blitzstein met Brecht, Kurt Weill, and the German "proletarian" composer Hans Eisler, with whom he worked at the Composers' Collective in New York. Under Eisler's influence, Blitzstein rejected neoclassical formalism, composing music for "social and political purposes."[137] His style of composition changed even more as, abandoning an earlier Marxist vocabulary, he looked to popular sources for musical ideas. In a series of articles published in the *New Masses* in the summer of 1936, Blitzstein declared his allegiance to proletarian music, attacked art-for-art's-sake music, and committed himself to a revolutionary cultural revival that joined art and politics. With Eisler as his model, Blitzstein fused Marxism with music to compose the "kind of music that would transform the velvet sweetness of *Die Dreigroschenoper* into political steel."[138]

Drawing on musical sources "from *sprachstimme* to arias, patter and the blues," Blitzstein wrote *Cradle* as a prounion, anticapitalist, sentimental, and experimental work.[139] When informed of its content, WPA officials in Washington tried to cancel *Cradle* by cutting off the Federal Theater's funds just hours prior to opening night. Undeterred, Blitzstein, Houseman, and Welles engaged a second theater, cajoled the ticket-holding first-nighters into walking twenty blocks uptown, dragged a rental piano to the theater, and opened the doors. When they discovered that their cast could not perform at a nonunion event, Blitzstein played and sang his work from the bare stage. As soon as Blitzstein completed the overture, Olive Stanton, who was to have played the female lead, Moll, suddenly rose from her seat in the audience to sing. Someone pivoted the spotlight, catching Stanton as she stood, and her character blazed to life. One after another the actors took their cues and sang their parts until the audience, overwhelmed, brought down the house.[140] Just as *Waiting for Lefty* had mirrored labor strife in 1934, Blitzstein's opera anticipated the working-class militancy of 1937, which included CIO sit-in strikes in the steel industry and organized protests against WPA project cuts.

Blitzstein intended *The Cradle Will Rock* as a stylized drama that dealt with social issues, utilizing American popular music from the 1920s and 1930s. In his opera, Blitzstein created a moral order in which whores are honorable and virtuous and the representatives of order—ministers, newspaper editors, and factory owners—are portrayed as whores. The plot unmasks the unbridled materialism of the greedy and shows the salvation of society led by the decent and honest union leader Larry Forman. Despite its cartoonlike quality, as a "play in music" *Cradle* dramatized life.

*The Cradle Will Rock* both warns and announces. Blitzstein's dramatic forces,

the Liberty Committee led by Mister Mister, Reverend Salvation, and President Prexy, and the organized collective of men and women led by Larry Forman confront one another. Blitzstein used dramatic prophecy in the opera's last lines.

> Well you can't climb down and you can't sit still;
> That's a storm that's going to last until
> The final wind blows . . . and when the wind blows . . .
> the cradle will rock!
> *Music, bugles, drums, and fifes*
> Curtain.[141]

In April 1938, the House Un-American Activities Committee (HUAC) launched an investigation of the "communistic" relationship between the Federal Theater Project and the Workers' Alliance. Hazel Hoffman, who had worked in the mail room of the Federal Theater Project's New York Unit, accused Hallie Flanagan of subversive political activities.[142] Despite her request to set the record straight, it would be eight months before Flanagan finally defended herself against charges of producing plays by "that radical" Marlowe and selling tickets to "front" groups like the ACLU (American Civil Liberties Union) and the Sisterhood of the Sunnyside Jewish Center.[143] In June 1939, President Roosevelt, who had declared that termination of the Federal Theater Project was "discrimination of the worst kind," signed the bill that abolished the Federal Theater and required a loyalty oath for new workers on federal relief projects.[144] At a July 1, 1939, performance of *Life and Death of An American* at the Maxine Elliott Theater, the director mounted the stage and informed the packed house that the Federal Theater, the "frilly artistic project," had ended.[145]

The artistic Popular Front in New York was short lived, yet it was an essential part of New York Modern. Between 1935 and 1939, the Artists' and Writers' Congresses and the Group Theater and Federal Theater projects mobilized modern art to save democracy, radicalize the masses, and defeat fascism. They drew on European expressionism and American vernaculars, grafting them to the urban realism that underlay New York Modern.

The Group and Federal Theaters' diverse productions introduced European ideas and techniques to the New York stage. The Group Theater momentarily sustained a socially committed artistic community, and the Federal Theater gave hope and employment to thousands of young theatrical professionals, holding the promise of a truly national theater. The dramatic realism of the Group and Federal Theaters borrowed from German expressionist drama and Stanislavsky's method acting, giving New York audiences an alternative to Broadway's light entertainment. The Artists' and Writers' Congresses moved artists directly into the political arena. For a time the congresses, serving as an artistic Popular Front, united a broad spectrum of reformist factions in behalf of socialist economic policies, public support for the arts, and an antifascist foreign policy. By the late 1930s, however, New York's artistic Popular Front foundered. Retreating before an increasingly hostile Congress, the New Deal curtailed and then terminated its support to the arts, and the New York Communist Party returned to its slavish conformity to Soviet policy.

Participants in the Federal and Group Theaters and the Artists' and Writers' Congresses failed in their most radical ambitions. Art did not change politics. Instead, they found that politicians were demanding, often overbearing, patrons. Political participation and governmental subsidy clashed with New York artists' most fundamental value—artistic freedom. Political activism, no matter how righteous the cause, muffled their artistic voices, reducing them to minor roles in a political chorus. Unwilling to accept second billing, New York artists disengaged from overt politics, determined to retain the autonomy of their artistic voices. By 1939, New York art had lost its political edge, but its artists had not abandoned social commitment. Free of organized politics, they discovered new artistic forms to express their individual and collective concerns with gender, sexuality, and race, which the politics of the 1930s had either dismissed as irrelevant or deemed too controversial. Paradoxically, unhampered by political entanglements or ideological orthodoxy, with the coming of war New York artists addressed modern life in even more radical terms. In New York, World War II opened the floodgates of artistic and social change.

# Behind the American Scene
## Music, Dance, and the Second Harlem Renaissance

In the 1930s, under the leadership of the Whitney Museum and the patronage of the New Deal, social realism in general and the American scene in particular dominated New York art. Politically sensitive and often critical of social and racial injustice, the American scene nonetheless represented the United States in idealized, sometimes pastoral, images—as a diverse and democratic nation of forthright, decent people. Such benign portraits reflected the ideals of a number of American scene artists, many of whom were the children of immigrants who had successfully acculturated to American society. For these artists—indeed, for their working- and middle-class audiences—the depression and World War II, especially in retrospect, constituted a golden age—a moment when labor triumphed, ethnic brothers assumed political leadership, communities and families came together to help one another, and Americans stood shoulder to shoulder against fascism, willingly sacrificing their lives to defend American democracy and freedom.

Even before the war ended, however, a number of New York artists, drawing on the images of the American scene, undermined its idyllic presumptions, implicitly challenging conventions of sex and gender in American society. In their modern dance *Appalachian Spring,* Martha Graham and Aaron Copland used the idioms of the American scene as a counterpoint to the continued exclusion of women and homosexuals. As the culminating masterpiece of the American scene, *Appalachian Spring* foreshadowed the issues, if not the styles, of postwar New York art.

In Harlem, at the same time, African American artists confronted the system of racial segregation embedded in American society and its representation in the American scene. In the wake of the 1935 Harlem riot and on the crest of the second Great Migration, artists of a second Harlem renaissance demanded that New York Modern include them and their New York. For them it was all too apparent that African American invisibility was the legacy of racism.

World War II abruptly and irreparably ended what many New Yorkers nostalgi-

cally considered the city's golden age. For the city's white working and middle classes, many of whom were second- and third-generation immigrants, the Great Depression had been a time of communal bonding, of community identity. The solidarity of the city's white working and middle classes, however, had begun with World War I, not the depression. With the outbreak of war in 1914, European immigration to the United States ended. Following the war, Congress enacted sweeping restrictions that closed the era of unrestricted European migration. Between 1914 and 1940 the city's white ethnic population remained unchanged for the first time in a century. With African Americans consigned to ghettos during the interwar years, whites enjoyed a moment of continuity and community. Even in the face of economic privation in the 1930s, white ethnic New Yorkers considered the city their own—governed by their political heros Fiorello La Guardia and Franklin Roosevelt.[1]

Confronting the depression, the city's white working classes closed ranks, strengthening their communities.[2] "Where I grew up guys were named Gargello, Iskowitz, and McGee. . . . It didn't matter what your ethnic background was. Nobody had anything," remembered a former Brooklynite who added, "Back in those days, the Italians and the Irish people didn't refer to their neighborhood by name but by the church they went to. Prospect Avenue was the main thoroughfare . . . and the shopkeepers were Dodger fans."[3] Interwar New York was a special time for many of its immigrants' children. "Poor as we were," wrote critic Alfred Kazin, "anxious, lonely, it seemed to me obvious . . . that to be outside of society and to be Jewish was to be at the heart of things."[4]

The mosaic of ethnic enclaves, built around shops, restaurants, churches, and candy stores, remained home to a majority of the city's eight million inhabitants. Kate Simon, young and female in the Bronx of the 1920s, remembered a neighborhood that did not change for thirty years. "To the west of Lafontaine was Arthur Avenue, a mixture of Jewish tenements and frame houses in which lived Italian families and a number of Irish. Beyond was Belmont whose only significance was that it held, at its meeting with Tremont, the movie house we all trooped to on Saturday after lunch."[5]

New York's ethnic golden age rested on dreams of mobility, conformity, and the transcendence of want and on the acquisition of Americanness. The image of New York as a city of poor yet stable ethnic enclaves, a patchwork of urban communities dominated by shops and synagogues, bustling thoroughfares, and parochial schools, was itself a nostalgic creation. New York's ethnic golden age had no room for those who did not conform to the city's mix of old-world customs and new-world dreams. New York Modern was dominated by white ethnic males, and its artists depicted women as subordinate or as objects of fantasy within a system that segregated blacks and other racial minorities and only hinted at the existence of homosexuals. Like much of the art of the American scene, the golden age of New Deal democracy was a moment frozen in time, sustained by the fragile unity imposed by the exigencies of the Great Depression and World War II.

In its long history, only during the 1930s did New York's population remain fun-

damentally unchanged, its economy stagnant. The equilibrium of the city's white ethnic neighborhoods was a fortuitous consequence of an economic disaster. White working- and middle-class males may have remembered the 1930s as a time of triumph over adversity, but for others it was a time of tribulation and struggle. Photographer Berenice Abbott's 1935 photographic essay, *Changing New York,* captured both the city's timelessness and its change.

During the early 1920s, before she returned to New York, Ohio-born Abbott had worked as an apprentice for Man Ray and Eugène Atget, the preeminent photographer of prewar Paris and the French counterpoint to Alfred Stieglitz. Immersed in the bohemian café life of French artists and intellectuals, Abbott joined the circle of American women who lived in Paris after World War I, which included Sylvia Beach, Djuna Barnes, and Janet Flanner. In 1929, Abbott closed her studio in Paris and returned to New York, where she taught photography at the New School for Social Research. In New York, Abbott developed a documentary, realist style that superficially resembled the idyllic images of the American scene.

In the mid-1930s, Abbott exhibited her work at the Museum of Modern Art and served as the museum's first director of the Department of Photography. The department's prize possessions were Atget's plates and negatives, which Abbott had rescued. In 1935, Abbott secured employment with the Federal Arts Project, which sponsored her MoMA show, *Changing New York.* Working collaboratively with close personal friend and *Art Union* editor Elizabeth McCausland, Abbott explored New York, photographing its neighborhoods, taking in its variety, and recording its quiet moments. She presented depression-era New York as a series of frames that undercut the myth of communal stability, images McCausland underscored with her captions. Abbott, as her show's title suggested, photographed a dynamic entity, not a timeless golden age. "I hope to present a coherent idea of this great uncrystallized city, the truest phenomenon of the twentieth century," she wrote.[6]

Abbott pictured New York with clarity and with little sentimentality. Some of her photographs of storefronts and skyscrapers, tenements and the el showed a city at rest. Yet, they also documented a city whose sheer monumentality and energy reduced its human inhabitants to ciphers.[7] The shadows on her buildings captured the loneliness of the modern city much as the paintings of Edward Hopper did.[8] But most of Abbott's photographs showed a city bristling with activity. *Tempo of the City* presented New Yorkers buying, hurrying, and striding as they scurried through midtown in midsummer. Abbott's and McCausland's New York was a complex city, its old neighborhoods and ethnic communities a subway stop away from the busiest crossroads in the world. Their New York consisted of two unequal worlds—one quaint and vanishing, the other impersonal, dynamic, and dominating.

In the 1940s, Aaron Copland, Martha Graham, Virgil Thomson, Doris Humphrey, Lincoln Kirstein, and Henry Cowell also addressed the nation's communal traditions, casting their subjects in mythic terms. Anxious to draw New York's working and middle classes into their concert and recital halls, they combined elements of European modernism with American imagery to create accessible modern works of art. Fresh but familiar, their music and dance reassured their audiences during a

Berenice Abbott's
New York. *Tempo of
the City,* "Fifth Av-
enue and 42nd Street,
looking west from
Seymour Building,
503 Fifth Avenue"
(1938).
*Berenice Abbott,
Changing New York*

time of conflict and war. Aaron Copland and Martha Graham, however, did not sim-
ply celebrate and update American traditions. They imagined a new America, quite
different from its past. As a woman and a homosexual, they understood that tradi-
tional America, and unchanged New York, had excluded them. Unwilling to spend
their artistic lives in exile, Copland and Graham, Cowell and Humphrey, like
Berenice Abbott, confronted New York audiences with the contradiction between
the idealized freedom of the American scene and the communal conformity and sub-
mission of American reality. Patriotic but not patriarchal, they dreamed of changing
not just New York but America.

## NEW YORK MUSIC:
## THE DAMROSCH YEARS

Aaron Copland, Marc Blitzstein, Roy Harris, Walter Piston, Henry Cowell, and Roger Sessions constituted a generation of modern American composers who came of age in the 1930s. Together, they changed American musical composition by opening it to the influences of European modernist experimentation, the rhythmic variations of jazz, and the homespun authenticity of the American folk song. As teachers, conductors, writers, and composers, the Copland circle redefined serious American music by insisting that their music be made accessible to the widest possible audience and by offering an American alternative to New York concert music.

The Copland circle coalesced in the 1920s, but its members had little impact on New York music until the late 1930s. Indeed, New York's concert music had changed little since the 1890s. The New York musical establishment—the Metropolitan Opera, the New York Philharmonic, and the Juilliard School of Music—clung to nineteenth-century European traditions, under the watchful presence of Carnegie Hall. The cultural anchor of 57th Street, Carnegie Hall had been the site of virtually every major New York musical event since its 1891 inauguration by Tchaikovsky, who had been welcomed by Walter Damrosch, conductor of the New York Symphony.[9] Damrosch directed the New York Symphony Society until 1928, when it merged with the New York Philharmonic and became the Philharmonic–Symphonic Society Orchestra, known since as the New York Philharmonic. Under Damrosch's leadership the New York Philharmonic catered to its upper-class patrons, lacing its standard Beethoven, Brahms, and Schubert repertoire with selections from Tchaikovsky, Wagner, and Mahler and conservative American composers like Daniel Gregory Mason and Deems Taylor. In 1928, Arturo Toscanini accepted the post of principal conductor at the Philharmonic, a position he retained until 1936, when he joined the National Broadcasting Company's Symphony Orchestra, with studios at Radio City.

Damrosch pioneered broadcast music, conducting the first nationally transmitted concert for NBC in 1927. As network musical adviser, Damrosch also hosted the famous "Music Appreciation Hour" for children. At his most adventurous, Damrosch commissioned George Gershwin's *Piano Concerto* and conducted the premiere of *An American in Paris,* but he ignored the works of Copland and other contemporary American composers. Damrosch's traditional musical taste dominated New York's musical establishment.

A mile south of Carnegie Hall, the Metropolitan Opera House on West 39th Street stood as the other pillar of New York's formal musical life. The Metropolitan had opened in 1883 and became America's longest-running opera association. Founded by New York's newest millionaires, who had been snubbed by the Knickerbocker-dominated Academy of Music on 14th Street, the Met moved New York's cultural center northward. Leopold Damrosch, Walter's father, set the Met's course for the next half-century. By 1900, the Met was home to German opera, which replaced the lighter Italian tradition. The selection of an Italian general manager in 1908, to-

gether with Toscanini's appointment as a conductor between 1908 and 1915, returned the Met's repertoire to a more broadly European balance.

The depression did not treat the Metropolitan kindly. With the Met's reserve fund severely depleted, the company shortened its season and sold its privately financed corporation, whose directors had been entitled to the single tier of boxes. This enabled the Metropolitan Opera Association to raise the funds to sustain its opera program, publish *Opera News,* and sponsor its radio broadcasts. Begun in 1931, the Saturday afternoon broadcasts of Metropolitan performances secured national sponsorship from Texaco and became a venerated musical tradition.

Apart from the Metropolitan Opera and the Philharmonic, New York offered a remarkable selection of concert music in the 1920s and 1930s. Town Hall, opened in 1921 on West 43d Street, hosted both serious and popular musical recitals, including the debuts of contralto Marian Anderson and guitarist Andrés Segovia. It also served as home to a half dozen small chamber, opera, and oratorio societies. In the late 1920s and early 1930s at least forty chamber groups, specializing in the repertoire of the eighteenth and nineteenth centuries, resided in or visited New York during the performance season. The formation of the city's two major professional schools of music—Juilliard in 1905 and David Mannes's School of Music, begun by Damrosch in 1916—completed the core of New York's concert music. By 1933, New Yorkers enjoyed access to a wide range of music—orchestral, chamber, opera, and choral—performed by premier professional musicians and conductors. But they rarely heard modern American concert music.

## A MODERN NEW YORK MUSIC

Following World War I, young American composers confronted a staid, archaic musical establishment indifferent, even hostile, to the compositions of European modernists, such as Stravinsky and Schoenberg, and American moderns, such as Ives and Copland. After the war, New York's aspiring composers, determined to participate in the modern revolution, left for Paris, many to study with French composer-teacher Nadia Boulanger at the newly created Fontainebleau School of American Music. Boulanger, renowned teacher of harmony, counterpoint, and organ, had been associated with Fontainebleau since its inception in 1921. On their return to New York, these young moderns—Aaron Copland, Walter Piston, Roy Harris, and Virgil Thomson—found themselves excluded from the city's formal musical life. In the 1920s, they formed their own organizations, determined to modernize New York concert music. Aaron Copland acted as the leader of New York's young composers, but once in New York, Copland found European modernism too constricting and too academic, unrelated to life as he knew it in the city. Influenced by the earlier work of Charles Ives and mobilized by the radical politics of the early 1930s, Copland, with Thomson, Harris, and Blitzstein, composed modern American music directed to popular audiences, which combined the musical innovations of European modernism with American folk idioms.

Born in 1900, Copland, the grandson of Russian Jewish immigrants, grew up in Brooklyn. A self-conscious "child of the twentieth century," Copland wanted to

Americans in Paris. *Left to right:* Virgil Thomson, Walter Piston, Herbert Elwell, and Aaron Copland (1924).
*Virgil Thomson Papers, Yale Music Library*

"know" America.[10] In 1921 he and his cousin, Harold Clurman, booked passage on the *France,* "got friendly with a guy named Duchamp," and arrived in time for classes at the Fontainebleau, where Copland studied with Boulanger for the school's inaugural year.[11] Most of Copland's circle—Thomson, Piston, and Harris—also studied with Boulanger. Composer Ned Rorem reflected on Boulanger's complex personality and professional dedication, noting that she accepted Jewish students "only when they were gifted or rich . . . whereas homosexuality was 'bad' only if it interfered with work."[12]

Copland, Jewish and homosexual, studied modern composition with Boulanger for three years. Living in Paris, Copland had come to France to study the "the new things in music."[13] Igor Stravinsky exercised a significant influence on Copland in his first years in France. The émigré composer's wildly original rhythms and pagan imagery scandalized and delighted Parisian audiences. Often, Copland found Stravinsky's latest score resting on Boulanger's piano when he came for his lesson.

In France, Copland also acquired a sense of American music's specialness and potential. "If composers like Ravel, Stravinsky, and Milhaud could use ragtime and jazz rhythms . . . here finally was music an American could write better than a European."[14]

Championed by Serge Koussevitzky of the Boston Symphony, Copland expanded his study to include German experimental music and returned to Europe on a Guggenheim Fellowship in 1925–26. Jazz rhythms made his music "seem American" and created the "magic wand" of contemporary polyrhythm, but Copland wanted more than a native sound. He wanted to write American music, but "with more sophisticated harmonies and in longer form," ridding his music of its romantic legacy and using contemporary sources without imitating them.[15]

Following World War I, modern music implied several things—the expressionistic, atomized, and atonal experimentations of German modernists led by Arnold Schoenberg, the neoclassical, antiromantic movement associated with Stravinsky and championed by Boulanger, and the idiosyncratic Whitmanesque work of Charles Ives.[16] Like Copland, most young American moderns gravitated to the Boulanger-Stravinsky alternative. In 1925, Stravinsky appeared as a guest conductor at the New York Philharmonic. Referring to the performances of Schoenberg and Edgar Varèse, critic Paul Rosenfeld wrote in the *New Republic*, "That evening the Atlantic rolled."[17]

Other New York musicians and critics, however, did not think European music could meet the needs of America. Henry Cowell, a protegé of Charles Ives, formed the New Music movement. Cowell insisted that Americans cut the "apron strings of European tradition."[18] Three years older than Copland and a native Californian, in the 1920s Cowell founded the New Music movement and the influential journal *New Music Quarterly*. The New Music Society sponsored concerts by the most experimental composers of the era. Cowell's compositions often featured what he called "tone clusters," in which he played the piano with his forearms, his clenched fists, or plucking at the strings of the soundboard.[19] Cowell believed that the variety and range of modern music was unlimited and largely untapped. Unimpressed with the European concert tradition, he insisted that modern composers draw on American folk music and all other music—Western and non-Western. For Cowell, there was no preferred form of modern music. Through his New Music Society he supported a catholic approach that envisioned a modern music expressive of American diversity, which he associated with a democratic society.

Through his friendship with musicologist Charles Seeger, Cowell discovered the earlier work of Charles Ives.[20] Ives and Cowell shared a common dream to declare American musical independence.[21] In 1927 the two met and agreed to support one another. Ives provided funding for *New Music Quarterly*, and Cowell published and performed Ives' works. Cowell's eclecticism proved critical. Cowell saw in Ives' music a precursor to his own. As an incipient modern, Ives had been buried by the conventions of Victorianism, but Cowell believed the older composer wrote with an original touch. As one of Cowell's friends stated, "By golly, Ives puts cowboy themes and hillbilly songs and camp meeting hymns into his symphonies. These are the tones of our country and we love them."[22]

Cowell worked closely with other contemporary composers to create a new American music. In particular, he cooperated with Edgar Varèse, a French-born composer. Cowell and Varèse collaborated in the International Composers' Guild, which in 1927 became the Pan American Association of Composers, devoted to the composition and performance of modern music in the Western Hemisphere. When Varèse returned to France in 1929, Cowell assumed direction of the organization. Like the New Music Society, the Pan American Association opposed the French-trained American moderns who had created the rival League of Composers.

The League of Composers, formed in 1923, published *Modern Music*, edited by Mina Lederman. The league and its journal supported the international and modernist tendencies of contemporary music, commissioning new works, publicizing concerts and recitals, and sponsoring radio broadcasts. Initially, *Modern Music* also represented the voice of the incipient American avant-garde, drawing Copland and Thomson to its ranks. In 1933, Lederman celebrated the tenth anniversary of her magazine by including articles by Copland and fellow composer Roger Sessions. The two essays reflected the division between the academically inclined Sessions and the civic orientation of Copland.[23]

Roger Sessions had lived in Europe since the mid-1920s, codirecting with Copland a series of concerts at the New School.[24] Born in Brooklyn in 1896, Sessions was raised as a New Englander, attended Harvard, and taught at Smith College before departing for Europe in 1926 to study with Boulanger. "Sessions gives the impression of being a philosopher-composer," wrote Copland, "rather than a composer pure and simple."[25] Sessions' music, serious and technically complex, explored tonality and reached for its metaphysical center. As a critic, Sessions' sense of impending doom and concentration on the inherently abstract nature of music led him to condemn the commercial and popular tendencies in contemporary composition.[26] Composers, argued Sessions, should create a "primary and spontaneous" art concerned with the "inner life."[27] Sessions believed that when music became commercial, it lent itself to vulgar, often political ends. Music's greatness, its viability, depended on its inner integrity. With the rise of fascism in the early 1930s, Sessions returned to the United States, where he accepted a series of full-time academic appointments, most importantly at Princeton.

Walter Piston also studied with Boulanger and like Sessions remained loyal to the neoclassicism of his teacher. Following his return from France in 1926, Piston taught at Harvard, where he stayed for the remainder of his career. Influenced by Stravinsky, Piston composed highly formal and demanding instrumental music that emphasized counterpoint and complex rhythmic structures. Copland regarded Piston's music as a "challenge to every other American composer" for its modern, neoclassical qualities.[28]

In contrast, Copland brought to his music an affection for American society.[29] Rejecting Sessions' elitism, Copland believed that radio offered a means to introduce modern music to new audiences. Rather than cloister himself in Ivy League universities, Copland taught at the New School, whose policies of adult education, open admission, and hostility to anti-Semitism sat well with his democratic sensibility. He also asked the city's musical organizations to expand the audiences for

modern music, much as Damrosch and Toscanini had done for the European symphonic repertoire twenty years earlier. "The day of the 'pathfinder' and the 'experimenter' is over," Copland declared. "We are in a period of 'cashing in' on their discoveries."[30] American music needed appreciative music critics to support the new composers who "speak directly to the American public in a musical language which expresses the . . . American scene."[31] By 1933, the League of Composers and *Music Quarterly* had grown strong enough to sustain both Copland's and Sessions' visions—the Americanist and the academic, the representational and the abstract.

Cowell continued to champion Ives, presenting a concert of his works in Paris in 1931 and publishing several of Ives' compositions in *New Music Quarterly.* Copland, too, promoted Ives' work. As one of the main movers behind the first Festival of Contemporary American Music, Copland included seven of Ives' songs at the Yaddo Festival held at Saratoga Springs in the summer of 1932.[32] In the 1930s, Copland moved away from the formal, modernist influence of Stravinsky and Boulanger, finding in Ives an American modern. Copland shifted his early affinity for jazz to American popular and folk music, though he realized that most New York concertgoers still preferred traditional European orchestral music.[33] Cowell and Copland believed that modern music should address radical and working-class audiences through a politicized music.[34] Marc Blitzstein, the advocate of *gebrauchsmusik,* or social music for mass action, spoke the loudest from the left.[35]

In 1932, Blitzstein, with other radical composers, formed the Composers' Collective, a spin-off of the John Reed Clubs. Cowell, ever the renegade, joined the collective and contributed several articles to the *New Masses,* advocating songs that supported the class struggle.[36] The collective included Cowell, Copland, Seeger, and Blitzstein. As the collective's secretary, Blitzstein organized the group's twenty-five or so regular members who met weekly in an apartment on West 14th Street.[37] The *New Masses* sponsored a competition for the best May Day song, which Aaron Copland won.[38] The experience with the Composers' Collective convinced Copland to return home and to abandon European experimentalism in favor of native popular music. Copland's decade-long exploration of American folk idioms flowed from this experience. It "was a very easy way of sounding American," explained Copland. "It was a . . . question of simplifying one's style for a broader audience."[39]

The Composers' Collective proved as short lived as its parent organization, the John Reed Club. In the aftermath of the first American Artists' and Writers' Congresses of 1935–36, its members recast the collective as a Popular Front musical group, the American Music League, with Copland, Thomson, and Harris continuing as the leaders of the new Americanized association. They replaced the pretensions of proletarian culture with a generalized appreciation of the American folk idiom, restoring Ives to the musical pantheon of modern New York composers.

## MUSIC FOR THE NEW DEAL

Even before the depression, an estimated five thousand professional musicians had lost their livelihood when "talkies" and phonograph records displaced live mu-

sic in the nation's movie and music halls. By 1933, twelve thousand of the fifteen thousand musicians' union members were unemployed. As in the other arts, relief efforts originated in the private sector. Walter Damrosch raised $320,000 in 1932 to found the Musicians' Symphony Orchestra for unemployed union members in New York, but his efforts and those of the Musicians' Emergency Aid Organization did little to ease the plight of the majority of professional musicians.[40]

The Federal Music Project of the Works Progress Administration in New York offered the same type of relief employment as other WPA programs in the arts. Unlike the Federal Arts and Theater Projects, however, the music program distanced itself from overt political expression. Under the direction of a traditional composer and musicologist, Nicolai Sokoloff, the Federal Music Project in New York presented itself as "reassuringly neutral."[41] Sokoloff, a Russian émigré, had served as the first conductor of the Cleveland Symphony and, in 1930, formed his own orchestra. Much like Damrosch, Sokoloff aspired to bring European concert music to a wider American audience. He divided the country into ten regions, each with its own director. At its height, in 1937, the Federal Music Project sustained 270 musical groups throughout the country, providing employment for thirteen thousand musicians. Sokoloff wanted to employ as many quality professional musicians as possible, a goal that brought him into conflict with organized unions, who sought work for any unemployed musician.

In New York, modern music found a small niche in the larger Federal Music Project. In October 1935, the New York regional director, Ashley Pettis, invited Roy Harris and Virgil Thomson to participate in the first Composers' Forum-Laboratory, where they performed and conducted their own works and responded to questions from the audience. Pettis intended that the Forum-Laboratory would present works of composers engaged in articulating modern American music, much as the Federal Arts Project had promoted American scene painters. Pettis wrote, "Here at Composers' Forum-Laboratory will be offered an opportunity to observe the composer at work for us. . . . A panoramic view will be had of what is happening in a musical way about us."[42] The Thomson-Harris presentation did just that. The two composers debated with their audience over the appropriateness of modern composition and the value of utilizing American musical sources.[43]

Thomson defended his individualism against the demands of the audience for social themes and political advocacy. Sensing that some wanted a demonstration of "my inherent trade unionism," Thomson stuck to his guns, insisting that "to encumber the social context . . . with all the impedimenta of modernism was to hinder communication."[44] A year later Copland hosted the Composers' Forum-Laboratory in New York and addressed the question of the nature of American music. Copland suggested that an American music had not yet emerged and remained still in the making. Music could be identified as American if it communicated an understanding of American experience to an American audience. American composers, he urged, needed to write from the depth of that experience and uncover the common sentiments in their culture.[45] By 1940 several hundred American composers had presented sixteen hundred of their works at the Composers' Forum-

Laboratory. When the government terminated the Federal Music Project in 1942, the Forum-Laboratory moved to San Francisco before its reconstitution in 1947 by Columbia University and the New York Public Library.

Thomson's appearance at the inaugural Forum-Laboratory marked his arrival as a New York composer. Earlier, Copland had asked Thomson to oversee a series of five concerts at the New School, succeeding the Copland-Sessions concerts. Pleased by his inclusion in Copland's circle, Thomson gladly obliged. Thomson, who hailed from Kansas City, received his education at Harvard and with Nadia Boulanger in Paris. He had worked his way through Satie-inspired modernist and minimalist compositions during his collaborative work with Gertrude Stein on their *Four Saints*. Residing in Paris and traveling irregularly to New York, Thomson earned a reputation as a lightweight if clever musical personality. Copland, however, took Thomson seriously. "Thomson is a man with a thesis . . . that so-called modern music is much too involved and pretentious in every way."[46] In the 1930s, Thomson abandoned his modernist training in favor of a more direct musical language and regularly drew on his midwestern secular and religious background to weave musical compositions out of American vernacular sources.

In 1936 the film critic Pare Lorentz, recently hired by photographer Roy Striker to make a documentary depicting the tragedy of the dust bowl for the Resettlement Authority, asked Copland to recommend someone to compose the score for the government film, *The Plow That Broke the Plains*. Copland suggested Thomson. In their discussion of the project, which aimed at a sympathetic portrayal of the New Deal's interventionist policies, Lorentz and Thomson turned to financial matters. When Thomson offered to write the music for the film for five hundred dollars, Lorentz gladly accepted. "All these high-flyers," Lorentz stated, "talk nothing but aesthetics. You talk about money; you're a professional."[47]

Lorentz had already completed the filming for the documentary, and he gave Thomson a week to complete a twenty-five-minute orchestral score depicting the physical landscape of the dust bowl's agricultural disaster. Thomson finished the score in two weeks.[48] Ivesian in spirit, Thomson's composition, quoting from *The Streets of Laredo, Git Along, Little Dogies,* and *Mademoiselle from Armentieres* and with an orchestration featuring saxophones, guitar, and banjo, undergirded the film. Lorentz used a minimal visual language that cut against the grain of footage showing the disaster of the Great Plains. Thomson's music underscored the folly of traditional American agricultural policy and practice. The success of the collaboration prompted Lorentz to ask Thomson to work with him again, in 1937, on a second New Deal film, *The River,* for the Farm Security Administration.

A larger budget and more preparation time enabled Lorentz and Thomson to produce a more complex and sophisticated film. Lorentz filmed the awesome floods of the Mississippi-Tennessee Rivers network in the spring of 1937. In his composition for *The River,* a paean to the virtues of flood control and the wonders achieved by the Tennessee Valley Authority, Thomson reached back to his pre–World War I childhood in Kansas City. Thomson identified hundreds of pre–Civil War American folk songs and discovered a gold mine of white spirituals, hymns whose religious sen-

timent he had already plumbed for his *Symphony on a Hymn Tune* in 1928. For *The River*, Thomson combined these spirituals with dance tunes and popular songs, such as *Hot Time in the Old Town Tonight* and *Go Tell Aunt Rhody,* in the main score.[49] The result, a kaleidoscope of American musical vernacular, black and white, secular and religious, paralleled Lorentz's poetic litany of American river names evoked in memory of the river's human and ecological history.

Living in New York during most of 1937, Thomson met regularly with Copland and Blitzstein at the automat on West 23d Street, just down from the Chelsea Hotel. Depositing nickels into the slots that dispensed coffee and plates of tuna on white bread, the collaborators formulated plans to make their music accessible. The Copland circle agreed to establish a "cooperative music press open to all composers whose music we should find acceptable."[50] With Copland serving as the acting president of modern American music, they founded the Arrow Music Press, naming it after the Arrow luncheonette located just across the street.[51]

That same year Lincoln Kirstein, working independently, founded a new dance company, Ballet Caravan, whose subject and style complemented the Copland circle. Kirstein immediately sought Thomson's collaboration to work with choreographer Lew Christensen in developing a dance for the new troupe. Thomson, who had studied privately in Paris, longed to write music for dance. Kirstein paid Thomson five hundred dollars to write a score for a "realistic ballet about American life, in a roadside filling station."[52] *Filling Station*, by Thomson and Christensen, made its debut on New Year's Eve, 1937, in Hartford, Connecticut. Ballet Caravan performed the piece regularly in the summers of 1938, 1939, and 1940, and the WPA orchestra played Thomson's suite several times during the ballet's first season.

"I wrote a score made up of waltzes, tangos, a fugue, a Big Apple . . . all aimed to evoke roadside America as a pop art," Thomson recalled.[53] With sets and costumes by painter Paul Cadmus, *Filling Station* appealed to a broad audience. Thomson's score derived from traditional dance and folk music that recalled a pastoral American past and from contemporary popular songs that affirmed the society's urban, mechanical present. Modulating between the melodic sweetness of a song of innocence and the celebrations of a marching band, Thomson's score sampled the mélange that constituted modern American popular music. The music for *Filling Station* filled out the compositional triptych that Thomson had begun with *The Plow That Broke the Plains* and *The River*. Together, they consolidated Thomson's musical version of the American scene by fusing the strands of serious composition and vernacular tradition and breaking down the class boundaries that separated popular and concert music. Rather than patronize the masses by uplifting their tastes, Copland, Thomson, and other New York moderns used elements of concert and vernacular styles to erase the class barriers inherent in traditional concert music.

The tragic dislocations of the 1930s had brought Copland and Thomson in touch with native and narrative musical ideas. Unlike the academic modernists, Sessions and Piston, who were isolated at Harvard and Princeton, Copland and Thomson daily confronted the grim realities of the depression in New York. Critical of art-for-art's-sake modernism, they worked through "proletarian" composition to the point

where their modern American-scene music bridged city and country, past and present. Thorough, organized, and efficient, Aaron Copland appeared at the center of the groups, associations, and programs that struggled through the 1930s to make contemporary music heard. By affirming the communal and the democratic, the traditional and the modern, Copland's new music celebrated American diversity.

Aaron Copland remained a "boy from Brooklyn." His urbanity was revealed less in specific references to the hurly-burly than in his outlook. Yet, as a modern composer he defined himself in civic terms. His work in the late 1930s included scores for school choirs, film, and dance. Like Thomson, Copland had long been fascinated by dance, and in 1930, Martha Graham asked him for permission to choreograph one of his austere pieces, *Variations,* which became her dance, *Dithrambic.* Initially surprised, Copland recalled, "I was utterly astonished that anyone would consider this kind of music suitable for dance. . . . Her choreography was considered as complex and abstract as my music."[54]

Ruth Page, a dancer and choreographer, gave Copland his first commissioned ballet score in 1934, for *Hear Ye, Hear Ye.* Copland's humor showed itself when he borrowed a musical suggestion from the *Star-Spangled Banner* for the score. In 1937, Copland worked with the choreographer Eugene Loring in the Ballet Caravan production of *Billy the Kid,* in which Copland liberally quoted from and alluded to folk materials. Then, in 1942, Agnes De Mille, who had created the dances for the immensely popular musical *Oklahoma!,* asked Copland to work with her on a western piece. When Copland declined, claiming that he had already done a "cowboy ballet," De Mille "got up and started loping around the studio," insisting that this was different. Indeed it was. *Rodeo* offered Copland an opportunity to combine serious dance and music in a popular format that bridged art and entertainment.[55] De Mille had conceived a lively square dance, balletic in presentation, for which Copland composed a musical celebration as he experimented with folk melodies and complex rhythmic structures. At the age of forty-three, Aaron Copland was "the most successful composer in America." He had earned the rewards of his professional standing—$4,557.00 in 1941.[56]

In the 1930s, Copland, Thomson, Blitzstein, Harris, Sessions, Cowell, and Piston dominated American concert music. Their music embodied the variety of American life and rejected nineteenth-century romanticism and the conventions of Germanic symphonic tastes. Accessible and vernacular, Copland's music affirmed the diversity of modern urban life. Moreover, Copland and his colleagues, Thomson, Blitzstein, and Cowell, like painters Charles Demuth and Marsden Hartley, thrived in New York's tolerant and open artistic community, a relatively sheltered haven for their homosexuality. Their affirmation of modern music represented a rejection of traditional sexual mores as well as a rejection of traditional music.

In 1936, Copland's circle was shaken by Henry Cowell's arrest and subsequent sentence to prison at San Quentin for child molestation.[57] Cowell, refusing legal counsel, was unsuccessful in his own defense, and he did not obtain his parole from prison until 1940. Two years later, the governor of California, Earl Warren, pardoned Cowell when both the judge and the prosecuting attorney affirmed his innocence. Beyond the tragedy of his arrest and incarceration, Cowell's ordeal underlined the

vulnerability of Copland and his circle. As gay men living under the constant fear of exposure, false accusation, and imprisonment, they used their music to forge a respected place for themselves in American life, much as choreographers Martha Graham and Doris Humphrey used modern dance to forge a new definition of American womanhood.

## THE NEW DANCE:
## MODERN AND AMERICAN

Dance in the 1930s consisted of a great many things, none of which could yet be called American or modern. To most refined concert audiences, dance continued to mean the great European ballet tradition dominated by classical choreography and governed by aristocratic aesthetic formulas—Degas's images of the dancer remained the classic model for cultured Americans in the early twentieth century. The first challenges to European ballet derived from several sources, foreign and indigenous, which eventually merged in the formation of modern dance and American ballet. Martha Graham codified the earthbound modern dance, and Lincoln Kirstein constructed an American form of ballet that merged classical techniques with images of the American scene. Both followed in the wake of the famed modernist troupe, the Ballets Russes, with its combination of Russian artistic daring and Parisian sophistication, which had entertained New York audiences in 1916. Its appearance, like that of the Moscow Art Theater in 1923, galvanized artistic attention and promised to revolutionize ballet. World War I and the Russian Revolution, however, reduced the Ballets Russes to a tantalizing but unfulfilled promise.

The art dance of Isadora Duncan and Ruth St. Denis similarly lost its appeal after World War I. Duncan died in a tragic accident in 1927, and St. Denis left New York for California to form the Denishawn Dance School with Ted Shawn in 1916. On the commercial stage, however, dance had never been more popular. Radio City's famed "Rockettes" represented the triumph of the commercialization of dance, which reached national audiences in the films of Busby Berkeley, Fred Astaire, and Ginger Rogers and in the popular Broadway musicals of the depression decade. The tap dancing of Bill "Bojangles" Robinson added the jazz to show business dance.

During the 1930s, however, Martha Graham, inspired by modernist notions of art, reformulated the earlier art dance of Isadora Duncan and Ruth St. Denis into modern dance, free of Broadway gestures as well as the rigid conventions of classical ballet. The child of a provincial professional family, Graham moved with her mother from Pennsylvania to California at the age of eight. In Los Angeles, Graham attended the Cunnock School of Expression, where she studied theater arts, literature, history, and philosophy. More important, in Los Angeles Graham discovered Ruth St. Denis, and in 1916 she joined Denishawn.[58] Over the next fifteen years Graham, with her Denishawn colleague Doris Humphrey, Charles Weidman, and Hanya Holm, formulated modern dance, free of St. Denis's Coney Island–Hollywood effects.

Graham's training at Denishawn, with its emphasis on costume dramatics to bolster the exotic, especially the historic, troubled her. In 1923, Graham left Denishawn

to join the John Murray Anderson Review, a Ziegfeld-like extravaganza that worked out of Greenwich Village.[59] Graham became the interpretative dancer in Anderson's act. Her move to Greenwich Village brought her into the artistic center of the city and into contact with a new artistic world. Graham saw the 1923 New York performances of the Moscow Art Theater and the first Broadway productions of Eugene O'Neill at the Neighborhood Playhouse. These performances, drawing on psychological and mythic sources that blurred the boundaries between dance and theater, suggested new dramatic possibilities. When John Murray Anderson created an experimental school of drama in the mid-1920s, Graham joined the faculty. Here, she stripped away virtually all of the Hollywood and vaudeville Denishawn excesses and created a modern dance that was spare, essential movement in space.

Graham recalled that as a young girl her father had taught her that "movement never lies."[60] She defined her task accordingly—to make the body an instrument to communicate the "involuntary movement of the soul." The body had to speak, and the dissonance of modern dance became a logical expression and necessary consequence of modern life. She considered angular or mechanical movement authentic. You could not dance, she argued, in the twentieth century with an eighteenth-century body. Graham insisted that her method added a "modern" element to the dance, instead of simply overturning the idols.[61] She believed that her technical hallmark, the contraction, the sending and receiving of the inner state of being, had been used for hundreds of years. Her innovation consisted in the degree to which she had made breathing a self-conscious essence of dancing. "There is nothing new in our body," she wrote. "Things are new in our consciousness so we can learn about ourselves."[62] Furthermore, she reoriented her dance to the floor, to gravity. Rather than defy gravity, as ballet aspired to do, she accepted it as part of existence and thus of expression. The floor commanded dancers to accept their limitations, requiring them to use their torsos as the center of expressive movement. "My only quarrel with ballet," declared Graham, "is that it did not say enough in the passionate-dramatic sense. I wanted to show inner, hidden, unrevealed behavior."[63]

Graham's choice of modern music to accompany her early dances reflected her understanding of dance. The contrapuntal, asymmetric, dissonant compositions of European modernists—Stravinsky, Maurice Ravel, and Zoltán Kodály—replaced the smooth harmonic and rhythmic structure of nineteenth-century romanticism. Graham sought out composers to write music for her dance, thus reversing the tradition of choreographing a ballet to fit an existing musical composition. Her inclusion of jazz rhythms brought the sound and feel of American cities into the dance.

Modern dance announced its emergence on January 30, 1930, at the Maxine Elliott Theater on Broadway, which Graham, Humphrey, Charles Weidman, and Helen Tamaris had rented for eight days. On a stage devoid of scenery, clad only in leotards, without orchestra, they danced Lamentation, performed to the piano music of Zoltán Kodály and "punctuated by America's great gift to the arts . . . rhythm; rich, full, unabashed."[64] Graham danced in a long jersey tube dress that suggested the industrial nature of her environment. Her arms and legs stretched the fabric into a fluid sequence of shapes as she abstracted her own physical density.[65] The dance demonstrated Graham's new technique, her liberation from the exotic influence of

Denishawn, and the communication of her absolute seriousness. In 1930, *Lamentations* revealed the classic Graham trademarks of stark simplicity, structural tautness, mythic overtones, and the tension born of contraction and release.

Sure of her ideas, Graham nonetheless depended on advice from colleagues such as Louis Horst. Graham first met Horst in 1921. As the two traveled cross-country with Denishawn's *Xochitl,* Horst insisted that Graham expand her education to include Friedrich Nietzsche and Arthur Schopenhauer.[66] Ten years older than Graham, Horst, a famed silent movie and vaudeville pianist, exercised a powerful influence over Graham, convincing her to abandon Denishawn and leading her to study the history of nontraditional dance.[67] In addition to becoming Graham's musical director, in 1934 Horst founded, edited, and published the *Dance Observer*—a journalistic one-man band—which he published until his death in 1964.[68] It was Horst who urged Graham to read Hart Crane's poem *The Bridge,* and who suggested that Graham and two of her younger dancers visit Flagstaff, Arizona.[69] There, high in the mountains of northern Arizona, Graham, Horst, and her protegés encountered a sect of Hispanic Indians, the Penitents, descendants of both Christian and native cultures who performed several ancient rites, including a flagellation "snake dance."[70] From this material Graham fashioned her own rite of spring, *Primitive Mysteries,* as a reenactment of the Penitent ceremony in honor of the Virgin. Dressed in simple white and surrounded by women in blue, Graham's Virgin danced her ritual celebration of all women and all dance.[71]

In New York, working in her new studio on lower Fifth Avenue, Graham entered the 1930s as the most important innovator in modern dance. Earlier, Graham had experimented briefly with political themes drawn from the expressionist influence in the Village theater. In dances like *Steerage* and *Strike* she dealt with contemporary themes that expressed events in "theatrical tones and patterns."[72] And again, like other New York artists in the 1930s, she found herself drawn to political causes.[73] Protesting the Nazi regime, she refused to perform at the Berlin Olympics of 1936, and she choreographed *Immediate Tragedy* and *Deep Song* in support of the beleaguered Spanish Republic.[74] Nonetheless, Graham remained committed to dance as dance.

In the summer of 1934, Graham joined Doris Humphrey, Charles Weidman, and Hanya Holm as faculty at Vermont's Bennington College School of Dance. Martha Hill, a physical education teacher at New York University, designed the Bennington summer program to give dancers and dance teachers an opportunity to study with the best American modern-dance practitioners. For the next eight summers, students spent six or eight weeks with their four guest instructors in a virtual laboratory for modern dance.[75] By 1937 the school had enrolled more than 130 students. Graham taught both choreography and technique, through which she refined her notion of the instrumentality of the body as a medium of expression.[76] In addition to the courses by Holm, Weidman, Humphrey, and Graham, students could choose to work with John Martin, the dance critic of the *New York Times,* on the history of dance, with Horst and Henry Cowell on the relationship between music and dance, or on dance criticism. The high point of the summerlong sessions was the festival series that culminated with a fellows concert. Before adoring students, the four mas-

At Bennington. *Left to right:* Louis Horst, Louise Kloepper, Hanya Holm, and Martha Graham. *Photograph from p. 52 of* Hanya Holm, *by Walter Sorrell* ©1969 *Wesleyan University Press, by permission of University Press of New England*

ter teachers—Graham, Holm, Humphrey, and Weidman—performed their most recent works.

In the last week of Bennington's 1937 summer session Graham surprised her students and colleagues by introducing Ruth St. Denis.[77] Although Graham had gone far beyond the training and inspiration of Denishawn, she graciously acknowledged her mentor. Graham and Humphrey owed an enormous artistic debt to "Miss Ruth." They had each worked and studied with her for more than a decade. As mature artists the two women had redefined art dance as modern dance. But whereas Humphrey retained an affinity for the modernist tendency toward abstraction, Graham was drawn to American themes. She found in American sources the images to express her ideas of universal human experience. With America's entry into the war the Ben-

240

nington experiment ended.[78] For seven summers the Bennington School of Dance had served as a wellspring for modern dance, bringing hundreds of aspiring dancers into personal contact with modern dance's foremost choreographers and composers.[79] It provided Graham the opportunity to perfect the theory and training of American modern dance at the time when Lincoln Kirstein and George Balanchine were working to create a new American ballet.

## BALLET CARAVAN:
## CREATING AN AMERICAN BALLET

Lincoln Kirstein and George Balanchine wanted to create a modernized American ballet. Inspired by the Ballets Russes, Kirstein believed that he could revitalize an archaic art by adopting an explicitly modern vocabulary and infusing it with American images. Indifferent to Graham's concern for female identity and community, Kirstein remained wedded to classical ballet's emphasis on discipline and contrived movement. The editor of the modernist journal *Hound and Horn,* Kirstein saw modernism as a means to create a new canon. The authority of the European ballet needed to be modernized, not recast into a new medium.

Kirstein first conceived of an American ballet after attending a performance of the Ballets Russes.[80] Under the guidance of Michel Fokine, Serge Diaghilev, and Vaslav Nijinsky, the Ballets Russes changed classical ballet into a modern form, free of the staid conventions of eighteenth- and nineteenth-century French and Italian ballet. The company's notorious 1913 premiere of Stravinsky's *Rite of Spring* in Paris marked the explosive entry of modernism into the grand tradition of ballet. The Ballets Russes brought to American dance the spirit and style of the European artistic avant-garde, the music of Satie, Prokofiev, and Stravinsky, and the sets of Picasso, Matisse, and Miró.[81]

In the spring of 1916, the Ballets Russes toured the major cities of the United States with qualified success. Nijinsky joined the company in April, too late for the New York engagement. Only then did other American audiences discover the athletic ability that enabled him to "float" in the air in defiance of gravity.[82] Similar in appeal to Ruth St. Denis, the Ballets Russes shared a disdain for the conventions of Victorianism. In February 1916, several weeks after the first New York performance by the Ballets Russes, a Manhattan municipal judge required Diaghilev to respond to charges that *Afternoon of a Faun* was sexually offensive. At the next performance the great choreographer placed the offending scarf demurely on nearby rocks instead of under the loins of a nearly naked nymph and muttered in French, "America is saved."[83]

In 1929, Kirstein attended the funeral of Diaghilev, and in 1933 he enrolled in the New York ballet classes of Michel Fokine. His age—twenty-five—and his height—six feet three inches—hampered his progress as a dancer. Instead, he decided to create a new ballet and persuaded his Harvard classmate Edward Warburg to finance an American Ballets Russes. On New Year's Day, 1934, George Balanchine, the last of the Ballets Russes's great choreographers, joined Kirstein in founding the New York School of American Ballet.[84] With financial help from Nelson Rockefeller,

Kirstein formed a traveling company of the school, which he called Ballet Caravan. The Ballet Caravan took American ballet on the road. For six summers, from 1935 to 1940, young dancers, often college-aged students, working for thirty-five dollars a week, crisscrossed the country performing new works even as they unloaded buses and struck the sets. Kirstein's energy animated their work. As he "wrote the ballet scenarios, commissioned the composers, and hired the designers," he also nurtured a new generation of American dancers, composers, and choreographers, including Eugene Loring, Lew Christensen, and Erick Hawkins.[85] In the 1930s their dances—*Yankee Clipper, Pocahontas, Filling Station,* and Aaron Copland's classic, *Billy the Kid*—covered the American scene.

Copland wrote, "When I suggested that, as a composer born in Brooklyn I knew nothing about the wild west, Lincoln informed me that Loring's scenario for *Billy the Kid* was based on the real life story of William Bonney, a notorious cowboy who had been born in New York."[86] Kirstein told Copland to draw on the folk-song tradition. Copland dutifully responded by working the themes of *Git Along, Little Dogies* and the *Old Chisholm Trail* into the score.[87] For Copland, *Billy the Kid* was the first of a series of three folk-inspired ballets, including *Rodeo* and culminating in *Appalachian Spring.* In 1938, Copland's work with Loring produced a dance that evoked the cowboy frontier. Quoting directly from folk idioms, Copland's music employed the harmonic device of open fourths and fifths, creating a synthetic musical representation of Americana.[88] Episodic, cinematic, and suggestive, *Billy the Kid* charmed audiences of the late 1930s and accomplished Kirstein's goal of creating an accessible, popular, apolitical native ballet.

In summer and fall of 1938, the Ballet Caravan worked its way across the northern rim of the United States. Performing at odd hours and in incongruous places, Kirstein learned that although some Americans genuinely loved "good dancing," others believed that "if it's American it isn't ballet." The Russians, he mused, might have danced Billy as a "lonely, romantic and tragic little figure." But for Kirstein, Loring, and Copland, Billy was a typical western American who represented the "anarchy inherent in individualism in its most rampant form."[89] Recreated during the depression, the image of Billy as outlaw hero, the ordinary figure who crisscrossed the line between civil and criminal, between actual and mythic, made him a parable of the times. Circumstances, not character, had uprooted Billy the Kid. *Billy the Kid* evoked a mythic past and implied an ambivalent present. *Filling Station,* by Lew Christensen with Thomson's music, looked only at the moment. Set at a roadside gas station, *Filling Station* had been commissioned by Kirstein as "a realistic ballet about American life."[90] A light fantasy in contrast to *Billy the Kid*'s seriousness, *Filling Station* provided Thomson his first opportunity to write for dance. The commission pleased him enormously.[91] His playfully direct music wove a course from march to jig, quoting repeatedly from children's songs and hymns. Thomson and Christensen performed and discussed *Filling Station* at one of the WPA's Composers' Forum-Laboratories. Even more than *Billy the Kid, Filling Station* represented the indomitable American spirit Kirstein had hoped to portray in his Ballet Caravan project.

Both Warburg and Rockefeller, however, lost interest in Kirstein's projects, and

by the early 1940s neither the School of American Ballet nor its Ballet Caravan could secure financial support. In 1946, Balanchine and Kirstein agreed to work together again, sustained by Kirstein's modest inheritance, and founded Ballet Society. A noncommercial dance company, Ballet Society offered experimental concerts to a limited subscription audience. Two years later they renamed their company the New York City Ballet and joined the newly created City Center for Music and Drama as its resident company. Their American ballet combined the formal aesthetics of classical ballet with the emergent spirit of American music and narrative.

## APPALACHIAN SPRING:
## A BRIDGE TO THE MODERN

In his Americanized ballet, Lincoln Kirstein revitalized classical ballet by using modern music, lively choreography, and American themes. Nonetheless, his American ballet retained many of the conventions of classical ballet. Martha Graham found little worth saving in ballet. She rejected its hierarchical male structure, its formulaic movements, its distortion of human forms, and its willingness to serve rather than challenge its audience. Graham argued that modern dance should be based on skilled, disciplined natural movement, on creative and collaborative work between artists, and on gender equality. In her 1944 *Appalachian Spring,* in collaboration with Aaron Copland and sculptor Isamu Noguchi, Martha Graham offered her mature vision of modern dance, at once modern, American, and provocative. *Appalachian Spring* allowed her to return to the major dramatic concern of her dance project, to render through movement the interior, private voice of human existence.

Isamu Noguchi, the Japanese American sculptor who created the spare, evocative set for *Appalachian Spring,* had known Martha Graham for more than a decade. American born and, until the age of fourteen, Japanese educated, Noguchi was the child of two cultures. When his Japanese father left his American mother, she sent Noguchi first to an English-speaking school in Yokohama and then to Indiana to attend a school picked, he recalled, from the *National Geographic* magazine.[92] Eventually Noguchi rejoined his mother in New York, took the name of her current companion, Dr. Noguchi, and apprenticed himself to Gutzon Borglum, the sculptor of Mount Rushmore. Before leaving Japan, Noguchi had learned carpentry, and in New York, at the age of eighteen, he enrolled at Columbia University, first as a premedical and then as a fine arts student. In the mid-1920s, Noguchi aligned himself with the modernist circle, which included Stuart Davis, Alexander Calder, and Alfred Stieglitz, who later introduced Noguchi to Constantin Brancusi, with whom Noguchi worked while a Guggenheim fellow in 1927. Noguchi had first seen Brancusi's work at Stieglitz's An American Place in 1926. He wrote of his experience as Brancusi's studio assistant in Paris, "Brancusi, like the Japanese, would take the quintessence of nature and distill it. . . . [He] taught me never to decorate . . . like the Japanese home."[93]

In the late 1920s, responding to "modernist formalism," Noguchi liberated himself from the ornamentalism of the old academic tradition but did not rush into modernism. Like his colleague Alexander Calder, whose *Circus* provided Noguchi em-

ployment as an assistant ringmaster, Noguchi held onto his spiritual center through a respect for natural materials, especially wood, and worked as a modern sculptor in the hand-carving tradition exemplified by the work of William Zorach.[94] Together with Zorach and Calder, Noguchi moved American sculpture along a path that embraced the style of European abstraction and the imagery of modern America.

Noguchi's friend, Calder, had gone to Paris in 1926 with a degree in mechanical engineering in hand and a background in art that included work with John Sloan at the Art Students League and a stint as an illustrator at the somewhat wicked *National Police Gazette*. He had covered the Ringling Brothers' circus for the *Gazette* in 1925, and later, in Paris, he converted his sketches into a miniature circus world constructed of wood and wire, which he exhibited in Europe and then the United States. Calder's fanciful spirit emerged as he played the role of ringmaster at the circus performances. His whimsical wire sculptures, which outlined the shapes and features of his menagerie, reversed the relation between mass and space, creating a line drawing in a sculptural image. Calder's engineering background fostered his fascination with machines and motion, especially motion in space. He experimented with suspending movable objects in fixed frames. He motorized some of his constructions and liberated others from the hold of their frames, letting them move kinetically, freely. His "mobiles" and "stabiles" borrowed heavily from the dadaists and constructivists in exploring the sculptural possibilities of modernist invention. Yet to the Europeans, Calder remained, in Léger's words, "one hundred percent American."[95] His technical training and inherent sense of humor appealed to his European colleagues, but the combination appeared essentially New World.

In the late 1920s, Noguchi and Calder spent several years together in France. When Noguchi found that his Brancusi-inspired sculpture failed to sell, he followed Calder's example and executed a series of lighthearted portrait sculptures in bronze and terra-cotta. His art spanned sculpture, landscape architecture, furniture, the relief that adorned Rockefeller Center's press building, and plans for Central and Riverside Drive Parks. Although his work incorporated the finely polished surfaces of modernist abstraction and the urban vocabulary of constructivism, Noguchi also participated in a series of social and political causes. In 1942 he voluntarily joined other Japanese Americans in their incarceration at an internment camp in Arizona. To his dismay, the federal government held him there—this time, against his will— for seven months. In 1943 he returned to New York to work with Martha Graham. Relieved to be free again, Noguchi recalled that "the deep satisfaction that comes with living under a cloud of suspicion lifted . . . and was followed by tranquility. I resolved henceforth to be an artist only."[96]

Noguchi's long association with Graham fulfilled his "dream of integrating the arts and breaking down barriers between public and private dream space."[97] Noguchi approached the theater of dance as a sculptor, treating space as the medium of his art."[98] With his help Graham defined *Frontier* in 1935 as a piece about the "conquering of space."[99] Noguchi constructed a set of remarkable simplicity, suspending two ropes that seemed to fly over a split-rail fence at the center of the stage. He anchored the ropes high above the audience, at either corner of the proscenium arch, from where they descended back past the fence to converge on the floor deep

behind the rail's frontier. Thus, Noguchi defined the dance by defining its space. His design "served to throw the entire volume of air straight over the heads of the audience." He later recalled, "This was the point of departure for all my subsequent theater work: space became volume to be dealt with sculpturally."[100]

Noguchi grasped Graham's idea that dance was movement in space and time because the two shared an almost metaphysical approach to art. His own work, which explored the spatial properties of sculpture, had evolved from the formalist idea of harsh simplicity—of the unadorned work—that characterized other modernist work in sculpture, architecture, and dance. In contrast, Graham's introduction of American themes drew on a larger cultural movement that challenged formalist aesthetics in reconceiving the nation's past.

In May of 1942, Erick Hawkins, at the time an understudy in the hit musical *Oklahoma!,* wrote to Elizabeth Sprague Coolidge suggesting that her foundation commission Aaron Copland and Paul Hindemith to compose modern chamber music for the Graham company.[101] In the fall of 1942, the Coolidge Foundation, through Harold Spivack at the Library of Congress, agreed to the commission and sent word to Graham, Copland, and the Brazilian composer Heitor Villa-Lobos to create two dance pieces of modern chamber music to be performed in the fall of 1943. Spivack and Coolidge had already expressed their desire to do "something patriotic next year."[102] They explored the possibility of responding to the "present emergency" by offering Villa-Lobos a commission to compose for a series of performances at American army bases.[103]

Created at the height of American participation in World War II, *Appalachian Spring* offered an image of America's mythic origins that rejected traditional male authority and conventional religion, questioning even the sanctity of marriage and the family. Edenic in conception, the dance depicted a first moment of domestic life dominated by women. As in much of wartime America, women commanded the metaphorical locale of *Appalachian Spring,* casting off conventional authority, working at their craft, and binding the world together. In form and content the dance mirrored the social and artistic transition of the nation, poised as it was between two eras. *Appalachian Spring,* with its apparently conventional tale of a frontier marriage—a call for unity in the midst of upheaval—offered a radically unconventional message of female equality.[104]

Graham worked on her script during the following six months and forwarded a version to Copland, who later remembered, "In the early fall of 1944 I asked her, what are you going to call it? She said, 'Appalachian Spring from the poem by Hart Crane.' But does it have anything to do with the story? 'No, I just liked the title and took it.'"[105] Having read Hart Crane's poetry since the 1930s, Graham knew full well what she was after. "This is a legend of American Living," she wrote to Copland, "the inner frame that holds together a people. These things flow from generation to generation." Graham imagined the simple springtime that would be the hallmark of *Appalachian Spring,* from the Shaker rocking chair, "with its exquisite bone-like simplicity," to a frozen moment in American time "peopled with certain characters who walk with us in the present." "That is why I have introduced an Indian Girl," she explained to Copland. "There is no reason realistically, yet she is always there."[106] Gra-

ham explained that the Indian Girl was not new to her. "Certain poems have used her as the figure of the land; for example Hart Crane in his poem, 'The Bridge.'"

Crane's poem, a modern evocation of the power of contemporary civilization to create a timeless monument, was his last. He built his poetic structure, the Brooklyn Bridge, as a point of reckoning, to be traveled by the mind's eye. Crane imagined the bridge as an artifact of universal meaning, beneath the span of which flowed the nation's memory. In Crane's imagination the Brooklyn Bridge served as both a sentinel and as pious salvation. It stands as witness, seeing all, recording the past and the present, the ordinary and the mythic. Crane's imagery invokes the spirit of "Powhatan's Daughter" as both an apparition and a testament, a solitary traveler climbing the iron and granite spires to find a source, an Appalachian spring, from which to observe the frontier spread out below.

> O Appalachian Spring! I gained the ledge:
> Steep, inaccessible smile that eastward bends
> And northward reaches in that violet wedge.[107]

Although Graham erased the Indian Girl from the final rendering of the dance, she faithfully translated Crane's poetic spirit. Graham, Copland, Crane, and Noguchi told *Appalachian Spring* as a story, finally, about the "vows" of a pioneer couple made "in a new town where the first fence has just gone up."[108] Their wedding day is seen not from their point of view but from Graham's, from the modern bridge that spans New York. As Graham confessed, her character originally had not been "an Indian's indian, but a white man's Indian."[109]

Graham intended to connect the rituals of pastoral life with biblical narration. Her original script blended a sense of impending crisis with the life cycles of transcendentalist Protestantism and the enduring quality of the American past. In the original script Graham imagined a moment central to the finished dance. As Powhatan's daughter entered, in anticipation of her wedding, she "begins to dance in some simple way . . . which becomes more like a psalm in its ecstatic quality."[110] As the song replaced the narrative, so the dance revealed the nature of Graham's creative process. "I have always chosen my subject when I was asking a composer to write for me," explained Graham in a letter to Elizabeth Coolidge. "I submitted to [Copland] the idea and a detailed script, not of the dance steps, etc., but of the idea and the action. The reason I have worked this way is that I find I only do things well when I can feel my way into them as a dancer . . . in my medium, my instrument, my body."[111] In finding his first musical theme, Copland was responding to Graham's request for a score whose spirit would embody the feelings of "important days even though they be simple ones."[112] Copland's use of the Shaker song *Simple Gifts* became the thematic hallmark of *Appalachian Spring*. *Appalachian Spring* narrated the rituals of courtship, marriage, and domesticity on the frontier. In a series of episodes, each of the major characters—the Revivalist, the Pioneer Woman, the Husbandman, the Bride, and a chorus of four young women in attendance—revealed and yet also hid private selves as they alternately danced into action and stood as frozen spectators, friezes to each other's expression.

Created in 1943 and executed in 1944, Noguchi's set for *Appalachian Spring* pro-

vided a lean, firm foundation. Modernist and polished, his sculpted rocking chair, floating on its base, provided the central place for Graham's female character to dream of domestic contentment. The chair's abstract quality also suggested a plow whose work the pioneer family required for survival. The gaunt piece united the labors of a family, its female connectedness through two generations of birth and child rearing, with agricultural labor and economic survival. So, too, Noguchi's frame house, the central focus of his set, the arbor and home to the family on whose sketched porch he balanced the form of the plow chair, suggested both lightness and solidity. Its whitewashed clapboards, whose trajectory pointed skyward, completed the creation of women's space, the frontier home. While Graham centered her women, mother and adult daughter, in the domestic space of Noguchi's home, the two male figures in the dance occupied distinctly separate spheres. The Bible-thumping minister stood on a pedestal, which he left only to deliver his cautionary sermon, while the Husbandman posed casually on the split-rail fence.

Copland had to create music appropriate to the script that Graham had sent him—"the music (in the ballet) is an accompaniment to what is going on on stage"—and to her unique "American" personality. Convinced that Graham's distinctiveness consisted in her "darkness and simplicity and directness," Copland knew that her dance movement and gesture asserted something "you couldn't connect with fancy European ballets with all their color and dash."[113] Given Graham's first scenario, where she identified the Edenic first day of the dance's setting and referred to the spiritual meaning of the characters' exchange, Copland's choice of the Shaker hymn redefined the structure and the content of the dance. In a sense, Copland Brooklynized his music for Graham. He made the central theme, the Shaker tune *Simple Gifts,* his own song.[114] The tune served as the musical substructure, the equivalent of Noguchi's set, on which he built his composition. Copland suggested the tune in the beginning of the piece, alluded to it through most of the development, and then stated it explicitly as an intricately woven variation and theme, which he spun out lyrically as the dance concluded. As Copland wrote it, the myth of the everlasting spiritual community as sanctified by the vows of the agrarian family was fraught with tension. Interpreting Graham's ambiguity about the possibility of a perfect state of being, Copland offered a musical facade. The lyrical fluency of the piece gently masked Copland's complex modern composition. Although melody seems to dominate *Appalachian Spring,* dissonance and consonance alternate and even clash as the music moves through the story.[115] In both composition and rhythm *Appalachian Spring* reveals fundamental musical tensions. Such tension was well suited to Graham's choreography, with its emphasis on contraction and release as the means by which the inner secrets of the soul were externally dramatized. In *Appalachian Spring,* Copland created a transcendent vision of the first day. As Graham said in the first scenario she sent to Copland, "At the moment of greatest tension . . . THE DAUGHTER . . . begins to dance in some simple way. . . . It becomes more like a psalm in its ecstatic quality."[116]

In late October 1944, Graham assembled her company in Washington: Louis Horst, still the faithful music director, and the dancers, Erick Hawkins, the Husbandman, Merce Cunningham, the Revivalist, and May O'Donnell, the Pioneer

Woman. Graham had walked through the auditorium at the Library of Congress a year earlier, and she planned her choreography to suit the space. Wartime Washington was a far cry from the archetypal Pennsylvania Spring. There, alongside three days of Mozart, Bach, Schubert, and Beethoven and preceded immediately by the newly commissioned works of Hindemith and Darius Milhaud, reposed *Appalachian Spring*.[117] The Coolidge Festival program proclaimed, "Part and parcel of our lives is that moment of Pennsylvania spring when there was a Garden eastward in Eden."[118]

The opening of *Appalachian Spring* took no more than two minutes. But it suspended the present, opened up the imagined world, and introduced the dramatic themes encompassed in the dance's next twenty-two minutes. The modernity of *Appalachian Spring* lay in its constant reminders that it was a work of art. The stylized openness of Copland's music matched the coded movement of Graham's choreography, which fit Noguchi's sculpting of dramatic space. Each collaborative aspect hid its complexity behind a surface of spare angular simplicity whose "look" was unmistakably modern.[119] Jean Rosenthal's lighting, bright but not ballet brilliant, illuminated the symbolic importance of the moment.

Graham structured *Appalachian Spring* into five unequal parts. The third, which occurred when the dance was two-thirds completed, introduced the Shaker theme and brought the Husbandman and the Bride together in tender exuberance. It was clearly the musical fulcrum of the dance, but not the dramatic one. For it was followed by a forbiddingly dark segment, visually memorable and historically revealing. No sooner had the young couple declared their love than the Revivalist and his four disciples intervened. Surrounded by the chorus of four adoring young girls, the itinerant preacher warned the couple of their darker, more turbulent natures. As danced by Hawkins, the Revivalist dominated not only his young followers but the entire company. In a moment of painterly imagery, recalling the work of Georgia O'Keeffe, the Revivalist prepared his message. Standing before his four refracted disciples, he gently placed his wide-brimmed black hat in the cradle of their hands— the black sunflower of the hat stemmed by the gentle blue of the girls' dresses. A powerful, entirely visual image, it expressed the tenderness and beauty of their arrangement, even as the Revivalist readied his sermon only to withdraw and watch silently as the couple struggled to reunite. In the dance's final moments, as Copland's opening theme resumed, the resolved couple returned to the rocker where they posed, she seated, he standing just behind, a tableau of Victorian domesticity. The figure of the Revivalist reminded the audience of the force and power of authority, his presence both dominant and awesome.

*Appalachian Spring* stood for a celebration of native virtues at a time of national emergency. Its feminism, the dominance of Graham's female dancers, and her redefinition of the importance of female space reflected the changes that American society had experienced at home—the home front, the frontier as home—and gave weight and poignancy to the moment. Copland, Graham, and Noguchi created *Appalachian Spring* at a time of artistic transition. Aesthetically contemporary, its modern language concealed under the guise of popular accessibility, the dance owed much to the 1930s. Its Americanism, its folk vernacular, and its depiction of the need

*Appalachian Spring.*
Martha Graham and
Erick Hawkins.
*Music Division,*
*Library of Congress*

for community all linked the depression decade to World War II. The American scene to which it responded offered an idealization. Gone was the gritty bite of overt social realism, of the urgency of political change, and of social criticism. In its place New York dancers, composers, and choreographers had created an American myth, Edenic and pastoral in sentiment, urban and contemporary in execution. The cultural images embodied in *Appalachian Spring* claimed a universal American place. The dance seized the spirit of contemporary urban longing for unity and diversity at a time of unprecedented change. To dream of a place without conflict or violence, as pastoral or perfect as the repose of a pioneer family, was to imagine a civilization and a world remote to Americans between 1939 and 1945.

Days after its Library of Congress opening John Martin, the dance critic of the *New York Times,* posted *Appalachian Spring*'s first review. "It is," Martin wrote, "as the saying goes, a natural . . . shining and joyous, a testament to the simple fitness of the human spirit." His colleagues on the *New York Herald Tribune,* Virgil Thomson and Edwin Denby, agreed. Denby was "touched" by the "fresh feeling of the hillside woods"; Thomson noted Copland's use of open fourths and fifths and called the work "musically interesting. It has style."[120] *Appalachian Spring* premiered in New

York in May 1945. Later that year Copland transformed the chamber composition into an orchestral suite. In 1945, Copland won the Pulitzer Prize for music for *Appalachian Spring*. A year later RCA recorded the suite, which the company touted in its *Record Review* of May 1946. Copland contributed to the commentary. He recalled that the title of the piece had been borrowed by Graham from a reading of one of Hart Crane's poems, "though the ballet bears no relation to the text of the poem itself."[121]

Graham and her colleagues self-consciously infused new ideas into New York Modern. A feminist woman, a Japanese American, and a homosexual Jew personified the "changes" in Berenice Abbott and Elizabeth McCausland's *Changing New York*. The dynamic and innovative thrust of the Ballets Russes, the internalized emotion of expressionism, and the force of modern painting, sculpture, and, above all, music informed modern dance. But even *Appalachian Spring,* like Copland's evocative American symphonies, skirted Harlem. Tellingly, Abbott and McCausland's *Changing New York* contained only one photograph of Harlem, although two of African Americans in Bedford-Stuyvesant. In the 1930s and 1940s art thrived in Harlem, largely unnoticed by white New Yorkers. A second Harlem renaissance heralded the second Great Migration and a radically transformed New York Modern.

## THE SECOND HARLEM RENAISSANCE

The first years of the depression were disastrous for Harlem's artists. But following the infusion of federal support through the Federal Arts and Theater programs, Harlem artists forged a second renaissance. The debilitating effect of the depression on Harlem's artists was exacerbated by the neglect and indifference of both La Guardia and Moses. Moses' parkways, tunnels, and bridges sped the automobiles of the middle class out of the clutter of the old city into the newly accessible suburbs, but he and La Guardia did little to improve the conditions of African American Harlemites. Harlem remained virtually untouched by the capital improvement projects of the New Deal. In the 1930s and 1940s, the New York City Parks Department added 255 city playgrounds, but only one of these was in Harlem.[122] The community, caught in the whipsaw of population increase and economic disaster, continued to be served by a single municipal hospital. The overcrowded Harlem Hospital relegated its handful of black physicians and nurses to menial, non-policy-making tasks and provided Harlem residents with substandard, segregated health care.[123]

In the 1930s, 125th street, home to the Apollo Theater, may have been the communities' commercial center, but ten blocks north, 135th Street was its cultural center. In a stretch of two blocks, from just west of Seventh Avenue to Lenox Avenue, stood the Harlem YMCA, the Schomberg Collection at the Harlem Branch of the New York Public Library and the offices of the NAACP, the Urban League, and the *Amsterdam News.* Four blocks to the south lay Harlem's legitimate theater, the Lafayette, home to the Harlem unit of the Federal Theater Project, and one block to the north, between Seventh and Lenox Avenues, was the Harlem Hospital. Harlem's largest church, the Abyssinian Baptist Church, led by Reverend Adam Clayton Powell Jr., occupied a Tudor-Gothic building on 138th Street, which, despite its

cavernous dimensions, was too small for even a fraction of its thirteen-thousand-member congregation. Members of Harlem's artistic community who taught at local settlement houses gravitated to the corner of 135th and Seventh, where they might encounter writers James Weldon Johnson, Countee Cullen, Claude McKay, sculptor Augusta Savage or painters Aaron Douglas, Charles Alston, and Romare Bearden. Despite the overwhelming adversity that Harlem faced in the 1930s, in and around 135th Street its artists and writers exploited the idealism of the New Deal and World War II to attack New York's racial apartheid.[124]

Romare Bearden understood the paradoxical effect of the Great Depression on Harlem's artists. "The 'movement,'" recalled Bearden, "was a positive, proud, and participatory realization of what it meant to be black—not on the soiré scale of the Harlem renaissance, but on a mass scale." During the second Harlem renaissance, New York's African American painters, sculptors, writers, musicians, actors, dancers, and poets enlarged the meaning of New York Modern. Through the support of the Federal Arts and Theater Projects, Harlem artists affirmed their independence and their place in New York.[125] While the first Harlem renaissance had been dominated by writers, visual artists led the second renaissance. Alain Locke, Bearden, Savage, and Alston used the resources of Harlem and the New Deal to transform New York's racial and artistic dialogue.

Locke and Bearden expressed different aspects of African American artistic alienation. In 1936, Locke, the intellectual founder of the first Harlem renaissance, published his *Negro Art: Past and Present,* which challenged African American artists to meet the aesthetic and social demands of their times. Locke refused to endorse the Museum of Modern Art's emergent art-for-art's-sake modernism. He insisted, rather, that Negro art define itself critically, as an art of liberation and resistance.[126] Bearden felt such broad categories too simplistic. Instead, he urged Harlem artists to reject the academicism and cultural essentialism that clamored for "Negro art." Although Bearden recognized the value of "genuinely" African American art, he repudiated the labeling of art by African Americans as Negro "when in fact there was nothing Negro about these works."[127] Bearden cared much more that African Americans possess the means to become artists than that they create an identifiably African American art. He understood himself as an artist who happened to be black. His black identity profoundly affected his work, but it neither defined nor limited his art, and he refused to allow it to be judged by racial criteria.

Prior to the Federal Arts program, between 1928 and 1934, Harlem's visual artists depended on the William E. Harmon Foundation, endowed by Elmer Harmon, a real estate tycoon who hoped to promote the advancement of Negro artists by bringing their work to public light. But the four-hundred-dollar prizes were too small to provide more than short-term support. Moreover, the foundation's activities were so limited that African American artists who applied for federal arts programs were unknown—professionally invisible—to New York museum and gallery curators.[128]

In the 1920s, the sculptor Augusta Fells Savage experienced the artistic anonymity imposed by racism. A founder of the Harlem Community Art Center and Harlem Artists Guild in the 1930s, Savage laid the groundwork for a revitalized Harlem renaissance. The Florida-born Savage had studied art at Cooper Union and in 1924 ap-

plied for admission to the Fontainebleau School of Art in France. After five years of frustrating confrontation, during which she worked as a laundress, she gained admission to the program. Black and white artists and politicians, the Rosenwald Fund, and Harlem civic clubs supported her effort to crack the school's policy of racial exclusion. Savage returned to New York in 1931, and, thanks to a grant from the Carnegie Foundation, opened her own studio school on 143d Street. The Harlem Community Art Center, funded by the Federal Arts Project, served Savage's immediate neighborhood. Working with a racially integrated staff, Savage and the Harlem Community Art Center taught workshops for more than fifteen hundred students between 1931 and 1936. The psychologist Kenneth B. Clark and the sculptor Gwendolyn Knight both studied art in Savage's workshop.[129]

In 1934 the short-lived PWAP shifted the financial patronage of Harlem artists from private to public agencies. The Whitney Museum–administered PWAP failed in Harlem. Except for Aaron Douglas, Palmer Hayden, and three others, no African American artists received PWAP employment as artists. Goodrich and the PWAP staff assigned black applicants to manual jobs. Nonetheless, the PWAP's unfilled promise of federal support convinced the Harmon Foundation that African American artists no longer needed private patronage. In 1935 the foundation terminated its awards and exhibitions. Similarly, in 1935, the College Art Association, which had given twenty thousand dollars to neighborhood art centers in Harlem, merged with the New York regional office of the Federal Arts Project.

Momentarily, the artists of Harlem had no support. Only Savage's studio school anchored the community. As Audrey McMahon launched the Federal Arts Project in New York, black applicants, now welcomed, discovered that they lacked the conventional artistic credentials—shows in commercial galleries, teaching positions, and critical reviews—to qualify for supervisory positions. Calls to the Harmon Foundation produced the documentation, proof that Harlem artists had worked professionally.

In 1935, Savage, Charles Alston, Aaron Douglas, and other Harlem artists met weekly to discuss "our special problems." Seventy-five African American artists joined Savage and Douglas to form the Harlem Artists Guild as dues-paying members. Many were already employed by WPA and FAP programs and belonged to the Stuart Davis–led Artists' Union; others were active members in the American Artists' Congress movement. But the Harlem Artists Guild addressed local issues of racism, poverty, and unemployment. The guild, headquartered on 136th Street, organized exhibits, protested WPA cutbacks, and served as a political fulcrum.[130] The guild received support from Davis, who printed news of the guild's work in *Art Front* and carried its demands for supervisory appointments to Audrey McMahon. As Alston remembered, "We formed it originally to create a pressure group to get more Black artists on the federal projects." Unlike the PWAP, the FAP provided meaningful employment for Harlem's visual artists, engaging 115 African American artists, about 6 percent of the total two thousand employed in all divisions of the FAP in New York City. Most received a weekly wage of $23.86, close to the national median income. Access to supervisory positions, however, proved far more difficult for black Harlemites.[131]

Augusta Savage (1940s).
*Photograph by Morgan and Marvin Smith.*
*Photograph and Prints Division, Schomberg*
*Center for Research in Black Culture, New*
*York Public Library; Astor, Lenox, and*
*Tilden Foundation*

Charles Alston, initially employed on the easel project of the WPA, became the FAP's first African American supervisor when McMahon appointed him to direct the mural project at Harlem Hospital.[132] Targeted for decoration by FAP muralists following the 1935 riots, the Harlem Hospital was a grim complex of soot-covered buildings suffering from general neglect. The mural division of the FAP had negotiated two sites—a nurses' dormitory and the children's ward—for murals. With Alston, twenty-five African American artists executed the Harlem Hospital murals.

One set entitled *The Pursuit of Happiness,* attributed to muralist Vertis Hayes, depicted the modern black scientific and intellectual community. The Hayes murals celebrated the achievements of African American life, linking the culture of Harlem with its hospital. Another set, by Alston, contrasted traditional and contemporary society, stressing the contributions and continuities of African American life. Alston and his team painted a history of black America that balanced contemporary events and achievements with events drawn from the African past. Wall-sized depictions of modern medicine at work faced a mural of traditional African medical practices. Hayes rendered the present in African American terms, emphasizing the life of black people. Alston did not. *Mystery and Medicine* showed African American and European American medical scientists working together, a fictional projection of racial integration. His proposal raised a storm of controversy.

Officials of the Harlem Hospital demanded that Alston alter his work portraying blacks and whites on an equal footing. Refusing to accommodate the racism of New York's medical community, Alston mobilized the Harlem Artists Guild to protest to officials at the WPA and the mayor's office, arguing that to reject the mural would "add another pillar to the ever growing structure of discrimination" in Harlem Hospital.[133] With support from FAP mural division head Burgoyne Diller and Louis T.

Harlem Hospital
WPA murals. *Mystery
and Medicine,* super-
vised by Charles Al-
ston (1938–39).
*Photograph by Peter
Rutkoff*

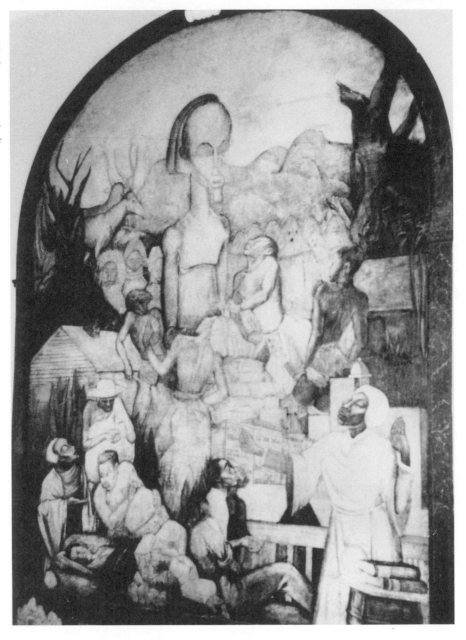

Wright, the hospital's chief of surgery, Alston and the Harlem Artists Guild con-
vinced the New York FAP officials to accept the murals as Alston designed them.[134]

Charles Alston had moved to New York from South Carolina in 1915. Educated
at Columbia University's Teachers College, where as a black male he was not al-
lowed to attend studio courses that used white nude female models, Alston contin-
ued his education at the Harlem Public Library. His exposure to the Schomberg Col-
lection of African art tempered his modernist university training, and his work as an

easel painter combined elements of both.[135] Alston loved and knew jazz and introduced black and white friends to Harlem jazz. Alston's later paintings, a series devoted to jazz and the blues combining cubist-inspired washes of color with a cool nocturnal palette, celebrated the music and people of Harlem.[136]

Alston did not consider himself a political artist. "In those days it was a Negro pride, now it's black and African," he later recalled. Interested in what went on in the world, he felt that as a black artist "you cannot but be concerned about . . . how it affects your people. . . . Picasso, I think, said art is a weapon. Should I commit my painting to visualizing the struggle that's going on? Or close my eyes and keep myself and my painting apart from that?" But in the 1930s, Alston turned to politics. "We were all involved. . . . You couldn't escape the social implications of painting then."[137]

Alston moved his community arts program from Utopia House to the Harlem Public Library and then to a renovated stable at 306 West 141st Street. Funded by the WPA, Alston's Harlem Art Workshop, along with Savage's Harlem Community Art Center, became the nucleus of Harlem's art. Studio 306, or just 306, became the hub of the Harlem Federal Arts Project. Jacob Lawrence and Bearden studied there with Alston; Lawrence maintained a small studio space in the building until 1940; and the artists assigned to work on the Harlem mural projects reported to work at 306. Alston lived in an apartment in the rear of the building, along with several other artists.

Studio 306 became the heart of the second Harlem renaissance. Buoyed by the financial and political support of the WPA, 306 brought Harlem's artists together. Alston, Lawrence, Bearden, Gwendolyn Wright, and Ralph Ellison worked and argued with Harlem's older generation of artists and writers—Aaron Douglas, Countee Cullen, Augusta Savage, Claude McKay, and Langston Hughes. Alston's studio offered, according to Jacob Lawrence, "a social and artistic atmosphere. I would hear talk about the various problems in their special fields of acting, theater, and so on. Romare Bearden was one of the younger people who frequented '306.' . . . He was experimental and scholarly, very much involved and curious."[138]

Bearden and Lawrence emerged as the dominant young painters of the second Harlem renaissance. Lawrence's work tied Harlem's artistic revival directly to the second Great Migration of African Americans to New York. Set off by the mobilization for World War II, the second Great Migration brought hundreds of thousands of rural blacks from the South to the cities of the North. As New York broke out of the depression and its economy boomed, the city welcomed, begged, enticed, and attracted new immigrants to its streets, mobilized its working women, and lured blacks with promises of freedom and opportunity. The second Great Migration's newcomers, however, encountered unrelenting discrimination in jobs and housing. The tensions of racial and social dislocation plagued New York, resulting in the second Harlem riot. The Harlem riots of August 1943 caused the deaths of 6 blacks, injuries to 185, and five million dollars' worth of estimated property damage. Shocked city officials portrayed the incident as the work of hooligans and poor southern migrants. In truth, Harlem's African Americans, frustrated by police brutality and blatant racial discrimination, took out their grievances on the visible symbols of racial

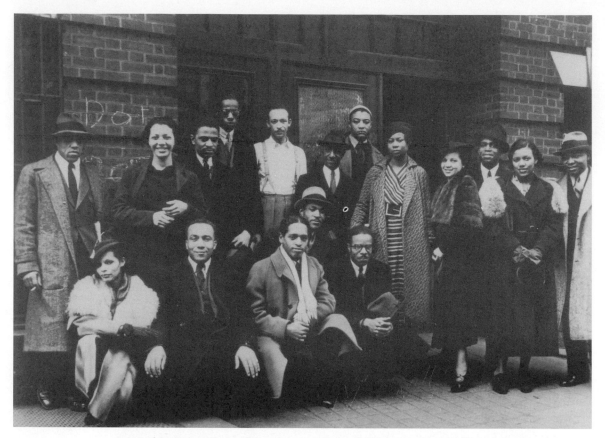

Artists of the Second Harlem Renaissance. *306 Group,* 306 West 141st Street. Left to right, back row: Add Bates, unidentified model, James Yeargans, Vertis Hayes, Charles H. Alston, Sollace Glenn, Elba Lightfoot, Selma Day, unidentified, Ronald Joseph, Georgette Seabrooke, Richard Reid; front row: Gwendolyn Knight, unidentified, Francisco Lord, Richard Lindsay, Frederick Coleman (circa 1938–40). *Photograph by Morgan and Marvin Smith. Photograph and Prints Division, Schomberg Center for Research in Black Culture, New York Public Library, Astor, Lenox, and Tilden Foundation*

oppression—the police and white-owned shops. The 1943 riot notwithstanding, Harlem remained intact as a community.[139]

  "People would come up to the centers," wrote Jacob Lawrence of his early apprenticeship at the Harlem Artists Guild. "People like Katherine Dunham, Countee Cullen, Langston Hughes. They may not have talked with me because I was too young, but I would hear their conversations with each other."[140] Lawrence, whose southern-born mother had migrated to New York with him in 1930, studied with Charles Alston at his 306 studio. The teen-aged Lawrence steeped himself in the ideas and personalities of the second Harlem renaissance. Lawrence also studied painting from 1937 to 1939 at the American Artists School on 14th Street with Anton Refregier, a active leader of the American Artists' Congress.[141] Influenced by the urban realism of the Fourteenth Street School and comfortable with modernist ideas, Lawrence began to paint the African American experience.

Between 1937 and 1938, Jacob Lawrence painted forty-one canvases for his *Toussaint L'Ouverture* series, a narrative of the eighteenth-century Haitian leader's life and his country's political liberation. "We know little of these people's achievements," Lawrence wrote following the completion of his first historical series. "Having no Negro history makes the Negro people feel inferior to the rest of the world. I don't see how a history of the United States can be written without including the Negro."[142] Lawrence moved next to the history of blacks in America, completing a series on Frederick Douglass and Harriet Tubman before receiving the first of three Rosenwald Fund Fellowships to paint the Great Migration and contemporary Harlem. In 1943, Lawrence signed with Edith Halpert's Downtown Gallery and received critical praise from *Fortune* magazine.

Lawrence's *Migration* and *Harlem* series both drew on and constituted Harlem in the early 1940s. Two of his paintings in the *Migration of the Negro* series—*During the World War There Was a Great Migration North by Southern Negroes* and *Another Cause Was Lynching. It Was Found That There Had Been a Lynching, the People Who Were Reluctant to Leave at First Left Immediately after This*—illustrated Lawrence's narrative modern style. *Lynching* displayed the dramatic quality of Lawrence's work. A hunched circle of ocher, solitary, representing perhaps victim, perhaps mourner, attends a black noose suspended from a branch, which Lawrence floated against the opaque and murky sky barely tinged with red and purple. In *A Great Migration,* Lawrence focused on African American masses, satchels in hand, heads bearing hats from all walks of life, leaving a mythical railway station's narrow doors to reach the promised lands of St. Louis, Chicago, and New York.

The collage quality of Lawrence's work crowded together his subjects—predominantly blue- and black-cloaked figures—dotting the canvas with salmon red and yellow. The subjects press against and over one another as they struggle to board the trains that will take them north. Lawrence told his audience that African Americans left the South to escape the violence of racial hatred. They left the South out of fear for their lives, without knowledge of what awaited them.

On completion of the *Migration* series, Lawrence turned to African American life in New York. The *Harlem Series* portrayed Lawrence's understanding of the variety and vitality of his own community. Combining elements of his earlier experimentation with collagelike figures and bold graphic images, Lawrence painted wartime Harlem. In *You Can Buy Whiskey,* Lawrence showed the poverty of cheap bootleg whiskey, his flattened figures, frozen in disarray, surrounded by green linoleum and rancid-yellow walls, a radio plugged into the wall to connect their misery to an imagined external, cultured world. The members of the tenement household stoop in weariness, defeated and despondent. Lawrence contrasted this impoverished and melancholy scene with *Harlem Society,* whose middle-class participants, dressed for a night on the town, are alive with festive mirth. Here, men's and women's eyes shine with pleasure. Their drinks and flowers are signs not of emptiness and expired hopes but of gaiety and fancy. Lawrence employed a flattened perspective in his *Harlem Series* scenes, decoratively swirling the smoke of his revelers' cigarettes in patterns and colors that are repeated on the nightclub floor. His paintings expressed his experience in Harlem, reflecting the social world he and Bearden had come to know.

As young men, the two painters, along with several others, often took off from 306 to gather at Joe's on 136th Street or at the Savoy Ballroom, whose manager admitted artists free of charge. At the Savoy they listened and danced to the era's great jazz bands, including Benny Moten and Benny Goodman. Bearden and Alston formed what the *Amsterdam News* called the "Dawn Patrol," hitting all the after-hours spots like Mom Young's, where, "for twenty-five cents, you could get a beer that she made herself in a coffee-can-size container. . . . This was a place where the artists came, and the show people came after the show."[143] Alston's 306, with the Harlem Artists Guild and Savage's Harlem Community Art Center, gave Harlem its own art institutions, replacing the white patronage of the 1920s. Black pride and artistic accomplishment, rather than racial uplift, characterized the second Harlem renaissance. From the Lafayette Theater, a few blocks south of 306, actors Rex Ingram and Canada Lee often walked to join Ellison, Langston Hughes, Countee Cullen, Bearden, Lawrence, and Alston. Studio 306, remembered Bearden, "evoked the feeling in African American artists of belonging to a creative community." Nothing, he added, was more stimulating to the crowd at 306 than the WPA Negro Theater Project.[144]

Bearden's observation was accurate. The second Harlem renaissance flourished under the auspices of the WPA, which enabled Harlem's visual and dramatic artists to participate in New York art. Largely segregated in Harlem, African Americans in the 1930s assumed control of their artistic organizations and composed art on their own terms, frequently addressing the racial inequities of American life but also affirming the value and richness of African American culture and society. Without the Lafayette Theater and the Harlem Artists Guild, the Federal Theater and Arts Projects in Harlem would have simply mirrored the segregation of American society. Augusta Savage's Harlem Community Art Center and Charles Alston's Studio 306 provided the means for Harlem's youth to become artists, writers, and actors. The depression proved an unintended blessing. Supported by federal programs and mobilized by their community's needs, Harlem's artists used their isolation to form an artistic community. Within the political and social context of the New Deal, the artists of Harlem's second renaissance worked alongside their white downtown counterparts as they broke through the city's de facto segregation. New York's federal arts programs initiated a process that within a decade abolished Jim Crow in New York. The second Harlem renaissance linked the Harlem literary movement of the 1920s with its bebop jazz revolution of the 1940s. Finally, New York Modern had begun to break out of its racial confines. A decade after the movies acquired sound, New York art obtained color.

In *Appalachian Spring,* Martha Graham, Isamu Noguchi, and Aaron Copland created a layered work of art. Accessible yet sophisticated, communal yet individualistic, *Appalachian Spring* called for a unity on the home front that embraced those who had traditionally been set apart. So too did Jacob Lawrence, Augusta Savage, Romare Bearden, and Charles Alston. As artists and as women, homosexuals, Jews, African Americans, and Japanese Americans, Bearden, Graham, Noguchi, Lawrence, Savage, Copland, and Alston stood both at the center and at the fringe

of New York art. Echoing the relief Noguchi felt following his release from internment, they did not retreat into apolitical aestheticism. Instead, they utilized the nation's traditional pastoral ideals to offer a modern urban idyll—a society that accepted women and men as equals, that resolved differences through consensus and dialogue, not authority and power, and that saw people as individuals without regard to their color, their sexual preferences, or their gender. Like World War II, New York Modern offered a bridge to the future.

# New York Blues
## The Bebop Revolution

On November 26, 1945, six young jazz musicians entered the recording studios of radio station WOR in New York. Teddy Reig, artist and repertoire man for Savoy Records, had engaged Charlie Parker and his Beboppers for the session.[1] Parker's group had played together for a month, performing at the Spotlight, one of 52d Street's many jazz bars.[2] The second cut recorded that day, *Ko-Ko,* announced the bebop revolution. Following Parker's lead, on the second take, in place of the danceable and melodically straightforward *Cherokee,* the musicians played bebop. *Ko-Ko's* harmonic complexity, rhythmic drive, and improvisational gestures, built on Parker's mastery of the blues, separated it from swing.[3]

Parker's solo in the middle section codified a new approach to jazz, and his extraordinary virtuosity institutionalized an aspect of jazz culture that Parker had brought with him from Kansas City. In the 1930s, Kansas City musicians engaged in a competitive ritual, the cutting contest, to prove who blew best. Parker's *Ko-Ko* said "no contest." In the midst of an inventive riff, as Parker's alto saxophone moved in and out of a faintly recognizable melody, he disclosed the popular tune of *Tea for Two.* The remnant served as pun and evidence, a display of a world that Parker's bebop rejected, a reminder of the social world that lay beyond his music. The white commercial music world of *Tea for Two* excluded and exploited Parker and other African American musicians. Record companies, booking agencies, and white musicians had frequently expropriated the music of black jazz players without acknowledgment, and almost always without payment. For a decade jazz musicians had played *Tea for Two,* extending the harmonic structure of *Cherokee.* Parker acknowledged the song's short but important history within jazz, but he also declared the arrival of bebop. His reference to *Tea for Two* indicated what bebop had left behind—white show business music. Parker believed that white musicians could not master the complex structure of *Ko-Ko.* They could not "cut it." Bebop was not simply a musical revolution; it was payback.

The timing of Parker's bebop revolution was not simply fortuitous. World War II

had cleared the way for fundamental change in music and race relations. Bebop's determination to take jazz back from white swing bands and to secure full credit and reward coincided with other African American efforts to end American apartheid. World War II triggered the second Great Migration of African Americans to northern cities, which reinvigorated the African American communities that had formed during the first Great Migration. These new migrants brought with them southern and southwestern folkways, including traditional blues.

Only a few years before the new migration reformer John Hammond had introduced jazz to the café format. At Café Society in Greenwich Village, integrated audiences listened rather than danced, giving musicians and singers greater opportunity for individual expression. Following the example of Café Society, in Harlem and then along 52d Street a number of small jazz clubs appeared, featuring small combos rather than swing orchestras. In these intimate jazz clubs, Charlie Parker and Charlie Christian, heirs to the southwest blues-riff tradition, along with jazz innovators Dizzy Gillespie, Thelonious Monk, and Kenny Clarke, found a new audience. First in Harlem, then along 52d Street, and finally in Greenwich Village, these jazz revolutionaries formulated bebop, a radically different jazz—improvisational, harmonically experimental, rhythmically daring, highly personal, and African American in identity. Blending a new and radicalized sense of avant-garde innovation with the blues vernacular, they became the beacons of postwar New York Modern, creating a modern music for a modern city.

Contemptuous of jazz entertainers, beboppers cultivated a chamber-style jazz composed for small combos featuring improvisation and experimentation. Bebop built on the style of jazz popularized in Kansas City, where, during the 1930s, black musicians, many working in the Count Basie Band, had already recast swing, investing it with blues riffs and fast-paced solos. Energetic, sometimes frantic, and bluesy, bebop's incendiary style, pulsing rhythm, and frenetic intensity moved away from the melodic, linear, and commercial qualities of swing. Clearly, the innovators of bop had schooled themselves in the jazz of the 1930s. Pushing swing to its limits, they created a new music that simultaneously challenged the racial barriers that plagued New York jazz.

Influenced by traditional African American blues, experimental European concert music, and urban jazz, bebop pioneers found themselves torn between an aggressive assertion of their racial identity and their artistic passion for music that acknowledged no racial barriers. The tension between African American blues and European concert music, between experimentation and commercial recognition, and between racial and artistic identity gave bebop the belligerent, critical edge that appealed to postwar dissidents. By the late 1940s and the early 1950s, in Greenwich Village coffeehouses bebop expressed the alienation of New York's postwar avant-garde from Cold War America. In the age of McCarthyism, bebop set the tone and the rhythm of New York Modern.

## BEFORE BEBOP

Jazz had always been a performer's art, intimately connected with its audience.[4] Yet, in the first three decades of the twentieth century, jazz remained racially segre-

gated. During the heyday of American jazz, between the two world wars, black and white jazz musicians coexisted but rarely, if ever, worked together. Black jazz musicians recorded on race labels and played before all-black audiences in Chicago, East St. Louis, Kansas City, and throughout the South. In Harlem, black jazz bands performed for black audiences at the Lincoln and Lafayette Theaters, at the Savoy Ballroom, and at dozens of small clubs.[5] A few black orchestras, like Duke Ellington's and Count Basie's, played at whites-only clubs in Times Square and Harlem. But even these black bands traveled on segregated trains, stayed in segregated hotels, ate in segregated restaurants, and played in segregated bands. With few exceptions, white bands received higher pay, played at better clubs and concert halls, received more publicity, and sold more records.[6]

In the 1930s, in New York, this pattern of racial segregation gave way, largely owing to the efforts of John Hammond and Barney Josephson. Hammond had regularly visited Harlem since 1927 when, as a senior at Hotchkiss, he decided to devote his life to jazz.[7] He dropped out of Yale two years later and began collecting jazz recordings. In 1931, Hammond moved to an apartment on Sullivan Street in Greenwich Village and removed his name from the Social Register. With the onset of the depression, Hammond, supported by his Vanderbilt family trust fund, worked as a disk jockey on WEVD, the radio station of the *Jewish Daily Forward*, where he played jazz records from his collection and paid performers ten dollars, out of his own pocket, for guest appearances.[8] Tall, awkward, and sporting a crew cut that grew white with age, Hammond wrote for several small English music periodicals and for the *Nation*, where he covered the *Scottsboro* case.[9] When the NAACP invited Hammond to join its board of directors in 1935, he eagerly agreed. Independently wealthy, committed to racial equality, and fascinated by jazz, Hammond used his social connections and money to promote black musicians and to end racial segregation in the jazz world.

Hammond adopted a two-front strategy. First, he actively searched for talented jazz musicians, such as Billie Holiday, Lester Young, and Charlie Christian. Second, he persuaded white producers, club owners, and bandleaders, like Barney Josephson and Benny Goodman, to hire black musicians. Hammond's first musical discovery occurred in 1933 at Monette's in Harlem. The owner and featured singer, Monette Moore, asked a young singer, Billie Holiday, to substitute for her on the evening that Hammond came around. Holiday had worked in Harlem clubs for two years, including Convan's, the Alhambra Grill, and Pod and Jerry's, all clustered near Seventh Avenue and 134th Street. Hammond described the young Holiday as a "tall self-assured girl with rich golden-brown skin [who] came over to your table and sang to you personally. I found her quite irresistible."[10]

So, too, did much of the jazz world. Eighteen at the time, Billie Holiday had lived with the drama and scars of Harlem since arriving from Baltimore six years earlier. When Holiday sang the blues, her audience knew that she had lived them. Hammond marveled that she possessed the unteachable gift of making every song her own.[11] Holiday's distinctive husky singing lent itself to the swing-band style of the 1930s, but her delivery, dramatic and soulful, appeared "too artistic" for many of the music copywriters who determined which bands and artists received exclusive rights

to popular songs. As a consequence, Holiday had failed to achieve commercial success.[12]

Two years after her discovery by Hammond, Holiday made her debut at the Apollo, where she "broke up the house" with her encore of *The Man I Love.*[13] The same year Holiday worked with Teddy Wilson, who, with Lionel Hampton, had just joined and integrated Goodman's orchestra. Hammond had been instrumental in that historic event, the first break in the racial segregation of jazz. Between 1935 and 1942, Holiday, singing with Hampton and Wilson, recorded scores of records aimed at black jukebox audiences. She also worked with Lester Young, with whom she had a special affinity, and with the Count Basie and Artie Shaw bands. In joining Shaw in 1938, Holiday became one of the first black singers to star with a white swing band. Her classic jazz repertoire, derived from her association with Hammond, moved from standard jazz ballads, such as *Did I Remember?,* to the Bessie Smith–inspired blues of *Fine and Mellow.*

In 1935, when Holiday joined Benny Goodman, Hammond and Goodman had worked together for three years. Hammond had first heard Goodman leading a group at the Onyx, a speakeasy on 52d Street owned by Joe Helbock. A jazz fan, Helbock placed a piano at the back of his place for the musicians who stopped by and announced themselves with a password, "I'm from 802," the musicians' union Helbock represented.[14] When his customer-musicians started to jam regularly, Helbock, thanks to the repeal of Prohibition, transformed the Onyx into 52d Street's first jazz club.[15] Hammond believed in the talent of his friends, and under his guidance Goodman recruited many of the best jazz performers of his era, black and white. In 1934, Goodman organized his first big band, a twelve-piece ensemble and, at Hammond's urging, engaged Fletcher Henderson as his arranger.

A "driving unaccented 4/4 that maintained a steady pulse against varied melodic accents" provided the rhythmic drive for the big swing bands of the 1930s.[16] In Goodman's case, however, the swing derived from the tension created by Goodman's tendency to play just before the beat.[17] Compared with the jazz bands of the 1920s, swing bands played more rhythmic figures, leaving short bursts of the melody to soloists, whose phrases contrasted with the riffs of the reed and horn sections that in turn passed the tune's themes back and forth between them.[18] By and large, the swing bands emphasized the sound of the whole at the expense of the virtuosity and spontaneity of the soloist. For many jazz musicians the rigid organization and structure of the swing bands was suffocating. They found a modicum of freedom by moving from band to band, serving as itinerant musicians or playing informally for each other in after-hours clubs, hotel rooms, or even on the roofs of tenements.

Goodman adopted swing in 1934 at Hammond's suggestion, beginning a long recording career with Columbia. Thanks to Henderson's reworking of jazz standards and contemporary popular tunes, Goodman established a firm musical identity. In July 1935, he invited Teddy Wilson to form a trio with himself and drummer Gene Krupa. The Benny Goodman Trio, the first racially integrated jazz group, played chamber-inspired jazz, recording the acclaimed *After You've Gone* in July 1935. Goodman expanded the trio to a quartet with the addition of a second black musician, Lionel Hampton, with whom the group recorded *Moonglow* in August 1936. At the

same time Goodman's big band acquired national fame thanks to several film appearances and a series of radio broadcasts. By 1938, Goodman had achieved unparalleled status as a popular musical star—the idol of legions of adoring teenaged fans, who acclaimed him the "King of Swing."

Goodman's popularity reached its apex with his famous concert at Carnegie Hall on January 16, 1938. Goodman, who played at his own coronation, "rocked the hall" while his exuberant fans danced as if the aisles belonged to the Paramount. "Swing today," the *New York Times* proclaimed, "is the most widespread artistic medium of popular emotional expression."[19] At Hammond's urging, Goodman invited Count Basie and five members of his band to join the orchestra. Together the two groups, one black, the other white, jammed an extended version of *Honeysuckle Rose,* providing the audience with their first extended exposure to Basie and Kansas City jazz. The spontaneity of the Carnegie Hall jam session culminated when Goodman drummer Gene Krupa joined the Basie rhythm section for the rest of the night. Later that evening members of Goodman's band went to the Savoy in Harlem, where they watched Chick Webb's house band engage Basie in a cutting contest that lasted until morning. News of the cutting contest spread through Harlem, forcing the Savoy to turn away an estimated twenty-five thousand fans. Late that morning Webb outdrummed Krupa, still playing with Basie, to the pleasure of those lucky enough to get inside, while the rest of Goodman's musicians jammed in their hotel rooms as the sun rose.[20]

A year later Hammond commandeered Carnegie Hall for his own concert, *From Spirituals to Swing,* to publicize the role of black musicians in the history of jazz.[21] Hammond unsuccessfully approached the NAACP, which found his concept too daring, and then the International Ladies Garment Workers' Union to sponsor the concert. Finally, Hammond convinced Eric Bernay, a financial backer of the *New Masses,* to fund the program and booked Carnegie Hall for December 23, 1938. Hammond spent the summer lining up his performers, finding folk-blues singer Sonny Terry, fashioning a Benny Goodman sextet with a young and innovative electric guitarist, Charlie Christian, and engaging the Kansas City Six, a segment of the Basie band that featured saxophonist Lester Young.[22] Hammond's *Spirituals to Swing* offered New Yorkers a joyful celebration of African American music and racial integration.

In 1932, at Convan's, Hammond had first heard William "Count" Basie playing piano for the Kansas City band of Benny Moten. Convan's had been one of Hammond's favorite jazz spots, recommended to him by Harlem painter Charles Alston. In 1935, Basie assumed leadership of Moten's band. On a talent-hunting trip, Hammond heard Basie, then playing at the Reno Club in Kansas City, over his car radio. Hammond called MCA's Willard Alexander in New York and arranged for them to fly to Kansas City, where Alexander signed Basie on the spot. Hammond set up a recording date in Chicago and a headliner engagement at the Roseland Ballroom in New York.[23] Under Hammond's guidance Basie reshaped his Kansas City blues–based band into one of the top jazz bands of the 1930s, gaining national recognition with the 1937 classic, *One O'Clock Jump.*[24]

The Basie band, which featured Lester Young on saxophone, rivaled Goodman's.

By the late 1930s, however, no one in jazz rivaled Young. By his twentieth birthday, Young, then with Joe "King" Oliver's band, had already developed a highly individual, harmonically advanced style of playing the tenor saxophone. The most influential jazz musician between Louis Armstrong and Charlie Parker, Lester Young remained an introspective and fundamentally private person.[25] As a teenager Young had played the drums and the alto sax before switching to the clarinet and tenor sax. Young spent his twenties moving from town to town throughout the Midwest and the Southwest. Electric guitarist Charlie Christian heard Lester Young first in Oklahoma City in 1929 and again in 1931 with Walter Page's Blue Devils. Young's narrative style of playing, in contrast with Coleman Hawkins' technical flights of fancy, had a lasting effect on Christian's development.[26]

Young played for Basie in Kansas City and arrived with the Count in New York in 1937. Young did not conform to the stereotype of a swaggering, aggressive black jazz musician. His shy, laconic personality permeated his music. His gentle manner combined with a sly sense of humor and a sure command of language. Young, who called all women "ladies" out of gallantry and genuine gentility, conferred the title "Lady Day" on Billie Holiday. She reciprocated by calling him "Prez," an affectionate contraction of "President," Young's democratic handle awarded in recognition of his cutting contest victories over rival Coleman Hawkins.

Shortly after his arrival in New York, Young accompanied Hammond and Basie to Clark Monroe's Uptown House in Harlem, where Holiday had just begun a three-month "residency." Although Basie already had a blues singer in Jimmy Rushing, he immediately signed Holiday. Holiday never recorded with Basie, but the experience led to her close friendship with Young. Lady Day and Prez shared the blues and a sense of narrative. For each of them the story to be told had artistic precedence, and the content of the blues told stories. Young emphasized the need for musicians to understand the words of the songs they played so they could improvise with meaning.[27]

In the southwest-blues tradition Young embraced a linear form of playing, derived from black folk songs and storytelling.[28] Young's solos displayed extraordinary smoothness, the consequence of his tendency to compress his range as he slid from note to note, breaking the boundaries of swing-band jazz. The conventional division of songs into segments of eight bars cramped Young's expressive ability. His pursuit of blues narratives also led him to explore innovative harmonic and rhythmic ideas.[29] Like many other Kansas City jazz musicians, Young often hung back behind the beat, slowing the rhythm and creating a tension between soloist and ensemble that emphasized the smoothness of his own exposition, which he punctuated with spaces of paused silence.[30] Young's innovations, concealed within swing, obscured his role in the development of bebop; nonetheless, his subtle innovations opened the way for the dramatic changes that lay ahead.

Even as Lester Young subverted the musical structure of swing, so the growing popularity of the small jazz combo undermined the economic and racial foundation of the big bands. Hammond used his connections and influence to promote both. Small groups and small clubs were easier to integrate and less susceptible to commercial pressure. The Kansas City Six, featuring Lester Young, with its two electric

guitars and absence of piano, made it a prototype of the postwar jazz ensemble. Innovative promoters established new jazz clubs whose intimate settings lent themselves to new forms of expression. The most influential was Café Society.

"Café Society," recalled Sir Charles Thompson (so dubbed by Young), "was the most high class club in the world."[31] Owned and managed by thirty-six-year-old Trenton, New Jersey, shoe manufacturer Barney Josephson, Café Society became New York's first integrated nightclub—"the wrong place for the right people," as Josephson once described it. With Hammond serving as unofficial musical director, Café Society, located on Sheridan Square in the Village, presented "first rate but generally unknown Negro and white talent."[32] Lester Young thought Café Society a perfect jazz environment. Nothing of the dive or the joint characterized Café Society. Josephson meticulously oversaw the installation and working of light, sound, and stage equipment. Josephson and Hammond wanted a leftist, Popular Front ambience at Café Society. When Hammond suggested Billie Holiday for the club's opening, Josephson readily agreed.

Holiday's unformed social and political attitudes, in part the result of a meager formal education that ended in the fifth grade, did not keep her from declaring, "I'm a race woman." But neither did they equip her to deal with the full implications of her appearance at the club.[33] Her stint with Artie Shaw had convinced Holiday that her future lay in solo performance. Mass audiences preferred the big band singer; Café Society seemed made for her. When poet-songwriter Lewis Allen presented Holiday with his evocative poem, *Strange Fruit,* about southern lynching, she hesitated. Holiday knew music far better than she understood politics. Nevertheless, she agreed to record *Strange Fruit,* its blues closer to a dirge than a shout. Holiday sung straightforwardly in a narrative understatement that underscored the song's content:

> Blood on leaves, and blood at the root,
> Black bodies swingin' in the Southern breeze,
> Strange Fruit hanging from the poplar trees.[34]

Café Society and *Strange Fruit* made Billie Holiday a star of New York's liberal, intellectual, New Deal left. It also sidetracked her career. Once a successful saloon singer of love songs, Holiday became an artist and cult figure whose deepening addiction to drugs accelerated her isolation. The song's political appeal reinforced Holiday's legend. Recorded on an obscure label, it received little radio play in the United States, and in England the BBC (British Broadcasting Company) banned it entirely.[35] Hammond believed *Strange Fruit* the worst thing that ever happened to Billie Holiday. It brought her modest fame but little fortune.[36]

Lena Horne followed Holiday at Café Society, remaining for two years as Josephson presided over the club's L-shaped basement room with gracious directness. When patrons voiced discomfort with Café Society's integrated seating, Josephson simply asked them to leave. Between 1939 and 1950, in Greenwich Village, Café Society hosted the great jazz voices of the era—Sarah Vaughan, Teddy Wilson, Art Tatum, and Fletcher Henderson in addition to Holiday and Horne—creating a new venue and a new audience for a new jazz.

In 1939, the jazz pianist Mary Lou Williams told Hammond about a guitar player

she knew back in Oklahoma.[37] In bringing Charlie Christian to New York with Goodman, Hammond unwittingly set in motion a sequence of events that led to bebop. Ever adventurous, Hammond found Christian playing at the Café Ritz in Oklahoma City and took the young electric guitar player with him to meet Goodman in Beverly Hills. Goodman looked at Christian, dressed in pointed yellow shoes, green suit, and purple shirt, and reluctantly agreed to humor Hammond.[38] Goodman assembled a group of musicians and asked them to play *Rose Room*, a tune that he assumed Christian did not know. For forty-five minutes, to Goodman's astonishment, Christian played chorus after improvised chorus. Goodman signed Christian to play with his sextet on the spot.[39] Teddy Wilson and Lionel Hampton had integrated Goodman's groups earlier, but Christian brought to Goodman and New York the black harmonic and blues influence of Kansas City. In the after-hours clubs of Harlem they created a new American music.

On the eve of World War II the big bands of the swing era found themselves circumscribed by the tastes of their adoring fans and the demands of booking agents, record companies, and theater owners. Popularized and commercialized, swing jazz had lost touch with its blues origins. Charlie Parker and Dizzy Gillespie restored the blues to jazz. In 1945, the year Parker recorded *Ko-Ko,* he was still a relatively unknown itinerant jazz musician with an insider's reputation for improvisational genius earned in after-hours jam sessions. But Parker's revelation had begun a decade earlier, in Kansas City, under the tutelage of Lester Young. When an interviewer asked Parker, "Did you ever listen to Lester Young?" Parker replied, "Every night."[40]

## THE BIRTH OF BOP

Charlie Christian linked the earlier innovations of Lester Young to postwar bebop. In New York's clubs, bars, and neighborhoods, Parker and Gillespie remade Kansas City jazz into bebop. Christian, born in either 1916 or 1919, died of tuberculosis in 1942; he spent the last year of his life in Harlem playing and jamming at Minton's and Monroe's, where young musicians came to experiment, discarding the conventions of swing. During World War II, Christian and the early beboppers reconstituted in Harlem the informal jazz culture of the Southwest—of Kansas City, Oklahoma City, and the tank towns in between.

Life in Oklahoma City, where Christian guided his blind father, who played guitar, exposed Christian to the guitar and blues tradition of the region as well as to the light classics with which they serenaded their patrons.[41] In Kansas City, Lester Young extended Christian's education. Christian translated Young's technique to the electric guitar, an instrument he started to play seriously in 1937.[42] Thus, when Christian arrived in New York he was playing an instrument that had not existed a decade earlier. Along with French-Belgian guitarist Django Reinhart, he transformed the electric guitar from a rhythm instrument to a solo voice. The "riff-tune" idea, derived largely from Kansas City jazz, worked perfectly with Christian's technical innovations. Abandoning the chorded rhythm style of playing, Christian strung together lines of single picked notes, producing smoothly improvised riffs that rose and fell with almost classical symmetry.

Christian's music was characterized by the riff-style of Kansas City jazz, the short rhythmic phrases and clusters of notes in harmonic phrases used by bands like Basie's, which "always carried a melody you could write a song from."[43] Kansas City rhythm sections also stressed all four beats rather than the accented second and fourth, giving the music its swing. Christian took this musical heritage and expanded it, continuing to play in a blues tradition but increasing the improvisational richness of his expression.[44] His improvisation amazed Harlem's jazz aficionados, who crowded into Minton's. He delighted in dissecting popular songs with challenging chord progressions and then building his improvisational lines on the structures he uncovered. At times he lifted other musicians' favorite riffs and quoted them in the middle of his own line.[45] An artist who talked to other artists, Christian assumed that his colleagues and his audience knew "the book." His innovations, playing the upper notes of a chord, the ninths and elevenths, substituting diminished chords for dominant sevenths, and temporarily abandoning syncopation, anticipated bebop.[46] Christian's innovative musicianship allowed him to extract all the "juices out of his blues background."[47]

Christian's death deprived modern jazz of one of its foremost experimental musicians. But Charlie Christian shared his ideas with a handful of young innovators—Charlie Parker, Dizzy Gillespie, drummer Kenny Clarke, and pianist Thelonious Monk. Together, in the small after-hours clubs of Harlem and then 52d Street, they created bebop.

The clubs that nurtured the bebop generation had started out as illegal speakeasies owned by a variety of black and white gamblers and bookmakers, bootleggers and gangsters, who transformed their chili parlors and juke joints into legitimate businesses. Henry Minton, the owner of a restaurant-bar on 118th Street and St. Nicholas Avenue, started his place as a supper club, called Minton's Playhouse, that served the local neighborhood and the Sugar Hill crowd.[48] Minton, the first black delegate to the American Federation of Musicians Local 802, charged a two-dollar cover and on Mondays offered "free whiskey" to the musicians who had performed at the Apollo.[49] The Monday night spreads became springboards for the legendary jams at his club between 1940 and 1944. They also circumvented union regulations prohibiting jam sessions in New York, which were designed to protect the wages of club musicians, the majority of whom were white. Minton's position as union delegate exempted him from the ban.[50]

Minton's club invited company. He located his dining room in the middle of his club. The dining area was surrounded in front by a bar and in back by the cabaret bandstand, so small that with a dozen players on stage the club felt like rush hour on the subway rumbling below. When he turned the club over to bandleader Teddy Hill in 1940, Minton's had become the gathering place for New York's experimental jazz. Hill extended the Monday evening jam sessions by forming a house band, which played for food. Hill's personnel in the early 1940s included drummer Kenny Clarke and pianist Thelonious Monk. Dizzy Gillespie, who had first played with Hill in 1937, joined them whenever he happened to be in New York, as did Parker.

When Minton's closed each morning, Kenny Clarke recalled, "we'd all head for Monroe's" to continue the night's playing and talking.[51] Located on West 134th

Street, Clark Monroe's Uptown House lacked Minton's food and elegance but served as a nightly hangout for musicians looking for action. A true after-hours club, Monroe's presented a floor show and featured a house band that allowed guest musicians to sit in.[52] At the 6:00 A.M. closing time, the musicians passed the hat. On a good night a share of the take approached the seven dollars a week that the nearby Collins' rooming house charged for room and board.[53] Or it might buy the next day's heroin. During the war Monroe's and Minton's became legendary Harlem after-hours places. But the neighborhood contained dozens of jazz bars where young musicians hung out and experimented with the new music.[54] Minton's (or Monroe's or even Dan Wall's Chili House on Seventh Avenue and 140th Street), wrote Ralph Ellison, "as a nightclub in a Negro community . . . was part of a national pattern." Each recreated the Kansas City jam session "but with new blowing tunes."[55]

Charlie Parker, the central figure in the bebop revolution, came from Kansas City and had worked in and out of New York since 1938. Constantly at odds with the pressure to entertain, Parker washed dishes and played the alto saxophone at Wall's in 1939. "I was working over *Cherokee,* and, as I did, I found that by using the higher intervals of a chord as a melody line and backing them with appropriately related changes, I could play the thing I'd been hearing. I came alive."[56] Parker's epiphany resulted in two fragmentary recordings of *Cherokee* in 1942. Parker, Gillespie, Clarke, and Monk, individually and collectively, built on that innovation and, in 1945, took it downtown as *Ko-Ko.*

Parker, born in 1920 of working-class parents, left school at the age of fourteen, trading his marching band tuba for an alto saxophone. He mimicked Lester Young, who held his tenor up and off to the side. Married and physically full grown at the age of fifteen, Parker burned with a desire to excel intellectually and musically. On a memorable evening in the summer of 1936, Young encouraged Parker to sit in. The session resulted in Parker's public humiliation when drummer Jo Jones crashed his cymbal at Parker's feet for failing to keep pace with the band.[57] Within a year Parker had mastered the scales and blues runs of all twelve keys, experimenting with idiosyncratic fingering, cutting his own reeds, and, in the middle of a solo, moving from one set of chord patterns, or changes, to the next.[58]

Kansas City jazz, which relied more on improvised solos than on orchestrated arrangements, fostered experimentation that superimposed the harmonically compatible riffs of one tune on another.[59] The harmonically inventive quotation depended on a musician's ability to retain and to play hundreds of blues riffs—jazz's legendary "book." Parker possessed the uncanny ability to imagine the possibilities of a tune and to explore their variety, drawing on the rich blues tradition that he had memorized.[60] Between 1936 and 1939, Parker spent an estimated fifteen thousand hours "woodshedding"—an apprenticeship honed in the dance halls, bars, grills, and chili houses of Kansas City. Parker, however, lacked a formal theoretical system with which to consolidate his intuitive innovations.

In the fall of 1938, shortly after his arrival in New York, Parker met Dizzy Gillespie, who was with Cab Calloway's band at the time. A year later Gillespie, who did not remember the earlier introduction, returned to Kansas City, where Calloway performed at a theater that permitted blacks to sit only in a segregated balcony, a "buz-

zards' roost." Told by a fellow trumpet player that he had to meet a new alto player, Gillespie went to the musicians' local; he sat down at the piano, and "Charlie Parker played. I never heard anything like that before."[61]

In 1940, Parker landed a job with Kansas City bandleader Jay McShann. McShann's band, a local successor to Basie's, kept the twenty-year-old Parker in the Southwest for most of the next year and a half—Parker's longest sustained stint with a single group. With McShann, Parker mastered the swing-band book, learning to play by the rules. In January 1942, weeks after Pearl Harbor forced Minton's to abandon its Monday evening spreads as excessive, McShann, with Parker, opened at the Savoy, sharing the bandstand with Lucky Millinder, whose band featured Dizzy Gillespie.[62]

Three years older than Parker, John Birks Gillespie, born in Cheraw, South Carolina, learned to play the trumpet at a Negro industrial school, the Laurinburg Institute in North Carolina, where he also learned music theory and harmony. In 1937 he joined Teddy Hill's band. At the age of twenty Gillespie traveled with Hill to England, where Gillespie, "trying my best to sound like Roy Eldridge," found himself relegated to third trumpet. On his return, while waiting for his 802 union card, Gillespie scrambled for work, playing gigs for Communist Party dances in Brooklyn and the Bronx.[63] He met and married Apollo dancer Lorraine Willis, earned seventy dollars a week working with Hill, and settled into family life. Gillespie's hip expressiveness gave bebop its renowned slang, just as the special glint in Gillespie's eyes captured his spirit of devilish rebellion.[64]

Gillespie's two closest musical collaborators, bassist Milt Hinton and drummer Kenny Clarke, found Dizzy irrepressible. Hinton, with whom Gillespie had played in the Cab Calloway band, remembered Dizzy's particular brand of slang, derived from Ben Webster. Together, Hinton and Gillespie spoke of "cows" (a hundred dollars), "lines" (fifty dollars), "softs" (chicks), and "pin" (dig), which enabled them to say elliptically, "Pin that Soft." To Hinton, the argot of the jazz musician extended the linguistic ingenuity "of all of black society," that historically used coded language in the presence of whites.[65]

In his harmonic sophistication, Gillespie seemed years ahead of the rest of the musicians in Calloway's band, and Hinton encouraged Gillespie's experimentation. Often the two would drag Hinton's bass up the back staircase to the roof of the Apollo, the Cotton Club, or the apartment building where Gillespie lived to try the chord progressions that Gillespie wanted to insert into Calloway's music. When Hinton could not follow the complex harmonic systems, Gillespie shouted the chords out to him.[66] He recalled encountering a "weird" change, "an E-flat chord built on an A, the flatted fifth. . . . Oooooman! I played the thing over and over again. . . . I found that there were a lot of pretty voices in a chord."[67] Gillespie, known as "Dizzy" because he was "dizzy as a fox," understood the significance of the bebop revolution. "Our music," he wrote, "emerged from the war years—the Second World War, and it reflected these times . . . fast and furious." The sheer speed of bop expressed a breathless, even desperate attempt to create something unique. "Sometimes," Gillespie continued, "when you know the laws you can break them."[68]

During the early 1940s, Gillespie's musical prowess grew. He played with Earl

Hines, alongside Parker in 1942–43, and with Billy Eckstine in 1944. These swing bands played popular jazz that bore little resemblance to the music Gillespie and other beboppers played at Minton's and Monroe's. Kenny Clarke explained, "We had no name for the music. We called ourselves modern."[69] Like many of the other jazz pioneers who congregated at Minton's and Monroe's, Clarke grew up in a musical family. His father played the trombone, and Clarke studied music in high school, mastering several instruments and learning theory. He first played for a local group before joining an East St. Louis band in 1934 that featured Charlie Christian.[70] Three years later Clarke, an extremely independent player, moved to New York. He resented the humiliations of performing in a racially prejudiced society, which forced him to accept inferior accommodations and working conditions. Living in Harlem reinforced his indignation. For the next several years Clarke was hired and fired by Count Basie and Louis Armstrong. He traveled and played in Europe and finally found a place with Teddy Hill's band, where he met Gillespie. When Hill moved to Minton's, he installed Clarke as the house drummer.

Many Harlem dance clubs, like the Savoy, required one fast dance number after the other. The unrelenting, double-time pace of these "flag wavers" wore Clarke out. Swing drummers kept time primarily through the right-foot-driven bass drum. Clarke wanted a rhythmic alternative to the repetitive and tiring pounding of eight beats to the measure.[71] Experimenting with jumping in on the open beat, Clarke dreamed of liberating the drummer to become an accompanist as well as a rhythmic anchor. He shifted the task of keeping time from the bass drum to the right-hand cymbal. Other rhythmic variations followed. Other band members complained that they no longer had a clear sense of the rhythm. "Depend on yourself," Clarke explained, "because if you're playing music, the tempo that you're playing is in your head."[72]

Clarke freed jazz musicians to follow their own rhythmic variations. He also freed the drum to resume its traditional African role as an independent voice. But not until Clarke played with Gillespie did he find a musician who appreciated the opportunity that his rhythmic innovations had created. By transferring time keeping to the right hand, Clarke also released the bass drum to provide off-beat accents, or what he and his friends came to call "bombs" or "klook-mops." With this reversal, Clarke freed up his left foot to play the high hat and his left hand to work on the snare. In diminishing the time-keeping role of the drummer, rejecting the role that drummers had been assigned since slavery, Clarke expanded the polyrhythmic and instrumental possibilities of the entire jazz ensemble.

Hill did not think Clarke's innovations worked for a swing dance band and fired him. Yet, when Hill took over Minton's with plans to make it into a musicians' hangout, he rehired Clarke, saying, "you play all the re-bop and boom-bams you want."[73] Gillespie understood immediately. Clarke's work on the cymbal fit perfectly with the trumpet as well as with Gillespie's rhythmic adventurousness.[74] Gillespie mastered Clarke's polyrhythmic drum innovations sufficiently to teach other musicians after Clarke joined the armed forces in 1943. Similarly, Gillespie's passion for the new music led him to Minton's resident pianist, Thelonious Monk, whose cryptic and oblique personality and far-out ideas about chromaticism informed his skills as com-

poser and performer. Gillespie credited Monk with showing him the oddly chorded configurations that not only inspired Gillespie's harmonic experimentation but also formed the foundation for Monk's bop anthem, 'Round Midnight.

Thelonious Sphere Monk lived in a spare apartment on West 63d Street in the San Juan Hill neighborhood, near Lincoln Square. Born in North Carolina, Monk came to New York in 1922. He started playing the piano at the age of six and learned his way around the instrument by himself. He gave lessons to neighborhood kids for seventy-five cents an hour, performed at local rent parties, and won an amateur-night contest at the Apollo.[75] Playing in the stride-piano style of Willie "the Lion" Smith, Monk joined an itinerant faith healer's band ("She prayed, we played") and returned to New York at the age of seventeen, accomplished but broke. Scuffling for work, including nonunion jobs that paid twenty dollars a week, Monk specialized in gigs whose contracts could be broken at a minute's notice.

Monk spread his small fingers flat, not arched, when he played. He cultivated a nontechnique, one which later incorporated his elbow or forearm as part of his search for chromatic alternatives to traditional harmonic structure. Refusing to draw distinctions between life and art, Monk played the piano where and when he could, eating and sleeping irregularly, depending for financial support on his wife, Nellie, who called him "Melodious Thunk."[76]

During Monk's tenure at Minton's, a young student at Columbia University, Jerry Newman, a jazz enthusiast and amateur recorder, occasionally performed at the informal floor shows that Hill organized. Newman lip-synched the words of celebrities, from FDR to Bob Hope, whom he had recorded from the radio. For compensation, Hill allowed Newman to set up primitive equipment to record the jazz sessions. With the cabaret stage flanked on either side by the "Gents" and "Ladies" rooms, the historic Newman recordings of 1941 and 1942 frequently registered the sounds of slamming doors and flushing toilets. Newman told Down Beat writer George Hoefer that Monk played brilliantly at Minton's, working his compositions, seated at the piano, over and over again, developing a succession of new ideas, pushing the limits of his composition.[77] Newman, however, cared little for Parker's work, and only an unexplained quirk of fate accounts for his historic recording of Parker's Cherokee at Monroe's in the summer of 1942.

Parker had just left McShann's band and settled in New York, making the rounds each night, looking for gigs and drugs. One evening tenor sax player Ben Webster asked Monroe about "that cat" Parker, "blowing weird stuff." Monroe promised to put Parker on stage the next night to play Cherokee, which Newman recorded on a paper disc.[78] The 1942 Cherokee at Monroe's, together with a second version that Parker recorded several weeks later with a pickup band in Kansas City, indicated just how far "the Bird" had flown beyond swing jazz.[79]

The band opened with a two-chorus statement of the tune's theme, a swing statement typical of those played in a hundred cocktail lounges, while the unknown pianist slipped in the Tea for Two theme. As Allen Tinney, one of the musicians who played regularly at Minton's and Monroe's, recalled, the musicians had "already developed a Tea for Two thing in the middle . . . and he dug this and right away started fitting in."[80] Parker's solo, sudden and strong, shattered the song's conventional the-

272

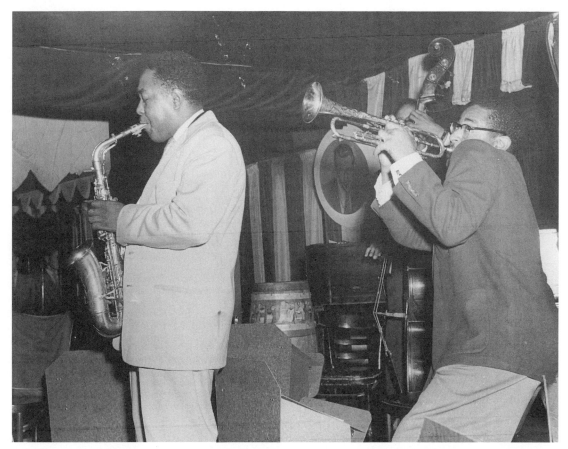

Bebop Pioneers.
Charlie Parker and
Dizzy Gillespie at
Birdland, New York
City (circa 1949).
*Photograph ©Duncan
Schiedt Collection*

matic statement. Not yet the howling and emotionally intense alto player of legend, Parker took his audience's breath away with a display of up-tempo improvisation, a series of riffs that challenged his band to keep pace. Pulling the band along, Parker negotiated the bridge and returned the tune to the band for a final restatement.[81]

Parker played almost as smoothly as his mentor, Lester Young, and yet the virtual double-time quality of his version of *Cherokee* created an entirely new rhythmic effect. Word of Parker's performances spread, making the late-night sessions at Minton's crowded affairs. Sometimes twenty or more musicians crowded onto the small stage, vying for attention. *Cherokee* became a way to catch the neophytes. "Because it was moving in half steps and [in] the different keys," the song determined who went back to the woodshed.[82] It took two years for Parker to complete *Cherokee*'s metamorphosis into *Ko-Ko,* at the November 1945 Savoy recording session.

For that occasion, Parker assembled a new group. Miles Davis, only nineteen, joined fellow trumpet player Dizzy Gillespie, bassist Curley Russell, drummer Max Roach, pianist Argonne Thornton, and Parker for the historic session. Davis, however, found *Ko-Ko's* opening section so daunting that he let Gillespie take the first eight bars in unison with Parker's alto saxophone. Only after Gillespie moved to the piano did Davis resume on trumpet.[83] Gillespie and Parker's opening burst forth

from their instruments with controlled precision. The staccato notes pushed forward, each one a sound in its own space, each separate from the next. Passing the theme back and forth, the players resumed for a last measure and then paused. The Parker-Gillespie introduction, however, only hinted at Parker's reformulation of modern jazz.[84]

Davis exclaimed, "Bird was a *fast* motherfucker." Parker's solo was remarkable for its combination of tempo and lyricism and became legendary for its intensity and its facility.[85] In two minutes Parker explored his alto's full range. He stretched, screeching, to reach one note from inside the preceding one, then in the next moment he soared melodically through the notes of a chord progression insinuated by the piano's occasional remnants of the original tune. Parker played one of the "greatest solos in the history of jazz."[86] Based on a combination of key signatures that coexisted in a single, unified, yet improvised and linear, melodic statement, Parker's *Ko-Ko* pushed jazz toward atonality. Careening through the song's complex labyrinth, Parker created both a showpiece and a masterpiece.[87]

Parker worked his way through the recording, his playing more complex and more lyrical. His alto moved up and down each phrase, creating a fluidity that united harmonic and rhythmic experimentation. In contrast to *Ko-Ko*'s hard-edged opening and closing sections, Parker and Gillespie, first in unison, then in solos, and once again in unison, played a swirl of almost pure abstract music. *Ko-Ko*'s atmospherics, its color and movement, its design and mood became its content. Despite Parker's ferocious speed and virtuosity, *Ko-Ko*'s roots lay in the blues, reaching back to Kansas City riffs and the "tragic accent" of Bessie Smith.[88]

Previously, Parker and other African American musicians had played and composed jazz only to have white musicians claim credit and financial rewards through rerecording, or "covering," the original tune with their own commercial versions. With bebop, Parker and his group tried to create jazz that was uncoverable. In *Ko-Ko,* Parker taunted the white-dominated music business with his scrap of *Tea for Two. Ko-Ko* began with laughter, moved to derision, and culminated in anger.

The short phrase taken from popular music's most recognizable tune also served as an ironic allusion to a shift in the politics of the music business. From mid-1942 to 1944, the recording ban had left jazz performers without a mass audience. Denied access to recording and radio, jazz musicians scratched out livings by playing in small clubs and for each other. Bebop emerged, in part, as a consequence of the commercial exile of jazz during World War II. *Ko-Ko*'s curious quotation reminded audiences and promoters that things had changed. Parker left intact only an allusion to jazz's commercial past. In revolutionizing jazz, Parker and others also threatened to revolutionize the business of jazz, liberating it from commercial entertainment and establishing it as art, controlled and defined neither by popular taste nor commercial producers but by its artists, most of whom were black.

## NOW'S THE TIME

Minton's and Monroe's provided bebop its first public venue, and bebop owed its slow development to the context of its birth. Parker, Gillespie, Clarke, and Monk

had each worked on both sides of jazz's musical street. Featured members of conventional swing bands and fiercely proud insurgents on their own time, their bebop revolution affirmed jazz's artistic power. As Ralph Ellison observed, "They were concerned . . . with art, not entertainment."[89] In musical terms Parker, Gillespie, Monk, and Clarke reworked popular pieces into jazz through harmonic and melodic substitution. Together, between 1942 and 1945, Gillespie and Parker completed the transformation. In 1942, after hearing the Nat King Cole trio's version of *How High the Moon*, Gillespie played it for Monk, who substituted a more complex set of chord changes that freed the soloists to expand their improvisational range. The new piece—named *Ornithology*, punning on Parker's shortened nickname, "Bird"—adhered to the harmonic structure of the original but no longer resembled it.[90]

When Parker and Gillespie found band work they signed on together, first with Earl Hines and then with Billy Eckstine, learning each other's books and passing musical ideas back and forth. Parker's facility and intuition complemented Gillespie's disciplined and theoretical approach. Each played with astonishing speed, displaying technical virtuosity that stunned even the most professionally accomplished colleagues. Parker and Gillespie acknowledged each other's contribution to the formation of bebop. Gillespie later said of Parker, "He played fast. He played notes others didn't hear. He attacked."[91] When not playing for Hines or Eckstine or jamming uptown, the two worked meticulously on theoretical exercises, experimenting with new scales and modes, fitting different chordal relations onto old tunes, and improvising, always exploring new lines of expression.

During one session Gillespie, improvising on the piano on chord changes based on "a thirteenth resolving to a D minor," noticed an incipient melody that he thought had a Latin feel, a special syncopation in the bass line. The tune, a composition based on improvisational exercises, remained untitled until bandleader Earl Hines suggested *Night in Tunisia,* in recognition of the North African landings in the fall of 1942.[92] Milt Hinton recounted a particularly vivid summer night at Minton's when Parker dropped by to talk and "really blow." The musicians jammed all night with the windows of the ground-floor cabaret open for cool air. Neighbors came by to drink out of paper cups or to complain about the late-night racket. "That was a great night. I remember the great feeling, the freedom of just blowing."[93]

This small core of jazz musicians created a distinct body of work so personal others found it difficult to copy. Mary Lou Williams suggested that the musicians stayed in Harlem because they feared "that the commercial world would steal what they had created." Downtowners, she noticed, often came into the clubs to scribble notations on paper napkins.[94] Monk complained, according to Nat Hentoff, "We'll never get credit for what we're doing here," and concluded that the musicians had to "create something that they can't steal because they can't play it."[95]

"What we were doing at Minton's," said Gillespie proudly, "was playing . . . creating a new dialogue among ourselves, blending our ideas into a new style of music." Gillespie intentionally made his music difficult, fooling newcomers into playing in B-flat while actually playing in F-sharp.[96] Similarly, Jerry Newman prided himself on being one of the few white persons—another, Jack Kerouac, then a football-scholarship student at Columbia, frequently sat at the bar drinking beer at the

Minton's and Monroe's sessions—to appreciate the bebop revolution. Johnny Carisi, an Italian American whose successful playing met with reluctant acceptance, believed that some at Minton's and Monroe's resented him because "you ofays come up here and you pick up our stuff."[97] Caught between an exploitative white commercial music establishment and the Tomming attitudes of older jazz musicians, the jazz beboppers played and composed for each other, developing a complex and rich subculture, in language, dress, attitude, and politics, to complement their music.

Monk and Gillespie cultivated the bebop-hipster image of the mid-1940s. In contrast to swing-band performers, who wore brightly colored iridescent dinner jackets, beboppers adopted Gillespie's adversarial style that included beret, dark glasses or horn rims, cigarette holders, and wide-lapelled tailored suits. Monk had started the style of wearing a beret and dark glasses. Parker remained the exception in "baggy clothes that looked like he had been sleeping in them for days."[98]

The boppers' stylistic avant-gardism, which mimicked and satirized middle-class respectability, had its slang counterpart. Jazz musicians had always used slang, partly for amusement, partly to identify outsiders. The bebop style, however, became the style of postwar New York's avant-garde, who found that the slang, dress, and music of bebop expressed their own social and cultural alienation. In addition to Gillespie's use of pig latin terms like "ofay" for *foe* and words like "hip" (coined by Howard McGhee, who said of Parker, "he hipped me to Stravinsky"), bebop musicians invented new slang terms. "Cool" and "wig" joined "Mezz," their word for marijuana, which derived from Mezz Mezzrow, who always had the best supply, and "razor," a draft whose chill cut into your back. As Gillespie put it, "As black people we just naturally spoke that way. As we played with musical notes, bending them into new and difficult meanings that constantly changed, we played with words."[99]

No one, however, played like Charlie Parker. Mose Allison, who worked with Miles Davis, described Parker as heir to the black musical experience, an embodiment of the blues and gospel tradition. Jay McShann said, succinctly, "Bird could play anything, because primarily, Bird was the greatest blues player in the world."[100] When his friends attempted to shake Parker free from the effects of drugs and alcohol, they appealed to his sense of racial and political pride. Max Roach, drumming protegé of Kenny Clarke who played with Parker on *Ko-Ko* and then at the Three Deuces on 52d Street, often found Parker "shooting shit." Roach reminded him "how much he meant to us, how much he meant to black people, how much he meant to black music."[101]

Parker's gifts extended well beyond the bandstand. Like Monk, he indulged in comic outbursts, putting on Oxonian accents, turning the old minstrel routine of travesty inside out, informing slightly bored patrons, "Ladies and Gentleman, the management has spared no expense this evening to bring you the Charlie Parker quintet."[102] His sense of humor and irony, however, barely concealed his political and racial consciousness. Parker, along with Gillespie, Clarke, Max Roach, Milt Hinton, and Art Tatum, formed a core of musicians whose political awareness played an important role in their musical lives. Hinton and Clarke both recalled that Parker spoke as passionately about social and political issues as he played. "He was always talking deep things about race or conditions in the country or about music. It

was such a joy to talk."[103] Gillespie engaged Parker in discussions about Baudelaire and radical congressman Vito Marcantonio. Gillespie, whose anger focused on American racism, refused to serve in the military, fearful of barracks conditions in the South. Because his work kept him constantly on the move, Gillespie assumed the draft would never catch up with him. He later wrote, "We were creators in an art form which grew from universal roots and which proved it had universal appeal. . . . We refused to accept racism, poverty, or economic exploitation. But there was nothing unpatriotic about it. If America wouldn't honor and respect us as men, we couldn't give a shit about America."[104]

W. E. B. Du Bois and Paul Robeson inspired Hinton and Parker. On the road the two often talked of Du Bois's message to black people. When they arrived at a new destination, "we'd get off the bus and be sure we got to this place to hear W. E. B. Du Bois and this would be the focal point of our conversation."[105] To Hinton and Gillespie, Paul Robeson symbolized the social aspirations of African Americans at a time when his reputation had been tainted by his Communist Party affiliation. Fearful of Red-baiters, the politically minded jazz performers reacted cautiously, meeting Robeson on one occasion in Cleveland to talk about music and race relations but generally keeping their distance. Hinton and Gillespie believed that fears of federal persecution prevented the majority of African Americans from listening to him.[106]

The American Communist Party proved equally troublesome. Trying to woo black artists and intellectuals into its ranks, the party played on racial-sexual stereotypes, using white women to recruit black males to meetings, anxious to "get a Teddy Wilson or a Charlie Parker" in attendance. In the end, the musicians knew that jazz best expressed their political values. "We played," said Hinton. "That was the kind of militancy that we exercised."[107]

The tension between art and politics was illuminated in a conversation between Gillespie and Clarke in which each responded to the question, "Did the music have anything to say to black people?" Gillespie answered with his usual directness. "Yeah, get the fuck outta the way." Clarke, who later moved to Europe after discovering its greater racial tolerance when stationed in France and Germany in 1944–45, thought bebop spoke the same message as Jackie Robinson's play on the ball field. Jazz, Clarke said, "was teaching them. . . . There was a message in our music. . . . Whatever you go into, go into it intelligently." Several years later, when Parker visited Clarke in Paris, he found him at peace with himself. In Europe, Clarke explained, a black musician could live as an artist without the additional burden of solving the dilemma of racial prejudice. Warned Clarke, "You're committing suicide in the United States."[108] But Parker understood that only in New York could he consummate his musical revolution. Paris offered Clarke a safe haven and personal happiness; New York offered Parker continued drug addiction, police harassment, the opportunity for artistic greatness, and participation in the early civil rights movement.

Parker recorded *Now's the Time* at the 1945 *Ko-Ko* session, demonstrating his political awareness. Written at the time of the double-V campaign—for military victory abroad and against Jim Crow at home—and in the wake of the postponement of the civil rights March on Washington movement, *Now's the Time* called African Americans to action at a time when white America was trying to return to the pre-

war racial status quo. In Parker's hands, the tune's lyric introduction became a moderately paced blues, slow enough to allow Davis to accompany Parker. But its melody, syncopated and snappy, provided the energy for a subsequent rock-and-roll covering. *Now's the Time* was greeted as an activist statement by a studio filled with admirers. The song equaled *Ko-Ko* in its musical ferocity, and its political stridency matched *Ko-Ko*'s claim of artistic independence from the music industry.[109] Together, they expressed the anger, pride, and determination of bebop.

In New York the original segregated system of recording, publishing, and performing had been loosely enforced as long as musicians respected the color line. In contrast, the New York Police Department (NYPD) adopted an aggressive policy that threatened the livelihood and civil rights of black jazz musicians. In 1931 the city had required the licensing of all cabarets—defined as clubs that both sold alcohol and offered entertainment. In 1940 the NYPD took over the licensing procedure and extended it to performers, requiring that all musicians be registered, fingerprinted, and given ID cards. The NYPD withheld the required cabaret card from anyone it deemed of bad character, which it largely defined as homosexual or in the possession of marijuana or heroin. Musicians found themselves hostages to a hostile and corrupt police department that used its licensing authority to harass and to silence militant black musicians.

The American Federation of Musicians Local 802, led by James C. Petrillo, was equally oppressive. The 802 leadership viewed black jazz musicians as "deviant and racially inferior."[110] In 1942, Petrillo ordered a recording ban, a strike by union members, against all recording studios, which had devastating effects on black jazz musicians. The union hoped to salvage the losses of hundreds of live-radio jobs to recordings by pressuring the record companies to pay royalties to a musicians' trust fund for every side played on radio or over a jukebox. To black jazz musicians, who depended on sales from the small jazz labels, the ban spelled financial disaster. Popular white swing bands, who enjoyed contracts with large record companies, had sufficient backlogs to release previously recorded music during the strike. Petrillo's ban prevented new jazz from being recorded, silencing bebop. The union sent its delegates through the city to assure compliance and to prevent illegal jams. Only Minton's position in the union exempted his club from the ban.[111]

The recording ban of 1942–44 had a dual effect. It seriously restricted the ability of musicians to make a living playing noncommercial esoteric jazz. At the same time, it drove them underground, freeing them to experiment. When the union lifted the ban in 1944 bebop reappeared, almost fully matured. After two years of silence, bebop's listeners heard a startlingly new jazz. The general public continued to dance to the big band swing of Benny Goodman and Glenn Miller, but the bebop "underground was years ahead."[112]

Bebop's black musicians had migrated to the city during the depression, blazing the way for the second Great Migration. By restoring the role of blues-based improvisation, these modern jazz revolutionaries insisted on receiving credit and maintaining control over their music and their careers. When Parker, Gillespie, Davis, Roach, and Russell recorded *Ko-Ko* in the late fall of 1945, they stepped out of their wartime obscurity into the postwar spotlight, much as other African Americans in-

sisted that the victory over fascism must be extended to segregation at home. With the end of the war and the recording ban, beboppers took their music and their attitude downtown to "the Street," opening a new era in New York music and race relations.

## THE STREET:
## BIRTH OF THE COOL

Bebop originated in the bars and after-hours clubs of Harlem during World War II. After 1944, residents of Harlem heard the pulse of the new jazz as it came from the loudspeakers, phonographs, and jukeboxes of their neighborhood. A young fan from Chicago recalled, "We didn't know the word bebop, but we knew they were different. We called it 'New York Jazz.'"[113] Urban in setting, modern in form, and vernacular in inspiration, bebop infused every performance with excitement and energy.[114] As Mezz Mezzrow, declared, "What a drag it must be for any musician with spirit to have to sit in a symphonic assembly line."[115] For four years the early bebop of Parker and Gillespie dominated New York jazz. But by 1949, Miles Davis and a younger cohort of classically trained, largely middle-class musicians challenged the ascendancy of Parker and Gillespie with "cool jazz." They did so not in Harlem but downtown, in the small cellar nightclubs along West 52d Street, known affectionately as "the Street."

The apartments in the brownstones that lined West 52d Street could be entered only from the second floor. In the space between stairway and house, builders had dug a lower entry to the below-ground first floor, just under the stairway, accessible by taking several steps down and turning left or right. In the cellars, marked by long, narrow awnings jutting out to the curb from the lower entrances, lay a warren of jazz clubs. During the depression, when middle-class residents of these brownstones moved away, an assortment of sign painters, private investigators, photographers, and piano teachers moved in.[116] The western end of the street housed two former speakeasies, the exclusive 21 Club and the Onyx, the jazz insider's nightspot. Because of their narrow width, the brownstone basement clubs could not accommodate the large swing bands. Instead, they booked bebop quartets and quintets. Kelley's Stables, the Hickory House, the Three Deuces, the Downbeat, and the Spotlight all catered to early bebop. Along with the Onyx and a Dixieland place, Jimmy Ryan's, these clubs made 52d Street the crossroads of New York jazz.[117]

Dizzy Gillespie dreamed of forming a big band to play bebop. In the summer of 1945, he left Parker in New York, formed his own band, the Hep-Stations, and embarked on a tour that included several dates in the South. The band dissolved after several racial incidents, but Gillespie returned to the big band format several times in the late 1940s, leaving Parker as the primary, and often helpless, organizer-leader of the bebop ensemble. In Gillespie's absence, Parker, who misplaced his horn as easily as his shirt, increasingly relied on his new protegé, nineteen-year-old Miles Davis, who gradually replaced Gillespie as Parker's musical confidant and collaborator.[118]

In 1944, Miles Dewey Davis secured his first professional job when he played

trumpet with the Billy Eckstine band in his home town of East St. Louis. Born in Alton, Illinois, in 1926 to a middle-class, college-educated, and musical family, Davis imbibed the Garveyite leanings of his dentist father and the musical talents of his mother. Proud of his family, which included a Harvard-educated uncle and a paternal grandfather who owned five hundred acres in Arkansas, Davis distinguished himself on the classical and jazz trumpet.[119] He sat in with Eckstine during the band's gig at the segregated Plantation Club in East St. Louis, where the management fired those band members, including Parker, who refused to enter through the rear entrance and instead walked through the whites-only front door. The short gig, however, convinced Davis that Parker played like no one he had ever heard.

A year later Davis passed his audition to Juilliard, rented a room for a dollar a day on Broadway and 147th Street, and set out to find Bird. He spent the next six months studying at Juilliard by day and at Minton's and Monroe's at night. Disdainful of the 52d Street scene and of white critics, Davis and Gillespie traded ideas on music theory. Davis discovered a book on Egyptian modes at the Juilliard library that he showed to Gillespie, who in turn explained his use of the flatted fifth, one of bop's harmonic trademarks.[120] Gillespie's erudition surprised Davis, whose middle-class education had led him to believe that working-class black musicians lacked formal theoretical training. Although at Juilliard Davis studied Stravinsky, Alban Berg, Prokofiev, and other contemporary classical composers, he found bebop more challenging.[121] Davis soon wrote to his father, "I'm quitting Juilliard because what they are teaching me is white and I'm not interested in that."[122]

For the next three years Davis worked in the clubs and small recording studios of midtown with the quintets organized by Parker. In July 1946, Parker suffered a drug-induced psychotic breakdown while performing in Los Angeles and spent the next seven months undergoing treatment in a state mental institution in Camarillo, California. In 1947, temporarily free of his addictions, Parker resumed playing with a new quintet that included Davis on trumpet.[123] Davis recalled that Parker's group simply did not indulge in "show business." The musicians thought of themselves as a self-contained unit playing for themselves. Private chatter, inside jokes, and gestures reinforced their distance from the audience, which, on 52d Street, had become increasingly white. Refusing to accept the role of entertainer, Davis played with his back to the audience. At times, he simply left the stage when others played. His arrogance expressed his contempt for commercial entertainment and his deep ambivalence about playing for whites. Wearing dark glasses, Davis projected the image of the black hipster—proud, defiant, and talented.

Davis did not sit quietly at his master's feet. Rebuffed when he urged Parker to include the young and experimentally inclined pianist John Lewis in the quintet, Davis expressed impatience with the formulaic nature of their music. Davis's aesthetic, closer to the phrasing of Lester Young than to the breakneck tempo of Parker and Gillespie, led him to conclude that "to play a note it has to sound good to me." He preferred playing "the most important notes in the chord, to break it up."[124] When critics noticed Davis as a player in his own right, he left Parker.[125] While Davis and Parker continued to play together on and off for the next year and a half, by the

summer of 1948 Davis's apprenticeship had come to an end. He had moved away from Parker's bebop.

In 1948 jazz entrepreneur Monte Kay, who had sponsored some of the organized jams on 52d Street in the mid-1940s, took over a chicken barbecue place on 47th and Broadway and transformed it into a jazz club, dubbed the Royal Roost. Kay cordoned off a no-drinking area to placate the police and court middle-class audiences. He invited disc jockey "Symphony" Sid Torin to broadcast live from the club on Tuesday nights. Kay's business acumen, particularly his exploitation of the radio, enabled modern jazz to overcome a second recording ban imposed for most of 1948. By 1949 several other clubs, including the historic Birdland, imitated the Royal Roost's policies and located on Broadway. When the Roost moved two blocks uptown, it rechristened itself Bop City. With cops "hanging from the ceiling," the new jazz clubs, featuring a ninety-cent cover charge, headlined bebop's best musicians, including Parker, Gillespie, Davis, Dexter Gordon, trombonist J. J. Johnson, and baritone saxophonist Gerry Mulligan.[126] Thanks to Sid Torin's remote broadcasts, New York jazz fans heard bebop despite the 1948 recording ban.

The ban upstaged the recording industry's most important technological change in a generation, the development of the long-playing microgroove record. Developed by Columbia Broadcasting System (CBS) in 1948, the LP revolutionized jazz. Together with the abandonment of the dance format in favor of the small club and then the concert hall, the LP allowed jazz musicians to duplicate the duration of the jam. No longer tied to the three-minute format dictated by the 78 rpm record, the new long-playing discs allowed jazz musicians to compose and record sustained improvisational performances. Owing to the difficulty of notating jazz, its published compositions had been limited by recording technology. With the LP, for the first time, jazz records resembled live jazz performances, much as a notated concerto resembled its concert performance.

The new possibility for jazz crystallized in Gil Evans' West 58th Street apartment. Evans' neighborhood, a foreboding collection of sooty apartments and wholesale warehouses, had little to boast of save its low rents and proximity to Carnegie Hall. Evans, a Toronto-born composer and arranger in his mid-thirties, occupied a one-room apartment on West 58th Street that became the "informal salon" of modern jazz.[127] Parker, ever on the lookout for places to crash, often stayed there, as did Davis and a younger circle of black and white musicians—John Lewis, Johnny Carisi, and Gerry Mulligan. As Evans recounted, "I just left the door open." Mulligan, a year younger than Davis, appeared and stayed, so poor that he left the apartment only to rehearse a pickup band in nearby Central Park.[128] Mulligan's musicianship included the saxophone and the piano, his original instrument.

Miles Davis enjoyed the stimulation provided by Evans and Mulligan. Through the summer of 1948 the Evans household argued about the best sound for a jazz band as Davis pondered the direction of his own work. In September 1948, Mulligan and Davis formed the core of a nonet, an innovative nine-piece jazz ensemble, which performed at the Royal Roost for two weeks. The Davis-led nonet played together for five months under cover of the second recording ban and did not set foot in a

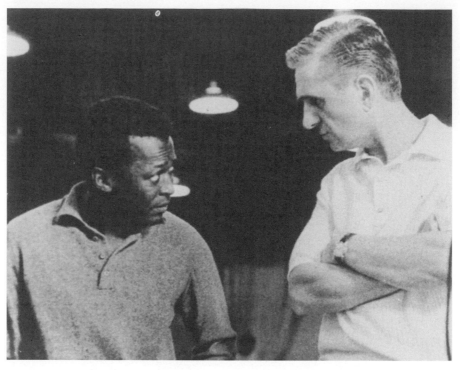

Birth of the Cool.
Miles Davis and
Gil Evans.
*Photograph ©Duncan*
*Schiedt Collection*

recording studio until January 1949, when they played the first of the three historic sessions that made up the *Birth of the Cool*.[129]

Evans, Davis, and Mulligan grafted big-band leader Claude Thornhill's "rich earthy sound," characterized by harmonic variety and subtlety, with the compositional ideas of Parker and Gillespie. Davis wanted to smooth out bebop's angularity and insistent aggressiveness, replacing it with a more mellow timbre and horizontal or narrative line. In addition, he hoped to restore the symphonic orchestral arrangements of Ellington and Henderson without losing the spontaneity of solo improvisation. Evans was ideally suited to the task. As Mulligan admiringly noted, Evans "can really notate a thing the way the soloist would blow it—the way they really sound."[130]

In the summer and fall of 1948, the nonet's salon-workshop, meeting first at Evans' apartment and then at the Royal Roost, led to the recording of *Birth of the Cool*. Jazz listeners accustomed to the raw power of the Parker-Gillespie bop style found the Davis-Evans music distant and unemotional. Music critics, however, especially John Wilson of the *New York Times,* who had earlier expressed open hostility to jazz, found much to praise. The neoclassical restraint and formal composition of cool jazz appealed to Wilson's preference for European concert music.[131] The addition of Gunther Schuller, who played French horn for the Metropolitan Opera, sealed the fusion between contemporary concert music and modern jazz, initiating a decade-long experimentation with what came to be called third-stream music.

Davis and Evans borrowed Thornhill's idea of using French horns and tubas to provide their jazz with the feel of a concert ensemble, blending features of the large

swing orchestra with the tightly articulated work of the bebop combo. Davis, Mulligan, and Evans wrangled for months before they came up with what they regarded as the ideal instrumentation for their chamber ensemble. The nonet included a classic jazz quintet of trumpet, sax, piano, drums, and bass together with a trombone, French horn, tuba, and second saxophone. Half the size of Thornhill's orchestra, the nonet allowed Davis to achieve the sound he desired without resorting to the cumbersome brass and reed sections of the traditional swing band.[132]

Davis recruited a core of musicians—John Lewis on piano and saxophonists Mulligan and Lee Konitz, who played for all three of the Capitol recording dates. Davis was criticized for choosing the smoothly mellow, and white, Konitz over Sonny Stitt, the saxophonist who played like Parker, but he set aside his racial anger in the face of musical talent. His long-term association with Evans and his close collaboration with Mulligan testified to modern jazz's transformation from the hard-edged revolution of Parker and Gillespie to the avant-garde compositions of Davis and Evans. In *Birth of the Cool,* Davis aimed for a smaller, softer music with "the voicing of a quartet" to lead his ensemble, weaving improvised solos into carefully arranged compositions by Evans, Mulligan, and John Lewis. In the spirit of the collective creativity that marked *Birth of the Cool,* Davis insisted that his arrangers receive formal credit. Although Capitol did not release the LP record of the *Birth of the Cool* until 1954, the dozen tunes Davis recorded in 1949–50 constituted a coherent whole. The new jazz of Davis-Evans-Mulligan slowed and smoothed the pace and drive of bebop without overthrowing its rhythmic, harmonic, and improvisational framework. It brought the harmonic color of Ellington and the velvet smoothness of Lester Young back into contemporary jazz.

*Birth of the Cool* illustrated the contradictions that characterized Miles Davis. A physically intimidating man who had trained as a boxer, Davis played a warm intimate trumpet. He accepted white colleagues into his band even as he railed against the tendency of producers to make his lyrical music too white.[133] In *Birth of the Cool,* Davis and Evans composed a jazz accessible to white audiences, avoiding the appearance of mysteriously complex esoteric harmonic references; yet they used instruments, like the French horn, to "create a dissonant effect . . . arising from timber rather than harmony."[134] Jazz inspired, middle class in its refinement, *Birth of the Cool* combined the raw working-class energy of Parker and Gillespie with the classical training and elegance of Davis and Evans.

The Davis-Evans experiment, thanks to the second recording ban, had been produced in virtual privacy. Silenced first by the recording ban and then by its own adventurousness, Davis's nonet opened the way for several new developments. The so-called cool, or West Coast, jazz of Mulligan, Konitz, and Lenny Tristano as well as the classically inspired work of John Lewis, Gunther Schuller, and the Modern Jazz Quartet drew directly on the Davis-Evans collaboration. Davis's career fell into disorder between 1950 and his recovery from drug addiction in 1954. After his recovery Davis, along with John Coltrane and Thelonious Monk, initiated a third phase of modern jazz, returning once again to the blues.

Davis's break with Parker had coincided with other changes on the Street. In 1948, the New York City police department and its narcotics unit cracked down on drug

use associated with the jazz clubs. Many of the clubs went under, forced out of business, or reopened as strip joints.[135] Only the Onyx and Three Deuces survived as jazz clubs. The decline of jazz on 52d Street did not mean the end of postwar jazz in New York. Rather, it was part of a decade-long migration of New York jazz, from Harlem to 52d Street and then to Greenwich Village, from racial exile to public recognition and then to avant-garde engagement.

## 'ROUND ABOUT MIDNIGHT: DAVIS, MONK, AND COLTRANE

The five years between the third nonet recording session in 1950 and the death of Charlie Parker in 1955 coincided with desperate years in American politics. The silencing of dissent reached its height under McCarthyism. In this context, New York postwar jazz underwent several critical changes. Its dominant stars, Davis, Parker, and Monk, were persecuted and silenced by the combination of substance abuse, suspected or actual, and the zealous enforcement of drug laws. Self-destructiveness and circumstances brought bebop to a halt. Modern jazz had lost its vitality, its performers out of date and out of ideas. Remarkably, after Parker's death in 1955, John Coltrane and a rejuvenated Miles Davis, along with Thelonious Monk, revived modern jazz, bringing it to full flower in Greenwich Village.

The revival of bebop at mid-decade belonged to the city. But its inner emotional intensity also appealed to the sense of exile, originally provoked by McCarthyism and sustained by the middle-class conventionality of the Eisenhower years. The coalition of black and white liberals, students, and activists who organized the Congress of Racial Equality (CORE) in the late 1950s, buoyed by the *Brown v. Board of Education* decision of 1954, found in the music of Miles Davis, Thelonious Monk, and John Coltrane an allied spirit. At the end of the decade jazz resurfaced in Greenwich Village, joining the internal exile of other New York avant-garde arts during what journalist I. F. Stone called the "haunted fifties."

Heirs to the same tradition, Davis and Gillespie stood at arm's length during the 1950s. Gillespie directed his anger inward, toward his music, whereas Davis projected it out to his audience and friends. By the 1950s, Davis had learned painfully that illegal drug use spelled disaster. New York police associated unorthodox lifestyles with subversive politics. Two of jazz's most politically outspoken artists, Charlie Parker and Billie Holiday, found their careers destroyed by a combination of judicial, political, and police persecution. Parker was denied the permit to play in public because of his drug dependency, even though most other jazz musicians also used illegal drugs, and Holiday was sent to prison for a year following her drug conviction in 1947.

Thelonious Monk lost his cabaret card in 1951 when police found narcotics in a car in which he was a passenger. When Monk refused to inform on Bud Powell, the police denied Monk, who did not use drugs himself, a cabaret card for six years. Only the intervention of several prominent white jazz critics, the American Civil Liberties Union (ACLU), and the jazz patroness Pannonica de Koenigswarter enabled Monk to recover his card. Following a prison term of sixty days, he still refused to

leave New York—"This is my city," he proclaimed. Like Davis and Parker, Monk was silenced in the early 1950s only to resurface when Riverside record executive Orrin Keepnews bought his contract for $108.27. Monk's 1957 engagement at the Five Spot, an artists' hangout in the Village, with a group that featured John Coltrane finally brought him musical celebrity.[136]

The three jazz artists who redefined jazz in the mid-1950s did so as idiosyncratic individuals who stood apart from the conformist consumer culture of the decade. Davis, Monk, and John Coltrane created jazz that transcended entrenched racial and social categories, ending the racial barrier that had historically divided New York's avant-garde. Despite their differences, between 1955 and 1960 these three African American musicians found themselves and their music inextricably connected.

Miles Davis, whose addiction to heroin had forced him into seclusion punctuated by sporadic recording and performing dates, broke free of his addiction through an act of supreme will power. Sinewy and irascible, Davis went cold turkey, sweating out an agonizing withdrawal that had reclaimed his music. In 1955, Davis appeared at the Newport Jazz Festival announcing his return. He played Monk's widely acknowledged bop masterpiece, 'Round about Midnight. His choice, a ballad Monk had written in the 1940s, reestablished Davis's musical base. He returned to his version of bebop—less frantic, carefully formed, and personally expressive.

Two years later Davis used the Monk tune as the lead song in his first album with Columbia. 'Round Midnight confirmed Davis's status as a major jazz musician and acknowledged his quintet—Philly Joe Jones, Paul Chambers, Red Garland, and John Coltrane—as one of the premier groups of the modern jazz era. Singly and together these members of the Davis quintet played a hard-edged, classic form of bebop, daringly improvisational, rhythmically sophisticated, emotionally intense. On a series of records between 1955 and 1958, first for Prestige and then for Columbia, Davis elaborated the simplicity of style and line that he had pioneered with Birth of the Cool, reviving the music of Parker and Gillespie but doing so on his own terms. He had taken the compression of bebop, the jagged mountains of notes peaked by the incredible speed of their delivery, and stretched them out along a simpler melodic line. His quintet, balanced between the melodic inventiveness of Davis and the boiling harmonic energy of John Coltrane, gave New York the best jazz of the decade.

Thelonious Monk's obscurity ended in 1957 when he took a quartet into the Five Spot Café. An abstract expressionist hangout on Cooper Square, the intersection of the East and West Villages, the Five Spot sponsored regular jam sessions for neighborhood musicians. Owner Joe Termini had recently adopted a jazz format and invited Monk to form a group that included a relatively unknown tenor sax player, John Coltrane, who had played with Davis. The Monk quartet stayed at the Five Spot for several months, enabling Monk to perform the music he had written over the previous ten years and thus to establish his reputation beyond New York's tightly knit jazz community.

Monk's stay at the Five Spot and his records for Riverside in the late 1950s resurrected his reputation. His composition Straight, No Chaser incorporated much of Monk's originality. Taken from a blues format, Straight, No Chaser offered listeners

a new jazz sound that combined urban blues and modernist composition with fragments of popular music. Bebop's second generation moved New York jazz from 52d Street to the bohemian confines of Greenwich Village, where their audiences treated them as artists, not entertainers. As full-fledged members of New York's avantgarde, however, Davis and Monk risked losing the vitality of the blues. Distant from Harlem, John Coltrane returned postwar New York jazz to its African American roots.

Coltrane grew up in a musical household. Following the death of his father in 1939, Coltrane moved with his mother to Philadelphia, where he studied music at several conservatories, mastering the alto saxophone and the clarinet.[137] For a decade Coltrane lived as a journeyman musician, playing the tenor as well as alto sax for several bands, including that of Dizzy Gillespie, who fired him because of his drug and alcohol dependency. Unable to secure a stable, long-term job because of the decline of bebop, Coltrane turned to the transient world of rhythm and blues, playing with Eddie "Cleanhead" Vinson, Bull Moose Jackson, and Big Maybelle. Coltrane refused, however, to walk the bar, to strut and wail, feet at drink level as patrons pounded their fists along the rail.[138] Still, the experience gave his music the rough and raunchy sound of blues, which he extended into complex harmonic structures.

Coltrane was hired in 1955 by Davis, who prided himself on finding a new talent previously overlooked by critics. Coltrane's big sound, extroverted and incessant, fit Davis's style and mood. But Davis could not tolerate Coltrane's disheveled absenteeism and dismissed him from the quintet in the spring of 1957. Coltrane then joined Monk for the stint at the Five Spot. In collaborating with Monk, he recovered a sense of spiritual renewal. The grandson of a minister, whose childhood home had been filled with books, music, and religion, Coltrane wrote that he "experienced, by the grace of God, a spiritual awakening."[139]

Monk's harmonic and rhythmic originality, his technical and theoretical command, meshed with Coltrane's search for spiritual meaning. Coltrane reached back to his academic training and drew from it a new harmonic approach to jazz. Playing what critics dubbed "sheets of sound," Coltrane's spurts of broken scales and spiked and ragged arpeggios, jumping up and down with astonishing speed, gave his music a sense of notes escaping "the gravity of tonality."[140] The sense of liberation, of upward movement, pushed Coltrane to expand the temporal structure of postwar jazz. In the innovative *Milestones* and *My Favorite Things,* Coltrane brought the extended jam session of after-hours bars and Greenwich Village coffeehouses to the commercial and concert format.

The 1958 recording of *Two-Bass Hit,* on the album *Milestones,* embodied the diverse and elastic nature of modern jazz pioneered by Davis and Coltrane. *Two-Bass Hit* opened with a short thematic statement. Typical of bebop, the trumpet-sax theme demonstrated the artistic cohesion of the group, and its mood, light and brassy, harked back to Davis's "cool" origins. The relatively straightforward thematic content masked the supporting rhythmic and then harmonic counterpoint. Coltrane and Davis's precision gave the piece a neoclassical feel as it gave way to an extended Coltrane solo. By the time Davis rejoined the piece, Coltrane had discarded its opening harmonic conventions as the two musicians engaged in a modal

dialogue.[141] No longer running the changes, Davis and Coltrane substituted a sequence of modal scales. Their departure retained its connection to the original piece, and in true bebop style, the two guided the last bars of the music back to the original thematic statement. Without agreeing, in *Two-Bass Hit,* Coltrane and Davis listened and spoke to one another, creating a musical dialogue that went beyond their individual voices—the musical substance of New York Modern.

Experimental and avant-garde, *Two-Bass Hit* led Coltrane a year later to his soprano saxophone classic, *My Favorite Things.* A thirteen-minute and then thirty-minute improvisation on the Rodgers and Hammerstein song from *The Sound of Music,* it became Coltrane's first significant commercial success, earning him more than a hundred thousand dollars. By appropriating one of Broadway's most popular songs, Coltrane fulfilled several of bebop's objectives. It was no longer necessary to cite brief, cute, or ironic references to popular music within the abstraction of improvisation. Insisting on the primacy of his highly intricate and theoretical interpretation, Coltrane insured his authorship of a new form of chamber music, which demanded his audience's full attention. In reworking popular music on their own terms, postwar jazz musicians replaced Tin Pan Alley's clichés with challenging and innovative music that expressed the traumas and confusion of postwar America. Drawing on

Blowing. The John Coltrane Quartet. Coltrane on alto and soprano sax, McCoy Tyner on piano, and Elvin Jones on drums. *Photograph ©Duncan Schiedt Collection*

African American blues, bebop participated in the reconstitution of postwar America, bridging the divide between white and black America and creating an adventuresome new urban sound free of political dogma, commercial compromise, and popular convention.

In the 1950s bebop belonged to the rebels, the bohemians, and the artists who found kinship with the music and its legend. In the context of the Cold War, McCarthyism, and middle-class conventionality, bebop offered a radically different beat, affirmed a radically different culture, and envisioned a radically different world. Allen Ginsberg's juxtaposition of "negro streets" and "angel headed hipsters" in his poem *Howl* established the beat generation's identification with the outlawed jazz musician. The self-styled hipsters of the 1950s found in both the angrily tragic Charlie Parker and the coolly indifferent Miles Davis variants of their own behavior. In Greenwich Village, at the Café Bohemia and the Village Vanguard and, later, at the Five Spot on Cooper Square, beat poets, abstract artists, and hip college students in black turtlenecks assembled, listened, and debated their distress all night. Davis, turning his back, explained that no one expected Rostropovich to warm up his audience, and "I ain't no Uncle Tom just to be up there grinning." Far from taking offense, his hip white audience applauded.[142]

In Greenwich Village, poet Frank O'Hara penned *The Day Lady Died* in homage to Billie Holiday, and Ginsberg likened *Howl* to the movement of Lester Young, "each verse being like a little saxophone chorus."[143] Abstract expressionist painter Larry Rivers played a jazz saxophone, and Jack Kerouac read poetry and Ginsberg chanted mantras to jazz accompaniments at the Village Vanguard. In the late 1950s, Miles Davis, Thelonious Monk, and John Coltrane saw their music reach new audiences, discovering that white artists and intellectuals, as well as middle-class blacks, embraced modern jazz both for its cultural message and its music. Abstract painter Jackson Pollock found bebop's speed and jarring harmony an apt analogue to his own work. Indeed, the postwar jazz of Parker, Gillespie, Clarke, Monk, and Coltrane anticipated the artistic and political concerns that New York's abstract expressionists explored visually in their equally revolutionary painting. Bebop did not just link Harlem to Greenwich Village; during World War II, it bridged the political and social engagement of the 1930s and the abstract alienation of the 1950s.

# Homage to the Spanish Republic
## Abstract Expressionism and the New York Avant-Garde

In 1949, *Life* magazine photographed Jackson Pollock posed in front of his massive *Number Twelve* and proclaimed him the nation's greatest painter. Brandoesque in appearance, Pollock wore a rebel's cloak as he stared, tight-lipped, at the camera. Two years later, *Life* published an even more famous photograph, *The Irascibles,* a group portrait of eighteen New York abstract expressionists protesting the antimodernist acquisition policy of the Metropolitan Museum of Art. With Pollock at their center, the Irascibles glared at their audience. Pollock, the tragic and Byronic artist of the century, stood with New York's other abstract painters assembled in his presence. The photograph depicted a group of middle-aged tweedy males. A single female artist, Hedda Sterne, had been included. In jackets and ties and well-polished shoes, the male painters looked like college professors, self-confident and recognized artists.

*Life* photographer Nina Leen posed Robert Motherwell sedately to Pollock's left, next to Clifford Still. Comfortable and attentive, the thirty-nine-year-old Motherwell had painted and taught at the center of abstract expressionism since 1947. Together, Motherwell and Pollock served as the intellectual and charismatic touchstones for abstract expressionism, whose triumph critic Clement Greenberg linked to American international supremacy. In truth, abstract expressionists, along with other members of New York's postwar avant-garde, rejected Cold War politics, and they vigorously defended their personal and political independence. In bars and taverns, discussion groups and intellectual brawls, the abstract expressionists breathed new life into the city's visual arts and brought to New York the excitement and experimentation of prewar Paris.

Abstract expressionism, like bebop, was rooted in World War II. Abstract expressionists began their careers in the 1930s, schooled in the ideas of John Dewey and trained in the American scene. With the outbreak of World War II and the arrival of refugee European surrealists, the rising generation of New York artists

*The Irascibles* (1951). Left to right, top row: Willem de Kooning, Adolph Gottlieb, Ad Reinhardt, Hedda Sterne; middle row: Richard Pousette-Dart, William Baziotes, Jackson Pollock, Clifford Still, Robert Motherwell, Bradley Tomlin; bottom row: Theodore Stamos, Jimmy Ernst, Barnett Newman, James Brooks, Mark Rothko. *Photograph by Nina Leen,* Life ©*Time Inc.*

spurned the American scene and the overt political commitments of the 1930s social realists. Yet, despite efforts, primarily by Clement Greenberg, to cast abstract expressionists as "pure painters" whose subject was art itself, most accepted Adolph Gottlieb's characterization that "abstraction . . . is the realism of our times." Abstract expressionists embraced the realist commitment to paint modern life in all its shapes, hues, tones, and tensions. Abstraction provided an evocative and symbolic vocabulary that artists used to express their apocalyptic era—a fundamentally new world defined by world war, the Holocaust, and atomic destruction. By the early 1950s, abstract expressionists, along with beat poets and writers and postwar jazz musicians, formed a new American avant-garde as heirs to both the Greenwich Village rebellion and the bohemianism of the prewar Parisian Left Bank.

Like modern jazz musicians, New York's abstract expressionists borrowed from and broke with their artistic predecessors. Highly individual, emotionally intense, rhythmically gestural, and intellectually honed, abstract expressionists abandoned the narrative, the representational, and the particular to explore the unconscious, the archetypical, and the universal. At a time when few willingly addressed the tragedies of World War II and the horrors of Dachau and Hiroshima, abstract expressionists confronted them directly. Finding visual realism too literal to commu-

nicate their sense of horror and sublime, New York's abstract expressionists resorted to radically nonrepresentational images. Jackson Pollock, William Baziotes, and Robert Motherwell all considered themselves heirs to the School of Paris. Yet, these successors to Picasso and Matisse also remained children of America, shaped by the politics and art of the 1930s. Moreover, they did not work or live for long in artistic isolation. They took part in an avant-garde movement that included jazz musicians, writers, poets, dancers, and composers who collectively established New York Modern's postwar preeminence. When *Life* featured Pollock and the Irascibles in 1951, the magazine proclaimed New York's eclipse of Europe, not just by the Marshall Plan and the North Atlantic Treaty Organization but also by New York's artistic avantgarde—two inherently opposing forces.[1]

## ART AND KITSCH:
## THE HERITAGE OF THE 1930S

New York's return to prosperity and international dominance allowed it to claim its place as the great world city of the Cold War era. Imperially proud, economically powerful, and culturally commanding, New York proudly displayed its importance. The New York School of painting, as abstract expressionism came to be called, symbolized for some the triumph of a radically introverted art divorced from experience. But in fact, like postwar movements in jazz and drama, abstract expressionism—the visual representation of New York Modern—remained anchored in the political and artistic heritage of the 1930s.

A number of abstract expressionists, influenced by the exiled surrealists who fled Paris in 1940, served their artistic apprenticeships in the 1930s under the auspices of the Federal Arts Project, including Pollock, Baziotes, Ad Reinhardt, Adolph Gottlieb, and Lee Krasner. Although these painters later rejected the representational realism of the American scene, they retained the political and social concerns of the New Deal and the FAP. The New York component of the FAP had never enforced an aesthetic orthodoxy. Alongside the dominant style of the American scene, the Federal Arts Project in New York nurtured the work of a younger generation of abstract painters—Ilya Bolotowsky, Byron Browne, and Arshile Gorky—who had been influenced by John Marin, Marsden Hartley, and Georgia O'Keeffe.

"It is our conviction," declared Holger Cahill, director of the Federal Arts Project, "that . . . we will move toward the life 'of free and enriching communion' envisioned by John Dewey as an ideal for American democracy."[2] The Federal Arts Project upheld, as did no other cultural program of the New Deal, the diversity implicit in Dewey's instrumental pragmatism. Neither Dewey nor Cahill expressed sorrow at the decline of academic art; they preferred a "democratic sharing of the art experience," a national art that no longer trailed the "clouds of vanished aristocratic glories."[3] Both wanted art to deal with life, demystified of the critical folderol that made it inaccessible to a democratic public. No single style or mode, they believed, could claim aesthetic hegemony over the variety of human voices that sought artistic expression.

In contrast with the early PWAP and the Treasury Department's Section of Paint-

ing and Sculpture, Holger Cahill's Federal Arts Project never enforced a single, exclusive vision of American art. Like Dewey, Cahill wanted to clarify the connection between "art and daily life."[4] A democratic pluralist, he believed that great artistic work would emerge from the mass of artists who found dignity and employment in the Federal Arts Project.[5] Between 1935 and 1943, the Federal Arts Project of the WPA produced 2,500 murals, 108,000 easel paintings, 18,000 sculptures, and more than 2 million prints and silkscreen posters. At its peak in 1936, the FAP employed more than five thousand artists nationally, 40 percent of them in New York City.[6] Organized like the PWAP, the FAP permitted 10 percent of its employees to participate as nonrelief workers. The New York City regional office paid its project artists one hundred dollars a month for a specified output of work. Project supervisors normally allowed four weeks for the completion of a 20″ × 30″ oil painting.[7]

Burgoyne Diller, an abstractionist who studied with Hans Hofmann, directed two major New York FAP mural projects. Diller assigned abstractionists Ilya Bolotowsky, Stuart Davis, Byron Browne, and Willem de Kooning to execute a series of murals, reliefs, and sculptures for the Williamsburg Houses, a low-income project in Brooklyn. Arguing that the artists had an obligation "to stimulate rather than restrict the direction of painting," Diller endorsed the project's goal of making art accessible to a broad public; yet he believed that workers needed more than images of factories and city streets at the end of a long working day.[8] Of the Williamsburg murals, Stuart Davis's *Swing Landscape* was "the Federal Arts Project's most outstanding public-scale abstract work." Cubist inspired and jazzy in spirit and title, Davis's mural hailed the exuberant culture of the city, its bridges and roadways, beaches and apartments.[9] Painted on a large, 86″ × 173″ canvas, *Swing Landscape* exhibited Davis's blend of social commentary, modernist aesthetics, and love for American jazz.

Diller also supervised Arshile Gorky's ten-panel mural series, *Aviation: Evolution of Forms under Aerodynamic Limitations,* painted for Newark Airport. Gorky employed the modernist images of Léger and Davis in an exploration of the rhythms and symbols of contemporary technological civilization. Gorky wrote for his entry in *Art for the Millions,* "I dissected an airplane into its constituent parts . . . to invent within a given wall space plastic symbols of aviation . . . in order to impress upon the spectator the miraculous new vision of our time."[10] When confronted with the political hostility of a handful of congressional critics who accused Gorky of planting a "suspicious" red star in one of the panels, he and Diller refused to alter the murals, earning the support of many of the employees of the airport. Their victory, however, proved short lived. During World War II, when the Army assumed operational control over the airport, the murals disappeared.[11]

The New York FAP easel division, which employed artists to work in their own studios, hired Reinhardt, Mark Rothko, Gottlieb, and Krasner. While employed by the FAP they organized the Ten, an association of abstract artists, precursors of abstract expressionism. Lee Krasner had studied with Hans Hofmann and painted geometrical cubist compositions. From 1934 through 1942, she labored in various divisions of the FAP, becoming a supervisor of the War Services Division window display project.[12] Krasner, along with Willem de Kooning, joined the radical Artists' Union in 1934–35.

The Nazi-Soviet nonaggression pact signed in the summer of 1939 severed the explicit ties between artistic and political experimentation. Gottlieb, Rothko, and critic-historian Meyer Schapiro withdrew from the American Artists' Congress in November 1939 when it refused to criticize the Soviet Union's invasion of Finland. They formed the American Federation of Painters and Sculptors, declaring their independence from politics, by which they, of course, meant the Communist Party.[13] As self-declared critics of Nazism and Stalinism, the federation leaders defended artistic freedom against political extremism. For many anti-Stalinist Marxists, the *Partisan Review* posed an alternative to an outmoded Popular Front. Independent leftists, who considered themselves progressive intellectuals and anti-Stalinists, gravitated towards the *Partisan Review*'s critical Trotskyism, which linked artistic experimentalism with antiauthoritarian radicalism or, in the words of its editors, Marxism and modernism.

Clement Greenberg's "Avant-Garde and Kitsch," published by *Partisan Review* in 1939, sounded the opening round in a bout that engaged New York artists and intellectuals for the next generation. Positing the superiority of a supposedly apolitical modernism, Greenberg sought to divorce art from left-wing politics. He declared fine art and mass culture irreconcilable. Labeling working-class and popular culture "kitsch," he urged artists to turn their backs on all popular influences that debased art. Mistrustful of Marxian proletarianism and democratic culture, Greenberg instructed the avant-garde to isolate themselves from society and to make art itself their subject.[14] Greenberg defined the avant-garde as the embodiment of a "superior consciousness," arguing that, in the 1930s, artists had abandoned that critical consciousness in favor of political orthodoxies and popular taste. To remain pure, to sustain their superior consciousness, the avant-garde had to liberate themselves from their "motionless" subservience to politics and society. A purified, isolated avant-garde would discover "independent" truths in abstraction. They must reject representational art and social concerns and, instead, "define their chief inspiration from the medium they work in."[15]

Educated in the radical circles that congregated on the street corners of Union Square and in the alcoves of the City College dining halls, Greenberg had earlier proclaimed his dedication to socialist art and culture.[16] But the events of the late 1930s, especially the revelations of the Stalin trials, convinced him that the enemy of avant-garde creativity lay hidden in what he called the rear garde, the culture of "kitsch." Contemporary "popular commercial art and literature with their chromotypes, magazine covers, illustrations, ads, slick and pulp fiction, comics, Tin Pan alley music, tap dancing, Hollywood movies" represented "debased [and] mechanical" culture.[17] Mass literacy and the need for urban diversion produced a popular culture, or *kitsch,* which in turn degenerated into the "official" art in the Soviet Union and Nazi Germany because it was the "culture of the masses."[18] Greenberg's deepening mistrust of popular culture set him at odds with Holger Cahill's FAP. Greenberg argued that modern American painting should divorce itself from popular culture, turn away from the world of shared experience, and make art the subject of art.

In the early 1930s, Greenberg had befriended modernist Hans Hofmann, who opened his American school in New York in 1934.[19] Hofmann arrived in New York

in 1932, having taught and painted in Paris and Munich for two decades. He had worked with the major figures in modern European art and considered himself heir to the cubist revolution. First at the Art Students League and then at his own schools on 57th Street and in Provincetown, Hofmann taught as a modernist but was not an art-for-art's-sake aesthete. Objects, he insisted, existed in negative space. The task of the modern artist was to translate spatial tensions as they appeared in nature into abstract pictorial relationships. Hofmann assumed the contingent nature of modern existence. "Life," he wrote, "does not exist without movement and movement does not exist without life."[20]

In technical terms Hofmann's intellectualized modernism focused on maintaining the two-dimensionality of the picture surface while depicting depth not as an illusion but as an inherent property of abstract painting.[21] Hofmann taught that through the use of color and form, the legacies of Matisse and Picasso, painters could "produce the perception of space and volume."[22] Hofmann abandoned illusionism while affirming nature and reality. But as an abstractionist, he wanted painting to stand for itself, not simply imitate the material world.[23] Hofmann's intellectualized painting courses found an eager audience. As a disciple of Hofmann's eclectic blend of metaphysical and formalistic aesthetics, Clement Greenberg endorsed Hofmann's effort to establish the artistic "autonomy" of painting.[24]

Lee Krasner, like Greenberg the child of Jewish immigrant parents, also studied with Hofmann. "I learned the rudiments of cubism in Hofmann's classes," she recalled. Hofmann appeared twice weekly to critique his students' work, and each week one of these sessions was followed by a public lecture. At one of the public sessions Krasner learned Hofmann's principle that modern art could grapple with the question of illusionism without returning to representation—that "the two-dimensional surface had to be punctured and then brought back to two-dimensionality again."[25] In 1935, Krasner joined the New York FAP, where, with Harold Rosenberg, she painted clowns for a children's hospital before assisting on Gorky's Newark Airport murals. An activist in the Artists' Union and an abstract painter in her own right, Krasner found no inconsistency between her art and political militancy.

Not until after World War II did the significance of Greenberg's abstractionist aesthetics become apparent. In 1943, Greenberg identified the as yet unknown Jackson Pollock as a painter who shared Greenberg's understanding of avant-garde art and the true heir to the cubist revolution. Art rode the crest of history, and abstract painting was the fulfillment of aesthetic history. Through a superior consciousness expressed in highly abstract art, the avant-garde created cultural consciousness.[26] In the wake of American military triumph Greenberg proclaimed the dual victory of American art and politics—each had made the other possible. American abstract painting was created in a society where "there was no need for political change." In turn, American dominance negated the necessity of a socially engaged art. The avant-garde could create consciousness through transcendent art only when it avoided politics.[27] In Pollock's postwar drip painting, Greenberg discovered a "*maître* in a class by himself." To ignore Pollock's stature as the "best painter of a whole generation" was to reduce American art to its provincial origins at the moment of its triumph.[28] Despite Greenberg's public profile, few New York abstract expres-

sionists accepted his political judgment. Most believed that World War II, the Holocaust, and the atomic standoff, far from signifying the triumph of democratic humanism, portended an age of darkness. Explained sculptor Seymour Lipton, "The war was all around you. You couldn't get away from it."[29]

## IMAGES OF HORROR

Robert Motherwell challenged Greenberg's effort to deradicalize modern art.[30] In concert with painter William Baziotes and critic Harold Rosenberg, Motherwell advocated social and intellectual engagement. Between 1939 and 1945, Motherwell and William Baziotes, influenced by the surrealist community in New York, shaped postwar abstract expressionism. Together with Jackson Pollock, Lee Krasner, Adolph Gottlieb, Mark Rothko, and Barnett Newman, Motherwell and Baziotes formed a new generation of New York avant-garde painters. Their paintings, particularly the wartime works of Gottlieb, Newman, and Rothko, underlined the importance of contemporary subject matter—the shattering experience of World War II and its unprecedented human cruelty—within the universalizing and esoteric vocabulary of abstract art.

"The future in America is hopeless," Motherwell wrote to his friend William Baziotes from Amagansett, Long Island, on the last Labor Day of the war. "For you as for me, there are only two possible courses, to go to France forever (which is what I am going to do) or remain here and be psycho-analyzed."[31] Motherwell, a California banker's son, and Baziotes, a child of Greek immigrants, had known each other since 1940. Baziotes, "short, a little stocky, with an oval face and dark . . . hair," arrived in New York in August 1933. A detective he had met at a restaurant on 14th Street told him about the free tuition at the National Academy of Design. Baziotes, who had been kicked out of high school, boxed, and he read eclectically—"Freud and Will Durant. Self-help. How to take a bath. The Japanese philosophy of physical culture," followed by the modernist French poets, Baudelaire, Mallarmé, and Rimbaud. He recalled, "Art came in like a growth. . . . I had to do it."[32]

After three years of study Baziotes left the National Academy and joined the WPA/FAP to teach at the Queens Children's Museum and later at the easel division, where he painted "some [abstract] canvases that weren't so good."[33] Still, Baziotes' early abstract work, much of it in watercolor, employed a "violent vocabulary of form and color" derived from Picasso's cubism. The appearance of *Guernica* at the Valentine Gallery in 1938 and at MoMA in 1939 moved him further towards abstraction.[34] Picasso used monochromes and myth to express the horrors of the Nazi bombing of a Basque town and combined elements of religious and psychological symbolism to capture the torment and drama of the Spanish Civil War. *Guernica* all too vividly demonstrated the limitation of representational art to express modern experience. Abstraction enabled artists to communicate more fully the horror of the modern world.[35]

In the summer of 1941, Baziotes' wife, Ethel, bumped into Robert Motherwell and the Chilean surrealist artist Roberto Matta in the subway. Matta urged Motherwell and Baziotes to get to know each other, even though Motherwell had paint-

ed seriously for only two years. As Motherwell recalled, Matta asked, "Are there any guys on the WPA who are interested in modern art and not in all that social realist crap?"[36]

Motherwell and Baziotes, along with Jackson Pollock, constituted the core of New York painters who responded to Matta's question. Between 1940 and 1945 they worked with an older cohort of European modern artists, mostly surrealists, exploring automatic drawing and the Jungian concept of a collective universal unconscious. These abstract expressionists spent the war years at home, working in their studios in the East Village, writing, painting, and talking. They gathered informally at Stewart's Cafeteria and the Cedar Tavern to discuss their art. Later, summer forays to eastern Long Island gave new impetus to their discussions. The bars and grills of Greenwich Village no longer echoed with slogans deriding "social fascism" or promoting "proletarian culture"; still, these young veterans of the depression and the Federal Arts Project craved the camaraderie of the John Reed Clubs and the Artists' Union.

Roberto Matta Echaurren had migrated from Chile in 1934, at the age of twenty-five, to Paris, where he worked in the architectural office of Le Corbusier. In the late 1930s, André Breton introduced Matta to his surrealist circle, which included Miró, René Magritte, and Picasso. Younger than his European counterparts, linguistically adept and energetic, Matta represented the émigré European modernists on their arrival in New York in 1940–41. Along with the theoretician John Graham, Matta provided a European education to his American colleagues, especially those no longer interested in social realism.

Following the fall of France in June 1940, the remnants of Parisian modernism fled to New York. Matta, Marc Chagall, Salvador Dalí, André Breton, Max Ernst, and Piet Mondrian, along with dozens of social scientists and writers, brought to New York the political and social habits of Paris.[37] In the early 1940s, however, their mood was one of despair. Echoing Motherwell's cry that "the future is hopeless," Adolph Gottlieb took courage from the exiles' example and declared, "The situation was so bad that I now felt free to try anything."[38]

Although New York artists had been aware of surrealists since Alfred Barr's 1936 MoMA show, their arrival, complete with costumes, journals, balls, and manifestos, proved alluring. Motherwell described the surrealists as "the most lively group of artists around." Matta had an especially "catalytic effect" on Motherwell. In 1941, Matta and Motherwell spent three months together in Mexico.[39] The social revolutionary work of Diego Rivera, José Orozco, and David Siqueiros had inspired the original federal arts programs, and now the surrealists discovered in the Mexican artists the combination of political independence and internationalism they prized. In 1938, André Breton, the most politically active of the Paris surrealists, visited Mexico to confer with Rivera and the exiled Leon Trotsky. Breton found Trotsky committed to the idea already "discovered" by Clement Greenberg: that revolutionary art had to remain free from political dogma even as it played the role of cultural emancipator. With Rivera, Breton issued a manifesto proclaiming art at once revolutionary and independent.[40] In New York, Breton reconvened his group of artists in exile and joined the Free France political network operating in the city.

Motherwell, who was to become the surrealists' most important American conduit and translator, returned to New York convinced of the need for a second *Armory Show.* He and Baziotes talked heatedly about the influence exerted by Matta and the surrealists. In 1942, Motherwell recalled that he "as the theoretician, and Baziotes as a friend of the artist," had decided to "explain all of this" to their American colleagues. Motherwell and Baziotes believed that they had stumbled onto something revolutionary. In the months just after Pearl Harbor, working in isolation, they approached Jackson Pollock.

Pollock, exempt from the draft on psychiatric grounds, had already moved to the fringe of the nascent abstract expressionist community in New York, where he knew and worked with de Kooning, Gorky, and then Baziotes. Pollock had apprenticed with Thomas Hart Benton at the Art Students League, the FAP, and the Artists' Union, and his need for recognition stood in conflict with his streak of isolated self-destructiveness. Fueled by alcoholism, anger, and rage, Pollock had engaged a series of Jungian analysts.[41] Pollock's lifelong attempt to bring his personal demons under control led to alternating bouts of creativity and despair.

By 1942, Pollock had discovered surrealism.[42] An admirer of Miró and Picasso, Pollock combined their ideas with his Jungian interpretation of archetypes and myths in his painting *Moon Woman,* after Picasso's *Seated Woman.* In *Moon Woman,* a depiction of a modern war goddess, Pollock examined female sexuality, investing his image with frightening power. The painting drew on the violence inherent in Pollock's inner struggle and reflected his effort to universalize the conflict of world war through "mythic imagery."[43]

Pollock listened carefully to Baziotes, who introduced him to Motherwell and Matta. For five hours they explained the meaning and significance of automatic writing. A second visit with Pollock led to further discussions with Lee Krasner, who in turn arranged for Motherwell to meet Hans Hofmann. The group coalesced into a comradely artists' circle. Often they gathered at Matta's studio, and in October 1942, coincident with allied landings in North Africa, Hofmann, Pollock, Krasner, Motherwell, and Baziotes collaborated on collective "automatic" poems and drawings, constituting themselves as an "American automatist movement."[44]

Surrealism offered the emergent abstract expressionists an alternative to cubism. The surrealists possessed both an ideology and a method based on the notion that the subconscious was the source of collective human identity and creativity. New York artists had first heard these ideas in 1937 when John Graham, the Russian émigré painter-theoretician, published his *System and Dialectic of Art.* "[The] artist," wrote Graham, "has to unite at one and the same time three elements: thought, feeling, and automatic 'ecriture.'"[45] Pollock and Gorky had been fascinated by Graham's ideas, which were legitimated by the appearance of the surrealist exiles in 1942.[46]

The practice of automatic "ecriture," automatism, or simply automatic writing, derived from a belief in poetic insight. The surrealists believed that artists gained access to the subconscious, a reserve containing a gallery of archetypal images, through a process of free association, of unwilled, or automatic, writing and drawing. The "method" of automatic writing implied that art expressed the truths of the universal human condition, which lay concealed within the psyche.[47] The expressionism of

New York's abstract painters derived far more from the surrealist method of automatic writing than it did from German expressionism. For Motherwell, Baziotes, and Pollock the intellectual excitement generated by their long talks with Matta convinced them that "plastic automatism" was a "weapon to invent new forms."[48]

Baziotes also drew on surrealist ideas and on Picasso's later work, especially *Guernica*. In 1942, Baziotes experimented with automatic technique, painting the first of his biomorphic abstractions hinting at mythic content. He believed that his work mirrored the "dark and demonic" side of his personality and called the act of painting "unpremeditated inspiration," recognizing that he approached a canvas with the anticipation that "each [painting] . . . has its own way of evolving. . . . Each beginning suggests something . . . then becomes a phantom that must be caught and made real."[49] In Baziotes' works of the mid-1940s the eyes and teeth of hidden monsters compete with controlled forms and shapes. "There is always a subject that is uppermost in my mind," he wrote. "Sometimes I am aware of it. Sometimes not."[50]

In October 1942, Baziotes joined Motherwell and Pollock in the international collage show presented by Peggy Guggenheim's Art of This Century Gallery. The opening celebrated the rescue of Guggenheim, her avant-garde collection, and her husband-painter Max Ernst from the war. Guggenheim surrounded herself with several of MoMA's advisers, including Alfred Barr and James Johnson Sweeney, who, in addition to Ernst, saw in the young New York abstract artists the link between European modernism and new artistic inventiveness.[51] At a time of unprecedented devastation, the New York painters represented a movement premised on internationalism and universalism. Motherwell, Baziotes, and Pollock saw regionalism as parochial and rejected the limitations of dogma and the formal restraints of conventional modernism, as well. The stylistic adaptations of biomorphism, rounded blotted shapes, suggested Jungian and surrealist archetypes as an alternative to the gridlike architecturalism of cubism and neoplasticism.[52]

Guggenheim's gallery, whose black walls added its own surreal quality, provided the first setting for the works of the new painters. In the next two years Guggenheim gave solo shows to Baziotes, Motherwell, Pollock, Hofmann, Clifford Still, and Rothko, signing Pollock and then Rothko to exclusive contracts. Pollock, following critical approval by Mondrian, received his first solo show in 1944 and accepted a yearly contract of monthly cash payments of $150 against his future sales. He also agreed to supply additional paintings, in kind, if his share of the gallery's sales fell below the annual income dispensed by Guggenheim.[53]

Surrealism also inspired Mark Rothko, a veteran of the FAP easel division and a participant in the independent abstractionist group, the Ten. In June 1943, Rothko and Gottlieb jointly wrote to the *New York Times* protesting art critic Edward Alden Jewell's "befuddlement" about their work. Their letter became a manifesto of the early abstract expressionists. Echoing Motherwell and Baziotes, they asserted the independence of the artistic imagination, the improvisational nature of creativity, and the rejection of illusionism. They closed saying, "We assert that the subject is crucial and only that subject matter is valid which is tragic and timeless. That is why we profess spiritual kinship with primitive and archaic art."[54]

Mark Rothko's 1942 painting, *The Omen and the Eagle*, alluding to the Agamem-

non trilogy, portrayed his own intellectual development. Of Russian Jewish birth, Rothko came to the United States in 1913, when he was ten, with his family, the Rothkowitzes. After studying at Yale and with Max Weber at the Art Students League, he joined the WPA and worked in the abstract cityscape tradition of Milton Avery. Although he was a social activist member of the Artists' Union, he refused to express his politics directly in his art. By 1940, Rothko, who had studied classical mythology, started reading Nietzsche. His *Omen and the Eagle* used myth as a symbol of inner psychic reality: "Dealing with the spirit of myth . . . [*Omen and the Eagle*] involves a pantheon in which man, bird, beast, and tree . . . merge into a single tragic idea."[55] Rothko's painting demonstrated that art "should dramatize the terror and struggle of existence" and, echoing his letter to the *New York Times,* that a return to archaic, preclassical myth could provide a paradigm for contemporary artists.[56] The painting's themes of war and sacrifice connected the past and present and, in Rothko's terms, the mythic and tragic. He confronted the horror of war by universalizing its irrationality, locating it in the collective unconscious.[57] Coincident with the unbelievable first news of Nazi genocide, *Omen and the Eagle* exposed Rothko's artistic intent. To celebrate the miracle of life, he expressed a "clear preoccupation with death."[58]

Adolph Gottlieb's life paralleled Rothko's. The son of Czech Jewish immigrants, Gottlieb lived on East 10th Street, studied with Robert Henri and John Sloan at the Art Students League, lived briefly in Paris, affiliated with Milton Avery and John Graham in the 1930s, and worked for the easel division of the WPA. In 1941–42 he started painting what he called "pictographs," archaeologically inspired "symbolic representations of ideas" that depicted archaic imagery in a grid.[59] In the series, which extended from the early 1940s to 1950, Gottlieb painted images of disembodied eyes, demonic hunters, bared shark's teeth, and preying monsters. His *Expectation of Evil* reflected his emotional response to the war. Gottlieb's pictograph of barbed wire, splayed fish, lifeless eyes, and a thug's face confronts the viewer with a pitiless view of what the French had just begun to call *l'universe concentrationaire.* In *Prisoners,* he restated the pictographic grid, even more directly, into an "enclosure for the damned."[60] Attempting to penetrate the incomprehensible, Gottlieb offered little comfort in his imagery of evil and terror. The moral void created by the war and the Holocaust heightened his despair. "To my mind," he said, "so-called abstraction is no abstraction at all. On the contrary it is the realism of our time."[61]

Gottlieb's close friend Barnett Newman concurred. "We felt the moral crisis of a world in shambles."[62] Serious, eccentric, intellectual, and independent, Newman had run for mayor of New York City in 1933, proclaiming himself both an artist and an anarchist. A graduate in philosophy from City College, he studied painting at the Art Students League and pursued graduate studies in ornithology at Cornell. As a conscientious objector, he remained politically independent, distancing himself from all formal organizations and protesting fascism, killing, and authority. His blend of radicalism and idealism suffused his painting with "utopian political meaning."[63] In the face of a world "in shambles," without order or meaning, Newman depicted the exalted and the sublime.[64] His untitled watercolor of 1945, which hints at the starkly dramatic vertical-stripe paintings that later became his hallmark, suggests an

Adolph Gottlieb,
*Expectation of Evil*
(1945).
©1990 Museum Asso-
ciates, Los Angeles
County Museum of
Art. ©Adolph and Es-
ther Gottlieb Founda-
tion, licensed by
VAGA, New York, N.Y.
Purchased with funds
provided by Burt
Kleiner and Merle
Oberon

ecology, as if Newman had focused an electron microscope on a single cell sus-pended in a primordial liquid. Rejecting the geometric tendency in cubism and the rhetorical commentary of social realism, Newman's paintings combined cellular bi-ology and mythology with surrealism.

Newman's 1946 oil painting *Genesis: The Break* anticipated the formal composi-tion of Motherwell's *Elegy* series, but to some critics the painting's "blackened sur-face" represented Newman's response to the atomic bomb.[65] Newman would later write, "The war, as the Surrealists predicted, has robbed us of our hidden terror, as terror can only exist if the forces of tragedy are unknown. We now know the terror to expect. Hiroshima showed it to us."[66]

So, too, for William Baziotes. From 1946 through 1948, Baziotes completed sev-eral large and important canvases. *Dwarf,* purchased by the Museum of Modern Art in 1949, expressed the modulating nature of his work. At 42″ × 36″, *Dwarf,* evoking both a star and a figure of childlike mystery, looms larger than Baziotes' easel paint-ings. Baziotes' central image, two connected biomorphic shapes whose eerie green iridescence conveys the drama of radioactive disfigurement, forms a dwarflike shape that contains sharply defined smaller figures. *Dwarf,* according to Baziotes, com-municates a "quiet horror and an overall sensuous feeling."[67] It came, he wrote, from the images he remembered from a book about World War I, of soldiers "decapitat-ed" at the waist, arms cut off. A disfigured image distorted by mutating radioactivi-ty, *Dwarf* speaks to the trauma of atomic destruction. Part grotesque, part artist's model, *Dwarf* bridged the gap between the experience of the early 1940s and the move towards more formalistic abstraction that Robert Motherwell and others adopted at the end of the decade.

World War II, with its endless revelations of human horror, shattered the artistic world that had nurtured New York's abstract artists. Images of combat, the Holo-caust, and atomic destruction remained fixed in their minds, even as American so-ciety struggled to return to normal. At the war's end the radically new paintings of Robert Motherwell, William Baziotes, Jackson Pollock, Mark Rothko, Adolph Gott-lieb, and Barnett Newman went unacknowledged. Only Peggy Guggenheim and Clement Greenberg took their work seriously.[68] As the art historian Michael Aupung noted, the war and the Holocaust "revealed new dimensions of human cruelty, greed, and irrationality," requiring a "pictorial equivalent of man's new knowledge and con-sciousness of his more complex inner self."[69] Far from embracing Greenberg's apo-litical, art-for-art's-sake aestheticism, New York abstract expressionists created rad-ically new visual forms whose content remained hidden and inaccessible to most viewers.

## THE ABSTRACT EXPRESSIONIST CONSTELLATION

From 1945 to 1949, New York's modern painters evolved from an unknown, virtu-ally underground artistic sect into a cadre of the city's most influential and celebrated painters. By 1949 most of them had shifted from their earlier representational ab-straction to an almost pure formalism, all the while insisting that their subject re-mained personal experience. Motherwell explained, "Non-representation for its

own sake is no more, though no less interesting than representation for its own sake. There simply happen to be certain problems of expression which representational means cannot solve."[70] William Baziotes agreed: "What happens on the canvas is unpredictable."[71]

In the vacuum left by the surrealists' repatriation and the 1947 closing of Art of This Century, New York abstractionists found new champions—gallery owners Betty Parsons and Sam Kootz and critic Harold Rosenberg. In the two years following the war Kootz's gallery became a center of abstract expressionism. Kootz, along with the Museum of Modern Art and art dealer Parsons, claimed credit for the increased visibility of abstract expressionism.[72] Among the forty galleries in New York that showed American art during this period, Samuel Kootz's, Betty Parsons', and Charles Egan and Irving Sandler's Tanager Gallery specialized in modern abstract art.[73] Together, Parsons and Kootz gave Pollock, Baziotes, Hofmann, Reinhardt, Motherwell, Still, de Kooning, Newman, and Rothko shows on a yearly basis.[74] In 1947, as Parsons brought in many from Guggenheim's lineup, Pollock signed a new contract with her gallery, for three hundred dollars a month.[75] Accustomed as they were to marginal artistic and social status, New York painters found the cycles of preparation, hanging, and review harrowing experiences.[76]

Attracting relatively few serious buyers, in the late 1940s the work of New York artists commanded relatively low prices. Baziotes hoped to sell his pictures for $400 each, and the highest price paid for a pre-1947 painting by an abstract expressionist went to Pollock who, through Art of This Century, sold a work for $750.[77] At Kootz's gallery in 1948, the New York abstract painters received between $100 and $950 for their work, whereas their European counterparts sold their work for five times as much.[78] Motherwell, Baziotes, Gottlieb, Hofmann, and David Hare signed with Sam Kootz when Peggy Guggenheim returned to Europe. Possessing only limited financial resources, Kootz, an internationalist who wanted to show his young American painters alongside contemporary European moderns, offered Motherwell a contract of two hundred dollars a month for a share of the painter's labor. When Kootz closed his gallery in 1948 many of the artists gravitated to Betty Parsons. Kootz reopened a year later and wanted to create both a sensation and a group identity with his show *Intrasubjectives*. The exhibit, featuring works by Baziotes, de Kooning, Gorky, Gottlieb, Hofmann, Motherwell, Pollock, Reinhardt, and Rothko, ran during September 1949.

By 1949 the abstract painters had achieved public recognition as a coherent artistic community complete with a formal identity—the "New York School." They organized schools, clubs, journals, formal and informal gathering places, and summer retreats, and in 1951 they embraced the sobriquet "abstract expressionists." In 1948, Motherwell had organized the abstract artists' first school, whose evening seminars subsequently evolved into the Club. As a painter, writer, editor, organizer, and teacher, Motherwell possessed a genius for bringing artists together, thus playing a pivotal role in the crystallization of the New York School of abstract expressionism. His recognition as a major painter and interpreter of abstract expressionism gained him special status in the movement.

Motherwell's essay, "The Modern Painter's World," marked his entry into the fore-

front of contemporary art and politics.[79] Reflecting the neo-Hegelian influence of the Frankfurt School, particularly the work of Karl Mannheim, Motherwell described the inaccessibility of abstract painters as a reflection of their alienation from "bourgeois" society. He viewed modern artists as "a kind of spiritual underground" whose service to individual freedom remained their highest calling. "Isolated from the consumer-driven, property-loving world, the artist and worker shared a common experience but expressed it in "irreconcilable" ways. The way to the future depended on the mutual pursuit of the workers' material and the artists' spiritual goals. "Weak as they are," wrote Motherwell, "it is these groups who provide the opposition. The [function of the] Socialist is to free the working class from the domination of property. . . . The function of the artist is to make actual the spiritual. . . . It is here that art instructs, if it does at all."[80]

The function of the modern artist, declared Motherwell, "is by definition the felt expression of modern reality." He insisted that art always contains a subject. Motherwell called for a reconsideration of the relation between art and politics. From his vantage, "the twentieth century has been one of tremendous crises"; the truly committed artist had to abandon the politics of the moment, of direct partisanship, in order to identify the spiritual essence of liberation.[81] Old doctrines that insisted that art was a weapon missed the point. Artists, he believed, must remain true to their art; in a bourgeois society this meant they must transcend social alienation by rediscovering spiritual and universal meaning. Echoing the positions taken by John Sloan and later by Stuart Davis, Motherwell held that only by abandoning overt politics could artists hope to have an impact on social consciousness. Only as artists could they make constructive contributions.

Motherwell described artists as free-floating intellectual defectors from the "decaying" middle class. Modern art expressed that alienation, an aspect of the modern condition that forced the artist "to abstract goods from reality." Only in opposition to middle-class materialism, concluded Motherwell, could modern artists find a "certain strength."[82] Without this strength, artists merely awaited the revolution, content to express their alienation. In contrast to Greenberg, Motherwell did not call for an isolated art for its own sake but rather asked artists to distance themselves from the immediacy of politics. Like Stuart Davis and John Sloan, Motherwell distinguished between art and politics, arguing for their distinctiveness based on an understanding of their interconnectedness.

Born in Aberdeen, Washington, to prosperous upper-class parents, Motherwell grew up in San Francisco. Academic and athletic success took him to Stanford, to the paintings of Matisse in San Francisco, the study of French aesthetics and civilization with Albert Guerard, and a degree in philosophy. As a philosophy student he worked with both the Anglo-American tradition of Bertrand Russell and Alfred North Whitehead and the writings of Karl Marx and Georg Friedrich Hegel. In college Motherwell underwent psychoanalysis. "Most of my generation are dead through self-destruction," he said in 1975. "I had the same characteristics, alienation, and psychoanalysis saved my life. I think if David Smith or Rothko had been analyzed they'd be alive now."[83]

Following a summer's grand tour in Europe with his father, Motherwell accept-

Robert Motherwell in
his studio.
*Peter A. Juley and Son,
National Museum of
American Art, Smith-
sonian Institution*

ed an allowance of fifty dollars a week in return for pursuing a doctorate in philoso-
phy. At Harvard, Motherwell studied with the intellectual historian and philosopher
Arthur Lovejoy. On leave at the time from Johns Hopkins, Lovejoy insisted that ideas
and images could be understood as "entities in the mind." His work *The Great Chain
of Being*, published in 1936, reinforced Motherwell's awareness of the German ide-
alist tradition.[84] Encouraged by Lovejoy, Motherwell spent the 1938 academic year
in Paris, steeping himself in French cultural history.[85] Intending to study the aes-
thetics of Delacroix, he fell in love with the French symbolist poets, Stéphane Mal-
larmé, Charles Baudelaire, Paul Valéry, and André Breton who, he believed, ad-
dressed the nature of art. Convinced that modern art was "the symbolist movement,"
he returned to the United States, where, in 1939, he enrolled at Columbia Univer-
sity to study with the critic and art historian Meyer Schapiro.[86]

Talented, fluent in Hebrew, blessed with a photographic memory, and gifted in
fine art, Meyer Schapiro had studied with John Dewey and Franz Boas while taking
classes at the National Academy of Design.[87] At Columbia in the 1930s, he earned
a reputation for dynamic classroom teaching, scholarly erudition, and political ac-
tivism. An independent socialist, Schapiro shunned formal party affiliation. In the

wake of the Soviet invasion of Finland he joined the editorial staff of *Marxist Quarterly* and resigned from the American Artists' Congress. His address, "Social Bases of Art," at the 1936 American Artists' Congress established his reputation as an innovative art critic. Schapiro's perspective, at once radical and original, gave Motherwell an active philosophical vocabulary.

Arguing that bourgeois art, embracing the values of the middle class, remained mired in individualism, Schapiro called for a revolutionary art that allied artists and the working classes. Art, for Schapiro, not only reflected the social basis of its production but also served the political and ideological values of its audience.[88] A year later Schapiro moved away from this position. In his article, "Nature of Abstract Art," Schapiro argued from a perspective that more directly influenced Motherwell. In the article, published by *Marxist Quarterly,* Schapiro maintained that the modern abstract artist remained essentially estranged from the members of the working classes and their revolutionary impulse. Alienation was artists' modern condition, a manifestation of their social isolation. Modern abstract art, argued Schapiro, could not be understood in simply formalistic terms, nor should it seek to play a revolutionary role. Rather, the modern artist had an obligation to abstract from reality to restore its nonmaterial meaning.[89]

In response to Schapiro's mentorship, between 1944 and 1947, Motherwell reached similar conclusions. He, too, believed that modern artists existed in a social vacuum. Middle class by origin, radical by inclination, contemporary artists could no longer, as had been true of the social painters of the depression, directly effect change. Inhabiting what Motherwell had already called the "spiritual underground," abstract painters reacted to the modern world aesthetically and intellectually. According to Motherwell, only Picasso, in his great "public" mural, *Guernica,* expressed the artist's human "solidarity." By transcending the limits of contemporary life, "by his own spirituality in a property-ridden world," Picasso had accomplished a "tour de force."[90]

In 1941, Motherwell translated his philosophical training into pictorial imagery. "Abstractions," he said, "have meaning. And what gives meaning is structure, and structure by definition is a relation among elements."[91] Between 1941 and 1947, Motherwell's work comprised elegantly composed collages, three of which he exhibited at Art of This Century in 1943, and a series of pictures evoking the Spanish Civil War. As a radical intellectual committed to a "socialist analysis," in *The Little Spanish Prison, Spanish Picture with a Window,* and *Spanish Prison Window,* Motherwell searched for a subject and a style. He remarked, "I never start with an image, but an idea drawn from my world. Though sometimes images may emerge from some chord in my unconscious."[92] Working with the most politically charged event of the 1930s and against the drama and power of Picasso's *Guernica,* Motherwell painted the impact of the Spanish Civil War, interpreting it in universal, painterly terms. Relying on surrealist automatism, Motherwell induced his subject to emerge on its own.

Motherwell's artistic breakthrough occurred in the wake of a political call to arms. During the winter of 1947–48, when many other abstract expressionists moved to a pure abstractionist style, Motherwell, along with critic Harold Rosenberg and avant-

garde composer John Cage, founded and edited a new cultural journal, *Possibili-ties*.[93] Intending the journal as a new voice for contemporary art, they wrote, "The deadly political situation exerts an enormous pressure." Art and politics could no longer work together. Rather, the demands of postwar politics, hardened by Cold War ideology and the apparent imposition of Stalinist governments in Eastern and southern Europe, had forced the issue of artistic political commitment at home and abroad. Motherwell and Rosenberg instructed artists and writers that to remain free they must abandon politics and accept the isolation inherent in their social position. "To write or paint," they concluded, "in the face of politics one needs faith in sheer possibility." After twenty years of artistic partisanship, grounded in the dreams of radicalism, the Popular Front, and the New Deal, New York artists hunkered down to work—as members of an international, not narrowly American, avant-garde.

Demonstrating their commitment to a liberated and international modern art, the editors of *Possibilities* reproduced Baziotes' *Cyclops* with commentary by Harold Rosenberg and French poet Paul Valéry, several statements by Pollock and Rothko, and a long review by Rosenberg on six contemporary American painters—Baziotes, Romare Bearden, Byron Browne, Gottlieb, and Motherwell—all of whom had ex-hibited at the Galerie Maeght in Paris in 1947. Describing the new Americans in Paris as artists who feel "no nostalgia for American objects," Rosenberg declared their disavowal of "cowboys, regions, oil wells, cornfields" as critical to the creation of a "transcendental world style." He saw in the new painting the triumph of abstract American art as simply art, produced by painters who have come from the far reach-es of the nation to "plunge themselves into the anonymity of New York." Their hero-ic isolation enabled them to realize that "only what he constructs himself will ever be real."[94]

Rosenberg's criticism gained him entrée to Motherwell's intellectual circle. His vision, a mixture of national pride and internationalism, asserted the international significance of abstract expressionism. He argued that abstract expressionists' aban-donment of the American vernacular was crucial to their importance and recon-nected them to the spirit and accomplishments of the School of Paris, pronouncing that the greatness of American abstract expressionist painters rested in their ability to meet European standards and accomplishments.[95]

Rosenberg's postwar essays, many published in *Partisan Review,* explored the re-lationship between art and politics. Prizing independence above all else, he argued that artists, in an age of political dogmatism framed by Stalinism and McCarthyism, retained a single obligation—creativity. New York's "Action Painters," Rosenberg's label for the abstract expressionists, demonstrated their liberation by painting. Their gestures, the flow and feel of their paint on canvas, became itself a statement. At a time of political oppression, creativity offered artists freedom. Rosenberg reaffirmed his roots in the intellectual tradition of the French avant-garde, but he also recast that tradition in American literary imagery. His most famous essay, "Parable of Amer-ican Painting," contrasted the Europeanized "redcoats" who marched "in file through the New World wilderness" with the "irreverent" and "anti-formal coonskinners" who knew but one principle, "if it's red, shoot!"[96] The new "action" painters, Rosen-

berg declared, embodied the swagger of America's sharpshooters. Ingenious and improvisational, they dared to break with tradition. Free and gestural, preserving their distance from oppressive politics, New York's abstract expressionists exhibited the rugged individualism of Daniel Boone.

Robert Motherwell, the most European of the abstract expressionists and the most international of his generation in outlook and artistic experience, typified the tension between Continental tradition and American practice. "If my generation," he recalled, "did anything . . . we stopped imitating Europe and began to use parallel principles in our own way."[97] Rosenberg and Motherwell wanted their American magazine to "look French," and, in planning the second issue in the spring of 1948, they decided to publish a "savage, barbaric, Rimbaudian poem" that Rosenberg had completed. Motherwell executed and decorated the poem in calligraphy, creating words and images in black and white.

Motherwell, "half-consciously, half-unconsciously," worked with black paint to signify the images in Rosenberg's poem. Unsuccessful, he blotted the partially formed shape and in so doing made "a strong, straight, thick black line and a very strong oval," which he thought reminiscent of Picasso's contrast of the curvilinear with the linear.[98] In early 1949, Motherwell took the "blot" from his drawing pad, enlarged the oval-vertical pattern in black and white, and painted a canvas, which he entitled *Five O'Clock in the Afternoon*. The small painting, 15″ × 20″, became the prototype for his series *Elegies to the Spanish Republic,* which he continued with the larger 47″ × 55″ *Granada* later that year.[99] The contrast of black shapes on the white ground of the *Elegies* continued the techniques of cubist-inspired collage that Motherwell had worked with for the previous eight years and the philosophical-metaphysical bent of his academic training. The blackness of death opposed the vitality of white, and the painting as a whole reinforced the sexual meaning of the oval-vertical imagery. The themes of savagery and sexuality as they revealed themselves in the "architecture" of organic and geometric shapes produced a "dialogue."[100]

For a decade Motherwell had painted images associated with the Spanish Civil War, but *Five O'Clock in the Afternoon* represented his solution to the challenges posed by social realism. Motherwell translated his subject, the great political drama of the 1930s, into imagery of human sexual and metaphysical speculation.[101] The painting's title, an allusion to a poem by the Spanish writer Federico García Lorca, *Llanto por Ignacio Sanchez Mejias,* referred to the death of a legendary bullfighter, gored, like the Spanish Republic, at the end of the day. Motherwell, who had steeped himself "in the legends of modernism as no other American painter," assembled his own symbolist analogy from the spirit of García Lorca's lament.[102] García Lorca's artistic radicalism, which contrasted with his cautious, though Republican, distance from political militancy, paralleled Motherwell's position. By capturing the drama of the Spanish Civil War through the life and death struggle of the bullfight, Motherwell achieved his artistic and philosophical goal. In the abstraction of the *Elegies,* Motherwell revived the political, but in alluding to the Spanish Civil War he concealed his own struggle with the present. "The Spanish Civil War," he recalled, "was an issue of black and white, of life and death, an overture to the Second World

War."[103] In 1949, when Cold War anticommunists judged even oblique references to leftist politics subversive, Motherwell had paid tribute to the left's last great cause.[104]

## THE TRIUMPH OF THE
## NEW YORK SCHOOL

The consolidation of the New York School of abstract expressionism followed a decade of experimentation. By 1956 the movement had achieved broad public recognition if not acceptance. The founding of the Club, an ongoing intellectual discussion, marked their transition from a small, almost secret circle into a highly visible avant-garde of international standing. Jazz musicians and dramatists, composers and dancers aligned themselves with the abstract expressionists to form a new bohemian community in Greenwich Village, reminiscent of pre–World War I radicals in the Village and on Paris's Left Bank.

Abstract expressionism, a name bestowed in 1951 by Alfred Barr of the Museum of Modern Art, synthesized twentieth-century European modernism, particularly surrealism, with American modern and representational traditions. Stylistically renouncing the American scene, the abstract expressionists nevertheless retained its political concerns and identification of New York City as the embodiment of the modern. Following World War II, the abstract expressionists, most in their late thirties and early forties, formed several groups and organizations in Greenwich Village—including the journal *Tiger's Eye,* the Subject of the Artist School, the Eighth Street Club, ongoing discussions at the Cedar Tavern, and the *Ninth Street Show.* Although proud of their collective avant-garde identity, most abstract expressionists protested efforts of dealers and critics to characterize them as a "New York School" and remained firm in their stylistic and intellectual individuality. Jackson Pollock, in particular, resisted attempts to define him collectively, insisting that his work be considered on its own terms. Pollock's assertions notwithstanding, New York's abstract expressionists functioned as a group, if not always as a school, and they indeed constituted an avant-garde, in concert with other artists in different mediums.

*Life* magazine's 1949 photo of Pollock as the greatest living American painter portrayed him as tough, his arms crossed and cigarette dangling, leaning, with squinty-eyed nonchalance, against his famous *Number* 12, 1948. Jeans, both jacket and pants, and a ratty scarf identified the thirty-seven-year-old Pollock as, in the words of Willem de Kooning, a "guy who works at some service station pumping gas." Others saw the pose as capturing something "purely" American—Pollock as cowboy, outlaw, biker. A year later, the photographer Hans Namuth persuaded Pollock to allow a series of candid studies of the artist at work. Namuth showed the artist at a seminal moment of abstract expressionism. Namuth's photographs captured Pollock with buckets of paint in hand, dancing over and around his canvas, swirling the paint, painting circles in the air, hovering, solitary, and alone. Pollock's move to his historic drip paintings, begun in 1948, seemed to fulfill Clement Greenberg's prophesy. Pollock appeared as the heir to cubism.

By 1949, Pollock had expanded the size of his canvases, and that summer he paint-

ed *Number* 30, 1950 (*Autumn Rhythm*), which measured 8′10½″ × 17′8″. Oversized but easel inspired, *Autumn Rhythm* captured and broke with the tradition of mural painting. Prior to abstract expressionism, American muralists had worked within the legacy of civic art of the WPA and inspired by the Mexican mural tradition. In a sense Pollock's wall paintings harkened back to his early training with muralist-realist Thomas Hart Benton.

*Autumn Rhythm,* a composition of black swirls and loops intertwined with strings and shadows of white and tan, suggests a primordial explosion and the traces of subatomic particles on the plate of an electron microscope, a chaotic yet structured universe. *Autumn Rhythm's* scale obscured Pollock's achievement. In the painting's density, its complexity, Pollock responded to Hofmann's sense of the dilemma of modern art. Having abandoned illusionism, modern painters, Hofmann had argued, needed to find alternative means to convey depth. Hofmann's solution was to work with the tensions of solids and splashes of color, all of which prefigured Pollock's drip paintings. The layering of *Autumn Rhythm* was Pollock's answer. Accepting the limitations imposed by the picture plane, Pollock created a depth of field through an overlapping composition that quickly became a visual metaphor of the atomic age. Pollock included *Autumn Rhythm* in his fall 1950 show at Betty Parsons' Gallery. Priced at seventy-five hundred dollars, the work did not sell. In fact, Pollock sold only one painting from the exhibit.[105] However, in 1957, a year after Pollock's death, the Metropolitan Museum of Art purchased *Autumn Rhythm* for thirty thousand dollars.[106] In the contemporaneity of its content and the intensity of its style, Pollock's work was typical of the abstract expressionist generation.

By the time Pollock painted *Autumn Rhythm* the abstract expressionist community had already formed. Between 1947 and 1949, Ruth and John Stephen followed Rosenberg and Motherwell's publication of *Possibilities* with a new journal, *Tiger's Eye.* The magazine reflected the temperament of its associate editor, Barnett Newman, who, with Motherwell, sought to define the new artistic movement. In December 1948, Newman's essay, "The Sublime Is Now," part of a published symposium sponsored by *Tiger's Eye,* proclaimed the need for a new spirituality and a new mythology that only contemporary American artists and poets could provide. Twentieth-century European art, Newman claimed, had failed to achieve the transcendental state, which he called the sublime, and instead had retreated into pure plasticity. Modernism had become simply stylistic innovation; it lacked a spiritual content. "I believe that here in America, some of us, free from the weight of European culture, are finding the answer," he wrote. American artists, Newman exclaimed, stood at the edge of creation. "The image we produce is the self-evident one of revelation."[107]

In the fall of 1948, coincident with the "Sublime" symposium in *Tiger's Eye,* Motherwell, David Hare, Baziotes, Rothko, and Newman founded their short-lived Subject of the Artist School in a studio at 35 West Eighth Street. The school, within walking distance from the Whitney Museum, the East Village, and the Cedar Tavern on University Place, served as a focal point for the community of abstract expressionists.[108] The Subject of the Artist School fulfilled Rothko and Gottlieb's manifesto-like 1943 letter to the *New York Times,* in which they asserted that the "subject is cru-

cial" and that "flat forms . . . destroy illusion and reveal the truth."[109] The school's founders taught classes one day a week, with Motherwell providing the group's intellectual energy. The program remained true to the founding principle of teaching "what modern artists paint about as well as how they paint."[110] But the influence derived, ultimately, not from its underenrolled classes, which had to be abandoned after an unprofitable year, but from its Friday evening sessions. For two years Studio 35, as the space came to be known after the school closed in 1949, continued the intellectual-cafeteria life inherited from the 1930s.[111]

The combination of intellectual speculation, artistic shoptalk, philosophical bull session, and social conviviality energized and stimulated a generation of Villagers. Infighting and argumentation, accented by occasional drunken outbursts and frequent flirtation, typified the painters' café life. The Subject of the Artist School's Friday night meetings, which regularly spilled over into late night revelry at the Cedar Tavern, provided a common ground for New York's postwar avant garde. With Motherwell as master of ceremonies the Friday evening sessions featured lectures, followed by heated discussions, by the "advanced" artists of the city. Harold Rosenberg, Hans Arp, John Cage, or Julien Levy held forth on subjects as varied as the impact of surrealism, the politics of art, and the meaning of Native American sandpainting. Motherwell neither asked for nor received donations to cover the Friday evening sessions, and many participants continued the seminars over inexpensive dinners washed down with "seventy-five cent sherry."[112] By late 1949 the Friday evening lectures at Studio 35 drew "everybody in New York who was interested in the avant garde."[113]

From the fall of 1949 through April 1950, the School of Art Education at New York University sponsored the series of Studio 35 meetings. The faculty and graduate students who administered the programs soon realized that their audience had become fixed and the sessions predictable. At the suggestion of painter Robert Goodnough, Studio 35 hosted a final three-day closed-door session in April 1950. The Artists' Sessions at Studio 35 had no formal agenda; its organizers agreed only to announce the dates and invite participants.[114] Seated around long linen-covered tables laden with bottles of wine and beer and plates of sandwiches, for three late afternoons, from four to seven, the twenty-five "advanced" artists argued about art. Only three women, Janice Biala, Louise Bourgeois, and Hedda Sterne, were included in the group, and Alfred Barr, lending a stamp of uptown legitimacy to the proceedings, was the sole nonartist. He agreed to serve, with Motherwell and sculptor Richard Lippold, as one of the moderators. Looking like an assembly of academics, the group inspired Gottlieb to quip, "It seems to me that we are approaching an academy version of abstract painting." Of the Irascibles, only Jackson Pollock refused to participate in the Studio 35 seminars.[115]

Alfred Barr asked, "What is the most acceptable name for your direction or movement? (It has been called abstract-expressionist, abstract symbolist, intrasubjectivist etc.) [Is there] any unity here?"[116] The question of identity, defined in terms of style and community, dominated the event, finally giving the movement, now almost a decade old, the name history has accepted. At the Studio 35 Artists' Sessions, artists expressed radically different conceptions of the role and place of

modern art. Works of art, some argued, were finished when they achieved some sense of inner compositional harmony; others felt that a work was finished only when it fulfilled its worldly obligation. They did agree, however, to celebrate their arrival, believing that American painting had now attained the level and achievement of the School of Paris. They also reaffirmed the importance of content, even though they understood that it was the artist who imposed meaning on the work.[117] In the end the participants refused to agree that they constituted a school or that they could be grouped under a common name. Instead, they concluded that they belonged to an "ideal society" inherently at odds with the "goals that most people accept."[118]

Still, isolated during the war years, the abstract expressionists had discovered the psychic and intellectual rewards of solidarity. Like their elders from the depression, New York abstract expressionists craved an artistic community. In the fall of 1949 some twenty painters and sculptors, many of whom were veterans of the Subject of the Artist School, gathered at the studio of Ibram Lassaw on the corner of Sixth Avenue and 12th Street to form the Club. "We always wanted a loft, like the Greek and Italian social clubs on Eighth Avenue, instead of sitting in one of those goddamned cafeterias," recalled one of the artists. "One night we decided to do it—we got up twenty charter members who each gave ten dollars."[119] The Club, also called, because of its location at 39 West Eighth, the Eighth Street Club, served as an artists' hangout where members could face each other "with curses mixed with affection, smiling and evil eyed each week for years."[120] Its membership was controlled by a combination of nominations from a voting committee and an implicit understanding that both "compatibility" and residence below 14th Street were equally important criteria for admission. The Club existed as a place for artists to talk about their work, to agree "only to disagree."[121]

Roundtable discussions and guest speakers widened the Club's reach beyond the technical and aesthetic concerns of its members. The November 1951 inaugural Wednesday evening members-only discussion began at half past nine and featured Motherwell and Max Ernst. Two weeks later, Lionel Abel spoke on the "modernity" of the modern world.[122] Dance critic and poet Edwin Denby, New York intellectuals like Hannah Arendt, architect Philip Johnson, and musician-composer John Cage appeared along with the usual cast of art world notables—Ad Reinhardt, Harold Rosenberg, Philip Guston—to engage in open, frank, and freewheeling discussion. In 1953, the Club heard a lecture by Joop Sanders, a local jazz musician, on bop and progressive jazz to complement Cage's presentation on contemporary music. The social function of the Club, centered at the Cedar Tavern, found a brief artistic outlet in 1951 when dealer and financial adviser Leo Castelli helped the Club rent space on Ninth Street for the group's only exhibit. The *Ninth Street Show* of sixty-one artists, for the most part abstract painters but without the participation of many of the movement's pioneers, attracted considerable attention from the city's art critics and reinforced the Club's self-proclaimed goal of promotion and solidarity.[123]

Painter Philip Pavia held the Club together, keeping the books, convening the voting committee, printing invitations to special events, seeking new ways to create a lively artistic community, and encouraging new members and new ideas. Younger

artists, like Helen Frankenthaler, Robert Rauschenberg, and Robert Goodnough, discovered the Club's intellectual excitement and fermentation. In 1955, Rauschenberg, with painter Jasper Johns, financed the Club's retrospective concert of the works of composer John Cage.[124] The event marked the arrival of a new generation of younger artists who extended abstract expressionist's ties to New York's larger postwar avant-garde.

None of these later abstract expressionists, however, matched the power of Willem de Kooning, one of the Club's most interesting and revealing painters. The Dutch-born European-trained abstractionist came to the United States in 1926. Half a generation older than his American peers, de Kooning worked on the WPA, exhibited with Baziotes, Gottlieb, and Rothko in 1944, and received his initial show in 1948 when he was forty-four years old. Clement Greenberg reviewed his initial solo exhibit glowingly, placing de Kooning alongside Pollock as an heir to, as well as respondent to the limitations of, the cubist tradition.[125] De Kooning only briefly abandoned the human figure in his slashing and sometimes frenzied applications of paint to canvas. After several years during which his pictures displayed the fragments of human anatomy, he worked to "reconstitute his gestures into recognizable figures."[126] The result, between 1951 and 1953, was the series *Women*, whose enormous energy and size turned the idealized female form inside out. De Kooning's female figures recalled the work of both Picasso and Pollock, but his subject remained far from idealized. Loud and sexual, oversized and fierce, this series of misogynous paintings evoked a mythic female whose depiction served as a reverse mirror to the restoration of postwar domesticity.

De Kooning's *Women* reflected the gendered construction of their imagery. Rather than idealizations, women had become frightening specters. Although extreme statements, de Kooning's *Women* underlined the male orientation of abstract expressionism. Like bebop musicians and beat poets, the Club's membership was almost exclusively male, and their defiant postures challenged not only female-dominated suburban culture but women themselves. Women took part in the Village avant-garde, but on the periphery, more as associates than as participants. Helen Frankenthaler was married to Robert Motherwell, Lee Krasner was the wife of Jackson Pollock, Elaine de Kooning was the wife of Willem de Kooning, and Hedda Sterne, the sole woman in the Irascibles portrait, was the wife of artist Saul Steinberg. Of the women abstract expressionists, only Helen Frankenthaler achieved recognition in her own right. Even so, the pattern of her career was telling.[127]

Frankenthaler, a New Yorker through and through, grew up in a comfortable East Side Jewish family and graduated from Bennington College. She studied briefly with Meyer Schapiro at Columbia and with Hans Hofmann in Provincetown before Adolph Gottlieb invited her to participate in a group show, *Fifteen Unknowns*, at the Kootz Gallery in 1950. Within a year, Frankenthaler became an acknowledged member of the abstract expressionist circle and a special favorite of Clement Greenberg.[128] Frankenthaler initially worked in the academic style of postcubism, influenced by Gorky, Pollock, and de Kooning. She painted multilayered translucent splashes of oil that had the appearance of watercolor and alluded to natural subjects. "In 1952," she recalled, "on a trip to Nova Scotia I did landscapes with folding easel

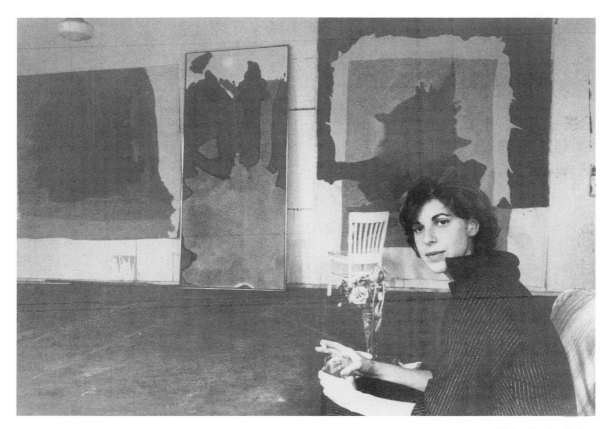

equipment. I came back and did the *Mountains and Sea* painting and I know the landscapes were in my arms as I did it."[129] Frankenthaler could not sell her painting—despite a price tag of a hundred dollars—and rolled it up for storage for the rest of the decade.[130]

Irving Sandler dismissed her work as overly feminine and "lacking the muscularity of heavy paint marks." "Her touch," he wrote, "is light, more often than not, delicate." James Schuyler, however, commended Frankenthaler for "going against the think-tough and paint-tough grain of New York School abstract painting." He added that "she chanced beauty in the simplest and most forthright way."[131] Pigeonholed as an interesting but female painter, Frankenthaler found herself excluded from Harold Rosenberg's list of American action painters because her "action is at a minimum."[132] An important personality in New York's abstract expressionist community, Frankenthaler did not receive artistic recognition until the 1960s, despite Greenberg's and Motherwell's judgment of her as a major painter.

Frankenthaler and Motherwell married in 1958. Her work over the next dozen years moved in several directions simultaneously. As she consolidated her style and intensified her colors, she replaced her lyrical landscapes and seascapes with large floating masses of color. *Small's Paradise* contains a series of frames around a central irregular image, in a sequence of "things inside of things." The title, a pun on the Harlem jazz club that Frankenthaler frequented and an allusion to miniature Per-

sian manuscript illustrations, only seemed contradictory. Frankenthaler found in both sources, the Persian and the African American, an exoticism whose commonality she expressed with the word "small."

## PAINTERS AND POETS,
## DANCERS AND CHANCE

The postwar New York avant-garde—bebop musicians, abstract expressionist painters, modern dancers, and beat poets—expressed their radical ideas despite the political pressure of the Cold War. The climate of repression rewarded conformity and punished dissent, especially among those who challenged American foreign or domestic policy. New York's avant-garde, from the abstract expressionists to the experimental composer John Cage, refused to be silenced by the conformity of the 1950s. Shaped by the experience of World War II, the second Great Migration, and the Cold War, this new generation expanded the sexual and racial boundaries of New York Modern.[133]

John Cage and the abstract expressionists sensed the affinities of their work. They had been influenced by European aesthetics; they valued the spontaneous movement for its encouragement of free creativity; and they were offended by the heavy-handed politics of the Cold War. Cage's radical and anarchic detestation of authority and structure, his discomfort with elite, academic definitions of art, and his refusal to indulge in the metaphysics of mythic speculation made him impatient with the self-importance of abstract expressionism. Pollock's gestural freedom, but not his pose, made him attractive to the Cage and Merce Cunningham circle that formed in and around the Club.

Egalitarian, experimental, and avant-garde, John Cage was sympathetic toward and highly critical of the abstract expressionists. At odds with the American musical establishment and never a member of Copland's group, Cage, a Californian, studied with Henry Cowell at the New School in 1933 before returning to Los Angeles to work with Arnold Schoenberg.[134] In 1938, Cage, the composer of several avant-garde chromatic pieces and twelve-tone series, moved to Seattle, where he met dancer Merce Cunningham. Returning to New York in 1943, he gained public attention for the first time by presenting a program of dissonant percussion music at the Museum of Modern Art. Cage worked closely with Cunningham as his musical director and accompanist. Cage's experimentalism as a composer and performer rested in his innovative adaptation of the piano. Inserting a variety of objects between the strings of the instrument, Cage expanded the piano's range of percussive sounds, each note's timbre altered according to the insertion. In his *First Construction (in Metal),* Cage employed an ensemble of six percussionists playing "orchestral bells, thundersheets, piano, sleigh bells, oxen bells, break drums, cowbells, Japanese temple gongs, Turkish cymbals, anvils, water gongs, and tam-tams."[135] Several of his later pieces employed electrical and mechanical sound devices—oscillators and amplified marimbas—as well as unorthodox rhythmic patterns derived from non-Western sources he had studied with Cowell.

Like many of the abstract expressionist painters and beat poets who had turned

to Eastern religions and philosophy, Cage found in Indian music nonlinear rhythmic patterns that he believed expressed emotional universality. At Black Mountain College in North Carolina in the late 1940s, Cage discovered the Zen lectures of Columbia professor Daisetz Suzuki.[136] Cage first studied the seminal texts of Zen Buddhism and then the Chinese book of changes, *I Ching,* which confirmed Cage's belief in the random order of the universe, a powerful theme in his music and philosophy. By 1951, Cage had rejected the notion that humans could impose reason on nature, believing instead that artists should discover the beauty or meaning that existed outside themselves.[137] His *Imaginary Landscape No. 4* voiced his sense of the haphazard pattern of life and art. Two musicians played the piece by working the volume and station knobs of a battery of a dozen radios whose broadcast content could never be the same from one performance to the next.

Influenced by the radical ideas of Marcel Duchamp, whom he had met in 1941, Cage embraced the dadaist's critique of modern painting as elitist and falsely existential.[138] He rejected the notion of art as masterpiece and was uncomfortable with the apparently self-referential nature of contemporary painting, adopting instead, as did Duchamp, the notion of art as common, everyday, and ready-made.[139] Art and religion, Cage believed, should never be confused. Art represented a single human response to life. Cage's musical compositions were highly unconventional, without reference to the traditions of harmony, rhythm, or linear continuity.[140] Cage found in the works of some abstract expressionists a kindred spirit that stressed the process of art rather than its completion. His break with the structures of musical rules was analogous to the abstractionists' disregard for the academic rules of composition. Cage intended his music as provisional and ordinary, no more special than any other aspect of reality, and he resented any claims to the contrary. His companion and colleague, Merce Cunningham, developed a complementary understanding of dance, which he conceptualized as "any" movement, insisting that "none of the actions in a dance has any significance beyond itself."[141]

Cunningham, like Cage, came to New York from the West Coast. The second male to join Martha Graham's company, he originated the role of the Revivalist in *Appalachian Spring* and danced in her company for eight seasons, from 1939 to 1946. As the first modern dancer to provide a significant philosophical as well as choreographical alternative to Graham, Cunningham expanded the independence of modern dance by insisting on its coexistence with, rather than dependence on, both music and design. As an abstractionist, Cunningham abandoned linear narrative and specific dramatic content. Choreographer Twyla Tharp later observed, "No one in the Cunningham company danced in roles with names other than their own."[142] Drawing on techniques from modern dance and ballet, Cunningham trained dancers in rhythmic agility and quickness and focused on the back, reversing Graham's attention to the midsection. For Cunningham, the audience became implicit collaborators in the emotional and physical movement of the dance. The abstract nature of his dance style, like Cage's ambiguous and ever changing musical compositions, invited and provoked. Drawing on an eclectic range of styles from the vernacular of tap to the aesthetic purity of ballet, Cunningham's dance shared the independent and abstract qualities of contemporary music and painting.

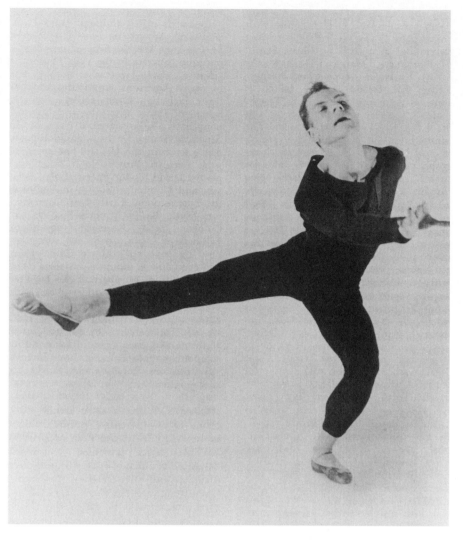

Merce Cunningham.
*Reprinted with the
permission of Simon
and Schuster, from*
The Dance Encyclo-
pedia, *by Anatole
Chujoy and P. W.
Manchester.* ©1967 *by
Anatole Chujoy and
P.W. Manchester*

The Cage-Cunningham "happenings," which displayed their central definitions of music as sound and dance as movement, took place in the churches and studios of Greenwich Village. In contrast with the Club, Cage and Cunningham sought unstructured sources for their work, believing that their art represented the change, play, and impermanence inherent in everyday life. For a 1952 mixed-media presentation during a summer session at Black Mountain College, Cage tossed I Ching coins to determine the intervals at which he, Cunningham, and painter Robert Rauschenberg would participate in their "event."[143] Defying all hierarchies, Cage and Cunningham relied on chance to create the patterns of nature that Cage believed were determined by the first principle of randomness. Art, he insisted, like life, was "accident determined," the result of improvisation and the incorporation of the quotidian into expressive performance.

Cage had worked with the New York painters since mid-1947, when he agreed to

collaborate with Rosenberg and Motherwell as music editor for *Possibilities*. He and Motherwell were well matched. Both rejected artistic posturing, preferring instead the radical and playful anarchism of Marcel Duchamp. Cage and Motherwell had spent time together at the experimental Black Mountain College in North Carolina, where in the late 1940s both had taught summer courses.[144] Black Mountain, in existence since the early 1930s, served as home to exceptional teachers, especially painter-printmaker Josef Albers. Cage had first learned about Black Mountain in the late 1930s. In 1948 he and Cunningham made a weeklong performing visit that reinvigorated the threadbare college's standing and spread word to other New Yorkers in search of a convivial summer artistic retreat. For the next half-dozen years Black Mountain College was a southern outpost of Greenwich Village. Its summer institutes in music and art hosted Jacob Lawrence, Balcomb Green, Franz Kline, and de Kooning along with Rauschenberg, Cunningham, Cage, and Motherwell.[145]

Cage and Motherwell shared a far-reaching interest in dada. In Motherwell's words, "There is a real dada strain in the minds of the New York School of abstract painters that has emerged in the last decade."[146] Cage was drawn to dada not only for its rejection of authority, both cultural and political, but also because of its manner of self-identity. "Being dada" paralleled his interest in Zen Buddhism, developed through attendance at the Columbia lectures of Suzuki, who introduced Eastern philosophy to a generation of New York poets and writers, especially Allen Ginsberg and Jack Kerouac.[147]

Like Cage, the beat poet Allen Ginsberg had studied Eastern philosophy, going so far as to throw I Ching coins one day in 1953 to divine the next stop on a cross-country journey, which led him to San Francisco and his friends Neil and Carolyn Cassady. Kerouac found in Buddhism a moment of philosophical peace in a whirlwind of existence that frightened and stimulated him. In the winter of 1954, Kerouac and Ginsberg walked the streets and frequented the taverns of San Francisco's North Beach, preaching and arguing the virtues of Eastern philosophy and religion. Four years later Suzuki, who lived on West 94th Street, invited them to tea. They wrote haiku, argued about old Chinese prints, and lapsed into silence. When Kerouac announced that he wanted to adopt Suzuki as his father, the elderly teacher waved his guests farewell with an enigmatic, "Remember the green tea."[148]

Like the abstract expressionist painters, Kerouac and Ginsberg, who were the two leading writers of the beat generation, wanted to discover the magical and the American. Prizing the experimental and the spontaneous, they exemplified the postwar avant-garde's sense of profound alienation from the society they sought to understand. Identifying with the outcast and the outlandish, with black jazz music and consciousness-expanding drugs, they crisscrossed America in the late 1940s and early 1950s in search of themselves and a truth they believed hidden by the stifling conventions of middle-class culture. In the bars and underground places of the East Village and Morningside Heights, these "subterraneans" listened to jazz, wrote and recited poetry, smoked marijuana, and engaged in sexual experimentation. Echoing the earlier attempts of the abstract expressionist painters to find inspiration in automatic writing and Jungian psychology, the beats prided themselves on the frenzy of their creativity. When Kerouac claimed that he wrote *The Subterraneans* in three

nights, he bragged that it was like "jazz and bop, in the sense of a tenor man drawing a breath, and blowing a phrase on his saxophone, till he runs out of breath, and when he does, his sentence, his statement's been made."[149]

Kerouac's *On the Road* brought the beats fame and its author unprecedented fortune. Ginsberg's *Howl,* however, established the movement's origins in the cultural clutter of New York's avant-garde. With its clear affinity to jazz and painting, *Howl* spoke with an authenticity that Ginsberg's mentor, William Carlos Williams prized. "Get locale, local speech, idioms," instructed Williams when Ginsberg told him that he wanted to "talk naturally in verse again."[150] Ginsberg wanted to write a poetical history of his generation. *Howl* documented the lives of the "subterraneans" who congregated at the San Remo, a bar in mid–Greenwich Village at the corner of Bleeker and MacDougal Streets. There, in the late 1940s and early 1950s, the actors of the experimental Living Theater drank and talked with Cage and Cunningham, artist and jazz musician Larry Rivers, and Ginsberg's collection of young poets and writers, including Kerouac, Gregory Corso, and William Burroughs. Ginsberg's poem, written in William Carlos Williams' triadic verse form and in the spirit of improvisational jazz, became the documentation of their lives.[151] By the time Ginsberg recited *Howl* to a wildly enthusiastic audience in San Francisco in October 1955, he had blended his Whitmanesque American voice with the spiritual centeredness of Zen Buddhism.

Indifferent, even hostile, to women, New York's postwar avant-garde accepted males of all persuasions and colors. For the first time the New York art community accepted a few African American artists as equals rather than subjects of missionary uplift. In 1946, Samuel Kootz, dealer and patron of the abstract expressionists, sponsored a group exhibition entitled *Homage to Jazz.* The show featured work from a number of abstract painters including Adolph Gottlieb, Jackson Pollock, and, significantly, Romare Bearden. Gottlieb's *Black and Tan Fantasy* tied abstract expressionism to Duke Ellington and early New York jazz.[152] Romare Bearden's work, on the other hand, evoked the blues, bebop, and the second Great Migration.[153] The next year Bearden participated in a second show with Kootz. An army veteran in his mid-thirties, Bearden had painted seriously since his apprenticeship at Charles Alston's Studio 306 in Harlem. Bearden became a social worker to continue his classes at the Art Students League with George Grosz. In 1940 he took a studio atop the Apollo Theater, where he painted in the social realist tradition of Ben Shahn, William Gropper, and Alston.[154]

Contemporary Harlem artist William Henry Johnson had introduced Bearden to patron Caresse Crosby, cofounder of the surrealist Black Sun Press, who brought Bearden to the attention of Samuel Kootz. By 1944, Bearden had abandoned his social realist style and adopted a modernist vocabulary that combined cubist and surrealist elements. His paintings, gouaches, and watercolors, completed just after the war, expressed an archaic spirituality. Bearden's primary influence, however, came from bebop and blues, not the Parisian surrealists.[155] "Jazz has shown me the ways of achieving artistic structures that are personal to me; but it also provides me continuing finger-snapping, head-shaking enjoyment."[156] In the 1940s, Bearden played with the "disharmony" of colors. Several of his works resembled stained-glass win-

dows, their religious themes framed by black lines that formed a vortex of movement. For the Kootz show, Bearden's *The Blues Has Got Me* and *A Blue Note* brought together the sacred and secular. In the 1950s, Bearden's work became less abstract and more explicitly African American, political, and urban. A contemporary of New York's abstract expressionists, Bearden stood apart.[157] But unlike earlier Harlem artists, Bearden received recognition in white artistic circles almost immediately.

The experimentalism of the beats, the innovative explorations of Cage and Cunningham, the haunting music of bebop, the acceptance of African Americans and homosexuals into artistic circles, and the artistic innovations of the abstract expressionists made postwar New York a center of avant-garde art. In the wake of World War II and under the Cold War's relentless pressure to conform, New York's avant-garde struggled to assert its independence. Cast as outsiders, the avant-garde formed a loose community of engaged painters, writers, jazz musicians, composers, dancers, and poets. They congregated in their favored coffeehouses and bars and identified themselves through their slang, their dress, and their complex and often convoluted art. Whether gay poets, nonconformist musicians, or anarchist painters, they defied the conformist culture of postwar America even as they affirmed the possibilities of urban life—a possibility that now included Harlem.

By the 1950s the new New York avant-garde had come of age. For some critics, bebop, abstract expressionism, the "happenings" of Cage and Cunningham, Bearden's blues paintings, and the antics of the beat poets captured the moral confusion and spiritual emptiness of postwar American culture. Suddenly celebrated and successful, many avant-gardists discovered that they could make a living from their art, allowing them to abandon the part-time teaching and loft world they had endured for two decades. Collectors, museums, and galleries competed for the works of the abstract expressionists, whose incomes and celebrity mounted each year.[158]

In 1951, the Museum of Modern Art staged its first significant show of abstract expressionism when it displayed Blanchette Rockefeller's collection, which featured works of Baziotes, Motherwell, Pollock, and Rothko. Barr's anointing of abstract expressionism as "our movement" at the Studio 35 sessions certified the "triumph" of postwar New York painting. New York's abstract expressionists had moved out of the shadows of obscurity into the glare of public recognition. Like Marilyn Monroe, Marlon Brando, and Joe DiMaggio they joined America's postwar pantheon of cultural icons. The *Life* photograph of the Irascibles captured the success and irony of New York's abstract expressionist's alienated idols.

Trained in the 1930s and inspired by surrealism, abstract expressionists redefined visual representation. As American artists they sought recognition as equals to their European modernist mentors, even as they interpreted the momentous events of their times in universal and mythic images. Spontaneous, predominantly male, and introspective, their abstract vocabulary shielded their work from political harassment. But their highly conceptual and personal art, with its tendency to essentialize particulars into universals, led many critics and patrons to overlook or, like Clement Greenberg, even to deny its content, thus reducing their monumental "wall paintings" to expensive and fashionable decor. In the late 1950s, when younger New

York painters like Robert Rauschenberg and Jasper Johns joined the Club, they cast a critical eye on the work of their predecessors.[159] Rauschenberg's and Johns' images of coffee cans, flags, targets, and jet fighters, created under the influence of the beat poets, returned New York painting to the details of daily life, making the content of their work obvious.

Still, the international recognition of New York's abstract expressionists marked the apogee of New York Modern, fulfilling the dual legacies of urban realism and modernism, of the Eight and 291, of the Whitney and MoMA. Their success, however, distanced them from New York and from New Yorkers. Universal, abstract, and precious, abstract expressionism appealed to the patrons of New York's art museums, not to the city itself. Critics of bourgeois values and Western capitalism, abstract expressionists, ironically, became the Cold War's prize possessions, the artists of the free world, their radical style transmuted by Clement Greenberg and the State Department into a new modernism, an imperial art, a demonstration of American power.[160] New York Modern had come almost full circle, from the time when young iconoclasts railed against a tradition that looked to a past, abstracted age instead of its contemporary realities.

Postwar politics and prosperity both hindered and stimulated abstract expressionists. Public recognition expanded their influence even as it gentrified their art. Under the pressure of the Cold War and McCarthyism, New York's postwar dramatists also concealed and obscured their political and social concerns. But, unlike abstract expressionists, the playwrights and directors of New York's postwar dramatic revival resisted all efforts to essentialize their work, retaining much of their 1930s social realism and political commitment. In the glaring lights of Broadway, New York's dramatists challenged the conventions of Cold War America and as a consequence found themselves driven off the stage and out of Hollywood. By the mid-1950s they, too, had become members of New York's artistic "secret underground."

# Life without Father
## Postwar New York Drama

In 1952, two years prior to the drama of the televised coverage of the Army-McCarthy hearings, American anticommunism menaced and then silenced theatrical expression in New York. From public hearings in Washington to executive sessions in Los Angeles, Cold War repression linked political subversion to artistic and personal freedom. Anything unconventional—sexual, religious, or aesthetic—became a sign of national disloyalty. For five years, the storm of anticommunism gathered intensity before it raked southern California late in the winter of 1952. From there, McCarthyism flattened, virtually overnight, New York's postwar theatrical renaissance.

Between 1945 and 1952, New York nurtured a revived dramatic community. Playwrights Arthur Miller and Tennessee Williams and their director, Elia Kazan, heralded a new American drama that was serious, poetic, and inventive yet accessible and commercially successful. Postwar New York drama, stimulated by experimental European expressionism and then challenged by anticommunism, gave audiences a searing and rejuvenated realism that focused on psychological torment amid unprecedented social change.

Miller, Williams, and Kazan grappled with McCarthyism's insidious and antidemocratic nature, probed the torment of secret homosexuality, affirmed the need to accept individual responsibility, and questioned the patriarchal nature of the American family. Reviving the tradition of urban realism, which they enriched with the voices of American social and regional vernacular and shaped with the techniques of European modernism, the postwar dramatists brought Broadway to the center of New York Modern. The plays of Miller and Williams once again spoke to the moment, to the array of public and private anxieties embedded in social and political change.

The postwar theatrical renaissance, in some ways a rebirth of the Group Theater, served as a counterpoint to commercial entertainment. The key to success on Broadway between 1939 and 1963 remained constant—comedy, melodrama, and musical

theater. *Life with Father* ran for a decade, from the opening of the Chicago World's Fair in 1939 to the opening of Birdland in 1949. In the late 1940s, while the plays of Williams and Miller set new standards of dramatic innovation and intensity, the comedic entries *Harvey, Born Yesterday,* and *Mister Roberts* brought audiences to the theater in droves. Similarly, the reformulation of the American musical theater, begun in 1943 with *Oklahoma!,* flourished. The first Rodgers and Hammerstein musical ran an astounding 2,248 performances, setting a new standard for the American musical. Subsequently *Carousel, South Pacific, My Fair Lady, West Side Story,* and *The Sound of Music* confirmed the success of the new formula, which combined original musical ideas—as in Leonard Bernstein's jazzy score in the 1957 production *West Side Story*—and dramatic books—such as James Michener's *Tales of the South Pacific.* [1]

Many factors conspired to produce an artistically and intellectually timid Broadway before the advent of the new theater. Spiraling production costs made it difficult to take the risks that serious drama required. In the 1920s and 1930s, Maxwell Anderson, Eugene O'Neill, and Clifford Odets had succeeded in a similar environment. Postwar drama, however, faced the added challenge of television. The astounding rise of commercial network television revolutionized American entertainment. Between 1948 and 1962 the percentage of American households that owned televisions exploded from a minuscule 0.5 percent to 84 percent. During the same period of time, attendance at movies fell by one-half. Broadway producers believed that to attract an audience willing to pay high ticket prices, they had to present profitable, popularly acceptable plays. [2]

McCarthyism led producers to define "acceptable" as "uncontroversial." *Life with Father,* a traditional drawing-room comedy about the eccentricities of a voluble yet lovable patriarch, anticipated Cold War conventions that tied national security to male authority and family stability. Its decade-long run reinforced the illusions of social stability that many in postwar America desperately sought, especially the image of middle-class urban America facing the momentous social and political changes of the 1940s. In contrast, dramatists who, in exploring the postwar American psyche, dared to examine the fringes of political or sexual unorthodoxy or questioned patriarchal authority risked their careers.

The decisions of Elia Kazan and Clifford Odets to cooperate and testify before the House Un-American Activities Committee in the spring of 1952 ended the postwar dramatic revival. In response, Broadway returned to the production of light drama and musicals. Ironically, McCarthyism spurred, for a short time, an unforeseen theatrical renewal in New York. The development of Off Broadway, home to unconventional, experimental, and unorthodox drama, owed its origin to the anticommunist trauma of the early 1950s.

## THE GROUP THEATER LEGACY

For a decade, from 1942 to 1952, Elia Kazan's directorial skill and artistic experimentation freed him to defy convention and to create a commercial version of the Group Theater. A prizewinning stage and film director, Kazan nourished the social

realist tradition of the Group Theater, blending and bending it to the talents of the postwar American theater. Two playwrights, Arthur Miller and Tennessee Williams, provided Kazan with a succession of plays—*All My Sons, A Streetcar Named Desire,* and *Death of a Salesman*—that demonstrated Broadway's capacity to present serious and commercially successful drama.

Still, these playwrights played a game of concealment. As heirs to the Group Theater they examined the personal and ethical dilemmas of modern life. They insisted that truth lay hidden in a secret inner core. Even before McCarthyism stifled political dissent and social criticism, the early Broadway plays of Miller and Williams proceeded cautiously. Kazan's direction replaced the political militancy of the Group Theater with a subtle social psychology that muted overt politics.

The 1938 investigation of the Federal Theater Project by the House Un-American Activities Committee was the initial assault on New York's experimental theater. As a result of the investigation, the Clurman-Strasberg-Crawford repertory company moved carefully in the last three years of the Group Theater's existence. In 1937, Harold Clurman assured Kazan that his future lay behind, rather than on, the stage. The aspiring director acted accordingly. Kazan followed Odets to Hollywood, where the playwright, now turned screenwriter and celebrity, arranged for Kazan to work for film director Lewis Milestone, director of *All Quiet on the Western Front.* Milestone served as Kazan's film mentor, insisting on meticulous planning and theatrical technique. The lure of lucrative film contracts and careers proved overwhelming to Kazan, as it did to many former members of the Group. Hollywood's studio system moderated their political stridency and undermined the coherence of the company. Still, Kazan believed that drama should edify. Although he had left the Communist Party, Kazan proudly proclaimed that he continued to think "like a communist."[3] Early in 1941, the Group Theater brought its decade-long experiment to an end with Irwin Shaw's *Retreat to Pleasure.*[4] During the same season Kazan directed his first independent and commercial Broadway play, *Café Crown,* a light comedy set in a Jewish eatery whose *hamish* ambience and wisecracking waiters mimicked the atmosphere of vaudeville and the Second Avenue Delicatessen on the Lower East Side.

In the next four years Kazan directed a series of plays before returning to Hollywood to make his first film, *A Tree Grows in Brooklyn.* His direction stressed movement from social to psychological issues, from the context of the characters to their obsessions and motivations. An alienated figure, Kazan drove himself toward acceptance. "My speech," he wrote proudly at the height of his career, "was still poor, New York street stuff. . . . Despite all that, I was for a few years a cult favorite. I spoke for the times."[5] But something remained incomplete. "I missed the Group Theater, what it stood for and the life it made possible." In 1946 he attempted to recreate the Group theatrical experience on the commercial stage. Kazan did not dream of a permanent repertory company governed by a coherent artistic and political vision. He remained too restless to tie himself down to any institution. Rather, he hoped to place himself at the center of a theatrical movement that adapted the Group Theater's artistic heritage to the postwar commercial stage.

When Group Theater alumnus Kermit Bloomgarden approached Kazan about

forming a joint company, Kazan expressed interest but begged off. But when Harold Clurman suggested they collaborate, Kazan could not resist; as he later recalled, "I was looking for a man smarter than I."[6] Kazan and Clurman agreed to work together, dividing the directing and the producing chores according to the choices of the prospective authors. Kazan directed their first effort, Maxwell Anderson's *Truckline Café*. The moderate success of the play, which featured two relatively unknown actors, Karl Malden and Marlon Brando, propelled Kazan into a frenzy of directorial activity.

In 1946 and again in 1947, Kazan approached former Group colleagues, acting teachers Bobby Lewis and Cheryl Crawford, about founding an acting studio to train a cadre of professional actors to work in film and on stage, employing the Group Theater's method realism.[7] Crawford suggested three of the young actors who had worked with her at the Experimental Theater, Eli Wallach, Anne Jackson, and Julie Harris. Kazan recommended three others whom he had signed for the next season— Marlon Brando, Kim Hunter, and Karl Malden.[8] In the fall of 1947, in its two courses, the Actors Studio enrolled seventy-two aspiring actors.[9]

Kazan shuttled back and forth between Hollywood and Broadway. In 1947 he won an Oscar for directing *Gentleman's Agreement,* a film about anti-Semitism, and directed the first of his three major New York plays, Arthur Miller's *All My Sons.* Within six months he not only launched the Actors Studio but also agreed to direct Tennessee Williams' new play, *A Streetcar Named Desire.* For the Williams play he cast the three students he had originally proposed for the Actors Studio. With Clurman as coproducer, Crawford and Lewis as academy colleagues, and a score of method-trained actors in waiting, Kazan saw Arthur Miller's *All My Sons* as the vehicle to recreate the Group.

Arthur Miller, at thirty-one, had spent the summer of 1946 seated at his kitchen table writing and polishing his latest play, *The Sign of the Archer.* His agent had identified the Theater Guild and the Clurman-Kazan company as potential producers. Miller chose the Clurman-Kazan team because he believed they embodied the Group Theater's tradition of "Stanislavsky and social protest."[10] Recalling that Clurman smelled "like a barbershop" and Kazan crackled with "the devil's energy," Miller sent the script to Clurman, who passed it back to Kazan with strong praise. Clurman judged the play equal to Lillian Hellman's best work. Kazan agreed, seeing Miller's treatment of a morally failed businessman as a "social statement."[11] Miller chose Kazan rather than Clurman as the director. After suffering through the failure of his previous play, *The Man Who Had All the Luck,* Miller believed that *Sign of the Archer* represented his last chance to make his mark as a serious dramatist.[12] Clurman and Kazan believed they had discovered the successor to Odets. In the fall of 1946, Miller revised his play and retitled it *All My Sons.*

Although Miller set *All My Sons* in the Midwest, he wrote about New York. Born in Manhattan, raised in Harlem and in Brooklyn, Miller identified himself with the second-generation immigrant experience whose theme, the overcoming of alienation and the conflict between fathers and sons, took him beyond the implicit ethnicity and locale of New York. He insisted that great drama concerned itself with the moral intensity that undergirded contemporary life. "How are we to live?" Miller

wrote in 1987. "Then as now, the miracle of New York City was the separation of one group from the experiences of others. The city is like a jungle cut through and by a tangle of separate paths."[13] Miller's New York, in the 1920s, before the depression, was Jewish. He dreamed "of pitching the winning game for Yale," denied his parents' foreign and Jewish origins, and denied also his father's authority. Twenty years later, Miller recalled that he "loved the city . . . but moved through it alone, unconnected."[14]

At the University of Michigan, Miller became a literary and political radical. In college he added Whitman, Ibsen, and Hart Crane to the Brooklyn radicalism he had picked up in front of Dozick's drugstore. Crane, Miller recalled, "was a wild outlaw . . . reforging the English language that had fallen into clichés. . . . He was trying to use New York as a metaphor in a way that nobody else was doing."[15] "I love the mimicry of language," said Miller. "I can imitate most languages." With a special ear for the voices of New York's boroughs, Miller drew from New York's profusion of rhythms and idioms to create his characters. Willy Loman, his most enduring character, was an amalgam of persons and voices. "If I can't hear it, I can't really write it."[16] In Brooklyn, Miller learned that speech served a complex social purpose, it signified the hopes or pretenses of people "trying to become more American." To speak like an American not only earned the second generation status, it also functioned as a "survival mechanism" in a society pervaded with anti-Semitism.[17]

Miller saw his father's economic failure as a consequence of capitalism's inner logic, but he also saw the family's loss of chauffeur, apartment, and seaside bungalow through his father's eyes. Marxism explained and forgave personal failure, holding the system, not the individual, morally responsible. Marxism and modern poetry unmasked the "hypocrisies behind the facade of American society."[18] When his colleague and mentor Harold Clurman wrote that Miller was "a moralist," he added that, in contrast to the social playwrights of the 1930s, Miller always concerned himself with the "individual in his moral behavior under specific social pressures."[19]

Miller acknowledged an enormous debt to Odets and the Group Theater. On vacations from Michigan, he attended Group Theater productions, critically admiring the ability of Stella Adler and Clifford Odets to act and to write about human endurance in the face of economic calamity. Miller saw as many of the Group Theater productions as he could. They remained vivid because, at bottom, the Group "was a tremendous collection of talent. I don't know of any such collection since."[20] The heritage of Adler and Odets, social realism, and the psychology of the method defined the theatrical community that Miller tried to emulate in his own plays. Miller wrestled with the family as the source of the values that undergirded modern society and politics.[21] He adjusted and extended the image of power and powerlessness to the complex of familial relationships between fathers and sons and between brothers and brothers. *All My Sons* opened to strong reviews on January 29, 1947, and ran for 328 performances, winning the Drama Critics' Circle Award and eclipsing O'Neill's *The Iceman Cometh* as the season's best drama. Miller's story of wartime corruption, guilt, and human frailty resonated with contemporary audiences, allowing them to sympathetically identify with the symbolic tale of family disintegration. *All My Sons* focused on the devastation caused by a revealed secret in the life

of a flawed though likable person. In Joe Keller's eventual suicide, in the light of ex- posed unethical business decisions, Miller looked at the tragedy of everyday life at a time when millions of ordinary men and women had perished in the world war. Keller's secret—his sale of defective engine blocks to the Air Force, which caused the deaths of dozens of military pilots, including his eldest son—destroyed him. Keller had survived only by denying his responsibility. Public revelation made his life unlivable.

*All My Sons* also paid homage to the realism of the Group Theater.[22] The cre- ation of art that "become[s] part of the lives of its audience" remained Miller's goal. For Miller, Joe Keller's tragedy lay in his inability to comprehend the consequences of his corruption. Keller's crime consisted in his disconnectedness from social re- sponsibility. Miller wanted his play to "lay siege" to the "fortress of unrelatedness" that underlay Keller's condition. As a realist he wanted his audience to mistake Keller's moral self-centeredness, the focus of the play, "for life itself."[23]

Kazan's reading of the play created a "hushed conspiracy" within the company. The Group Theater veterans—Kazan, Clurman, actors Arthur Kennedy and Karl Malden, and set designer Mordecai "Max" Gorelik—objected to what they saw as the injustices of the commercial theater. Gorelik realistically rendered the Kellers' midwestern backyard, its wooden porch overlooking the shaded ensemble of table and chairs. Like Kazan, Gorelik understood the play's symbolism, and he con- structed a small rise, a grave, around which all the living characters had to con- sciously move. "You have," he told Miller when the author asked him about the mound, "written a grave yard play."[24] Gorelik's memorial to the Kellers' son, the pi- lot whose death could be laid at the feet of his father, remained critical to the pro- duction, a symbol of the playwright's underlying morality "that the consequences of actions are as real as the actions themselves."[25] As the physical center of the staged play, Gorelik's grave memorialized the deaths, and, by implication, the ambiguous deaths, of all young men who went to war under the banners of the murky right- eousness of their fathers.

Miller used the Kellers' backyard to examine the small-town midwestern, essen- tially American, texture of the play. Filled with midwestern slang and the gossip of small-town bonhomie and the vestiges of an unexamined capitalist culture, the first act of *All My Sons* evokes a world of courtesy, "want ads, parsley, and Don Ameche."[26] Miller's second-act indictment of war and moral responsibility was both devastating and disguised. Keller's acceptance of responsibility was coincident with the actual events of the Nuremberg trials. The play and the trials occurred when most Ameri- cans found it impossible to consider the question of war guilt in relation to their na- tion's military victories. Miller forced his audience to look inward, to the moral make- up of an unquestionably ordinary American, and outward, to the universal issue of responsibility. He made it possible to transpose places like Auschwitz or Hiroshima into symbols of human disintegration. The power of the play, however, like the Kellers' backyard, covered over the social issues, the misuse of power and wealth, that served as its premise. Miller couched his politics with great care. World War II had been over for a year; the Cold War had not yet begun.

*All My Sons* demonstrates the structure of human life that undergirds apparent

chaos. Written during the war, *All My Sons* pushed the audience to grasp the sense-lessness of its context. Miller took a familiar antiwar theme, betrayal by the captains of industry, the munitions makers, and softened its political criticism. World War II offered little comfort to economic determinists. Its causes could be ascribed less to class greed than to moral failure. As such, *All My Sons* reached for a symbolic truth when Americans yearned to reassert social and cultural norms. Unlike the social playwrights of the 1930s, Miller offered no easy political alternatives. The impetus for change and the moral strength to carry it out, he argued, reside in human consciousness, not in policy and programs.[27] *All My Sons* offers both criticism and comfort—Joe Keller represents universal moral confusion rather than class duplicity.

In April 1947, Tennessee Williams attended *All My Sons* and told Kazan that the "play is dynamite. It ought to take both prizes [the Pulitzer Prize and the Drama Critics' Circle Award] easily. . . . I will write Miller my congratulations (though tinged with envy)." Williams added that Kazan's work "tops any direction I have seen on Broadway" and asked Irene Mayer Selznick, the producer of his newest play, to send Kazan a copy of the script.[28] Kazan liked what he read and agreed to a meeting. Williams' combination of plain talk and flattery convinced Kazan that he could do justice to the play that would become *Streetcar Named Desire*. Williams wrote to Kazan, "There are dreamy touches in your direction which are vastly provocative but you have the dynamism my work needs."[29]

Like Miller, the thirty-six-year-old Williams had written plays his entire adult life. Working in the seclusion of regional theaters and in the shadowy homosexual underground, Williams presented a highly unconventional, elusive, and provocative profile. Williams' plays were about survival. Like Miller, he moved from the conventional political radicalism of the depression to a more personal and confessional tone. His relentless, though masked, investigation of human sexuality, its isolation and its power, thrust him into the world of children, which he explored autobiographically. His 1945 *The Glass Menagerie* dissected a fatherless family living a marginal social existence at a time of national dislocation. Its own universality, the fragility of family life, couched in 1930s lower-middle-class meagerness, corresponded to the experience of millions of American families whose children yearned for their fathers "gone to war."[30] Williams' own vulnerability mirrored the experiences of the society from which he felt socially and sexually alienated.

Thomas Lanier Williams was named by his parents in 1911 in honor of Thomas Lanier Williams, the first chancellor of the Western Territory that became Tennessee.[31] Williams grew up in the embrace of his grandfather, an elderly and kind clergyman, with whom the family lived in Mississippi. His mother, "the indomitable Miss Edwina," a southern lady of standing and strong opinions, and his father, a traveling shoe salesman who drank heavily, served as the archetypes for a succession of his dramatic characters. They also explained his constant sense of loss. The fourth member, a sister Rose, harbored the secret around which the family's complex tensions and neuroses centered.

Weak and sickly, isolated and dependent on his imagination, Williams suffered the family's apparent economic success when they moved from the small-town parish life of Mississippi to the industrial-urban sprawl of St. Louis.[32] University

City, Missouri, an unfashionable suburb with an "ugly region of hive-like apartment buildings . . . and fire escapes," isolated Williams even further. Left to entertain himself in a small suite of rooms whose collection of delicate glass animals "came to represent in my memory all the softest emotions that belong to the recollection of things past," Williams began to write.[33] His childhood became the source of a short story and play, *The Glass Menagerie,* a reflection of the empty family structure and the inner sensitivities of his youth.

Williams' education was interrupted by stints at factory labor, periodic bouts with illness, including a probable heart attack in 1934, and what he called simultaneous attractions for "writing for the theater" and "young men."[34] As Williams fought in fits and starts to accept his homosexuality, he remained closest to his sister, Rose. A young poet with a penchant for the dramatic, Rose confessed to Williams her guilt over sexual fantasies and behavior that led her to conclude that the two of them had to die together. Her depression wounded their mother's social and cultural pretensions, and sometime in 1934 or 1935 Rose underwent a lobotomy and was institutionalized for the remainder of her life.[35]

Williams identified with political radicalism in the 1930s. He voted for Norman Thomas in his campaign for the presidency in 1932. Williams' early writings reflected his political sentiments. An early play focused on the misery of coal miners engaged in a strike against controlling agents and owners.[36] Later, Williams wrote *The Headlines,* the first of a series of "social" plays, for the Mummers, a St. Louis theater company whose community sustained Williams for five years and provided him with the friendship and camaraderie of writers, students, "whores and tramps and even a post-debutante." Their work, he remembered, packed a wallop, and they burned like "fierce little flames."[37]

In 1938, Williams submitted the draft of a new play to the Group Theater's new playwrights contest, and with the hundred-dollar prize money he set out for New York.[38] In 1940 he enrolled in John Gassner's playwriting course, a component of Erwin Piscator's Dramatic Workshop at the New School for Social Research. Gassner, impressed with Williams' gift for language, forwarded a play from the course, *Battle of Angels,* to the Theater Guild for production. The December 1940 closing of *Battle of Angels,* a commercial disaster, in Boston staggered Williams. Living at the YMCA and working as an elevator operator on the night shift and then as a movie theater usher, Williams spent the war years scuffling for enough money to repair an ever worsening cataract condition. Finally, in 1944, he wrangled a job writing screenplays for MGM, at two hundred and fifty dollars a week. The studio detested his work. Williams, reciprocating, quit, only to discover that the studio insisted on paying him for the six months remaining on his contract.[39]

Living off his MGM severance pay, Williams decided to write one last play. He spent the summer of 1944 working on *The Gentleman Caller,* which, as *The Glass Menagerie,* he finished at the Harvard Law School dormitory "in the rooms of a wild boy I'd met in Provincetown in the summer."[40] *The Glass Menagerie* opened in Chicago in December 1944 and in New York the following March. The most directly autobiographical of Williams' works, the play centers on the illusions of a young man whose artistic aspirations are thwarted by his family, a wistfully sentimental

mother and a shy, crippled sister. Obsessed with the desire to marry her daughter off to one of the gentleman callers she remembers from her youth, the poet's mother lives equally in the past and present. Williams used the glass animal figurines of the title to symbolize the fragile beauty of the imagination even in the musty and crowded surroundings of his oppressive family. The figurines establish the emotional tone of the play, standing for the loneliness and vulnerability of the lives of children whose families had been stretched by the dislocations of war and the home front. Constantly on the move, leaving behind their extended families and backyard gardens, the working-class family of the World War II era suffered the distress of urban shoebox housing, factory discipline, and the frightening vulnerability of its children. *Menagerie* won the Drama Critics' Circle Award, played 561 performances over sixteen months, and made Williams wealthy and depressed. A powerful play, *Glass Menagerie* hinted at Williams' concerns, which, given the political climate, he felt he could not address publicly. "Reactionary opinion," he wrote, "descends on the head of any artist who speaks out against the current of prescribed ideas."[41] Williams added, "We are all under wraps . . . trembling before the specter of investigating committees."[42]

## A STREETCAR NAMED DESIRE AND DEATH OF A SALESMAN

Between 1947 and 1949, as Miller, Williams, and Kazan presented the New York theater its two most powerful, challenging, and successful plays—*A Streetcar Named Desire* and *Death of a Salesman*—anticommunism, the domestic arm of the nation's Cold War arsenal, targeted American artists, especially those in the performing arts. The acceleration of the Cold War was marked by the Berlin airlift in 1947 and the explosion of the Soviet atomic bomb in 1949. The rejuvenation of the House Un-American Activities Committee in 1947 and the convening of the Waldorf conference in 1949 brought the struggle back home to the arts in New York. The intensification of political oversight forced Williams and Miller to abandon the political rhetoric of the 1930s. At the height of their artistic talents and riding the crest of financial success, they responded and resisted by cloaking their radicalism in linguistic invention. Their intent, however, in collaboration with Kazan, designer Jo Mielziner, and actors trained by the Actors Studio, was to undermine the rhetorical conventions of American anticommunism and challenge the cultural assumptions of the Cold War. Together, Miller, Williams, and Kazan offered New York drama two alternative visions—Miller's moral and Williams' sexual—to the timid assumptions of the times.

Both *Streetcar* and *Salesman* won Pulitzer Prizes, achieved widespread popular success, and made their respective playwrights wealthy beyond their dreams. Artistic success notwithstanding, Miller and Williams shared a sense of the tragic social and psychological nature of contemporary life, and they tried to translate the mutability of daily life into accessible drama. They combined American realism and European modernism and added their own affection for local idiom. Their use of popular themes and language masked their political and sexual radicalism. Ordinary

speech, vernacular jibes, in-jokes, and clichés became expressions of social and cultural criticism. Miller's stage directions described Willy Loman's blue-lit house as having "the air of a dream." Williams depicted the almost translucent Blanche as having lost the family home of Belle Reve, the "beautiful dream" of an America long past. Both playwrights believed that something had failed in America. Willy Loman and Blanche Dubois were the tragic refuse of change.

Williams first wrote *Streetcar* as a series of several scenes, and then as a one-act play, about a lonely southern school teacher. Set in various cities—Chicago, Atlanta, and finally New Orleans—Williams exposed the inexorable triumph, the human price, of America's urban-industrial transformation. First titled *Blanche's Chair in the Moon,* then *The Moth,* and later *The Poker Night,* the play-in-progress shifted the ethnic background of the Stanley Kowalski character from Italian to Irish to Polish.[43] All three versions of *Streetcar* presented an aspect of Williams' own concealed self-portrait in Blanche Dubois, a poet of delicate disposition, confronted by the massive sexual energy of her masculine opposite, Stanley Kowalski.

Williams rewrote and consolidated these fragments into a full-length play.[44] Even before Williams completed a final draft of the play, he and Kazan discussed its themes, characterizations, and casting.[45] "I think," Williams wrote to Kazan, "its best quality is its authenticity or its fidelity to life." The fully developed story, a play in eleven scenes, tells of Blanche's retreat from the failed family plantation, Belle Reve, to the apartment of her younger sister Stella and her husband, Stanley, in New Orleans. Williams, convinced that he had captured life itself, meditated, "sometimes a living quality is caught better by expressionism than what is supposed to be realism."[46] Gradually, Blanche, the focus of the play, reveals her past life, her secret, and her vulnerability. Her collision with Stanley leaves her without pretension, without resource, dependent, as she poignantly says, on the "kindness of strangers."

The play's triangle, with Stanley at the apex of power and Blanche at the emotional base, proved irresistible for Kazan. Its combination of realism and expressionism employed symbolic truths that encircled Williams' themes of the passing old order, of sexual energy, of human fragility and desperation. Williams, as Blanche, wrote, "I don't want realism. . . . I want Magic! . . . Yes, yes, magic. . . . I don't tell the truth, I tell what *ought* to be the truth."[47]

In California, Kazan's friendship with Hume Cronyn and Jessica Tandy made the actress a "solution to our most pressing casting dilemma in a flash." When Kazan returned to New York in September 1947, he anointed Marlon Brando, whose five minutes in *Truckline Café* Kazan had described as "sensational." Brando, a twenty-four-year-old midwesterner, had studied with Stella Adler at Erwin Piscator's Dramatic Workshop at the New School. The young, muscular, and masculine Brando, whose introverted hipness combined with canny improvisational skills, seemed an obvious artistic choice for the part of Stanley. Williams agreed. Kazan then hired Karl Malden, a Chicagoan of Serbian extraction, for the part of Mitch, Stanley's friend and Blanche's suitor. Malden, a former steelworker and semiprofessional basketball player, had played in *All My Sons* and later won an Oscar for his performance in the film version of *Streetcar.* Kim Hunter, a young actress from Kazan's class at the Actors Studio, took the part of Stella, Blanche's younger sister.

Williams' theme, bristling human sexuality simmering under the surface of social convention, cloaked his characterization of Blanche, a displaced self-portrait of fragility, dependence, and alienation. In creating Blanche as a woman and allowing her to fall prey to the aggressive sexuality of Kowalski, Williams projected his own sexual identity through allusion. Convinced that in art people "are shown as we never *see* them in life but as they *are*," Williams persuaded Kazan to adopt his vision of Blanche and Stanley as characters whose nature cannot be fixed.[48] The director worked with Brando and Tandy to establish the play's development, shifting the audience's point of view from Stanley's early reaction to Blanche as a villainous bitch to pity for her vulnerability and, finally, loss at his violent hands. Blanche, reasoned Kazan, had to be "a heavy" in the beginning, taunting Stanley until, revealing her pain, she led the audience to "feel the tragedy" born of their understanding of her inner integrity.[49] Blanche Dubois, a "butterfly" caught in the light of contradiction, subsists on illusion. When Stanley cruelly tears the illusions away, Blanche is left holding the shreds of a past she has sought to conceal.

Kazan observed about Blanche, "her tradition is her tragedy." He portrayed her antagonist, Kowalski, realistically. A tough, unselfconsciously intuitive man, Stanley's urban ethnicity contrasts with Blanche's delicate southern ways. "A hoodlum aristocrat," as Kazan called him, Kowalski sexually dominates Blanche, bringing her down to his level.[50] Instructing Brando to play Kowalski with all the orality at his disposal, Kazan emphasized Stanley's constant pleasure, his sexuality, and his primal appetites—smoking cigars, chomping cold chicken, and seeking approval. Brando's famed bellow, "Stellaaaaaah!" became a signature for the actor, the character, and the play.

Brando provided the insight to Stanley Kowalski and drew attention to Williams' poetic inventiveness. "I'm an ear man," Brando remarked with studied bluntness. He heard Stanley's coarseness of speech, his flat nasality, as a revelation of character. "Stanley didn't give a damn how he said a thing," said Brando. Kowalski has "no awareness of himself at all."[51] His use of words flies in all directions. "Especially when you've been exercising like bowling is," Stanley proclaims with clumsy virility. In Williams' writing, Blanche's "kindness of strangers" clashes with Stanley's "they requested her to turn in her room key for permanently"; the contrast distills the antagonism, social and psychic, between the two characters.

When Arthur Miller, still mulling over his "salesman" play, saw *Streetcar*, he realized just how "brilliantly" Williams and Kazan had used speech.[52] Miller noted that they had taken language beyond the confines of realism, reforging expression that had "fallen into clichés."[53] Early in the play, Stanley tells Blanche to "cut the rebop." Williams specified, in the stage directions, a "tinny piano being played with the infatuated fluency of brown fingers." "This 'Blue Piano,'" in Williams' words, expressed the "loneliness and rejection, the exclusion and isolation of the Negro and their . . . longing for love and connection."[54]

Williams and Kazan used jazz allusions to express Stanley's "intermingling," the dominant image used in the explosive third scene, "The Poker Night." Williams' directions for the set referred to the lurid nocturnal brilliance of a van Gogh painting. Drunk, taunted and tortured by Blanche, who has tuned a white plastic radio to play

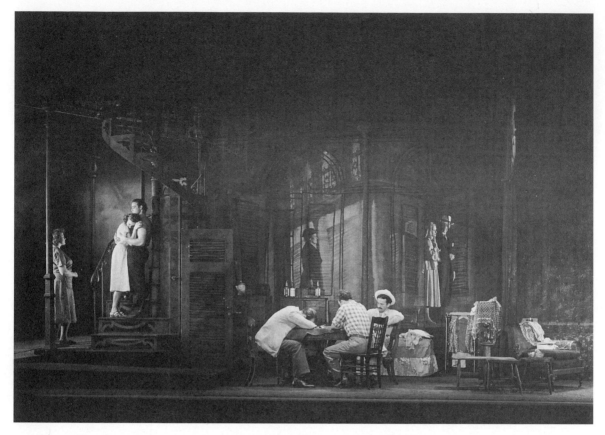

A *Streetcar Named Desire* (1947), by Tennessee Williams, starring Kim Hunter, Marlon Brando, and Jessica Tandy, directed by Elia Kazan, set designed by Jo Mielziner. *Photograph by Eileen Darby*

a German art song, Stanley explodes. Identified with black jazz, instinct, and sexual desire, "with a shouted oath," he heaves the radio out of the apartment window. So much for Blanche, so much for the alien German high culture. Stanley assaults Blanche's refinement, her culture, as he has her body.

In Stanley's sexual dominance, a prefiguration of the death of Blanche's world and the disintegration of her spirit, Williams mirrored the language Stanley uses to separate himself from both Blanche and Stella. With poker, a game controlled by fate, as a continuing image, Stanley yells at the two sisters, "What do you think you two are? A pair of Queens?" Blanche's tragically suicidal husband, Allan Grey, bears a name that both evokes the word *gay* and alludes to the Grey Poet, Walt Whitman. As Williams wrote in *Streetcar*'s last line, "This game is seven-card stud."

Arthur Miller recognized the subversiveness of Williams' work. Its experimentalism concealed and acknowledged forbidden sexuality. "*Streetcar*," Miller exclaimed, "had printed license to speak at full throat."[55] Drawing on Williams' lead, Arthur Miller placed Willy Loman's desperate choice, the taking of his own life, squarely at the center of *Death of a Salesman*. He placed the blame less squarely. Willy kills himself, but his social condition as a small man in the unforgiving culture of commerce has dealt him a mortal blow. From *Streetcar*'s example Miller realized that the play he planned to write "couldn't be encompassed by realism." His salesman, Willy Loman, lives with the past, a shimmering presence that threatens at any

332

moment to come "crashing in to overwhelm his mind." Miller wanted his play to reflect the "unbroken tissue that was man and society, a single unit rather than two."[56]

Originally entitled *The Inside of His Head,* Miller's play was inspired by a chance encounter with a salesman for whom hope had been "food and drink." The story Miller wrote, when rearranged chronologically, tells of the social tragedy of Willy Loman's life and death. The salesman, prosperous and full of beans and hope in the 1920s, grasps at an empty dream.[57] In bending the narrative conventions of realism, *Salesman* begins by announcing its end, its story "determined by what is needed to draw upon [Willy's] memories." The play's action occurs during the last day in the life of a traveling salesman who, like Blanche, finds that the illusions he has lived by no longer shelter him from the realities he has dodged. Bobbing and weaving, flailing about, Willy Loman's final flurry of anger and pathos turn inward. To Miller, the play presents the attempt of those around Willy, his wife, Linda, and his two sons, Happy and Biff, to understand "what was killing him."[58] Miller wanted his audience to ask the same question. Superficially, it is Willy's demons, the smallness of his life, that consume him, but Miller concealed his more fundamental indictment, uttered by Charlie, a minor character in the play who serves as chorus and conscience. "Nobody dast blame this man," declares Charlie. "A salesman is got to dream, boy. It comes with the territory." Not a member of the family but perhaps the only friend Willy has ever had, Charlie knows and tells the truth. The territory, as Charlie knows, is the salesman's special province, his workplace and bread basket, a place so tough Willy can only hope to ride "on a smile and a shoe-shine." Charlie delivers the goods of Miller's play; he hands Willy back to the system that has destroyed him.

As a portrait of an American family, *Death of a Salesman* stood at midpoint between the "kitchen sink" realism of Odets and the televised wisecracks of the 1950s *Honeymooners.* Like *Streetcar,* *Death of a Salesman* depicts a socially failed and psychologically frail soul whose ordinary yet tragic existence derives less from Ibsen than from Sholom Aleichem. Willy Loman's bluster, his muddled ethics, his jealousy and loves, and his hidden secrets lead him to the gates of heaven, there to beg, like some lost shtetl soul, for a crust of bread. Willy suffers at the hands of a capitalist system that broke down in the depression and fails again in the prosperity of postwar America. He cannot comprehend his relationship to his circumstances. In his social and psychological alienation, Willy becomes the opposite of his neighbor, the affably cynical and successful Charlie, winner of the financial rewards of capitalism and the alter ego of the audience. Willy's last act, his suicide, brings his family the prosperity, in the form of a life insurance policy, that his life has denied them.

Miller mailed his script to Kazan, who read "the damned disturbing play" in one sitting and called Miller to tell him that "his play had 'killed' me." Kazan recognized the resemblance between Willy and his own father, and it bound him even more closely to Miller, whom he regarded as a brother, an artist who struggled to climb out of Willy Loman's lower-middle-class world. Miller, too, realized that his play had worked. Kazan sounded like someone had just died, and "it filled me with happiness. Such is art."[59] Planning the production, Kazan approached Kermit Bloomgarden and Walter Fried to act as producers. The Group Theater veterans assured the play's financial backing.[60]

As a story about the unraveling of a single life, *Death of a Salesman* presented no textual problems. From Kazan's point of view, however, the original script, which began only with directions ("The salesman is revealed. He takes out his key and opens an invisible door") represented a "play waiting for a directorial solution."[61] Kazan and Jo Mielziner created Willy Loman's world, a space and mood whose melancholy they evoked even as the curtain rose. "A melody is heard, played upon a flute. It is small and fine, telling of grass and trees and the horizon," Miller later wrote, hinting at a time before capitalist commerce when people like Willy felt at one with their surroundings and with themselves.

Miller imagined Willy as a small man in deep middle age, a combative, blustering bantam whose outward demeanor stands in pitiful contrast with his concealed anguish. Miller and Kazan, however, asked Group veteran Leo Cobb to read for the part. In the 1930s, Cobb, a large overflowing man, had played parts in *Waiting for Lefty* and *Golden Boy* before graduating to several Hopalong Cassidy movies in the 1940s. In his late thirties at the time, Cobb loudly informed Miller and Kazan, "This is my part. Nobody else can play this part. I know this man."[62] Cobb portrayed the older Loman, the stoop of his shoulders sagging under the weight of years of hidden angst, a perfect accompaniment to the actor's own bulk. Lee J., as he called himself, strode into Bloomgarden's office just prior to the start of rehearsals to proclaim, "This play is a watershed. The American theater will never be the same."[63]

Kazan, too, first thought of Willy as a "small man who wears 'little shoes and little vests.'" He guided Cobb toward a richer understanding of Willy, a reading that bore a remarkable similarity to his interpretation of Blanche. Willy Loman represented for Kazan "everything misguided about the system we live in"; yet in the hands of the director, Willy emerged as a figure of pity and even affection. A combination of compassion and social criticism marked the Kazan-Miller collaboration on *Death of a Salesman*. Their social psychology condemned Willy's ethic, a vision that Kazan characterized as one "that makes you believe that the terrible things which happen are true . . . [and] inevitable." Willy's fault lies not in himself but in the fact that "he had the wrong dream."[64]

Kazan's reading was prompted by Miller's use of language and cliché. Willy's homilies, his instructions to his children—to be well liked, to sell one's self, to get by— become his character. The very things that the system of commercial capitalism has taught him—to get ahead no matter what the cost, to conceal the consequences— have become his lessons, which Willy internalizes and transmits. His personal betrayal, a seedy affair in a hotel room interrupted by Biff's unannounced appearance, mirrors his external confusion.[65] Willy's moral flaws derive from the economic system, which possesses his soul, his true self residing, like Blanche's, in another time.

Jo Mielziner understood that Miller's desire to reach beyond the limits of realism to explore Willy's mind as he simultaneously thought, remembered, and fantasized demanded instant time changes "from the present to the past and back again."[66] Mielziner's design made the salesman's house a single unit that encompassed what would otherwise have required fifteen different sets.[67] Willy's skeletal home, the salesman's symbol, served as the play's center, which Kazan surrounded with all the nonhome locales—washrooms, restaurants, hotels, and offices."[68]

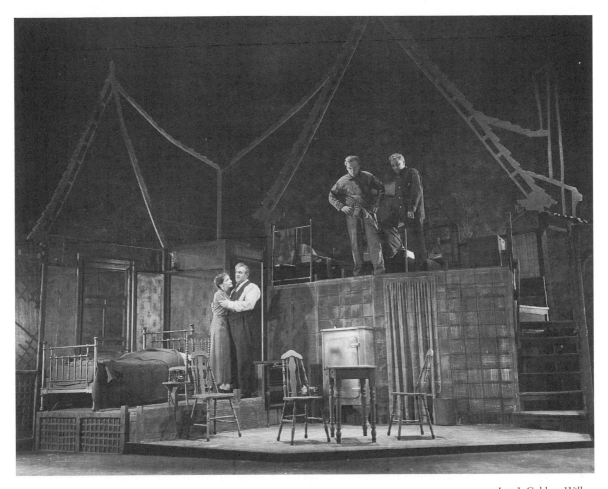

Lee J. Cobb as Willy in *Death of a Salesman*, by Arthur Miller, directed by Elia Kazan, set designed by Jo Mielziner. *Photograph by Eileen Darby*

Miller's blending of time was integral to understanding *Salesman*. Mielziner created two projections establishing the major temporal moments of the play and then translated Miller's most enduring theme in visual and poetic terms. Alienated and alone in the present, Willy remembers a pastoral time "of grass and trees and the horizon." Mielziner hung a backdrop of unbleached muslin behind the framed house. On the muslin he painted the outlines of a city with hulking tenements that surrounded Willy and his family with "angular shapes" whose "angry glow" revealed "a solid vault of apartment houses." Hemmed in, with the broken symbols of the culture that has defeated him—a refrigerator in constant need of repair—Willy recalls the past. As his boys suddenly appeared, high in spirit and hope, Biff's confidence so strong he could hardly contain himself, Mielziner projected the shadows of leaves, their presence suggesting a light and open airiness, "blotting out the apartment houses." This, thought Mielziner, was the key to dramatizing Willy's "day dreaming."[69]

By blending realism with expressionism, Miller, Kazan, and Mielziner reshaped postwar American theater. Following the artistic and commercial success of *Streetcar,* and influenced by Williams' sense of language, the team created *Salesman,* in a

sense, as the last production of the Group Theater.[70] Although Miller and Kazan both aspired to the Group Theater's heritage of social drama, free of ideological pretense and accessible to mass audiences, they also drew back from the Group's strident politics. Willy Loman became a midcentury Everyman, a symbol of the contradictions of a capitalist culture that continued to cling to the dreams of community. Miller, Kazan, and Mielziner employed experimental techniques borrowed from expressionism and modernist stream of consciousness as a "means of rendering the character of Willy Loman."[71] The play's political message remained just out of earshot.

The characters in *Death of a Salesman* disclose themselves by their speech, their idioms, their images, and by jokes. Miller understood that popular language gave his play a tone that made it understandable to a broad public.[72] His characters create their own idiom, what Miller called "bastard elegance," of inverted cliché that uncovers the "rents in the American dream" that lay at the heart of the play.[73] Willy peppers his speech with outmoded clichés ("never fight with a stranger, boy") and occasional poetic imagery, which presses the concrete and the abstract absurdly against each other ("the world is your oyster, but you don't crack it open on a mattress"). The social anxiety that he works to overcome remains embedded in the way he chooses to express himself. He can no more conceal his inner self than he can deny the mass of buildings that overshadow his meager home. Reduced to a set of adages ("You can't eat the orange and throw away the peel—a man is not a piece of fruit"), Willy expresses his hopelessness, the condition that leads him to take his life. Miller marshaled the colloquial voices of New York, and by alternating the rhythms of elation and despair, he illuminated "the disparities between Willy's dreams and reality."[74]

*New York Times* critic Brooks Atkinson proclaimed the play a hit. *Death of a Salesman* played for 742 performances and won the Antoinette Perry Award, the New York Drama Critics' Circle Award, and the Pulitzer Prize. Cobb emerged as a great dramatic actor who gave a "heroic performance" in an "epic" that had become "poetry in spite of itself."[75] By opening night, Miller realized that the "conspiracy" of Kazan and Mielziner had spread through the cast and crew. They had created something "brand new." *Death of a Salesman* had become New York drama. It sustained the heritage and community, if not the politics, of the Group Theater. As a "kind of conspiracy to overthrow silence," *Streetcar Named Desire* and *Death of a Salesman* demonstrated that serious, well-conceived, and well-executed drama could attract a popular audience and achieve financial success.[76] Miller, Williams, Kazan, Mielziner, Brando, Cobb, Malden, Clurman, Bloomgarden, and Fried seemed poised to preside over an American theatrical renaissance. Anticommunism, not the indifference of popular audiences, would soon destroy their dream.

## THE WATERFRONT

Late in the winter of 1949 dozens of leftist American intellectuals and a small handful of Soviet personalities gathered for a conference at the Waldorf-Astoria Hotel. Outside, as nuns prayed for the souls of the sinners gathered within, New York

University professor, former Trotskyite, and anticommunist philosopher Sidney Hook demonstrated against the meetings. The Waldorf conference, more properly the Cultural and Scientific Conference for World Peace, furnished McCarthyism with more "evidence" of American subversive activity than any other single event in the postwar era. The U.S. attorney general identified and placed on a list of "suspected Communists" all who attended or supported the Waldorf conference.

Aaron Copland, Philip Evergood, W. E. B. Du Bois, Mark Van Doren, Norman Cousins, Norman Mailer, Lillian Hellman, Clifford Odets, Budd Schulberg, Langston Hughes, Rexford Tugwell, and Paul Robeson all attended the conference. Arthur Miller agreed to chair a session at which Odets spoke. The Waldorf conference was the last act of the New Deal–Popular Front artists and intellectuals who had participated in the Artists' and Writers' Congresses of the 1930s. For three days in 1949, the most critical year of the Cold War, American communists, socialists, and liberals discussed world peace and cultural exchange. Harvard professor F. O. Matthiessen, speaking on civil rights and civil disobedience, found himself challenged by representatives of the liberal anticommunist literary movement that included Max Eastman, Dwight McDonald, and Mary McCarthy.[77] The Soviet delegation included Dimitri Shostakovich, who announced his nation's continued commitment to peace and intellectual freedom but refused to respond to questions about Soviet persecution of artists. The U.S. State Department had refused visas to Hungarian and Romanian representatives.

Miller, chairing a session on writers and politics, introduced Odets and sat back, listening in astonishment. Why, Odets asked rhetorically, have politicians failed? Why have they pushed Soviet and American society to the brink of war? Miller remembered vividly, "The audience pressed forward, straining to hear his voice. Then, slowly, his hand rose above his head, his fist closed, and at the top of his voice Odets, who had fourteen years earlier sent the young Elia Kazan as Agate on stage in *Waiting for Lefty*, yelled, 'MONEEY! . . . MONEEEY!'"[78]

The domestic front of the Cold War—the trials of Alger Hiss and Julius and Ethel Rosenberg, the attorney general's list, the investigations of the House Un-American Activities Committee (HUAC), and Senator Joseph McCarthy's Senate hearings—loomed over New York's modern artists in the 1950s. The political alliances that transformed Richard Nixon, Roy M. Cohn, and Joe McCarthy into powerful and feared anti–New Deal ideologues ruled the day. In 1947, Congress reorganized the House Un-American Activities Committee under the leadership of J. Parnell Thomas, counsel Robert Stripling, and Richard Nixon. President Harry Truman and his advisers Clark Clifford and Attorney General Tom Clark agreed that the Democratic Party should pursue a high-profile anticommunism policy. In 1947, anticipating the upcoming presidential election, Truman issued a presidential order that required federal employees to sign loyalty oaths stating that they did not belong to the Communist Party. The Truman administration agreed to support HUAC's new authority to ferret out political subversives identified by the attorney general.[79]

John Rankin, HUAC member and congressman from Alabama, asked Thomas to call for a "cleansing" of the film industry. In September, HUAC subpoenaed forty-two prominent screenwriters, actors, and directors. Of those identified by HUAC

as communist or fellow travelers, nineteen refused to cooperate. Of the nineteen, all but six were Jewish, and of these thirteen the committee focused on the so-called Hollywood Ten.[80] Dalton Trumbo, Howard Fast, Alvah Bessie, and John Howard Lawson were the most prominent writers and directors called to testify. Some had been active in the Communist Party in the 1930s, but they were actually charged with disloyalty, based on the communist themes and symbols that had been disguised or smuggled into their commercially successful films in the 1940s.

In October 1947, the committee summoned dozens of other Hollywood personalities, including Gary Cooper, Ronald Reagan, George Murphy, Walt Disney, and Robert Taylor, who asserted that communism had become rampant in Hollywood during the war. Actor Adolphe Menjou stated proudly, "I am a witch hunter if the witches are Communists. I am a Red-baiter. I would like to see them all back in Russia."[81] Reagan, president of the Screen Actors' Guild, responded to Nixon, "I detest, I abhor their philosophy."[82] Studio head Jack L. Warner, in a secret executive session, accused Miller and Kazan of subversion.

When hostile witnesses appeared, HUAC produced their Communist Party cards and refused to allow them to read prepared statements. Writers Ring Lardner Jr., Samuel Ornitz, and Adrian Scott were silenced by HUAC's tactics of intimidation and manipulation. In protest, John Huston, Gene Kelly, and Humphrey Bogart organized rallies, produced a radio program, and collected a thousand signatures supporting the Hollywood Ten. The reaction of the studios, however, proved more critical. Louis Mayer told Katharine Hepburn that he would not allow her to perform unless she cleared her name. Five of the Hollywood Ten, the writers and directors who remained hostile to the committee, lost their jobs as their studios released them from long-term contracts when the hearings ended. In April 1948, Trumbo and Lawson were tried and convicted for contempt of Congress. Two years later, in 1950, the Supreme Court, with William O. Douglas in dissent, upheld the convictions of the Hollywood Ten, who served their sentences at a Danbury, Connecticut, prison.[83] Following his release a year later, one of the Hollywood Ten, director Edward Dmytryk, agreed to testify as a friendly witness. Dmytryk went back to work immediately.[84] The rest would wait for more than a decade to have their real names used on the credits of the films they had been required to make pseudonymously.

In the spring of 1952, the second round of hearings on communist infiltration of the motion picture industry reached its climax with the testimonies of Kazan and Odets in the spring of 1952. These hearings targeted individuals rather than the content of their films. Studio heads and craft guilds agreed to cooperate with the committee and with the parallel activities of the Motion Picture Alliance for the Preservation of American Ideals, a watchdog group presided over by John Wayne. The first round of investigative hearings had failed to establish that the accused writers had advocated radical or subversive ideas, asserting only that they had contributed to Communist Party causes, signed petitions, or attended meetings and barbecues with party members. In 1952, with the blacklist in full operation, HUAC counted on the film industry to enforce its edicts. The prominent and near-prominent named names, expanding the list of potential witnesses. To defend their stars and person-

nel, studios hired professional "cleaners" to assist the accused in clearing their names. On the side, the cleaners published newsletters that contained libelous charges provided by cooperative newspaper columnists Westbrook Pegler, Walter Winchell, or Victor Riesel, which became "the evidence" that the cleaners offered to disprove. At its best, the cleaners served as a form of political protection, creating and then discrediting the evidence that sustained the black list.[85]

This second round of investigation began when actor Larry Parks revealed his Communist Party membership as well as names of Hollywood personalities who had been Communists during World War II. Sterling Hayden, a decorated war hero, then identified Group Theater veteran Morris Carnovsky. The testimony of Parks and Hayden set off a chain of incrimination that implicated more than a thousand film, radio, television, and theater professionals. Although Broadway producers did not actively participate in the blacklist, the trail of gossip, innuendo, and defamation smeared actors and technicians whose livelihoods depended on work in several mediums and forced them to respond to spurious or circumstantial charges. As each friendly witness—Edward G. Robinson, Jerome Robbins, Lee J. Cobb, Clifford Odets, and Elia Kazan—cooperated, new names were offered up, corroborated by information provided by blacklisting networks through publications such as *Red Channels* or *Aware!*

Investigators for HUAC were especially interested in the cooperation of witnesses from Broadway who had ties to Hollywood. Kazan, Odets, Lillian Hellman, Budd Schulberg, and John Garfield became targets whose cooperative testimony, it was hoped, would further HUAC's momentum. The committee interpreted refusal to cooperate or invocation of the First and Fifth Amendments as admissions of guilt. Those named by others faced the almost impossible choice of some form of cooperation or sure professional ruin.[86] Some witnesses cooperated by naming only those already named. Some secured permission from friends and acquaintances before naming them. Others claimed faulty memory.[87]

For weeks in the winter of 1951–52, Kazan and Odets had worried that their names would appear on the subpoena list. They feared the appearance of an anonymous process server at their door that would lead to the ruin of their careers and alienate them from friends they implicated. A sense of dread descended as they struggled, like Willy Loman, with the legacy of the past. Kazan grappled with the dilemma. "Why," he asked himself, "should I be the only one not to give names?" Darryl Zanuck told him, "name names for chrissake." Kazan's wife, Molly, urged him to "tell the truth." Moreover, as the director of the film version of *Streetcar Named Desire,* nominated for an Academy Award, Kazan had a directorial reputation to protect. Kazan claimed that at the HUAC executive session on January 14, 1952, he had decided not to talk about others and had remained true to that conviction. But the *Hollywood Reporter* printed an account of his testimony.[88] Informed that he would be asked to repeat his testimony in public, Kazan spent the next several weeks reconsidering his position.

Kazan and Odets, the two comrades from the Group Theater, appeared as friendly witnesses in the spring of 1952. Kazan acknowledged that he had given some names in the executive session of January 14 and was now prepared to "name all of them."[89]

Kazan's testimony spared him cross-examination. He simply read a statement reiterating his identification of those Group Theater members who served in his "unit" in the mid-1930s. In addition to those previously named, Kazan included Odets and Paula Miller, wife of Lee Strasberg, who had given him permission to name her. Kazan denied that he had sponsored the Waldorf conference and claimed that Jim Proctor, Arthur Miller's publicist, had erroneously included his name on a petition supporting the conference. Two days later, on April 12, 1952, Kazan published a full-page ad in the *New York Times* explaining his action. From that day on, actor Zero (Sam) Mostel referred to Kazan as "Looselips."[90]

Odets testified in executive session ten days later and then in open hearings on May 19, 1952. He named virtually the same Group Theater members as Kazan had and defended his decision to testify on the grounds that the *Daily Worker* had once called him a "hack writer."[91] Playwright Lillian Hellman responded differently. Counseled by Abe Fortas and Joseph Rauh Jr., Hellman offered to testify freely about her own activities but not those of others. When the committee refused to grant the exemption, Hellman refused to answer the counsel's questions, invoking the Fifth Amendment. Instead, she released a letter to the committee. Hellman wrote, "I cannot and will not cut my conscience to fit this year's fashions."[92] As the most daring resistant to HUAC's campaign to date, Hellman offered an alternative to the categories of "friendly" and "hostile" witnesses that HUAC had tried to impose.

Miller, in contrast, enjoyed the momentary luxury of avoiding the controversy. As he listened to the hearings in Washington, however, he recognized their ritualistic quality and kinship to the seventeenth-century Salem witch trials. Both the HUAC hearings and the Salem trials, Miller thought, demanded the spectacle of public confession before the governmental "decree of *moral* guilt."[93] Determined to write a play about the dilemmas posed by the conflict between state authority and individual responsibility, Miller traveled to Salem to examine the records at the local historical society. He had already imagined a character, John Proctor, who, having committed adultery with a young woman, suddenly discovers that she has become his wife's chief accuser of witchcraft.

On his way to Salem, Miller visited Kazan's home in Connecticut. Kazan confessed that he had named names at the executive session several months earlier. Miller acknowledged the gloomy logic of Kazan's position: "Unless he came clean he could never hope, at the height of his creative powers, to make another film again."[94] As Miller prepared to leave for Salem, Molly Kazan spoke, "You're not going to equate witches with this!"[95] Molly's words echoed as Miller heard the news of Kazan's testimony on his car radio, and he mused that some people in Salem had fully believed in the existence of witchcraft.[96] Moral guilt connected the two events over the span of three centuries.

Miller's *The Crucible* derived directly from the HUAC hearings. Set in Salem in 1691, the play examines the contagion of accusation that results when a group of young women first admit to and then accuse others of witchcraft. Setting the young against the elderly, the poor against the well-to-do, and the state against the individual, the storm of hysteria destroyed Salem. Miller added dramatic details of his own invention: first, a sexual affair between the historical John Proctor and his young

housekeeper, Abigail Williams, who in turn sets out to destroy Proctor's wife, through the accusation of witchcraft; and second, the ecstasy with which his protagonists prayed and danced. "Yes, I understood Salem in that flash," he wrote, "it was suddenly my own inheritance."

The play's central moment, John Proctor's refusal to sign a false public confession that would spare his life, revealed Miller's probing of the role of conscience and social conformity. At the center of a passionate triangle, Proctor, filled with shame at his own infidelity and his continued longing, understands the ardor of his wife's accuser and only later comprehends that his sense of justice outweighs his inner need for expiation. Proctor's refusal to confess ultimately brings him to the gallows. Confronting the power of colonial theocracy, and in the face of enormous public pressure, Proctor affirms his sense of self and of justice by allowing the state to take his life.

By breaking the politically imposed dynamic of "confession and forgiveness," Proctor rejects the notion that the state, not the individual, possesses the authority of conscience.[97] As Miller wrote in the middle of the first act, "like Reverend Hale and others on this stage, we conceive the Devil as a necessary part of a respectable view of cosmology." Proctor, unable to accept the hand of the devil, confesses only to his private guilt, his sexual lust for Abigail. Later during his hearing, when confronted with an offer to trade his name for his life, he pleads, "How may I live without my name? I have given you my soul; leave me my name." Finally, in the light of understanding, he cries, "I have confessed myself! Is there no good penitence but it be public?"

*The Crucible* met neither critical nor commercial acclaim. The Broadway version, which opened in January 1953, lasted only half a year and barely broke even. Despite a formidable cast, which included Arthur Kennedy, Beatrice Straight, and E. G. Marshall, *The Crucible* suffered from Kazan's absence. Jed Harris, Kazan's replacement as director, lacked the sensibility and the political courage to blend realism and expressionism to create the "subjective reality" that Miller believed the play needed.[98] Clearly, however, the play's modest reception derived from its topicality. "In the teeth of the McCarthy gale," Miller explained, the play simply could not hold. *The Crucible* was both of the times and against them.

Two years earlier, Kazan and Miller had agreed to work on a film project. In 1950, they made the rounds of the major film studios to peddle Miller's screenplay, *The Hook*. Its setting, the Red Hook waterfront district in Brooklyn where Miller had worked as a fitter during the war, and its Italian working-class characters were staples of Miller's writing. In probing the conflict between moral strength and social, political, and economic survival, *The Hook* shared with virtually all of Miller's serious work the theme of integrity. Miller constructed the story of *The Hook* from a series of episodes he had witnessed on the docks. There, reformers challenged the stranglehold that a combine of union officials, loading bosses, and local politicians exercised over rank-and-file longshoremen. The film script pleaded for a return to grassroots democracy in the labor movement and the reform of corrupt hiring practices.

Miller and Kazan bounced from producer to producer before closing an appar-

ent deal with Columbia studio chief Harry Cohn.[99] Miller and Kazan agreed to allow the studio to examine the political themes of the script. Cohn brought in a union representative, a "fixer" he employed to clear the project. The fixer recommended that the film's major character, Marty, become a staunch anticommunist. Miller first agreed to some rewriting and left for New York, only to call back and tell Kazan that he wanted to withdraw from the project. Kazan dutifully informed Cohn, who responded, "Miller is a Communist. I could tell just by looking at him." As for Kazan, Cohn said, "You're just a good-hearted whore like me."[100] Ironically, Miller's *Hook* provided Kazan the outline for his critically acclaimed anticommunist film, *On the Waterfront,* which opened in July 1954 and enjoyed enormous box-office success. The film's story answered Miller's questions of guilt, conscience, and redemption. Kazan shot much of the film in Hoboken, New Jersey, with actors he had trained in the theater, including Brando, Cobb, and Malden.

The story of *On the Waterfront,* Terry Malloy's decision to break the code of silence to testify before an investigative committee on the corrosive effects of union racketeering, bore a striking resemblance to *The Hook.* The difference lay in Terry's willingness to testify. Kazan developed the *Waterfront* script with writer Budd Schulberg, who had also appeared as a friendly witness before HUAC and who had diligently researched the story of a local Hoboken longshoreman, Tony Mike de Vincenzo, a hiring boss blacklisted for bucking the union.[101]

Filmed in black and white at a time when most studio productions appeared in technicolor, *On the Waterfront* was striking for its visual authenticity. The effect of steam and condensation, menacing snow-laden clouds, and the river's whitecaps enhance the film's ambiguous quality. Harbor whistles obliterate human voices as the characters struggle to overcome the ethic of "deaf and dumb." Kazan used language to convey his meaning: stool pigeons became in his hands the birds that Brando's character lovingly plays with on his tenement rooftop. Rats, mice, and vermin abound. Terry's famous, "I coulda been a contenda," delivered in slurred speech by Brando, echoes the lines in Miller's earlier screenplay.

Kazan was well aware that his reputation and career depended on the film's success. Cohn, the Columbia Pictures mogul who had vetoed Kazan's earlier effort with Miller, approved of the Kazan-Schulberg version. Terry, Brando's character, as he yells at Cobb, "I'm glad what I done," could have been Kazan, saying, "I am glad I testified."[102] Produced at a cost of $880,000, *On the Waterfront* earned its director and star $100,000 each. Brando roundly declared his bitter disapproval of Kazan yet agreed to work with him for the picture. Kazan, ever the fighter, identified with Terry: "*On the Waterfront* was my story: every day I worked on that film, I was telling the world where I stood and my critics to go fuck themselves. As for Art Miller the film spoke to him."[103]

By 1953 the rebirth of the modern postwar theater in New York had fractured. McCarthyism destroyed the artistic community that had sustained a brief moment of energy and creativity. In the face of impending disaster, Miller and Kazan reacted differently, and for the next decade their paths diverged widely. McCarthyism, however, did not silence alternative theater in New York. Although Broadway producers

might have lacked the courage to mount the Miller and Williams plays, others did not.

## OFF BROADWAY

The commercial failure of *The Crucible* forced innovative and provocative New York drama if not underground at least off Broadway. At the end of World War II, only two small New York theaters, the Cherry Lane and the Provincetown, presented Off-Broadway plays. Two events resurrected a new, experimental, and controversial Off Broadway. First, in 1950, Actors' Equity officially designated as Off Broadway any theater outside the bounds of midtown, the area defined by 34th and 56th Streets and Fifth and Ninth Avenues, whose houses accommodated from two hundred to three hundred patrons. Actors' Equity then authorized its membership to work Off Broadway at a minimum scale of five dollars per week.[104]

This new territorial and contractual arrangement legitimated a new company, then called the Loft Players. Composed of young actors who had worked together in Woodstock, the Loft Players hoped to present new plays financially unfeasible on Broadway. The group refurbished a club on Sheridan Square in Greenwich Village, operating first as a cabaret. In 1951, on a makeshift stage with a horseshoe seating area, the rechristened Circle in the Square launched its career with a "quirky and surrealistic" production of William Berry's *Dark Side of the Moon*.[105]

Two years later, Circle in the Square's production of Tennessee Williams' *Summer and Smoke* proved the viability of Off Broadway. Directed by Panamanian José Quintero and starring Geraldine Page, *Summer and Smoke* ran for almost a year, establishing Page as a major star and Off Broadway as the primary venue for alternative theater in New York. The Williams play had failed commercially in its Broadway production in 1948. Its themes of emotional and sexual intensity proved too difficult for audiences at the time, its small production no match for the success of *Streetcar*. Brooks Atkinson's favorable notices—of the first Off-Broadway production reviewed on its opening by a first-string critic—validated the Circle in the Square. In the next two years Quintero and artistic director Theodore Mann negotiated with Eugene O'Neill's widow to mount what would be critically acclaimed productions of *The Iceman Cometh* and *Long Day's Journey into Night*. Working in the tradition of American social and psychological realism, Circle in the Square demonstrated that important American drama could be sustained Off Broadway, even if it was necessary to rely on the earlier work of Williams and O'Neill to do so.[106]

By mid-decade several other theaters and producers joined the Circle in the Square Off Broadway. The Living Theater, created by Julian Beck and Judith Malina, reestablished the relationship between radical arts and politics. Malina and Beck began to collaborate just after the war. In 1946, working with New York's avant-garde artists, composer John Cage, modern dancer Merce Cunningham, and poets Kenneth Rexroth and William Carlos Williams as creative consultants, Malina and Beck produced experimental plays by artists from other mediums, playing in living rooms and lofts. In 1951, they took over the Cherry Lane, assumed the title the Living The-

ater, and spent the rest of the decade courting bankruptcy and scandal.[107]

Beck and Malina planned a repertory company, but limited finances and their liberal anarchism hindered their efforts. The New York City Fire Department closed down their 1953 presentation of French avant-garde playwright Alfred Jarry's *Ubu, the King* because of its sexually explicit language and overt references to homosexuality. Over the next six years the Living Theater moved several times, settling in 1957 on Fourteenth Street and Sixth Avenue, where Malina and Beck produced William Carlos Williams' *Many Loves.* Later, the company produced its most historically important work, Jack Gelber's *The Connection.*

Gelber's play startled the New York stage. A harbinger of the theater of engagement and confrontation of the 1960s, *The Connection* evoked the spirit of Odets's *Waiting for Lefty.* Its hard-hitting directness and contemporary subject—heroin addicts—shocked and attracted audiences. As audiences arrived they found the actors in midstory. At intermission the cast improvised and mingled with the audience.[108] A direct challenge to the artistic and political values of the middle-class audience on whose patronage the Living Theater depended, *The Connection* evoked a violent urban world with a hidden underclass that made it more akin to the later works of O'Neill than to the work of Miller and Williams. Unacceptable as a mainstream drama company, the Living Theater carved an avant-garde niche Off Broadway. In 1961, the U.S. Department of State declined sponsorship of the Living Theater at an international festival in Paris. An official explained, "You ask me to help you get to Europe with one play about fairies, another about junkies, and a third by a Commie. Do you think I'm nuts?"[109]

In contrast to the confrontational iconoclasm of the Living Theater, the Phoenix Theater and the American Shakespeare Festival brought classical drama to large, new audiences. In 1953, director Norris Houghton and producer Edward Hambleton wanted to establish a conventional theater with a large house, free of the demands of commercial success, to perform limited runs of classical drama. They renovated the Stuyvesant on Second Avenue and 12th Street, an eleven-hundred-seat theater, which had become a movie house after the decline of the Yiddish theater and had then fallen vacant. Renamed the Phoenix, the new theater opened in December 1953. The first season featured Hume Cronyn and Jessica Tandy in *Madam, Will You Walk* and a John Houseman production of *Coriolanus.* Houghton and Hambleton funded the productions at an eighth of the cost of an equivalent Broadway offering, played to 60 percent capacity for six weeks, and charged three dollars per ticket.[110] With funding from the Ford Foundation, the Phoenix established itself as a viable alternative theater in New York. Like the Living Theater, the Phoenix, from the beginning, ran afoul of the politics of the 1950s. In 1954 two of the largest and most powerful blacklisting organs of McCarthyism, *Red Channels* and *Counterattack,* assailed the Phoenix on two counts. First, they censured Houghton and Hambleton for visiting the Soviet Union, and second, they condemned Houseman for his association with Orson Welles in the 1930s Mercury Theater production of *Julius Caesar.* The Welles-Houseman *Caesar* had gained notoriety for its contemporary parallel with fascism and its attack on appeasement, which the anticommunist crusade catalogued as "radical."

But it was not anticommunism that derailed the Phoenix Theater. Rather, the Phoenix suffered by presenting unusual, controversial, and experimental plays at a time of widespread conformity. In the 1950s, *The Sound of Music* proved a safe bet. Shakespeare was not. Joseph Papp found this difficult to comprehend. A television director and stage manager for CBS, Papp founded the New York Shakespeare Festival. Born Joseph Papirovsky to immigrant parents in Williamsburg, Brooklyn, in 1921, Papp had tried his hand in the experimental Actor's Laboratory Theater in Los Angeles after the war before moving back to New York and on to his job with CBS. Blacklisted and dismissed after his HUAC hearings, Papp founded the Shakespeare Workshop in the basement of a Lower East Side church in 1954. He presented his first Shakespeare performance in Central Park in 1956 and inaugurated the Delacort Theater in the park in 1959.[111]

The creation of the New York Shakespeare Festival was the result of Papp's single-minded belief that a broad-based public could love and appreciate Shakespeare and that Shakespeare could be presented in an accessible, American style. His devotion to civic culture derived directly from the traditions of the New Deal and Mayor La Guardia's patronage of the arts at the City Center. To make his dream an institutional reality, in the late 1950s Papp took on Robert Moses, whose iron grip on Central Park threatened Papp's policy of free theater. Papp took Moses to court for insisting on charging the festival for improvements to the site of the outdoor theater. The appellate division of the New York State Supreme Court concluded that Moses, who made an issue of Papp's alleged radical background, had made an "arbitrary, capricious, and unreasonable decision." Papp moved to conciliate Moses, and by the early 1960s the New York Shakespeare Festival, or simply Shakespeare in the Park, had become a New York tradition.

By the end of the decade, Off Broadway had produced more than a thousand plays that, because of commercial and political constraints, would have been impossible on Broadway. Ironically, Off Broadway in the 1950s became home to those American playwrights, Miller and Williams, who had dominated the New York stage in the late 1940s. Anticommunism had not only splintered New York's postwar theatrical community, it had also pushed Broadway's best playwrights downtown, out of town, and even overseas.

In 1955 director Martin Ritt called Miller and asked for a "curtain raiser" to the one-act play, *A Memory of Two Mondays,* that Miller, Ritt, Bloomgarden, and Robert Whitehead planned to produce that spring. Miller quickly adopted an older, discarded idea, a tragedy drawn from his days working and prowling around Red Hook. There, working with the characters who were to inspire *The Hook,* he had come across the story of two Italian immigrant dockworkers who had been turned in to the Immigration and Naturalization Service and deported. In two weeks Miller transformed the street story into a one-act play in verse, *A View from the Bridge.* The story became a classic legend of betrayal, another portrait of an informer, and an exercise in the limits of convention and morality.

Concerned that the illusion of realism might prevent audiences from distinguishing the action of a play "from its generalized significance," Miller framed *A View from the Bridge* with the choruslike voice of the narrator-character, Alfieri, which al-

NEW YORK MODERN

lowed the viewer to go beneath the story of revenge and desire.[112] Structurally and intellectually the lawyer Alfieri became Miller's means to restore social drama, plays that addressed the question, "How are we to live?" Once again, Miller wrote about overcoming alienation, of regaining a human community at a time of great "moral uneasiness."[113] The protagonist, Eddie Carbone, vengefully betrays the illegal immigrant who has set his eyes on Eddie's niece. Eddie "denounces in others the sin (of desire) which he suspects in himself."[114] *A View from the Bridge* proved that New York contained the stuff of international drama. "Red Hook is full of Greek tragedies."[115]

Like *The Crucible,* the Broadway production of Miller's one-act plays received unenthusiastic notices and even less public attention. The actors in the production could not master the "lingo and the feel" of the play, which seemed to them simply a story of revenge.[116] A year later, English director Peter Brook successfully restaged the play in London with Anthony Quayle and Mary Ure. Miller expanded the play by adding a second act and developing his two female characters. Brook stripped the set to a minimum, allowing Miller space for Eddie's unadorned tragedy to emerge. In the extended version only the narrator remains a poet, his symbolism etched against the background of the story's urban realism.[117] The effect enhanced Miller's initial description, recited by Alfieri: "But this is Red Hook. . . . This is the slum that faces the bay on the seaward side of Brooklyn Bridge. This is the gullet of New York swallowing the tonnage of the world."

Miller remained politically vulnerable during the 1950s. In March 1956, *Aware* ("an organization to combat conspiracy in entertainment-communications") attacked, providing thirty pages of "documentation" on Miller's "communist front connections," including his 1949 signature of a petition in support of Paul Robeson and his participation in the Waldorf conference. *Aware* also exposed, with municipal approval, the decision by the New York City Youth Board to withdraw sponsorship and cooperation with Miller for a projected screenplay on juvenile delinquency. Miller, who had lived with a street-gang social worker, had written a thirty-page treatment concluding that the urban environment—its decay and its alienation from nature—had robbed these toughs of their boyhood, of their inherently decent instincts.[118]

In June 1956, HUAC called Miller to answer questions, ostensibly about passport violations. Miller ignored the offer of Chairman Francis Walter of Pennsylvania to cancel the hearing if Miller's wife, Marilyn Monroe, would agree to pose shaking Walter's hand.[119] Instead, Miller engaged Joseph Rauh Jr., who had defended Lillian Hellman four years earlier, as his counsel. Miller answered questions about himself. Then, after a long day of probing, when the committee council asked Miller to corroborate the presence of a colleague at a Communist Party meeting in 1947, he refused. "All I can say, sir, is that my conscience will not permit me to use the name of another person."[120] Later that year Miller was sentenced to a month in jail with a fine of five hundred dollars for supplying false passport information. Two years later his case was overturned on technical grounds.[121] Seven years of silence followed. Miller did not write another play until 1964.

In 1958, however, the Off-Broadway theater movement climaxed its decade-long period of experimentation with a rousing revival of *The Crucible.* Producer Paul Lu-

bin transformed an old ballroom and theater club on Broadway and 32d Street into the Martinique Theater and chose *The Crucible* for its debut. As intimate as a Broadway house was imposing, the Martinique's arena stage, patchwork amenities, and off-beat location made it an unlikely place for a restaging of Miller's least successful full-length play. But producers Lubin and Franchot Tone, a Group Theater veteran, and director Ward Baker mounted Off Broadway's most successful and longest-running play. *The Crucible,* which opened in March 1958, played for more than 565 performances, surpassing O'Neill's *The Iceman Cometh,* before closing in the summer of 1959. The new production included a narrator whose commentary linked the Salem past with the present. Hailed as a "superb revival," the *New York Times* concluded that the play "loses nothing of its power."[122] The "controversy gone," the "hysteria passed" to Off Broadway, reviewers and audiences discovered the moral tale they had rejected five years earlier. Miller, along with Tennessee Williams and Eugene O'Neill, had recovered his place as an American playwright.

With controversy consigned to Off Broadway, the apprenticeship of young actors

Proctor accused. *The Crucible,* by Arthur Miller, produced Off Broadway, Martinique Theater (1958). Tim O'Connor played Proctor and Barbara Stanton, Abigail. *Photograph by Eileen Darby*

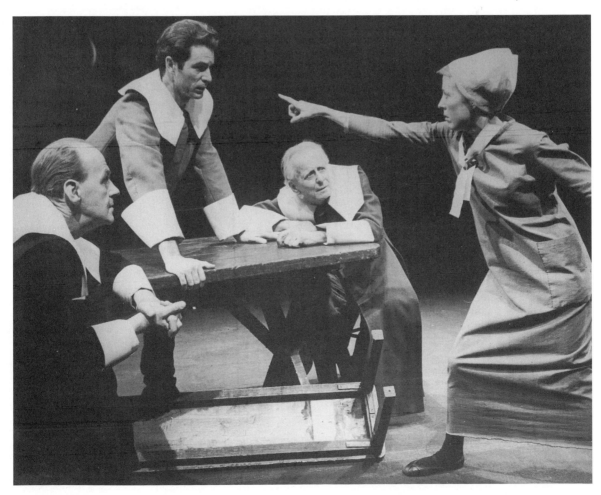

fell to the Actors Studio, which Kazan had founded in 1947. Two years later, Kazan and television director Martin Ritt inaugurated the Actors Studio Television series, one of the first among several distinguished and live dramatic series that earned for the new medium a modicum of respect and the fabled epithet, "Golden Age." The series, which ran for a season on ABC (American Broadcasting Company) before moving to CBS, provided the Actors Studio with unprecedented and unduplicated financial support. Appropriately, the first program included Tennessee Williams' *Portrait of a Madonna,* a one-act play first performed in Los Angeles three years earlier with Cronyn and Tandy.[123] Thus, in effect, the Actors Studio Television series began with a one-act version of *Streetcar.*

By 1951, the Actors Studio cried out for consolidation. Kazan's prominence kept his attention elsewhere. Only Lee Strasberg worked continuously at the Actors Studio for longer than two years. Strasberg had just reclaimed some of his tattered reputation by directing Odets's *The Big Knife* and an adaptation of Ibsen's *Peer Gynt.* Strasberg stabilized and became synonymous with the Actors Studio for the remainder of his life. By the mid-1950s, Strasberg had attracted to the Actors Studio an array of young actors whose careers contributed to his legend: James Dean, Anne Bancroft, Steve McQueen, Joanne Woodward, Ben Gazzara, and Pat Hingle. Strasberg resurrected the affective memory exercises of the method, pushing his young actors to retrieve their emotional experiences. When some, like Eli Wallach, accused Strasberg of practicing "without a license," the director responded, "What counts in the Method is to revolt against the heroic, romantic, rhetorical theater."[124]

Walter Kerr, the reviewer of the *New York Herald Tribune,* put the contribution of the Actors Studio in artistic and historic perspective: "From a low-keyed naturalism into open fire [the Actors Studio] has evolved a pattern for the plays of Tennessee Williams, Arthur Miller . . . our best playwrights." The Actors Studio temporarily reunited two veterans from the Group Theater. What remained, for Strasberg and Kazan, who continued his affiliation with the Actors Studio throughout the 1950s, was the dream of a permanent repertory company.

The founding of the Lincoln Center Repertory Theater, under the artistic direction of Elia Kazan, provided the opportunity. On January 23, 1964, Kazan directed the Lincoln Center Repertory's production of Arthur Miller's *After the Fall.* Its cast featured a dozen nationally prominent young actors whom Kazan had recruited from the Actors Studio. Faye Dunaway, Hal Holbrook, Jason Robards Jr., Salome Jens, David Wayne, and Barbara Loden appeared in the play. The play was set on an arena stage specially built for the ANTA–Washington Square Theater that duplicated the exact size, seating, and sight lines of the uncompleted future home of the repertory company uptown at Lincoln Center.

The title and the first act of Miller's *After the Fall* identify the incomprehensible guilt associated with the Holocaust and an American lawyer's political betrayal of a close friend. The direction and the casting of the second act, including Barbara Loden, who wore a silver-blonde wig that resembled Marilyn Monroe's hair, connected the character, visually and viscerally, to Miller. Betrayal and lust are the themes of the play. The writer and director each believed the play was about the other.

The close relationship between the Actors Studio and Lincoln Center repertory

company was short lived. When the Lincoln Center corporation affiliated with Juilliard rather than with the Actors Studio, Kazan resigned. Strasberg assumed control and produced James Baldwin's first play.[125] Baldwin had based *Blues for Mister Charlie* loosely on the lynching murder of Emmett Till, a landmark moment of the civil rights movement. The play opened four months after the opening of *After the Fall,* but the two works were separated by a millennium of racial and generational consciousness. Miller and Kazan, whose friendship had been severed by anticommunism, achieved in *After the Fall* a resolution of sorts, collaborating on a play about guilt, the Holocaust, and passion. Their best work had, however, been playing on and off Broadway for the previous twenty years.

In contrast, James Baldwin, who had stage-managed for Kazan, was barely forty when he completed *Blues for Mister Charlie.* Baldwin wrote about the present and the future. The play's topicality derived from Baldwin's own experience. Its title underlined the importance of the blues to African Americans as a means to cope with racial injustice. Baldwin's implicit message illuminated Miller and Williams' theatrical strategy of concealment. Virtually all postwar New York artists had covered over their moral and political intent as they sought to universalize their alienation and events almost too monstrous to address directly. It was as if the horrible secrets of the times—the mass murders of Auschwitz and Hiroshima, the racial murders in the South, political betrayal at the hands of trusted friends, the conflict between fathers and sons, and forbidden sexual longings—could only be faced obliquely. The themes, and the reality, of suicide and self-destructiveness ran like subterranean streams through postwar New York art. Blanche Dubois, Willy Loman, Joe Keller, Charlie Parker, and Jackson Pollock found in death a release from unbearable life.

Postwar New York artists, caught between the overtly left-wing commitments of the depression era and the anticommunism of the Cold War, were forced to struggle against political conformity and financial success. Some moved away from the overtly political in favor of aesthetic experimentalism, but together—Miller and Williams, Motherwell and Baziotes, Parker and Davis, Cage and Cunningham—they addressed the cultural events and issues of their times. In postwar New York each surreptitiously expressed his vision and his concern. Neither the Cold War nor postwar prosperity muted the many voices of New York Modern.

African American jazz musicians, abstract expressionist painters, playwrights and directors of the postwar revival, and avant-garde dancers, composers, and poets together transformed the artistic dialogue of New York Modern. They individually and collectively adapted New York's heritage of urban realism to their own artistic needs. By incorporating the language of the blues, surrealism, and expressionism, of the speech and places of New York, the city's postwar artists sustained the vitality of New York art.

By the early 1960s, New York Modern expressed the nation's cultural wealth and its international dominance. In the process many of its practitioners had become wealthy and famous. In 1955, the Rockefellers, in conjunction with New York City, decided to monumentalize New York Modern. Lincoln Center, a modern academy for the performing arts, celebrated the city's postwar artistic preeminence, the her-

alded "triumph of New York art." The city's younger artists rebelled. Neither Lincoln Center nor the city's other art edifices represented their New York. They could not identify with the ideals and struggles forged during the Cold War. In their eyes, the modernist White City at Lincoln Square seemed to be looking backwards. For many younger New York artists, the ever changing city demanded new voices, new visions, new art—a new insurgency, a new secession.

# Renovating the Modern
## Monuments and Insurgents

On April 15, 1956, Robert Moses, chair of the Mayor's Slum Clearance Committee, announced a new program of neighborhood improvement to be funded by Title 1 of the Federal Housing Act. "Aggressive slum-clearance," reported Joseph C. Ingraham of the *New York Times*, "can rid the city of its 400,000 substandard dwelling units in the next fifteen to twenty years. Among the most dramatic of the soon-to-be-started private projects, Mr. Moses said, is the combination cultural, educational, and housing center in the Lincoln Square area."[1] Twenty-eight months later, the Lincoln Center project was under way. "Wreckers went to work yesterday on the first of more than 400 buildings," reported the *Times*, "that are to be torn down to clear a thirteen-block area for the $205,000,000 Lincoln Square Development. Demolition began at 107 West 64th, a four-and-a-half-story brownstone built in 1881 for one family and servants." The *Times* continued, "Its most recent use was as a rooming house in which thirty-two persons were living in twenty-one rooms apportioned among twelve apartments."[2]

The construction of Lincoln Center exemplified the social conflicts that plagued New York in the 1960s. The federal government's urban renewal program subsidized slum clearance and neighborhood rehabilitation. All too often, however, city governments, New York's in particular, used federal grants and their authority of eminent domain to forcibly remove the poor from unsightly locations rather than improve living conditions as mandated by law. In the 1950s and 1960s, the working poor in New York were the victims, rather than the beneficiaries, of urban renewal. Working with the Rockefeller family, Robert Moses manipulated federal largesse, using funds earmarked for the improvement of urban housing, to build a center for the performing arts comparable in scope to Rockefeller Center.

Located on Broadway just north of Columbus Circle, Lincoln Center functioned as a bridgehead for the gentrification of the Upper West Side. Occupying the heart of the old San Juan Hill tenement district, the Lincoln Center complex forced the

removal of hundreds of poor families to distant high-rise projects, in many cases little more than public warehouses for the dispossessed. Like the Museum of Modern Art, Lincoln Center was more than an artistic diversion of the Rockefeller family; it was a grandiose effort to imprint their cultural aesthetic on the city at large. In collusion with Moses, the Rockefellers employed the cause of art to justify the destruction of a strategically located but poor neighborhood. In the place of San Juan Hill, the Lincoln Center Project anchored an attractive upper-middle-class enclave even as it provided a splendid home for the modern arts. In the 1960s, however, art proved a double-edged sword. The champions of New York's marginalized social groups, drawing on the city's tradition of avant-garde engagement, used their art to attack Moses, the Rockefeller family, and all they represented, returning modern art to New York's streets.

In the 1950s, the Museum of Modern Art had institutionalized Alfred Barr's modernist aestheticism, and in the 1950s its architectural equivalent, the International Style, became the New York Style. New York's stark, air-conditioned, steel, glass, and concrete postwar skyscrapers assembled along midtown's thoroughfares overshadowed its prewar beaux arts and art deco landmarks much as postwar prosperity sealed off its upper and middle classes from the city's poverty, social dislocation, and racial resentments.

The postwar ascendancy of New York Modern had brought the movement full circle. At the start of the twentieth century New York's early moderns embraced urban realism to circumvent, indeed, to overthrow, the stultifying classist formulas of Beaux-Arts neoclassicism. Once again in the 1960s, the city's insurgent artists confronted an entrenched establishment of renowned artists, powerful galleries, influential critics, and wealthy patrons, museums, and recital halls. In their opinion, abstract expressionism and other accepted modes of New York Modern had lost touch with the city, becoming little more than adornments of a new upper class. The construction of Lincoln Center, on the rubble of working-class tenements, ironically seemed to proclaim New York Modern as the rightful successor to Beaux-Arts academicism.

In the early 1960s, however, new artists challenged the upper-class appropriation of the arts. A new realism, focusing on the details and people of New York, defiantly insisted that the proper subject of modern art remained modern life. The arts of New York belonged to the city, not just to its upper class. Following the lead of political radicals, feminists, and African American, Hispanic, and homosexual activists, New York artists resisted the determination of MoMA and its patrons to gentrify the neighborhood and to essentialize modern art. Instead, the city's avant-garde renewed New York Modern's tradition of iconoclastic insurgency.

Rejecting the accoutrements of bourgeois life, artists discovered the city's neglected neighborhoods of SoHo, Tribeca, and the East Village. Simultaneously, New York's economy eroded, creating a surplus of abandoned light-manufacturing buildings. Artists moved into the lofts of the old industrial-factory economy just as new waves of black, Hispanic, Asian, and West Indian immigrants arrived searching for jobs that had already vanished to Birmingham and Macao. In the 1960s, the city's artists and writers converted the city's derelict factories, with their multistoried lofts,

cast-iron frames, and freight elevators, into new artistic communities, remaking these neighborhoods into a new New York.

The first years of the 1960s saw little evidence of the coming barrage of artistic voices. Instead, the New York art world seemed preoccupied with the construction of artistic monuments. The designs for Lincoln Center alone employed a half-dozen American and European architectural firms. At Lincoln Center, New York City constructed new homes for the New York Philharmonic, the Metropolitan Opera, the New York City Ballet and Opera companies, the New York Public Library's collection for the Performing Arts, the Lincoln Center Repertory Company, and the Juilliard School of Music. By mid-decade, the Guggenheim and the Whitney Museums had also built new structures for their expanding collections. The architects for these art projects—Frank Lloyd Wright, Marcel Breuer, Wallace Harrison, Max Abramovitz, Eero Saarinen, Gordon Bunshaft, Philip Johnson, and Pietro Belluschi—gave New York an astonishing range of buildings that celebrated the city's postwar artistic preeminence. Together, from Lincoln Center at the southwest corner of Central Park to the Guggenheim Museum at the park's northeast corner, New York's new cultural edifices inscribed a golden horseshoe of residences and culture around three sides of Central Park. A haven for the city's affluent upper and middle classes, regentrified Central Park, except for the northern end adjoining Harlem, created a protected enclave beyond the reach of New York's other half, who lived and worked in the peripheral neighborhoods of Washington Heights, Lower Manhattan, the South Bronx, and Bedford-Stuyvesant.

The museum mile, Fifth Avenue from the Guggenheim to the Metropolitan, with a one-block detour east to the Whitney, redefined Manhattan's East Side. Grand prewar buildings lined Fifth, Madison, and Park Avenues from 61st to 96th Streets. Tree-lined side streets sheltered limestone-faced town houses whose glass and wrought-iron entry doors protected consular officials and bond market executives from furtive glances of passersby. In the neighborhood's pastry shops and boutiques, French was almost a second language. With the demolition of the Third Avenue el in the 1960s, luxury buildings sprouted along Second and Third Avenues, thoroughfares formerly dominated by sooty tenements and taverns. Miles of white-faced modernist-inspired wedding-cake apartment buildings with street-level galleries, shops, and deluxe stationery stores gave the refurbished East Side an upscale cachet. The new middle-class residents of the expanded Upper East Side rubbed shoulders and shopping bags with the upper class of Fifth and Park Avenues. The galleries along Madison Avenue, drawn to the new Whitney Museum of American Art, scattered themselves southward toward the great palaces of upper-class consumption that encircled the southwest corner of Central Park—the venerable Plaza Hotel, the tantalizing children's bazaar of F.A.O. Schwartz, and the block-square Bloomingdale's department store.

Across Central Park, Lincoln Center secured a mixed neighborhood of old and new, wealthy and poor. The Upper West Side's prewar apartment buildings shielded strollers on Broadway and West End Avenue from tenements and overcrowded brownstones, homes to recently arrived Puerto Ricans and working-class Europeans who gave the pre–Lincoln Center neighborhood its grit and edge. Locksmiths and

junk shops adjoined street-side cafés and oriental restaurants adorned with fresh-cut flowers on glass-topped tables. In the 1960s, the Upper West Side, from Columbus Circle northward to Columbia University, bristled with activity and energy and was home to a broad spectrum of Manhattanites.

In the 1960s, the Upper East and West Sides of Manhattan reflected the class differences within the city. The Upper East Side remained genteel and exclusive, whereas the Upper West Side sustained a socially divergent, ethnic flavor even in the face of gentrified prosperity. Both East and West Siders, however, enjoyed an urban ambience unrivaled in America. New Yorkers to the core, Manhattan's upper and middle classes lived curiously provincial lives secure in their midtown haunts. They could respond politically yet remain socially isolated from their fractious and rapidly changing city. In contrast, New York's newest avant-garde, having adopted the "other New York" as their home, made that New York the subject of their art. Installationists Mimi Gross and Red Grooms, photographer Diane Arbus, writer James Baldwin, and dozens of other artists in various mediums subverted and then revitalized New York Modern, restoring a critical, socially conscious edge to New York art through unblinking images of their city.

## THE WHITE CITY REVISITED

The Lincoln Center Project and the gentrification of Manhattan's East and West Sides represented a second phase of New York's postwar development. Following World War II, from 42d Street northward to Central Park South between Sixth and Lexington Avenues, corporations had built a forest of imposing glass and steel skyscrapers that redefined New York's skyline, replacing the city's older beaux arts and art deco architecture with the sleek modernism of Hitchcock and Johnson's International Style.

New York's neoclassical urbanism still dominated the city at the end of World War II, a result of the scarcity of construction since 1929.[3] Even Manhattan's soaring towers, the source of its distinctively modern skyline, were almost all built within beaux arts conventions—tall buildings whose external decorative scheme and formal organization connected new steel-frame and elevator technology with historical allusions. Neither the art deco towers of the 1920s, Rockefeller Center, nor even the famed Empire State Building strayed far from the civic architecture of McKim, Mead, and White. After World War II, however, Hitchcock and Johnson's International Style overshadowed all else. The Corbusier-conceived United Nations building, executed in 1947 by Harrison and Abramovitz on land donated by the Rockefellers, prefigured the 1952 Lever House by Gordon Bunshaft for Skidmore, Owings, and Merrill. The classic example of postwar glass-curtain skyscrapers, however, was Mies van der Rohe's Seagram Building on Park Avenue, completed in 1958.

Designed by Mies, the bronze and glass Seagram Building borrowed heavily from the formal geometry of the Lever House and the United Nations building. Its monolithic shape soared upward not from a horizontal service base but from a concrete courtyard reminiscent of a European plaza. Philip Johnson designed the interiors and the Four Seasons Restaurant at the building's East 52d Street entrance. Like

nearby Rockefeller Center, the Seagram Building combined architectural design with urbanism. The open plaza invited midtown shoppers and museumgoers to enjoy the play of fountains and a respite of shaded elegance. Other midtown and Wall Street International Style skyscrapers followed suit. Banks and publishers vied with television networks and insurance companies to identify their products with architectural modernism, proclaiming New York's postwar economic and cultural ascendancy.

Lincoln Center's scope, its complex public and private political deals, involved compromise and consensus, but above all, Lincoln Center was a Rockefeller project. John D. Rockefeller III gave the single largest gift and chaired the Exploratory Committee that oversaw the planning and construction. In their patronage of high

culture, the Rockefellers dwarfed all competitors. The Lincoln Center for the Performing Arts was guided by their hand and by their taste.

Lincoln Square, several blocks north of Columbus Circle, was formed by the confluence of Broadway, Eighth Avenue, 59th Street, and the southern edge of Central Park. Lincoln Square comprised two sets of triangular islands where Broadway cut diagonally across Columbus Avenue between 62d and 66th Streets. Robert Moses' Lincoln Center urban renewal project, or slum clearance program, extended well beyond Lincoln Square and included the tenement district of San Juan Hill. Bounded by 61st Street to the south and 70th Street to the north, San Juan Hill, the home of jazz pianist Thelonious Monk, consisted of a pocket of five-story tenements and small shops with occasional garages and lofts, several churches, a government building, and the High School of Commerce. The city evicted seven thousand residents to build the center for the performing arts in a neighborhood that Moses hoped would become an upscale counterpart to the new Upper East Side.

Title 1, enacted by the Federal Housing Act in 1949 and administered by the Housing and Home Finance Agency, funded urban renewal. Congress authorized city agencies to condemn land deemed unlivable and to resell it to private investors at reduced prices. The Housing and Home Finance Agency agreed to pay the costs of legalizing public authority to transfer private property from one group of private owners to another. In New York, Robert Moses, who chaired the Mayor's Slum Clearance Committee, ignored the crucial requirement to improve the quality of life for neighborhood residents and focused instead on razing unseemly sectors of the central city—displacing the African Americans, Italians, and Hispanics who had made these neighborhoods their home. Albert Cole, an Eisenhower appointee who headed the Housing and Home Finance Agency at the time, christened urban renewal and slum clearance a "bulldozer philosophy."[4]

In 1954, Moses targeted Lincoln Square for urban renewal, proclaiming that aggressive slum clearance would eliminate thousands of "substandard" buildings. Moses envisioned the seventeen-block tenement district as a mixture of middle-class housing, educational institutions, and a park. He showed his plans to his old friend Wallace K. Harrison, coordinating architect for Rockefeller Center and the United Nations and the consulting architect for the Metropolitan Opera House. Aware that the Metropolitan Opera bridled under its declassé downtown location and the inadequate storage space it provided, Moses invited Harrison and the Metropolitan to join the Lincoln Square Project.[5]

In approaching Harrison, Moses also drew in John Rockefeller III. Within a year, the Lincoln Square Project also included specific projections to house the New York Philharmonic and the New York City Ballet and Opera companies, in residence at the time at the City Center. In the fall of 1955, Rockefeller convened the Exploratory Committee, which included Charles Spofford, chair of the Executive Committee of the Metropolitan Opera and chair of the New York Philharmonic, and Edgar Young, Rockefeller's liaison for the entire project. The Exploratory Committee met biweekly at the Century Club, and Spofford contributed fifty thousand dollars to fund the initial planning. In the spring of 1956, the committee approached composer William Schuman, president of the Juilliard School of Music, inviting him to ex-

pand the school's program to include drama and to join Lincoln Center. Moses believed that the prestige of a cultural center supported by the city's major art patrons would overcome objections to the demolition of San Juan Hill and the removal of its residents.

The Rockefeller committee endorsed Moses' grand plan. In mid-April 1956, Rockefeller presided over a daylong meeting at the Pierre Hotel on Madison Avenue to coordinate a center for the performing arts with Moses' goal of slum clearance. The Pierre meeting heard the mayor of Louisville, Kentucky, account for the revitalization of the Louisville Symphony despite the central city's having become "all black." The mayor predicted that in twenty years New York would "be as black as Louisville," a change that would "drive white money and leadership out."[6] On the same day, Moses leaked to the *New York Times* his plans for a massive "slum-clearance" program that included new housing for five thousand middle-income families, a new campus for Fordham University, and Lincoln Center for the Performing Arts.[7] The initial plans for Lincoln Center placed the cultural arts center in a four-block-square area between Columbus and Amsterdam Avenues, with the Opera House backed up to Amsterdam and Philharmonic Hall and the New York State Theater turned away from Columbus Avenue. The axis ran north and south, sealing Lincoln Center from the surrounding city and creating a cloistered mall with limited access from the south end at 62d Street. Raised half a story above street level, the plans for Lincoln Center pictured a fortress-oasis, grand and isolated.

Projecting the loss of housing for fifty thousand persons in Manhattan over the next twenty years, the center's engineering consultants concluded that such depopulation would not have "any real significance," since the center's audience would come from "the suburbs." The report did not mention race, nor did it divulge that the fifty thousand nonwhites expelled from Manhattan would be housed in public projects on the city's periphery or in abandoned tenements in the South Bronx.[8] Moses valued the land at eight dollars a square foot when cleared. The city stipulated a cash allowance of four hundred dollars to each family for relocation. Of the seventy-five million dollars estimated for the Lincoln Center Project, the city allocated only 2.3 million dollars for the removal, relocation, and demolition of the four-block area, and of that minuscule amount, more than half went to demolition.

Despite the collusion of Moses and Rockefeller, each mistrusted the other. Separated by a deep chasm of religious differences, they worked as uneasy allies. But neither anticipated opposition from Lincoln Square residents. Within weeks of the initial "slum-clearance" announcement, Harris Present, a Manhattan lawyer who worked with the city's Hispanic residents, received a phone call from Eleanor Black, wife of Algernon Black, a neighborhood activist and religious leader. Eleanor Black explained that she had given Present's name to local tenants who "were very upset about the Lincoln Square Project."[9] Present quickly organized a group of twenty-five Lincoln Square residents, many in their eighties, to take on Moses. Believing that slum clearance ought to mean neighborhood improvement, not obliteration, Present worked for the next two and a half years to save the neighborhood. He confronted Moses and Rockefeller in the press and before city government, forcing the Board of Estimate and the City Housing Authority to approve as compensation

the construction of a thousand low-cost housing units on Amsterdam and 89th Streets.[10] The success radicalized Present, who grasped the cynicism of the city's response. "Finally I understood that Slum Clearance had become urban transfer—people transferred from one project site to another to another to another."[11]

Present asked the courts to examine the constitutionality of the city's transfer of private property, through a federal agency, to Fordham University, a private Catholic institution. He argued that the new Manhattan campus of Fordham, to be built south of the performing arts complex, violated the constitutional doctrine of separation of church and state. Present lost his case but not before obtaining a stay of execution from Supreme Court Justice John Harlan. At each stage in the struggle, the city, the state, and the Supreme Court heard the residents' pleas and arguments, but in the end, they supported Moses' determination to wield the city's authority to seize private property in the name of slum clearance and cultural uplift.

The Housing and Home Finance Agency, presided over by Albert Cole, a moderate Republican from Kansas, had originally opposed the project. Cole questioned the social benefits of the proposed Lincoln Center. Moses had applied for thirty-one million dollars in federal assistance out of a total project estimate of seventy-five million dollars. Cole recalled that it took "a great deal of creative interpretation . . . to say that Lincoln Center primarily benefited that project area." In January 1957, as Cole was weighing his decision, Rockefeller paid him a visit. Rockefeller claimed that the city and the Exploratory Committee needed additional funds for underground parking. Cole felt that an extra six million for the facility was unjustified and suggested that he and Rockefeller confer with Sherman Adams, a key Eisenhower adviser. Over lunch Adams instructed Cole, "I don't think approval of this would wreck your little ship." Deferring to administrative pressure, the next day Cole's agency approved the additional six million.[12]

The full scope of the Lincoln Square Project—the performing arts superblock, the downtown Fordham campus, and the seventy-five million dollar Lincoln Tower complex of five thousand middle-class cooperative apartments—was announced in August 1957. A year later the first residents of Lincoln Square were relocated when the New York State Supreme Court confirmed lower court rulings that authorized the payment of bonuses by the Lincoln Center Project to ease relocation. In the end, the center paid "self-relocators" between $275 and $500 per family. It also employed agents to locate public housing for one hundred of the neighborhood's poorest residents, paying $150 for each successful placement.[13] On July 19, 1959, the new Lincoln Square Co-Op advertised apartments with six rooms, two baths, and two terraces for six thousand dollars. The monthly carrying charges added $207 per month to the mortgage.[14] Only a year earlier, Felipe and Julia Rodriguez and their seven children had paid $59 a month for a three-room apartment on West 64th Street between Amsterdam and Columbus Avenues.[15]

On March 14, 1959, President Dwight D. Eisenhower ceremoniously broke ground for the construction of the new Philharmonic Hall. Without irony, the New York Philharmonic played Aaron Copland's *Fanfare for the Common Man*. In five years Robert Moses had transformed Lincoln Square from a vital low-income neigh-

borhood into an empty lot strewn with rubble. It took another six years to complete Lincoln Center.

One vexing institutional problem remained—the place of City Center, created by Mayor Fiorello La Guardia in 1943 as a home for New York's municipal opera and ballet companies. Lincoln Kirstein, codirector of the New York City Ballet, resigned from the City Center board in 1959, believing that the City Ballet would become a tenant rather than a standard-bearer of the new arts center.[16] The following year, however, Kirstein's old college friend, Nelson Rockefeller, recently elected governor of New York, endorsed the state's participation in the Lincoln Center Project. The Rockefeller family, including John Rockefeller III, Nelson Rockefeller, and David Rockefeller of the Chase Bank, proposed to house the City Center companies at the New York State Theater at Lincoln Center. The theater would be financed by the state as part of the 1964 World's Fair—located seven miles away in Flushing, Queens. The State Theater would later become the property of the city and of Lincoln Center. Built on commercial property owned by Joseph Kennedy on Columbus Avenue between 62d and 63d Streets, the New York State Theater required negotiations with state, federal, municipal, and private entities from Tammany Hall to Pocantico Hills. The complex deals gave City Center's board the means to move La Guardia's municipal arts programs to Lincoln Center.[17] Kirstein and Balanchine secured their theater, publicly funded, Rockefeller supported, and, now, socially validated.

The Rockefellers chose the aristocratic, urbane, Vienna-born René D'Harncourt as Lincoln Center's architectural coordinator. D'Harncourt, who in 1948 had replaced Alfred Barr at the Museum of Modern Art, possessed the social adroitness and artistic credentials to work with Lincoln Center's wealthy patrons. Initial discussions between the six cooperating architects—Wallace Harrison and Max Abramovitz for Philharmonic Hall, Gordon Bunshaft, of Skidmore, Owings, and Merrill, for the library, Eero Saarinen for the Repertory Theater, Pietro Belluschi for Juilliard and the chamber music hall, and Philip Johnson for the New York State Theater—resolved basic issues. The architects elevated Lincoln Center above street level and designed a taxi lane between the steps leading up to the plaza and the avenue in front.[18] Lincoln Center rose west of Broadway, now along a north-south axis, giving passersby a glittering vista of light, marble, and glass. But the complex remained above and beyond street-level pedestrians. The architects agreed on a uniform size and mass for Philharmonic Hall and the New York State Theater, which flanked the Opera House. They chose Roman travertine marble, from the imperial quarries, to face the center's structures, creating a modern—and permanent—White City. The center's major buildings, architecturally distinct from one another, were unified by colonnades that monumentalized the International Style's prohibition against decoration. Michelangelo's Roman Campidoglio plan, with Johnson's fountain at its heart, gave the center a European plaza, festive and urbane, in the heart of the city. Lincoln Center rose like a jewel from the rumbling streets of the city.

The New York State Theater, its Broadway side masked with marble, rejected box

Lincoln Center for the Performing Arts, Lincoln Square looking west. *Metropolitan Opera Archives*

The Campidoglio, designed by Michelangelo. *Engraving by Etienne Dupérac (1569)*

seats as socially exclusive. The repertory theater, named after benefactor Vivian Beaumont, was built around an arena stage designed by Jo Mielziner. The stage, like the circular dance spaces pioneered by Doris Humphrey and Martha Graham, invited experimentation and new audience perspectives. Saarinen and Bunshaft, architects for the theater and the library, merged their two buildings, placing the archival and storage facilities of the New York Public Library for the Performing Arts at the rear of the theater and bringing together, on the center's secondary north plaza, ordinary library patrons with the Beaumont's finely attired theatergoers. The reflecting pool in front of the two buildings defined an outdoor public space, isolated from Amsterdam

Avenue yet inviting to students, researchers, and music aficionados, giving the formal plaza in front of the Opera House a classically urbane ambience.

When asked to support Lincoln Center, Henry Ford had replied, "This is a Rockefeller town. What the hell are we doing!" The Ford Foundation administrator in charge of support for the arts, W. McNeil Lowry, however, convinced the foundation to support Lincoln Center artists, if not its buildings. Opposed to the center as an example of elitist culture and mistrustful of its bankers and board members, Mac Lowry nonetheless oversaw a series of innovative grants to the New York Opera to commission new operas. Lowry was heartened by the company's adherence to a top ticket price of $3.95.[19] Later, he offered a grant to the Metropolitan Opera to commission a work by Marc Blitzstein about Sacco and Vanzetti. When colleagues blanched at the idea, Lowry replied bluntly, "If we don't want to be in this field where there are both Communists and homosexuals—we ought to get out of the arts, which I hope we won't do."[20]

In 1957, Day and Zimmerman, the consultants to the Exploratory Committee, estimated the cost of Lincoln Center at seventy-four million dollars. Lowry believed the total price tag would be four times that amount. Magnificent and inviting to the upper middle classes of the metropolitan area, Lincoln Center reconstituted the urban grace and leisure earlier exemplified by the works of McKim, Mead, and White at the turn of the century. Lincoln Center's architectural modernism, its stark International Style softened by references to classical European plazas and to New York's Beaux-Arts-inspired civic urbanism, made the center both an inviting and a socially exclusive public place. The center rose above and apart from the surrounding West Side tenements and Broadway's bustling street life, much as the modern art collected and exhibited by New York's elite museums stood apart from the concerns and problems of contemporary New York. The sequestering of the modern arts within the pristine confines and hushed halls of the new Whitney and Guggenheim Museums, in the elegant quarters of the Museum of Modern Art, and in the new academy of the performing arts at Lincoln Center had transformed New York Modern's commitment to the irreverent and contemporary into an affirmation of the prestigious and monumental.

## REBUILDING THE GUGGENHEIM AND THE WHITNEY

In the 1960s, New York's fine arts institutions moved uptown, making the Upper East Side a center for modern art. In relocating to more secluded and protected locations in proximity to their patrons, the city's modern art museums joined in the process of neighborhood renewal, pushing aside the old inhabitants of the East Side. At the same time, art became an important economic enterprise, critical to the city's identity and prosperity. Although New York's upper classes controlled its fine arts institutions, they found themselves increasingly accountable to public authority as well as to the demands of their middle-class constituents. After World War II, major museums became too large and too expensive to sustain themselves on the largesse of wealthy patrons alone.

New York's art institutions became, at one and the same time, gentrified, more public, and more responsive to the marketplace in the 1960s. The directors of New York's museums had to pay more attention to fund-raising, social graces, and the restroom amenities in their buildings than they ever had before. Indeed, artistic decisions were increasingly dictated by financial necessity. Even the Museum of Modern Art, sustained by Rockefeller money, could not completely distance itself from public taste and economic concern. As the great art museums of New York—the Metropolitan, the Guggenheim, the Whitney, and the Museum of Modern Art— became increasingly dependent on upper-middle-class support, they separated themselves from New York's escalating social and political problems. With the construction of new buildings for the Whitney and Guggenheim Museums and the completion of Lincoln Center, New York art turned its back on the city's other half, losing its critical edge and falling out of touch with large segments of the city and modern life.

In 1932, when Hitchcock and Johnson had organized MoMA's seminal *International Style* exhibit, they had acknowledged Frank Lloyd Wright as the best architect—of the previous century. In 1955, however, when Johnson introduced Wright to a symposium at Yale as "America's greatest living architect," Wright leaned back in his chair and whispered loudly enough for everyone to overhear, "Attaboy, Phil. Try a little harder."[21] Wright's biomorphic design for the Guggenheim Museum, realized shortly after his death in 1959, contrasted with the glass towers of International Style modernism that dominated Manhattan's postwar skyline. The Guggenheim reaffirmed the variety of architectural styles inherent in modernism yet banished by Hitchcock and Johnson a quarter of a century earlier. Like its collection, the Guggenheim's architecture was iconoclastic and controversial.

The Guggenheim collection was born in 1929 when the Baroness Hilla Rebay von Ehrenweissen traveled with Solomon Guggenheim to Dessau, Germany, to meet Wassily Kandinsky, whose paintings made up the core of the collection Rebay eventually assembled. A decade later Rebay opened the Museum of Non-Objective Painting in rented quarters at 25 East 54th Street, near the Museum of Modern Art.[22] In 1943 the museum initiated discussions with Wright to design a permanent home for the Kandinsky-dominated collection. Two years later Wright unveiled his plan to create a single gallery formed by an upwardly spiraling ramp on a rectangular base. Wright had experimented with the spiral form, which he called the "architecture of the within," since the 1920s, when he built the Gordon Strong Planetarium in Maryland and designed an "urnlike" house for himself in the Mojave Desert. The motif, which Rebay likened to the ziggurats of Mesopotamia, was consistent with her conception of the museum as a "temple" housing the expressionist works of Hans Arp, Max Ernst, Rudolph Bauer, Hans Richter, and Kandinsky.[23]

Wright spent a dozen years refining the plans, eliminating and then resurrecting the spiral design, exploring the sculptural potential of reinforced concrete, and creating a "molded space forcefully conditioned by the path of movement through it."[24] In the meantime the museum acquired a lot on Fifth Avenue between 88th and 89th Streets, several blocks to the north of the Metropolitan Museum. Overlooking Cen-

tral Park, the Guggenheim site allowed Wright to relate his curvilinear design to the curves of Central Park's roads, paths, and nearby reservoir.

Following Guggenheim's death in 1949, the project was set back further when the baroness, as Rebay preferred to be called, attacked Wright. The appointment of Harry Guggenheim, Solomon's nephew, as president of the Guggenheim Foundation and Rebay's replacement by Alfred Barr's disciple, James Johnson Sweeney, saved the museum from oblivion. Sweeney broadened the collection by including works by Paul Klee and Lyonel Feininger, adding sculpture, and absorbing Katherine Dreier's collection. Sweeney changed the name to the Solomon R. Guggenheim Museum and revived plans to house the collection in Wright's building.

In 1953, the Guggenheim announced Wright as its architect-artist, exhibiting his most recent model for the museum along with a retrospective show, *Sixty Years of Living Architecture*.[25] Wright set up shop in the Plaza Hotel and supervised the construction of his sole New York project.[26] Wright's Guggenheim Museum captured an aspect of New York's artistic spirit. Singular and unconventional, the museum took its place amid New York's eclectic architecture. Although paintings could not be hung level to the descending ramp and the building's architectural identity overpowered its collection, the Guggenheim Museum captured the enduring tension between the untamable city and the rebellious Wright.[27]

In contrast, the choice of Bauhaus-trained Marcel Breuer as the architect for the new Whitney Museum of American Art seemed an impossible contradiction. Breuer's International Style training diverged from the Whitney's traditional patronage of representational American painters and sculptors. When the Whitney chose Breuer in 1963, the museum had expanded its collection to include nonrepresentational work.

The years between the death of Gertrude Vanderbilt Whitney, in 1942, and the opening of the Breuer building in September 1966 marked the museum's transition from Greenwich Village experiment to Upper East Side institution. It was a troubling time for the museum. Maintaining its "no juries, no prizes" commitment to a democratically based contemporary American art proved easier than resisting pressures to develop a permanent collection that celebrated the life's work of living artists and embraced the principle that "a museum should always be open to the new, the young, and the experimental."[28] Even more difficult, however, was the task of retaining an independent identity. In 1947, a year before her death, Juliana Force, along with director Herman More and associate director Lloyd Goodrich, entered into the first of two institutional mergers that threatened to end the Whitney's autonomy.

The 1947 agreement between the Metropolitan, the Whitney, and the Museum of Modern Art recognized each museum's unique domain. The Metropolitan agreed not to buy works of modern art, and each museum agreed to lend paintings and sculpture to the others. The Museum of Modern Art and the Metropolitan also agreed to sell or trade works that logically belonged in the other's collection. Finally, Force decided to merge the Whitney with the Met, the new Whitney to be housed in an American wing. The 1947 agreement, which would have created a partitioning of the New York art market, anticipated the eventual dissolution of the Whitney. A

year later, however, when the two organizations squabbled over the design for the Whitney wing, Force withdrew from the discussion and, just before her death in 1948, launched the museum in a different direction. Moore, Goodrich, and the Whitney family members who controlled the board concurred in the change. The Whitney would move to expanded quarters on West 54th Street to a site donated by the Museum of Modern Art; it would abandon its policy of not honoring contemporary, living artists with individual shows; and it would accept donations to expand its permanent collection. In sum, the Whitney imagined itself as an American annex to MoMA. After 1954, the two museums, located only a block apart, complemented each other's collection.

During the 1950s, the Whitney's expanded collection included American abstract art, especially the work of the abstract expressionists. The Whitney mounted shows by Arshile Gorky, Robert Motherwell, George Grosz, and Hans Hofmann alongside those on Edward Hopper, Jack Levine, Stuart Davis, Arthur Dove, and Philip Evergood.[29] At the end of the decade, when Lloyd Goodrich assumed the directorship, the museum appeared ready to declare its independence from the Museum of Modern Art and the Whitney family. Although the building on 54th Street accommodated four times as many visitors as the original space in Greenwich Village, the museum had little room to exhibit its expanded permanent collection. Goodrich reversed the last remnant of the agreement with the Met and MoMA that prohibited the Whitney from collecting pre-twentieth-century works of art. New money, new collections, and new policies required a new building.

Goodrich, along with a half dozen new trustees, infused the museum with the energy to purchase a lot on the southeast corner of Madison Avenue and 75th Street, and in 1963 the trustees announced Marcel Breuer as the architect of the new museum. The members of the building committee understood that, "in moving from downtown to midtown . . . the Whitney had lost some of its identity, had indeed been absorbed into a complex of buildings . . . rather than permitted to stand . . . devoted to American art."[30] The Whitney sold its 54th Street building back to the Museum of Modern Art for two million dollars, which it used to purchase land for its new building. The half-block frontage on Madison Avenue, approximately 103 feet, fell short of the "power and size" that the building committee had hoped to achieve. The architect had to design a building large enough to satisfy the demands of the curatorial staff, and stay within the Whitney's budget, in a mere thirteen thousand square feet of floor space.[31]

Breuer had come to the United States at the invitation of Walter Gropius at Harvard in 1938 and had worked on the UNESCO headquarters in Paris and the Abbey Church of St. John's Monastery and College in Minnesota. Both projects demonstrated his departure from the International Style as he expressed his preference for the "walled effects of masonry," of reinforced concrete, over steel curtain, or skeletal, walls.[32] In the Whitney building Breuer worked from the inside out, from the street in. Breuer acknowledged the urban neighborhood around the Whitney by stepping the building up and over Madison Avenue. Yet, he also extended a concrete bridge to the street, separating the Whitney from its immediate environment and

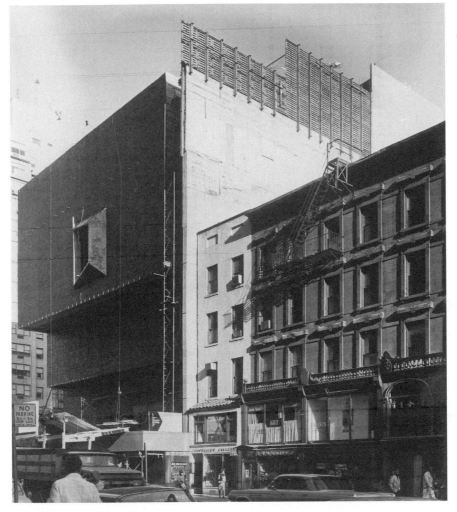

The Whitney "up-town." The Whitney Museum of Art, 945 Madison Avenue (1965), built by the HRH Construction Corporation, designed by Marcel Breuer. *Photograph by Bill Rothschild. The Whitney Museum of American Art*

protecting the museum's massive facade from the city's disruptions. Moat, bridge, and wall gave the new Whitney an embattled appearance.

Viewed from the north, the Whitney building, a miniature shadowed tower, sculpted a silhouette that echoed New York's traditional step-back construction. Like the Guggenheim and Lincoln Center, the Whitney remained in tension with its urban surroundings—acknowledging the presence of the city yet keeping its distance. Unlike Wright's building, however, Breuer's building did not overpower its collection. Breuer intended the Whitney's flexible gallery space, white walls, and ceiling grid over controlled lighting to focus visitors' attention on the exhibits.[33]

The movement of the Whitney and Guggenheim uptown into fashionable but isolated quarters mirrored New York's uneven pattern of postwar prosperity. The regentrification of the Upper East and West Sides was also marked by growing poverty and discord on the city's periphery. Municipal services creaked under the burden

of increased demands and decreased funding. Manhattan's deindustrialization emptied out the old manufacturing lofts of the East Village, SoHo, and Tribeca. Slum clearance revived Manhattan's central neighborhoods on the East and West Sides, but on its outskirts a new city, poor and nonwhite, materialized. The discrepancies were too dramatic to ignore. In the 1960s, just as political radicals and community activists challenged the city's elites, African Americans, homosexuals, and women artists rejected art that ignored or excluded them. Radical artists attacked the city's modern art establishments as bastions of stagnant, classist culture. Like New York's turn-of-the-century avant-garde, in the 1960s a new generation insisted that modern art continue to address contemporary urban life, that its voice once again become many voices, and that it respond to individual creativity and social renewal.

## ART OF CONFRONTATION:
## JAMES BALDWIN

The year 1963 cut through American cultural and political history like a fault line. The March on Washington, the rededication of the Students for a Democratic Society and the Southern Christian Leadership Conference, the American military escalation into Southeast Asia, and the assassination of President John F. Kennedy in November anticipated the epic movements and events of the decade. The traumatic events of 1963 released a wellspring of political resentment and energy that had accumulated since the end of World War II.

In New York, the mayoralty of John Lindsay, an anti-Tammany reform Republican who tailored his progressive alliance in the image of La Guardia, marked the change. Lindsay, wealthy and socially prominent, identified with New York's traditional liberal and new insurgent groups and promised to restore New York's urban character. During his first years in office he killed Moses' scheme for a 30th Street crosstown elevated expressway, opened Central Park to pedestrians on weekends, and dubbed New York "Fun City." Under Lindsay, New York City's lone entry into the popular arts found a singular champion in Doris Freedman. The daughter of the legendary builder Irwin Chain, Freedman headed the mayor's Office of Cultural Affairs and presided over a series of public art projects that enlivened the vacant walls of city buildings.[34] When Lindsay left office in 1973, however, the West Side Highway collapsed, and New York City stood on the verge of bankruptcy, a fifth of its inhabitants living below national standards for poverty.[35] The most dramatic symbol of New York's disarray occurred on November 9, 1965, when the city lost its electric power and the lights went out. New Yorkers realized that they could no longer take for granted the city's civility or its prosperity. More than even the racial explosions of the decade, the massive antiwar mobilizations, and New York's transit and newspaper strikes, the 1965 citywide blackout demonstrated New York's limits and weakness. On November 9, even the Rockefellers found themselves stranded in the dark.

Lindsay constructed a heroic political image of himself as a mayor who cared and who wanted to make the city work for all of its inhabitants. But he accomplished little. At the end of the decade New York seemed out of control and unsalvageable. Paradoxically, however, New York artists, disenchanted with the gilded world of the

city's uptown art establishment, thrived on New York's disorder and confusion. In the 1960s, New York's artists reclaimed the radicalism of modern art and rekindled the flame of New York Modern. James Baldwin, Diane Arbus, Red Grooms, Mimi Gross, and a host of others instigated a new modern art, shorn of gentility, that inaugurated a new New York secession, disparate and discordant, at arm's length from the city's midtown art establishment. Alienated from New York's art monuments, they undermined the city's modern academy with anger, humor, and inventiveness. Only the wrecker's ball that, in 1963, reduced McKim, Mead, and White's magnificent Pennsylvania Station to rubble rivaled their effectiveness.

In April 1964, James Baldwin, born in 1924 at Harlem Hospital, oversaw the opening of his play, *Blues for Mister Charlie*. Baldwin insisted that tickets for the ANTA Theater on Broadway be affordable. Baldwin's play spoke to its integrated audiences with anger and sorrow. *Blues for Mister Charlie* forced them to confront the perplexing nature of racial and sexual identity. James Baldwin, a gay man in a heterosexual culture and a black playwright in a white theater industry, had raised his fist in protest.[36]

As a child Baldwin had served as an apprentice preacher at a succession of Harlem storefront Pentecostal churches for three years. After graduating from Frederick Douglass Junior High, where he studied English with Countee Cullen, Baldwin took the el north to the Bronx to attend De Witt Clinton High School. Surrounded by middle-class Jewish classmates, Baldwin edited the student literary magazine and wrote his first stories and poems. Baldwin found the conflict between his schooling, his religious background, and his overbearing stepfather unresolvable. Abandoning Harlem, his family, and his religion, Baldwin moved to Greenwich Village and later to Paris. In the bohemian enclaves of the West Village and the Left Bank, Baldwin came to terms with his color and his homosexuality, which he described in his first two books, *Go Tell It on the Mountain* and *Giovanni's Room*. In 1945, Baldwin first met Richard Wright,[37] sixteen years older than Baldwin, who quickly assumed the role of mentor. He agreed to read Baldwin's manuscript, recommended him for a fellowship, and introduced him to the editors at Harper and Brothers. For three years Baldwin followed Wright's lead, working his way into New York publishing and writing a series of literary essays for the leading liberal magazines—*Commentary,* the *New Leader,* and the *Nation.*[38]

One of a handful of African Americans who lived in Greenwich Village, Baldwin hung out with an assortment of jazz, literary, and theater friends, including Marlon Brando and Tennessee Williams. Baldwin, realizing the importance of confronting his sexual identity, introduced himself to acquaintances as a homosexual, to "preempt the shame."[39] Baldwin's openness contrasted with prevailing socially accepted attitudes and behaviors. Hassled by police and humiliated by public contempt, gay men in New York had resisted by organizing a complex cultural underground, a network of clubs, concerts, bars, and enclaves, both in Harlem and the Village.[40] Baldwin, however, chose personal and artistic confrontation.

Baldwin confronted and stung Richard Wright with the 1949 publication of "Everybody's Protest Novel," written for an experimental Parisian literary magazine. The essay attacked African American literary stereotypes from *Uncle Tom's Cabin* to

*Native Son.* Baldwin also criticized the political novel, arguing that the social art of the depression had shoved artistry rudely aside. Hoping to make his argument stick, Baldwin took aim at Wright, declaring that the main character in *Native Son,* Bigger, was "Uncle Tom's descendent."[41] Baldwin and Wright collided in Paris, screaming at each other in a café. Wright insisted that all literature was political. When Baldwin disagreed, Wright starkly observed, "Here you come again with all that art-for-art's sake crap."[42]

Baldwin remained in France for a decade. He returned to New York in 1957, a critically acclaimed author of two novels, a play, and a fistful of published essays. At a time when American racial complacency had been violently rocked by the murder of Emmett Till and the bombing of Martin Luther King Jr.'s home, Baldwin acted. In the summer of 1957 he roamed the South, stopping in Little Rock, Montgomery, and Birmingham. In Georgia he wrote, "It was on the outskirts of Atlanta that I first felt how the Southern landscape—the trees, the silence, and the fact that one always seems to be traveling great distances—seems designed for violence, seems, almost to demand it."[43] Later that fall he returned north to work on a script, based on his novel *Giovanni's Room,* for the Actors Studio. Although the Actors Studio declined to send the play to Broadway, a year later Elia Kazan invited Baldwin to work with him as a production assistant and residential playwright. Baldwin accepted, believing that the Actors Studio would allow him to examine American racial and sexual hatred.[44] Baldwin worked with Kazan on the Actors Studio productions of Archibald MacLeish's *J.B.* and Tennessee Williams' *Sweet Bird of Youth* and joined a circle of African American dramatists that included playwright Lorraine Hansberry, director Lloyd Richards, and actors Sidney Poitier and Harry Belafonte. Poitier and Baldwin discussed adapting *Go Tell It on the Mountain* for the stage, and Kazan suggested that Baldwin use Emmett Till's murder as the basis for a play about the civil rights movement.[45]

A second trip to the South in 1960 took Baldwin to Martin Luther King Jr.'s church in Atlanta, and in 1961 he met Malcolm X and Elijah Muhammad. In 1963, Dial Press published Baldwin's newest book, *The Fire Next Time.*[46] The *New Yorker* editor William Shawn recalled, "Baldwin's piece had a political content. It was exciting. It was unexpected."[47] Baldwin wrote *The Fire Next Time* in a serious, accessible, and deeply personal style. He wrote of being born black "in a white country, an Anglo-Teutonic, antisexual country," in a society that confused him.[48] A nation divided racially, Baldwin believed, could not survive. For too long he had dismissed the Nation of Islam's demand for a "separate black economy."[49] A racially divided America created a violent separateness in which white liberal fears and Black Muslim aggression glared at each other across the abyss of racial hatred and history. Baldwin tried to speak to both groups. He now believed that the "American dilemma" could only be mitigated by political action.

Baldwin worked on two fronts, political and artistic, to bridge the gap in American race relations—behind the scenes politically and on stage through his play *Blues for Mister Charlie.* In May 1963, a week after his appearance on the cover of *Time* magazine, Baldwin agreed to meet with Attorney General Robert F. Kennedy. The meeting at Kennedy's New York apartment on Central Park South began with con-

frontation and ended in frustration. With Harry Belafonte acting as a conciliator, black and white activists faced off against Kennedy administration officials. Baldwin demanded federal protection for black Americans, especially in the South.[50] He snapped at Kennedy, "You do not understand at all. Your grandfather came as an immigrant from Ireland and your brother is President of the United States. . . . My ancestors came to this country in chains, as slaves. We are still required to supplicate and beg you for justice and decency."[51]

Baldwin carried his confrontational style into *Blues for Mister Charlie*. Combining modernist symbolism with African American speech, *Blues for Mister Charlie* underscores the racial and sexual violence that undergirded segregation and threatened the civil rights movement.[52] Starring Burgess Meredith, Diana Sands, and Rip Torn, the play opened to mixed reviews in April 1964. Inspired by the aggressive edge of Jean Genet's *The Blacks*, which Baldwin had seen in France, *Blues for Mister Charlie* challenged its audiences to comprehend the deep-seated cruelty of racism. Baldwin set the play symbolically, in Plaguetown, whose two institutions, its church and court, he divided racially into "WHITETOWN and BLACKTOWN."[53]

*Blues for Mister Charlie* tells of the murder of Richard Henry, son of the town's black minister, Meridian, by the extraordinarily ordinary Lyle Britten, owner of a down-at-the-heels grocery where Richard Henry stopped for a Coke. As the play begins the murder has already taken place, but Henry's death haunts the townsfolk—whites, because they know the truth of his murder, and blacks, because they believe the truth will never be told. Shuttling between the two racial tribes, Baldwin creates the character of Parnell James—a liberal newspaper editor who hunts with the murderer and retains the confidence of the victim's father and minister—hoping, like Baldwin, to explain each side to the other. Parnell also embodies the virtuous cowardice that Baldwin experienced with white liberals. When called to testify, to deny the accusation of rape leveled against Henry, Parnell freezes, unwilling to refute the lie. The black chorus in Baldwin's courthouse laments, "What do you think of our fine friend *now?* He didn't do it to us rough and hard. No, he was real gentle. I hardly felt a thing. Did you? You can't never go against the word of a white lady, man, not even if you're white."

Baldwin used sexual imagery to provoke his characters and the audience. Richard Henry brags to his former lover, Juanita, of his white female conquests: "I take their money and they love it." Baldwin exposed racist mythology in *Blues for Mister Charlie*. African Americans would achieve neither justice nor equality until human beings could penetrate the veil of prejudice. Baldwin did not, however, resolve the conflict between Black Muslim separatism and white liberal inaction. He ended the play with the murderer's acquittal and an exchange between the liberal Parnell and the weary Juanita, the two most decent characters in his play, one black the other white, one female the other male. Parnell asks Juanita, "Can I walk with you?" The best she and Baldwin could respond in the early spring of 1964—months before the murderous Freedom Summer and the ill-fated attempt of Medgar Evers' successors to capture the Democratic Party's convention credentials—was, "Well, we can walk in the same direction, Parnell."[54]

The production of *Blues for Mister Charlie* reflected the tensions of the play it-

self. Baldwin feuded with actors, producers, and director, insisting that the play remain open even after the Actors Studio posted a closing notice at the end of the first week's run. Baldwin had cajoled the producers into charging aggressively low ticket prices, hoping to attract black audiences. He believed that any attempt to close the play prematurely smacked of racism. Baldwin single-handedly mounted a public campaign to keep the play open for an additional three months, defying Broadway tradition—his style no less confrontational than his play.[55]

Years earlier, Baldwin had attacked Richard Wright for writing political novels. Now, in the wake of the civil rights movement, Baldwin had become Richard Wright's successor. Baldwin's urban blues echoed the pain of a society struggling to redefine itself. His hip alienation and moral outrage revived African American drama, paving the way for the Negro Ensemble Company's production of Charles Fuller's *A Soldier's Play* and later the acclaimed historical works of August Wilson. He also broke the silence that had cloaked homosexuality. In the 1960s, once again, New York art had become politics.

## PHOTOGRAPHING THE CITY:
## DIANE ARBUS

Just as Baldwin refined his identity as an African American and a homosexual in the context of his work and his life in New York, photographer Diane Arbus recovered her identity as a woman and an artist while working in the male-dominated profession of commercial photography. In the 1940s and 1950s, Arbus labored, literally, in the shadow of her spouse. Her artistic career in the 1960s emerged from her battle to remain independent. She photographed the extraordinary that she found everywhere in the ordinary. Overweight nudists and horn-rimmed mambo dancers from Queens became subjects of her relentless pursuit of the bizarre in the everyday life of New York.

Born in 1923, Diane Nemerov shared her family's upper-middle-class Jewish heritage. Her mother's family owned Russek's, a prosperous fur-emporium-turned-carriage-trade-department-store, on Fifth Avenue. The Nemerovs lived comfortably at a variety of addresses on Park Avenue and Central Park West. Diane and her older brother, poet Howard Nemerov, attended the Fieldston School in the Bronx, and at the age of fifteen, she fell in love with City College student Allan Arbus. Her high school classmates, often in awe of Diane's shyly critical intelligence, expressed shock when they learned that their friend "wasn't going to college, she was getting married."[56]

Immediately following World War II, Diane and Allan Arbus collaborated as fashion photographers. Allan had studied photography in the Signal Corps; Diane took classes with Berenice Abbott; the Russeks supplied the cameras and darkroom. In 1947, *Glamour* magazine published their first assignment, "The New Sweater Is a Long Story."[57] The parents of two children, the Arbuses worked as a successful commercial photography team for the next decade. Allan photographed and Diane posed models and worked out the details of the shoot. Between 1957 and 1959, as their partnerships, marital and professional, came undone, Diane Arbus launched her own

career as a photographic artist. The breakup of her marriage and business propelled her into an oscillating pattern of creativity and depression that ended with her suicide in 1971.

Susan Sontag's critical evaluation of Arbus's rejection of the tradition of American photographic compassion, "the sense that what is presented is precisely a private vision, something voluntary," tied Arbus to the confessional poets Sylvia Plath and Anne Sexton.[58] Arbus combined her fascination with the odd with a static compositional style reminiscent of that of her first teacher, Berenice Abbott.[59] Her early work with her husband in fashion and advertising trained her to pose her subjects. She enticed, even seduced, her subjects to reveal themselves. Norman Mailer, whom Arbus photographed in 1963 sprawled, legs wide apart, across his ratty velour easy chair, commented acerbically, "Giving a camera to Diane is like putting a live grenade in the hands of a child."[60]

In the late 1950s, Arbus resumed her formal photographic training. She enrolled in the classes of Lisette Model, a Parisian-educated photographer who taught at the New School, where she learned "[not to] shoot until the subject hits you in the pit of your stomach."[61] Model's grainy wartime portraits of New York's jazz hangouts and overweight women bathing at Coney Island complemented Arbus's commercial training. Arbus also drew on the work of *Daily News* photographer Weegee (Arthur Felig), whose fascination with the lurid and sensational linked him to the Parisian photographer Brassaï.[62]

Arbus's background in commercial and art photography gave her a distinct perspective. She scoured New York searching for her own sensations. "Lately I've been struck with how I really love what you can't see in a photograph. An actual physical darkness. And it's very thrilling for me to see darkness again."[63] Discovering and then presenting a secret forbidden side of urban life, New York's hidden freak show, Arbus created a body of work that resembled Robert Frank's. Frank, whose film *Pull My Daisy* documented the antics of the beats, had published his own photo-essay, *The Americans,* in 1959. But where Frank photographed the mundane and the ironically strange, like the jukeboxes and flags that characterized provincial America, Arbus remained firmly rooted in New York.

Arbus prowled the city's streets day and night, capturing the images of an eccentric blind street person, "Moondog," who stood silently on the corner of Sixth Avenue and 54th Street wrapped in a khaki army blanket, his sightless eyes peering out from beneath a Viking helmet while he begged and recited poetry. "Fascinated by weirdos," Arbus frequented Hubert's Freak Museum on Broadway and 42d Street. There she helped Professor Leroy Heckler feed his flea circus and photographed over and over again the three-legged man or Congo the Jungle Creep, a Haitian named Hezekiah Trambles.[64] In 1964, *Harper's Bazaar* purchased, but did not publish, Arbus's photograph of dance pioneer Ruth St. Denis, barefoot and elegantly posed, draped in a luxurious velvet cape. Arbus posed St. Denis, then in her eighties, as an old and eccentric woman willing to be flattered no matter how unflattering the portrait. The photograph, typical of many "celebrity" pictures that Arbus took, belonged to Arbus's 1960s portfolio. Arbus seemed in perpetual revolt against success and against the conventions of her cultural upbringing.[65] Like pop artist Andy

Warhol, who had also apprenticed in commercial art, Arbus worked the realms of boredom and the freak show, all the time creating memorable images of New York.

Diane Arbus documented a city of an ever widening cast of strange characters, whose stares she caught with snapshot immediacy, their shadows starkly illuminated by flash. She photographed middle-aged nudists, Puerto Rican dwarfs, sequin-pantied hermaphrodites, and vacant-eyed debutantes. Arbus befriended Eddie Carmel, a 495-pound eight-foot-tall man who worked as a broker selling mutual funds in an office on 42d Street, and took roll after roll of pictures of her "Jewish giant." *A Jewish Giant at Home with His Parents in the Bronx, N.Y.* displayed Carmel, ill with incurable bone disease, in his family's living room. Taller than the ceiling, Eddie bent his huge head down to look into his mother's uptilted face. His mother gazed upwards, bewildered at her son's immensity, while Carmel's father, indifferent and bored, looked through his child. Eddie dwarfed his parents, making them physically diminished and mentally oblivious.

Diane Arbus's suicide in 1971, at the height of her creativity, coincided with her most troubled period. A woman alone in New York with two children, she photographed the city's outcasts, at the same time engaging in and distancing herself from the unconventional reality she discovered. At a time of unprecedented change, when revolutionary perspectives and consciousness challenged the images and conventions of middle-class culture and society, Arbus celebrated the bizarre, which both attracted and frightened her. Her sensational show at the Museum of Modern Art, a year after her death, prompted John Szarkowski, MoMA's director of photography, to conclude, "Her pictures challenge the basic assumptions on which most so-called documentary photography has been assumed to rest. . . . Her real subject is no less than the unique interior lives of those she photographed."[66]

Rejecting convention, Diane Arbus nonetheless bristled at being categorized as a female photographer. She was, she insisted, a woman who took pictures. Her pictures documented a world and its people, a forgotten New York that most people refused to acknowledge. Arbus used her photography to expand contemporary consciousness to include even those deemed freaks, New Yorkers whose style and substance rendered their differences—and humanity—in subversive terms compared with the images of beauty and normality that pervaded commercial culture and commercial photography. In seeking out subjects she found that she had to venture far beyond the walls of her parents' Upper East and West Side sanctuaries. It was as if her subjects were the very people Lincoln Center had so carefully displaced. Arbus had made them visible once again.

## RUCKUS MANHATTAN

Four years after Arbus's death, Red Grooms and Mimi Gross Grooms completed a massive installation piece, *Ruckus Manhattan.* Gross and Grooms filled *Ruckus Manhattan* with an Arbus-like cast of characters. The two pop-inspired artists, however, translated Arbus's grotesquely dark image of the city's people into a riot, a celebration. As subversives, Mimi Gross and Red Grooms held up a mirror of laughter. Their *Ruckus Manhattan*, which opened to its first visitors on November 20, 1975,

offered a fresh vision of the city, seen from the perspective of SoHo and Tribeca, New York's newest art enclaves. The Gross and Grooms partnership did not survive the project, in part, because Gross believed Grooms, having listed her only as an assistant director, had claimed *Ruckus Manhattan* as his work alone. Gross's resentment of her husband's condescension coincided with the awakening of other New York women artists who protested their relegation to the background of New York art.

Mimi Gross, daughter of New York sculptor Chaim Gross, belonged to the city's artistic culture. Educated at Music and Art High School and then at Bard College, Gross grew up in an environment peopled by her parents' friends—Raphael and Moses Soyer, Edward Hopper, Milton Avery, William Zorach, and Philip Evergood. A second-generation Jewish artist, with easy access to Provincetown and the Whitney, Mimi Gross possessed a free spirit, a social conscience, and a taste for the outrageous. A New Yorker through and through, Gross found even the unconventional Bard confining. Before graduation she dropped out and made her way to Europe.

In 1960, Gross traveled through Italy and the Mediterranean with fellow artist Charles Grooms. A Nashville-born, Chicago- and New York–trained painter, sculptor, and filmmaker, Red Grooms had arrived in New York in the mid-1950s. He took courses at the New School, where Gross's father taught, and studied in Provincetown with Hans Hofmann. New York opened Grooms' eyes to the possibility of cities as spectacles. Intrigued, like Arbus, by the colorfully eccentric, the circus, the carnival, and the midway, Grooms discovered New York's exotic excitement. He plunged into the grungy bohemianism of Lower Manhattan with an enthusiasm that he attributed to his having grown up "in squaresville."[67]

Mimi Gross met Red Grooms in 1957, when both filtered in and out of the alternative gallery and social scene on the periphery of Greenwich Village. They were introduced at the Phoenix Gallery on East 10th Street by a mutual friend, the artist Jay Midler, who encouraged Grooms to open his own gallery. Since 1959, Grooms and a host of other New York artists, bored with the conventions of abstract expressionism and the static nature of academic art, had staged a series of happenings, in the anarchic spirit of John Cage and Merce Cunningham.[68] Grooms set up the Delancy Street Museum on the Lower East Side, where he featured his performance-art happenings. He played "Pasty Man" in his first production, *Burning Building*, a ten-minute "play" performed in 1959 in a converted boxing gym on Delancy Street. Grooms displayed his fascination with common spectacle, the bizarre, and pyromania. Painter Jim Dine was in attendance, the sole member of the premiere's audience.[69] In his depiction of a madcap pyromaniac evading the clutches of a Keystone cop firefighter, Grooms created a fast, wacky, visually exciting, and stimulating happening.

Grooms and his friends were particularly critical of abstract expressionism. Its uptown galleries, self-congratulatory schools, and fawning critics smacked of bourgeois convention and, worse, of staid and formulaic art. As writer Tom Wolfe observed, "Today the world of art in New York, the world of celebrities, the world of society, press agents, gossip columnists, fashion designers, interior decorators, and other hierophants have all converged on Art. . . . Art—and the Museum of Modern

Art in particular—has become the center of social rectitude, comparable to the Episcopal Church in Short Hills."[70]

In 1960, Grooms left New York to travel with Gross. The two spent the next eighteen months traveling through Italy, with a foray into Greece and Egypt, occasionally accompanied by an English bluegrass banjo player and a horse. The latter they named Ruckus as it pulled their wildly decorated wooden cart through northern Italy. The wagon that Ruckus hauled bore the legend, *Il Piccolo Circo d'Ombre di Firenze*.[71] Gross's down-to-earth artistic flair proved a sure fit to Grooms' fascination with popular amusement. When they began to work collaboratively on large installations, Grooms remarked, in studied contradiction, "I do most of the painting. Mimi and I do the painting. She's a wonderful painter."[72]

Mimi Gross and Red Grooms returned to New York in 1962 to find that happenings, often performed at the Judson Church on Washington Square, had become major events, in Grooms' words, "painter's theater." The short-lived happening movement had begun in New Jersey. Rutgers University art professor Allan Kaprow, who had studied with Hans Hofmann and worked closely with sculptor George Segal and pop artist Roy Lichtenstein, inaugurated the happenings, a painter-directed movement whose alternative spirit paralleled the Off- and Off-Off-Broadway experimental theater. Happenings—part theater, part performance art, and part sculptural installation—were influenced by John Cage. In the late 1950s, Kaprow attended the "Composition of Experimental Music" course that Cage taught at the New School.[73] Cage's combination of anarchic artistic radicalism and disdain for all forms of elitism made him a perfect foil to the now gentrified acceptability of abstract expressionism.

But the painters who took up the happenings movement, recounted Grooms, "wanted to be in show business. I had no talent." Instead, Grooms focused on experimental films and on the mixed-media sculptural collages that became his trademark.[74] The art of Red Grooms and Mimi Gross defied conventional categorization. Working in three dimensions, painting on cardboard, papier-maché, cut-out and cut-up canvas, and wood, their assemblages and dioramas evoked a combination of 1960s underground cartooning, urban social realism, and European classicism. The result was a distorted and crowded realism characterized by Grooms as a "nutty perspective" that he attributed to his fascination with Italian Renaissance art. By mid-decade, Grooms and Gross had become associated with pop art, but they resisted the tendency of pop artists, such as Andy Warhol, to appropriate techniques from advertising and fashion. Grooms and Gross, however, shared pop artists' determination to "let the world in again."[75] The city and its outrageous inhabitants became their home and their model. "New York," noted Grooms, "is all people . . . it is so frantic or unplanned or something."[76]

Gross and Grooms located a cavernous loft in Little Italy, two blocks north of the busy intersection of East Broadway and Canal Street. At the western fringe of Chinatown, the dilapidated factory district of SoHo and the even more narrow and claustrophobic streets of Tribeca teemed with ethnic, social, and sexual variety. SoHo's attraction to artists corresponded directly to the gentrification of Greenwich Village. The construction of Washington Square Village, an apartment complex to

the south of Washington Square, forced rents skyward during the 1960s, making it impossible for poor artists to live in the Village. Gross, Grooms, and hundreds of other young artists pushed into the vacated loft district between Houston and Canal Streets. Violating unenforced New York City fire department regulations, New York's newest avant-garde made SoHo its home. In 1973, New York designated the neighborhood as the SoHo–Cast-Iron Historic Landmark District, marking the beginning of the neighborhood's respectability.

It took Mimi Gross and Red Grooms a decade to translate their Lower Manhattan neighborhood into *Ruckus Manhattan*. By the late 1960s, Gross and Grooms had combined their artistic careers and completed several major "sculpto-picto-ramas," including *The City of Chicago* and *The Discount Store*. Filled with human and architectural cutouts and constructions, the installations of the late 1960s anticipated *Ruckus Manhattan* without approaching its larger-than-art, smaller-than-life scale.

*Ruckus Manhattan* required a vast work space. Grooms and Gross successfully negotiated with Creative Time, a nonprofit agency, to obtain an extraordinary workshop and exhibition area, rent free. Located in I. M. Pei's glass and steel tower at 88 Pine Street, a short walk from the Stock Exchange and the Fulton Fish Market, their new studio-gallery contained thirty-foot ceilings, sixty-four hundred square feet of floor space, and a blocklong plateglass window open to the street. Pei's International Style skyscraper heightened the "nutty perspective," created by the crush of older tall buildings and narrow winding streets, that builders had shoehorned into Wall Street.[77]

Grooms' uptown gallery, the Marlborough, provided financial support for their Manhattan project. In the fall of 1975, *Ruckus Manhattan* opened at Pine Street, followed six months later by a second, expanded opening at Marlborough's 57th Street gallery, coinciding with the nation's bicentennial. Gross and Grooms intended *Ruckus Manhattan* to be part of the city's celebration, allowing revelers to discover New York within their miniature representation.

*Ruckus Manhattan*, though conceived by Mimi Gross and Red Grooms, was built by twenty-two other collaborators. It consisted of a dozen separate installations recreating Lower Manhattan from the Narrows to Wall Street, from the World Trade Center to Chinatown. The largest segment, *Wall Street*, stretched fifty-one feet, and the walk-through subway car, filled with characters Arbus might have discovered had she had a sense of humor—a bag lady and a nodding salivating drunk—measured nine feet high, eighteen feet wide, and thirty-seven feet long. The project, originally titled *Gotham City* in deference to Grooms' fascination with comic books, included a bright-yellow harbor ferry, an elastic model of the Brooklyn Bridge, a monstrously gothic Woolworth Building, and *Ms. Liberty*, whose lurid red platform shoes alluded to the disco and fashion craze captured by the movie *Saturday Night Fever*.

For years Gross and Grooms had dreamed of constructing a New York installation. The yawning exhibition area at Pine Street allowed them to expand their original plans. Gross bicycled around Lower Manhattan taking copious notes, sketching plans for the subway and Woolworth Building sections, her sense of and attention to detail a match for Grooms' sense of the absurd. Grooms usually worked at Pine

Street assisted by various associates, and Gross assembled a crew to work with her at their Tribeca studio. The two collaborated separately, with Gross assuming direction of the ferry, the Woolworth Building, the subway, and *Ms. Liberty*. The Marlborough Gallery's fifteen-hundred-dollar advance failed to cover the cost of materials, forcing Gross and Grooms to use their savings to finance most of the construction. Two weeks before the scheduled opening, they ran out of money, but the crew agreed to finish the project pro bono.[78]

The Ruckus Construction Company decided to bring the Pine Street sidewalk superintendents, the spectators who daily peered through the gallery's plateglass windows, into *Ruckus Manhattan*. Mimi and Red used likenesses of the faces of the spectators on the denizens of *Ruckus Manhattan* who slept on the subway or covertly examined the stock at the 42d Street King Porn Bookstore. The artists also agreed to a contest: "If anyone spotted the most beautiful girl in the world we would run out into the street and get her." When a young black office worker from Wall Street strolled by, Mimi overtook her and asked her to pose, convincing her that the offer was on the up and up.[79] Within a week Mimi recast the woman into *Ms. Liberty*, whose fifteen-foot height stretched to include the lit cigarette that served as her torch. Built of fiberglass, celastic, and vinyl, *Ms. Liberty* became the project's hallmark.

Gross made her sassy. *Ms. Liberty*, her dress hiked up to her knees and bearing a pocketbook above Emma Lazarus's "Give me your tired, your poor," stood atop her shimmering pedestal, allowing the gawking passengers on the *Marine and Aviation Ferry* to give her the eye. *Ms. Liberty* became the show's symbolic colloquial statement, a stunning African American New York woman, a new personification of liberty. Mimi Gross saw in *Ms. Liberty* the city's diversity, its women, and her own emerging consciousness. Gross recalled that the green crown atop *Ms. Liberty*, mimicking the styrofoam headbands hawked by vendors during the bicentennial, failed to work as she had intended, because it distorted the statue's face. Grooms concurred with her assessment. Unhappy with the piece, he allowed Gross to sign her name on the soles of *Ms. Liberty*'s shoes, the only part of the show that Gross was allowed to claim.[80]

*Ruckus Manhattan,* a kaleidoscope of cityscapes, part emergent consciousness and part grand vision of two energetic and entertaining artists, celebrated the vitality of contemporary New York. As art, it defied category. Gross and Grooms begged, borrowed, and stole from the divergent traditions that made up New York Modern— Beaux-Arts classicism, urban realism, European modernism, New York commercialism, American popular culture, and the city itself. While Grooms' human cutouts bore the stamp of Picasso, the strutting red sandals sported by Gross's *Ms. Liberty* evoked Dorothy's shoes in *The Wizard of Oz*.

In miniaturizing New York, Gross and Grooms acted as spielers, inviting its citizens—an estimated hundred thousand visitors trooped through and over its subway, ferry, and bridge—to examine themselves. In *Ruckus Manhattan,* the audience found the familiar, the haunting, and the unexpected. Mimi Gross and Red Grooms constructed New York in the image of their avant-garde neighborhood. Bursting at the seams, their New York was a place of affection, even of joy—a utopia of sorts.

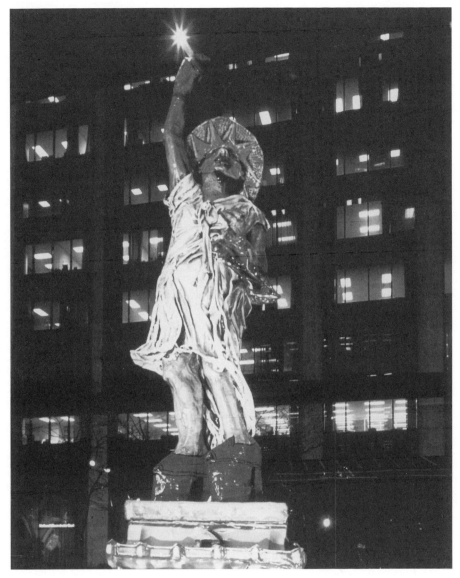

*Ms. Liberty.* Sculpture
by Mimi Gross; base
by Constance Harris
(1975–76).
*Photograph courtesy
of Mimi Gross*

For all its eccentricities, *Ruckus Manhattan* presented the city as a haven for the familiarly odd, a peaceful version of Arbus's freak show. In the midst of fiscal crisis and social discord, Manhattan remained, for Gross and Grooms, a magical city of dreams and fantasy, vibrant and young at heart.

For much of their professional careers Mimi Gross and Red Grooms had worked together, though each had also pursued independent careers. Grooms, however, received credit for their joint projects. As "company director" he signed the gallery contracts that rewarded their joint success. For a decade and a half Mimi Gross had been content to work alongside Grooms, cooperating, supporting, and allowing him to take credit for their work. As members of an artistic avant-garde, Grooms and Gross worked for wonder, but also for recognition and reward. Finally, Gross real-

ized, "I'm in a generation that was broken down by male dominance. I'm the end of a type."[81] On the nation's bicentennial, Mimi Gross forged an image of female independence. *Ms. Liberty* expressed the changing consciousness of women artists. No longer content to stand, like abstract expressionist Hedda Sterne, in the background, they demanded a place of their own at the center of New York's modern arts.

Lincoln Center and the antimonument of *Ruckus Manhattan* expressed the divisions that rent New York. The illusions of unlimited power, arrogantly asserted by the city's politicians, succumbed to the ebb of New York's imperial moment. Its golden age had passed. In the 1970s, New York remained a great city, still the most important center of American and modern art. Much had changed since the nineteenth century even as much remained. Lincoln Center, the Museum of Modern Art, and the Whitney and Guggenheim Museums attested to the city's transformation from Victorian to Modern.

*Ruckus Manhattan,* however, alluded to the continuities. Contemporary New York remained as out of control as Gilded Age New York. Each era boasted irresponsible millionaires, crime and disease-infected tenements, violent streets, rampant materialism, widespread abuse of drugs, and obsession with sexuality, even as the complexion and ethnicity of New Yorkers continued to change with the city's artistic styles and landmarks. Still, New York endured as a great and unbounded city, a ruckus of vitality, ambitions, opportunities, dreams, violence, and disappointments. In 1976 the city retained all the excitement that it had exuded in 1876. Grooms and Gross's *Ruckus Manhattan,* like New York, was irrepressible and uncontrollable, yet irresistible. Their satiric, affectionate, and acerbic portrait acknowledged and celebrated what Robert Moses had failed to comprehend and, finally, feared—that modern New York defied category, defied all efforts to impose order. A black *Ms. Liberty,* in beckoning miniskirt and red platform shoes, symbolized the spirit of New York Modern. *Ruckus Manhattan* was an artistic construction of what New York had been, what it was, and what it might be.

New York Modern identified and expressed the tensions and dynamism of New York City. It was a dialogue between the city and its artists. The New York renaissance's dream of an encompassing beaux arts aesthetic and the Museum of Modern Art's vision of a prescriptive modernism were just that—dreams and visions. Instead, New York Modern articulated the volatile, uncontrollable complexity of an ever changing city, a city comprising an enormous variety of people drawn from all parts of the world. Over the course of a century, the urban realism that provided the syntax of New York Modern repeatedly renewed, renovated, and reconceptualized itself, accepting the challenge and insights of European modernism, absorbing and criticizing American commercial and vernacular culture, and responding to New Yorkers' ever widening range of concerns. Dynamic and insurgent, New York Modern simultaneously validated and subverted itself. Like the city, it remained a work in progress, its cacophony always reasserting itself, defeating all efforts to orchestrate an artificial harmony or an authoritative, unified aesthetic.

Never simply art in New York, New York Modern also largely defined American art in the twentieth century. After the Civil War, history happened to New Yorkers

sooner than it happened to other Americans. On a grander scale and in greater variety, modern America remade itself in New York. The 1886 erection of Frederic Bartholdi's *Statue of Liberty* in New York Harbor heralded the emergence of a new nation made up of people drawn from all corners of the world. New Yorkers, from beaux arts patron Mariana Van Rensselaer to pop artist Red Grooms, embraced, celebrated, and authenticated this modern diversity. In dance, books, television, music, drama, painting, photography, and advertising, New York's artists imparted their values and images to other Americans, influencing how we understood ourselves, our society, and the modern condition. Mimi Gross's African American *Ms. Liberty*, in her miniskirt and red platform heels, affirmed Bartholdi's vision even as it subverted and updated its meaning.

Still, New York Modern remained incomplete and selective. It never encompassed the lives of all New Yorkers. No artistic movement could. Felipe and Julia Rodriguez remained outside its frame, victims of its success. It never represented everything, nor did it speak for everyone. New York Modern could never be tidy or uplifting, nor even reassuringly stable. But it was real.

PROLOGUE   Before the Modern: The New York Renaissance

1. *New York Times,* Mar. 26, 1893.

2. Brooklyn Museum, *American Renaissance: 1876–1917,* Richard Guy Wilson, Dianne H. Pilgrim, and Richard N. Murray, curators (New York, 1979).

3. Herbert Croly, "New York as the American Metropolis," *Architectural Record* 13 (1903): 193.

4. Brooklyn Museum, *American Renaissance.*

5. Ibid.

6. As they are based on nineteenth-century statistics, these figures are only estimates, but the pattern of growth they project is accurate. Roger S. Tracy, "The Growth of Great Cities," *Century* 33 (1897): 79–81; Edward Spann, *The New Metropolis: New York City, 1840–1857* (New York, 1981); U.S. Census Bureau, *Fifteenth Census, 1930* (Washington, D.C., 1931), 486, 498, 711, 746.

7. Spann, *New Metropolis.*

8. Timothy J. Gilfoyle, *City of Eros: New York City, Prostitution, and the Commercialization of Sex, 1790–1920* (New York, 1992), 23–178.

9. Ibid., 179–96.

10. Frank Luther Mott, *A History of American Magazines, 1885–1905* (Cambridge, Mass., 1930–68), 2:383–405, 469, 493; 3:25, 187, 330, 457–80, 536–55; 4:511, 717.

11. "New Homes of New York," *Scribner's Monthly* 8 (1874): 63–76. According to Elizabeth Collins Cromley, in 1910 New York had more than three hundred thousand white-collar wage earners. *Alone Together: A History of New York's Early Apartments* (Ithaca, N.Y., 1990), 172.

12. Roy Rosenzweig and Elizabeth Blackmar, *The Park and the People* (Ithaca, N.Y., 1992), 340–69.

13. Ernest Flagg, "The Ecole des Beaux-Arts," *Architectural Record* 3 (1894): 303–13, 419–28, and 4 (1894): 38–43; Richard Whiteing, "American Student at the Beaux-Arts," *Century* 1 (1881): 259–72. Also see Richard Chafee, "The Teaching of Architecture at the Ecole des Beaux-Arts," in *The Architecture of the Ecole des Beaux-Arts,* ed. Arthur Drexler (New York, 1977).

14. Leland Roth, *McKim, Mead, and White, Architects* (New York, 1983), 1. Also see Herbert Croly and Henry Desmond, "The Work of Messrs. McKim, Mead, and White," *Architectural Record* 20 (1906): 153–246, for an appreciative evaluation by contemporary "modernists."

15. Robert Stern, Gregory Gilmartin, and John Montague Massengale, *New York, 1900* (New York, 1983).

16. Sarah Burns, *Inventing the Modern Artist: Art and Culture in the Gilded Age* (New Haven, Conn., 1996).

17. Nicolai Cikovsky Jr., "William Merritt Chase's Tenth Street Studio," *Archives of American Art Journal* 16, no. 2 (1976): 2–13; Garnett McCoy, "Visits, Parties, and Cats in the Hall: The Tenth Street Studio Building and Its Inmates in the Nineteenth Century," *Archives of American Art Journal* 6, no. 1 (1966): 1–8; Burke Wilkinson, *Uncommon Clay: The Life and Works of Augustus Saint-Gaudens* (New York, 1985); Margaret French Cresson, *Journey into Fame: The Life of Daniel Chester French* (Cambridge, Mass., 1947), 61–71; Mary Daniel Chester French, *Memories of a Sculptor's Wife* (Boston, 1928), 154–68; Will H. Low, *A Chronicle of Friendships* (New York, 1908), 231–83.

18. List of instructors is found in Art Students League, "Instructors: 1875–1925," microfilm roll NY59–20, Archives of American Art, Smithsonian Institution.

19. Society of American Artists, *Exhibition Catalogs, 1878–1888,* New York Public Library. The 1889 catalog not only lists members and exhibitors but designates where and with whom each member studied. In addition to this information, the lists indicate the value the society placed on its members' European credentials.

20. [William Crary Brownell], "Young Artists' Life in New York," *Scribner's Monthly* 19 (1879): 355–68; Will H. Low, "Education of the Artists, Here and Now," *Scribner's Magazine* 25 (1899): 765–68; Marchal E. Landgren, *Years of Art: The Story of the Art Students League of New York* (New York, 1940).

21. Michele H. Bogart, *Public Sculpture and the Civic Ideal in New York City, 1890–1930* (Chicago, 1989), 260–67; John Hutton, "Picking Fruit: Mary Cassatt's *Modern Women* and the Woman's Building of 1893," *Feminist Studies* 20 (1994): 318–48.

22. John Gillis, ed., *Commemorations: The Politics of National Identity* (Princeton, N.J., 1994); John Bodnar, *Remaking America: Public Memory, Commemoration, and Patriotism in the Twentieth Century* (Princeton, N.J., 1991); Richard N. Murray, "Painting and Sculpture," in Brooklyn Museum, *American Renaissance,* 153–89; Bogart, *Public Sculpture and the Civic Ideal;* Wilkinson, *Uncommon Clay;* Hutton, "Picking Fruit"; Lorado Taft, *History of American Sculpture* (New York, 1930), pt. 3; Sylvester Baxter, "Art in the Street," *Century* 49 (1906): 697–703; William Ordway Partridge, "The American School of Sculpture," *Forum* 29 (1900): 492–500; Russell Sturgis, "The Work of J. Q. A. Ward," *Scribner's Magazine* 32 (1902): 385–99; Will H. Low, "Frederick MacMonnies," *Scribner's Magazine* 18 (1895): 617–28; Royal Cortissoz, "Landmarks of Manhattan," *Scribner's Magazine* 18 (1895): 531–44.

23. See Gillis, *Commemorations,* Bodnar, *Remaking America,* and Bogart, *Public Sculpture and the Civic Ideal.*

24. Lois W. Banner, *American Beauty* (Chicago, 1983), 128–74.

25. [Brownell], "American Student at the Beaux-Arts." Also see Murray, "Painting and Sculpture"; Lois Fink and Joshua C. Taylor, *Academy: The Academic Tradition in American Art* (Chicago, 1978); Richard Leppert, *Art and the Committed Eye: The Cultural Functions of Imagery* (Boulder, Colo., 1996); and Kenneth Clark, *The Nude: A Study in Ideal Form* (Garden City, N.Y., 1959); David Sellin, *The First Pose, 1876: Turning Point in American Art* (New York, 1976); Leo Steinberg, *The Sexuality of Christ in Renaissance Art and in Modern Oblivion* (New York, 1983).

26. Quoted in Lloyd Goodrich, *Thomas Eakins: His Life and Work* (New York, 1933), 20.

27. For a discussion on the underlying sexuality of conventional Victorians, see Karen Lystra, *Searching the Heart: Women, Men, and Romantic Love in Nineteenth-Century America* (New York, 1989).

28. George Parsons Lathrop, "The Progress of Art in New York," *Harper's New Monthly Magazine* 86 (1893): 740–52; Randall Blackshaw, "The New New York," *Century* 42 (1902): 493–513; Frank Edwin Elwell, "New York as an Art Center," *Arena* 32 (1904): 258–65; Royal Cortissoz, "New York as an Art Center," in *American Artists* (New York, 1923), 313–24; Brooklyn Museum, *American Renaissance.*

29. Michael Quick, *American Expatriate Painters in the Late Nineteenth Century* (Dayton, Ohio, 1976); Richard Kenin, *Return to Albion: Americans in England, 1760–1940* (Washington, D.C., 1979).

30. Mariana Van Rensselaer, "Picturesque New York," *Century* 23 (1892): 164–75.

31. Mariana Van Rensselaer, "The Madison Square Garden," *Century* 25 (1894): 732–47.

32. Mariana Van Rensselaer, "Midsummer in New York," *Century* 40 (1901): 483–501. See

Cortissoz, "Landmarks of Manhattan," and Blackshaw, "The New New York," for similar "tours" of beaux arts New York.

33. Mariana Van Rensselaer, "Places in New York," *Century* 31 (1896–97): 501–16.

34. Charles Fenton, "Founding of the National Institute of Arts and Letters in 1898," *New England Quarterly* 32 (1959): 435–54; Lillian B. Miller and Nancy A. Johnson, *Portraits from the American Academy and Institute of Arts and Letters* (Washington, D.C., 1987).

35. Geoffrey T. Hellman, "Profiles: Some Splendid and Admirable People," *New Yorker*, Feb. 23, 1976, 43–48.

36. Robert Underwood Johnson, *Remembered Yesterdays* (Boston, 1923), 451.

37. Patricia Hills, *Turn-of-the-Century America: Paintings, Graphics, Photographs, 1890–1910* (New York, 1977), surveys turn-of-the-century changes in American art, which is largely New York art. Also see Milton Brown, *American Art to 1900: Painting, Sculpture, Architecture* (New York, 1977). For broader cultural and intellectual changes, see John Higham, "The Reorientation of American Culture in the 1890s," in *Writing American History* (Bloomington, Ind., 1970); Jackson Lears, *No Place of Grace: Antimodernism and the Transformation of American Culture, 1880–1920* (New York, 1981); George Cotkin, *Reluctant Modernism: American Thought and Culture, 1880–1900* (New York, 1992); Daniel Joseph Singal, ed., *Modernist Culture in America* (Belmont, Calif., 1991); James Turner, *Without God, without Creed: The Origins of Unbelief in America* (Baltimore, 1985); Lewis Erenberg, *Steppin' Out: New York Nightlife and the Transformation of American Culture, 1890–1930* (Chicago, 1981); William Leach, *Land of Desire: Merchants, Power, and the Rise of a New American Culture* (New York, 1993).

**ONE**   Times Square: Urban Realism for a New New York

1. *New York Times*, Jan. 1, 1905.

2. *New York Times*, Jan. 1, 1906.

3. *New York Times*, Dec. 31, 1904.

4. William R. Taylor, ed., *Inventing Times Square: Commerce and Culture at the Crossroads of the World* (Baltimore, 1996).

5. William R. Leach, *Land of Desire: Merchants, Power, and the Rise of a New American Culture* (New York, 1993). Also see John Higham, "The Reorientation of American Culture in the 1890s," in *Writing American History* (Bloomington, Ind., 1970); Jackson Lears, *No Place of Grace: Antimodernism and the Transformation of American Culture, 1880–1920* (New York, 1981); George Cotkin, *Reluctant Modernism: American Thought and Culture, 1880–1900* (New York, 1992); Daniel Joseph Singal, ed., *Modernist Culture in America* (Belmont, Calif., 1991); Lewis Erenberg, *Steppin' Out: New York Nightlife and the Transformation of American Culture, 1890–1930* (Chicago, 1981).

6. Carl E. Schorske, *Fin-de-Siécle Vienna: Politics and Culture* (New York, 1979); Roger Shattuck, *The Banquet Years: The Arts in France, 1885–1918* (Garden City, N.Y., 1958).

7. Randall Blackshaw, "The New New York," *Century* 42 (1902): 493–513; Rupert Hughes, *The Real New York* (New York, 1904); Bayrd Still, *Mirror for Gotham* (New York, 1956); John C. Van Dyke, *The New New York* (New York, 1909).

8. Lincoln Steffens, "The Modern Business Building," *Scribner's Magazine* 22 (1897): 37.

9. David C. Hammack, *Power and Society: Greater New York at the Turn of the Century* (New York, 1982), 223–27.

10. Walter Laidlaw, comp., *Population of the City of New York, 1890–1930* (New York, 1932); Ira Rosenwaike, *Population History of New York City* (Syracuse, N.Y., 1972); Still, *Mirror for*

*Gotham;* Lloyd Morris, *Incredible New York* (New York, 1951); Roger S. Tracy, "The Growth of Great Cities," *Century* 33 (1897): 79–81; Herbert Croly, "New York as the American Metropolis," *Architectural Record* 13 (1903): 193–206.

11. Laidlaw, *Population of the City of New York,* 247, 268, 275, 299.

12. Frederick C. Jaher, "Nineteenth-Century Elites in Boston and New York," *Journal of Social History* 6 (1972): 32–77, and "Style and Status: High Society in Late-Nineteenth-Century New York," in Jaher, ed., *The Rich, the Well Born, and the Powerful: Elites and Upper Classes in History* (Urbana, Ill., 1973); Helen L. Horowitz, *Culture and the City* (Lexington, Ky., 1976); Neil Harris, "Four States of Cultural Growth: The American City," *Indiana Historical Society Lectures, 1971–1972* (Indianapolis, 1972).

13. Hammack, *Power and Society,* 303–26.

14. Jacob Riis, *How the Other Half Lives: Studies among the Tenements of New York* (New York, 1890).

15. H. Wayne Morgan, *Unity and Culture: The United States, 1877–1900* (Baltimore, 1971).

16. Still, *Mirror for Gotham,* 205–34, 257–78.

17. Immanuel Tobier, "Manhattan's Business District in the Industrial Age," in *Power, Culture, and Place: Essays on New York City,* ed. John Hull Mullenkopf (New York, 1988); Robert Stern, Gregory Gilmartin, and John Montague Massengale, *New York, 1900* (New York, 1983); William R. Taylor, ed., *In Pursuit of Gotham: Culture and Commerce in New York* (New York, 1992).

18. Taylor, *Inventing Times Square.*

19. Erenberg, *Steppin' Out,* 30–145.

20. Taylor, *Inventing Times Square;* Allen Churchill, *The Great White Way: A Recreation of Broadway's Golden Era of Theatrical Entertainment* (New York, 1962).

21. Harry Griswold Dwight, "An Impressionist's New York," *Scribner's Magazine* 38 (1905): 544–54.

22. For a sampling of artists' experiences, see Waldo Frank, *America and Alfred Stieglitz: A Collective Portrait* (New York, 1934); Guy Pène du Bois, *Artists Say the Silliest Things* (New York, 1940); John Sloan, *John Sloan's New York Scene,* ed. Bruce St. John (New York, 1965); Jerome Myers, *An Artist in Manhattan* (New York, 1940); Ruth St. Denis, *An Unfinished Life* (Brooklyn, N.Y., 1939); Isadora Duncan, *My Life* (New York, 1927); James Gibbons Huneker, *Steeplejack* (New York, 1921); Paul Rosenfeld, *Port of New York* (New York, 1924); Theodore Dreiser, *The Color of a Great City* (New York, 1923); William Dean Howells, *A Hazard of New Fortunes* (New York, 1890); and Robert Henri, *The Art Spirit,* comp. Margery Ryerson (New York, 1984).

23. Stern, Gilmartin, and Massengale, *New York, 1900,* 167–68.

24. William R. Taylor and Thomas Bender, "Culture and Architecture: Aesthetic Tensions in the Shaping of New York," in Taylor, *In Pursuit of Gotham.*

25. Merrill Schleier, *The Skyscraper in American Art, 1890–1931* (Ann Arbor, Mich., 1986); Carl W. Condit, *American Building Art: The Nineteenth Century* (New York, 1960).

26. Montgomery Schuyler, "The Skyscraper Problem" (1903) reprinted in Schuyler, *American Architecture,* ed. William H. Jordy and Ralph Coe (Cambridge, Mass., 1961), vol. 2.

27. Ada Louise Huxtable, *The Tall Building Artistically Reconsidered: The Search for a Skyscraper Style* (New York, 1982).

28. Schuyler, "The Woolworth Building" (1913), reprinted in Schuyler, *American Architecture.*

29. William Innes Homer, *Robert Henri and His Circle* (Ithaca, 1969), and Rebecca Zuri-

er, Robert W. Snyder, and Virginia M. Mecklenburg, *Metropolitan Lives: The Ashcan Artists and Their New York* (New York, 1996). Also see David E. Shi, *Facing Facts: Realism in American Thought and Culture, 1850–1920* (New York, 1995), 181–274.

30. Du Bois, *Artists Say the Silliest Things,* 82, 84, 86–87.

31. For the details of Henri's life and of his associates, we have relied on Homer, *Henri and His Circle.*

32. Du Bois, *Artists Say the Silliest Things,* 88–89.

33. Henri, *Art Spirit,* 16.

34. Ibid., 32, 79, 45. Also see Shi, *Facing Facts,* 251–74.

35. Homer, *Henri and His Circle,* 120–22. Sloan, *New York Scene,* 278–79; *Art News* ( Jan. 1 and Jan. 16, 1909). See the Jan. 16, 1909, announcement for the Henri School of Art, in the George Bellows Papers, Amherst College Library, Amherst, Massachusetts.

36. *New York Sun,* Mar. 16, 1907; *Art News* (Mar. 23, 1907).

37. Homer, *Henri and His Circle,* 126–28.

38. Sloan, *New York Scene,* 118, 124, 126, 173; Ira Glackens, *William Glackens and the Eight* (New York, 1957), 76–78.

39. *New York Sun,* May 15, 1907.

40. Homer, *Henri and His Circle,* 136–38.

41. Brooklyn Museum, *The Eight* (Exhibition Catalog, Nov. 1943–Jan. 1944) (Brooklyn, 1944).

42. *Town Topics.* Quoted in Glackens, *William Glackens and the Eight,* 89.

43. "Growing Pains of American Art," *Current Literature* 44 (Apr. 1908): 393–97. Apart from the reviewer's own opinion, the article provides a good summary of reviews of *The Eight Exhibition.*

44. Bennard B. Perlman, *The Immortal Eight* (Cincinnati, Ohio, 1979); Rowland Elzea, *John Sloan's Oil Paintings: A Catalogue Raisonné* (Newark, Del., 1991), 2 vols.

45. Homer, *Henri and His Circle,* 151–55.

46. Quoted ibid., 149.

47. Elizabeth Kendall, *Where She Danced: The Birth of American Art Dance* (Berkeley, Calif., 1979); Ann Daly, *Done into Dance: Isadora Duncan in America* (Bloomington, Ind., 1995).

48. Kennedy Galleries, *The Art Students League of New York, 1875–1975* (New York, 1975).

49. Benjamin McArthur, *Actors and American Culture, 1880–1920* (Philadelphia, 1984); Lois W. Banner, *American Beauty* (Chicago, 1983).

50. Kendall, *Where She Danced,* 4–13.

51. St. Denis, *An Unfinished Life,* 9.

52. Ibid., 1–10; Kendall, *Where She Danced,* 18–25; Suzanne Shelton, *Divine Dancer: A Biography of Ruth St. Denis* (Garden City, N.Y., 1981), 2–20.

53. St. Denis, *An Unfinished Life,* 15.

54. Ibid., 18.

55. Ibid., 22.

56. Shelton, *Divine Dancer,* 37–65.

57. Ibid., 55–58. Most references use the patrons' married names: Mrs. Stuyvesant [Mame Anthon] Fish, Mrs. Karl [Marie Schevill] Bitter, Mrs. Arthur [Dr. Virginia Merriweather Davis] Davies, Mrs. Edwin [Evangeline Wilbour] Blashfield, Mrs. J. Alden [Ella Baker] Weir, Mrs. Richard Watson [Helena de Kay] Gilder, and Mrs. Henry [Mary Kenan] Flagler.

58. St. Denis, *An Unfinished Life,* 72, 73.

59. Loie Fuller, *Fifteen Years of a Dancer's Life* (Boston, 1913), 51–57.

60. Isadora Duncan, "America Makes Me Sick," reprinted in *Isadora Speaks,* ed. Franklin Rosemont (San Francisco, 1981), 129.

61. Duncan, *My Life.*

62. Ibid., 43, 44. Madeline Force Astor was the wife of John Jacob Astor.

63. Isadora Duncan, *The Art of Dance,* ed. Sheldon Cheney (New York, 1928), 56.

64. Ibid., 62–63.

65. Duncan, *My Life,* 75.

66. Sloan, *New York Scene,* 352.

67. The WNET documentary film, "Pioneers of Modern Dance" (New York, 1977), written by Elizabeth Kendall, contains footage of all of the early modern dancers, including the only filmed record of Isadora Duncan. The Dance Collection of the New York Public Library at Lincoln Center has available numerous filmed performances by other dancers as well as filmed reconstructions of their dances.

68. Quoted in Kendall, *Where She Danced,* 87.

69. Caroline Caffin and Charles Caffin, *Dancing and Dancers of Today: The Modern Revival of Dancing as an Art* (New York, 1912).

70. Irene Castle, *Castles in the Air* (Garden City, N.Y., 1958). Also see Kendall, *Where She Danced,* 87–101, and Marshall Stearns and Jean Stearns, *Jazz Dance: The Story of American Vernacular Dance* (New York, 1968), 95–102.

71. Shelton, *Divine Dancer,* 122–58.

72. Huneker, *Steeplejack,* 266.

73. Ibid., 1; Arnold Schwab, *James Gibbons Huneker: Critic of the Seven Arts* (Stanford, Calif., 1963), 26–34.

74. Huneker quoted in Schwab, *James Gibbons Huneker,* 176.

75. H. Wiley Hitchcock, *Music in the United States: A Historical Introduction* (Englewood Cliffs, N.J., 1969), 43–53.

76. Irving Kolodin, Francis D. Perkins, and Susan Thiemann Sommer, "New York," in *The New Grove Dictionary of Music and Musicians,* ed. Stanley Sadie (London, 1980), 13:171–89.

77. John H. Mueller, *The American Symphony Orchestra: A Social History* (Bloomington, Ind., 1951); Kolodin, Perkins, and Sommer, "New York."

78. Schwab, *James Gibbons Huneker,* 35–40.

79. Ibid., 68, 229.

80. Edward A. Berlin, *King of Ragtime: Scott Joplin and His Era* (New York, 1994), and Edward L. Ayers, *The Promise of the New South: Life after Reconstruction* (New York, 1992), 373–408.

81. Quoted in John Edward Hasse, "Ragtime from the Top," in Hasse, ed., *Ragtime: Its History, Composers, and Music* (New York, 1985), 8.

82. Ibid., 1–39. Also see the classic study of ragtime, Rudi Blesh and Harriet Janis, *They All Played Ragtime* (New York, 1950), and Berlin, *King of Ragtime,* 3–12.

83. Berlin, *King of Ragtime.*

84. Ibid.; Addison W. Reed, "Scott Joplin," in Hasse, *Ragtime,* 125–26.

85. William J. Schafer and Johannes Riedel, *The Art of Ragtime: Form and Meaning of an Original Black American Art* (Baton Rouge, La., 1973), 54–55.

86. Ibid., 5–89. Also see essays by Guy Waterman, "Ragtime," and "Joplin's Late Rags: An Analysis," and Roland Nadeau, "The Grace and Beauty of Classic Rags," in Hasse, *Ragtime.* There are several recorded anthologies of Joplin's rags. Among the best is *Scott Joplin: The Red Back Book* (Hollywood, Calif., 1973) by the New England Conservatory Ragtime En-

semble, conducted by Gunther Schuller. For the written scores of Joplin's work, see Vera Brodsky Lawrence, ed., *The Collected Piano Works of Scott Joplin* (New York, 1971). For ragtime's impact on urban entertainment, see Erenberg, *Steppin' Out.*

87. Reed, "Scott Joplin, Pioneer," 126–28; Peter Gammond, *Scott Joplin and the Ragtime Era* (New York, 1975), 28–104.

88. Quoted in Jervis Anderson, *This Was Harlem, 1900–1950* (New York, 1982), 31.

89. *New York Age,* Mar. 5, 1908.

90. Lawrence, *Collected Works of Scott Joplin,* vol. 2; Schafer and Riedel, *Art of Ragtime,* 205–25.

91. Reed, "Scott Joplin, Pioneer," in Hasse, *Ragtime,* 132–33.

92. Barbara Tischler, *An American Music: The Search for an American Musical Identity* (New York, 1986); Alan Howard Levy, *Musical Nationalism: American Composers' Search for Identity* (Westport, Conn., 1983); Hitchcock, *Music in the United States*; Larry Starr, *A Union of Diversities: Style in the Music of Charles Ives* (New York, 1992).

93. Charles Ives, *Memos,* ed. John Kirkpatrick (New York, 1972), 130.

94. Ibid., 34–85; J. Peter Burkholder, *Charles Ives: The Ideas behind the Music* (New Haven, Conn., 1985), 58–59.

95. Ives, *Memos,* 57.

96. Ibid., 70, 71.

97. Burkholder, *Charles Ives,* 43–65; Starr, *Union of Diversities.*

98. Brewster Ives, interview by Vivian Perlis, Jan. 24, 1969, reprinted in Perlis, *Charles Ives Remembered: An Oral History* (New York, 1976), 74.

99. John Becker to Evelyn Becker, 1933. Evelyn Becker recounted the conversation to Vivian Perlis, Oral History Collection, Yale Music Library.

100. According to Maynard Solomon ("Charles Ives: Some Questions of Veracity," *Journal of the American Musicological Society* 40 [fall 1987]: 443–70), Ives deliberately fabricated his claim as a pioneering modernist composer. According to Solomon, in the 1920s, in the wake of Arnold Schoenberg and Igor Stravinsky's modernist revolution, Ives altered several of his pre–World War I compositions to make them more polytonal, dissonant, and polyrhythmic, seemingly, to establish his priority over Schoenberg and Stravinsky as "the first modernist."

101. Ives, "Diary of a Commuter," June 26 [1914], Ives Collection, Yale Music Library. Frank R. Rossiter, *Charles Ives and His America* (New York, 1975), 140, 141, 168–69; Starr, *Union of Diversities.*

102. St. Denis, *An Unfinished Life,* 152.

103. Quoted in Schwab, *James Gibbons Huneker,* 55, 211.

104. Duncan, *My Life,* 340–42.

105. Shelton, *Divine Dancer,* 119–86.

TWO  Paris and New York: From Cubism to Dada

1. Gertrude Stein, *The Autobiography of Alice B. Toklas* (New York, 1933), 142.

2. *New York Tribune,* Oct. 24, 1915.

3. Kenneth Hayes Miller Papers [1915], Archives of American Art, Smithsonian Institution.

4. *New York Tribune,* Oct. 24, 1915.

5. In Europe the term *postimpressionism* referred to all modern work between impressionism and cubism. In the United States, however, the term was applied, literally, to all

postimpressionist work, including cubism, expressionism, futurism, and dada, reflecting American unfamiliarity with the subtleties of European modernism. Thus, while all modernist American work prior to 1918 can be labeled "postimpressionist," the term applies to European modern work only between impressionism and the cubist revolution. High Museum of Art, *The Advent of Modernism: Post-Impressionism and North American Art, 1900–1918*, Peter Morrin, Judith Zilczer, and William Agee, curators (Atlanta, 1986), 9–56.

6. *Art News* (Jan. 24, 1914).

7. Judith K. Zilczer, "The Aesthetic Struggle in America, 1913–1918: Abstract Art and Theory in the Stieglitz Circle" (Ph.D. diss., University of Delaware, 1975), 236–71; Judith K. Zilczer, "'The World's New Art Center': Modern Art Exhibitions in New York City, 1913–1918," *Archives of American Art Journal* 14, no. 3 (1974): 2–7.

8. Alexander Brook, interview, July 7, 1977, Archives of American Art; Lloyd Goodrich, interview, 1963, Archives of American Art; Whitney Museum of American Art Papers, rolls 2362 and N592, Archives of American Art; Whitney Studio Club and Galleries Administrative and Exhibition Record, 1916–1930, Archives and Records Center, Whitney Museum of American Art; Bernard Harper Friedman, *Gertrude Vanderbilt Whitney: A Biography* (Garden City, N.Y., 1978); Whitney Museum of American Art, *The Whitney Studio Club and American Art, 1900–1932*, ed. Lloyd Goodrich (New York, 1975).

9. John Quinn Memorial Collection, New York Public Library, viewed on microfilm at rolls 2017, 2017A, 2017B, 2017C, 2017F, 2017K, 2017L, and 2017P, Archives of American Art; Zilczer, *The Noble Buyer: John Quinn, Patron of the Avant-Garde* (Washington, D.C., 1978); B. L. Reid, *The Man from New York: John Quinn and His Friends* (New York, 1968); Katherine Dreier Papers, Correspondence file; William Innes Homer, *Alfred Stieglitz and the American Avant-Garde* (Boston, 1977); Ruth L. Bohan, *Société Anonyme's Brooklyn Exhibition: Katherine Dreier and Modernism in America* (Ann Arbor, Mich., 1982); Francis Naumann, "Walter Conrad Arensberg: Poet, Patron, and Participant in the New York Avant-Garde," *Bulletin of the Philadelphia Museum of Art* 27 (1980): 2–32.

10. Zilczer, "World's New Art Center."

11. Jackson Lears, *No Place of Grace: Antimodernism and the Transformation of American Culture, 1880–1920* (New York, 1981).

12. William Crary Brownell, *French Art: Classic and Contemporary Painting and Sculpture* (New York, 1892), 113.

13. William Crary Brownell, "Two French Sculptors," *Century* 19 (1890): 17–32; "The Paris Exposition," *Scribner's Magazine* 7 (1890): 18–35; and *French Art*, chaps. 3 and 6; Theodore Robinson, "Claude Monet," *Century* 22 (1892): 696–701; Jean François Raffaelli, "Impressionists," *Scribner's Magazine* 17 (1895): 630–32; Samuel Isham, "French Painting at the Beginning of the Twentieth Century," *Scribner's Magazine* 38 (1905): 381–84; Frank Fowler, "The New Heritage of Painting of the Nineteenth Century," *Scribner's Magazine* 30 (1901): 253–56.

14. Aline Saarinen, *The Proud Possessors: The Lives, Times and Tastes of Some Adventurous American Art Collectors* (New York, 1958), 144–73.

15. John Rewald, *The History of Impressionism* (New York, 1973), 529–31, 548.

16. Quoted in Linnea Wren, "John La Farge: Aesthetician and Critic," in *John La Farge*, ed. Henry Adams, Kathleen A. Foster, Henry A. La Farge, H. Barbara Weinberg, Linnea H. Wren, and James L. Yarnell (New York, 1987).

17. Wanda Corn, *The Color of Mood: American Tonalism, 1880–1910* (San Francisco, 1972); Abraham Davidson, *The Eccentrics and Other American Visionary Painters* (New York, 1978);

William Gerdts, *American Impressionism* (New York, 1984); Doreen Bolger, *J. Alden Weir: An American Impressionist* (Newark, Del., 1983); Patricia Hills, *Turn of the Century America: Paintings, Graphics, Photographs, 1890–1910* (New York, 1977).

18. Frederic C. Moffatt, *Arthur Wesley Dow: 1857–1922* (Washington, D.C., 1977), 11–49.

19. Lawrence W. Chisolm, *Fenollosa: The Far East and American Culture* (New Haven, Conn., 1963); Van Wyck Brooks, *Fenollosa and His Circle* (Westport, Conn., 1976).

20. Moffatt, *Arthur Wesley Dow,* 57.

21. Chisolm, *Fenollosa.*

22. Arthur Wesley Dow, *Composition* (New York, 1900), 21.

23. Arthur Wesley Dow, "Constructive Art Teaching," *Teachers College Bulletin,* no. 17 (1913): 3, 4. Also see Dow, *Theory and Practice of Teaching Art* (New York, 1908).

24. Moffatt, *Arthur Wesley Dow.*

25. Alfred Stieglitz, "The Photo-Secession" (1903), in *Photography: Essays and Images,* ed. Beaumont Newhall (New York, 1980); Dorothy Norman, *Alfred Stieglitz: An American Seer* (New York, 1973); Homer, *Stieglitz and the American Avant-Garde.*

26. Beaumont Newhall, *The History of Photography* (Garden City, N.Y., 1964); Linda Nochlin, *Realism* (New York, 1971).

27. Richard Rudisill, *Mirror Image: The Influence of the Daguerreotype on American Society* (Albuquerque, N.M., 1971); Newhall, *The Daguerreotype in America* (New York, 1976). Also see Harrison C. White and Cynthia A. White, *Causes and Careers: Institutional Change in the French Painting World* (New York, 1965).

28. See exhibition catalog, *A Day in the Country: Impressionism and the French Landscape,* ed. Andrea P. A. Belloi (Los Angeles, 1984), and Allan Sekula, "The Traffic in Photographs," in *Modernism and Modernity,* ed. Benjamin H. D. Buchloh, Serge Guilbaut, and David Solkin (Halifax, Nova Scotia, 1983). Eadweard Muybridge's collaborative work with Thomas Eakins, *Animal Locomotion: An Electro-Photographic Investigation of Consecutive Phases of Animal Movements* (Philadelphia, 1887), is a famous example of painters' use of photography, but the impact of photography on painting was much more pervasive and subtle. Also see Alan Trachtenberg, ed., *Classic Essays on Photography* (New Haven, 1980); Newhall, *Photography: Essays and Images.*

29. Françoise Heilbrun, "The Landscape in French Nineteenth-Century Photography," in Belloi, *Day in the Country,* 349–67.

30. Muybridge, *Animal Locomotion;* Newhall, *History of Photography,* 117–40.

31. Quoted in Norman, *Alfred Stieglitz,* 29.

32. Norman, *Alfred Stieglitz,* 36–39.

33. Paul Strand, "Alfred Stieglitz and the Machine," in Waldo Frank, *America and Alfred Stieglitz: A Collective Portrait* (New York, 1934), 285.

34. Stieglitz, "The Photo-Secession," 167.

35. Robert Doty, *Photo-Secession: Stieglitz and the Fine Art Movement in Photography* (New York, 1960), 28–30, 35; Norman, *Alfred Stieglitz,* 48.

36. William Innes Homer, *Alfred Stieglitz and Photo-Secession* (Boston, 1983), chaps. 6 and 7.

37. *Photo-Secession,* nos. 1 (Dec. 1902) and 2 (Apr. 1903).

38. Stieglitz, "Photo-Secession."

39. Homer, *Stieglitz and Photo-Secession,* 34–58.

40. Corn, *Color of Mood.*

41. The "academic" character of Photo-Secession is revealed in coverage of the 1902 Na-

tional Arts Club show. Alexander Black, "The New Photography," *Century* 64 (1902): 813–22, and Alfred Stieglitz, "Modern Pictorial Photography," *Century* 64 (1902): 822–26.

42. *Camera Work* (Apr. 1906), 48; Doty, *Photo-Secession,* 38–50.

43. Homer, *Stieglitz and the American Avant-Garde*; Zilczer, "Aesthetic Struggle in America"; Delaware Art Museum, *Avant-Garde Painting and Sculpture in America, 1910–1925* (Wilmington, Del., 1975); High Museum of Art, *Advent of Modernism*; Abraham Davidson, *Early American Modernist Painting, 1910–1935* (New York, 1981).

44. Edward Steichen, *A Life in Photography* (Garden City, N.Y., 1963).

45. Ibid.; Julia E. Crummie, "American Artists in Paris, 1900–1914" (Ph.D. diss., University of California, Berkeley, 1973).

46. James R. Mellow, *Charmed Circle: Gertrude Stein and Company* (New York, 1974), 13–30.

47. Ibid., 41.

48. Stein, *Alice B. Toklas,* 41–85.

49. Ibid., 34.

50. Mellow, *Charmed Circle.*

51. Museum of Modern Art, "The Rue de Fleurus, 1906–1914/15," in *Four Americans in Paris: The Collections of Gertrude Stein and Her Family* (New York, 1970), 87–95.

52. Mellow, *Charmed Circle*; George Wickes, "Gertrude Stein, the Mother of Us All," in *Americans in Paris* (Garden City, N.Y., 1964), 11–65; Shari Benstock, "Gertrude Stein and Alice B. Toklas: Rue de Fleurus," in *Women of the Left Bank: Paris 1900–1940* (Austin, Tex., 1986), 143–93.

53. Lucille M. Golson, "The Michael Steins of San Francisco: Art Patrons and Collectors," in Museum of Modern Art, *Four Americans in Paris,* 35–50.

54. Stein, *Alice B. Toklas,* 86–142; Mellow, *Charmed Circle,* 168–226; Steichen, *A Life in Photography*; Homer, *Stieglitz and the American Avant-Garde,* 45–80; Delaware Art Museum, *Avant-Garde Painting and Sculpture in America*; Crummie, "American Artists in Paris, 1900–1914."

55. Lloyd Goodrich, "Notes on a Conversation with Max Weber," unpublished manuscript (June 16, 1948), 1, roll NY59–8, Archives of American Art; Holger Cahill, *Max Weber* (New York, 1930); Whitney Museum of American Art, *Max Weber* (New York, 1949); Alfred Werner, *Max Weber* (New York, 1975); Homer, *Stieglitz and the American Avant-Garde,* 124–37.

56. Max Weber, *Essays on Art* (New York, 1916).

57. Marsden Hartley, "291 and the Brass Bowl," in Frank, *America and Alfred Stieglitz,* 236–42.

58. Homer, *Stieglitz and the American Avant-Garde,* chap. 3.

59. For the activities of 291, we have relied on *Camera Work* as well as Doty, *Photo-Secession,* Norman, *Alfred Stieglitz,* Sue Davidson Lowe, *Stieglitz: A Memoir/Biography* (New York, 1983), and Homer, *Stieglitz and Photo-Secession,* and *Stieglitz and the American Avant-Garde.*

60. Stieglitz to Waldo Frank, July 6, 1935, Stieglitz Papers, Beinecke Library, Yale University.

61. Homer, *Stieglitz and the American Avant-Garde,* 81–268.

62. Ibid.

63. Stieglitz to Kandinsky, May 26, 1913, Stieglitz Papers.

64. Frederick S. Wight, *Arthur Dove* (Berkeley, Calif., 1958); Homer, *Stieglitz and the American Avant-Garde,* 108–23; Davidson, *Early American Modernist Painting,* 48–54.

65. Elizabeth McCausland, *Marsden Hartley* (Minneapolis, 1952); Homer, *Stieglitz and*

*the American Avant-Garde*, 220–32; Davidson, *Early American Modernist Painting*, 23–28.

66. Davidson, *Early American Modernist Painting*, 23–28.

67. Ibid.

68. Meyer Schapiro's "The Introduction of Modern Art in America: The Armory Show" (1952), reprinted in Schapiro, *Modern Art: Nineteenth and Twentieth Centuries* (New York, 1978), 135–78, provides an excellent discussion of the significance of the *Armory Show* for American artists. We have relied primarily on Walt Kuhn's 1938 privately published recollection, *The Story of the Armory Show* (New York, 1972); Milton W. Brown's detailed reconstruction for the show's fiftieth anniversary exhibition, *The Story of the Armory Show* (New York, 1963); and the *Armory Show* Papers, Museum of Modern Art. Martin Green's *New York, 1913: The Armory Show and the Paterson Strike Pageant* (New York, 1988) treats the *Armory Show* and the Paterson Strike as formative moments of American culture.

69. Kuhn, *Story of the Armory Show*, 4.

70. Ibid., 5.

71. Ibid.

72. Ibid., 5–7; Brown, *Story of the Armory Show*, 32–44.

73. Walt Kuhn to Gertrude Stein, Nov. 7, 1912, Gertrude Stein Papers, Beinecke Library, Yale University.

74. Ibid., 12.

75. Ibid., 13–15.

76. Brown, *Story of the Armory Show*, 81–82.

77. Kuhn, *Story of the Armory Show*, 16.

78. Brown, *Story of the Armory Show*, 85–98.

79. *Arts and Decoration* 3 (Mar. 1913). George Roeder, *Forum of Uncertainty: Confrontations with Modern Painting in Twentieth-Century American Thought* (Ann Arbor, Mich., 1980).

80. Kuhn, *Story of the Armory Show*.

81. Brown, *Story of the Armory Show*, 85–91, 104, 108, 120–22.

82. Kenyon Cox, "Cubists and Futurists Are Making Insanity Pay," *New York Times*, Mar. 16, 1913.

83. Brown, *Story of the Armory Show*, 85–106, 123, 162, 182–211.

84. Quoted in Francis Naumann, "The New York Dada Movement: Better Late than Never," *Arts Magazine* 54, no. 6 (Feb. 1980): 143–49.

85. Hans Richter, *Dada: Art and Anti-Art* (New York, 1965), 9.

86. Rudolf E. Kuenzli, ed., *New York Dada* (New York, 1986); Dickran Tashjian, *Skyscraper Primitives: Dada and the American Avant-Garde* (Middletown, Conn., 1975); William C. Agee, "New York Dada, 1910–1930," *Art News Annual* 34 (1968): 105–13; Naumann, "New York Dada Movement," 143–47; Naumann, "Walter Conrad Arensberg," 2–32; Galerie im Lenbachhaus, *New York Dada: Duchamp, Man Ray, Picabia*, ed. Arturo Schwarz (Munich, 1973). Also see the entire issue of *Arts Magazine* 51 (May 1977), which is dedicated to "New York Dada and the Arensberg Circle."

87. Hans Arp, *Dadaland*, quoted in Richter, *Dada*, 25.

88. Richter, *Dada*; Tashjian, *Skyscraper Primitives*; Kuenzli, *New York Dada*; Robert Motherwell, ed., *The Dada Painters and Poets* (New York, 1951).

89. *New York Times*, Feb. 16, 1913.

90. Quoted in William A. Camfield, *Francis Picabia: His Art, Life and Times* (Princeton, N.J., 1979), 48.

91. *New York Tribune*, Oct. 24, 1915, reprinted in Kuenzli, *New York Dada*, 131.

92. Camfield, *Francis Picabia*, 46–56, 71–109.

93. Man Ray, interview by Arturo Schwarz, in *Arts Magazine* 51 (May 1977): 119.

94. Quoted in Naumann, "Walter Conrad Arensberg," 11.

95. Ibid.

96. Quoted in Roger Conover, "Mina Loy's 'Colossus': Arthur Cravan Undressed," in Kuenzli, *New York Dada*, 107.

97. Robert Reiss, "'My Baroness': Elsa von Freytag–Loringhoven," in Kuenzli, *New York Dada*, 81–101.

98. Louis Bouche Papers, autobiographical manuscript, Archives of American Art.

99. Bouche, quoted in Reiss, "My Baroness," 86–87.

100. Gabrielle Buffet, "Arthur Cravan and American Dada," in Motherwell, *Dada Painters and Poets*, 13–16; Conover, "Arthur Cravan Undressed," 102–19.

101. Calvin Tomkins, *The Bride and the Bachelors: Five Masters of the Avant-Garde* (New York, 1965), 19–35. Marcel Duchamp, *The Complete Works of Marcel Duchamp*, ed. Arturo Schwarz (New York, 1970).

102. Quoted in Tomkins, *Bride and the Bachelors*, 36.

103. Anderson Galleries, *The Forum Exhibition of Modern American Painters* (New York, 1916). Also see Knoedler and Company, *Synchromism and Color Principles in American Painting: 1910–1930*, ed. William G. Agee (New York, 1965); Gail Levin, *Synchromism and American Color Abstraction: 1910–1925* (New York, 1978); Davidson, *Early American Modernist Painting*; and Agee, "Willard Huntington Wright and the Synchromists: Notes on the Forum Exhibition," *Archives of America Art Journal* 24, no. 2 (1984): 10–15. Katherine Dreier Papers contains correspondence relating to the 1917 exhibition, its financial audit, and a copy of the organization's by-laws. Clark S. Marlor, *The Society of Independent Artists: The Exhibition Record, 1917–1944* (Park Ridge, N.J., 1984), chronicles the 1917 exhibit and the subsequent history of the Society of Independent Artists, including a listing of exhibitors.

104. Francis Naumann, "The Big Show: The First Exhibition of the Society of Independent Artists," *Artforum* 17 (Feb. 1979): 34–39, and (Apr. 1979): 49–53; Tashjian, *Skyscraper Primitives*, 52–54.

105. Tomkins, *Bride and the Bachelors*, 43–45; Naumann, "Walter Conrad Arensberg," 30; Richter, *Dada*, 167–98.

106. Quoted in Ruth L. Bohan, "Katherine Sophie Dreier and New York Dada," in *Arts Magazine* 51 (May 1977): 98.

107. Man Ray, *Self Portrait: Man Ray* (New York, 1973), 89–90.

108. Katherine S. Dreier, *Western Art and the New Era* (New York, 1923), 71, 90; Katherine S. Dreier, *Modern Art* (New York, 1925).

109. Man Ray, *Self Portrait*; Arturo Schwarz, *Man Ray: The Rigor of Imagination* (New York, 1977); Francis Naumann, "Man Ray and the Ferrer Center: Art and Anarchy in the Pre-Dada Period," in Kuenzli, *New York Dada*, 10–30.

110. Man Ray, *Self Portrait*, 66–67.

111. Bohan, *Société Anonyme's Brooklyn Exhibition*, 27–38.

112. Copy of *New York Dada* reprinted in Motherwell, *Dada Painters and Poets*, 214–18.

113. Quoted in Tomkins, *Bride and the Bachelors*, 38.

114. The drawings, many of Duchamp's notes, and superb plates of *The Bride Stripped Bare by Her Bachelors, Even*, are contained in Duchamp, *Complete Works*.

115. Ibid.

116. Tomkins, *Bride and the Bachelors*, 39–68.

117. Tashjian, *Skyscraper Primitives*.

118. Barbara Haskell, looking at the impact of Picabia, Duchamp, and Gleizes on Amer-

ican painters, makes a similar point, although by examining the technical aspects of their painting rather than their attitude; *Charles Demuth: 1883–1935* (New York, 1987), 121–72.

**THREE** Bohemian Ecstasy: Modern Art and Culture

1. *New York Times,* Sept. 12, 1913.

2. Keith Norton Richwine, "The Liberal Club: Bohemia and the Resurgence in Greenwich Village, 1912–1918" (Ph.D. diss., University of Pennsylvania, 1968); Francis P. Naughton, "Making the Greenwich Village Counterculture" (Ph.D. diss., New School for Social Research, 1977); and Floyd Dell, "The Rise and Fall of Greenwich Village," *Century* 110 (1925): 645–55, and 111 (1925): 48–58.

3. Richwine, "Liberal Club," 104–16.

4. Ibid.

5. Ibid., 116–27.

6. Naughton, "Greenwich Village Counterculture"; Kenneth Lynn, "The Rebels of Greenwich Village," in *Perspectives in American History,* ed. Donald Fleming and Bernard Bailyn (Cambridge, Mass., 1974), 335–80; Caroline Ware, *Greenwich Village, 1920–1930* (New York, 1965); Albert Parry, *Garrets and Pretenders: A History of Bohemianism in America* (New York, 1960); Rick Beard and Leslie Cohen Berlowitz, eds., *Greenwich Village: Culture and Counterculture* (New Brunswick, N.J., 1993).

7. Allen Churchill, *The Improper Bohemians: A Recreation of Greenwich Village in Its Heyday* (New York, 1959); Parry, *Garrets and Pretenders.*

8. *Art News* (Oct. 21, 1905); Florence Levy, *Art Education in the City of New York* (New York, 1938); Marjorie Jones, "A History of Parsons School of Design, 1896–1966" (Ph.D. diss., New York University, 1968).

9. Lynn, "Rebels of Greenwich Village," 334–77. Also see Leslie Fishbein, *Rebels in Bohemia: The Radicals of the Masses, 1911–1917* (Chapel Hill, N.C., 1982), and Robert Humphrey, *Children of Fantasy: The First Rebels of Greenwich Village* (New York, 1978).

10. Humphrey, *Children of Fantasy.*

11. Steven Watson, *Strange Bedfellows: The First American Avant-Garde* (New York, 1991); Martin Green, *New York, 1913: The Armory Show and the Paterson Strike Pageant* (New York, 1988); Arthur Frank Wertheim, *The New York Little Renaissance: Iconoclasm, Modernism, and Nationalism in American Culture, 1908–1917* (New York, 1976); Henry F. May, *The End of American Innocence: The First Years of Our Own Time, 1912–1917* (New York, 1959); Lynn, "Rebels of Greenwich Village," 335–77; Floyd Dell, "Rents Were Low in Greenwich Village," *American Mercury* 65 (Dec. 1947): 662–68; Ware, *Greenwich Village;* Parry, *Garrets and Pretenders.*

12. Rebecca Zurier, *Art for the Masses, 1911–1917: A Radical Magazine and Its Graphics* (New Haven, 1985).

13. Max Eastman, *Enjoyment of Living* (New York, 1948), 399. Eastman quotation from *Masses,* Dec. 12, 1914.

14. Humphrey, *Children of Fantasy,* 158–206.

15. Eastman, *Enjoyment of Living,* 439–44.

16. Floyd Dell, *Women as World Builders* (Chicago, 1913), 32, 10.

17. Floyd Dell, *Homecoming: An Autobiography* (New York, 1933); Eastman, *Enjoyment of Living;* Dale Kramer, *Chicago Renaissance: The Literary Life in the Midwest, 1900–1930* (New York, 1966).

18. Fishbein, *Rebels in Bohemia.*

19. Kenneth Hayes Miller to Rhoda Dunn, Oct. 29, 1915, Kenneth Hayes Miller Papers,

microfilm roll N583, Archives of American Art, Smithsonian Institution.

20. Fishbein, *Rebels in Bohemia,* 74–112; Shari Benstock, *Women of the Left Bank: Paris, 1900–1940* (Austin, Tex., 1986); Jonathan E. Weinberg, *Speaking for Vice: Homosexuality in the Art of Charles Demuth and Marsden Hartley, and the First American Avant-Garde* (New Haven, 1993); George Chauncey, *Gay New York: Gender, Urban Culture, and the Making of the Gay Male World, 1890–1940* (New York, 1994).

21. Quoted in Fishbein, *Rebels in Bohemia,* 78.

22. Mabel Dodge Luhan, *Movers and Shakers,* vol. 3 of *Intimate Memories* (New York, 1933), 3–4 and 6.

23. Ibid., 12–13.

24. Ibid., 83.

25. *New York Times,* Feb. 26, 1913.

26. *Masses,* June 1913, 14.

27. Luhan, *Movers and Shakers,* 188.

28. Two interesting and provocative accounts of the Paterson Pageant and its communal meaning for Villagers are Naughton, "Greenwich Village Counterculture," 158–75, and Green, *New York, 1913.*

29. Avis Berman, *Rebels on Eighth Street: Juliana Force and the Whitney Museum of American Art* (New York, 1990); Bernard Harper Friedman, *Gertrude Vanderbilt Whitney: A Biography* (Garden City, N.Y., 1978).

30. Berman, *Rebels on Eighth Street,* 51–101.

31. Friedman, *Gertrude Whitney,* 238–387. Berman, *Rebels on Eighth Street,* 11–36, 84; Lloyd Goodrich, ed., *Juliana Force and American Art* (New York, 1949).

32. Quoted in Berman, *Rebels on Eighth Street,* 138–39.

33. Quoted ibid., 137, 138.

34. Quoted ibid., 155.

35. Ibid., 157.

36. Ibid., 192.

37. Whitney Studio Papers, roll Nwh4, Archives of American Art.

38. Some of the records and papers of the Whitney Studio Club are available at the Archives of American Art; the balance remain in the archives of the Whitney Museum of American Art. See Berman, *Rebels on Eighth Street,* 154–254, for a detailed account of the Whitney Studio Club.

39. Patricia Hills and Roberta Tarbell, *The Figurative Tradition and the Whitney Museum of American Art: Paintings and Sculpture from the Permanent Collection* (New York, 1980).

40. Barbara Haskell, *Charles Demuth: 1883–1935* (New York, 1987), 49–96; Chauncey, *Gay New York.*

41. Weinberg, *Speaking for Vice.*

42. Haskell, *Charles Demuth,* 48–96.

43. Dell, "Rents Were Low in Greenwich Village," 665.

44. John Sloan, quoted in Zurier, *Art for the Masses,* 26.

45. Richard Fitzgerald, *Art and Politics: Cartoonists of the "Masses" and the "Liberator"* (Westport, Conn., 1973).

46. Helen Farr Sloan, interview by authors, New York City, Apr. 1986. John Sloan, *John Sloan's New York Scene: 1906–1913,* ed. Bruce St. John (New York, 1965).

47. John Sloan, *Sunday, Women Drying Their Hair,* at the Addison Gallery, Phillips Academy. See Patricia Hills, "John Sloan's Images of Working-Class Women, 1905–1916," *Prospects* 5 (1980): 156–91.

48. See exhibition catalog prepared by David W. Scott and E. John Bullard, *John Sloan, 1871–1951: His Life and Paintings* (Washington, D.C., 1971).

49. Unsigned typed document in George Bellows Papers, Amherst College Library, Amherst, Massachusetts, with penciled notes in Sloan's hand.

50. According to Zurier, the poem was written by Bobby Edwards and appeared in *Quill* 1 (Oct. 1917): 12.

51. Zurier, *Art for the Masses,* 41–46.

52. Milton W. Brown, *American Painting from the Armory Show to the Depression* (Princeton, N.J., 1955), 79–98.

53. Brooks Atkinson, *Broadway* (New York, 1970).

54. Jack Poggi, *Theater in America: The Impact of Economic Forces* (Ithaca, N.Y., 1965), 28–64.

55. Ibid., 65–108.

56. For informed contemporary opinion, see Walter Pritchard Eaton, "Audiences," *Theater Arts Magazine* 7 (1923): 21–28; Oliver Sayler, *Our American Theater* (New York, 1923); and Sheldon Cheney, *The Art Theater* (New York, 1925). Also see Edmond M. Gagey, *Revolution in American Drama* (New York, 1987).

57. Mary Heaton Vorse, *Time and the Town: A Provincetown Chronicle* (New York, 1942), 37.

58. Hutchins Hapgood, *A Victorian in the Modern World* (New York, 1939), 391–94.

59. Robert Károly Sarlós, *Jig Cook and the Provincetown Players: Theater in Ferment* (Amherst, Mass., 1982), 15–16. Helen Deutsch and Stella Hanau, *The Provincetown: A Story of the Theater* (New York, 1931), while less reliable and less complete than Sarlós, contains firsthand accounts unavailable elsewhere.

60. Sarlós, *Jig Cook and the Provincetown Players,* 18–19.

61. Susan Glaspell, *Road to the Temple* (Boston, 1928), 252–53. The term "beloved community" was commonplace among Greenwich Village radicals (see Casey Nelson Blake, *Beloved Community: The Cultural Criticism of Randolph Bourne, Van Wyck Brooks, Waldo Frank, and Lewis Mumford* [Chapel Hill, N.C., 1990]) but it originated with Harvard philosopher Josiah Royce.

62. Sarlós, *Jig Cook and the Provincetown Players,* 22–23.

63. Glaspell, *Road to the Temple,* 253–54.

64. George Cram Cook and Frank Shay, eds., *The Provincetown Plays* (Cincinnati, 1921), 178.

65. Glaspell, *Road to the Temple,* 254.

66. Susan Glaspell, *Plays,* ed. C. W. E. Bigsby (New York, 1987), 35–45.

67. Provincetown Players' Minute Books, Provincetown Players Papers, New York Public Library.

68. Cook to Glaspell, Sept. 19, 1916, George Cram Cook Papers, Berg Collection, New York Public Library.

69. Sarlós, *Jig Cook and the Provincetown Players,* 36.

70. Ibid., 34–59.

71. Hapgood, *Victorian in the Modern World,* 394.

72. Glaspell, *Road to the Temple,* 236.

73. Sarlós, *Jig Cook and the Provincetown Players,* 52–59.

74. Arthur Gelb and Barbara Gelb, *O'Neill* (New York, 1962).

75. Gagey, *Revolution in American Drama,* 29.

76. The Gelbs suggest that "though the Provincetowners were not aware of O'Neill when

they hastened back to their theater in the late spring of 1916, O'Neill was aware of them" (*O'Neill,* 308).

77. Cited in Sarlós, *Jig Cook and the Provincetown Players,* 67–68.

78. Provincetown Playbill, 1915–24, Cook Papers.

79. Quoted in Sarlós, *Jig Cook and the Provincetown Players,* 75.

80. Ibid., 76–80.

81. Ibid., 92–95.

82. Provincetown Playbills, 1915–24, Cook Papers.

83. Sarlós, *Jig Cook and the Provincetown Players,* 95–103.

84. Ibid., 104–22.

85. Glaspell, *Road to the Temple,* 286.

86. Gelb and Gelb, *O'Neill,* 444–47.

87. Eugene O'Neill, *Plays: The Emperor Jones; Gold; The First Man; The Dreamy Kid* (New York, 1925), 11.

88. Broun review quoted in Gelb and Gelb, *O'Neill,* 446–47. Du Bois quotes from *Crisis* 22 (1921): 55–56, and, on a later production starring Paul Robeson, *Crisis* 28 (1924): 56–57, quoted in the Provincetown Playbill.

89. O'Neill's Notebook [1914–29] (O'Neill Papers, Beinecke Library, Yale University) contains an accounting of O'Neill's annual royalties from plays.

90. Provincetown Players Papers, Scrapbooks, Billy Rose Collection, Lincoln Center, New York Public Library.

91. The reorganization of the Provincetown Players is well documented in the O'Neill Papers and the Harry Weinberger Papers, Yale University Library.

92. O'Neill to Kenneth Macgowan [summer 1923], O'Neill Papers.

93. Russell Lynes, *The Lively Audience: A Social History of the Visual and Performing Arts in America, 1890–1950* (New York, 1985), 166–216.

94. Atkinson, *Broadway,* 197.

95. Dell, "Rents Were Low in Greenwich Village," 664.

96. See Paula Fass, *The Damned and the Beautiful: American Youth in the 1920s* (New York, 1977). Much of the material for this chapter, and all other work on the Greenwich Village renaissance, relies heavily on the numerous memoirs and autobiographies of its participants, which publishers eagerly sought out for the next thirty years.

## FOUR New York Modern: Art in the Jazz Age

1. Joseph Stella, "Discovery of America: Autobiographical Notes," *Art News* 59 (Nov. 1960): 65.

2. Lewis Mumford, *Sketches from Life: The Autobiography of Lewis Mumford* (New York, 1982), 130.

3. Charles Demuth to Alfred Stieglitz, Oct. 10, 1921, Alfred Stieglitz Papers, Beinecke Library, Yale University.

4. "Autobiography," typescript, William Carlos Williams Papers, Beinecke Library, Yale University, 331 (published as William Carlos Williams, *Autobiography of William Carlos Williams* [New York, 1967]).

5. William Carlos Williams, "American Spirit in Art," typescript, Williams Papers, 1.

6. William S. Lieberman, ed., *Art of the Twenties* (catalog of the Museum of Modern Art) (New York, 1979); Milton W. Brown, *American Painting from the Armory Show to the Depression* (Princeton, N.J., 1955), 79–196; High Museum of Art, *The Advent of Modernism: Post-Impressionism and North American Art, 1900–1918,* Peter Morrin, Judith Zilczer, and William

C. Agee, curators (Atlanta, 1986); Abraham Davidson, *Early American Modernist Painting, 1910–1935* (New York, 1981).

7. Meyer Schapiro, "Introduction of Modern Art in America: The Armory Show," in *Modern Art: Nineteenth and Twentieth Centuries* (New York, 1978), 135–78; Brown, *American Painting,* 167–96; Sam Hunter, *American Art of the Twentieth Century* (New York, 1972), 164–202; Dickran Tashjian, *William Carlos Williams and the American Scene: 1920–1940* (New York, 1978).

8. Van Wyck Brooks, *The Wine of the Puritans: A Study of Present-day America* (New York, 1908), 91, 129–30, 140, 141.

9. Casey Nelson Blake, *Beloved Community: The Cultural Criticism of Randolph Bourne, Van Wyck Brooks, Waldo Frank, and Lewis Mumford* (Chapel Hill, N.C., 1990); Hugh M. Potter, "False Dawn: Paul Rosenfeld and Art in America, 1916–1946" (Ph.D. diss., University of New Hampshire, 1980); Wanda M. Corn, "Apostles of the New American Art: Waldo Frank and Paul Rosenfeld," *Arts* 54 (1980): 159–63.

10. Nicholas Joost, *Scofield Thayer and the "Dial"* (Carbondale, Ill., 1964).

11. Waldo Frank, *Our America* (New York, 1919), 8–89.

12. Paul Rosenfeld, *Port of New York: Essays on Fourteen American Moderns* (1924; reprint, Urbana, Ill., 1966).

13. Ibid., 292–95.

14. Stieglitz to Rosenfeld, Sept. 5, 1923, in Stieglitz Papers.

15. Williams, "Autobiography," 20–21, 31, 79, 94a, 104, 107.

16. Williams, "American Spirit in Art," 3–4.

17. Williams, "Autobiography," 94, 163–212.

18. Ibid., 298–99.

19. Williams, "Autobiography," 20–21, 79.

20. Tashjian, *William Carlos Williams,* 71–72; Barbara Haskell, *Charles Demuth: 1883–1935* (New York, 1987), 183.

21. Williams, "Autobiography," 327–45, 348, 550, 551, 294.

22. William Carlos Williams, *In the American Grain* (New York, 1925).

23. Lewis A. Erenberg, *Steppin' Out: New York Nightlife and the Transformation of American Culture, 1890–1930* (Chicago, 1981). Scott Fitzgerald's best-selling and influential *This Side of Paradise* (New York, 1920) articulated the Jazz Age sense of freedom and its association with New York.

24. Paul Carter, *The Twenties in America* (New York, 1968), and *Another Part of the Twenties* (New York, 1977); Lloyd Morris, *Incredible New York* (New York, 1951); Paula Fass, *The Damned and the Beautiful: American Youth in the 1920s* (New York, 1977); Jackson Lears, "Uneasy Courtship: Modern Art and Modern Advertising," *American Quarterly* 39 (spring 1987): 133–54; W. Parker Chase, *New York, 1932: The Wonder City* (New York, 1983). For a recent detailed look at the New York intelligentsia in the 1920s, see Ann Douglas, *Terrible Honesty: Mongrel Manhattan in the 1920s* (New York, 1995).

25. Stella, "Discovery of America," 66–67.

26. Ibid., 65.

27. Ibid., 41–42.

28. Ibid., 42, 64, 65.

29. *New York, Interpreted* (1920), Newark Art Museum, Newark, N.J. In addition to Stella's autobiographical account in *Art News* ("Discovery of America"), see Irma Jaffe, *Joseph Stella* (New York, 1970).

30. Marguerite Zorach, interview, 1958, Columbia Oral History Project, Columbia University.

31. Quoted in Roberta Tarbell, *Marguerite Zorach: The Early Years, 1908–1920* (Washington, D.C., 1973), 36. Also see Marylyn Friedman Hoffman, *Marguerite and William Zorach: The Cubist Years, 1915–1918* (Manchester, N.H., 1987).

32. Marguerite Zorach, interview; Tarbell, *Marguerite Zorach,* 50–51.

33. Marguerite Zorach Papers, roll NY83–3, Archives of American Art, Smithsonian Institution, contains exhibition catalogs, clippings, and personal papers. Also see J. P. Slusser, "Modernistic Pictures Done in Wool," *Arts and Decoration* 18 (1923): 30.

34. Marguerite Zorach, "Embroidery as Art," *Art in America* 44 (fall 1956): 47–51, 66–67.

35. Quoted in Sue Davidson Lowe, *Stieglitz: A Memoir/Biography* (New York, 1983), 201.

36. Jan Garden Castro, *The Art and Life of Georgia O'Keeffe* (New York, 1985); Laurie Lisle, *Portrait of an Artist: A Biography of Georgia O'Keeffe* (New York, 1980).

37. Castro, *Art and Life of Georgia O'Keeffe,* 41–74.

38. Davidson, *Early American Modernist Painting,* 182–294.

39. Castro, *The Art and Life of Georgia O'Keeffe.*

40. Brown, *American Painting,* 103–96.

41. Jonathan Weinberg, *Speaking for Vice: Homosexuality in the Art of Charles Demuth and Marsden Hartley and the First Avant-Garde* (New Haven, Conn., 1993); George Chauncey, *Gay New York: Gender, Urban Culture, and the Making of a Gay Male World, 1890–1940* (New York, 1994).

42. Haskell, *Charles Demuth.*

43. *Little Review, The Machine Age Exhibition* (New York, 1927); Richard Guy Wilson, Dianne H. Pilgrim, and Dickran Tashjian, *The Machine Age in America: 1918–1941* (New York, 1986), 231–34. Also see *The Precisionist Painters: 1916–1949,* ed. Katherine Lochridge (Huntington, N.Y., 1978); Tashjian, *William Carlos Williams,* 73–88; William C. Agee, "Morton Livingston Schamberg: Notes on the Sources of the Machine Images," in *New York Dada,* ed. Rudolph E. Kuenzli (New York, 1986), 66–80; Brown, *American Painting,* 103–32.

44. Museum of Modern Art, *Art of the Twenties.* Also see Thomas R. West, *Flesh of Steel: Literature and the Machine in American Culture* (Nashville, Tenn., 1967), for similar machine-age images in American writing in the 1920s.

45. Demuth to Stieglitz, Nov. 28, 1921, Stieglitz Papers.

46. Avis Berman, *Rebels on Eighth Street: Juliana Force and the Whitney Museum of American Art* (New York, 1990).

47. Brown, *American Painting,* 167–95.

48. *Art Students League Catalogs* (1900–30), Art Students League Archives, New York. The catalogs contain faculty lists, conditions of instruction, and courses offered. Kennedy Galleries, *Paintings and Sculptures by One Hundred Artists Associated with the Art Students League of New York* (New York, 1975) contains a sampling of the work associated with the league as well as a list of students. Also see Ronald Pisano, *The Art Students League* (Huntington, N.Y., 1987), which focuses on the most influential league faculty, and Marchal E. Landgren, *Years of Art: The Story of the Art Students League of New York* (New York, 1940).

49. Landgren, *Years of Art.*

50. *Art Students League Catalog* (1923–24), Art Students League Archives, 1.

51. *Art Students League Catalogs* (1900–1930), Art Students League Archives.

52. *Art Students League Catalogs* (1910–30), Art Students League Archives.

53. Mary Twombly, "The Art Students League of New York," *Bookman* 12 (1900): 248–55.

54. Alexander Brook, interview, July 7, 1977, Archives of American Art; Lloyd Goodrich, interview by Harlan Philips, 1963, Archives of American Art; *Art Students League Catalogs* (1910–30), Art Students League Archives.

55. Isabel Bishop, "Kenneth Hayes Miller," *Magazine of Art* 45 (1952): 168–70.

56. Lincoln Rothschild, *To Keep Art Alive: The Effort of Kenneth Hayes Miller, American Painter (1876–1952)* (Philadelphia, 1974), 17–45.

57. Reginald Marsh, "Kenneth Hayes Miller," *Magazine of Art* 45 (1952): 170–71.

58. Miller to Rhoda Dunn, Mar. 15, 1916, Kenneth Hayes Miller Papers, Archives of American Art; Rothschild, *To Keep Art Alive*. Also see Richard Leppert, *Art and the Committed Eye: The Cultural Functions of Imagery* (Boulder, Colo., 1996), 103–274.

59. Stella, "Discovery of America," 66–67.

60. Leppert, *Art and the Committed Eye*. For an earlier view, see William Gerdts, *The Great American Nude* (New York, 1974). Lieberman's *Art of the Twenties* provides an interesting if selective sample of modern art in the 1920s as represented in the collection of the Museum of Modern Art. A recent theoretical analysis is Laura Mulvey's *Visual and Other Pleasures* (London, 1989). Elizabeth Cowling and Jennifer Mundy (*On Classic Ground: Picasso, Léger, De Chirico, and the New Classicism, 1910–1930* [London, 1990]) argue that after the war Picasso, Léger, and other "Southern European" modernists also sought to establish a dialogue with classical painting and sculpture.

61. Fass, *The Damned and the Beautiful*.

62. See Watson's lead editorial, *Arts* 1 (1923): 1.

63. Berman, *Rebels on Eighth Street*, 294–96.

64. Forbes Watson Papers, roll D47, frame 525, Archives of American Art (July 3, 1930), contains much of *The Arts* correspondence and business records, including the 1930 financial report ordered by Whitney.

65. Berman, *Rebels on Eighth Street*, 254.

66. Quoted ibid., 263.

67. Brown, *American Painting*, 79–98.

68. Demuth to Stieglitz, Downtown Gallery Papers, Archives of American Art.

69. Brown, *American Painting*, 79–99.

70. Ibid., 92–95; Henry McBride–Alfred Stieglitz Correspondence, Henry McBride Papers, Archives of American Art.

71. Calvin Tomkins, *Merchants and Masterpieces: The Story of the Metropolitan Museum of Art* (New York, 1970), 231–32.

72. Brown, *American Painting*, 94.

73. Susan Noyes Platt, *Modernism in the 1920s: Interpretations of Modern Art in New York from Expressionism to Constructivism* (Ann Arbor, Mich., 1985), 5–34.

74. Rosenfeld, *Port of New York*, 242, 253. Also see Waldo Frank, *America and Alfred Stieglitz: A Collective Portrait* (New York, 1934).

75. Lowe, *Stieglitz*, 195–304.

76. Stieglitz to McBride, Apr. 16, Nov. 17, and Nov. 28, 1928, McBride Papers, roll 12.

77. Stieglitz to Paul Rosenfeld, Sept. 5, 1923, Stieglitz Papers.

78. Judith Zilczer, *"The Noble Buyer": John Quinn, Patron of the Avant-Garde* (Washington, D.C., 1978).

79. John Quinn Papers, John Quinn Memorial Collection, New York Public Library; B. L. Reid, *The Man from New York: John Quinn and His Friends* (New York, 1968).

80. Judith Zilczer, *Noble Buyer*; Judith Zilczer, "The Dispersal of the John Quinn Collection," *Archives of American Art Journal* 19, no. 3 (1979): 15–21.

81. "Edith Halpert," *Current Biography* (July 1955): 35; University of Connecticut Museum of Art, *Edith Halpert and the Downtown Gallery* (Storrs, Conn., 1968).

82. Downtown Gallery Papers.

83. William Zorach, interview, 1958, Columbia Oral History Project, Columbia University.

84. Downtown Gallery Papers, Scrapbook, roll ND-46.

85. Charles C. Alexander, *Here the Country Lies: Nationalism and the Arts in Twentieth-Century America* (Bloomington, Ind., 1980), chaps. 3 and 4.

86. Patricia Hills and Roberta Tarbell, *The Figurative Tradition and the Whitney Museum of American Art: Paintings and Sculpture from the Permanent Collection* (New York, 1980), 90–107; Roberta Tarbell, "The Impact of the Armory Show on American Sculpture," *Archives of American Art Journal* 18, no. 2 (1978): 2–10.

87. William Zorach, "The New Tendencies in Art," *Arts* 2 (Oct. 1921): 10–15.

88. William Zorach, interview.

89. Ibid.; William Zorach, *Art Is My Life* (Cleveland, 1974).

90. William Zorach, interview.

91. Ibid.

92. William Zorach, *Zorach Explains Sculpture: What It Means and How It Is Made* (New York, 1947), 191–276; Roberta Tarbell, *William and Marguerite Zorach: The Maine Years* (Rockland, Maine, 1979).

93. Gail Levin, *Edward Hopper: An Intimate Biography* (New York, 1995), draws on the letters and diaries of Jo Nivison Hopper, which, for the first time, provide significant insight into Hopper's personal life. Also see Brian O'Doherty, *American Masters: The Voice and the Myth in Modern Art* (New York, 1974), 1–46.

94. Gail Levin, *Edward Hopper: The Art and the Artist* (New York, 1980), 4–33.

95. Levin's *An Intimate Biography* details the at times enormous tension that existed between the Hoppers. The biography draws on Jo Nivison's letters and diaries and presents the conflict largely from Nivison's point of view. Levin's biography illuminates much of the tension evident in Hopper's paintings.

96. Ibid.

97. The 1996 Whitney Museum retrospective of Hopper's work included most of his major paintings, sketches, and notes. See Levin's catalog of the show, *Edward Hopper: The Art and the Artist.*

98. Stuart Davis, *Stuart Davis,* ed. Diane Kelder (New York, 1971), 20.

99. Ibid., 26.

100. Michele H. Bogart, *Artists, Advertising, and the Borders of Art* (Chicago, 1995). Karen Wilkin, *Stuart Davis* (New York, 1987), is the best comprehensive account of Davis's life and work. It includes color reproductions of his most important paintings.

101. Downtown Gallery Papers, Nov. 28, 1927, roll ND-46.

102. Stuart Davis, interview, 1953, Whitney Museum of American Art (WMAA) Archives.

103. Stuart Davis, *Stuart Davis* (New York, 1945), n.p. Copy in New York Public Library.

104. Davis, "Self-Interview," *Creative Art* 9 (Sept. 1931): 211.

105. Davis, *Stuart Davis,* n.p.

106. Kirstein to Barr, Correspondence file, *Murals by American Painters and Photographers,* Archives of the Museum of Modern Art (MoMA), New York.

107. Registrar Records, Archives of MoMA.

108. Museum of Modern Art, *Murals by American Painters and Photographers,* Lincoln Kirstein and Julien Levy, curators (New York, 1932).

109. Lowery Stokes Sims, *Stuart Davis: American Painter* (New York, 1991), 216–18.

110. Williams, "American Spirit in Art," 2.

111. Downtown Gallery Papers, Nov. 28, 1927, roll ND-46.

FIVE   Rhapsody in Black: New York Modern in Harlem

1. Carl Van Vechten to Gertrude Stein, Nov. 15, 1924, in Gertrude Stein, *Letters of Gertrude Stein and Carl Van Vechten, 1913–1946,* ed. Edward Burns (New York, 1986), 1:108–9.

2. *New York Times,* Feb. 13, 1924.

3. Bernard Gendron, "Jamming at Le Boeuf: Jazz and the Paris Avant-Garde, 1917–1923," *Discourse* 12, no. 1 (fall–winter 1989–90): 3–27.

4. Quoted in Oscar Thompson, *Great Modern Composers* (New York, 1941), 46.

5. Gilbert Seldes, *The Seven Lively Arts* (New York, 1924), 83.

6. Barbara Tischler, *An American Music: The Search for an American Musical Identity* (New York, 1986), 92–125; Kathy J. Ogren, *The Jazz Revolution: Twenties America and the Meaning of Jazz* (New York, 1989), 139–61; Gail Levin, "American Art," in *"Primitivism" in Twentieth-Century Art: Affinity of the Tribal and the Modern,* ed. William Rubin (New York, 1984), 452–72; Mary Herron Dupree, "Jazz, the Critics, and American Art Music in the 1920s," *American Music* 4 (1986): 287–301; David Ross Baskerville, "Jazz Influence on Art Music to Mid-Century" (Ph.D. diss., University of California, Los Angeles, 1965); Robert Goldwater, *Primitivism in Modern Art* (Cambridge, Mass., 1938); Burton W. Peretti, *The Creation of Jazz: Music, Race, and Culture in Urban America* (Urbana, Ill., 1992).

7. For the details of Van Vechten's life we have relied on Carl Van Vechten, interview, 1960, Avery Library, Columbia University, his personal letters at the New York Public Library and the Beinecke Library at Yale University, collections of his numerous published letters and writings already cited, and several biographical studies, including Bruce Kellner, *Carl Van Vechten and the Irreverent Decades* (Norman, Okla., 1968); Edward Lueders, *Carl Van Vechten* (New York, 1965); and P. F. Kluge, "Wanderers: Three American Writers of the Twenties" (Ph.D. diss., University of Chicago, 1967).

8. Kellner, *Carl Van Vechten and the Irreverent Decades,* 162–210.

9. Carl Van Vechten to Fania Marinoff, May 6, 1925, Carl Van Vechten Papers, New York Public Library.

10. Romare Bearden and Harry Henderson, *A History of African American Artists* (New York, 1993), 123. Also see an early assessment of "primitivism" in Goldwater, *Primitivism in Modern Art.*

11. Van Vechten to Stein, June 30, 1925, *Letters of Stein and Van Vechten,* 116–17.

12. Alfred Knopf to E. McKnight Kauffer, Mar. 15, 1930, Van Vechten Papers.

13. W. E. B. Du Bois, *The Souls of Black Folk* (1903; New York, 1969), 45.

14. David Levering Lewis, *W. E. B. Du Bois: Biography of a Race, 1868–1919* (New York, 1993), 265–96.

15. James Weldon Johnson, *Black Manhattan* (New York, 1930), 159.

16. Seth M. Scheiner, *Negro Mecca: A History of the Negro in New York City, 1865–1920* (New York, 1965).

17. Frank Moss, *Story of the Riot* (New York, 1900), quoted in Jervis Anderson, *This Was Harlem, 1900–1950* (New York, 1982), 44; Jim Haskins, *James Van DerZee: The Picture Takin' Man* (New York, 1979).

18. Johnson, *Black Manhattan,* 145–259; Gilbert Osofsky, *Harlem: The Making of a Ghetto* (New York, 1966), 3–126; Anderson, *This Was Harlem,* 49–136; Haskins, *James Van DerZee.*

19. Johnson, *Black Manhattan,* 160–69. See Haskins, *James Van DerZee,* for the portraits of Harlem's middle class.

20. Johnson, *Black Manhattan,* 126–44; Anderson, *This Was Harlem,* 59–136.

21. Also see David Levering Lewis, *When Harlem Was in Vogue* (New York, 1981); and Nathan Irvin Huggins, *Harlem Renaissance* (New York, 1971).

22. Alain Locke, ed., *The New Negro: An Interpretation* (New York, 1925); Huggins, *Harlem Renaissance;* Lewis, *When Harlem Was in Vogue;* Houston Baker Jr., "Modernism and the Harlem Renaissance," in *Modernist Culture in America,* ed. Daniel Joseph Singal (Belmont, Calif., 1991), 107–25; Houston Baker Jr., *Blues, Ideology, and Afro-American Literature: A Vernacular Theory* (Chicago, 1984).

23. Locke, introduction to *The New Negro,* 4.

24. Alain Locke, *Negro Art: Past and Present* (New York, 1936), 48, 61.

25. Gary A. Reynolds and Beryl J. Wright, eds., *Against the Odds: African American Artists and the Harmon Foundation* (Newark, N.J., 1989).

26. Quoted in Bearden and Henderson, *A History,* 147.

27. Jontyle Theresa Robinson and Wendy Greenhouse, *The Art of Archibald Motley Jr.* (Chicago, 1992).

28. Ibid., 185–99.

29. Amy Helene Kirschke, *Aaron Douglas: Art, Race, and the Harlem Renaissance* (Jackson, Miss., 1995); Studio Museum of Harlem, *Harlem Renaissance: Art of Black America* (New York, 1987), 27–30, 129–31.

30. Alain Locke, *The Negro and His Music* (New York, 1936), 130.

31. Eileen Southern, *The Music of Black Americans* (New York, 1983), 395–456; Samuel A. Floyd Jr., ed., *Black Music in the Harlem Renaissance* (Westport, Conn., 1990).

32. Emmet J. Scott, *Negro Migration during the War* (New York, 1920); James R. Grossman, *Land of Hope: Chicago, Black Southerners, and the Great Migration* (Chicago, 1989); Carole Marks, *Farewell—We're Good and Gone: The Great Black Migration* (Bloomington, Ind., 1989); and Joe William Trotter, *The Great Migration in Historical Perspective* (Bloomington, Ind., 1991).

33. Osofsky, *Harlem,* chap. 9.

34. Ibid. Also see Arna Bontemps, "Two Harlems," *American Scholar* 14 (1945): 167–73. Cheryl Lynn Greenberg, *"Or Does It Explode": Black Harlem in the Great Depression* (New York, 1991), although it focuses on the 1930s, begins in the 1920s. Greenberg offers updated and comprehensive statistics on Harlem.

35. Langston Hughes, "The Negro Artist and the Racial Mountain," *Nation* 122 (June 23, 1926): 692–94.

36. Gunther Schuller, *Early Jazz: Its Roots and Musical Development* (New York, 1968); Martin Williams, *The Jazz Tradition* (New York, 1983).

37. Johnson, *Black Manhattan,* 170–230.

38. Samuel Charters and Leonard Kunstadt, *Jazz: A History of the New York Scene* (New York, 1962), 185–92.

39. Ronald L. Morris, *Wait until Dark: Jazz and the Underworld, 1880–1940* (Bowling Green, Ohio, 1980).

40. Duke Ellington, in *Hear Me Talkin' to Ya: The Story of Jazz As Told by the Men Who Made It,* ed. Nat Shapiro and Nat Hentoff (New York, 1955), 168–70.

41. Johnson, *Black Manhattan,* 104–25; Reid Badger, *A Life in Ragtime: A Biography of James Reese Europe* (New York, 1995).

42. Badger, *A Life in Ragtime,* and Reid Badger, "James Reese Europe and the Prehistory of Jazz," *American Music* 7 (1989): 48–67.

43. Quoted in Gunther Schuller, *Musings: The Musical World of Gunther Schuller* (New York, 1986), 39.

44. Charters and Kunstadt, *Jazz: The New York Scene,* 37; Badger, *A Life in Ragtime.*

45. Badger, *A Life in Ragtime;* Schuller, *Early Jazz,* 247–50; Dan Morgenstern, "James Reese Europe," *New York Times,* July 9, 1989.

46. Louis Armstrong, *Satchmo: My Life in New Orleans* (Englewood Cliffs, N.J., 1954); Martin Williams, *Jazz Masters of New Orleans* (New York, 1967).

47. Charters and Kunstadt, *Jazz: The New York Scene,* 51–55.

48. Ibid., 56.

49. Ibid., 56–61; Schuller, *Early Jazz,* 175–82.

50. Martin Williams, "Jazz, the Phonograph, and Scholarship," in *Jazz Heritage* (New York, 1985).

51. "Black Swan," in *The New Grove Dictionary of Jazz* (New York, 1988), 1:112–13, and "Okeh," ibid., 2:266–67. Also see William Howland Kenney, *Chicago Jazz: A Cultural History, 1904–1930* (New York, 1993), 117–46, for a comprehensive and detailed account of "race" records.

52. Perry Bradford, *Born with the Blues: Perry Bradford's Own Story* (New York, 1965), 114–29; Charters and Kunstadt, *Jazz: The New York Scene,* 83–92.

53. Imanu Amiri Baraka [LeRoi Jones], *Blues People: Negro Music in White America* (New York, 1963), 78, 98, 108–10; Frank Tirro, *Jazz: A History* (New York, 1977), 114–48; Clyde Vernon Kiser, *Sea Island to City* (New York, 1932).

54. Garvin Bushell, "Jazz in the Twenties," in *Jazz Panorama,* ed. Martin Williams (New York, 1962), 82; Kiser, *Sea Island to City.* Also see Robert Farris Thompson, *Flash of the Spirit: African and Afro-American Art and Philosophy* (New York, 1983), and "African Influence on the Art of the United States," in Armstead L. Robinson, Craig C. Foster, and Donald H. Ogilvie, eds., *Black Studies in the University* (New Haven, Conn., 1969), 122–70.

55. John Chilton, *Jazz Nursery: Jenkins Orphanage Band* (London, 1980).

56. Garvin Bushell, *Jazz from the Beginning* (Ann Arbor, Mich., 1990), 19.

57. Schuller, *Early Jazz,* 214–25.

58. James P. Johnson, "Conversations with James P. Johnson," *Jazz Panorama,* ed. Martin Williams.

59. Willie "the Lion" Smith, *Music on My Mind: The Memoirs of an American Pianist* (New York, 1975), 155.

60. The Harlem stride tradition is recorded in James P. Johnson, *Father of the Stride Piano,* Columbia; *James P. Johnson,* Time-Life; *James P. Johnson, 1921–1926,* Olympic; *New York Jazz,* Stinson; *Yamekraw,* Folkways; Willie "The Lion" Smith, *Harlem Piano,* Good Time Jazz; *The Original Fourteen Plus Two, 1938–1939,* Commodore; Fats Waller, *Ain't Misbehavin',* Archive of Folk and Jazz Music; *Ain't Misbehavin',* RCA; *Complete Fats Waller,* vol. 1, RCA.

61. *Jazz Piano,* a six-album collection selected by Martin Williams and annotated by Dick Katz and Martin Williams (Washington, D.C.: Smithsonian Institution, 1989), largely focuses on the New York jazz piano tradition.

62. Richard Hadlock, *Jazz Masters of the Twenties* (New York, 1972), 145–71.

63. Duke Ellington, *Music Is My Mistress* (New York, 1973), 95.

64. Bushell, *Jazz from the Beginning,* 18.

65. The pioneering and classic work on African American music, blues, and jazz is Baraka's *Blues People;* see especially 60–94. Also see Derrick Stewart-Baxter, *Ma Rainey and the Classic Blues Singers* (London, 1970); Daphne Duval Harrison, *Black Pearls: Blues Queens of the 1920s* (New Brunswick, N.J., 1988); Bruce Bastin, *Red River Blues: The Blues Tradition in the Southeast* (Urbana, Ill., 1986); Charles Keil, *Urban Blues* (Chicago, 1966); Paul Oliver, *Blues Fell This Morning* (London, 1960); and Tirro, *Jazz,* 68–69, 118–23.

66. Sandra R. Lieb, *Mother of the Blues: A Study of Ma Rainey* (Amherst, Mass., 1981).

67. Chris Albertson, *Bessie* (New York, 1972), 42–60.

68. Ibid., 65–117, and Albert Murray, *Stomping the Blues* (New York, 1976). Also see Linda Dahl, *Stormy Weather: The Music and Lives of a Century of Jazz Women* (New York, 1984), 136–61. Bessie Smith's recorded performances are available in five double-album sets produced by Columbia: *Any Woman's Blues; The Empress; Empty Bed Blues; Nobody's Blues but Mine;* and *The World's Greatest Blues Singer.*

69. Carl Van Vechten, "Negro Blues Singers," *Vanity Fair* 26 (Mar. 1926): 67, 106, 108.

70. Baraka, *Blues People,* 81–94; Martin T. Williams, *Classic Jazz* (Washington, D.C., 1987), 10–12; Williams, *Art of Jazz: Essays on the Nature and Development of Jazz* (New York, 1960); Schuller, *Early Jazz,* 226–41; Paul Oliver, *Savannah Syncopators: African Retentions in the Blues* (New York, 1970).

71. Baraka, *Blues People;* Albertson, *Bessie.*

72. Walter C. Allen, *Hendersonia: The Music of Fletcher Henderson and His Musicians* (Highland Park, N.J., 1973); Kenney, *Chicago Jazz,* 117–46.

73. Charters and Kunstadt, *Jazz: The New York Scene,* 165–84.

74. James Lincoln Collier, *Benny Goodman and the Swing Era* (New York, 1989), 35–40.

75. Ibid., 35–38; Gunther Schuller and Martin Williams, *Big Band Jazz: From the Beginnings to the Fifties* (Washington, D.C.: Smithsonian Institution, 1983), annotation and recordings.

76. Schuller, *Early Jazz,* 245–78; Hadlock, *Jazz Masters of the Twenties,* 194–218; Allen, *Hendersonia;* Charters and Kunstadt, *Jazz: The New York Scene,* 165–83; and Bushell, *Jazz from the Beginning.* Most of the Henderson orchestra's most important recordings are in *Fletcher Henderson: Developing an American Orchestra, 1923–1937* (Washington, D.C.: Smithsonian Institution, 1983).

77. Schuller, *Early Jazz,* 89–133; Williams, *Jazz Tradition,* 52–64; James Lincoln Collier, *Louis Armstrong: An American Genius* (New York, 1983), 3–216. Armstrong's early recordings are available on *The Genius of Louis Armstrong,* Columbia; *The King Oliver Creole Jazz Band,* Olympic; *King Oliver's Jazz Band, 1923,* Smithsonian; and *Louis Armstrong and King Oliver,* Milestone. His best recorded solos, cut after he left the Fletcher Henderson Orchestra, are available on *Louis Armstrong: The Hot Fives,* vols. 1 and 3, Columbia; and *Louis Armstrong: The Hot Fives and Eights,* vol. 2, Columbia.

78. Quoted in Shapiro and Hentoff, *Hear Me Talkin' to Ya,* 228–29.

79. John Edward Hasse, *Beyond Category: The Life and Genius of Duke Ellington* (New York, 1993), 34–60.

80. Ibid., 231.

81. Ellington, *Music Is My Mistress,* 71–73.

82. Williams, *Jazz Tradition,* 100–121; Schuller, *Early Jazz,* 318–57.

83. Ellington, *Music Is My Mistress,* 73; Hasse, *Beyond Category;* Ken Rattenbury, *Duke Ellington: Jazz Composer* (New Haven, Conn., 1990).

84. James Lincoln Collier, *Duke Ellington* (New York, 1987), 64–74, makes a compelling argument in behalf of Mills' importance, especially in giving Ellington "his" orchestra.

85. Quoted in George Hoefer, "Cotton Club Parade, 1923–1936," typescript of 1965 article written for *Down Beat,* on file at the Institute of Jazz Studies, Rutgers University, Newark.

86. Hoefer, "Cotton Club Parade," and James Haskins, *The Cotton Club* (New York, 1977). Also see William Howland Kenney, *Chicago Jazz: A Cultural History, 1904–1930* (New York, 1993), and Ogren, *Jazz Revolution,* for insightful accounts of the culture of jazz clubs and the jazz cultural revolution.

87. Quoted in Morris, *Wait until Dark,* 5.

88. Barney Bigard, *With Louis and the Duke: The Autobiography of a Jazz Clarinetist* (New York, 1986), 49–52; Haskins, *Cotton Club,* 43–61; Morris, *Wait until Dark.*

89. For biographical details of the Ellington orchestra, see John Chilton, *Who's Who of Jazz: Storyville to Swing Street* (New York, 1972).

90. Hasse, *Beyond Category,* and Baraka, *Blues People,* 160–63.

91. On jazz "improvisation," see Charles Blancq, *Sonny Rollins: The Journey of a Jazzman* (Boston, 1983), 26–36. Also see Schuller, *Early Jazz,* 318–57; Hasse, *Beyond Category;* Williams, *Art of Jazz;* and Mercer Ellington, *Duke Ellington in Person: An Intimate Memoir* (Boston, 1978), 42, 67.

92. Stanley Dance, *The World of Duke Ellington* (New York, 1970), 50.

93. James Alan McPherson, ed., *Trains and Train People in American Culture* (New York, 1976); Collier, *Duke Ellington,* 112–13.

94. Collier, *Duke Ellington,* 114–15.

95. A rich sampling of Ellington's early recordings can be heard on *Duke Ellington and His Orchestra,* vol. 1, *The Brunswick Era, 1926–1929,* MCA; *Duke Ellington and His Orchestra,* vol. 2, *The Jungle Band: The Brunswick Era, 1929–31,* MCA; and *Duke Ellington at the Cotton Club,* RCA.

96. Most critics consider the period 1938–41 to be the Ellington orchestra's most creative era; during this time it recorded such masterpieces as *Ko Ko, Pyramid, Braggin' in Brass, Harlem Air Shaft, Chelsea Bridge, Perdido, Cotton Tail, In a Mellotone, Sophisticated Lady, Warm Valley, Frankie and Johnnie, Blue Serge,* and *Take the A Train.* These can be heard on the Smithsonian Institution's eight-album annotated collection: *Duke Ellington, 1938, Duke Ellington, 1939, Duke Ellington, 1940,* and *Duke Ellington, 1941.*

97. Hasse, *Beyond Category,* 144–269.

98. Quoted in Shapiro and Hentoff, *Hear Me Talkin' to Ya,* 224–25.

99. Quoted in J. A. Rogers, "Jazz at Home," in Locke, *New Negro,* 221–22. Also see Ogren, *Jazz Revolution,* and Peretti, *Creation of Jazz.*

100. Ralph Ellison, *Going into the Country* (New York, 1986), 224–25.

101. Trotter, *Great Migration;* Grossman, *Land of Hope;* and Baraka, *Blues People,* chaps. 6 and 7. Also see Baker, "Modernism and the Harlem Renaissance," 107–25, and introduction to *Blues, Ideology, and Afro-American Literature.*

SIX    Modernism versus New York Modern: MoMA and the Whitney

1. Paul Goldberger, *The Skyscraper* (New York, 1981), 13. See also Robert A. M. Stern, Gregory Gilmartin, and Thomas Mellins, *New York, 1930: Architecture and Urbanism between the Two World Wars* (New York, 1988), 31.

2. Stern, Gilmartin, and Mellins, *New York, 1930,* 73. Also see Warren Sussman, *Culture as History* (New York, 1984).

3. Stern, Gilmartin, and Mellins, *New York, 1930,* 23–27.

4. Goldberger, *The Skyscraper,* 51–93. The jukebox description comes, says Goldberger, from architectural historian Vincent Scully.

5. William Lieberman, ed., *Art of the Twenties* (catalog of the Museum of Modern Art) (New York, 1979).

6. Stern, Gilmartin, and Mellins, *New York, 1930,* 26–28.

7. Ibid., 575. Also see Cervin Robinson and Rosemarie Haag Bletter, *Skyscraper Style: Art Deco in New York* (New York, 1975), 15–26.

8. Stern, Gilmartin, and Mellins, *New York, 1930,* 679.

9. Carol H. Krinsky, *Rockefeller Center* (New York, 1978), 11.

10. Ibid., 131.

11. Federal Writers Project, *The WPA Guide to New York* (1939; New York, 1972), 319, 333.

12. *New York Times,* Dec. 26, 1932. Trains, ferries, ocean liners, and tugboats were all delayed or their schedules canceled, and, the *Times* reported, "Only one plane left Newark Airport during the afternoon."

13. *New York Times,* Dec. 28, 1932.

14. Brooks Atkinson, *New York Times,* Dec. 28, 1932.

15. *New York Times,* Dec. 28, 1932.

16. Bertram Wolfe, *The Fabulous Life of Diego Rivera* (New York, 1967), 331. The full title of Rivera's mural was *Man at the Crossroads Looking with Uncertainty but with Hope and High Vision to the Choosing of a Course Heading to a New and Better Future.* Also see Krinsky, *Rockefeller Center,* 147–50, and the memoir by Edward Lanning, "New Deal Mural Projects," in *The New Deal Art Projects: An Anthology of Memoirs,* ed. Francis V. O'Connor (Washington, D.C., 1972). Picasso was subsequently offered the commission. He accepted on the proviso that, in addition to receiving a fee of thirty-two thousand dollars, he would not be required to submit a preliminary sketch.

17. A. Conger Goodyear, *The Museum of Modern Art: The First Ten Years* (New York, 1940). See also Russell Lynes, *Good Old Modern* (New York, 1978), and Alfred Barr, *Vanity Fair* (Sept. 1929).

18. Goodyear Archives, Museum of Modern Art. See, for example, Abby Rockefeller to Frank Crowninshield, July 30, 1929.

19. Crowninshield to Goodyear, Aug. 1, 1929, Goodyear Archives. A decade later Barr, retrospectively, also claimed ownership of the idea that the museum-to-be would function as a temporary exhibitor and part-time collector. See his "Notes for the Reorganization Committee," Feb. 23, 1938, Barr Papers, Archives of American Art, Smithsonian Institution.

20. Sachs to Goodyear, June 25, 1929, Goodyear Archives.

21. Abby Rockefeller to Goodyear, July 12, 1929, Goodyear Archives.

22. Harvard *Crimson,* Oct. 30, 1926.

23. See Dwight McDonald, "Profile: Alfred Barr," *New Yorker,* Dec. 12, 1953. Barr's papers are, for the most part, available at the Archives of American Art. The authors thank Rona Roop of the Museum of Modern Art and Bill McNaught of the Archives of American Art for their help in this area.

24. Barr's notes in the early 1930s indicate that he visited England and France in 1923, but they record no comments about the artistic nature of that earlier trip. Notes file, Barr Papers.

25. Alfred Barr, "Paris," Nov. 1928, Barr Papers.

26. Helen Searing, "International Style: The Crimson Connection," *Progressive Architecture,* no. 2 (1982): 90.

27. Alfred Barr, Mar. 2, 1928, Notes file, Barr Papers.

28. Barr to Sachs, Apr. 11, 1940, Barr Papers.

29. Crowninshield to Goodyear, June 28, 1929, Goodyear Archives.

30. Goodyear to A. Rockefeller, "Plan for Exhibition," Nov. 1929, Goodyear Archives.

31. Crowninshield to Goodyear, Sept. 5, 1929, Goodyear Archives.

32. A. Rockefeller to Goodyear, July 12, 1929, Goodyear Archives.

33. Searing, "International Style," 88–89.

34. Philip Johnson, interview by authors, New York City, June 1985. See also Calvin Tomkins, "Profiles: Form under Light," *New Yorker,* May 23, 1977.

35. Robert A. M. Stern, *George Howe: Toward a Modern American Architecture* (New Haven, Conn., 1975), 60–65.

36. Searing, "International Style," 95, indicates that the terminology was already current in architectural circles, but Barr claimed otherwise. See following note.

37. Henry-Russell Hitchcock, "Built to Live In," and Philip Johnson, "The Exhibition on Modern Architecture." Both may be found in the *International Style Exhibition* file, Office of the Registrar, MoMA.

38. Johnson, "Exhibition."

39. Helen Searing, *In Search of Modern Architecture: A Tribute to Henry-Russell Hitchcock* (New York, 1965).

40. Henry-Russell Hitchcock, "The Decline of Architecture," *Hound and Horn,* advance issue (1927): 28–35.

41. Henry-Russell Hitchcock, "Modern Architecture, a Memoir," *Journal of the Society of Architectural Historians* (Nov. 1980).

42. Nicholas Fox Weber, *Patron Saints* (New York, 1992), paints an excellent portrait of Kirstein and his generation of avant-garde patron-promoters.

43. Hitchcock, "Decline of Architecture," 31.

44. Ibid., 34.

45. See Hitchcock's four important articles from the late 1920s, two of which appeared in English and two in French: "Frank Lloyd Wright and the 'Academic Tradition' of the Early Eighteen-Nineties," *Arts* (May 1928); "The Architectural Work of J. J. P. Oud," *Arts* (Feb. 1928); "J. J. P. Oud," *Cahiers d'Art* (1925); "L'Architecture Contemporaine en Angleterre," *Cahiers d'Art* (1925).

46. Henry-Russell Hitchcock, *Modern Architecture: Romanticism and Reintegration* (New York, 1929); and Johnson, interview. See also Philip Johnson to Philip Lovell: "The work of FLW was included as being historically important and contributing to the International Style but hardly of it," Apr. 16, 1932, *International Style Exhibition* file, MoMA.

47. Hitchcock, "Architecture Chronicle," *Hound and Horn* (Oct.–Dec. 1931).

48. Hitchcock, "Built to Live In."

49. See *Four Great Masters of Modern Architecture,* a verbatim record of a March 1961 symposium, at the Avery Library, Columbia University. Especially valuable is Johnson's "A Personal Testament," 110–11. See also "Modern Architecture Symposium: The Decade 1929–1939," *Journal of the Society of Architectural Historians* (Mar. 1965). Finally, there is Philip Johnson, *Mies van der Rohe* (New York, 1947), in which Mies is praised as an "artist."

50. Johnson, interview.

51. Philip Johnson to Barr, July 11, 1931, *International Style Exhibition* file, MoMA. It appears that Johnson and Barr shared these sentiments.

52. Philip Johnson to Mrs. John D. Rockefeller Jr., Mar. 27, 1931, *International Style Exhibition* file, MoMA.

53. Sandra Honey, "Mies at the Bauhaus," *Architectural Association Quarterly,* no. 1 (1978).

54. Mies van der Rohe to Philip Johnson, Sept. 1, 1932, Mies van der Rohe Archives, MoMA.

55. See Richard Pommer, "The Architecture of Urban Housing in the United States during the Early 1930s," *Journal of the Society of Architectural Historians,* no. 4 (1978). Also see Richard Guy Wilson, "International Style, the MoMA Exhibition," *Progressive Architecture,* no. 2 (1982).

56. Johnson to Barr, July–Oct. 1931, Correspondence file, Barr Papers. Johnson wrote excitedly to Barr on October 16, "Even Mendelssohn has become international."

57. Museum of Modern Art, *Modern Architecture, International Exhibition* (New York, 1932).

58. See "International Style Celebrates Its Fiftieth Birthday," *Architectural Record* (June 1982).

59. Henry-Russell Hitchcock and Philip Johnson, *The International Style* (1932; New York, 1966).

60. Stern, Gilmartin, and Mellins, *New York, 1930,* 357.

61. Barr to Goodyear, Dec. 1, 1932, Goodyear Papers. In requesting the sabbatical, Barr explained that he had grown depressed from his dependence on sleeping tablets and needed a "rest from responsibilities."

62. Goodyear, *The First Ten Years.*

63. Alfred Barr, "The Permanent Collection," draft report, Apr. 1933, 2–3, Barr Papers.

64. Ibid., 17.

65. See Barr to Paul, Mar. 22, 1932, and Apr. 28, 1935, Barr Papers.

66. Barr to Kirstein, Oct. 3, 1933, Barr Papers.

67. Ibid.

68. Alfred Barr, "Report to the Trustees," 1934, Barr Papers.

69. Alfred Barr, "Chronicle," in *The Museum of Modern Art: Its History and Collection* (New York, 1981).

70. Alfred Barr, "The 1929 Multi-Departmental Plan," 1941, Barr Papers.

71. Alfred Barr, *Cubism and Abstract Art* (1936; reprint New York, 1966), 19–20, 179.

72. *New York Post,* Mar. 17, 1936.

73. Alfred Barr, *Fantastic Art: Dada and Surrealism* (New York, 1937), and the extensive correspondence in the folder "Fantastic Art," Office of the Registrar, MoMA. Unfortunately, the folders for the *Cubism and Abstract Art* show are now empty.

74. *New York Times,* Jan. 19, 1937.

75. Alfred Barr, "Report to the Trustees," 1934, Barr Papers.

76. Ibid.

77. See Stern, Gilmartin, and Mellins, *New York, 1930,* 136–42, and Peter M. Rutkoff and William B. Scott, *New School: A History of the New School for Social Research* (New York, 1986).

78. Tom Mabry to Alfred Barr, June 18, 1936, and Alfred Barr to Philip Goodwin, July 6, 1936, Barr Papers.

79. Dean Hudnut (of the Harvard School of Architecture) to Barr, Sept. 29, 1936, Barr Papers.

80. Alice Goldfarb Marquis, *Hope and Ashes* (New York, 1986), 16.

81. Ibid., 170.

82. Quoted in Stern, Gilmartin, and Mellins, *New York, 1930,* 144–45.

83. Marquis, *Hope and Ashes,* 114. Abby Rockefeller donated approximately $200,000 to the Museum of Modern Art between 1929 and 1934. In the same period of time her husband, John D. Rockefeller Jr., contributed $450,000 to the Museum of the City of New York, $1.5 million to the Metropolitan, and $5.6 million to create the Cloisters in the wilds of Washington Heights. He did not very much like modern art.

84. Meyer Schapiro to Alfred Barr, May 17, 1936, Barr Papers.

85. Roberta Tarbell, "Gertrude Vanderbilt Whitney as Patron," in Patricia Hills and Roberta Tarbell, *The Figurative Tradition and the Whitney Museum of American Art: Paintings and Sculpture from the Permanent Collection* (New York, 1980), 1. See also Robert Wernick, "Whitney Museum Is an Enduring Vanderbilt Legacy," *Smithsonian* (Aug. 1980), 92–100.

86. Nathaniel Burt, *Palaces for the People* (Boston, 1977), 332–35.

87. Introduction to the *First Catalogue of the Whitney Museum of American Art,* 1932, Whitney Museum of American Art Archives.

88. Introduction to *First Catalogue of the Whitney,* 3.

89. Wernick, "Whitney Museum," 97.

90. Edward Alden Jewell, "American Art Comes of Age," *New York Times Sunday Magazine,* Nov. 22, 1931.

91. A. Hyatt Mayor, "Art Chronicle," *Hound and Horn* (spring 1932).

92. Ibid.; Mayor reported that there were "not many American painters for whom I would give two dollars *and* shelf space," 289.

93. Whitney Museum Staff Minutes, Jan. 20 and 28, 1932, WMAA Archives.

94. Whitney Museum Staff Minutes, Feb. 9 and 18, 1932, WMAA Archives.

95. Juliana Force, Sept. 30, 1932, WMAA Archives.

96. Stuart Davis to Max Weber, Nov. 10, Nov. 7, 1932, and Walter Pach to Juliana Force, Nov. 7, 1932, Force Correspondence file, WMAA Archives (alas, the only extant letters).

97. Whitney Museum Staff Minutes, Jan. 21, 1931, WMAA Archives.

98. See "Thomas Benton," in Artists file, WMAA Archives.

99. Thomas Hart Benton, catalog for the *Arts of Life in America* murals, WMAA Archives. The Whitney sold the murals to the New Britain (Conn.) Museum of American Art in 1953 for five hundred dollars; Thomas Benton, note, 1953, Artists file, WMAA Archives.

100. See Matthew Baigell, *Thomas Hart Benton* (New York, 1975). See also Hills and Tarbell, *Figurative Tradition,* 59.

101. Hills and Tarbell, *Figurative Tradition,* 70.

102. Patricia Hills, "Painting, 1900–1940," in Hills and Tarbell, *Figurative Tradition.*

103. *Nation,* Dec. 4, 1929.

104. Lloyd Goodrich, "The Paintings of Edward Hopper," *Arts,* no. 3 (Mar. 1927).

105. Lloyd Goodrich, interview by Harlan Philips, 1963, 2–20, Archives of American Art.

106. Ibid., 27.

107. Alexander Brook, interview, July 7, 1977, Archives of American Art. Brook also recalled how much Miller was influenced by Freud and how he somehow managed to incorporate what he had read into his teaching.

108. Goodrich, interview (1963), 85.

109. Lloyd Goodrich, "The Opening Season," *Arts,* no. 2 (Oct. 1929), 83.

110. Lloyd Goodrich, *Thomas Eakins: His Life and Work* (New York, 1933), 155. Goodrich's expanded two-volume version was published under the same title in 1982 by Harvard University Press. In addition, he wrote several short studies in conjunction with subsequent Eakins exhibits and even at the time of his death in 1987 was at work on yet another Eakins study. Goodrich's vision of Eakins—public, literary, and original—set the standard and influenced subsequent scholarship for fifty years. The recent publication of, among others, Elizabeth Johns, *Thomas Eakins: The Heroism of Modern Life* (Princeton, N.J., 1983), adds to the interpretative framework.

111. Lloyd Goodrich, "The Problem of Subject Matter and Abstract Esthetics in Painting," paper presented at symposium, Whitney Museum of American Art, Apr. 10, 1933, WMAA Archives.

112. Hills and Tarbell, *Figurative Tradition.*

113. Cited extensively in Lloyd Goodrich, *Reginald Marsh* (New York, 1972), 44–46.

114. Lloyd Goodrich, notes for Katherine Schmidt Schubert Bequest, Lloyd Goodrich Papers, WMAA Archives.

115. Goodrich, interview (1963), 292.

116. See Francis V. O'Connor, "The New Deal Art Projects in New York," *American Art Journal* (fall 1969), and "New Deal Murals in New York," *Artform* (Nov. 1968). See also Marlene Park, "City and Country in the 1930s: A Study of New Deal Murals in New York," *Art Journal,* no. 1 (fall 1979).

117. For estimates, see Francis V. O'Conner, *The New Deal Art Projects: An Anthology of Memoirs* (Washington, D.C., 1972), and *Federal Support for the Visual Arts: The New Deal and Now* (New York, 1971); and Belisario R. Contreras, *Tradition and Innovation in New Deal Art* (Lewisburg, Pa., 1983). Many come from the lists compiled from the College Art Association, which provided some pre-PWAP-FAP relief.

118. Public Works of Art Project (PWAP), "Final Report," Record Group 121, National Archives, coindexed at the Archives of American Art. The report is also said to be located in the George Biddle Papers, Library of Congress. See Richard D. McKinzie, *The New Deal for Artists* (Princeton, N.J., 1973).

119. George Biddle Diaries, June 23, 1933, Biddle Papers, Archives of American Art.

120. Edward Bruce, memorandum, Nov. 10, 1933, PWAP, "Final Report."

121. George Biddle, memorandum, Nov. 10, 1933, Archives of American Art.

122. McKinzie, *New Deal for Artists,* 6, and Contreras, *Tradition and Innovation,* 30.

123. McKinzie, *New Deal for Artists,* 7. See also Bruce to John Ankenney (director of the Dallas Art Association), telegram, Dec. 10, 1933, quoted in PWAP, "Final Report."

124. Bruce to Duncan Phillips and other regional directors, telegram, Dec. 10, 1933, PWAP, "Final Report"; O'Connor, *Federal Support for the Visual Arts,* 19. The Regional Committee included Bryson Burroughs of the Met, Gordon Washburn of the Albright-Knox Gallery, Beatrice Winter of the Newark Museum, E. M. M. Warburg, a trustee of MoMA, Mrs. Whitney, and William Fox of the Brooklyn Museum; PWAP, "Final Report," Region 2.

125. O'Connor, "New Deal Art Projects in New York," 60.

126. Ibid.; and Goodrich, interview (1963).

127. Marius Aldrich to Juliana Force, Feb. 26, 1934, Papers of the New York Region, PWAP, Record Group 121.

128. Bruce to Ankenney, telegram, Dec. 10, 1933.

129. Papers of the New York Region, PWAP. These records, available at the Archives of American Art, are duplicates of those that repose at the National Archives.

130. Evergood correspondence in the files of the Papers of the New York Region, PWAP, Archives of American Art.

131. McKinzie, *New Deal for Artists,* 30; Vernon Porter (PWAP official) to Paul Cadmus, May 31, 1934, Cadmus file, Papers of the New York Region, PWAP.

132. See the important study, Gerald M. Monroe, "The Artists' Union of New York" (Ed.D. diss., New York University, 1972).

133. Monroe, "Artists' Union," 44.

134. Bruce to the Secretary of the Artists' Union, Mar. 28, 1934, PWAP, Final Report.

135. Lloyd Goodrich, interview by authors, New York City, Jan. 1987.

136. Soyer file, Papers of the New York Region, PWAP.

**SEVEN**   True Believers on Union Square: Politics and Art in the 1930s

1. Robert Caro, *The Power Broker: Robert Moses and the Fall of New York* (New York, 1974).

2. Ibid., 327.

3. Ibid., 328.

4. Charles Garrett, *The La Guardia Years: Machine and Reform Politics in New York City* (New Brunswick, N.J., 1961), 62–120.

5. Caro, *Power Broker,* 360–411.

6. Ibid., 465.

7. Marshal Berman, *All That Is Solid Melts into Air* (New York, 1982), 293.

8. Robert Carter, "Pressure from the Left: The American Labor Party, 1936–1954" (Ph.D diss., Syracuse University, 1965), 2–10.

9. Ibid., 19.

10. Ibid., 19–22, and Garrett, *La Guardia Years,* 264–67.

11. Carter, "Pressure from the Left," 80.

12. See the extensive literature on this subject: Daniel Aaron, *Writers on the Left: Episodes in American Literary Communism* (New York, 1961); James B. Gilbert, *Writers and Partisans: A History of Literary Radicalism in America* (New York, 1968); and Terry A. Cooney, *The Rise of the New York Intellectuals: Partisan Review and Its Circle* (New York, 1986).

13. Malcolm Cowley, *The Dream of the Golden Mountains* (New York, 1980).

14. Malcolm Cowley, *Exile's Return* (New York, 1934), 287, 307.

15. Gilbert, *Writers and Partisans,* 107.

16. Ibid., 102–8, and Aaron, *Writers on the Left,* 205.

17. Mark Naison, *Communists in Harlem during the Depression* (Urbana, Ill., 1983), 60.

18. Ibid., 60–72, 72.

19. Harvey Klehr, *The Heyday of American Communism* (New York, 1984), 79.

20. Eric Homberger, "Proletarian Literature and the John Reed Clubs," *Journal of American Studies* 19 (Aug. 1979): 232. Also see Helen A. Harrison, "John Reed Club Artists and the New Deal," *Prospects* 5 (1980).

21. David Shapiro, ed., *Social Realism: Art as a Weapon* (New York, 1973), 19.

22. Anton Refregier, "Report of Student Exhibition," 1932, Stuart Davis Papers, Archives of American Art. The Davis Papers contain a valuable collection of documentation for the entire decade, including the minutes of the various steering committees of the American Artists' Congress (1936–40). See also Harrison, "John Reed Club Artists," 242–43.

23. Harry Potamkin (executive secretary of the John Reed Clubs) to Granville Hicks, Feb. 18, 1933, Granville Hicks Papers, Syracuse University.

24. Homberger, "Proletarian Literature," 324.

25. Matthew Baigell and Julia Williams, eds., *Artists against War and Fascism* (New Brunswick, N.J., 1986), 5.

26. Joseph Milton King, "Making the Revolution—Maybe: Deradicalization and Stalinism in the American Communist Party, 1928–1938" (Ph.D. diss., City University of New York, 1983), 398.

27. Cited ibid., 304.

28. Quoted ibid., 204.

29. Quoted ibid., 308.

30. Monty Penkower, *The Federal Writers Project: A Study in Government Patronage of the Arts* (Champaign, Ill., 1977), 12–27.

31. *Partisan Review* 1 (Feb.–Mar. 1934).

32. Gilbert, *Writers and Partisans,* 122.

33. Richard Pells, *Radical Visions, American Dreams* (New York, 1973).

34. "Thirty Years Later: Memoirs of the First American Writers' Congress," *American Scholar* 35 (1966), proceedings of a symposium moderated by Daniel Aaron and attended by Malcolm Cowley, Granville Hicks, and William Philips.

35. W. H. Auden to Franklin Fulsom (League of American Writers), Nov. 11, 1939, League of American Writers (LAW) Papers, University of California, Berkeley.

36. League of American Writers, "Report on the Second American Writers' Congress," LAW Papers.

37. "Thirty Years Later," 506. The papers from the first and second congresses were published in two collections edited by Henry Hart: *American Writers' Congresses* (New York, 1935), and *The Writer in a Changing World* (New York, 1937).

38. Sam Smiley, "Friends of the Party: The American Writers' Congresses," *Southwest Review* 54 (summer 1969): 290–300.

39. League of American Writers, Executive Board Minutes, May 1936, LAW Papers.

40. Naison, *Communists in Harlem,* 152, 169.

41. Irving Howe and Louis Cosier, *How We Lived* (New York, 1979), 35.

42. Cowley to Hicks, Jan. 1936, Hicks Papers.

43. Browder to Hicks, Mar. 17, 1937, Hicks Papers.

44. Auden to Hicks, Nov. 11, 1939, Hicks Papers.

45. Cowley to Hicks, June 24, 1941, Hicks Papers.

46. Gerald M. Monroe, "The Artists' Union of New York" (Ed.D. diss., New York University, 1972), 154.

47. Stuart Davis, handwritten memo, June 1935, Stuart Davis Papers.

48. Karen Wilkin, *Stuart Davis* (New York, 1987), 15.

49. Patricia Hills and Roberta Tarbell, *The Figurative Tradition and the Whitney Museum of American Art: Paintings and Sculpture from the Permanent Collection* (New York, 1980), 160–70.

50. Stuart Davis, handwritten memo, May 1935, Davis Papers.

51. Stuart Davis, draft "call" for the first American Artists' Congress, Davis Papers.

52. Stuart Davis, minutes of the Executive Committee, Dec. 9, 1936, Davis Papers.

53. Baigell and Williams, *Artists,* 218–30.

54. Stuart Davis, notes, May 6, 1937, and Executive Board minutes, May 20, 1937, Davis Papers.

55. See, for example, Berenice Abbott, "Photographer as Artist," *Art Front* (Sept. 1936); Elizabeth Noble [McCausland], "Official Art," *Art Front* (Sept. 1936), and "New Horizons," *Art Front* (Nov. 1936); and Meyer Schapiro, "The Public Uses of Art," *Art Front* (Nov. 1936). Hills and Tarbell, *Figurative Tradition,* 176.

56. Monroe, "Artists' Union," 103–30.

57. Gwendolyn Bennett, "The Harlem Artists Guild," *Art Front* (May 1937).

58. Baigell and Williams, *Artists,* 31; Wilkin, *Davis,* 144.

59. Davis to Pearson, Feb. 1940, Davis Papers.

60. Baigell and Williams, *Artists,* 32.

61. Peter Bauland, *Hooded Eagle: Modern German Drama on the New York Stage* (Syracuse, N.Y., 1968), 43.

62. Ronald Willis, "The American Laboratory Theater," *Tulane Drama Review* (fall 1964): 110–15.

63. Jack Poggi, *Theater in America: The Impact of Economic Forces* (Ithaca, N.Y., 1965), 109–25.

64. Elmer Rice, *Minority Report* (New York, 1963), 49–144, 144.

65. Ibid.

66. Robert Hogan, *The Independence of Elmer Rice* (Carbondale, Ill., 1963), 3; Frank Durham, *Elmer Rice* (New York, 1970), 40.

67. Rice, *Minority Report,* 198.

68. Poggi, *Theater in America,* 74.

69. Cheryl Crawford, *One Naked Individual* (New York, 1977), 52.

70. Harold Clurman, *The Fervent Years* (New York, 1945), 25.

71. Poggi, *Theater in America,* 101–25.

72. The series *Best Plays of . . .* contains a wealth of detail on American drama throughout the century.

73. Clurman, *Fervent Years,* 17. See also Wendy Smith, *Real Life Drama: The Group Theater and America* (New York, 1990).

74. Clurman, *Fervent Years,* 35.

75. Ibid., 34.

76. Harold Clurman, "The Group Theater Speaks for Itself," Harold Clurman Papers, Lincoln Center for the Performing Arts (LCPA) Archives.

77. Clurman, transcript of radio speech, Nov. 1932, Clurman Papers.

78. Crawford, *Naked Individual,* 53.

79. Clurman, *Fervent Years,* 39.

80. Mel Gordon and Laurie Lassiter, "Acting Experiments in the Group," *Drama Review* (winter 1984): 27.

81. David Garfield, *A Player's Place: The Story of the Actors Studio* (New York, 1980), 21.

82. Ibid., 123.

83. Ibid., 22.

84. Quoted in Cindy Adams, *Lee Strasberg* (New York, 1980), 118.

85. Crawford, *Naked Individual,* 78.

86. Adams, *Strasberg,* 44.

87. Gordon and Lassiter, "Acting Experiments," 8.

88. Bud Bohnen, July 1932, Roman Bohnen Papers, LCPA Archives.

89. Clurman, *Fervent Years,* 36–37, and Crawford, *Naked Individual,* 53–55.

90. Clurman, *Fervent Years,* 112–13.

91. Clifford Odets, "Awake and Sing!" in *Six Plays* (New York, 1939).

92. Group Theater, "Reunion," *Tulane Drama Review* (summer 1984): 532.

93. Stella Adler, interview by authors, New York City, Mar. 1986.

94. Group Theater, "Reunion," 508, and Adler, interview.

95. Bud Bohnen to Art Young, Oct. 9, 1934, Bohnen Papers; and Clurman, *Fervent Years,* 139.

96. Crawford, *Naked Individual,* 70.

97. Margaret Brenman-Gibson, *Clifford Odets, American Playwright* (New York, 1981), 316.

98. Clurman, *Fervent Years,* 316. See also Adler, interview.

99. Clurman, *Fervent Years,* 149.

100. See, for example, Gerald Weals, *Clifford Odets, Playwright* (New York, 1971), 46–50; R. Baird Schuman, *Clifford Odets* (New York, 1962); and Harold Cantor, *Clifford Odets* (New York, 1972).

101. Poggi, *Theater in America,* 84.

102. Harold Clurman, "Plans for a First Studio," spring 1936, Clurman Papers.

103. Group Theater, "Reunion," 550.

104. Clurman, *Fervent Years,* 235; Brenman-Gibson, *Odets,* 525.

105. Hallie Flanagan, *Arena* (New York, 1941).

106. Gerald Rabkin, *Drama and Commitment* (Bloomington, Ind., 1964), 102. See also

Morgan Himmelstein, *Drama Was a Weapon* (New Brunswick, N.J., 1964), 63.

107. Jane De Hart Mathews, *The Federal Theater* (Princeton, N.J., 1967), 10.

108. Rice, *Minority Report,* 348.

109. Flanagan, *Arena,* 51.

110. Mathews, *Federal Theater,* 42.

111. John O'Connor and Lorraine Brown, *Free, Adult, Uncensored: The Living History of the Federal Theater Project* (Washington, D.C., 1978), 22.

112. Mathews, *Federal Theater,* 18–23.

113. Himmelstein, *Drama Was a Weapon,* 11.

114. Mathews, *Federal Theater,* 9.

115. Flanagan, *Arena,* 65.

116. Ibid., 71.

117. Rice, *Minority Report,* 358, and Flanagan, *Arena,* 67.

118. O'Conner and Brown, *Free, Adult, and Uncensored,* 6.

119. Ibid., 10; Himmelstein, *Drama Was a Weapon,* 91.

120. Mathews, *Federal Theater,* 87–88.

121. Ibid., 93.

122. Ibid., 100–101.

123. Ibid., 101, 188.

124. John Houseman, *Run-Through: A Memoir* (New York, 1972), 180.

125. Ibid., 97.

126. Virgil Thomson, *An Autobiography* (New York, 1985), 236–47, 241.

127. Ibid., 241.

128. Houseman, *Run-Through,* 184.

129. Ibid., 194.

130. Ibid., 98.

131. Mathews, *Federal Theater,* 76.

132. Houseman, *Run-Through,* 203.

133. O'Connor and Brown, *Free, Adult, and Uncensored,* 18. See also Edith Isaacs, *The Negro in American Theater* (College Park, Md., 1968), 106.

134. Houseman, *Run-Through,* 280. E. Quita Craig, *Black Drama of the Federal Theater Era* (Amherst, Mass., 1980), 71.

135. Marc Blitzstein, *The Cradle Will Rock,* Columbia Recording.

136. Houseman, *Run-Through,* 211.

137. Barbara Zuck, *A History of Musical Americanism* (Ann Arbor, Mich., 1980), 201–3.

138. Ibid., 206.

139. Houseman, *Run-Through,* 248–64.

140. Blitzstein, *Cradle Will Rock,* liner notes.

141. *Cradle Will Rock,* scene 9.

142. Mathews, *Federal Theater,* 200.

143. Ibid., 271.

144. Ibid., 275.

145. Flanagan, *Arena,* 365.

EIGHT  Behind the American Scene: Music, Dance,
and the Second Harlem Renaissance

1. Whereas there are numerous studies of New York's pre–World War I European immigrants and their experience in the city, most of the work on New York ethnic neighborhoods

in the 1930s and 1940s is largely impressionistic, relying heavily on autobiographies. John Bodner, Roger Simon, and Michael P. Weber, in *Lives of Their Own: Blacks, Italians, and Poles in Pittsburgh, 1900–1960* (Urbana, Ill., 1983), delineate the tightly woven ethnic communities that evolved following the end of unrestricted European immigration in 1924. Although Pittsburgh differed significantly from New York, there was much that was alike. When combined with the immigrant studies of New York and the numerous "ethnic" autobiographies and novels, *Lives of Their Own* paints a compelling picture of a golden age in American ethnic working-class neighborhoods—the subject of much of the American scene.

2. William Barrett, *The Truants* (New York, 1983), 21.

3. Quoted in Peter Golenbock, *Bums: An Oral History of the Brooklyn Dodgers* (New York, 1984), 83, 155.

4. Alfred Kazin, *Starting Out in the Thirties* (New York, 1962), 47–48.

5. Kate Simon, *Bronx Primitive* (New York, 1983), 2.

6. Quoted in Michael Sundell, "Berenice Abbott's Work in the 1930s," *Prospects,* no. 5 (1980): 269. The quote is from her application for support for the project in the early 1930s.

7. Sundell, "Berenice Abbott's Work," 274.

8. Berenice Abbott, *Cheese Store,* in *New York in the Thirties* (New York, 1973, reprint of the 1939 edition, originally published by Federal Writers' Publications), plate 36 (Feb. 2, 1937).

9. See the remarkable entries in the *New Grove Encyclopedia of American Music* (New York, 1985), "New York," by Irving Kolodin, Francis D. Perkins, and Susan Thiemann Sommer, and "Walter Damrosch," "Leopold Damrosch," and "Frank Damrosch."

10. Aaron Copland and Vivian Perlis, *Copland: 1900 through 1942* (New York, 1984), 8, 95. This ostensible autobiography is actually a double text, part oral history, the manuscript of which is in the Yale music history project, and part biography, in this case written by Vivian Perlis, who also has collected the materials (which are themselves a third source) in the Yale collection. This chapter makes full use of each of the three aspects of the Copland-Perlis project. See also Victor Berger, *Aaron Copland* (Westport, Conn., 1971); Arnold Dobrin, *Aaron Copland: His Life and Times* (New York, 1967); Julia Francis Smith, *Aaron Copland: His Work and Contribution to American Music* (New York, 1955); JoAnn Skowronski, *Aaron Copland: A Bio-Bibliography* (Westport, Conn., 1985); and Neil Butterworth, *The Music of Aaron Copland* (London, 1985).

11. Aaron Copland, interview by Vivian Perlis, Dec. 1975–Dec. 1976, in *American Music Series 2,* vol. 1, *Aaron Copland.*

12. Leonie Rosenstiel, *Nadia Boulanger: A Life in Music* (New York, 1982), 162. See also Elaine Brody, *Paris, the Musical Kaleidoscope: 1870–1925* (New York, 1987), 239.

13. Copland, interview (Perlis), 88–91.

14. Ibid., 95.

15. Ibid., 148–223.

16. Frank Rossiter, *Charles Ives and His America* (New York, 1975), 216.

17. Rita Meade, *Henry Cowell's New Music* (Ann Arbor, Mich., 1978), 13.

18. Ibid., 4.

19. Ibid., 35.

20. Rossiter, *Charles Ives,* 192.

21. Ibid., 214.

22. Bernard Herman, quoted ibid., 247.

23. Virgil Thomson, *An Autobiography* (New York, 1966), 254. Aaron Copland, *The New Music,* rev. ed. (New York, 1968).

24. Peter M. Rutkoff and William B. Scott, *New School: A History of the New School for Social Research* (New York, 1986), 56.

25. Copland, *New Music,* 127–30.

26. Roger Sessions, "Music in Crisis," *Modern Music* (Jan.–Feb. 1933).

27. Don McDonagh, *Martha Graham: A Biography* (New York, 1973), 200.

28. Copland, *New Music,* 131.

29. Aaron Copland, "The Composer in America, 1923–1933," *Modern Music* (Jan.–Feb. 1933): 87–92.

30. Copland, "Composer in America," 91.

31. McDonagh, *Martha Graham,* 202.

32. Rossiter, *Charles Ives,* 245.

33. Ibid., 247.

34. Barbara L. Tischler, *An American Music: The Search for an American Musical Identity* (New York, 1986), 106–9.

35. Rossiter, *Charles Ives,* 274.

36. Tischler, *An American Music,* 115.

37. See Barbara Zuck, *A History of Musical Americanism* (Ann Arbor, Mich., 1980), and Charles Seeger, *Reminiscences of an American Musicologist* (New York, 1972), 179–236 (originally, "Reminiscences of an American Musicologist," 1966, recorded as part of the Oral History Program, University of California, Berkeley). See also Copland and Perlis, *Copland,* 222.

38. Seeger, *Reminiscences,* 179–236.

39. Copland, interview (Perlis), 353, 369.

40. Tischler, *An American Music,* 135.

41. Ibid., 138.

42. Quoted by B. C. Vermeersch in "Composers' Forum," *New Grove Encyclopedia of American Music.*

43. Tischler, *An American Music,* 147. See also Thomson, *Autobiography,* 254.

44. Thomson, *Autobiography,* 248, 254.

45. Tischler, *An American Music,* 147.

46. Copland, *New Music,* 135.

47. Thomson, *Autobiography,* 259.

48. Ibid., 216.

49. Kathleen Hoover and John Cage, *Virgil Thomson: His Life in Music* (New York, 1959), 180.

50. Thomson, *Autobiography,* 278.

51. Ibid.

52. Virgil Thomson, interview by John Gruen, Sept. 24, 1977, Dance Collection, Lincoln Center for the Performing Arts (LCPA) Archives.

53. Quoted in Tischler, *An American Music,* 120.

54. Copland and Perlis, *Copland,* 199.

55. Copland, interview (Perlis), 429–30.

56. Copland and Perlis, *Copland,* 349.

57. Rossiter, *Charles Ives,* 270.

58. Elizabeth Kendall, *Where She Danced: The Birth of American Art Dance* (Berkeley, Calif., 1979), 155–59. So serious was Graham that, Kendall remarks, "she had missed all of American popular culture." See also Agnes De Mille, *Martha: The Life and Work of Martha Graham* (New York, 1991), and Martha Graham, *Blood Memory* (New York, 1991).

59. Kendall, *Where She Danced,* 178–80.

60. Martha Graham, "The Medium of Dance," interview, 1953, Oral History Project, LCPA Archives.

61. Ibid.

62. Ibid.

63. Martha Graham, "Art in the United States," interview by Wallace Terry, *Voice of America,* Aug. 28, 1962.

64. Quoted in Ernestine Stodelle, *Deep Song: The Dance Story of Martha Graham* (New York, 1984), 53–54.

65. Kendall, *Where She Danced,* 209.

66. Stodelle, *Deep Song,* 33–36.

67. See Martha Graham, interview by Gertrude Shurr and Nik Kravitsky, videocassette, Arizona State University, Jan. 30, 1984, in celebration of Horst's one hundredth birthday, LCPA Archives. See also Jack Anderson, *Ballet and Modern Dance* (Princeton, N.J., 1986), 156–58.

68. Graham, interview (1984).

69. See the accounts in Stodelle, *Deep Song,* and Graham, interview (1984).

70. The account of Graham's encounter with the Penitents may be found in Kendall, *Where She Danced,* 210–24; Stodelle, *Deep Song,* 72–77; McDonagh, *Martha Graham,* 80–85; and Graham, interview (1984).

71. Kendall, *Where She Danced,* 213; and McDonagh, *Martha Graham,* 70–75.

72. Kendall, *Where She Danced,* 205.

73. Martha Graham, interview by Jane Dudley, Dec. 29, 1975, Dance Collection, LCPA.

74. Stodelle, *Deep Song,* 99.

75. Marjorie Church, "The Bennington Dance Festival," *Dance Observer* (Aug.–Sept. 1936).

76. Diane Rudhyar, "My Bennington Experience," *Dance Observer* (Aug.–Sept. 1937): 74–75.

77. Naomi Lubell, "The Bennington School," *American Dancer* (Oct. 1937): 12–15.

78. Claudia Moore, "An Historical Survey of Selected Dance Repertories and Festivals in the United States since 1920" (master's thesis, New York University School of Education, 1942), 7–50.

79. Lois Balcolm, "Bennington in 1942," *Dance Observer* (Aug.–Sept. 1942): 87–88.

80. Bernard Taper, *Balanchine: A Biography* (New York, 1960), 159.

81. Anderson, *Ballet and Modern Dance,* 84–110.

82. Richard Buckle, *Diaghilev* (New York, 1979), 294–309.

83. Ibid., 309.

84. Anderson, *Ballet and Modern Dance,* 129–31. See also Lincoln Kirstein, *Ballet: Bias and Belief* (New York, 1983).

85. See "Where It All Began," *Ballet News* 2, no. 5 (Nov. 1980).

86. Copland and Perlis, *Copland,* 279.

87. Marcia Siegel, *The Shapes of Change* (Boston, 1975), 118–19.

88. Copland and Perlis, *Copland,* 280.

89. Kirstein, *Ballet,* 65.

90. Thomson, interview.

91. Ibid. The Dance division of Lincoln Center has two film versions of *Filling Station,* one from the 1939 tour of Ballet Caravan and the second from a 1954 television program, *Your Show of Shows,* hosted by Steve Allen, who promised a dance with "no tights, no skirts."

92. Isamu Noguchi, *A Sculptor's World* (New York, 1968). See also Sam Hunter, *Isamu Noguchi* (New York, 1981), and the exhibition catalogs by John Gordon and Dore Ashton for shows at the Whitney Museum (1968) and the Pace Gallery (1983), respectively.

93. Quoted in Hunter, *Isamu Noguchi,* 33–34.

94. Patricia Hills and Roberta Tarbell, "Sculpture, 1900–1940," in Hills and Tarbell, *The Figurative Tradition and the Whitney Museum of American Art: Paintings and Sculpture from the Permanent Collection* (New York, 1980). See also Wayne Anderson, *American Sculpture in Process* (Boston, 1975), 3.

95. Anderson, *Ballet and Modern Dance,* 13.

96. Noguchi, *Sculptor's World,* 55.

97. Hunter, *Isamu Noguchi,* 66.

98. Noguchi, *Sculptor's World,* 101.

99. McDonagh, *Martha Graham,* 106. See also Stodelle, *Deep Song,* 96.

100. Noguchi, *Sculptor's World,* 128.

101. Wayne Shirley, "The Sources of 'Appalachian Spring,'" draft manuscript. As Shirley notes, the actual letter is not in the files of the Elizabeth Sprague Coolidge Collection at the Music Division of the Library of Congress, and its contents must be assumed from several replies in the same collection. Most of the sources used in this portion of the narrative come from the Coolidge Collection files.

102. Spivack to Coolidge, Jan. 31, 1942, Coolidge Collection.

103. Coolidge to Spivack, Feb. 9, 1942, Coolidge Collection.

104. Maureen Honey, *Creating Rosie the Riveter: Class, Gender, and Propaganda during World War II* (Amherst, Mass., 1984).

105. Aaron Copland, interview by John Gruen, Sept. 9, 1975, LCPA Archives.

106. Martha Graham, "Script for Aaron Copland—from Martha Graham," undated, Coolidge Collection.

107. Hart Crane, "The Bridge: To the Brooklyn Bridge," in *The Complete Poems and Selected Letters and Prose of Hart Crane,* ed. Brom Weber (New York, 1966), from the section, "The Dance," 70–75.

108. Graham, "Script for Aaron Copland."

109. Ibid.

110. Ibid.

111. Graham to Coolidge, Aug. 2, 1942, Coolidge Collection.

112. Graham, "Script for Aaron Copland."

113. Aaron Copland, interview by John Gruen, July 7, 1975, LCPA Archives.

114. See Copland, interview (Perlis), 2:436. Copland says that he found the song in the collection, *'Tis the Gift to Be Simple.* He is probably referring to E. D. Andrews, *The Gift to Be Simple: Songs, Dances, and Rituals of the American Shakers* (New York, 1940).

115. "Copland," in *New Grove Encyclopedia of American Music* (New York, 1985), 500.

116. Graham, "Script for Aaron Copland."

117. The correspondence and the programs of the Coolidge Festival, especially the notes from Copland to Spivack, may be found in the already noted Coolidge Collection at the Library of Congress.

118. The first example of the program may be found in the Library of Congress (Coolidge Collection) materials already cited. The legend quoted was the only one left from a slew of biblical aphorisms, which Graham had intended to use and which one suspects was removed from the program by Copland. By the same token, the "Pennsylvania spring" statement, available for all to read, would easily account for the reception that Copland remembers.

119. Isamu Noguchi, interview, Jan.–Feb. 1979, LCPA Archives.

120. John Martin, *New York Times,* Nov. 5, 1944; Edwin Denby, *New York Times,* May 20, 1945; Virgil Thomson, *New York Herald Tribune,* May 20, 1945.

121. *RCA Victor Record Review,* May 1946.

122. Robert Caro, *The Power Broker: Robert Moses and the Fall of New York* (New York, 1974), 510.

123. Dominic Capeci, *The Harlem Riot of 1943* (Philadelphia, 1977), 37–39.

124. Charles Alston, interviews, 1962 and 1968, Archives of American Art, Smithsonian Institution. See also the Charles Alston Papers, Archives of American Art.

125. Nathan Irvin Huggins, *Harlem Renaissance* (New York, 1971), 303. Romare Bearden and Harry Henderson, *A History of African American Artists* (New York, 1993), 227.

126. Beryl J. Wright, "The Harmon Foundation in Context," in *Against the Odds: African American Artists and the Harmon Foundation,* ed. Gary A. Reynolds and Beryl J. Wright (Newark, N.J., 1989), 22–24.

127. Bearden and Henderson, *History Of African American Artists,* 230; Gary A. Reynolds, "An Experiment in Inductive Service," in Reynolds and Wright, *Against the Odds,* 40.

128. Reynolds and Wright, *Against the Odds,* 33–81.

129. Bearden and Henderson, *History of African American Artists,* 168–73.

130. Charles Alston to the New York office of the WPA/FAP, n.d., Alston Papers.

131. Marlene Park and Gerald E. Markowitz, *New Deal for Art* (Hamilton, N.Y., 1977), 19.

132. See the excellent article by Marlene Park, "City and Country in the 1930s: A Study of New Deal Murals in New York," *Art Journal,* no. 1 (fall 1979).

133. Alston to the WPA, n.d., Alston Papers.

134. Alston to S. H. Greenhill, Department of Public Works, Feb. 13, 1959, Alston Papers. Twenty-five years after he had completed the murals, Alston agreed to restore them.

135. Alston, interview (1968).

136. Bearden and Henderson, *History of African American Artists,* 263.

137. Alston, interview (1968).

138. Quoted in Myron Schwartzman, *Romare Bearden: His Life and Art* (New York, 1990), 82.

139. Capeci, *Harlem Riot,* 129.

140. Quoted in Patricia Hills, "Jacob Lawrence's Expressive Cubism," in Ellen Harkons Wheat, *Jacob Lawrence, American Painter* (Seattle, 1986), 15.

141. Wheat, *Jacob Lawrence,* 32.

142. Ibid., 40.

143. Schwartzman, *Romare Bearden,* 88.

144. Bearden and Henderson, *History of African American Artists,* 235.

NINE  New York Blues: The Bebop Revolution

1. Jack Chambers, *Milestones 1: The Music and Times of Miles Davis to 1960* (New York, 1983), 36.

2. James Patrick, "Charlie Parker and the Harmonic Sources of Bebop Composition: Thoughts on the Repertory of New Jazz in the 1940s," *Journal of Jazz Studies* 6, no. 1 (1979): 12.

3. Lawrence Koch, *Yardbird Suite: A Compendium of the Music and Life of Charlie Parker* (Bowling Green, Ohio, 1988), 68.

4. Lawrence Levine, "Jazz and American Culture," *Journal of American Folklore,* no. 102 (1989): 7–8.

5. Samuel Charters and Leonard Kunstadt, *Jazz: A History of the New York Scene* (New York, 1962), 102–61.

6. Dizzy Gillespie, *To Be or Not to . . . Bop* (New York, 1979), 109.

7. James Lincoln Collier, *Benny Goodman and the Swing Era* (New York, 1989), 97. See also John Hammond, with Irving Townsend, *On Record: An Autobiography* (New York, 1977), 64–66.

8. Hammond, *On Record*, 73.

9. Collier, *Benny Goodman*, 98.

10. John Chilton, *Billie's Blues: The Billie Holiday Story, 1933–1959* (New York, 1975), 14.

11. Gunther Schuller, *The Swing Era* (New York, 1989), 529.

12. Chilton, *Billie's Blues*, 44.

13. Ibid., 11.

14. Scott Deveraux, "The Emergence of the Jazz Concert, 1935–1945," *American Music* (spring 1989): 8.

15. Collier, *Benny Goodman*, 103.

16. Charters and Kunstadt, *Jazz: The New York Scene*, 248.

17. Collier, *Benny Goodman*, 153–54.

18. Charters and Kunstadt, *Jazz: The New York Scene*, 238–40.

19. Quoted in Collier, *Benny Goodman*, 214–18.

20. Charters and Kunstadt, *Jazz: The New York Scene*, 257.

21. Hammond, *On Record*, 200.

22. Ibid., 201.

23. Schuller, *Swing Era*, 229.

24. Koch, *Yardbird Suite*, 22.

25. Schuller, *Swing Era*, 547.

26. Ibid., 564. See also Frank Büchmann-Møller, *Lester Young* (Washington, D.C., 1988).

27. Schuller, *Swing Era*, 548.

28. Ibid.

29. Ibid., 549.

30. Büchmann-Møller, *Lester Young*, 44.

31. Quoted in Schuller, *Swing Era*, 549. Büchmann-Møller, *Lester Young*, 107.

32. Chilton, *Billie's Blues*, 62.

33. Ibid., 68–69.

34. Billie Holiday, *Strange Fruit*, Verve.

35. Schuller, *Swing Era*, 543; Chilton, *Billie's Blues*, 69; and James Lincoln Collier, *Jazz: The American Theme Song* (New York, 1993), 306.

36. In July 1959, ten years following her conviction and jail term for drug possession and four months after the death of Lester Young, Eleanora Fagan McKay, Lady Day, died, seventy cents left in her savings account. Schuller, *Swing Era*, 546.

37. Kate Simon, *Bronx Primitive* (New York, 1983), 302.

38. Charters and Kunstadt, *Jazz: The New York Scene*, 268. This "discovery" story has several variants, and it's not clear who inserted the sartorially outrageous Christian onto the bandstand that night, Hammond or several members of Goodman's group who felt sorry for the newcomer. All versions, however, converge on the "he knocked their sox off" conclusion of Christian's playing.

39. Schuller, *Swing Era*, 564.

40. Ross Russell, *Bird Lives!: The High Life and Hard Times of Charlie Parker* (New York, 1973), 14.

41. Ralph Ellison, *Shadow and Act* (New York, 1972), 235; Schuller, *Swing Era*, 563.

42. Collier, *Benny Goodman*, 263.

43. Schuller, *Swing Era,* 572. See also, Raymond Horricks, *Dizzy Gillespie* (New York, 1984), 14.

44. Charters and Kunstadt, *Jazz: The New York Scene,* 314.

45. Leonard Feather, liner notes, *The Harlem Jazz Scene, 1941,* Esoteric Records, 1957.

46. Collier, *Benny Goodman,* 265.

47. Horricks, *Gillespie,* 14.

48. Miles Davis, *Miles: The Autobiography* (New York, 1987), 52. See also, Horricks, *Gillespie,* 13, and Feather, liner notes, *Harlem Jazz Scene.*

49. Ellison, *Shadow and Act,* 201.

50. Gillespie, *To Be or Not,* 140.

51. Kenny Clarke, interview, Paris, France, Sept. 30, 1977, Institute for Jazz Studies (IJS), Newark, N.J.

52. Dan Morgenstern, liner notes, *Charlie Parker: First Recordings,* Onyx 221.

53. Milt Hinton, interview, Washington, D.C., 1976, IJS.

54. Ellison, *Shadow and Act,* 205.

55. Koch, *Yardbird Suite,* 35.

56. Quoted in many sources, including Koch, *Yardbird Suite,* 20, and Ellison, *Shadow and Act,* 229.

57. Brian Priestly, *Charlie Parker* (New York, 1984), 15. See also Russell, *Bird Lives!,* 62.

58. Russell, *Bird Lives!,* 5.

59. Patrick, "Charlie Parker," 4.

60. Russell, *Bird Lives!,* 143. Patrick invokes the idea of a contrafact, drawn from classical musical analysis, wherein original melodies are discarded and new ones created on the basis of the original chord structure. This, he and many others argue, was the basis of the bebop revolution. "Charlie Parker," 1–5.

61. Quoted in Gillespie, *To Be or Not,* 116.

62. Koch, *Yardbird Suite,* 29.

63. Gillespie, *To Be or Not,* 72–79; Horricks, *Gillespie,* 25.

64. See the photograph in Horricks, *Gillespie,* 55.

65. Hinton, interview (1976).

66. Milt Hinton, interview, 1977, IJS.

67. Gillespie, *To Be or Not,* 92.

68. Ibid., 210.

69. Quoted in Nat Shapiro and Nat Hentoff, eds., *Hear Me Talkin' to Ya: The Story of Jazz As Told by the Men Who Made It* (New York, 1955), 350.

70. George Hoefer, notes, "Hot Box," in *Down Beat,* Feb. 1, 1962. Hoefer, longtime columnist for *Down Beat,* deposited his notes and rough drafts at the IJS.

71. Hoefer, "Hot Box" (Feb. 1, 1962); Clarke, interview.

72. Clarke, interview.

73. Quoted in Hoefer, "Hot Box" (Feb. 1, 1962); Clarke, interview.

74. Clarke, interview.

75. Monk's biographical information derives from several sources, including Hoefer, "Hot Box," in *Down Beat,* Feb. 11, 1948; *Time,* Feb. 28, 1964 (Monk, amazingly, appeared on the cover), IJS; and Collier, *Jazz,* 383. Monk actually seems to have been born any time between 1917 (according to the *New Grove Encyclopedia of American Music* [New York, 1985]) and 1920 (according to Hoefer).

76. Joe Goldberg, *Jazz Masters of the Fifties* (New York, 1965), 28.

77. Hoefer, "Hot Box" (Feb. 11, 1948).

78. Morgenstern, liner notes, *Charlie Parker.*

79. Garry Giddens, Robert Bergman, and Will Freidwald, liner notes, *Charlie Parker: The Complete 'Birth of Bebop,'* Stash.

80. Quoted in Ira Gitler, *Swing to Bop* (New York, 1985), 71.

81. Koch, *Yardbird Suite,* 30.

82. Gitler, *Swing to Bop,* 69.

83. James Patrick, "The *Ko-Ko* Session," *Journal of Jazz Studies* 8, no. 2 (1981): 78–81.

84. Koch, *Yardbird Suite,* 67.

85. Gillespie, *To Be or Not,* 233.

86. Koch, *Yardbird Suite,* 68.

87. Ira Gitler, *Jazz Masters of the 1940s* (New York, 1966), 27.

88. Max Harrison, "Jazz," in *The New Grove Encyclopedia of Gospel, Blues, and Jazz* (New York, 1980), 294. Says Harrison, "the piece could almost be described as a *presto lamentoso.*"

89. Ellison, *Shadow and Act,* 210.

90. Gillespie, *To Be or Not,* 202–8.

91. Gillespie, *To Be or Not,* 151.

92. Koch, *Yardbird Suite,* 36.

93. Hinton, interview (1977).

94. Gillespie, *To Be or Not,* 149.

95. Quoted in Shapiro and Hentoff, *Hear Me Talkin' to Ya,* 340.

96. Gillespie, *To Be or Not,* 145.

97. Quoted ibid., 143.

98. Davis, *Autobiography,* 57.

99. Gillespie, *To Be or Not,* 281.

100. Quoted in Koch, *Yardbird Suite,* 63.

101. Quoted in Gillespie, *To Be or Not,* 235.

102. Russell, *Bird Lives!,* 167.

103. Hinton, interview (1977).

104. Gillespie, *To Be or Not,* 287.

105. Hinton, interview (1977).

106. Ibid.

107. Ibid.

108. Quoted in Russell, *Bird Lives!,* 274.

109. Ibid. The main theme of *Now's the Time* later became known as "Hucklebuck."

110. Paul Chevigny, *Gigs: Jazz and the Cabaret Laws in New York* (New York, 1991), 4–22.

111. Gillespie, *To Be or Not,* 140.

112. Koch, *Yardbird Suite,* 35.

113. Quoted in Gitler, *Swing to Bop,* 6.

114. Charles Blancq, *Sonny Rollins: The Journey of a Jazzman* (Boston, 1983), and Lee Brown, "The Theory of Music: 'It Don't Mean a Thing,'" *Journal of Aesthetics and Jazz Criticism* (spring 1991), contain the best discussions of the components of jazz in general and bebop in particular.

115. Quoted in Levine, "Jazz and American Culture," 19.

116. Russell, *Bird Lives!,* 162.

117. Koch, *Yardbird Suite,* 41.

118. Ibid., 47–61.

119. Davis, *Autobiography,* 14–43; Chambers, *Milestones,* 18.

120. Chambers, *Milestones,* 30.

121. Davis, *Autobiography,* 60.

122. Ibid., 73.

123. Priestly, *Parker,* 33.

124. Davis, *Autobiography,* 70.

125. Priestly, *Parker,* 37.

126. Koch, *Yardbird Suite,* 139.

127. George Hoefer, "Miles Davis," notes, n.d., IJS.

128. Chambers, *Milestones,* 42.

129. Ibid., 98. The two other sessions, on April 22, 1949, and March 9, 1950, combined with the January 21, 1949, date to make up the Capitol recording, which the company did not release together in an LP until 1954.

130. Hoefer, "Miles Davis."

131. Chambers, *Milestones,* 118.

132. Ibid., 98.

133. Davis, *Autobiography,* 120.

134. Raymond Horricks, *Gil Evans* (New York, 1984), 26.

135. Koch, *Yardbird Suite,* 97.

136. Goldberg, *Jazz Masters,* 32.

137. Sorab Modi, "John Coltrane," *Grove Dictionary of American Music* (New York, 1987), 475. See also John Litweiler, *The Freedom Principle: Jazz after 1955* (New York, 1988), 81.

138. J. C. Thomas, *Chasin' the Trane* (New York, 1975), 66.

139. Litweiler, *Freedom Principle,* 85. The statement may be found on the liner notes to Coltrane's album, *A Love Supreme* (MCI-Impulse).

140. Litweiler, *Freedom Principle,* 87.

141. Chambers, *Milestones,* 278. See also Blancq, *Sonny Rollins,* 77.

142. Some, including several critics assembled to pay tribute to Davis in St. Louis, argue that Davis intended, perhaps manipulated, the response. Miles Davis Symposium, Washington University, St. Louis, Mar. 1995.

143. David Rosenthal, *Hard Bop: Jazz and Black Music, 1955–1965* (New York, 1992), 78.

TEN   Homage to the Spanish Republic: Abstract Expressionism
and the New York Avant-Garde

1. See, for example, Clement Greenberg's 1957 essay, "The Late Thirties in New York," in *Art and Culture: Critical Essays* (Boston, 1961), 234: "By 1943, Pollock, I know, was taking it for granted that any kind of American art that could not compete on equal terms with European art was not worth bothering with."

2. Quoted in Francis V. O'Connor, ed., *Art for the Millions* (Boston, 1973), 44.

3. Holger Cahill, foreword to O'Connor, *Art for the Millions,* 35–37.

4. Richard D. McKinzie, *The New Deal for Artists* (Princeton, N.J., 1973), 80.

5. John Dewey, *Art as Experience* (New York, 1934), 330.

6. Marlene Park and Gerald E. Markowitz, *New Deal for Art* (Hamilton, N.Y., 1977), xiii; McKinzie, *New Deal for Artists,* 81.

7. Park and Markowitz, *New Deal for Art,* 17.

8. John Lane and Susan Larsen, eds., *Abstract Painting and Sculpture in America, 1927–1944* (New York, 1983), 22–23.

9. Ibid., 64.

10. Ibid., 23; Park and Markowitz, *New Deal for Art,* 107; Gorky quotation from O'Connor, *Art for the Millions,* 73.

11. McKinzie, *New Deal for Artists,* 166. A few of the airport project's studies have survived. The Newark Museum continues to show them.

12. See *Flying Tigers: Painting and Sculpture in New York, 1939–1946* (Providence, R.I., 1985), 63.

13. See chapter 8 for a full discussion of the American Artists' Congress.

14. Clement Greenberg, "Avant-Garde and Kitsch," *Partisan Review* 6, no. 5 (1939): 34–49. (Republished in *Art and Culture.*)

15. Ibid., 7.

16. Serge Guilbaut, *How New York Stole the Idea of Modern Art: Abstract Expressionism, Freedom, and the Cold War* (Chicago, 1983), 37.

17. Greenberg, "Avant-Garde and Kitsch," 9.

18. Ibid., 19.

19. William Seitz, *Hans Hofmann* (New York, 1972), 31.

20. Quoted ibid., 11.

21. Irving Sandler, *The New York School: The Painters and Sculptors of the Forties* (New York, 1978), 2.

22. Diana Crane, *The Transformation of the Avant-Garde: The New York Art World, 1940–1985* (Chicago, 1985), 46.

23. Peter M. Rutkoff and William B. Scott, *New School: A History of the New School for Social Research* (New York, 1986).

24. Crane, *Transformation of the Avant-Garde,* 46.

25. Barbara Rose, *Lee Krasner* (New York, 1983), 24.

26. Judith Tolnick, "The Painting: A Background," in *Flying Tigers,* 19. See also Greenberg's "Art Chronicle: Jackson Pollock," *Nation,* Nov. 27, 1943.

27. Annette Cox, *Art-as-Politics: The Abstract Expressionist Avant-Garde and Society* (Ann Arbor, Mich., 1982), 153.

28. Greenberg, "*Partisan Review* 'Art Chronicle': 1952," in *Art and Culture,* 147.

29. Stephen Polcari, *Abstract Expressionism and the Modern Experience* (New York, 1991), 17.

30. Ann Eden Gibson, *Issues in Abstract Expressionism* (Ann Arbor, Mich., 1990), 34.

31. Robert Motherwell to William Baziotes, Sept. 6, 1944, Baziotes Papers, Archives of American Art, Smithsonian Institution.

32. Donald Paneth, untitled manuscript (commissioned, but not published, by *Commentary,* 1952–61), Baziotes Papers, 30.

33. Ibid., 28.

34. *Flying Tigers,* 41–44.

35. Ibid., 8.

36. Sidney Simon, "Concerning the Beginnings of the New York School: 1939–1943," interview by Robert Motherwell, in *Abstract Expressionism: A Critical Record,* ed. David Shapiro and Cecile Shapiro (New York, 1990), 38. (Originally published in *Art International* [summer 1967].)

37. David Shapiro and Cecile Shapiro, introduction to *Abstract Expressionism,* 5.

38. Ibid., 9.

39. Simon, "Concerning the Beginnings," 36.

40. Maurice Nadeau, *The History of Surrealism* (Cambridge, Mass., 1969), 209.

41. Steven Naifeh and Gregory White Smith, *Jackson Pollock: An American Saga* (New York, 1989), 329.

42. Cox, *Art-as-Politics,* 86.

43. Simon, "Concerning the Beginnings," 43.

44. Ibid., 39. See also Naifeh and Smith, *Jackson Pollock*, 423.

45. *Flying Tigers*, 19.

46. Dore Ashton, *The New York School: A Cultural Reckoning* (New York, 1972), 124–26.

47. Irving Sandler, *The Triumph of American Painting: A History of Abstract Expressionism* (New York, 1970), 96.

48. Ibid., 34.

49. *Flying Tigers*, 42.

50. Ibid., 43.

51. Guilbaut, *How New York Stole the Idea of Modern Art*, 67; Lane and Larsen, *Abstract Painting*, 43.

52. Lane and Larsen, *Abstract Painting*, 42.

53. Naifeh and Smith, *Jackson Pollock*, 451.

54. Mark Rothko and Adolph Gottlieb, letter to the editor, *New York Times*, June 7, 1943, cited in Ashton, *New York School*, Sandler, *Triumph of American Painting*, and *Flying Tigers*.

55. Sandler, *Triumph of American Painting*, 175. See also the important article by Stephen Polcari, "Mark Rothko: Heritage, Environment, and Tradition," *Smithsonian Studies in American Art* (spring 1988): 33–63.

56. Polcari, "Mark Rothko," 34–41.

57. *Flying Tigers*, 40. Polcari, "Mark Rothko," 42.

58. Mark Rothko, quoted in Polcari, *Abstract Expressionism*, 137.

59. *Flying Tigers*, 14.

60. Stephen Polcari, "Adolph Gottlieb's Allegorical Epic of World War II," *Art Journal* (fall 1988): 204.

61. Quoted in Polcari, *Abstract Expressionism*, 171.

62. Quoted in Polcari, "Gottlieb's Allegorical Epic," 202.

63. Cox, *Art-as-Politics*, 71–73.

64. *Flying Tigers*, 77–79.

65. Ibid., 80.

66. Ibid., 79.

67. Baziotes to Barr, Apr. 26, 1949, Baziotes Papers.

68. See, for example, Ashton, *New York School*.

69. Michael Aupung, *Abstract Expressionism: The Critical Developments* (New York, 1987), 23. The second part of the quotation is from Rothko.

70. Quoted in Sandler, *Triumph of American Painting*, 93.

71. Quoted ibid., 96.

72. Crane, *Transformation of the Avant-Garde*, 120.

73. Ibid., 2.

74. Sandler, *Triumph of American Painting*, 211.

75. Naifeh and Smith, *Jackson Pollock*, 544.

76. Robert Motherwell, interview by John Jones, Oct. 25, 1965, Archives of American Art. The authors are grateful to the artist and his estate for permission to consult this significant oral history.

77. See two important articles by Dierdre Robinson, "The Market for Abstract Expressionism," *Archives of American Art Journal* 25, no. 3 (1985): 18–23, and "The Avant-Garde and the On-Garde: Some Influences on the Potential Market for the First Generation Abstract Expressionists in the 1940s and Early 1950s," *Art Journal* (fall 1988): 215–21.

78. Robinson, "Market for Abstract Expressionism," 19.

79. Robert Motherwell, "The Modern Painter's World," *Dyn* (Nov. 6, 1944): 9–15. Motherwell to Baziotes, Sept. 6, 1944, Baziotes Papers.

80. Motherwell, "Modern Painter's World," 10. See also Karl Mannheim, *Ideology and Utopia* (1929; New York, 1968). For the story of the transmutation of neo-Marxism from Germany to France, and hence into the hands of other Western intellectuals, see also Mark Poster, *Existential Marxism in Postwar France* (Princeton, N.J., 1975).

81. Motherwell, "Modern Painter's World," 9.

82. Ibid., 14.

83. Robert Motherwell, interview by Paul Cummings, 1971, Archives of American Art, 12.

84. Bruce Kuklick, *The Rise of American Philosophy* (New Haven, Conn., 1977), 362–63.

85. Simon, "Concerning the Beginnings," 33.

86. Motherwell, interview (1971), 15.

87. Alan Wald, *New York Intellectuals: The Rise and Decline of the Anti-Stalinist Left from the 1930s to the 1980s* (Chapel Hill, N.C., 1987), 213.

88. Ibid., 215; Guilbaut, *How New York Stole the Idea of Modern Art,* 21.

89. Guilbaut, *How New York Stole the Idea of Modern Art,* 24.

90. Motherwell, "Modern Painter's World," 10.

91. Quoted in Stephanie Terenzio, *Robert Motherwell and Black* (Storrs, Conn., 1980), 125.

92. Quoted in Jack Flam, "With Motherwell," in *Robert Motherwell: Essays by Dore Ashton and Jack Flam* (New York, 1983), 17.

93. Ashton, *New York School,* and Guilbaut, *How New York Stole the Idea of Modern Art,* agree on the importance of this Cold War winter, though for very different reasons.

94. Harold Rosenberg, "Introduction to Six American Artists," *Possibilities* (winter 1947–48): 75–85.

95. Cox, *Art-as-Politics,* 130; Wald, *New York Intellectuals,* 222.

96. Harold Rosenberg, "Parable of American Painting," in *The Tradition of the New* (Chicago, 1959), 13–22.

97. Motherwell, interview (1965), 15.

98. Ibid., 18.

99. Terenzio, *Motherwell and Black,* 25–27.

100. Flam, "With Motherwell," 20.

101. Motherwell, interview (1971), 71.

102. Dore Ashton, "On Motherwell," in *Robert Motherwell: Essays,* 31.

103. Motherwell, interview (1971), 72.

104. David Caute, *The Great Fear* (New York, 1978), 252.

105. Naifeh and Smith, *Jackson Pollock,* 616–20.

106. Robinson, "Market for Abstract Expressionism," 23.

107. Barnett Newman, "The Sublime Is Now," in "What Is Sublime in Art," *Tiger's Eye,* no. 6 (Dec. 1948): 51. See also Ashton, *New York School,* 184–92.

108. Sandler, *New York School,* 30.

109. Cited in Ashton, *New York School,* 128.

110. Ibid., 193.

111. Irving Sandler, "The Club," *Art Forum* (Sept. 1965): 48.

112. Motherwell, interview (1971), 56.

113. Ibid., 58. See also Ashton, *New York School,* 198.

114. Robert Goodnough, "Artists' Sessions at Studio 35," in *Modern Artists in America* (New York, 1951), 9. This publication had been intended as a continuing one; however, the

stenographic report of the Studio 35 conference proved to be its sole issue. See Ashton, *New York School,* 198.

115. Goodnough, "Artists' Sessions," 10. See also Naifeh and Smith, *Jackson Pollock,* 602.

116. Goodnough, "Artists' Sessions," 10.

117. David Hare, in Goodnough, "Artists' Sessions," 10.

118. Robert Motherwell, in Goodnough, "Artists' Sessions," 21.

119. Good quoted in Sandler, *Triumph of American Painting,* 373.

120. Sandler, "The Club," 51.

121. Ibid., 53.

122. Lionel Abel, "The Modernity of the Modern World," Philip Pavia Papers, Archives of American Art.

123. Guilbaut, *How New York Stole the Idea of Modern Art,* 204.

124. Sandler, *New York School,* 34.

125. Clement Greenberg, "Review of an Exhibition of Willem de Kooning," in Shapiro and Shapiro, *Abstract Expressionism,* 229. (Originally published in *Nation,* Apr. 24, 1948.)

126. Sandler, *Triumph of American Painting,* 133.

127. Irving Sandler's appropriately titled *The Triumph of American Painting: A History of Abstract Expressionism,* published in 1970, notes Elaine de Kooning, "herself a painter," as an oral history source and devotes no single segment to any of the women abstract artists of the time. Twenty years later the volume edited by David Shapiro and Cecile Shapiro, *Abstract Expressionism: A Critical Record,* perpetuates the male character of the Club.

128. Karen Wilkin, *Frankenthaler: Works on Paper* (New York, 1984), 32.

129. Henry Geldzahler, "An Interview with Helen Frankenthaler," *Artforum* 4 (Oct. 1965): 36.

130. E. A. Carmen Jr., *Helen Frankenthaler: A Painting Retrospective* (New York, 1989), 12. Carmen notes that the painting was exhibited twice during the period.

131. Sandler, *New York School,* 67; Schuyler quotation ibid.

132. Quoted in John Elderfield, *Frankenthaler* (New York, 1989), 73.

133. I. F. Stone, *The Haunted Fifties* (New York, 1963).

134. Rutkoff and Scott, *New School,* 230–34.

135. "John Cage," in *New Grove Encyclopedia of American Music* (New York, 1985).

136. Martin Duberman, *Black Mountain: An Exploration in Community* (New York, 1972), 99–100.

137. "John Cage," in *New Grove Encyclopedia,* 599.

138. Sandler, *Triumph of American Painting,* 164; John Cage, interview by authors, New York City, 1977.

139. Sandler, *Triumph of American Painting,* 164.

140. Rutkoff and Scott, *New School,* 231.

141. Quoted in Sandler, *Triumph of American Painting,* 166.

142. Twyla Tharp, *Push Comes to Shove* (New York, 1992), 52.

143. Sandler, *Triumph of American Painting,* 168.

144. Duberman, *Black Mountain,* 288.

145. Ibid., 290.

146. Robert Motherwell, *The Dada Painters and Poets* (New York, 1951), xiii.

147. Allen Ginsberg, interview by authors, Gambier, Ohio, Mar. 1992.

148. Dennis McNally, *Desolate Angel: Jack Kerouac, the Beat Generation, and America* (New York, 1979), 255.

149. Quoted in Ann Charters, *Kerouac: A Biography* (New York, 1973), 188.

150. Quoted in Barry Miles, *Ginsberg: A Biography* (New York, 1989), 146.

151. Miles, *Ginsberg,* 187.

152. Chad Mandeles, "Jackson Pollock and Jazz: Structural Parallels," *Arts Magazine* (Oct. 1981): 139–41.

153. Ben Wolf, "Abstract Artists Pay Homage to Jazz," *Art Digest* (Dec. 1, 1946): 15.

154. Studio Museum of Harlem, *Memory and Metaphor: The Art of Romare Bearden* (New York, 1991), 23.

155. Matthew S. Witkovsky, "Romare Bearden and Abstract Expressionism," *Black American Literature Forum* (summer 1989): 257–82.

156. Romare Bearden, in Studio Museum of Harlem, *Memory and Metaphor,* 65.

157. Ibid., 34.

158. Robinson, "The Avant-Garde and the On-Garde." Robinson's article, in addition to claiming the longest journal title of the decade, points out the activities of collectors Roy Neuberger, Eleanor Gates Lloyd, and Fred Olsen in addition to Nelson Rockefeller as early collecting champions of the abstract expressionists. More difficult to track is the role of architect Philip Johnson, who purchased a large number of works directly from the painters and fed them to the Museum of Modern Art over the next decade.

159. Ashton, *New York School,* 212; Sandler, "The Club," 231.

160. Guilbaut, *How New York Stole the Idea of Modern Art.*

**ELEVEN**    Life without Father: Postwar New York Drama

1. Garff B. Wilson, *Three Hundred Years of American Drama and Theater* (Englewood Cliffs, N.J., 1982), 279–81. See also Gerald Berkowitz, *New Broadways: Theater across America, 1850–1980* (Totowa, N.J., 1982), 1–12.

2. Jack Poggi, *Theater in America: The Impact of Economic Forces* (Ithaca, N.Y., 1965), 87–88.

3. Elia Kazan, *A Life* (New York, 1988), 132.

4. David Garfield, *A Player's Place: The Story of the Actors Studio* (New York, 1980), 40.

5. Kazan, *A Life,* 136.

6. Ibid., 295.

7. Garfield, *Player's Place,* 48.

8. Ibid., 46.

9. Ibid., 51.

10. Arthur Miller, *Timebends: A Life* (New York, 1987), 269.

11. Kazan, *A Life,* 319.

12. Miller, *Timebends,* 133, 269.

13. Arthur Miller, "On Social Plays," preface to the two-act version of *A View from the Bridge,* republished in *Theater Essays of Arthur Miller,* ed. Robert Martin (New York, 1978), 57.

14. Miller, *Timebends,* 62, 145.

15. Arthur Miller, interview by authors, New York City, Feb. 1993.

16. Ibid.

17. Ibid.

18. Miller, *Timebends,* 115.

19. Harold Clurman, introduction to *The Playwrights Speak,* ed. Walter Wager (New York, 1962), xiv.

20. Miller, interview (Feb. 1993).

21. Miller, *Timebends,* 86.

22. Ibid., 144; Miller, introduction to *Collected Plays* (New York, 1956), 1:16.

23. Miller, introduction to *Collected Plays,* 17–19.

24. Miller, *Timebends,* 274.

25. Miller, introduction to *Collected Plays,* 18.

26. Leonard Moss, *Arthur Miller* (Boston, 1980), 20.

27. C. W. E. Bigsby, *A Critical Introduction to Twentieth-Century Drama* (New York, 1985), 171.

28. Kazan, *A Life,* 227.

29. Ibid., 328.

30. William M. Tuttle Jr., *Daddy's Gone to War* (New York, 1993).

31. Tennessee Williams, *Memoirs* (New York, 1975), 10.

32. Bigsby, *Twentieth-Century Drama,* 22.

33. Ibid.

34. Williams, *Memoirs,* 34.

35. Bigsby, *Twentieth-Century Drama,* 24. Given Williams' love for linguistic games, for hidden messages, one wonders about the title of his play, *The Rose Tattoo,* whose film version, starring Burt Lancaster and Anna Magnani, was among the most successful renderings of a Williams play.

36. Bigsby, *Twentieth-Century Drama,* 26.

37. Tennessee Williams, "Something Wild," in *Where I Live* (New York, 1975). (Originally published in the *New York Star* [1945], 10.)

38. Bigsby, *Twentieth-Century Drama,* 35.

39. Williams, *Memoirs,* 69–76.

40. Ibid., 83.

41. Williams, "Something Wild," 12. Williams clearly revised this 1945 essay four years later to serve as the introduction to his *Forty-seven Wagons Full of Cotton.*

42. Robert Motherwell, "The Modern Painter's World," *Dyn* (Nov. 6, 1944): 9–15.

43. David Richard Jones, *Great Directors at Work* (Berkeley, Calif., 1986), 156.

44. Kazan, *A Life,* 340.

45. Williams, *Streetcar,* scene ten.

46. Kazan, *A Life,* 329.

47. Ibid., 338.

48. Ibid., 330. Even the name *Blanche Dubois* seems a disguise: a "white" Du Bois.

49. Toby Cole and Helen Krich Chinoy, "Notebook for *A Streetcar Named Desire,*" in *Directors on Directing* (New York, 1976), 367.

50. Ibid., 374.

51. Brando, in Jones, *Great Directors,* 149.

52. Miller, interview (Feb. 1993).

53. Ibid.

54. Quoted in Jones, *Great Directors,* 190.

55. Miller, *Timebends,* 182.

56. Ibid., 188.

57. Miller, introduction to *Collected Plays,* 23.

58. Miller, *Timebends,* 182.

59. Ibid., 185. See Kazan, *A Life,* 355.

60. Kazan, *A Life,* 361.

61. Ibid.

62. Miller, *Timebends,* 186.

63. Quoted ibid., 187.

64. Kazan, *A Life,* 359.

65. Robert Martin, introduction to *Arthur Miller (New Perspectives)* (Englewood Cliffs, N.J., 1986), 4.

66. Jo Mielziner, *Designing for the Theater* (New York, 1965), 13.

67. Jo Mielziner to Jim Proctor, "Outline of Progressive Stages in the Development of the Production of *Death of a Salesman,"* memo, Mar. 10, 1949, and Mielziner, entry, Sept. 1949, Jo Mielziner Papers, Lincoln Center for the Performing Arts (LCPA) Archives. These notes became the spine of Mielziner's chapter on *Salesman* in *Designing for the Theater,* written sixteen years later, and provide interesting details not included in the book.

68. Mielziner, *Designing for the Theater,* 25.

69. Jo Mielziner to Jim Proctor, memo, Oct. 15, 1948.

70. See for example, Brian Parker, "Point of View in Arthur Miller's *Death of a Salesman,"* in *Twentieth Century Interpretations of Death of a Salesman* (Englewood Cliffs, N.J., 1983), 45.

71. Ibid., 45. Parker concentrates on the forms of German expressionism; the allusion to Joycean style is that of the authors.

72. Arthur Oberg, "*Death of a Salesman* and Arthur Miller's Search for Style," in Parker, *Twentieth-Century Interpretations,* 72.

73. Arthur Miller, interview by authors, New York City, Mar. 1993; Oberg, "Miller's Search for Style," 73.

74. Oberg, "Miller's Search for Style," 78.

75. Brooks Atkinson, *New York Times,* Feb. 11, 1949.

76. Miller, interview (Mar. 1993).

77. William L. O'Neill, *A Better World* (New York, 1982), 163–69.

78. Miller, *Timebends,* 240.

79. Garry Wills, introduction to Lillian Hellman, *Scoundrel Time* (New York, 1976), 8–12.

80. David Caute, *The Great Fear* (New York, 1978), 487–92.

81. Ibid., 492.

82. Robert Vaughn, *Only Victims* (New York, 1972), 76. Napoleon Solo, brother of Han, strikes back.

83. Caute, *Great Fear,* 498.

84. Vaughn, *Only Victims,* 109.

85. Caute, *Great Fear,* 521–25.

86. Vaughn, *Only Victims,* 154. See also Caute, *Great Fear,* 510.

87. Vaughn, *Only Victims,* 167.

88. Kazan, *A Life,* 449–53.

89. Testimony of Elia Kazan, House Un-American Activities Committee (HUAC), *Communist Infiltration of the Hollywood Motion Picture Industry,* pt. 8, 82d Congress, Apr. 10, 1952, 2407.

90. Victor Navasky, *Naming Names* (New York, 1980), 207.

91. Testimony of Clifford Odets, HUAC, *Communist Infiltration,* May 20, 1952, 3511.

92. Hellman, *Scoundrel Time,* 92.

93. Miller, *Timebends,* 331.

94. Ibid., 333. Kazan, *A Life,* 461.

95. Miller, *Timebends,* 337.

96. Ibid., 339.

97. Miller, introduction to *Collected Plays,* 40.

98. Ibid., 39.

99. Miller, *Timebends,* 304.

100. Kazan, *A Life,* 412.

101. Ibid., 499.

102. Ibid., 500.

103. Ibid., 529.

104. Howard Greenberger, *The Off-Broadway Experience* (Englewood Cliffs, N.J., 1971), 12.

105. Richard Cordell and Lowell Matson, eds., *The Off-Broadway Theater* (New York, 1974), xv–xvi.

106. Poggi, *Theater in America,* 174.

107. Ibid., 176.

108. Berkowitz, *New Broadways,* 41.

109. Poggi, *Theater in America,* 179.

110. Ibid., 183.

111. Berkowitz, *New Broadways,* 37.

112. Miller, "On Social Plays," preface to the London production of *A View from the Bridge* (London, 1956), 51. See also Miller, introduction to *Collected Plays,* 47.

113. Miller, "On Social Plays," 59.

114. Bigsby, *Twentieth-Century Drama,* 200.

115. Miller, quoted ibid., 201.

116. Miller, *Timebends,* 355.

117. J. L. Styan, "Why *A View from the Bridge* Went Down Well in London: The Story of a Revision," in Martin, *Theater Essays of Arthur Miller,* 139.

118. *Aware,* no. 18 (Mar. 7, 1956). See "Juvenile Delinquency Film," memo, 1955, Cage File, Drama Division, LCPA Archives.

119. Miller, *Timebends,* 406.

120. Testimony of Arthur Miller, House Un-American Activities Committee, *Investigation of Unauthorized Use of United States Passports,* pt. 4, 23d Congress, June 21, 1956, 4655–87.

121. Miller, *Timebends,* 449.

122. *New York Times,* Mar. 12, 1958.

123. Garfield, *Player's Place,* 73.

124. Quoted ibid., 146.

125. Ibid., 231.

## TWELVE  Renovating the Modern: Monuments and Insurgents

1. *New York Times,* Apr. 16, 1956.

2. *New York Times,* July 29, 1958.

3. See the suggestive and stimulating essay by Thomas Bender and William R. Taylor, "Culture and Architecture: Some Aesthetic Tensions in the Shaping of Modern New York City," in William Sharp and Leonard Wallock, *Visions of the Modern City* (New York, 1983), 189.

4. Albert Cole, interview, New York City, Apr. 4, 1991, Oral History Project, Lincoln Center (LC) Archives. Cole, the administrator of the Housing and Home Finance Agency in Washington, D.C., during the Eisenhower administration, had an unusual and remarkably unbiased view of goings on in New York.

5. Allan Rich, *The Lincoln Center Story* (New York, 1976), 13.

6. Edgar Young, interview, June 11, 1990, Oral History Project, LC Archives.

7. *New York Times,* Apr. 16, 1956.

8. Day and Zimmerman, Inc., Engineers, "Report on Survey to Determine Feasibility of Creating and Operating a Performing Arts Center in New York City," report to the Exploratory Committee for a Performing Arts Center, 1957, LC Archives.

9. Harris L. Present, interview, Feb. 15, 1991, Oral History Project, LC Archives.

10. *New York Times,* Aug. 31, 1956.

11. Present, interview.

12. Cole, interview.

13. Braislin, Porter, and Wheelock, Inc., "Relocation Analysis," Oct. 1958, LC Archives.

14. *New York Times,* July 19, 1959.

15. *New York World Telegram and Sun,* Dec. 3, 1958.

16. Curiously, Kirstein, scion of Filene's, and Blum, of Abraham and Strauss, had the kind of assimilated Jewish pedigree that enabled them to move in the high-culture circles of New York dominated by the Rockefellers. Blum recalled that one day just after the war Robert Moses, who possessed a similar cultural-religious background, came by to tell his father, "I've got a Christmas present for you. The Long Island Expressway isn't going to go through your living room." After thirty years of reflection, Blum stated in 1990, "I may have been put on the Board as a professional Jew." Robert Blum, interview, June 30, 1990, Oral History Project, LC Archives.

17. Young, interview.

18. Ibid.

19. W. McNeil Lowry, interview, Jan. 11, 1990, Oral History Project, LC Archives.

20. Ibid.

21. Meryle Secrest, *Frank Lloyd Wright* (New York, 1992), 545.

22. Solomon R. Guggenheim Foundation, *From van Gogh to Picasso, from Kandinsky to Pollock: Masterpieces of Modern Art* (New York, 1990).

23. Secrest, *Wright,* 249.

24. William Jordy, *The Impact of European Modernism in the Mid-Twentieth Century* (New York, 1986), 280.

25. Lewis Mumford, "The Skyline," *New Yorker,* Nov. 28 and Dec. 12, 1953.

26. Marcus Whiffen and Frederick Koeper, *American Architecture, 1607–1976* (Cambridge, Mass., 1981), 370.

27. Secrest, *Wright,* 548.

28. Lloyd Goodrich and John Baur, "American Art of Our Century," in Goodrich, *Whitney Museum of American Art: A Brief History,* Whitney Museum of American Art (WMAA) Archives.

29. See Whitney Museum of American Art, "Exhibition Schedule," WMAA Archives, updated regularly.

30. Bernard Harper Friedman, "The Whitney's New Home," n.d., WMAA Archives.

31. Flora Irving Biddle to her parents, Flora Miller and G. MacCulloch Miller, June 5, 1963. The authors are grateful to Anita Duquette of the Whitney Museum of American Art for providing a copy of the letter.

32. Whiffen and Koeper, *American Architecture,* 396.

33. Marcel Breuer, "The Architect's Approach to the Design of the Whitney Museum," *Whitney Review* (New York, 1955–56), 4.

34. Robert A. M. Stern, Thomas Mellins, and David Fishman, *New York, 1960* (New York, 1995), 1167.

35. Ibid., 33.

36. W. J. Weatherby, *James Baldwin: Artist on Fire* (New York, 1989). See also David Leemings, *James Baldwin: A Biography* (New York, 1994), and Horace A. Porter, *Stealing the Fire* (Middletown, Conn., 1989).

37. James Baldwin, *Nobody Knows My Name: More Notes of a Native Son* (New York, 1961), cited in Leemings, *James Baldwin,* 49. See also James Campbell, *Talking at the Gates: A Life of James Baldwin* (New York, 1991).

38. Leemings, *James Baldwin,* 405–17.

39. Campbell, *Talking at the Gates,* 33.

40. See for example, John D'Emilio, *Sexual Politics, Sexual Communities: The Making of a Homosexual Minority in the United States, 1940–1970* (Chicago, 1983), and George Chauncey, *Gay New York: Gender, Urban Culture, and the Making of a Gay Male World, 1890–1940* (New York, 1994).

41. Weatherby, *James Baldwin,* 73.

42. Ibid., 75; Campbell, *Talking at the Gates,* 65.

43. Quoted in Campbell, *Talking at the Gates,* 121.

44. Leemings, *James Baldwin,* 150.

45. Ibid., 156.

46. James Baldwin, "Letter from a Region in My Mind," *New Yorker,* Nov. 17, 1962, 38; James Baldwin, *The Fire Next Time* (New York, 1963); Leemings, *James Baldwin,* 409.

47. Quoted in Campbell, *Talking at the Gates,* 160.

48. Baldwin, *Fire Next Time,* 44–50.

49. Ibid., 72.

50. Weatherby, *James Baldwin,* 220–25. See also Campbell, *Talking at the Gates,* 166.

51. Weatherby, *James Baldwin,* 222–23.

52. Ibid., 249.

53. James Baldwin, *Blues for Mister Charlie* (New York, 1964), 1.

54. All quotes are from the Dial Press edition of James Baldwin, *Blues for Mister Charlie* (New York, 1964).

55. Campbell, *Talking at the Gates,* 196–99.

56. Patricia Bosworth, *Diane Arbus: A Biography* (New York, 1984), 48.

57. Ibid., 72.

58. Susan Sontag, *On Photography* (New York, 1973), 40.

59. Janet Malcolm, *Diana and Nikon* (Boston, 1980), 117.

60. Norman Mailer, inside cover notes to Diane Arbus, *Diane Arbus: Magazine Work* (New York, 1984). The Mailer photograph appeared in the *New York Times Book Review,* Nov. 17, 1963.

61. Bosworth, *Diane Arbus,* 129.

62. Sontag, *On Photography,* 46.

63. Diane Arbus, *Diane Arbus* (New York, 1972), 9.

64. Bosworth, *Diane Arbus,* 168.

65. Sontag, *On Photography,* 44.

66. John Szarkowski, inside cover notes to Arbus, *Arbus.*

67. Red Grooms, interview by Paul Cummings, Mar. 4, 11, and 18, 1971, Oral History Project, Archives of American Art, Smithsonian Institution.

68. "Conversation with Red Grooms," 1965, Archives of American Art.

69. Judd Tully, *Red Grooms and Ruckus Manhattan* (New York, 1977), 7.

70. Tom Wolfe, *The Kandy-Kolored Tangerine-Flake Streamline Baby* (New York, 1965), 248–49.

71. Tully, *Ruckus Manhattan,* 8; Mimi Gross, interview by authors, New York City, Sept. 1994.

72. Grooms, interview.

73. Sally Barnes, *Greenwich Village, 1963* (Durham, N.C., 1993), 51–54.

74. Grooms, interview.

75. Ibid.

76. Ibid.

77. Tully, *Ruckus Manhattan,* 11.

78. Gross, interview.

79. Ibid.

80. Gross, interview.

81. Ibid.

Index

Index

Index

Index

Index

Index

Library of Congress Cataloging-in-Publication Data

Scott, William B., 1945–
    New York modern : the arts and the city / William B. Scott and
Peter M. Rutkoff.
        p.   cm.
    Includes bibliographical references and index.
    ISBN 0-8018-5998-0 (acid-free paper)
        1. Arts, American—New York (State)—New York.   2. Arts,
Modern—20th century—New York (State)—New York.   3. New
York (N.Y.)—Social life and customs—20th century.   I. Rutkoff,
Peter M., 1942–        .   II. Title.
NX511.N4S38   1999
700′ .9747′ 10904—dc21                                          98-41864
                                                                    CIP